Marc Chagall

Also by Sidney Alexander

HISTORY
Lions and Foxes: Men and Ideas of the Italian Renaissance

NOVELS

The Hand of Michelangelo
Michelangelo the Florentine
The Celluloid Asylum

POETRY

Tightrope in the Dark
The Man on the Queue

TRANSLATIONS

The Berenson Collection (with Frances Alexander)
The History of Italy by Francesco Guicciardini, translated by Sidney
 Alexander
The Maine Cemetery: Variation on Valéry

PLAYS

Salem Story
The Third Great Fool

chagall

Marc Chagall
A Biography

—— By ——

Sidney Alexander

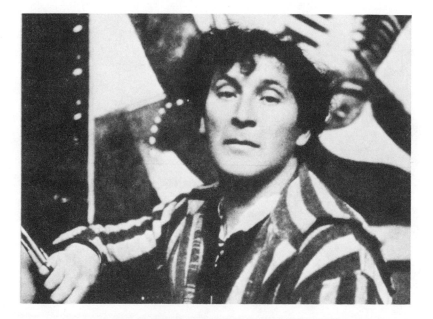

G. P. Putnam's Sons
New York

SBN: 399-11894-2

Alexander, Sidney, 1912-
 Marc Chagall

 Includes index.
 1. Chagall, Marc, 1887- 2. Painters—Russian
Republic—Biography.
ND699.C5A67 1978 759.7 [B] 77-16526

PRINTED IN THE UNITED STATES OF AMERICA

For Frances
always

A Chassid was asked whether he visited his Tsadik (a saintly man) to hear his words of wisdom.

"No," he answered. "I want to see how he ties his shoelaces."

Contents

Acknowledgments

In the interest of shaping a living biography out of living words, I have drawn as much as possible from numerous interviews conducted in France, Belgium, Italy, Switzerland, Israel, Mexico, Canada and the United States. This was especially necessary in view of the fact that published writings on Chagall's life and art have often been authorized or controlled to some degree: omissions and distortions are not infrequently willed. The result is inevitably auto-hagiography wherein the sitter dictates his portrait for posterity.

I am deeply grateful to all those whose vivid memories served to quicken my re-creation of Chagall's life and times. And I also want to thank the many others not specifically mentioned in the text—friends and acquaintances of the artist at one time or another in his long life, museum directors, gallery owners, dealers, fellow artists, critics, writers, etc.—who have spoken freely to me, thus providing those observations *viva voce* that are so often more revealing than published writings or other documentation. My most important debts with regard to interviews are embodied in the text.

I must however make special mention here of my profound gratitude to Virginia Leirens, Chagall's companion over a period of seven years, and mother of his son David. Without her cooperation an entire period of the Maestro's life would have remained, as it has hitherto, in the realm of conjecture. Enduring with patience and courage the auctorial probe and scalpel, Virginia Leirens prepared for

11

me a memoir of her years with Chagall from 1945 to 1952, embodying entirely new materials rich with insights and presented with candor, taste and sensitivity. I have woven much of this into the pertinent chapters.

Chagall's son David and his stepsister Jean McNeil have also been most gracious in providing me with intimate memories of their childhood. I also thank the artist's daughter, Madame Ida Chagall Meyer, for our interview in Paris, which added certain touches to my portrait.

Edouard Roditi, who has written with wit and erudition on this subject and the whole ambiance of the Ecole de Paris, was most generous in sharing his personal and critical observations.

In the course of this book I have made it my business to see *in situ* every work of art by Marc Chagall I could. Inasmuch as this artist's fecundity equals, or possibly exceeds, Picasso's, this has entailed many miles and many years of travels. Museum directors have been most cooperative always. Franz Meyer, the artist's former son-in-law and author of a fundamental work on Chagall, now Director of the Kunstmuseum in Basel, was candid and informative. Madame Elisheva Cohen, Curator at the Israel Museum in Jerusalem, took me down into the vaults to show me works by Chagall not usually on exhibition. Conversations with the librarian of the Tel Aviv Museum, Mira Friedman, cast light on certain ambiguities. Most cooperative and sympathetic always was the Yiddish poet Abraham Sutzkever, the artist's friend over many decades. I profited immensely from conversations with him and drew much from his writings. Others in Israel whose observations illuminated if they did not resolve that riddle—the "Jewish" artist—were Dani Karavan, the sculptor, and his wife Chava; Dr. Bezalel Narkiss; Lilik Schatz; David Lazer; Amnon Barzel; Gabriel Talphir; Joseph Buxenbaum; and the mayor of Jerusalem, Teddy Kollek. Beth and Amos Elon in Florence prepared the way for many of these fruitful visits in Israel.

In the United States special thanks must be expressed to Max Lerner, Meyer Schapiro and Boris Aronson: their chromatic conversations brought magically to life Chagall in Berlin after World War I, and in exile in New York during World War II. Chaim Gross was kind enough to provide me with Chagall's "corrected" drawing; the sculptor and his wife Renee were a bubbling font of anecdotes.

I am very grateful to M. L. Shneiderman, whose conversation is as

sharp as his excellent articles in both the Yiddish and American press. The Reverend Marshall C. Smith, Minister of the Union Church of Pocantico Hills, New York, was kind enough to permit me to read his doctoral thesis on the magnificent Chagall windows. Pierre Matisse, Chagall's dealer, revealed in obliquity facets of his long relationship with the artist and generously provided me with photocopies of invaluable old catalogues. Others in the United States who helped were: Alexander Calder, Rebecca and Raphael Soyer, Alfred Werner, Emily Genauer, Marissa Goldberg, Zero Mostel, Theodore Fried, Irene Roth, Paul Friedman, and Herman Rabin. The librarians at YIVO, Institute for Jewish Research, were always patient and cooperative.

In Rome I listened with a delight to the Spanish poet Rafael Alberti's memories of Chagall in Paris in the thirties. In Florence I profited from conversations with Ulrich Middeldorf, Giovanni Colacicchi, Mikulās Rachlík and Signora Marcella Traballesi. The Marchese Bino Sanminiatelli analyzed Vitebskian verve with Tuscan wit: I am most grateful for those afternoons in his villa. In the hills near Carrara, Jacques Lipchitz' widow Yulla recounted the relationship between the sculptor and the painter. Wanda Lattes presented some glinting personal observations of Chagall's visits to Florence which were omitted from her articles in *La Nazione*. At a swimming pool near Fiesole, Jack Murphy and Piet Nijland unexpectedly came up with the long-sought key to an untapped treasure box of Chagalliana. Ayala Zacks Abramov kindly permitted me to examine her private collections in Toronto and Tel Aviv.

My mother, Sadie Alexander, scanned the Yiddish press in the United States and provided invaluable assistance in translation. In Florence, I was fortunate to have the help of Rachel Graetz, who spent many hours reading and helping me to translate Chagall's Yiddish letters as well as articles about the artist in Hebrew.

My editor, William Targ, initiated this project and was unfailing always in his support, encouraging when the sails hung limp, and perspicacious in his criticism. My wife, Frances, as always X-rayed every word in the text from a literary and human point of view, assayed both the writing and the writer with wit and warmth, and performed another of her magic acts of paleography: deciphering and typing the huge manuscript.

Part One
Vitebsk
1887-1906

The world in which Marc Chagall grew up is no more now than shards of memory. The log cabins of his Vitebsk served to stoke the ovens of Treblinka. His fiddlers on the roof have flown to Paradise . . . via Hell.

An imaginative reconstruction of that world—its physical housing and the souls it housed—is of course possible and even suggestive. But the real images of Pestkovatik, the village where he was born on July 7, 1887, and the larger nearby town of Vitebsk where he grew up, serve only as points of departure. To set the Chagallian *stetl* alongside the real *stetl* is a lesson in metaphysics. His Vitebsk is the capital of a state of mind. His nostalgia became even more attenuated after the destruction of the Pale by the Nazis. His fable could no longer be measured against bricks and mortar: he was looking at a specter through the wrong end of a telescope; physical annihilation only intensified the original psychic distance from the "real." Now, especially, his Paris-Vitebsk binomial became a yoking of a dream and a view through the window. But even the reality of Paris was metamorphosed as it was seen. The metamorphosis of Vitebsk had taken place long before. For the physical act of seeing is only the trampoline from which Marc Chagall takes off on his acrobatic

visions. He is a seer, not a see-er. He witnesses, he testifies. His world is all transformation, myth.

To compare, by means of documents, the stories of Sholem Aleichem, Bialik, Samuel, Silver, to reanimate the ectoplasmic sepia inhabitants of photo albums, to read or hearken to the memories of survivors, to reconstruct in the mind that entire vanished world which the Germans destroyed provides us only with a ghost map of Chagall's terrain. His *stetl* is drenched in Oriental color. The dominant color of the real *stetl* was mud. Chagall's wooden houses are mother-goosish, dwellings of good fairies and demons. The real isbas were not unlike American log cabins, but not so well fitted together, dreary habitations indeed. In Chagall they are domiciles of dream.

What was the real Vitebsk? Certainly not a little Jewish village. The paintings of Ivan Puni, a Russian Dadaist, show us a modern factory town. There were certainly village enclaves, whole neighborhoods of Jews within it. But not even this bears on Chagall's *stetl*, which is no more a place than the "space" within which a medieval *fond' oro* Madonna sits. Chagall's blue is as metaphysical as medieval gold. Since Heaven was not a place, there were no laws of perspective; since Chagall's creatures occupy Heaven (or Hell) there is no reason why they must obey the law of gravity or any other law. The art of rendering appearances has nothing whatever to do with visionary art. Visionaries are not visual.

The real Vitebsk of Chagall's youth was a bustling city situated on both sides of the Dvina River in Byelorussia, not far from the Lithuanian border. Probably founded before the tenth century and mentioned in Russian chronicles as early as 1027, Jewish tradesmen came to Vitebsk in the fifteenth century, possibly earlier. In 1897, when Marc Chagall was ten years old, Vitebsk had a Jewish population of 39,520 out of a total of 65,371. There were several synagogues, many houses of prayer, schools for boys and girls, a rabbinical school, a Talmud Torah, a Jewish hospital. It was certainly not a dream village of weightless inhabitants. The law of gravitation—not to speak of taxation or segregation—had not been abolished. The inhabitants were quite solidly attached to the earth. Extensive trade was carried on by Jewish merchants with Riga and foreign countries. The chief articles of export were breadstuffs, flax, hemp, beet sugar, and timber.

Jews were especially prominent in manufacturing. Hundreds of Jewish tailors were employed in making clothing sold in stores of the large Russian cities. In that very year of 1897 when the ten-year-old Chagall was seeding his soil for future visions, a Jewish machinist established a shop in Vitebsk for manufacturing plows; by 1905, just before Marc went to study painting under Jehudah Pen, there was an annual output of between 25,000 and 30,000 plows made in five factories by about 400 Jewish mechanics.

Vitebsk had fifteen Jewish machine shops, Jews worked in linen mills, manufactured eyeglasses, were cabinetmakers and the like. That not a trace of this imagery appears in Chagall's paintings simply proves that he almost never—with the exception of very brief "realistic" periods—painted what he saw but what he felt.

But if his cities are psychic fabrications, Chagall's depiction of nature—stenographic as it is—yet bears a closer relationship to tangible fields, skies, seas. In no sense a landscape artist, his in-scapes are nevertheless affected by his surroundings. One can without too much difficulty trace out in his paintings the various places where Chagall has made them: the first realistic landscapes dating from his return to Russia in 1914, the regions of France he variously visited or lived in between the wars, the Mexican gouaches of 1942-43, the "window" paintings of upstate New York in the Adirondacks (1945-48), the marines of Saint-Jean-Cap-Ferrat (1949), the Greek gouaches (1952-53), the soul-scapes of Gordes and Provence (1950 on).

So, undoubtedly, the countryside around Vitebsk must have been deposited into the memory bank of images from which artists make withdrawals all their lives. Although the family moved a few years after Marc's birth from the little wooden cabin in Pestkovatik—"the bump on the head of the rabbi in green"—to a stone house in Vitebsk near the domed Ilynsky church and railroad station on the right bank, the boy made frequent journeys to his maternal grandfather, the butcher, at Lyozno. From his earliest years imagery of town and country interflowed: lion-colored fields of grain insinuating their golden strips between the little wooden houses, countryside commingling inextricably with village and town, house and tree, forest and street, wheat and shops, nature and human nature.

At his birth, so Chagall's mother told him, a great fire broke out in the quarter of the poor Jews behind the prison. So bed and mattress,

mother and child had to be carried to a secure place across the city. Images throng of the Christ child and the flight into Egypt. This fire appears in several paintings, notably in the *White Crucifixion* of 1939. But above all, in his archly innocent way, Chagall tells us, he was "still-born," he didn't want to live. The infant was a "white bubble" . . . "As if [in an incongruous self-indulgent image] it had been crammed full of paintings by Chagall." So we have a still-birth heralded by flames, pricked into life by pins, dunked into a bucket of water. "Finally I whimpered." Chagall's admonition not to draw psychological consequences from this fabulous account of his birth is obviously an invitation to do just that.

From the very start of his autobiography we are faced with mythmaking, the complicated clear Chagall with his concealed confessions and sly revelations. He opens his heart to you but first performs a magician's trick of transforming the heart into another organ. There is no such thing as a *fact* in Chagall's memoir and his seeming naïveté is calculated to the fingertips. He is the choreographer of the sincere: a great actor in paint; and the canvas is his stage.

This does not make lies of his truths, insincerities of his sincerities. Malleability is the secret of great recitation; the actor must be available to every deformation of reality to speak his truth. The "meanings" in Chagall, therefore, must be sought far below the surface of that painting-skin he likes to talk about.

Most of our knowledge of Chagall's family is derived from his autobiographical sketch, *My Life*, characterized like his paintings by abrupt expressionist leaps and lacunae—which he began to write in Russia in 1921 (when he was thirty-four years old), completed in Berlin in 1922, but was not to publish until ten years later when the first French edition appeared. *My Life* bears the same relationship to the "facts" as do Chagall's paintings: "real facts" are resmelted in a crucible to make a work of art, a metaphor machine. To say that *My Life* is a masterly construction is not to doubt its veracity; it is rather to stress that the prose of event has been transmuted into poetic drama, and that in these pages reality is rearranged quite as freely as it is in Chagall's canvases. "At these words, my head gently detached itself from my body and wept near the kitchen where they were preparing the fish." When Marc and Bella embraced, did their nuptial flight up to the ceiling and out the window take place first in

Vitebsk, or in the celebrated painting, or in the pages of his memoir?

Like his painting, *My Life* is a troubling alloy of naturalism and magic fiction, the two elements sometimes attest to a caustic verve, caricature, self-mockery; a motley of moving clumsiness, sometimes a squall of colors, fireworks. As Elisa Debenedetti puts it in her surgical analysis of Chagall's mythmaking: ". . . in order that *My Life* might be fruitful as a true autobiography of Chagall, it would be necessary to correlate it with an apparatus of notes that would spell out everything" to which Chagall alludes or had pushed into the background of exceptional moments in this book, which, like his paintings, combines "hermetic allusiveness with almost shameless confession." He hides under the bed or flings off the covers and shows himself and his beloved naked in an intimate embrace. The writing is like his painting—visceral. "My canvases vibrate with sobs." But his candor also contains a complementary dose of not so innocent astuteness.

For Chagall not only assimilates himself to the world but he makes the world assimilate the Jewish childhood he carries within him as the ancient Hebrews carried their tents. Having enjoyed a childhood which was certainly less poor, less suffocating than, let us say, that of Soutine, in a Jewish community that was already communicating better with the outside world, he is able to look back with a different perspective, more joyous, unusually nostalgic for a Jew who had moved to the West. Then at a moment of great success, after shows in Berlin and Paris, he proceeds to transfigure his memories. In the crucible of his imagination all the mud becomes rainbows. But though no one can fail to take delight in these lyrical bursts, these syncopes and ellipses of imagery, they hardly serve as an accurate, realistic picture of the world Chagall grew up in.

My Life is indeed more valuable as a psychic autobiography than as a straightforward narration of events in a life. Especially must one keep in mind the fact that these pages were written after 1919 when he had already in great part, and perhaps definitely, found himself. Obviously it is the fate of every autobiography to follow after the facts and interpret them. But precisely for this reason, *My Life* does not succeed in giving that freshness of Chagall's paintings which the reader might be tempted to search for. The artist's life, beginning with his childhood, the simultaneous growth of his intimate world and the discovery of the external world and his confrontation with it:

all this which conditioned the birth of so special a kind of painting appears, vice versa, in the book already conditioned by the mode of seeing and transfiguring already elaborated in his preceding pictorial experience. Ambiences, places, feelings, situations, episodes are represented there as if they were equivalent paraphrases of Chagall's paintings. At the end the artist himself admits it: "These pages have the same value as a painted surface. . . ."

"If there were a hiding place in my pictures, I would creep into it. . . ." A book, therefore, to be read with extreme circumspection, as a confirmation *a posteriori*, a ratification sought for on a literary level of what has been achieved on a figurative level.

The new neighborhood where the family lived was ". . . simple and eternal, like the buildings in the frescoes of Giotto." Churches, fences, shops, synagogues . . . and coming and going, trotting about their affairs with the peculiar haste of those driven by History or God or the Czarist State—craftsmen, rich men, beggars, shopkeepers, schoolboys creeping like snails reluctantly to *cheder*, chickens pecking in the courtyard fenced with wooden palings. Chagall tells us about the stars . . . "my sweet ones" . . . but he doesn't say very much about the mud of unpaved streets, the unattractive garments of men and women alike, the tasteless décor of even middle-class and wealthy families, the generally unaesthetic surface of life in the Pale of Settlement.

And that this memory picture should evoke the fairy-tale architecture of the great Tuscan founding father of European painting reminds us once again of the endemic mythmaking of Chagall's mind.

Since Vitebsk was the second-largest city of the province, and more than half of its population Jews, there was no ghetto physically or even psychologically. Jews moved freely everywhere about the city, and if there were the usual majority of the poor and those of modest income, there were also numerous professionals, doctors, lawyers, teachers, bankers, rich merchants in some cases intermarried into the Christian community. And of course, the Jews, especially as they became more and more emancipated through education or participation in liberal or revolutionary movements, were inevitably Russified.

When young Marc visited his paternal grandfather, the rabbi at Rejitsa, the countryside through which he passed—with its vast flat plains, almost like an American prairie, roads bordered with half-wild

shrubbery, fields of golden wheat, thick forests penciled white with birch stands—was a Russian landscape. Calm and peaceful flowed the Dnieper and its tributary, the Soj. Countryside mingled inextricably with village and town: house and tree, forest and field, wheat and marketplace, nature and human nature, the vastness, the solitude, the sordidness—these were Russian images; although in the small *stetl* especially, Jewish men wore the ritual fringes and the black flowing caftan and fur-trimmed hat which they had inherited from the Ukrainian and Polish gentry. The women's dress was like that of their Russian Christian neighbors: long skirts, long sleeves, high buttoned collars; and even that part of their costume which was distinctively Jewish—their wigs, which they wore in accordance with the prescription to shave their hair at marriage that they not be attractive to other men, were made so beautifully as to become cosmetic and aphrodisiac rather than prophylactic.

Aside from the few distinctive differences, the dress of Jews in the villages was no different from that of other peasants: shapeless clothes of thick brown linen woven at home. In Rejitsa Marc saw them swirling along (his countrymen always seemed to be in a hurry: was it a rendezvous with destiny?) with their full beards, their floating lappets, their sturdy boots. The first sign of emancipation, whether Zionist or Socialist, was to shave off one's beard and get into a "European" suit. When the provincial Chagall meets the sophisticated Léon Bakst for the first time, "It seemed only by chance that he was dressed in European fashion. He is a Jew. Above his ear are twisted reddish locks. . . ."

Fixed though they might be in the ritual of centuries, distinctive in their food habits and ceremonials, buried in their own cemeteries and washed in their own public baths; although there were distinctly Jewish professions—circumcisers and *shameses, cheder-melameds* (teachers in primary school) and psalm sayers, makers of *tsitsis* (fringed garments) and jesters who entertained at weddings—there was much else in their lives that was indistinguishable from that of their Russian neighbors.

They were furriers, carters, weavers. They cultivated their little garden plots. They kept small grocery stores (Marc's mother began to do this to supplement her husband's limited earnings). They peddled their merchandise from village to village. They were rope-makers, tailors, carpenters.

On the Sabbath—Saturday—they doffed their quotidian garments of

filth and toil (as Machiavelli put it, describing his sacral interludes with classical sages) and garbed themselves decently in their Sabbath clothes and gathered together in their little synagogue to recite their prayers and sing their psalms.

It was a peaceful area, dotted with hamlets and tranquil villages, studded with Orthodox and Catholic churches as well as synagogues. But like the rivers which in spring would burst their covering of ice and inundate the banks, so the human calm was sometimes broken: a wave of pogroms would hurl against the Jewish villages or neighborhoods, and then, like a storm, would pass and life resume its peaceful way. So, frequently, in Marc Chagall's most lyrical works, the violence is there: sometimes implicit in the hysterical garish colors and grotesque maceration of "normal" form, sometimes explicit in images of burning isbas, proud old Jews clasping onto their Torahs like children clasping onto Mama's skirts, Christ Crucified in tallith and phylacteries.

The synagogues, usually constructed of wood, on rare occasions displayed marks of architectural originality. Forbidden by law to be higher than the churches, inside there might be splendid accoutrements in an Oriental style, with embroidered cloths for the Torahs, crowns of silver, Hanukah lamps, and finely engraved censers. A synagogue could not stand too close to a church because the chanting of prayers might interfere with Christian services. Most of the structures were archaic, bare, simple; some few had second stories, carved towers, and outside galleries. Some of the *shuls* were built like fortresses with heavy gates so that the Jews might take refuge in the house of God from the wrath of man.

Animals were everywhere: in the streets, in the fields, in the alleyways between the isbas: chickens, geese, ducks, cats, dogs, goats, cows. All of these creatures very soon inhabited Marc's canvases. In some of the towns near the Polish border, an almost primitive animism expressed itself in endowing plants, animals, all of nature with Jewish characteristics. At the approach of the High Holy days . . . "fish trembled in the water." In springtime blossoming bushes "were getting ready for Pesach." Trees swayed in the wind "like Jews on the day of Yom Kippur." A rooster crowed like a "hoarse cantor." A goat looked like the rabbi: were not both of them bearded? Chagallian metamorphosis was in the air he breathed.

Despite the Mosaic injunction against the making of images—

"Thou shalt not make unto thee any graven image, or any likeness of anything that is in heaven above or that is on the earth beneath or that is in the water under the earth. Thou shalt not bow down thyself to them"—this celestial *diktat* has, in the millennial history of the Jews, been interpreted rather freely according to circumstance.

In fact, the injunction is ambiguous to begin with. Is it limited to "graven" images—that is, carved sculptures (what about modeling?) or reliefs? Does it include painting as well? Does it refer only to those images which were worshipped? "Thou shall not bow down thyself to them." And does the phrase "any likeness of *anything*" include inorganic as well as organic, a landscape or a rock as well as a man?

Throughout Jewish history this ambiguity has left a limited field for Jewish visual art. There has always been the phenomenon of departure from strict Mosaic rule. The stiff-necked people are also very flexible. Even as early as the third century the synagogue frescoes of Dura-Europos included figurative as well as nonfigurative subject matter. Lions embroidered on the hangings in front of the Holy of Holies, figures in Torah coverings or silver caps—all these are found throughout the Middle Ages. And although one cannot find any Jews mentioned in the artists' guilds of the Italian Renaissance, this does not prove that there were no Jewish painters or sculptors, but merely that they could not join a Christian guild. It is difficult to conceive of a Jew in the Guild of St. Luke; it is even more difficult to conceive at that time of a Jew painting a Crucifixion or a Betrayal of Judas.

At any rate, fifteenth and sixteenth-century Italian Hebrew Bibles and Haggadahs (the book read at the Passover ceremony) with their wealth of illumination are in this respect indistinguishable from Christian Bibles or Missals. In the Jewish Scriptures as in the Christian, we find beautifully designed richly colored illustrations of Adam and Eve, Expulsions from the Garden, and fanciful beasts and flowers and all those likenesses forbidden by the Decalogue.

Nevertheless, these exceptions are oases in the desert.

The ancient temple of Solomon, as best as we can reconstruct it in the mind's eye from Biblical description (mostly quantitative) and archeological excavation, must have been an impressive but ugly building. Among the great peoples of antiquity, the Jews—up until the nineteenth century—are notable for their lack of interest and

achievement in the visual arts.* Compared with the record of the
Egyptians, the Assyrians, the Persians, the Greeks, the Romans,
there seem to be no notable Hebrew creations in sculpture, painting,
or architecture. The Mosaic injunction against image-making might
explain the relative paucity of Jewish achievement in the first two
arts. And the wanderings of the *Galut* have been adduced to explain
the lack of architecture, which is an art of *place,* of a people *situated.*
But the Bible is full of inveighings against the Jewish failure to obey
the laws: hence why did they not disobey the Fourth Commandment
as well and make visual art? And there certainly were spans of
centuries both during the periods of the ancient states of Israel and
Judah, and afterward during the Diaspora (in Spain, for example),
when the Jews were seated in one place for many centuries, which
should have given rise to an architecture. Yet a survey, as in Cecil
Roth's *Jewish Art,* of two thousand years and more of handicrafts,
temple embroideries, curtains for the Ark, Torah caps, silver point-
ers, Haggadah lamps, the synagogues of Amsterdam and Prague, etc.,
forces one to the conclusion that the Jews built magnificent cathe-
drals of the mind but not of stone, created brilliant images in poetry
but not in paint, and praised Jehovah in passionate cantorial chant but
not in statues.

Certainly in the Pale of Settlement of Chagall's boyhood, Jewish
artists were as rare as dodos, and the few that existed were looked
upon with suspicion by their co-religionists. There is no proof of the
tradition that Hayim Ben Isaac Segal, who in the eighteenth century
had decorated the timber synagogue of Mogilev with murals, was an
ancestor of Chagall. And one wonders, as in so many of the "facts"
of *My Life,* whether this was not an insertion to create artistic
forebears. Surely there was no heritage of art in his immediate family
and none in the Jewish world around him.

Nor was Russian life any more conducive to the visual arts.
Russian villages were quite as dismal as Jewish ones. Russian
household decoration, appliances, domestic articles, mode of dress,
sleds, church architecture were certainly not on a par with the

* Bruno Zevi, an Italian architectural historian, argues that the Jews are fundamentally a
"temporal" rather than "spacial-minded" people; and thereby deduces an "anti-classical
disintegrating" treatment of space in painting, sculpture, and architecture by Jews. The notion,
similar to Spengler's metaphysical historiography, is more suggestive than demonstrable.

aesthetic ambience in which Italians or Frenchmen or Englishmen or Czechs grew up. There was a poverty of style in Eastern Europe as there still is. Nor were the peasant traditions: the tablecloths, linen, embroideries, woodblock molds, which the *Lubok* movement of populist Russian painting picked up and brandished as a weapon against the stultifying academic art taught in the academies—another aspect of Panslavism versus Westernization—intrinsically important.

And yet from these two nonvisual traditions—Jewish and Russian— grew the artist Marc Chagall. Out of two poverties he made a richness.

Unlike the vast majority of his co-religionists who have come from the same region and willingly blotted it from their memories, Marc Chagall has always felt a nostalgia for the Vitebsk of his youth. Of the millions of immigrants who fled pogrom, prejudice, and poverty of the Russo-Polish Pale at the end of the last century and the first decade of this century, it is rare indeed to find any who look back poetically at the *stetl* which they have left.

In this sense, Marc Chagall is thoroughly untypical, thoroughly un-Jewish one might say. Most Chagalls become French Jews, English Jews, American Jews. He became a French-*Russian* Jew. He made no effort to blot out his past—even that which might have been unpleasant in it—but recreated it and cultivated it, carrying it in his head wherever he moved.

There are no family records in the *stetl*. Certainly nothing akin to, say, the baptismal records of any Italian city, where even the most modest family may trace back its heritage in yellowing ecclesiastical record books. But in Vitebsk, or Mogilev Province south of Vitebsk, where the artist claims his forebears came from, no tangible evidence is available. In those few cases where Russian secular administration files for the Jews may have existed, Nazi occupation destroyed them. All that we know is that the family name was originally Segal, a most common name in Byelorussia, that the painter's father first changed it, and Marc added the second *l* to Frenchify the pronunciation, perhaps because *chagall* in Russian means "to stride with big steps."

My Life contains touching portraits of the father and mother and a host of characterizations of various uncles, aunts, and grandparents, set down as swiftly as Chagall's drawings.

Have you ever seen sometimes, in the paintings of the Florentines, one of those characters whose beard has never been trimmed, with dark smoldering eyes, whose complexion of burnt ochre is fretted with lines and wrinkles.

That's my father.

Indeed several of Chagall's portraits of his father resemble the nobly plebeian figures of Masaccio's Brancacci Chapel frescoes in the Carmine.

He wonders if he has to speak of his father. "What's a man worth if he's worth nothing?" And yet with filial piety, with pity (which is not quite love), with a certain remoteness, he sketches the portrait of the man who for thirty-two years hauled barrels of herring in order to support, with his miserable pittance of twenty rubles a month, a wife and a family of eight children, of whom Marc was the eldest. Zachar was his name. His clothes were wet with brine, his hands frozen, he shuffled home from his backbreaking labors and fell asleep over supper. Everything about him was sad, inaccessible. He was always tired; only in his blue-gray eyes did there glimmer at times a sweet reflection; only rarely was there the adumbration of an enigmatic smile in the yellowish face. Tall and thin, in his big-pocketed shabby herring-stained clothes, he entered the house and evening entered with him.

Then, with his huge wrinkled brown hands, tanned as leather from dipping all day in cold pickle brine, he smiled a fugitive smile as he drew out of his cavernous pockets first a red checkered handkerchief, blowing a shofar blast, and then distributed gifts for his numerous children (every year another until they totaled two boys and seven girls, one of whom, Rachel, died at birth)—a heap of cakes, some frozen pears. But he almost never spoke. He was what Jack London called "a work beast." Oddly, his father, a religious teacher, had apprenticed two of his sons in manual trades: Zachar to a herring merchant, and Zussy to a hairdresser.

After dinner Zachar fell asleep, head on the table. At the sabbath meals, he was snoozing even before he had time to recite the prescribed prayers. Then his wife, a distant cousin lively and bird-bright as he was slow and reptilian, would eagerly perform that role sacramentally reserved to men.

In words, in paint, Chagall later offers up propitiatory images of

his work-belabored father who went to the synagogue every morning at dawn, then came home to light the samovar and drink some tea before commencing his daylong odiferous wrestle with herring barrels from depot to railroad station. Zachar reminds him of the woodcuts in the Haggadah with their paschal simpletons, and he hastens to cry Pardon! He envisages a portrait which was to have the effect of a candle, in flame and extinguished at the same time, its odor that of sleep. A real portrait, of 1914, shows us Zachar not asleep but grimacing his misery under the questioning glance of a grandmother and a cat.

Up to the last years of his life he earned no more than twenty rubles a month.

Surely the abundant fish in Chagall's canvases that swim or fly vertically and horizontally, surveying snow-white Russian towns or sunlit Riviera beaches, keeping time with grandfather clocks or sprouting unlikely gulls' wings, are the herrings of Zachar. And here we are confronted full-face with the ambiguity of symbols. During the first Christian centuries fish are the symbols of Christ: the acrostic of the Greek letters of his name, as well as a reference to the Apostles: fishers of men. In several cultures the fish is the symbol of the male organ. How many of these ancillary meanings have accrued to Chagall's fish? Or should one say, to Zachar's herrings?

In moments of emotional crisis, Chagall has displayed a fatalism, a brooding stillness, a monolithic melancholy during which he stares into space, motionless, without will, frozen. If this aspect of his personality is the heritage of Zachar, Chagall's active operational side is inherited from his mother, Feiga-Ita. How different from her weary, brooding husband was this lively enterprising little woman. She came of a family of doers, not brooders. Feiga-Ita is all sparkle and blossom alongside her dismal potato of a husband. When they had married, her husband had possessed a certain physical allure; he had even presented her with a magnificent scarf. But over the years as he thickened into his routine of prayers, herrings, and lighting the samovar, all the vitality of the family derived from her. As was not infrequently the case in the *stetl*, she was the active element, the *nishoma* of the family, the fluttering, hovering, chiding, urging, protective Jewish mother. Her father was the powerfully built ritual butcher of Lyozno, her stepmother a wrinkled, shawled little babushka as we see them depicted in Chagall's early pictures. Her

father spent half his life sleeping on the stove, a quarter in the synagogue, and the rest in his butchery. He rested so much that his wife couldn't stand it and died in the flower of her youth, apparently, Marc would suggest, of amorous neglect. When Marc went out to visit his grandfather in Lyozno, the Russian priest smiled at the pretty curly-haired boy, and pigs, like little dogs, ran to greet him.

In order to supplement her husband's meager twenty rubles, Feiga-Ita opened a small grocery shop; and later, in the courtyard of the stone house where they moved near the railroad station, she had three small isbas built. With this added income, one cannot say that the Chagalls were poor. The artist is fond, with typical overdramatization, of contrasting the poverty of the Chagalls with the wealth of the family of his future fiancée, Bella Rosenfeld, whose father owned three big jewelry shops in Vitebsk.

So, in language as vivid and images as startling and leaps as unexpected and ligatures as omitted as in any of Chagall's paintings, *My Life* presents us with a gallery of family portraits.

He sees his mother "managing the house, ordering around my father, ceaselessly building little isbas, setting up a grocery shop and stocking it with a cartload of merchandise, all secured without money on credit. . . ." (The Russian signboard of this shop figures in several of Chagall's early pictures.) In the evening when the shop is shut, and Papa dozing at table, the silence, the stillness, the inactivity, the very lambent glow of the lamplight bores her. She begins drumming her fingers on the table (one thinks of Chagall drumming his fingers on the drawing board in the printshop . . . "What shall I make? What shall I make? . . . I guess I'll make a Chagall"), irritated by her somnolent family, and says, "Marc, my son, speak to me."

She loves to talk. But what can he say to her? He "is a kid, she is a queen."

On Friday evening when work-weary Zachar invariably fell asleep over the prayers after the plentiful sabbath meal, Feiga-Ita seized this opportunity to chant the rest of the prayers in unison with her eight children.

The pages of *My Life* dealing with his mother are a curious amalgam of sophistication and infantilism, especially when we consider that they were written when the artist was already a married man, a father, ripe with the experience of the Russian Revolution and his first Paris sojourn.

Sometimes I don't want to speak of her, but to sob.

At the cemetery I rush to the gate. Lighter than a flame, than an aerial shade, I run toward tears!

I see the river fading into the distance, the bridge further off and nearby is the eternal enclosure, the earth, the tomb.

Here is my soul. Search for me here, here I am, here are my paintings, my birth. Sadness, sadness.

Here is her portrait.

It is the same. Am I not in it myself? Who am I?

But marvelously ironic and without a trace of sentimentality are the passages dealing with the family preparing to go to synagogue on the Day of Atonement:

Before going to temple, my father, stooped over and out of breath, finds the prayer book for my mother and shows her the dog-eared pages.

"Here. From here to here."

Seated at the table, he underlines the selected pages with a pencil, with his nails.

In one corner he writes: "Begin here." "Weep." Then: "Listen to the Cantor."

And mama went to the temple, sure that she would not shed tears in vain but only when and where she should.

If absolutely necessary—if the thread of the prayer escaped her—she looked down, from the top of the women's balcony.

When the sign "weep" approached, she began, like all the others, to shed divine tears. Their cheeks grew red and tiny wet diamonds ran drop by drop glistening on the pages. . . .

His father all in white makes Marc think of the prophet Elijah.

He prays and weeps with dignity, without excessive gesturing. Occasionally he turns to his neighbors sternly requesting silence or a pinch of tobacco.

To Marc the synagogue seems entirely peopled with saints. He runs off to a garden, plucks a big green apple, bites into it, and savors the delicious juice of sin. The passage is so knowing in its naïveté, so calculated a working over of the prototype scene in the Garden of Eden.

The little boy runs home and lies to his mother. Oh yes, he says, he has fasted all day.

And at the end of that long day delicious with wrongdoing, concealment, and penitence, he cries out:

"If You exist, make me *blue,* fiery, lunar, hide me in the altar with the Torah, do something, God. . . ."

"Make me blue"—Chagall's mystical color of happiness—"hide me in the altar"—the hiding behind the altar curtain is the hiding in mother's skirts and the mother is the presiding deity of this household, as in so many Jewish families, notwithstanding the male-dominated emphasis of Levitical legalism and the patriarchal tradition of Jewish religious law and practice.

So, the indefatigable Feiga-Ita managing her defeated drudge of a husband, her eight children, her grocery shop, her building operations, completing poor Zachar's unfinished prayers, undoubtedly became in the eyes of her eldest son a combination Rebecca-Isis-Mary figure, the primordial Great Earth Mother image that was to condition Chagall's amorous life. In his wife he sought always the managing mother: someone to love him, protect him, surround him with maternal warmth and security, and probably he also unconsciously expected in his spouse the business acumen that Feiga-Ita displayed in the most untoward circumstances.

Furthermore since there were six sisters, the basic atmosphere of the household was feminine, a nest, a refuge. Again and again, both in *My Life* and in his paintings, the imagery is that of concealment, the child hiding in his mother's skirts against an alien intrusion, an antagonistic world. There is the Outside, and there is the Inside. Inside all is snug and warm, the safety of the maternal enclosure. Outside blow the cruel winds of criticism, competition, manipulation. One acts out there, as one must, only to return as soon as possible to the warm shelter of the Inside for nourishment and rearming.

Chagall's paintings are inhabited with lovers. And he was bathed in love. He must have been, to judge from the earliest photographs, an extraordinarily beautiful child, with his slanting azure fawn's eyes, his chestnut-brown ringlets, his sweet shapely lips, and his flashing sickle smile. He early became aware of his charm and made use of it. The little boy grew up adored by his mother and younger sisters. The good looks probably came from Zachar. A family portrait, taken when Marc was a grown young man, shows the father very

handsome and clear-eyed, with proud bearing, qualities which are entirely lacking in Chagall's word portrait. Feiga-Ita, on the other hand, seems plain, thickset. Only the eyes stare dead ahead resolutely facing the camera.

One of the greatest terrors of the youth in the Pale was conscription into the army—which meant twenty years. How many trigger fingers were "accidentally" cut off to avoid this military imprisonment! In Chagall's account this frightening theme is deftly brushed in: One night he hears someone moving outside the house. "Mama!" he cries, "it must be the guard who has come to take me into the regiment!" "My son, hide quickly under the bed!" A scene from opera buffa, inasmuch as it was a false alarm, and especially because Marc immediately takes advantage of the ludicrous situation to describe his childish joy and the fantasy he derived from it: "You can't imagine how happy I am, I don't know why, flattened out under a bed or on a roof, in whatever hiding-place." Hiding seems to be one of the principal components of Chagall's joy. He wants to "creep into" his pictures. He wants to hide his "feelings in the opulent tail of a circus horse." He loves to look out at the street from his hiding place at the window. His pictures are full of lurking images, scratched in obscure corners of the stained glass, peering out of trees, lost in velvety deep blue night skies, swallowed in bouquets of flowers. Along the frame, in out-of-the-way corners, tiny figures or objects are magically endowed with life—walking lampposts, flying ladders. "I don't know where he gets those images," said Picasso. "He must have an angel in his head."

Chagall's is a dreaming brush and a sly eye. "If I have made pictures, it's because I remember my mother, her breasts which have warmly nourished and exalted me and I am ready to hang on the moon."

An odd remark from one who tells us that he sleeps perfectly well at night without Herr Doktor Freud!

Instead of describing his six sisters and his brother, Chagall remarks slantingly that he "would be so seduced by the harmony of their hair, of their skin" that love would cause him to "leap into them," stirring up the canvases and his readers with "my colors of a thousand years." An elaborate self-defeating metaphor to cover the fact that for most of his long life Chagall seems to have kept up very

little contact with his numerous siblings. David, four years his junior, died of tuberculosis in a sanatorium in the Crimea in 1921; the artist's son is named after him. Of his sisters, Aniuta, Zina, Lisa and Maria, the twins, Rosa, Maroussia, and Rachel who died at birth, he hardly ever speaks.

But in the kangaroo paragraphs of *My Life* a battalion of uncles and aunts, grandparents living and dead, cousins near and far, pass chromatically in review:

Pale Aunt Mariassja vending herrings, spices, farina, oats to the muzhiks. Aunt Relly with a "tiny nose like a gherkin," giggling, shaking her breasts as she curdles fresh cream into cheese. Aunts Mouissa, Gouttija, Chaja, "winged like angels" flying through the markets. Even then Chagallian creatures, especially relatives, did not walk on the earth like ordinary folk. They flew and everyone regarded them in astonishment. It is this perpetual transformation of the commonplace to the miraculous that makes the pages of *My Life* so dramatic if sometimes sentimental as art and so dubious as document. Like Van Gogh, Chagall writes as if he were painting. Aunt Mariassja is "lying on a divan. Her yellow hands are folded, crossed. Nails black and white. Eyes black and yellow. Teeth shining nebulously." The autobiography is a literary byproduct of his painting, *ex post picturam;* it must always be kept in mind that *My Life* was written after the artist's thirtieth year, when both the Chagall style and *persona* (that was to serve him well for a long life) had already been formed. With all its seeming baring of soul, the book conceals as much as it reveals.

All his uncles were good Jews. Some had bigger bellies, some had emptier heads, some had black beards, some brown.

"In short, painting."

Most colorful of the uncles was Uncle Neuch, who grabbed whatever prayer shawl was available, especially not his own, intoned the Bible in a loud voice, and played the violin like a shoemaker. All day long he bought cattle from the peasants, and Marc loved to go with him to market where he picked up the livestock and drove them to the stables.

Playing the violin, he buzzed like a fly.

Uncle Juda was always lying on the stove.

Uncle Israel always sat in the same place in the synagogue, holding

his hands behind him, intoning his prayers and swaying, swaying, back and forth, side to side, mumbling, sighing.

Uncle Zussy is the only barber in Lyozno, who cuts his hair with pitiless love.

Another relative in Lyozno found nothing better to do than promenade down the main streets of the village in full daylight, wearing nothing but a shirt. What joy Chagall takes in recounting this episode—probably fictional—the sansculotte whose daring act reminds the artist of the paintings of Masaccio and Piero della Francesca. Oddly, all these references to the Quattrocento Tuscan painters were written before Chagall had ever seen any of their works.

Of these scratch-edged portraits Chagall remarks: "May God pardon me if in my description I have not placed all that *bleating* love which I have in general toward all people." The adjective which I have italicized is significant of a Chagallian ploy which is to become habitual over the years: the adroit flashing flicker of self-mockery with which he pricks his own sentimentality before it balloons into the grotesque.

Vacations Marc often spent with his grandfather, the burly ritual butcher of Lyozno. Once during a feast day—Succoth or Simchas Torah—the grandfather disappeared. He was discovered up on the roof where he had climbed, settled himself down on a flue, and proceeded to munch on carrots. "Not bad for a painting," Chagall remarks. How many bearded Jews on rooftops inhabit his painted world!

But more shudderingly profound as a source of imagery were the days when little Marc witnessed his grandfather at his bloody trade.

Dear young old man!

How I loved you when I was in Lyozno in your house, smelling the dried cows' skins. . . .

Grandfather is in his stable with a big-bellied cow: she is standing. She looks stubborn.

Grandfather approaches and speaks to her:

"Heh, listen here, let's have those legs, I have to tie them, people need merchandise, meat, y' understand?"

She collapses with a sigh.

And little Marc extends his arms to embrace her muzzle, to whisper some words of consolation to her: she needn't be so upset. He promises the cow that he is not going to eat her meat. What more could he do?

She hears the rustling of rye and behind the hedge she sees the blue sky.

But the butcher, in black and white, knife in hand, tucks up his sleeves. One scarcely hears the prayer as, drawing taut her neck, he plunges the blade into her throat.

Pools of blood.

Impassively, the dogs, the chickens standing round await a drop of the blood, a morsel fallen by chance to the ground.

One hears only their clucking, their rustling and Grandfather's sighs amidst the jets of fat and blood.

And you, little cow, nude and crucified, in the heaven you dream. The resplendent knife has lifted you up into the skies.

Silence.

The intestines twine and the cuts of meat are separated. The skin peels off.

Rosecolored bloody chunks glide. Steam mounts into the air.

What a craft to hold in one's hands!

I want to eat meat.

Thus, every day two or three cows are killed and fresh meat is made available to the proprietor of the domain and the other inhabitants.

For me Grandfather's house was redolent with the sounds and smells of his art.

It was not only the suspended skins, drying like linen.

In the obscurity of the nights, it seemed to me that there were not only odors, but an entire herd of happiness, staving in the floor boards, flying in space.

The cows were cruelly slaughtered. I pardon everything. Their skins dried saintly, wafting tender prayers, praying the heaven-ceiling for the expiation of their murderer's sins.

My grandmother always fed me meat very well done, roasted, grilled or cooked. What was it? I don't exactly know.

Perhaps the stomach, the neck, or the flanks, liver, lungs. I don't know.

At that time, I was particularly bestial, and, it seems to me, happy.

Grandfather, I still remember you.

The passage is extraordinary, adumbrating as it does basic Chagallian themes. Making due allowance for the clowning, which is an essential part of all Chagall's performances, whether in life or art, the clowning is like Chaplin's, tragicomic, compassionate, and mocking at once. The little cow is crucified and sanctified, lifted to the heavens. At the same time, Marc referring to his puberty ("At that time, I was particularly bestial, and, it seems to me, happy.") when the tides of sex were already beginning to yearn in his loins, has a great desire to eat meat after witnessing the slaughter. He forgives his grandfather his bloody act, he forgives everything. Gnawing the bone of well-done *flanken,* he blesses the saintly little cow and prepares to populate hundreds of canvases with her carcass.

Cunning in its foreshortening and ellipses, the entire scene is depicted in the colors of blood: as much a verbal transcription of Chagall's paintings as it is a transfigured memory of his childhood.

His art, so populated with fish, beasts, and birds, might seem in flagrant contradiction to the iconoclastic tradition of the Jews. Animals, however, have been the chief living subjects that Jewish art has employed, apparently in the belief that making images of this branch of God's creation is not explicitly forbidden by the Mosaic stricture. Certainly Jewish art over the centuries is filled with depictions of animals. Embroidered lions rampant caper on Torah curtains. Owls are inscribed on Judaic coins, the friezes and capitals of the synagogue at Capernaum contain human figures as well as animals. Birds stand on the rim of a fountain basin of the fifth-century Naro Synagogue in Tunis exactly as they do in Pompeian mosaic. Goats are among the river gods, stalks of wheat, the ring of familiar zodiacal symbols painted inside the dome of a timber synagogue at Khodorov near Lvov, erected in 1651. Haggadahs, of course, were illustrated with woodblock engravings of animals and sometimes even illuminated with miniatures. Animals as well as figural and vegetable decorations are abundant in Esther scrolls, the so-called Megillahs.

A book entitled *Jewish Folk Ornament,* published in Vitebsk in 1920 in Yiddish, with linoleum blocks cut by M. Malkin and S. Yudavin, contains illustrations derived from Hebrew fonts, gravestones, embroidery, etc., astonishingly similar, especially as bestiary, to Chagall's images. As a fellow Vitebskite, Marc was of course acquainted with the artists who had cut the blocks. And undoubtedly in the cemetery he had often seen those backward-gazing cocks, the mystic triangle of hands, and in the synagogue, the mythological lions rampant on the hangings for the Ark.

Thus Chagall's bestiary, derived primarily from what he witnessed in his grandfather's barn and the life around him, also had antecedents in the Jewish tradition. His zoomorphism could feed on living models. The *stetl* was full of animals: cows, goats, chickens, ducks, geese. Jewish families in the Pale kept pets, usually cats, bestowing on them affectionate Jewish names and speaking to them in Yiddish. Dogs were considered non-Jewish.

Virginia Leirens, the artist's companion for seven years (1945-52), writes:

> Chagall is not an animal lover in the sense that he has never had a close contact with animals, but he has always observed them searchingly and identified himself with them in a symbolical way, beginning with the bulls slaughtered by his grandfather, the horse that pulled small carts and the cocks and chickens kept by his parents and eaten once a week. In High Falls there were cows in the field opposite the house and he used to watch them rub their noses on the fence. He was pleased when I decided to keep chickens, their cheerful noise created an atmosphere of familiarity. But animals are never pets for him, they have a universal character. Every cow is The Cow. He has as little sentimental attachment for domestic animals as for fishes and birds but animals are a powerful element in his subconscious heritage. We had cats in High Falls but they made little direct impression on him. In Vence we were given a handsome white and grey one by Matisse and this cat became "Le Chat de Matisse." It was the only time I heard him refer to any particular animal. But I never saw him stroke it. I like cats and when I caressed it too voluptuously Chagall used to get jealous.

He dislikes dogs and has had a fear of them ever since he was badly bitten as a child. The long scar is still visible on his forearm. Once he was walking with Jean aged six or seven and a vicious dog flew out at them. Jean, terrified, clung to Marc and he took her in his arms and reassured her. Later she learnt that he had a terror of dogs himself and whenever a dog came by she ran to protect him.

*

Surely there was an abundance of fish in Chagall's boyhood: herring, carp, gefüllte fish were a staple part of the diet in Eastern Europe, his father was literally piscatorially drenched. Aunt Mariassja as well as Mama sold herring, pickled and dried, in her grocery shop. Fish motifs are found in Tunisian Jewish decoration. Eastern European and Mideast art are rich in animal motifs, sometimes folkish, sometimes mythological in treatment. It's hardly likely that Chagall saw any of this before he went to Paris, where the resources of the great museums were available to him. Everything came by a kind of osmosis: the crowing of Vitebskian roosters, the mooing of Lyozno cows, echoed in his head in Paris.

What teases more is the zoomorphism: the loving interplay, the ceaseless transformations from animal to human and vice versa, the creation of a strictly private mythological bestiary—winged fish, donkeys in trees, violin-playing roosters, green goats clasping spectral brides, zooming off into the night sky like sperm trails. In some instances the symbolism is clear, in others multiple interpretations may bring us closer to an interpretation which in all likelihood the artist never intended and certainly never constructed according to a planned symbolic system. Chagall hates, and justly, literary interpretations and objects as violently as Nabokov to psychoanalytic readings. On the conscious level his dreams are organized. He is an artist above all; he "explains" in terms of optical engineering: this *holds,* he *needed* that to fill a space, notice the texture here, the scumbling there, the "chemistry" of the painting skin, the composition. But although visual technology is certainly very much in the forefront of Chagall's thinking while he works, this does not penetrate to the well of dreams that rush forth unbidden to set his skilled hand in motion.

In Grandfather's barn, the little cow became a happy saint in Heaven. As in Ovid's *Metamorphoses,* or in Joyce's Night-Town, creation is all transformation, all nature is a mythological bestiary, of symbols changing as we watch: the bird-headed men of Chagall are not unlike the bird-headed gods of ancient Egypt and Mesopotamia; the donkey, winged or not, is usually Marc himself, beside himself, one might say, with animal passion, often upside down in the clouds.

<div align="center">*</div>

Marc Chagall wrote his autobiography at the age of thirty; he had already been painting it for more than a decade. It was as if his earliest experiences—his family, the tumbledown wooden houses of Vitebsk, the view across the broad flowing Dvina, the chickens and the cows, synagogues and muzhiks, his eccentric *tantes* sipping tea from saucers, his dead-weary father shining like an angel with pickle brine—provided him with enough "documentation" for life. Dream-Vitebsk has the power of a hallucination. An enraptured elfin child, shy, cuddled by his mother and sisters, given to fainting fits when he confronted difficulties, Marc from the start saw nothing but miracles. Only with maturity, making use of accepted symbols, did every peddler with the sack become the Wandering Jew, every cow the Christ. But even then, the little boy experienced the extraordinary in the commonplace, the legendary in the quotidian. This is the mark of a poet. And Chagall is above all a poet whose medium happens to be painting. But at first he dreamed of becoming a singer (a great and famous singer of course), a musician, a dancer, a word-poet.

Like every boy in the Jewish community he was studying at the *cheder,* the religious school, where after the Reforms of 1907 supplementary secular courses also had to be given in Russian by an outside teacher. At any rate, under the usual assortment of Hebrew teachers, most of whose pedagogy consisted of rote "learning" reinforced by rappings on the knuckles, Marc entered the world of the Bible and there met the personages whom he was to depict as if they were Vitebskian neighbors. In *cheder* he learned enough Hebrew to read the Holy Books; to his parents he spoke Yiddish; to his brother, sisters, and friends, Russian. This was to be his linguistic troika till French was added to the traces.

Amidst holy days and herrings the boy "studied" first at home with a little rabbi from Mogilev who looked as if he had escaped from a circus. This rabbi, like most of the personages of *My Life,* is presented as a caricature. Every Saturday instead of swimming in the Dvina, poor Marc had to study the Bible. But the Haskalah, the Enlightenment, that together with Zionism was already invading the Chassidic communities, presented itself in the person of one of his *cheder* teachers, Djatkin, who did not wear a beard and was open to modern culture beyond the usual rounds of medieval Jewish learning. From him Marc absorbed the necessary dosage of Torah to be able to recite his prayers in Hebrew and be confirmed. He also took violin lessons and studied singing: as a member of the synagogue choir he dreamed of becoming a celebrated cantor.

He was a dreamy, shy, timid boy. His cheeks were too pink, his hair too curly, his slanting eyes too much like those of a woodland creature; he moved like a gazelle. He did not easily make friendships, with either boys or girls. Sometimes the ruder boys, irritated by his girlish prettiness, set upon him physically. His favorite angle of vision early became that of an observer at the window: safely inside looking out at the activity in the street—a stage where puppets jerked out their comedies and tragedies gesticulating and swooning, clothed in mystic violet and screaming vermilion. The "window view" becomes Chagall's basic point of view toward life: the game of inside and out, the secret observer not himself observed, the clownish voyeur.

When he was thirteen, after several years of *cheder,* his mother tried to enroll him in the communal Russian school, but he was not accepted because of the *numerus clausus.* Undaunted, the bustling Feiga-Ita bribed a professor with fifty rubles and Marc immediately entered the amenable professor's course in the third grade. There he wore the black military uniform of the Russian schoolboy, and with a cap floating on his curly froth of hair, he concentrated on looking at the girls through the open windows. The professors wore blue redingotes with gold buttons. The sight of all those heads in the class made Chagall stammer despite the fact that he had learned his lessons. During six years of Russian communal school, he did not distinguish himself, though he advanced regularly. Only geometry delighted him, he says in *My Life:* "In that I was unbeatable. Lines, angles, triangles, squares carried me far off toward enchanting horizons. And during the hours devoted to drawing, I lacked only a

throne." Since Chagall had already been geometrized by Cubism when he wrote this passage, one wonders how much true sight there is in hindsight?

In an interview with Edouard Roditi in 1958, Chagall recounted how he became a painter:

> In our little milieu of workers and artisans of a ghetto province, we scarcely knew what an artistic career might be. In our house there wasn't a single painting, not a single engraving on the walls of the rooms. At most we had some photographs, memories of the family. At Vitebsk up to 1906 I had never in my life seen drawings or paintings. But one day in the communal school I caught one of my comrades as he was copying with a pen an illustration from a magazine. This boy was my enemy, the best student of all, but also the most wicked, the one who persecuted me the most, and mocked most cynically at my dreamy look, my *schlemiel* behavior, the dunce of the class. In seeing him draw I was absolutely flabbergasted. For me this was a vision, an apocalypse in black and white. I asked him how he went about it. "Imbecile," he replied, "go find a book in the library, choose an image which pleases you and copy it."
>
> And that's how I became a painter. I went to the municipal library, I asked for a volume of the illustrated review *Niwa* and I brought it home where I chose a portrait of the composer Anton Rubinstein, a drawing which gave me the impression of "being crinkled," it was kneaded with tiny live features which represented the wrinkles and folds in the great man's face. I copied this little portrait, then others but art was not yet in my eyes a vocation nor a profession. All those drawings, I pinned on the walls of our house.

Roditi remarked that Soutine's parents had been horrified when their son manifested a desire of becoming a painter. "Did your family show similar sentiments of horror for your artistic penchants?"

> My father was a pious man. Perhaps he knew that our religion forbade the reproduction of the human figure. But the idea never came to him that precisely this childish game, I mean

these little pieces of paper with which I was amusing myself by copying what I found printed on other pieces of paper, that this was what was being so solemnly forbidden. Nobody in my family thought about any scandal yet in my vocation as an artist.

One day one of my class chums, a boy of a more fortunate and more cultivated family than mine, came to see me at home. He went into ecstasies about my drawings that he saw pinned all over the walls. "But you're a real artist!" What did that word mean that he had just uttered? I was a lazy boy. In class I learned with difficulty, always being too distracted. At home they never asked me what métier or profession I wanted to choose. When one is poor one has no vocation, one accepts the first grub that one finds. As for me it was difficult to imagine that I could ever do anything useful in life. That word "artist" perhaps offered a solution for my problems, and I asked my friend what it meant. He replied, citing to me the names of the great academic painters of czarist Russia, Ilya Repin and Vasily Vereshchagin. At Vitebsk I had never heard mention of these painters of great historic scenes reproduced at that time in all the magazines, although these were the models I was borrowing for my little drawings. Still, such was the origin of my madness. I had found a vocation. But my father scarcely realized what this métier of artist that I had just chosen might mean. As for me, I understood very soon that I had to attend a school and perhaps obtain some diploma. In the kitchen my mother was preparing bread that day. I went to her to speak to her about my plan. She understood nothing of my proposal and sent me out to take a walk. . . .

I searched all over Vitebsk for a master who might teach me my craft as an artist. Finally I discovered the atelier of Jehuda Pen, a provincial portraitist who taught art to several students. I asked my mother to accompany me there, somewhat as I might have asked my parents to come with me to discuss with an artisan his terms to take me on with him as an apprentice. But my mother first wanted to consult one of my uncles, who had a reputation in our so-little literary milieu of being a great reader of journals. This uncle cited again by way of example the names of Repin and Vereshchagin, but he added that an artist

must have talent, a thing about which I had not yet thought. My mother decided on the spot that they would permit me to learn my craft as an artist if Professor Pen estimated that I had some talent. All this took place in 1907. I was scarcely 17.

"What were your impressions of your first visit at Pen?" asked Roditi.

When we arrived there, my mother and I, the master was not in his studio, but we were received by one of his pupils who was practicing drawing. Under my arm I had carried with me a roll of my little drawings to show to the master. When she saw in Pen's studio so many beautiful portraits of mustachioed generals, their chests bedecked with decorations, or women of the province with opulent décolletés, my mother had a moment of weakness: "My poor son, you will never know how to do that as well!" She was already prepared to leave, dragging me back home in her wake. At that time I was so timid that I held on to her skirt with a nervous hand for fear of losing her in the crowd when we went out into town.

But my mother waited around several minutes to admire Pen's works all the while questioning his pupil on the possibilities of the future that this fine métier might offer. The young dauber had just explained to us that art does not involve either merchandise or a shop, when Pen came back from his courses in town. In the blink of an eye he examined my drawings. My mother asked him if I had any talent. He replied evasively that I had "something." These words were sufficient. The matter was in the bag and I became at once a pupil of Professor Pen but I remained only a few months with him, having quickly understood that this poor Pen could scarcely teach me an art which corresponded to the aspirations which more every day I felt burgeoning in my spirit. Nevertheless he had the gentleness to appreciate the importance of the sacrifices that my apprenticeship caused my parents and he soon proposed to charge nothing for the teaching that he so freely lavished. My progress, besides, was so rapid that from 1908 on I was able to go to St. Petersburg to enroll in the Free Academy which the painter Léon Bakst was directing.

The five rubles for the lessons at Pen's were provided by Zachar, who sent them spinning into the courtyard: a gesture full of the ambiguity of a pious Jew who washed his hands of sinful image-making the while he yields to the importunities of a busy little wife, protective of her darling son. But certainly the seventeen-year-old Chagall did not undergo the physical beating and humiliation Chaim Soutine was to suffer from his father when he painted a portrait (by memory) of the rabbi of Smilovitz. The winds of the Haskalah were already blowing in Vitebsk.

Chagall did not learn very much from Pen, an academic painter whose pedagogy consisted primarily of extensive copying from dust-laden plaster casts: arms, legs, ornaments, of Greek and Roman works. Instinctively from the start Chagall felt that this was not "his way," yet he persisted in order to learn as much of the craft as he could.

The signboard outside Pen's studio—PEN'S SCHOOL OF PAINTING—which had attracted young Marc was lettered in white upon a blue ground. "It trembled in the sun and under the rain." Blue is always a mystic color to Chagall; the color of the sky, of day or night, of flight. But when he began to study he found that he alone of all the pupils used violet, for the others an audacity. They were still immersed in that tobacco-stained twilight gloom that dominated European painting until the Impressionists flung open the blinds and let the sunlight in. But although the French pictorial revolution and several indigenous ones as well—commencing with the Wanderers with their choice of secular subjects, folk motifs, and icons—had already been under way for some time in Russia too, none of this had affected Pen, a dignified aristocratic gentleman with neatly trimmed graying beard and academic tastes. Jehuda Pen was a portrait artist and salon painter with a traditional notion of art as the tasteful and skillful rendering of what the eye saw. It is not likely that he could have had much sympathy for the eccentric young man whose cheeks were too pink (Chagall was already rouging them) and whose vision was turned too much inward to be concerned with perfecting his grasp of eternal reality. As a result of his unaccountable taste for violet, Chagall tells us, Pen gave him lessons free! He studied with Pen for several months. A portrait of Chagall by Pen dated 1906 or 1907, when Chagall was nineteen, shows us a dapper, handsome young chap with broad-brimmed hat set at a rakish angle, gloves on long fine fingers, and a wispy blondish moustache above shapely

knife-thin lips. The portrait was done or must have been completed several years after Chagall had left his first master to range in wider fields. There is, if not affection in it, at least a steady vision. Chagall claims in *My Life* that he "loves" Pen, that he lives in his memory "like my father."

This did not soften the hurt Pen felt when in January 1919 Chagall, newly appointed Commissar of Arts of Vitebsk, failed to enlist his former master among the faculty of his radical new academy. Chagall felt that Pen's academic style did not fit into the "revolutionary" ideas of his school. Pen was so offended that he painted a picture of himself on his deathbed with Chagall debonairly sitting by the bedside. Apparently the offense had not been mitigated by Marc's selection of hundreds of Pen's works for an exhibition of Vitebsk artists organized by Chagall even before he had received his formal appointment as commissar. At that show he hung only five pictures of his own. But since these included such astonishing works as *Promenade,* with Bella spinning in purple ecstasy above the town, love-drunk Marc bestriding his bride's shoulders, Pen's mediocrity must have been all the more emphasized. Later Chagall did enroll his old teacher as a member of his faculty.

Chagall's style of painting while studying with Pen was, in the artist's own words, "realist-impressionist, as were most of the Russian masters who had returned from Paris to reveal vague new ideas they had borrowed there. . . ." But another term that might be applied would be anti-realist realism: the lumpish clods of pigment resolving into middle-class Russians and village Jews, the clumsy drawing of hands, the anatomical and perspective distortions were not only signs of the technical limitations of a young artist; they were also a declaration of independence from the eye.

He was not yet airborne; this is the waddling of an inexperienced fowl struggling to take off.

Part Two
St. Petersburg
1906-1910

In the winter of 1906-07, after several months at Pen's and a brief interlude as a retoucher at a photographer ("I saw no need of . . . rejuvenating faces so that they look different, never natural"—an incongruous remark from the anti-naturalist Chagall), Marc decided he had to escape the narrow confines of Vitebsk and move on to St. Petersburg. He was then twenty years old, which would seem to cast doubt on his chronology of having been seventeen when he enrolled at Pen's. But the important question to consider is the odd indifference of a twenty-year-old Russian Jew, in the full flower of mind and heart and body, to the two fundamental movements of liberalization at that time sweeping through the entire Pale of Settlement. Marc Chagall was not then, and was never to become, either a Zionist or a Socialist. Yet these two doctrines and, soon, various odd crossbreeds between the two, were battering down the walls of the ghetto. In the First Duma Chagall's future patron Maxim Vinaver spoke out courageously for full equality of all Russian citizens including Jews, who still, despite the liberalization initiated by Alexander II, were limited in their rights of movement, restricted from the universities, and treated as second-class citizens. But also within the ghetto itself, the winds of Haskalah (Enlightenment),

49

which had begun to blow in the last century largely from Germany,
had carried the spores that were to fertilize latent Zionism and
Socialism: both tendencies rebelling in their various and sometimes
antagonistic ways against what they considered old-fashioned reac-
tionary Judaism. This old-fashioned reactionary Judaism was itself
cloven in two: on the one hand the intellectualized casuistical
Talmudism of the rabbinate centering largely around Vilna in Latvia,
and the emotional God-intoxicated Chassidic movement widespread
throughout Byelorussia and southwest into Galicia and Poland.

Mithnaged and Chassid—this conflict of head and heart is a
recurrence in late-nineteenth-century Judaism of similar antinomies
to be found in all major religions: in Christianity—hair-splitting and
mind-honing Thomism versus joyous and simplistic Franciscanism; in
Buddhism—the doctrines of the Greater and the Lesser Basket; in
Islam—the rigid puritanical Wahhabi doctrine and populist, mystical
Sufism. So in the Jewish world of Eastern Europe, there were those
who climbed up to God on steps of precedents, rabbinical citations
and disputations of Talmud and Gemara. And there were those who
leaped up to God, clapping hands and singing joyous hymns of
praise. Although the revival movement of Chassidism founded by the
famous Israel Baal Shem Tob a century earlier had already suffered
the fate of all reforms—rigidifying into caste and superstition (the
wonder-working rabbis with their princely courts) what had begun
as a populist rebellion against rabbinical legalism and strict ritual—it
was still the dominant movement in Chagall's youth. And, as might
be expected of an anti-rational movement stressing music and dance,
emotion rather than reason or talmudic logic as the path to Paradise,
Chassidism was the matrix for entire generations of Jewish artists,
musicians, and writers.

Chagall himself has admitted in his own deflective way the
importance of Chassidic Judaism as a formative element in his art.
His autobiographical memoir depicts a devoutly Chassidic family; and
Burning Lights, the autobiographical sketches written by Bella, his
first wife, are mostly descriptions, fervid and overheated, despite the
perspective of fifty years, of the regular round of religious festivals
which her family, wealthier than Chagall's, celebrated.

From Chassidism Chagall derived his distrust of the rational.
"Personally, I do not think a scientific bent is good for art.
Impressionism and Cubism are alien to me. Art seems to me to be a

state of soul more than anything else. The soul of all is sacred."

"One hundred percent intuitive" is Virginia Leirens's character-
ization of Chagall's way of thinking, acting, reacting. She almost
never saw him read a book, yet he seemed to have absorbed all sorts
of astonishing knowledge—the knowledge he needed—through his
pores. Certainly if we analyze various Chagallian pronouncements on
art, society, the State of Israel, France, Communism, present-day
Russia, it would defy the most expert logician to make a coherent
structure of them.

Instead of the Aristotelian logic of the excluded middle we find in
his public and private statements—aside from his art—the logic of the
included middle, that is, poetic logic. Or perhaps, as has been
surmised by some critics, the topsy-turvy, spaceless, boundless non-
Newtonian Chagallian world reflects the Cabalistic component which
is found in Chassidism. The *Zohar* is populated with happy and
luminous souls, shining seraphim flying between heaven and earth.
Without doubt, these mystic flights, these interlocked spaces are
suggestive of Chagall's paintings, but there is no evidence that he
ever read the *Zohar* or other Cabalistic works. Chassidism, of course,
is antithetical to logic. "The Messiah will not come on the Sabbath,
for the holiness of the Sabbath is so great that even the redemption is,
by comparison, profane."

Hence why should not goats fly?

Chassidic mysticism, however, may be extrapolated far beyond the
intentions of its promulgators. In Chagall's case distrust of doctrine, a
substitution of universal "love" for any established religion, made it
possible for the artist to embrace the central Christian image—the
Crucifixion—as a symbol of redemptive suffering in general, es-
pecially the suffering of his own people during the rise of the Nazis
and the tragedy of the war. Although he had dealt with the
Crucifixion as a theme as early as 1912 (the *Golgotha*—like a
glittering Russian Oriental bazaar in the Museum of Modern Art),
he was to make increasing use of this theme during the tragic years
of the rise of Hitlerism and World War II: the Jew in tallith and
phylacteries on the Cross, frequently with Torah-embracing mourn-
ers and synagogues racked by brown-shirted storm troopers and
angels—Jewish angels—blowing shofar horns over the Crucifixion.
This was the paradox that was to bring down on his head the wrath
of not a few of his, one cannot say co-religionists, but fellow Jews.

This most Jewish of artists creates stained glass windows in Roman Catholic and Protestant cathedrals, where, as in Reims, the Synagogue is depicted with her eyes veiled, blind to the substitution of the New for the Old Law.

But a discussion of Chagall's particular type of "Jewishness" might best be deferred till later. In an essay appearing in a book commemorating Vitebsk, Chagall, drawing upon his unfailing and lively wit, as always, to gauze his scarcely concealed irritation, confronts the problem: What is a Jewish Artist?

And still you insist that I write and speak about Jewish art. I will, for the last time.

What sort of thing is it? Only yesterday Jewish artistic circles fought for this so-called Jewish art. Out of the tumult and heat emerged a group of Jewish artists and among them also Marc Chagall. This misfortune occurred when I was still in Vitebsk. Just returned from Paris, I smiled in my heart.

Then I was busy with something else. On the one hand, the new world, Jews, my hometown's narrow streets, hunchbacked herring residents, green Jews, uncles, aunts with their questions, "You have, thank God, grown up."

And I kept painting them. . . .

On the other hand, I was a hundred years younger then and I loved them, I just loved them. . . .

This engrossed me more, this captivated me more than the idea that I was anointed a Jewish artist.

Once, still in Paris, in my room at La Ruche, where I worked, across the partition I heard Jewish emigrant voices quarreling: "What do you think, was Antokolsky not a Jewish artist, after all, nor Israels, nor Liebermann?"

When the lamp burned so dark and lit up my painting, standing upside down (that's how I work—laugh!), and finally when at dawn the Parisian sky began to grow light, I gayly scoffed at the idle thoughts of my neighbors about the fate of Jewish art: "So be it, you talk—and I will work."

Representatives from all countries and peoples—to you my appeal. Confess: when Lenin sits in the Kremlin, there is not a stick of wood, the stove smokes, your wife is not well, do you have national art now?

You, wise B., and you others who preach international art, the best Frenchmen, and (if they are still living) you will answer me: "Chagall, you are right."

Jews, if they have a feeling for it (I happen to), may weep at the passing of the decorators of the wooden stetl synagogues (why am I not in the grave with you?) and of the carvers of the wooden synagogue clackers (saw them in Ansky's collection, was amazed). But what really is the difference between my crippled great-grandfather Segal, who decorated the Mohilev synagogue, and me, who painted murals in the Jewish theatre (a good theatre) in Moscow?

Besides, I am sure that if I let my beard grow, you would see his exact likeness. . . .

By the way, my father.

Believe me, I put in no small effort. And we both expended no less love (and what love). The difference was only that he took orders also for signs and I studied in Paris, about which he also knew something.

And yet, both I and he and others as well (there are such, taken together) are still not Jewish art.

And why not tell the truth? Where should I get it from? God forbid, if it should have to come from an order! Because Efross writes an article or M. will give me an academic ration!

There is Japanese art, Egyptian, Persian, Greek, but from the Renaissance on, national arts begin to decline. The distinctive traits disappear. Artists—individuals arise, subjects of one or another country, born here or there (may you be blessed, my Vitebsk) and a good identity card or even a Jewish passport expert is needed so that all artists can be precisely and fully nationalized.

Were I not a Jew (with the content that I put in the word), I would not be an artist at all, or I would be something else altogether.

There is nothing new in that.

As for myself, I know quite well what this small people can accomplish.

Unfortunately, I am modest and cannot tell what it can accomplish.

Something to conjure with, what this small people has done!

When it wished, it brought forth Christ and Christianity.
When it wanted, it produced Marx and Socialism.

Can it be then that it would not show the world some sort of
art?

Kill me, if not.

Well, obviously, since nobody wants to kill him, we relinquish the
temptation to submit this farrago of insight and clowning, this
dancing around the core of a problem like a kitten playing with a ball
of yarn, to any systematic analysis.

Or like a charming woman, mistress of her god-given gifts,
turning on all her charm . . . in order to avoid a troubling question.

At the age of twenty, on the eve of his departure for St.
Petersburg, Marc Chagall moved like a dancer and looked like an
angel. Tousle-haired, slant-eyed, dreamy and intense in bewildering
succession of mood, shy and narcissistic, and at the same time
energetic and ambitious, the young artist might be viewed against a
set of dates and events which would serve, like the perspective
converging lines of a Renaissance picture, to fix his image against his
times.

On July 14, 1904, a Socialist Revolutionary assassinated the
Russian Interior Minister Plehve, hoping this would spark a revolu-
tionary explosion. The next year the longed-for revolution did occur
in the wake of the disastrous Russo-Japanese war. But the Revolution
of 1905 proved brief and aborted, only to be succeeded by a backlash
of reaction. The failure of the 1905 Revolution had tragic conse-
quences for Jews, setting off before the end of the year 1905 a new
wave of pogroms.

Nevertheless, although the regime remained autocratic as ever, the
Czar maintained his promise to convene a Duma, an elective
legislative assembly, and twelve Jewish deputies, six of them Zionists,
were elected to the First Duma, convened on May 10, 1906.

Competing with the Zionists, striving for a return to ancestral
Palestine as a solution of the Russian Jewish "problem," was the
Jewish Labor Bund, which held forth the perspective of an autono-
mous secular Jewish culture within a Socialist Russia.

Most young Jews of Chagall's generation participated—either
organizationally or in terms of emotional commitment—in one or
another of these social upheavals. The edifice of traditional Judaism,

whether in its Talmudic or Chassid phase, was crumbling under a succession of blows: Enlightenment (Haskalah), assimilationism, conversions (especially in Germany but also in Russia), mass emigration to America, particularly after the Kishinev pogrom of 1903, Maccabean armed resistance groups among the youth, the rise of the great mass of Jewish artisans and factory workers to dispute the centuries-old domination of rabbis and scholars within the community or the small group of wealthy Russianized educated Jews who served as bartering agents with the Czar, exchanging loans of money for liberalization of restrictive legislation.

That Marc Chagall managed to negotiate amidst all this agitation—social, political, religious, national, cultural—that rocked the Jewish enclave in Eastern Europe, nailing up his own mezuzah against the Angel of Death, bespeaks astonishing gifts of equilibrium, indifference, devotion to one's own craft, fanatical ambition, and complete seizure by the Muse.

The only comparable case I can find is that of James Joyce, who walks out of a room when the discussion turns on politics, exiles himself as his nationalist (one-eyed) compatriots and fellow writers roil in the agitation of Sinn Fein and Easter bombings; employs "cunning" to preserve his artistic independence, and carries his own chalice through the battlefield, not spilling a drop.

One may praise or condemn this according to one's lights but the Dreaming Egoist is a familiar silhouette in the landscape of Art.

*

St. Petersburg was his first real experience outside the Jewish enclave. He had been there once before, when, accompanied by an uncle, he had been sent to a hospital in the capital after having been bitten by what was feared to be a rabid dog. With his usual self-dramatization Marc was certain that he would meet the Czar in the street. He had the impression that the bridge over the Neva was floating in the sky. He returned to Vitebsk to find his mother "half-nude." His younger brother had just been born.

Tables covered in white. . . . Rustling of sacramental garb. An old man, murmuring prayers, cut with a sharp knife the little tip of flesh under the belly of the newborn child. He sucked the

blood with his lips and with his beard muffled the baby's cries and sobbing. I am sad. Silently, alongside the others, I munch cakes, herrings, spice-bread.

Once again one wonders to what degree this is a true description of the actual event, primitive hygiene and all, or a verbal transcription of a circumcision scene already painted.

But now that Marc was a grown young man, did he see the elegant broad-avenued capital on the Neva with any more reality than before? The initiative to study in St. Petersburg had come from his friend Victor Meckler, a fellow student at Pen's. Meckler came from an affluent Jewish family in Vitebsk, served later as Chagall's entrée into a cultured middle-class circle where he was to meet his future wife. A photograph of 1906 shows Marc and Victor together: both handsome, sensitive-looking boys. He too had ambitions as a painter and as a matter of fact had asked Marc to give him lessons, which Chagall agreed to do but without accepting a fee.

It was Victor Meckler who persuaded his window-watching friend to break away from the provincial world of Vitebsk and look out on Europe through St. Petersburg, the window on the West.

At his departure, Zachar had flung at him under the table, in his usual deprecatory fashion, twenty-five rubles, this time with a valedictory admonition: this was to be his final contribution to his son's absurd choice of career. The money did not last very long. Once again Chagall had to take a job as a retoucher with a photographer, named Jaffe, who was also an academic painter. Surely Chagall's impatience with the realistic image was intensified by this uninteresting work. At any rate, the income proving insufficient, he turned for help to a famous academic sculptor, I. S. Guinsburg, small, dark, brusque, who had a studio at the Academy of Beaux Arts, had studied under Antokolsky, and was on intimate terms with the writers Leo Tolstoy and Maxim Gorki, the painter Repin, the singer Chaliapin. Guinsburg, apparently taken by Chagall's charm, gave him a letter of introduction to his brother, the Baron David Guinsburg.

Baron Guinsburg was then fifty years old, a prince among the Jews, the third generation of a famous family of financiers, philanthropists, communal leaders. He was one of the very few Jews who might have audience with the Czar, participating in delegations

to the autocrat of all the Russias, squeezing bargains for the benefit of the poor mass of his co-religionists. Aristocratic in mien and by family heritage, he bridged by his multiformed interests the many curious interlocking and yet separated worlds of Eastern Jewry. Conservative in politics, nevertheless he helped radical Jewish Zionists and Socialists. A Hebrew scholar, a pious Jew observant both of sabbath and dietary laws, he had studied in German and French universities, served as a youth in the Russian army, traveled widely, and now worked in St. Petersburg. In a memoir, his daughter describes the great house in St. Petersburg where young Chagall appeared with his petition for help.

My father inherited from his grandfather Ossip, a library of 10,000 volumes. He was constantly supplementing this, purchasing entire collections, as well as individual volumes, through catalogues received from Paris.

Father had bookcases sent from Paris to Petersburg, four meters high, one meter deep. They were of oak, with glass doors. Every shelf had a side vent to allow for air circulation. The lower sections had no glass. There, about two thousand four hundred rare manuscripts were kept. There were oversized folios with engravings by Gustave Doré, the Bible and La Fontaine's fables [both of which Chagall himself was later to illustrate!], the works of Molière in large format; many art works, sheathed in rollers, one of them, very large, decorated with illustrations and elaborate inscriptions; arabesques; copies of gravestone inscriptions and ornamentation, colorful engravings of Jewish interest.

When the timid Vitebskite came, the great library already numbered fifty-two thousand volumes, not counting the collection of French and Russian newspapers and magazines. The tradition in the family was that the Baron's library was second in the scale of private libraries only to that of the King of England.

... my father even on a very short trip, always kept a small Hebrew Bible in his pocket, a French Bible in his suitcase, two volumes of Lermontov's poems, as well as two large diction-

aries, Arabic-French and French-Arabic, which he needed for
his work.

The children had a French governess and a Russian teacher. The
chief rabbi gave them Hebrew lessons. They studied piano, drawing,
dance.

A small suite in the house was set aside to house Jews refused
residence permits in the capital city. Here they lived in hiding until
the Baron could obtain the proper documents for them. While they
were in hiding, they did not leave the house; food was brought into
their rooms by the servants.

This, then, was the personality and ambiance to which Marc
Chagall turned for help. When he had decided to go to the capital,
he had to secure the authorization necessary for Jews who wished to
issue forth from the restricted Pale. Marc's father, despite his doubts
about his son's strange profession, had cooperated to the extent of
obtaining from a merchant a temporary certificate stating that Marc
Chagall was employed by him to deliver some merchandise in St.
Petersburg.

According to Chagall, the Baron was disposed to help young artists
in the hope of discovering another Antokolsky, his friend, a famous
sculptor very much in vogue at the time. At any rate, Guinsburg
gave Marc a monthly subvention of ten rubles. Chagall's account of
the interview is somewhat less than grateful. The Baron, he thought,
knew very little about art, but "felt it his duty to meet me and be
gracious with me [why was it his duty?], while telling me stories
concluding with the moral that an artist should be very prudent. . . .
For example, a wife could prove of great importance in the life of an
artist. . . ."

The subvention lasted four or five months, then on one visit for
funds Marc was advised by the magnificent valet de chambre that
this was to be the final payment. There follows a series of recrimina-
tions against the Baron, who did not care how poor Marc would
survive after he had descended the sumptuous staircase. And why had
he been so courteous in the first interview if he had no real faith in
the Vitebsk boy's artistic gifts? And how could he be expected at the
age of seventeen (another example of elastic chronology) to earn his
living by selling his drawings? Go peddle newspapers, that's probably
what the Baron thought.

This passage of *My Life,* indeed most of the pages devoted to the St. Petersburg years, are unusually charged with class feeling, a sense of discomfort, embarrassment, in the presence of the rich, influential Jews of the capital. It is the familiar story of the provincial in the great city. He was presented to ... "a pleiade of Maecenas. Everywhere, in their salons, I felt as if I had just come out of the bath, my face red and burning." He meets the lawyer Goldberg who had the "right" to hire Jewish servants so long as they dwelt and took their meals in his house. So Marc Chagall became one of the domestic help of the Goldbergs.

But before this, he had only enough means to rent a corner in various furnished rooms, sharing quarters with what seems to be a series of refugees from the novels of Dostoevsky. There was a sculptor, like a wild animal, who screamed and "ferociously pounded his clay so that it shouldn't dry up on him," and hurled a lamp at Marc's head. And there was a mysterious Persian who loved him "like a bird," and subsequently committed suicide in Paris. On one occasion Marc could not even have a bed all to himself and had to share it with a worker. But of course this worker with very black moustaches was really "an angel." He was so kind that he shoved himself as close as possible to the wall to leave room for Marc, and turned his back so Chagall could breathe fresh air.

One night in bed alongside the angelic worker with the black moustaches, Marc heard the rustle of wings. It was a real angel. The room was so brilliant with light that Marc couldn't open his eyes. "After having rummaged everywhere [the angel] rose and passed through a cranny in the ceiling, carrying off with him all the light and blue air."

Chagall says that his painting *The Apparition* evokes this dream. Or more likely perhaps the painting evoked the written account of the dream.

Indeed, as Clive Bell so cogently puts it: "Art has nothing to do with dreams. The Artist is not one who dreams more vividly, but one who is a good deal wider awake than most people. His grand and absorbing problem is to create a form that shall match a conception, whatever that conception may be. He is a creator, not a dreamer."

Another time he rented half of a room, separated by a curtain from the other half, occupied by a drunkard and his poor put-upon wife. By day the drunkard worked as a typographer, by night he was an accordionist in a public garden. One evening Marc heard the fracas

and curses of a violent quarrel on the other side of the curtain. Then
he saw the drunken husband chasing his wife down the corridor,
brandishing a knife, and screaming—"You have no right to refuse
your lawful husband!" Chagall remarks: "I learned then that in
Russia, not only did the Jews have no right to live, but neither did
the Russians, crammed together like vermin in horses."

How remote from the Russian reality could Marc have been that
only at the age of twenty, as a result of witnessing a squalid domestic
scene, did he manage to achieve such a realization?

On arriving at St. Petersburg, Marc had gone to take the entrance
examination for admission to the School of Arts and Crafts of the
Baron Steglitz. Acceptance also entailed authorization to reside in the
capital and a subvention to cover at least part of his expenses.

But he was frightened by the exam, which entailed making copies
of the plaster ornaments heaped up all over the place so that it
seemed a department store.

Chagall was convinced that studies from these sepulchral casts
were chosen purposely to frighten off Jewish students so that they
could not obtain the indispensable authorization.

But why, one may ask, would not drawing the plaster ornaments
be equally difficult for Christians? Or Muslims or Buddhists for that
matter?

At any rate, he failed the exam, and had to enter a more accessible
school, that of the Society for the Protection of the Arts.

But this didn't prove very much more stimulating.

Pedagogy here consisted in daylong copying of a roomful of
plaster heads of various departed Greek and Roman citizens. Marc,
"poor provincial," was supposed to gain skill of hand and inspiration
of heart by penetrating into the nostrils of Alexander of Macedon or
"some other plaster idiot."

He spent most of his time gazing languidly at the dust-laden
breasts of Venus and dreaming of the flesh-soft pulsing breasts of
Aniouta or Nina.

Marc lost almost two years at this school, which was directed by
Nicolas Roerich, later to emigrate to New York where he set up the
Roerich Museum on Riverside Drive. Chagall says that the teaching
was "non-existent," that Master Roerich devoted himself to writing
laughable poems, historical-archeological books, which with smiling
clenched teeth (how very tooth conscious is Chagall in all his

writing!) he would read to his uncomprehending students. The studio, located on Moyky Canal, was freezing in winter and stank of the dormant water of the canal, not so dormant humanity, and oil paint. Sometimes Marc would be reprimanded in the still-life class before all the students and flush burning red; later he was to be praised for the vigor of his drawing. But when finally he had won a scholarship of sixteen rubles a month, he was still dissatisfied with the type of academic instruction stressed there. And after the bestowal of such high-toned criticism as "What kind of shit are you drawing there?" he abruptly left the school.

This was in July 1908 and Marc was so furious that he didn't even bother to collect his last month's scholarship.

For the next two years, with frequent visits home to Vitebsk, Chagall pursued his art studies in the capital, at a variety of schools and with private teachers, living always very poorly, and always engaging in various subterfuges to obtain the necessary legal permission to reside in the capital.

Only a little more than a year before Chagall arrived in St. Petersburg, one of the Jewish delegates to the First Duma, Schmarya Levin, though a graduate of a German university, discovered that he had no legal permit to live in the city since he was not a businessman. So absurd was the system.

Every delegate had to register his name together with his religion and his nationality. One of the "Jewish" deputies, a famous editor of a Russian periodical, Gregory Yollos, insisted on enrolling himself as a Jew by religion and a Russian by nationality. Old-line objection to this was met by a former Jew named Gerzenstein who had converted and hence registered as Russian Orthodox by religion, and Jew by nationality. Thus the books were balanced!

Once returning to the capital without a safe-conduct, Chagall was arrested at the frontier because he had failed to pay the expected bribe. He spent several weeks in jail in company with thieves and prostitutes and by his own account did not have such a bad time, dreaming Chagallian dreams of severed heads floating around the cell.

Upon his release, he became apprentice to a sign painter since manual workers received the residence permit without too much difficulty. He liked the work and did a series of signs, taking pleasure in seeing them swinging outside the market, over the entrance to a butcher shop or fruit store. Letters and signs are frequent in Chagall's art, either playing a part in the design or serving—Hebrew

letters especially—as the armature for a composition. Typical also is the sleight-of-hand game of distributing the letters of a word, sometimes the signature of the artist in Roman or Hebrew letters, over various parts of the canvas or writing them backward. Sometimes he signed his full name, sometimes, as in Hebrew, he adopts only the consonants:

Chgll, sometimes llaghC, or aligns the letters C_h
It is a world without up or down, left or right. _a
All the elements of his cosmos are subject to _g_a
endless permutation. _l_{l.}

*

Curiously inserted into the elastic chronology of *My Life* after the departure for St. Petersburg is a chapter of purple sighs and iridescent exhalations dealing with Marc Chagall's awakening to the glories of the other sex. It is impossible to determine exactly when all the events brushed therein with a very delicate brush actually took place.

The years of study in St. Petersburg were interspersed by many short or long interludes in Vitebsk. So, although we cannot fix the exact year, it must have been in 1908 or 1909 that Marc Chagall met the girl who was to become his future bride and muse, his soul, as Feiga-Ita had been the *nishoma* of her family.

He was then twenty-five or twenty-six, very handsome, and aware of it, given to gazing in the mirror and not ashamed to apply reddening to his lips and rouge to his pale fawn's cheeks to attract the other sex. The number of self-portraits dating from 1907-1915 show Marc gazing at Marc with unconcealed admiration, tinctured with the saving grace of humor. He exaggerates his long doe-shaped blue-green eyes, set aslant above high cheekbones, his chestnut-brown mop of curls, the delineated shapely lips winged as gulls, the long, delicate, high-bridged nose, the slender, gracile figure. The head is usually tilted, cocked at the spectator (himself), sometimes topped with a rakish Russian cap, but more often bare to display the abundant curls. The earliest self-portrait (1907) displays a handsome wisp of blondish moustache, with the sharp edges of his mouth ("too sharp" as a future biographer was to comment) turned upward as in Van Gogh's self-portraits. Most beautiful is the famous "smirking"

line drawing, perhaps dating from 1906 or 1907, together on the same sheet with marvelous profile portraits of his parents. Chagall even from the beginning is a master of leaving out, his white space illuminates, aerates, highlights the secure yet delicate line, the stippling, dotting, skipping, scratching, undulating traceries of his thought, left behind like the glittering web of a spider in the sun.

But of course Marc Chagall did not become aware of sex for the first time at the age of twenty-five. With all his reticences—his personal timidity reinforced by the acceptable social behavior of Jews at that time and in that community—some early pages of *My Life* pulse with the nascent passion that was to play so important a role in Marc's life and art.

Frequently erotic, but not obsessively so, as in the case of Picasso, Chagall differs from the Spaniard also in the durability and singleness of his passions. He never loved but one woman at a time, and his first marriage with Bella Rosenfeld was apparently a blissful union that lasted for twenty-nine years. Bella's role as muse and manager, vestal virgin and mother, counselor and *éminence grise,* angel and house-keeper is celebrated in hundreds of paintings. Her transformed image does not cease to appear even after her tragic and unexpected death in 1945. His union with Virginia Leirens lasted for seven years, to be shattered only by his young mistress's flight; his present marriage dates from 1952.

Chagall's eroticism is within the framework of the Jewish family tradition and his attitude toward women was undoubtedly shaped during his growing-up years in Vitebsk. The role of women in the Jewish community was ambiguous. By law and custom, subordinate; symbolically relegated behind the lattice in the women's section of the synagogue; frequently not given religious instruction so that they either "stole" their knowledge of Hebrew, listening in on their brothers' instruction, or learned their prayers by rote—their official role in a fiercely patriarchal religion was to be good mothers, good wives, and leave all dealings with a stern Jehovah to their husbands. In actual practice, however, the women were more often than not the ruling force in the home, the core of activity and training of the children, active in business enterprises sometimes independently of their husbands (as in the case of Chagall's mother), sometimes in cooperation with their husbands. The Jewish mother became legend-ary for her activity—the pulsing heart of the family, the cohesive

nucleus, the goad to lazy husbands or dreamy daughters, the spoilers of sons, ceaseless matchmakers, busybodies, and, in some cases, pests and disturbers of the peace.

Though Art and Eros are inseparable, protean are the patterns of their embrace. A study of the sex lives of artists reveals the entire gamut of erotic behavior from promiscuity to puritanical repression, from Maupassantean satyriasis to Jamesean abstinence, from Picassoan polygamy (simultaneous and sequential) to Chagallian monogamy.

Monocausality is an intellectual disease, unfortunately rife in certain circles: single-string deduction is reduction. Gonads do not explain symphonies. Michelangelo did not attack the white marble with fury because he "missed" his mother's breast. Fortunately, great artists are not diminished by the imbecility of their commentators.

The erotic component in Chagall's art is certainly very strong. But in his life he was very "chaste." Brought up in a rigidly moralistic Jewish milieu in which the polygamy of the Bible might be prayed about, but surely not practiced; where most marriages were arranged (as was that of Zachar and Feiga-Ita) and where the sex act was for propagation and male gratification only and performed without imagination or tenderness or playful preparation, Chagall has all his life poured all of his passion into his painting rather than into his partner. As far as the woman was concerned there were few kisses, no love games, brief and primitive couplings. Fantasy, inventiveness—all that went into his art.

In this sense, the eroticism in Chagall's painting has a very different significance from that in Picasso's. The Malagan bull keeps a pictorial diary of his passions: love affairs which inevitably turn into hate affairs. We can read the paintings like fever charts: these billowing pillowy undulations—say, *The Mirror* of 1932—relate to his sexual joy with Marie-Thérèse Walter; these savage slashes with a jagged-toothed sword is his destruction of Dora Maar; these monkeys and this grotesque dwarf putting on masks in the presence of a lunar-cool nude girl is Picasso raging against the dying of the phallus.

But no such one-to-one relationship may be found in Chagall's art. Populated as it was from the beginning with lovers, flying brides swooping whitely into deep blue skies, donkey-men blazing purple-red with desire, boy-girl double forms and double faces in bouquets of flowers, rigid fish and receptive concavities of crescent moons—

none of these shapes or images serves to tell us anything about the state of Chagall's emotional life at any given moment. They are rather a repertory of symbols and shapes to be used whenever they are needed for the formal exigencies of his painting.

Thus his art, like his life, is not a graph of warmings and coolings. Like many great lovers, Chagall is capable of finding all Women in one Woman. His fidelity is inclusive not exclusive. "How can you always remain attached to the same wife?" Picasso the protean scornfully asked Aragon, who had made of his life-long marriage to Elsa Triolet a public (too public) literary affair. "I like to see her change," blandly replied the poet.

Chagall, however, didn't see any changes in his Bella, as he has never seen any changes in himself. His world is just as timeless as it is spaceless.

Like any normal boy, Marc had become increasingly aware of the opposite sex as he approached puberty and the sweet torment increased during his teens: " . . . when I walked on the roof during the great fires, when I went bathing or sketching," he continued assiduously to court the schoolgirls swirling along the quays. The "courtship" was obviously telescopic. The hems of their long petticoats, stirred up in him an erotic froth: foam on the Dvina.

And the girls were aware of him, too, he remarks, not without a preen of narcissism. Some of them told him so. Besides there was "the testimony of the mirror" in which "the figure of my precocious adolescence was composed of a mélange of paschal wine, ivory-colored flour, and rose petals pressed between the leaves of a book."

He admired himself and more than once his family caught him stealing glances in the long looking glass. He was really thinking, he says, of the difficulties he would one day encounter, painting his self-portrait. But since these love glances in the mirror took place long before he ever thought of becoming an artist, this "explanation" is another of those abundant *ex post picturam* passages in *My Life*.

Before St. Petersburg, he went through the usual assortment of schoolboy puppy loves. There is Nina, with whom he walks under the bridge at Lyozno. It is night. On a bench. Alone. They hear the clipclop of a distant fiacre. "You can do as you wish," she breathes hotly into his ear. He kisses her. Again. After all there is a limit.

"Soon dawn." He is not content. (No wonder.) They return to

his parents' house. The air is stifling. Everyone is asleep. Should they? Tomorrow will be Saturday. Should—? It's so hot! Should—?

His reticence floods the mind with suggestions.

The negative space of his telling is like the semicolon of Stendhal's *Le Rouge et le Noir* which contains an entire night of love in its typography. Tolstoy tells us only that Anna Karenina had white arms in a novel which is always passionate, never prurient.

So Chagall's omissions echo with allusiveness, like the white space of his drawings.

He was in fact "ignorant of active romanticism." He trailed after Aniouta for four years, sighing all the way. This grand passion culminated in a timid kiss and one or two embraces down on the riverbank, notwithstanding the erotic stratagems mounted by this "violent girl" and her friends "to draw me into the trap."

When Aniouta came down with smallpox, Marc, timid, at the foot of her bed thought those little red splotches were the result of his stolen embrace the other evening.

There was Olga, Aniouta's friend. She had short legs, a turned-up nose, squinty eyes. The sight of her sets him aboil "with all sorts of desires, but she dreams of eternal love."

He wearies of her fluttering hands, her stumpy legs, her "eternal love," and courageously embarks on his third romance. Now he is ferocious. He "embraces right and left." But all his loves wilt almost as soon as they are born.

The rains wash away his flirtations.

What was to prove the most crucial of these ante-Bella romances was with Thea Brachman, daughter of a well-to-do doctor in Vitebsk. A photograph of Thea shows us a handsome girl, strong, dark, determined. She was a typical product of the cultural revolution that for three-quarters of a century had been shaking up the airless, closed world of Eastern Jewry. An intellectual, studying then in Moscow, Thea was a refined young woman, more upper-middle-class Russian in mien and attainments than Jewish; and, like all young people who had grown up in a cultured milieu, touched with the new ideas of Socialism, secular Zionism, and if there was any religious belief or practice at all, it would be of the Haskalah or "enlightened" brand.

Thea had traveled abroad, read French, German, and English books as well as the Russian classics, and played Chopin on the piano while Marc stretched out in a swoon on the grand divan next to the

doctor's waiting room. (How different from his Zayde at Lyozno dozing on the high ledge above the stove!) Here everyone spoke Russian with a cultivated lisp amidst the slushing *nyets* and crisp *da*'s interspersed with rapier quotes from French novels or poetry. Here he heard Lermontov lionized, Pushkin proclaimed, Tolstoy titanized, Dostoevsky denied. Here on the walls of Dr. Brachman's rich lush apartment crowded with Meissen porcelain and Biedermeier chests of drawers, he might have seen examples of Russian nineteenth-century painting: a moralistic genre piece by Repin mayhaps, or a landscape by Isaac Levitan. The room was dense with foliage: a dark green screen of indoor plants was ranged along the walls near the piano. In this circle of enlightened young people whom he had met through Victor Meckler, Marc was soon writing juvenile verses about mignonettes and moons, listening to (probably not participating in) heated political discussions, and savoring of his first introduction into a refined Russianized world of art lovers and intelligentsia.

In October 1909 on one of his trips back from St. Petersburg, Chagall met at Thea Brachman's the girl who was to become his wife, his guardian angel, his muse for the next thirty years. In 1944, Bella wrote in *Burning Lights* pages burning still after almost three decades of life with Marc: incandescent memories of their romance.

But twenty years before that, in his memoir of 1922 Marc Chagall had already written his account of their meeting:

> He was at Thea's, lying on the couch in her father's, the doctor's office, waiting for her. She was busy, preparing dinner. Her dog, big and fat, is twining around her legs.
>
> [As in his grandfather's butcher shop Marc associates food with sex.]
>
> I deliberately choose that spot so that Thea might approach me, embrace me. I stretch out my arms, the arms of salutation.
>
> Sound of a bell.
>
> But it was not Thea. He was annoyed. A friend of Thea's, prattling.
>
> This unknown young girl's visit and her voice singing as if from another world, troubled me.
>
> [Later Thea and Marc go out for a walk. On the bridge they run into the girl again.]
>
> She is alone, all alone.
>
> Brusquely I feel that I shouldn't be with Thea, but with her!

Her silence is mine. Her eyes, mine. It is as if she had
known me for a long time, as if she knew everything about my
childhood, my present, my future; as if she watched over me,
fathomed me to my very soul although I was seeing her for the
first time.

I feel that she is my wife.

Her pale complexion, her eyes. How large, round, black they
are! They are my eyes, my soul.

Thea now seems of no importance to me, a stranger.

I have entered into a new house and I am inseparable from it.

Bella's account plays almost exactly the same notes, but in a dif-
ferent key: a chapter in her *Burning Lights* entitled simply "The
First Meeting" is an astonishing gospel of love according to Saint
Marc. Astonishing, especially if we consider that this ardent memoir
was written in 1943 and 1944, thirty-five years after the event. How
long the flame burned!

The Rosenfelds were one of the wealthiest Jewish families in
Vitebsk. Bella's father was the proprietor of three large jewelry
shops; and the family's great stone house near the Cathedral was as
far removed—in terms of social distance—from the Chagalls' modest
stone house as the latter was from the wooden isbas rented out by
Feiga-Ita.

Bella, like her friend Thea, moved in circles which hitherto Marc
had not known: emancipated young people who, even if their families
continued (like the Rosenfelds) to be observant of Jewish religious
tradition, were affected by the new winds blowing through the
ghetto. Bella had won a gold medal as one of the four best lycée
graduates in Russia; she had studied and lived alone in Moscow; and
had ambitions to become an actress.

On this occasion in 1909, Bella had just returned from the spa at
Marienbad, where her mother went every summer. Bella had already
been to Berlin, Vienna. She was burning with impatience to tell her
friend Thea about her travels. So now she stood outside the window
of her friend's house knocking at the pane. Bella loved to visit her
friend's home. She loved the lace curtains and the flowers and the
plants everywhere, the palm trees in great pots, the cut flowers in
vases. From the outside she thought their house was like the others
and yet it was different. Especially different to her because it was to

be the chamber of an ordained encounter. The mystic vocabulary was employed by Bella herself in telling the story a third of a century later.

There was a secret in that house, residing perhaps in the foliage, or in the music which pierced the closed windows so that the neighboring houses listened all day to the sonatas of Mozart and Beethoven. Every passer-by stopped for a moment outside the windows, head tilted, listening, then, recomforted, continued his path. That house always full of guests, laughter, music. When no one played the violin, it rested on the piano, its mute bow awaiting the sound-endowing hand. Thea's mother would insist that Bellotchka eat a *blini,* or would comment on her clothes, bird-chattering, flicking from room to room. All day she seemed to be dancing a quadrille.

Many friends came into that house, always the same friends. Thea's three brothers always gay, mocking, playing music, performing little theatrical charades.

When Bella came to that house of music, of birds everywhere, of pots of flowers, of laughter, she felt she had become another being.

But this day there was something different. When Thea finally opened the door, her face seemed to be trembling as if she were carrying some great secret that she wished to conceal.

Thick-laden plant shadows were silhouetted against the windows. Evening fell. Thea was scarcely listening to her words. She seemed to be suspended like the great chandelier above her head. The ceiling of the dark room merged with oncoming night. Bella had the sensation that she was no longer alone. She felt an inquietude. The plants on the window ledges, on the little round tables seemed to be reaching forth their green arms, the blossoms were gulping down the night air, gorged with blackness. She heard them breathing breathing sighing. A sleeping bird stirred. It launched a cry. She turned her head.

"A ray of light, a shaft cut through the obscurity. I listened. Someone was entering. A new shadow seemed to fall on Thea's face."

What was it with Thea today, Bella wondered, her friend was always gay, always in society, inundated the world with songs, played the piano, or spoke German, declaimed her own poems or those newly published. What was there with her today? Why was she so bemused? Weren't they friends? Why, to every remark of

Bella's, did she answer distractedly with a mysterious contained smile, keeping her head turned toward her father's office? Dr. Brachman, though a "healer" without a degree, was held in high repute in Vitebsk; in the Jewish community especially his status was practically that of a physician.

"Who is there?"

Now the dog Marquis was barking; and the aviary—the vain parrot, the lovebirds, the canaries—were all chattering.

> Toward whom is Thea inclining her ear? Her father must be in town, taking care of his patients. Is that a shadow outlining itself in the opening of the door? I am afraid. Laughter chokes in my throat.
>
> Who is there? What is she hiding from me?
>
> The door noiselessly opens. My back burns. I am nailed to the spot. I fear to turn around. A flame seems to pursue me. I see it sliding along the walls. The face of a young man emerges. A face as white as the wall.

All these references to "flames," "nailed to the spot," the paralysis of Bella's being at this celestial apparition makes of this first encounter with her future husband a veritable epiphany, the visitation of an angel.

The hushed mystical tonality of her account reveals a sexual passion that was kept shrouded from the world by Bella's famous silence.

> Where did he come from? I had never seen him. He did not resemble either Thea's brothers' friends or anyone. He gesticulated as if he feared to put his foot on the earth. Had he just awakened? His hand is raised and he had forgotten to lower it. It hovers there like a stalk of cane.
>
> What does he mean to do with that hand? Greet me? Strike me? Perhaps I have troubled his sleep? How could it be that he sleeps here, in full daylight? His head is a tangle of curls. His little ringlets dangle, interlaced, fall over his forehead, masking eyes and eyebrows.
>
> But when his eyes piercingly gaze, they are blue, they have come from heaven. [Here explicitly is the celestial reference!

The son of Zachar, the herring hack, is a *veritable angel!*]
Strange eyes, not like everyone's eyes, long, almond-shaped.
Each eye looks from its own side, little barques floating off one
from the other. I have never seen such fawn's eyes, unless it
was in an illustrated bestiary. Blessed mouth. I don't know if it
means to speak or to bite with those white and nipping teeth.
Everything about him in him is lurking movement like an
animal at rest, ready to bound at any instant.

She has the impression the young man's arms and legs are
elongating and folding. He is laughing all the while. Is he laughing in
a dream? Is she making him laugh?
How could Thea have fooled her? Why didn't she say imme-
diately that a stranger was at her house? She had recounted all sorts
of stupidities. He had heard everything and now he was laughing at
her. What effrontery! Laughing right under her nose!

. . . I remained planted in the midst of the room. I wanted to
flee, flee my senseless comrade and her bizarre friend. What is
he thinking about? I see his forehead crease in a deep furrow.
Now he is approaching me. I lower my eyes. No one says a
word. Each of us listens to the other's heart beating.
I cannot stand it any more.
"Thea, I must go home . . ." My lips scarcely open. My head
is on fire.
"Why? Where are you running? You have such a beautiful
voice! I want to hear you laugh!"
He speaks! He is speaking to me! He is not afraid of the
silence! He is killing me!
[No sooner does Bella meet Marc than he "kills" her!]
I don't understand anything, he doesn't know me. What does
he want of me? What is he saying about my voice?
I look at Thea.
"You know, this is the artist . . . I spoke to you about him."
Thea is finally alive.
My blood rises in my face as if I had been caught *in flagrante*.
Thea speaks volubly, perhaps in order to put me at my ease. A
wave of words engulfs me.
"Ah! . . . Yes! . . ." I don't know what to say. The spider

web contracts. Words crawl up along my hands, my neck, gall
my skin, stifle me. I grab my hat, my cape and I find safety in
the street.

Poor Bella felt refreshed by the breeze, she felt that her head was
once again on her shoulders. But as she walked, a double—the face of
the young man—seemingly accompanied her, breathing with her
breathing and buzzing in her ears. If she chased him, he came back
around on the other side.

In her little circle of friends, she had at times met some artists, but
no one with such a face. Victor Meckler, for example, was charming,
handsome, but it was like bitter chocolate, repulsive as his pictures.

An authentic artist, she thought, opened his heart to you and
delivered it to others through his work. And the painters in her circle
didn't displace an atom of air. They were all so concerned with
themselves.

But this artist whose image was pursuing me was like a
shooting star. One could not seize it. Perhaps because it blazed
with coldly penetrating fire, perhaps it was because this star
nebulously disappeared from view. And his name! He must live
up to it! A true carillon!

Shooting stars, a clang of bells, cold penetrating flames, a baroque
orgasm of imagery that reminds one of Bernini's Saint Teresa
swooning at the vision of an angelic arrow—all this is set off in less
than a minute by Marc's visitation!

She thought he was strong and had broad shoulders but still he
seemed to be without legs. He was borne on tresses of light.

It was difficult for Bella to be friendly with young people. As soon
as they looked at her she wanted to disappear from their eyes. But
this stranger . . . she could feel his teeth nipping at her from a dis-
tance, those pointy teeth. . . .

At home, after the shattering experience, Bella recalled that Thea
had told her that Victor had presented one of his young artist friends
to her. Very poor, no place to work, and when he painted he had to
clamber up onto the kitchen stove. His family was afraid he would
soil everything with his colors. Only perched up on the stove among
the barrels and the clucking of chickens, it was only there that he did

not annoy anyone around him, handing the paintings down to his sisters, who spread them out on the new-washed brick floor.

Now Bella narrates the mystical otherworldly effect Marc's apparition had upon her.

> While I was thinking about him, his face floated toward me, changed, like multiple faces. They glided, one pursuing the other: here, his glistening eyes, his glittering teeth; a luminous ray emanated from him; there, on the same visage, a dark screen descended; the light disappeared, I could no longer see anything. . . .

Sacred and sexual epiphanies employ the same imagery. And in the numerous works Marc was to derive from and dedicate to Bella, identical visionary imagery reappears again and again: rays of light, swooping heavenly creatures, emanations, multiple faces, metamorphoses, phosphorescent dots, sprinkles and sheen and glimmerings in deep flesh-blue skies . . .

Back home thinking about the young man, Bella muses that he resembles an animal, a veritable animal! His glance assailed her, ripped her open. He bounded supple as a cat, pirouetted. She wonders whether he would be cruel?

Now she recalls that Thea had spoken enthusiastically about him. She wanted to help. She had even told Bella one should be sympathetic to artists. Their families were hostile. And where would they find models? Models were very expensive. We ought to pose for them. Nude studies, she added hastily.

Bella gasped.

That evening, almost as if carried along on the stream of her imagining, Bella found herself on the bridge crossing the river en route to Thea's house. And there again she met Thea and her friend. Marc was laughing. Laughing so much that Bella felt she wanted to cry. "His teeth shone as if he had not closed his mouth. However, his lips were so fine that they could not imprison either mouth or teeth. Was he still laughing at me?" Bella wondered. Now she noticed that his eyes were green-gray: sky and water.

When the young man, to Thea's obvious displeasure, invited Bella to walk with them, she thought that every word came from another

world. They all walked together: laughing Marc and swooning Bella
and Thea "with a red thread like a serpent in her eyes."

She meets Chagall again when she's out walking with her brother.
Perhaps it was the effect of the lights at the drink stand, but at one
point Chagall remarks: "A yellow neck! Your skin is yellow!" At
which Bella feels nude in the middle of the street. Her brother had
seen a strange young man approach her, speak to her, speak of her
neck, her skin. Always talking about colors. He had spoken about
colors on the bridge.

She felt the tears springing to her eyes. She raised her hands to her
neck, touched her dress, and suddenly realized that she was wearing
yellow lace around her neck.

Subsequently the bridge became their meeting place, their para-
dise. They walk along the river: Bella terrifiedly shy but becoming
more and more secure in Marc's presence. Strolling along the bank
the bridge above them seems to hang in air; the river sparkles like a
serpent; the low houses lining the banks are sleeping.

To enchanted Bella, Marc glides like the river, he floats. They sit
on a stump. He seems to be as much at home there as in his own
house. He knows every bird, he sees in the dark. The imagery
describing Marc is always that of a wild woodland creature, an
emanation of nature itself.

Sitting there on the bank with Marc, she imagines her family
seated around the dining table, her parents, her brothers. The shop is
closed. Her mother wonders where she might be. Suddenly her
meditations are interrupted by Marc's "What are you thinking
about? Why don't you say something? Is it true that you are called
the 'Queen of Silence'?"

The final chapter of Bella's little memoir entitled "The Birthday"
deserves to be quoted in its entirety for the nature of its imagery and
the tremulousness of its confession:

"Do you remember, we were seated one summer evening above
the river, not far from the bridge. Everything was in flower around
us."

So the lyric pulse of recollection begins to throb like Leopardi's:

Silvia, rimembri ancora
Quel tempo della tua vita mortale . . .

"The bench is right at the brink of the abrupt bank." (She is at the precipice of her desired ecstatic fall.)

Below, the somnolent river, murmuring, about to doze.

At our feet, flowers and bushes emerge from the high grass trembling along the slope.

Our bench is small, tight. Our heads lean toward the river, contemplating it.

We sit there silently.

Why speak?

We look at the sun which is setting toward us.

It takes a long time to disappear. It wavers, reddens, and is effaced in the heavens. As it sets it projects flames, embraces the cross of churches and the entire city extending far far into the distance. Spent, pale, it is lost at the horizon.

Again how transparent is the metaphorical veil: the red sun which takes a long time to disappear, projecting flames in its passage.

We look at it from the height of our escarped bank as if we dominated it. The hill mounts toward the sky merging with the low banks. The vanished sun, the little white clouds gathered at sunset commence their round. They harass the least little star which tries to shine. Here is a vast extension of dark blue sky surging and chasing the clouds. We remain seated, we look. We wait for the moon.

When will it be permitted to emerge?

One turns about and suddenly there it is.

In an instant, it pierces the obscurity, bestriding the clouds; it is outlined with a luminous halo. Everything had become clear in our eyes.

Biology and nature flow together. The sudden moon making clear what Bella and Marc both want. Suddenly piercing the obscurity, defining with a halo the impetuous surge of their young bodies.

And there it is, hiding again, slipping behind a sombre cloud. At first it shows only an eye, then one profile, the other veiled, lost in the night.

Frolicsome, the moon plays, juggles with the clouds, chasing them, with the river which had seized it from the moment of its appearance, cradling it in its waves. But perhaps it is only playing with us? It knows, the moon, that we are there for her alone.

It was day then it is night. It is said that everyone is born under a star . . . I turn toward you.

Now she addresses her husband in direct discourse, summoning him to remember their first encounters as she remembers them.

Your eyes, filled with sky, glisten.

"Tell me, how old are you?" I suddenly ask. "When were you born? Do you know?"

You look at me as if I had fallen from the clouds.

"Do you really want to know? I often ask myself that question. My father told me that in order to free my brother David from military service, he added two years to my age.

"One does not fool the good Lord in any event. As for lying to a bureaucrat, the Eternal will pardon that. Provided that David was not drafted into the army."

"But really then, when were you born?"

"If you wish we can calculate it. I am the eldest. Niouta is the eldest of my sisters. Not long ago I heard my mother shout at Papa one evening at table:

" 'Hatché, why don't you take care of Hanke?' That's how our Niouta was called—'Everything rests on me. Must she still wait a long time? With God's help she will soon be seventeen. Stop at the marriage broker, he's on your way.'

"Then if Niouta is seventeen, I must be at most nineteen."

"What is your birthday? Do you know?"

"Why should you know everything? That will make you look old."

"Everything? Only when you were born."

"Who knows! Except Mama! And Mama has certainly forgotten, with so many children. But when my sisters argue with me, they taunt me with: 'You're crazy, you, born in the month of Tammouz. . . .' "

All the stars which had flocked to listen to your story burst into laughter with us.

"You know what I think? You're going to say that I'm a fool. It could be that you came into the world the year in which your father registered your birth. But you would have been so frightened about it that in order to revive you, he would have had to take off those few years. . . ."

"Do you really think so?"

A shadow brushes across your face. The sky darkens at the same moment.

"Don't you understand that I was joking?" I dare to smile a bit.

"You're not annoyed?"

Most likely this entire passage is an expression of the Bella of 1944 writing, rather than the Bella of 1909 thinking. All their long life together the amused, perceptive wife knew of her husband's desire "to take off a few years."

In the interview with Edouard Roditi in 1958 Chagall repeated (with variations) this same story:

> Officially I was born in 1887. But I still have the impression, despite my gray hairs, of being much younger. It could be that my parents falsified my birth date. I was the oldest of a numerous family, and if my parents could prove a difference of four years between me and my next born brother, I was exempt in Czarist Russia from military service. Perhaps on paper I was made older by two or three years in order to lend more worth to my quality as the eldest son and support of my family when I was in fact still very far from being able to support. . . .

Roditi had the impression that Chagall wanted to take refuge among his family memories instead of answering his questions. Like a psychoanalyst who brings back his patient to order when the "resistance" of the latter leads him to attempt evasions, Roditi insisted on keeping the painter's vagaries in the traces but it was like bridling a cloud.

Chagall's flexibility with the date of his birth extends to the dating of his pictures, as well as to most other "facts" relating to his life. To a metamorphic mind all "facts" are subject to disintegration and reintegration. This may make the task of a biographer difficult, but

since "Truth" is neither capitalized nor singular, Chagall's "truths"
are frequently revelatory.

Myself [continues Bella after this playful duel], I don't know
any longer how I finally ended by learning the date of your
birthday.

On that day, from morning on, I wandered the outskirts of
town, gathering a great bouquet.

I still remember how I scorched my hands trying to pick tall
blue flowers above a hedgerow.

[Here is the first appearance of the famous Chagallian blue
flowers; the image lasts with him all his life.]

A dog began to bark.

I barely saved myself, fled to safety, without picking the
flowers. How beautiful they were! I hastened to gather others,
directly in the fields, with grass and roots so that you could be
more aware of the earth. And once home, I reassembled all my
shawls of color, my squares of silk. I even made use of my
embroidered bed-cover and in the kitchen took a cake, and
some bits of fried fish which you liked so much. Then all
decked out in my party clothes, and loaded like a mule, I took
the road to your house. Don't imagine that it was so easy to
carry all that.

It was a warm day. The sun had been blazing from early
morning. The streets were torrid. Even the stones sweated heat.
I still had to cross half the town before arriving at your house.

The shopkeepers were catching a breath of air at their
doorsteps. Everyone knew me, knew where I was going. They
exchanged glances.

Where is she running, that crazy girl, with so many
packages?

"Is she running away from her family—God forbid!—to join
her fine young man? One can expect anything of girls today!"

It is fortunate that you live on the other side of the river.
One can take a short cut, reach the bridge, cross it, and on the
bank I am free.

The windows are closed on the little houses at the water's
edge. The housewives are guarding themselves against the sun.
They are busy in their kitchens, which have their backs to the

river. I finally breathe. Pure sky. Freshness of the stream. The water runs, I too, the sky catches hold of me again. It plunges lower and lower, clasps me around the shoulders, helps me to run. That summer you had your own room. Do you remember? Not far from your parents' home, a room rented from a policeman. His white cottage with red shutters like his summer *kepi* with red piping was at the corner of a street. There was a long courtyard which enclosed a big garden. In the center was a church.

You undoubtedly thought that policeman and Holy Church protected you from everything, from yourself also.

Isn't that so?

I tapped at your shutter which you often left half-open even during the day. In order to soften the light or not to be seen from the street?

You come yourself to open it. Your landlord must not see me—my visits were too frequent—and, above all, with packages. A bar locks it from the inside. It takes time to slip it out.

"What is it?" Quickly you allow me to slip in and you open your eyes wide. "Where are you coming from?"

"You think with packages one must be coming from the station? Guess, what date is it?"

"Ask me an easier question. I don't even know what day it is."

"No . . . not that . . . Today is your birthday!"

You remained with your mouth gaping. If I had announced the arrival of the tsar in our town, you could not have been more stupefied.

"How do you know?"

I quickly untied my multicolored shawls, hung them on the wall. I stretched one out on the table, I placed my bed cover on your cot. And you . . . you turned around, you rummaged among your canvases. You pulled one out, set it up on the easel.

"Don't budge! Stay where you are . . ."

I still have the flowers in my hand. I can't stand still. I want to put them in water. They're going to fade. But very quickly, I forget them. You have thrust yourself upon the canvas which trembles under your hand. You dip the brushes. Spurts of red, blue, white, black. You drag me into floods of color. Suddenly

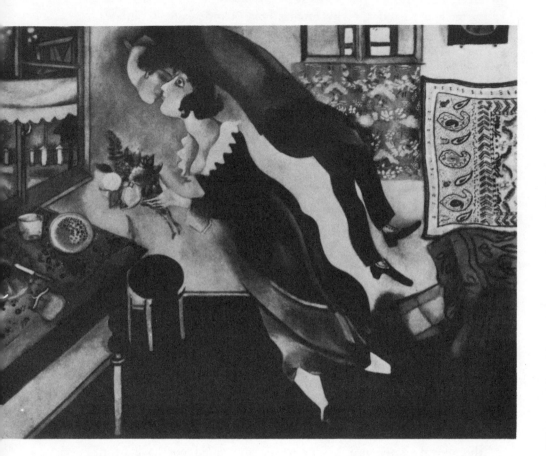

L'Anniversaire (The Birthday), 1915.

you tear me from the earth, you yourself take off from one foot, as if you were too restricted in your little room. You rise, you stretch your limbs, you float up to the ceiling. Your head turns about and you make mine turn . . . You brush my ear and murmur . . .

I hear the melody of your sweet and grave voice. Even in your eyes one hears that song, and both in unison slowly we rise above the bedecked room and we fly. At the window we want to go right on through it. Outside, clouds, a blue sky calls us. The walls decorated with shawls spin round and make our heads spin. Fields of flowers, houses, roofs, yards, churches float below us . . .

"Do you like my painting?" Suddenly you are on the earth. You look at your painting, you look at me. You pull back from the easel, you look at it closely.

"Is there still much to do? Can it be left as it is? Tell me, where must I still work on it?"

You speak for yourself alone. You wait and you are afraid of what I am going to tell you.

"Oh, it's beautiful. It's as beautiful as if you had flown in it . . . We will call it the Birthday."

Appeased, your heart abates.

"Will you come back tomorrow? I will paint another picture . . . We will fly . . ."

That Bella was capable of writing an aerodynamic love idyll still so murmurous with sighs, exhalations, gasps of Eros thirty-five years after the event is an astonishing performance. The actual painting, *The Birthday,* in the Franz Meyer-Ida Chagall catalogue is dated 1915. But dates mean nothing in this weightless world of outer space into which these lovers were rocketed. So faithfully does the canvas depict in painted imagery what Bella describes in words that one feels it has emerged from the same mind and hand.

Marc himself in *My Life* sets all these flying maneuvers in 1914 or 1915, just before his marriage to Bella Rosenfeld. Then he tells us, morning and night, Bella used to bring to his studio sweet cakes from her house, grilled fish, boiled milk, various decorated fabrics, even boards which were useful as easels.

I had only to open the window of my room and blue air, love and flowers entered with her.

All dressed in white or else in black, she has flown for a long time over my canvases, guiding my art.

I never complete a painting or an engraving without asking for her "yes" or "no."

*

"The greatest gap in nature," said William James, "is between two minds." This human condition, operant even between the most fused of lovers, the most twin-starred of couples, was true of Marc and Bella, of course, as well. But they breached that greatest gap more often and more successfully than most: that is to say, they remained lovers, though married; monogamous but not monotonous; lovers to the end, in a story so felicitous as to offer little drama to the biographer or novelist. Out of this domestic Eden, lived and remembered, poured an endless series of painted epithalamia: Bella as goddess; Bella as Venus; Bella as Bathsheba; Bella as the Shulamite of the Song of Songs; Bella as the bride in her sperm-spurting gown, a sex comet; Bella as white whish of rocket soaring toward the moon; Bella as Bella Bella Bella.

Even after her death (when he was living with Virginia) whenever he painted a bride . . . it was Bella; whenever he painted a bridal veil . . . it referred to Bella.

We don't know of course what their physical unions were like—no one can know—we can only deduce their bliss from Marc's paintings and writings, and from Bella's memoir.

Apparently from the day Marc Chagall met Bella, they ceased to walk on the ground. They soared over Vitebsk, Paris, Moscow, Leningrad, Berlin, New York, Cranberry Lake. Their life together was one long nuptial flight.

That is not to say that every day was bliss. Eden is not Eden without storms. Eternal sunshine is a bore, and boredom is the first slithering of the serpent in the garden.

Of course Marc and Bella Chagall must have had their violent days, their tempests, their quarrels, their misunderstandings. Certainly the greatest gap in nature always remains—no matter how fiery

might seem the fusion, how permanent and perfect the flung soldering of flesh and spirit.

Quite different by temperament, the secret of their successful union probably resided in their differences. They supplemented each other. The identity that Marc proclaims so mystically in his memoir (". . . my eyes, my soul") is a sentimental distortion of the truth. Identity more often than not destroys unions, but certain temperamental differences are fruitful. At any event, unison is less interesting than harmony; and a succession of harmonies becomes cloying without the occasional needful abrasiveness of cacophony.

Before the gendarme, his studio had been the isba in the courtyard which his mother had rented to an old man named Javitch. Through the window he could see a hillside on which was a Russian onion-domed church. There was a cot, his canvases pinned to the walls. Here, he tells us, Bella used to come, tapping delicately on the door with her fine fingers. She almost always brought with her, pressed against her bosom, a big bouquet of sorb blossoms, nebulous green pricked with red. Flowers and embraces. Clasping her in his arms, he dreamed of pictures he would paint.

One such picture, the fine portrait entitled *My Fiancée in Black Gloves,* must have been painted the summer after they had met. Head swiveled under a blue beret, black-gloved hands resolutely in contrast against the hips of her form-revealing white dress, the picture displays a willful, determined Bella, far indeed from the tremulous panting creature of her own description.

One day Bella posed nude for him. Timidly he advanced to the couch. "I swear, I was seeing a nude for the first time."

However, a sepia pastel sketch of 1908 was done from a model at school; and two red nudes of 1909, one from the side and the other from the front, thighs open, heavily outlined in black, were posed by Thea Brachman.

Perhaps Bella's daring act—unthinkable for a nice Jewish girl in that restrictive pious world, and especially in such close proximity to Marc's family—had been provoked by Thea's earlier act of liberation. Both cases were indicative of the new revolutionary spirit of Russian Jewish youth. But Bella was more likely motivated by biology than ideology.

Marc claims that although the naked girl on the couch was "almost" his fiancée, he ". . . was afraid even to approach her, to come closer, to touch all that delectability."

She was like a dish stretched out before his eyes.

The next day when his mother came to his studio, she saw the study: "... a naked woman, her breasts, her dark blot."

Marc was ashamed, his mother too.

"Remove that girl!" she exclaimed.

"—Little Mamma! I love you too much. But ... Haven't you ever seen yourself nude? And I just looked. I only drew her. That's all."

But I obey my mother. I remove the picture and instead of that nude, I make another painting, a procession.

Curious is the identification of girl and mother. "Little Mamma! I love *you* too much . . . Haven't you ever seen yourself nude . . ."

This story—Bella's daring act, her posing nude for the young man with whom she was already madly in love—is not told at all in *Burning Lights.*

Was the "procession" (painted over the nude) *The Funeral* (1909-14), as Venturi confidently asserts? Possibly. Love and death are extremes, and in so metaphorical a mind as Marc Chagall's, extremes often meet. A similar association is found in Soutine's deathbed instructions that one hundred francs be given to the rabbi's children so that they might eat candy and dance on his grave.

Later, when he rented the studio in the house of the gendarme, Bella could come and go at her pleasure. The gendarme with his burly figure and drooping moustaches might have been his inspiration for *The Soldier Drinks* of 1912. Once again there is a Russian church outside his window, the Illynsky church, its bulbous dome golden against the snow. One evening, as Bella was preparing to return to her parents' home, embracing at the door, the lovers stumbled against a big bundle at their feet. This turned out to be an abandoned infant wrapped in a cheap blanket, which they turned over to the gendarme. Another evening, having remained with Marc so late that the front gate was locked, Bella had to drop out through the window into the alley.

The next day the court was buzzing with gossip about the young Jewish painter's girl who was so inflamed that she climbed in and out the window to be with her lover.

Marc's comment on all this chatter:

"Go tell them that my fiancée remained purer than a Madonna by Raphael and as for me, I was an angel!"

Whether he was or not is less revealing than the self-image he projects into the world.

*

During the years 1909 and 1910 Marc spent about half his time in St. Petersburg, half in Vitebsk. And whenever he shuttled from the white gleaming city on the Neva to the bustling overgrown *stetl*-metropolis on the Dvina, he was moving between new Russia and old Russia, the Europe-oriented capital and the still medieval-oriented world of ghetto Jewry in his hometown. The contrasts must have been bracing, challenging, disturbing. He had come to St. Petersburg just two years after the abortive Revolution of 1905; the reaction that followed had only dampened fires, not extinguished them; twelve years later they were to burst forth again, and reduce the czarist autocracy to cinders.

But it is unlikely that Marc Chagall was very aware of the great changes that were stirring outside of what were now his two obsessions: art and Bella. Enclosed in his own ego, an artistic and erotic bubble, he floated in the tides of history like a somnambulist. This dedication to self, this furtherance of one's own career, is not uncharacteristic of artists; but Chagall's silence in his autobiography regarding the social agitation of his youth, both in the Russian sphere at large and the Jewish in particular, echoes not with indifference, but stronger than that, deliberate effacement of anything that might deflect him from his chosen path.

Ever since the emancipation of the serfs in 1861, a new Russia had been struggling to be born: in fits and starts, in strivings and failings, in tongues of flame and brutal quenchings. In his quest for patrons, Marc had made the acquaintance of the titled wealthy like the Baron Guinsburg, or upper-middle-class professionals like the lawyer Goldberg, and later what was to prove more significant, the famous liberal lawyer and political figure Maxim Vinaver.

But the lower depths were stirring also, the social dislocation of millions of peasants to the new factories forming a new proletariat was to prove crucial. The restlessness of workers and peasants had resulted in a firecracker of uprisings, strikes, political assassinations.

When Marc was growing up under the *chupah* of his mamma's skirt, joying at Pesach gatherings, dreaming under "his stars," sorrowing for the glowing-eyed cows of Lyozno, the Chassidic world of Russian Jewry, which he celebrates so nostalgically in his autobiography, was already being shaken out of its century-old closure. Not only was this Noah's Ark being battered by waves from without, there was fraternal dissension within: assimilationists and Haskalah enlightenment, Westernization and mass emigration to the United States, secular movements of Bund and Zionism, Marxist internationalism and dream of return to the Biblical homeland.

Despite the defeat of the Revolution, and although the regime remained as autocratic as ever, the Czar kept his promise made in a manifesto of October 1905 to convene a Duma, or elective legislative assembly. Earlier that same month a Jewish delegation had been received by the new Prime Minister, Count Witte: the delegation had come to plead for full rights for Jews, those second- or third-class citizens deprived of full suffrage, restricted in residence, occupation, and the right to travel, limited by the *numerus clausus* for admission to universities and professional schools. Among the delegation were two Jews who played a role in Marc Chagall's career: Baron Horace Guinsburg, brother of Baron David, who had put him on a stipend; and Maxim Vinaver, who five years later was to be the patron who made it possible for Marc Chagall to pursue his art studies in Paris.

Maxim Moyseyevich Vinaver was one of the founders and leaders of the Constitutional Democratic Party, called the Cadets from the Russian pronunciation of the two letters *C* and *D*. One of the rising group of middle-class Jewish professionals who accommodated their moderately observant Jewishness with secular Russianness, Vinaver— a dignified man with a high forehead over deep-set, penetrating eyes—was a clear thinker and masterful speaker, especially notable for his capacity—unusual in good speakers—to listen thoughtfully to others.

When Count Sergei Witte curtly advised the delegation that nothing would be forthcoming unless the Jews promised publicly to abstain from revolutionary activities ("It is not your business to teach us. Leave that to Russians . . . and mind your own affairs."), Vinaver had the courage to reply that ". . . it is the duty of the Jews to offer every possible support to those Russians who are fighting for the political emancipation of the country."

Later when the historic First Duma convened, it was the same Maxim Vinaver who composed the answer to the speech from the throne, insisting on civic equality for all Russian citizens in the new constitution. In another speech in the Duma he openly declared: "Let the government know, once and for all, without civic equality, there can be no tranquility in this country."

During the Duma debate on the govenment's role in fomenting the pogroms of 1905, news came of a new horrible pogrom in Bialystok, where on June 14 to 16, 1906, eighty Jews were killed and hundreds wounded. Surely the slaughter at Bialystok (about 300 miles from Vitebsk) was a subject of concern in Marc's hometown. He was nineteen years old at the time.

The only blood on the pages of *My Life* is that of the slaughtered cows at Grandfather's barn in Lyozno.

In St. Petersburg, Moscow, Kiev, Odessa, Vilna, Bialystok, and undoubtedly Vitebsk as well, the Jewish community in the days after 1905 was agitated by the various proposals for reform, the new wave of pogroms, Vinaver's speeches in the Duma. When the Second Duma met in 1907—the very year Marc went to St. Petersburg— there were only four Jewish members left. All the active liberals of the First Duma who had signed a manifesto against government repression had been forbidden to participate in the Second Duma. Many were arrested or exiled.

It seems difficult to believe that among the young enlightened circle in which Marc Chagall moved, especially after Victor Meckler had introduced him into the Thea Brachman group, none of these issues and events were in any way being debated. He met this group about a year or so after the violent agitations following upon the convening and subsequent liquidation of the First Duma. Emigration out of the Pale, especially to the United States, was also reaching a peak point at that time. From 1899 to 1914, 1,486,000 Jews went to the United States, 250,000 to other countries outside Europe, and an equal number, 250,000, to various countries in Western Europe. The disintegration of the real Vitebsks, that was to culminate in the Second World War, had already begun.

Dream Vitebsks, however, are impervious to history. If any agitation, during those tumultuous years, would have affected the young Marc Chagall, it would have been the new modern currents in

the world of art. For the St. Petersburg in which he now was spending half his time, studying (unsatisfactorily) at various schools and with various masters, was as much aboil with revolutions in painting and literature and theater as in politics.

From the late nineties Modernism in various guise had affected all the arts of Russia: poets, painters, sculptors, and musicians had all rebelled against the academism, the history painting, the realism, the storytelling of the previous generation.

A generation gap is not only endemic in the arts, it is a sign of vitality. Not infrequently parents are rejected by re-enthroning grandparents: the immediate past is repudiated by reaffirming a more distant past. Such was the case, for example, in sixteenth-century Italy when Mannerism—a revolt against the stability of late Renaissance classicism—was superseded in the eighties and nineties by the Bolognese school, the neo-High Renaissance style of the Carracci—inflated Raffaello. Repudiation, reaffirmation, revolution, revival—here is the systole and diastole of art, the heartbeat of its vitality.

The arts in Russia were no exception to this rule. In the visual arts the sociological realism of the Wanderers (a nineteenth-century school that had rebelled against the academies, stressing a return to folk art and experience, icons, populist themes) was no longer in favor, not even such highly popular storytelling masters as Ilya Repin or the sweeping historical canvases of Vassily Surikov.

The rebirth of imagination in Russian painting, architecture, music, literature, and the theater had been sparked by a group of lively, sophisticated, upper-class Westernized young men in St. Petersburg in the nineties centering around Alexander Benoit, Léon Bakst, and Serge Diaghilev. In 1898, in St. Petersburg, they issued a magazine called *Mir Iskusstva (World of Art)* and for the next decade organized exhibitions, shook up the anecdotalists, denounced the moralistic utilitarian view of art promulgated by the Wanderers and the Academics, preached Art for Art's Sake; and from 1906 on, when Diaghilev took his new Ballets Russes to Paris, ricochetted upon the West from which they had received much—not all—of their inspiration in the first place, repaying with interest what they had borrowed.

In essence, the *Mir Iskusstva* group was the Russian expression of the *fin de siècle* swoon that held all Europe in its perfumed embrace at the end of the century. The pages of *Mir Iskusstva* published sym-

bolist poets like Aleksandr Blok and Konstantin Balmont, the historical novelist and religious mystic Dmitry Merezhkovsky together with the French symbolists Baudelaire, Verlaine, Mallarmé. Here the new music of Scriabin was discussed, and the tendrils of Art Nouveau twined among explicatory Proustian prose. Here were published works by or about Beardsley, Burne-Jones, Whistler, Puvis de Chavannes, Monet, Degas, and after 1904 French Post-Impressionists, and members of the Vienna Secessionists group and the Munich school. Later, from 1904 to the war, in publications and exhibitions, the work of Gauguin, Van Gogh, Cézanne, Picasso, and Matisse were promulgated.

From 1905 to 1910, especially, the very years of Chagall's apprenticeship, St. Petersburg was a caravansary where all the new ideas of the West were being exchanged. And the chief merchants of exchange were the St. Petersburg aesthetes: a peculiar Russian elixir of languor, decadence, perversity, and mysticism, peculiar in that the innate Slavic emphasis on didactic salvationalist art, art as gospel, managed somehow to persist amidst the sibylline cloudy unfurlings of the banners of Art for Art's Sake.

Diaghilev, especially, a rosy-cheeked, boisterous provincial, when he had been summoned to the capital by his cousin, Dimitry Filosofov, one of the founders of *Mir Iskusstva,* proved to be an energetic and canny organizer. If his taste was lavish, his energy was seemingly endless. He was the catalyst of the group: not a creator like his friends but an organizer, an energizer, and he more than anyone else was the electricity in the circuit that had brought Western ideas into Russia and was to bring Russian ideas into the West. Like many upper-class Russians of his generation, Diaghilev had made the Grand Tour in his youth. And much as British gentle youth would on their Grand Tour of the eighteenth century bring home a view of the Grand Canal by Canaletto, so Diaghilev had sought out European painters, bought a sketch from Lehmbruck and come home enthusing over Böcklin.

After 1903, when *Mir Iskusstva* folded, Diaghilev turned his overflowing energy to organizing exhibitions of Russian art. In 1905 a gigantic show of Russian eighteenth-century portraiture, gathered from obscure country houses all over the vast land, was held in the Tauride Palace. The entire affair was pure theater: a night opening with Czar Nicolas attending, pictures lit by candles, and décor by

Léon Bakst, who had conceived of the show as if it were set in a garden. Later Diaghilev arranged exhibitions of modern art, including examples from such barbarian outposts as Glasgow. Though an ardent Modernist, Diaghilev was at the same time a traditionalist in his love for the elegant architecture of St. Petersburg, much of it by the Italian Rastrelli, for the music of the eighteenth-century Italians: Scarlatti, Cimarosa, and Pergolesi.

By 1906 the indefatigable Diaghilev had turned his energies to organizing the Russian section at the Salon d'Automne in Paris. The great novelty of this exhibition was the icons, few of which had been seen before in Western Europe. Bakst had painted the halls in various colors and lined the walls with canvas. But Diaghilev insisted on "his own crazy idea: to hang the ancient icons . . . on a dazzlingly sparkling brocade that covered from top to bottom the large hall . . . effective in a theatrical way, but the ancient paintings lost some of their importance amongst such sparkle and their colors seemed dim and messy."

From 1906 on, Diaghilev was mostly abroad, after 1906 especially with his ballet company. These lavishly staged ballets fascinated the Parisians, curious about the wild untamed barbaric Slavs, and served as a spectacular introduction of Russian painting, music, and dance to the West. In 1907, three years before Marc Chagall went to Paris, Diaghilev had already introduced the five nationalist Russian composers—Glinka, Cui, Moussorgsky, Rimsky-Korsakov, and Borodin—in a series of concerts in Paris, and the following year brought there the Imperial Theatre's smashingly successful production of Moussorgsky's *Boris Godunov* with Chaliapin in the lead role, and sets and costumes by Benoit.

There is no explicit evidence that Marc Chagall, a Jewish provincial apprentice painter, thrust now into the whirlpool of Russian artistic and political life, was deeply affected by all this agitation. The formal influence of the new painting we can deduce from his work, not from his writings. A number of the canvases of Mikhail Larionov of those years are related to Chagall's work in their willful primitivism, distortions, reduction of human figures to elements in a design, sophisticated folksiness, blatant color, and a general repudiation of perspectival retinal art. But Larionov was almost always in Moscow and Marc could not have seen much of his work. Certain Chagallian

qualities one also finds in the paintings of David Burliuk, Natalia Goncharova, and Kazimir Malevich, in his pre-Suprematist phase.

But even then, as all through his career, Chagall remained stubbornly his own man. Like Raphael, the great bee of the Renaissance who borrowed nectar from every flower in the garden to brew his own honey, so Chagall borrowed from everyone and was indebted to none. With all the kinships in his early painting with the Russian Modernists, the uniqueness of Chagall's imagery is apparent from the start. Goncharova's haycutters, high-chromed as a children's coloring book, may be patterned and flat, but they do not soar above the earth; Larionov's drunken soldiers are embedded into a design, but their heads do not part from their bodies.

In his 1958 interview with Roditi, Chagall claimed that he left Pen in 1908 to go to study at the free academy with Bakst. But in *My Life* the sequence of teachers is quite different, and Nicolas Roerich alone is mentioned as sole director of the Imperial School. At any rate, after leaving that institution, Chagall worked for several months at a private school headed by Savel Seidenberg, a painter of genre scenes from Russian history in the style of Repin. This proved equally unsatisfactory for Chagall's temperament and he cast about for another instructor or guide. From the start, when he came to St. Petersburg, Chagall had, like any serious young artist, been "available."

Soon after his arrival at the capital, he had copied a canvas by Isaac Levitan. Levitan was a nineteenth-century Russian Impressionist who had inspired his friend Chekhov to some of his most beautiful descriptions of Russian landscapes. Chagall also met friends of Levitan and of Serov, another master of Russian Impressionism, "especially some of the collectors who encouraged them and at whose homes I could admire these painters' works."

It is impossible to judge the quality of the work Marc had accomplished up to the point of his departure from the Imperial Free School. In the first place, there is the general out-of-time vagueness of Chagall's dating, and second, because Chagall claims that all his St. Petersburg canvases were stolen by a framer named Antokolsky.

On arriving at St. Petersburg I needed money. One day I discovered a framer . . . whose window was full of framed photographs and paintings that he had on sale, perhaps for the

artists who were also his customers. I had the courage to bring
him all my work, hoping to sell him some canvases. He asked
me to leave everything and to come back the following week.
When I came back he pretended that I had never left anything
with him. I had no receipt. As in a scene of a novel by Kafka,
he even pretended not to know me, asking me: Who are you?

Roditi remarked dryly that this would indicate that the framer was
the first to recognize the market value of Chagall's work and had sold
everything immediately.

"Whatever is the case, I never saw again a single one of those
paintings."

Meyer's account specifies "about one hundred works" which
would seem to be an enormous production for an apprentice artist
recently come to the capital.

In *My Life* the episode is said to have occurred much later—in
1910—just before Marc's departure for Paris. He was then living on
Zacharjewskaya Street, where he had been lodged by Vinaver, then
his patron, in an apartment used for the editorial offices of the
magazine *Dawn*.

Marc had made a copy of a painting by Levitan which Vinaver
possessed. He liked the rendering of moonlight in it. It was as if
candles were shining behind the canvas.

Not daring to lift the canvas off the wall, Marc had copied it
standing on a couch.

It was this copy he carried to the framer Antokolsky, who, to his
great surprise, purchased it on the spot for ten rubles. Passing the
shop a few days later, Marc saw his copy in the window of the
framer's, bearing the signature "Levitan." The proprietor smiled
amiably and asked Chagall to make him other copies. A bit later,
Marc brought Antokolsky a "pile of my own canvases" hoping he
would sell these as well as the copies.

But the following day, when I asked him if he'd sold
anything [wasn't that a bit hasty?], he replied with an as-
tonished air: "Pardon me, Sir, but who are you? I don't know
you."

Thus I lost fifty of my canvases.

Whether fifty, as in this account, one hundred as in Meyer's, whether shortly after he came to St. Petersburg, or just before he departed for France, the amorphous story changing form with every telling (like one of the artist's own pictorial metamorphoses) is an anticipation of two traumatic "thefts" which Chagall was to suffer in his life: his painful discovery upon his departure from Russia in 1922 that all the works he had left with Herwarth Walden in Berlin before the war had been scattered or sold at derisory prices; and his shock upon his return to Paris the following year that all the paintings he had left at La Ruche in 1914 had disappeared.

In all these cases the vagueness of the circumstances tempts one to speculate to what degree we are dealing with actual factual events and to what degree with a paranoia felt so intensely as to become a tangible reality. But the feeling is a *fact* even when the objective justification for the feeling is not.

And with artists we are dealing above all with masters and shapers of feelings.

*

Among the scattering of teachers Chagall studied with in St. Petersburg, Léon Bakst was undoubtedly the most renowned. He had already accompanied the Ballets Russes troupe to Paris, where his sets and costuming for *Schéhérazade* and costumes for *Firebird* had created a sensation. A key member of the *Mir Iskusstva,* Bakst was companion of the dynamic Diaghilev, and hence at the center of the Russian modern movement, that peculiar mixture of European Art Nouveau and Slavic splendor. His work, more significant as stage design than painting, was undulant, sensual, orgiastic in line and color. In 1911, several years after Marc enrolled at the Svanseva School, Bakst's designs for the ballet *Narcisse* included nymphs gauzily clad in forest-green, arms flung upward in ecstasy, displaying much hair under the armpits. In 1912 Bakst sent Nijinsky out onstage in a pair of splotched black and white tights and nothing else. In this costume the squat Scythian, leaping like a fawn in heat, made voluptuous love with a long blue-green veil.

Although these triumphs were still to come, Bakst was already at the height of his fame when Marc Chagall nervously presented

himself at the apartment on Sergiushkaja, and found the Maestro still
abed at one o'clock in the afternoon, a sophisticated touch which
served to additionally intimidate the provincial young man. While
waiting, Marc looked about the walls of this apartment, strangely
silent, without cries of children or "the odor of a woman," and saw
on the walls images of Greek gods and an altar curtain from a
synagogue in black velvet embroidered in silver. When Bakst finally
came into the room, smiling "either in pity or benevolence" at the
stammering Vitebskite with his portfolio of drawings, Marc noted
that above the Maestro's ears still dangled reddish earlocks of a
Chassidic Jew. "He might have been my uncle or my brother."

Léon Bakst in fact had emerged not from the voluptuous mists of
antiquity but from the most unvoluptuous Pale of Settlement not far
from Marc's birthplace. His original name was Rosenberg and here
he stood "as if by chance dressed in European style," smiling with "a
row of gleaming teeth, rose and gold."

Perhaps it was this kinship of origin that encouraged Marc to
study with Bakst at the Svanseva School as long as he did, almost a
year and a half, until Bakst left for Paris. For, from the start, when
Bakst had drawlingly pronounced his limited appreciation for Cha-
gall's talent, pupil and master did not vibrate sympathetically to-
gether. Chagall appreciated Bakst's stress on free color, untied to
optical reality. But Marc felt that

> . . . this art of Bakst and his friends was aristocratic and refined
> and sometimes decadent, while Levitan, Repin and the "Wan-
> dering" painters of the preceding generation extolled a sort of
> Populism, a bit socialist, a return of the artist to the land and to
> the life of the Russian people. It is this Populist Impressionism
> rather than that more esthetic style of Russian painters like
> Grabar which first attracted me. But I've always understood
> Populism in my fashion.

The self-evaluation is just, candid. Marc was then and always to be
his own man. The teaching method at the Svanseva School involved a
weekly critique by the Master. Bakst came every Friday and went
down the line of canvases, making languid but incisive criticisms of
each. Among his students was the daughter of Tolstoy; next to
Chagall the dancer Nijinsky drew like a child and smiled invitingly

at Chagall's "audacities." When Bakst approached the ballerino, he contented himself with smiling and tapping the young man lightly on his muscular shoulder. But Chagall's work was treated with drooping indifference, to Marc's burning-faced embarrassment. And when a second work received the even more humiliating critique of silence, Chagall simply left the school and stayed away for almost three months.

In *My Life* Chagall says:

> There's no use concealing it: something in his art remained foreign to me. . . . Perhaps it wasn't Bakst's fault but that of the artistic society *Mir Iskusstva* . . . where there flourished stylization, estheticism, all sorts of sophisticated worldly fashions and mannerisms. . . .

Marc knew he could learn nothing from Bakst, perhaps from no one. He felt that he was incapable of receiving real instruction; the most he could derive from any school would be certain information. Fundamentally (and correctly), he trusted only his own instinct. Nevertheless, at last he returned to the Bakst school and knew the satisfaction of seeing one of his works finally tacked onto the wall—a sign of the Master's approval.

But the real importance of the period with Bakst was that there in the midst of St. Petersburg Chagall discovered Paris. Bakst's studio was Europe in miniature. There, in that perfumed Symbolist atmosphere, a bit musky, a bit gamey, he may have learned very little about the art of painting, but he was already breathing a new air of sophistication, of elegance, a hint of Paris already shining on his horizon. In the same building lived the poet Vyacheslav Ivanov, leader of mystical Symbolism. Poets, scholars, artists—the intellectual elite of St. Petersburg—regularly met in this apartment, called the Tower, listening with rapture to this professor who looked like a Hebrew prophet and pronounced his oracles in Latin and Greek as likely as in his native Russian. Chagall probably never attended any of these poetic religious séances, but at Bakst's studio he was in proximity with that world as well as the world of Paris. He too was writing Russian poetry at the time, ". . . as if I were breathing. What is the difference whether a word or a sigh?"

And when he wasn't painting, he was wandering the streets of St.

Petersburg, that useless city, improbable as a luxurious Italian villa transplanted to the forests of Kurland, a caprice of crowned Westernization.

The streets paved with wood. The wide, silent Nevsky Prospect. The endless bridge of the Trinity. Houses of reddish granite facades, luminous windows: to Marc they seemed of crystal.

He liked to wander about old Petersburg: the Piazza of Hay with its bearded muzhiks and skinny artisans, drunks and thieves. The Vosnesensky Prospect, where at dusk under the pedestrians' feet swarmed the prostitutes: the cheap ones with their heads covered with shawls and the three-ruble whores wearing hats. This neighborhood had been Dostoevsky's favorite haunt—Gorohovaia Street, Gogol Street, the Catherine Canal—where in humid unlighted side alleys a drunken workman was beating his disheveled loose wife on the head, she all tears, cursing obscenely and refusing to return home.

Skimming over these lower depths, down the Nevsky fled the well-fed horses of the rich, beating the ice under their iron shoes: the ladies in their sables and the sparkling officials squeezed into the narrow sleds. Functionaries, students, vagabonds ambled along sidewalks walled high with snow. Shops abundant with merchandise in illuminated windows. Occasionally patrols of mounted Cossacks thundered by, carbines slung behind their shoulders, whips held in their right hands.

Marc, who loved to eat but could not afford to spend a kopeck beyond the simplest repast, marveled and suffered at the sights of these Petrogradians gorging themselves on blini and caviar, ham and spongecake, tasty Easter rolls. And they drank and they drank and they drank—those who could manage it, mixing vodka, beer, and wine. They were no "Chagalls": they did not stride with big steps: they tottered, they fell.

At each visit home, Vitebsk seemed more and more restrictive, a tighter hoop. He was packed in a herring barrel; he was stifling.

He tried to convince his father. The whole family should move to Paris. With astonishing prescience, he knew . . . he, Marc, was on the verge of great success. Financial too. "Listen, Papa. You already have a great son, a painter. Why not quit this life of yours? Making your boss richer by your hellish work . . . ?"

An adumbration of a sad smile in Zachar's brine-tinted face. "What? I should go where? And *you're* going to support me? Of course."

And Marc prowled the streets and prayed:

"God, Thou who conceal Thyself in the clouds, or behind the shoemaker's house, disclose my soul, that doleful soul of a stammering kid, show me my path. I don't want to be like the others; I want to see a new world."

Then, as in a canvas which perhaps he had already painted, the Lord responded: ". . . the town seemed to snap, like the strings of a violin, and all the inhabitants began to fly above the earth. . . . Familiar characters installed themselves on the roofs. . . . All the colors ran together, became wine and my canvases gushed with drunkedness. . . ."

Because Marc wants to go to Paris, Jehovah issues an apocalypse. How could he stay here? What could he talk about with his work-beast father, with his bustling buoyant Mama, with Uncle Neutch and his out-of-tune violin, with the butcher of Lyozno?—Were they interested in the Master of Aix, or the painter who had cut off his ear, could they talk about cubes and squares, about Paris?

"Vitebsk, I abandon you.

"Live alone with your herrings!"

The deputy Vinaver was the Maecenas that made Paris possible.

Chagall speaks of him as "almost a father." He remembers his luminous eyes, his thick eyebrows that quizzically danced up and down as he spoke, the fine chiseled cut of his mouth, his slightly trimmed beard, his noble profile.

He was the first to buy Marc's paintings.

Vinaver did everything to encourage the young painter. Every day, Vinaver would ask with a smile: "Well, how are things going?"

His editorial office at the *Dawn* was full of Marc's paintings and drawings. Discussions between the young artist and the older Deputy oddly intermingled with the voices of the editors talking politics, Jews, the Duma. Vinaver finally permitted Marc to sleep in the editorial office and use it as a studio. When their conversations were interrupted by the entrance of a journalist putting a question to the Deputy, Marc, shrunk behind a pile of magazines, thought of *his* Dawn. And with a humility too pronounced to be entirely without

guile, Chagall tells us that this great man Maxim Vinaver, this celebrated Deputy of the Duma, "nevertheless loved those poor Jews, coming down with the bride and groom and musicians from the top of my canvas"—a reference, of course, to *The Marriage,* painted in 1910.

Generous Vinaver even ran to Marc in his "editor's office-studio" to urge him to hurry to his apartment where a collector had become very interested in Chagall after seeing Vinaver's collection of his works.

Invited to the elegant Passover Seder at Vinaver's, Marc observes the Deputy's wife as she smilingly gives instructions to the servants: to Chagall she seems to have descended from a fresco by Veronese (painter of the sumptuous *Banquet in the House of Levi* at the Venice Accademia) whereas, earlier, his own proletarian father had been compared to the earth-bound figures of Masaccio—so unfailing is his pictorial class consciousness!

In 1910, when Marc Chagall was twenty-three years old, Vinaver purchased two of his paintings and guaranteed him an allowance of forty rubles a month, to be sent through the Crédit Lyonnais, that would enable him to live in Paris.

Part Three
Paris
1910-1914

Paris was an explosion, a sunburst.

Four years earlier, another painter-emigrant had written home, "My Italian eyes cannot get used to the light of Paris."

For Amedeo Modigliani, the City of Light was too gray, too rainy, too dim, too gauzy after the brilliant golden effulgence of his native Tuscany. But for Marc Chagall, after the pallid northern wintry haze of St. Petersburg, Paris was "light, color, freedom, the sun, the joy of living." The inclusion of several items on that list indicates that degrees of brilliance are psychological as much as meteorological.

And indeed Chagall recognized this when he told Roditi: "It was from my first arrival in Paris that I could finally express in my work the rather *lunar* joy that I had sometimes known in Russia, that of my childhood memories of Vitebsk."

Now, settled into the comfortably furnished lodgings at 18 Impasse du Maine, rented from the artist Ehrenburg, cousin of the writer Ilya Ehrenburg, Marc began his true career as the Painter of the Third Eye—the one that looks backward. For he brought to his art two atavisms and two folklores: the ghetto and Russia. And when he went to Paris, he had not been uprooted but transplanted, carrying with him always Russian soil on his boots and the flicker of sabbath candles in his eyes.

A watercolor self-portrait of 1911 shows him in this apartment: a pensive, poetic, quizzical young man with almond-shaped slanting eyes peering pinpointedly with azure fire into past and future at once: hence the ambiguity of the focus. Gaunt high cheekbones (Marc wasn't eating too much those days) are scratched into relief as in Van Gogh's pen portraits. Head aslant, cupped pensively on one hand, elbow leaning on the table; the other hand is so badly drawn both in its position and anatomy that one can hardly justify it as the planned awkwardness Chagall was liberally to display all his life in the treatment of hands.

Since Ehrenburg had been obliged to return to Russia for a while, he had left in the studio a great many pictures over which Chagall, driven to audacity by poverty, finally painted some of his own works. In later years, enraged on discovering the disappearance of pictures he had left at La Ruche in Paris and *Der Sturm* in Berlin, did he remember with any mitigatory twinges of conscience his own "thefts" of Ehrenburg's work?

As in the oil of 1910, *The Studio,* we can see in this watercolor the rattan armchair, the divan, the easel, the rugs, and the hangings, but unlike the paintings where these furnishings are distorted à la Van Gogh, here they are sketched in with rather timid but academic correctness. But on the easel is perhaps the preliminary sketch of a painting Marc was then working on, certainly not timid and not academic, the work that his friend Cendrars was later to entitle *A la Russie, aux ânes et aux autres.*

When he had arrived at the Gare du Nord after four days in a third-class carriage, rumpled, unshaven, weary with lack of sleep, he had been met at the station by Victor Meckler, who had come to Paris the year before. The first few nights Marc spent on the floor of Meckler's hotel room, listening with dismay to his friend's disillusion with the City of Light. He had taken as his pictorial god that Paganini of the brush, John Singer Sargent; he rejected both the brains and gonads of contemporary painting—the cerebral Cubists and the explosive Fauvists.

"What's the point of our being here?" Victor said discouragingly. "What can we achieve in Paris? Everything has already been said. Let's return."

They didn't worship in the same temple. The two young men soon quarreled. Within a year Victor returned to Russia.

Meanwhile, finding that the two rooms of Ehrenburg's flat were

more than sufficient for his needs, Marc shrewdly sublet one to a copyist named Malik.

Thus, settled, sporadically attending some art classes when he wasn't working, Marc set about discovering Paris.

After the first blush of the light, the first intoxication with the new sights, sounds, smells—the special odor of Paris compounded of woodfires, baguettes, cheese, and Gauloise cigarettes—Marc felt so estranged that he wanted to return to Vitebsk. This panic, these doubts, were assuaged only after he had visited the Louvre.

Vinaver's allowance worked out to one hundred and twenty-five francs a month. Aside from his palimpsests atop poor Ehrenburg's creations, Marc bought old pictures which were cheaper than new canvases (and already primed) at a shop in Montparnasse.

The art schools—La Palette, where Segonzac and Le Fauconnier taught, and La Grande Chaumière—were far less influential on his art than the museums. He haunted the Louvre for the Old Masters, and the private galleries and salons for the New Masters.

But most of all, he wandered the city, exploring it as a lover explores the body of his beloved.

The overwhelmingness of Paris had made him doubly mute. He spoke only a few words of the language: that swift, darting tongue, that twittering of morning birds in trees. And even in the tongues he did speak—Yiddish, ritual Hebrew, Russian—the deepest things he could not say. His saying was by the making of images. He was "a painter without awareness—aware." At moments of revelation he could never seem to find the appropriate words.

Paris was such a moment. As he walked the redolent streets, lounged along the quays of the Seine, ambled the narrow winding hills of Montmartre or the student-bustling Latin Quarter, he was in a state of constant excitation, as if his thirsty creativity was greedily gulping draughts of long-dreamt-for water. His soul had been nourished in Vitebsk, but Russia was not enough. He thirsted for an art that grew from the ground, not from the mind. The national art of his homeland was not enough for him. It lacked awareness, he thought, it lacked delight in civilization. The "full mystique of the highest order" could be found only in France, so he put it many years later, stammering even then for the right words to describe the first impact of Paris upon him.

He wanted to see those things he had dreamed of—the visual

revolution, the changes in colors that erupted spontaneously with forceful lines, as in Cézanne, or with free eruptions, as in Matisse.

He found of course the visual qualities he looked for. Artists especially always do. The actual gray light of Paris was transformed in the crucible of his longing to a brilliant tropical light; so the soft and nuanced hues of the northern French countryside he saw bathed in violent color. Everything glowed with "the light of freedom"—the freedom of being thousands of miles away from his homeland, affording him the luxury of nostalgia from afar—a comfortable state in which grimness, poverty, and fanaticism take on the rainbowed hues of folklore and the picturesque. What saved him from sentimentality was the fact that his pictorial intelligence did not stop at this romantic gauzing of the reality he had left: he pushed it several stages farther, right over the cliff into a topsy-turvy world. Thus instead of picturesque Vitebsk, we get grotesque Vitebsk, Vitebsk viewed through the wrong end of a telescope, Vitebsk falling down a dream-blue chasm—and this is stronger: these images, bound at that period especially by the iron hoops of new nascent Cubism, imposed a grid over his free floating colors. These images are never sentimental; indeed, with all their screaming emotion, they are rigorous, controlled.

Everywhere in the streets young Chagall saw the sources of Chardin and Cézanne. Behind the gates of Paris he saw nature paintings, "not those old sceneries in old museums, but sensitive sceneries imbued with the winds of the times" (the imprecision of the phrase is curiously eloquent of the picture-man grappling with language), "the sceneries of Pissarro, Van Gogh, Manet and Seurat."

And when he ambled through the long halls of the Louvre—ambling with his body, his senses tensed like a bow, his fingers involuntarily twitching in mimetic brush strokes—he felt that the images of street and field, city and country had entered these halls and were fixed forever on the walls. Nor did they stagnate there; they continued to be a vibrant force. After one of these excursions, charged like a dynamo, he would paint all night, scarcely eating, enraged with color, engaged with form.

And he was exploring the city—the great sprawling million-limbed metropolis—in a state of dream. Everything excited him: the shop signs, the smell of oranges and pears heaped up in marvels of equilibrium; the *boulangeries* from which every morning issued

Parisians bearing yard-long sweet-smelling crisp breads like farinaceous penises, sailing off on their bicycles with these fragrant lances; the silvery icy glistening fish market (awakening Papa at a flash); the ruler-straight boulevards, and the sycamore trees on the Boul' Miche, cafés where bohemian students strictly observed the bourgeois ritual of handshaking; the drunken *mecs* who reminded him of the derelicts of St. Petersburg; the pale tinted sky against which thousands of pink chimney pots flickered their tongues; the Eiffel Tower in its balletic sweep, proclaiming the aesthetics of Technology.

He was twenty-three years old and in Paris, the center of the world, the center surely of the world of art.

More than all else, those first weeks especially, when he was still very timid, with all his ambitions to assert his own brand of simple pagan art in this sophisticated world, the Louvre was his cave of Circe.

At St. Petersburg he had discovered the treasures of the Hermitage. There he had first seen Rembrandt, which had inspired several somber-hued self-portraits, Marc in beret, searchingly examining himself: unquiet Narcissus.

Now in these rotundas and long galleries lined with Veronese, Manet, Delacroix, Courbet, Russia was banished from his mind. He wanted to be nowhere else.

By contrast with these glowing affirmations of the Old and New Masters at the Louvre, the Impressionists at Durand-Ruel, the contemporary painters he had seen at various dealers, and at the Salon d'Automne—where he ran past acres of mediocrity to the central hall, "the heart of French painting of 1910," featuring the work of Bonnard, Matisse, Gleizes, Roger de la Fresnaye—the art of Russia seemed lunar, in a state of desuetude, fatally condemned to trail after the West.

And as he became involved in the technical artistic revolution in France, his thoughts returned obsessively to his birthplace. The doubts and dreams he had had in Russia now reawakened and troubled him. Truthfully, what kind of an artist did he want to be? Pictures were not only a decoration, as Bakst conceived of them, Art was to some extent a mission. The realistic revolution was only external. Perspective did not create real depth. Neither light nor shadow really illuminates a painted object. The third dimension of

the Cubists still didn't allow us to really see the subject from all sides.

He didn't realize then that he was thinking of concepts beyond the current splashing of ideas. He didn't realize that at a period of technical art, realistic art, formal art he was putting himself into jeopardy. Soon he would be accused of being "literary." The first time the word was spat at him, he paled. He quickly came to feel that the appellation *"poète"* applied to him when he moved to La Ruche—Who? Oh, Marc Chagall? You mean the Poet?—was a term of abuse.

He began to see himself in a mirror as another and as a stranger. Mesmerized by the "eye" of the French painters, by their sensitivity, he began to torture himself with the thought that perhaps there was an altogether different way of seeing.

. For example, he reasoned—suddenly lost in private labyrinths of thought, amidst the smoky jabber of the Rotonde—perhaps these trees wait for someone to come again and see them differently? Perhaps there are other dimensions, fourth, fifth. And these dimensions do not have to be "literary" or "symbolic" or "poetry"? . . .

Whenever he got into arguments on these questions, he roared like a lion, frustrated by the great rage of being unable to express himself in French. Perforce, he was limited to thinking aloud his thoughts only to his countrymen—and yet he preferred to isolate himself from them; he was even then a "loner." Relentlessly the problem of "literature" in painting forced him to speak out his thoughts, even if their subtlety was inevitably reduced to a heap of shattered glass by his fractured and fracturing French. Didn't he have the will to escape from "literacy" and "symbolism" in art? Wasn't it indeed "literary" art that he saw in the Impressionists and Cubists since "literary" meant everything was explained from beginning to end? In this interpretation, of course, Marc Chagall reveals that he simply failed to understand what Impressionism was all about, for surely if there was anything that Impressionist art was not, it was an "explanation from beginning to end." The Impressionists explained nothing: their ideal was Verlaine's "Nuance," suggestion, they aspired to the condition of music above all. "Prends l'éloquence et tords-lui son cou!" ("Take rhetoric and wring his neck!") Nor did the Cubists "explain"—they presented an idea rather than represented a retinal image.

Again and again in these soundless dialogues with self in the

museums (not always so soundless to judge by suddenly startled fellow spectators) he found himself faced with a certain dualism. On the one hand, he was enthused by artists like Delacroix, Ingres, Chardin—and on the other hand, he was saddened because he had to express himself. Such a dialogue is endemic in the formation of a style. Influences absorbed, influences fought off as if they were parasites sucking one's artistic blood. Mirrors, spiders, trembling pools, tarantulas.

What had happened in France over the last century, Marc felt, was a search—a search for new gods, a complete language, new sources of light. And in the course of this search, new technical instruments were forged and then cast away as inadequate.

Wasn't this a mission? he mused. Didn't Delacroix discover a new freedom, even when he copied Rubens? Didn't his whites suddenly take on unexpected vigor, didn't his brush strokes begin to dance to a more enthusiastic rhythm? And what of Monet experimenting with Goya's blacks and grays? And weren't the curlicued brush strokes of that mad Dutchman Van Gogh influenced by Japanese woodcuts?

His days and nights were filled not only with the act of painting, but thinking about painting, haunting the museums, reliving in his person the history of art as the egg repeats the history of the race—a pictorial ontogeny recapitulating phylogeny: the Impressionists discovering color theory from Helmholtz. Cézanne—looming ever larger on his horizon at that time—introducing Tintoretto with his perceptions in blacks and red-browns. El Greco, the Byzantine frescoes, the geometric shapes joining with the tradition of the primitive French painters of the school of Avignon. And again Cézanne, from whose grids and rectangular bricks of pigment—nature euclidized—the Cubists were to build their own structures, which were to collapse later into the splinters of decorative art—gray cubism and collage.

These waves of art styles, the crest of one foaming onto the trough of its predecessor, fell in succession on young Chagall's naked soul and available body.

His sporadic attendance at La Palette and La Grande Chaumière, where he could do studies from the nude, really affected him very little. No strong artist learns in an academy and, besides, Marc Chagall had always been a terrible student; he was learning by exposure and by immersion; he was certainly not an intellectual, though he might sometimes clothe his intuitive nakedness in bor-

rowed intellectual garments. But he was (and is) very intelligent, dartingly so, and he delighted in stabbing out at the imprecision of art jargon, which ". . . outwardly assumes correctness but is usually just an approximation."

But although he responded at once to the magic of Paris, deeply within he guarded the still fragile structure of his already formed personality. For that was beginning to affirm itself even before the journey out of Russia: paintings such as *Dead Man* or *Burial* are evidence of it.

Yes, his style might—must—suck nourishment from French art, but it had to remain *his* style. Already he knew—a mindful rocket—the vector of his flight, the inner space (that was outer space) he aimed for.

"I had the impression that we were still just wandering around on the surface of matter. . . ."

He didn't want to be just an epidermal painter. The chaos of breaking up and trampling on the habitual surface of things . . . Down with naturalism, impressionism and realistic cubism. . . .

This juxtaposition of what, to a scandalized philistine, could never be conceived as parallel terms—Realism and Cubism—reveals that the young Marc Chagall, with his magnetic eyes that struck some as frightening, witchcraft eyes hallucinated and hallucinating, had seen through the new phenomenon to the bottom. What difference really did it make if the guitar on the table is taken apart and all its facets displayed all at once in the same plane? It was simply a way of freezing the walk around the table, of coping in the static medium of painting with the dynamic challenge of the motion picture camera. But seeing all sides of the guitar at once did not endow it with more significance: it remained, in ultimate import, realistic, retinal, epidermal.

". . . Welcome to the frenzy in us! A great bath of expiation! A fundamental revolution, not just a superficial one!"

Cultivate his own chaos. Dip his brush into his own frenzy. This was the task, disciplined by what might prove useful to him in this Babel of new techniques, new art movements, new conceptions that was the art world of Paris.

Russian art, Chagall felt sadly, had been always condemned to reflect the art of the West. It was lunar, this solar. Standing in front

of the Manets in the Louvre, he realized that Russian painters were by their very nature doomed to be unfaithful students. "The best Russian realist grates against Courbet's realism. The most authentic Russian Impressionism leaves one perplexed by comparison with Monet and Pissarro."

In *My Life*, he declares that it was at this time that he understood why his own art had been uncomprehended in Russia, why he had been "the fifth wheel of the carriage." Undoubtedly the time cog has slipped here; when Chagall left Russia in 1910 he wasn't a fifth wheel, he wasn't a wheel at all, certainly not a big one. Writing in Berlin 1923, Marc Chagall ascribes thoughts to himself in Paris 1910, a self-pitying lament that Russian artistic circles had failed to understand his art, it seemed bizarre, a foreign language to them.

"I can't speak of it."

"I love Russia."

He loves Russia, but always in his most passionate avowals, one senses the inevitable and understandable note of ambiguity.

Perhaps it is his "Oriental soul" which sets him apart. Then swiftly the trip-hammer of self-mockery: perhaps the dog bite left a permanent scar on his soul.

He was trying to find the sense of art. And he felt that he could not find it in the perfection of his craft alone. He didn't want to think any longer about the icy flaming classicism of David or Ingres, or the Rubens-swollen romanticism of Delacroix, or even the geometrism of Cézanne and his latter-day disciples, the Cubists.

The schools were useless. No academy could have given him what he was discovering every day at the exhibitions, in the shop windows, in the museums, in the streets of Paris. Haunting the markets, munching on a cucumber, he observed the workers in their blue smocks: "the most zealous disciples of cubism," all witnessing, he felt, to the famous French qualities of *mesure, clarté.* That he was frequently seeing preconceptions doesn't matter. All seeing is selective anyway.

His first months in France, bathed in what to him were blinding light and high colors, attracted Marc to Van Gogh, another northerner who had been set afire there. *The Studio,* an oil of 1910 of Ehrenburg's apartment, reminds one immediately of Van Gogh's *The*

Bedroom. But here the emotional seismic tremor is more violent, almost as violent indeed as the pictorial earthquakes of Chaim Soutine. And the colors too—the bile-mustard twisted rug, the ingot-red chairs and picture frames, awry and glowing, the harsh emerald green—all these are, if not more intense, more subjective than the Dutchman's.

In *The Sabbath,* perhaps the first painting Marc completed in Paris, we see his Third Eye of nostalgia looking back at Vitebsk through a lens of Paris-ground sensibility. The painting might well be called the judaization of Vincent Van Gogh. In Vincent's *Night Café* and other works of the Arles period, human figures are similarly disposed within a space like bits of furniture. Here the tones are variations of lurid reds instead of Vincent's greens and yellows. But as in Vincent, the board floor converges irrationally and irregularly toward a vaguely defined vanishing point; the walls are brushed thick, almost as if the paint had been troweled on like plaster by a mason, lending an odd touch of realism to the unreal scene.

Clock and swinging lamp and sabbath candles betoken more than themselves: the material objects become time stopped, light perpetual. The thick aureoles around the candle flames remind one of the similarly thick-pigmented aureoles around the swinging lamps of Vincent's Arles picture, or even earlier in his career, the lamp above the *Potato Eaters.* And indeed this picture has a certain kinship in the thickset tragic clumsiness of its human personages.

The window frames looking out on a black night create, witting or unwitting, a cross below which hangs, in heavily modeled folds, the curtain. The combination of cross and curtain recalls an altar, although it is difficult to prove, nor could the artist prove himself, that this was intended.

Around the Sabbath table sit three figures grotesque as broken dolls. Two children are peripheral: one looks melancholically into the picture from the frame; the other at the far distant edge of the table is merely an egg staring in flushed red light dead ahead like one of Pontormo's mannerist neurotics. In the foreground an odd, twisted, broken-necked old man rests his head in an anatomically impossible position on the back of the chair rest.

Surveying all this, legs astride in the doorway, stands Mama, somewhat mad, looking with chromatic wariness over the whole scene as if the other five figures in the room were the debris of a

battle. Next to her, under the clock with its frozen pendulum and the hands pointing eternally to ten minutes to one, sits Zayde, huddled and grotesque, with strange Oriental slanting eyes. To the far left, cut off by the frame, the little boy on a ruby-figured bedspread suggests the artist in his attentive and somewhat suspicious spectator-ism. The wooden bed is yellow, as in Van Gogh, and pointed yellow slippers accent and spot its blue-gray shadow.

The entire picture emanates an atmosphere of tragedy. These Jews are huddled together, without composition, together but separate, each lost in his own staring innerness, against the black alien world seen against the cross of the windowpane.

Surely this is not the happy Sabbath that Bella was to write about in later years.

*

Even before he moved to La Ruche, that ghetto occupied by refugees from the ghetto, Marc found plenty of fellow Russians—observant or nonobservant Christians or Jews—with whom he could speak. Ilya Ehrenburg, the cousin of the painter whose rooms (and canvases) Chagall occupied, came back from a trip to Bruges, which had struck him as a city of death; and wrote fifty poems on the beauty of the world which had disappeared; on Marie Stuart; on the Virgins of Memling. Ehrenburg had come to Paris in 1907 at the age of eighteen, three years before Chagall. Arrested as a revolutionary in Moscow the year before his departure, the future Soviet drum-beater, journalist, and novelist—meteorologist of freezes and thaws—was at that time what might be called a post-swoon Symbolist who conceived of poetry as a masked ball. His politicizing coexisted with his poeticizing. He had already struck up a friendship with Anatoly Lunacharsky, who was to become the first Commissar of "Enlighten-ment." More significantly, Ehrenburg had already met Lenin in Paris the year before, when he had been struck by the shape of Lenin's "extraordinary cranium" which made him think "of architecture rather than anatomy." Eight years later everyone in the world was talking about the gentleman who ordered bock beer in the café on the Avenue d'Orléans, the favorite gathering place for Russian Bolsheviks in Paris.

A little room on the first floor of the café, not far from the Lion de Belfort, had been set aside for the Bolsheviks, gratis so long as they paid for their drinks. All the Russians drank grenadine with seltzer, which amused the French, who fed the thick red syrup to their children or used a drop of it in their apéritifs, but considered the Russian concoction but another example of Muscovite barbarism then quite à la vogue in Paris. With his splendid productions of the Ballets Russes Diaghilev had already paid back, and with interest, Russia's cultural loans from the West. Paris was full of Russians: there were rich Russians and poor Russians, Russian Orthodox and Russian Jews—the Russian taxi drivers were to come later, after the Revolution. To the fundamentally classical French, whose architectural sense of style Chagall was to discern in every heaped-up fruit stand display, and whose intellectuality and cerebralism Marc found in peddlers as often (or more) than in painters—the Russian incursion was a necessary relief. Especially after 1907, when Diaghilev introduced his ballets, with Bakst's orientalized sets and daring costuming and Nijinsky's incredible leaps, enthusiasm for all things Russian was a reaction against Cartesian cerebration, *logique,* even the anti-logical *logique* of a Rimbaud with his prescriptions for disordering the senses, his systemized colors of vowels.

But the Russians! Oh, the Russians were so splendid, so Scythian, so untrammeled! They galloped like wild Tatars right across the tidy geometric gardens. There was nothing Latin about them, either in their liturgy (were they not even translating Western Marxism into Eastern Leninism?) or in their logic. "The biology of the shadow has not yet been studied," blandly wrote Byely.

And so often, to the tidy conservative (even revolutionary-conservative) French, the Russian arts—and behavior—seemed to be organisms held together unaccountably without ligatures. Some of the more discerning—Gide, for example—had already found this in nineteenth-century Russian literature. Dostoevsky's unpredictable leaps should have prepared them for Nijinsky's. But the art of artful incoherence—which Chagall was to practice so beautifully—was still puzzling to the French mind despite the fashion for all things Russian.

The philosopher most in vogue in those days was Henri Bergson, scion of a Warsaw Orthodox Jewish family, but French of the French by birth and education. His lectures at the Collège de France

attracted enormous audiences of the elegant and the erudite, who listened with delight as the philosopher demonstrated with impeccable logic the limitations of all logic.

So though French reaction to the Russian invasion was not to burn down their city—in defense as the Muscovites had done a century before—they were at best titillated or they howled (as at the opening of Stravinsky's *Le Sacre du Printemps*) or they were vastly entertained by the Russian arts, without really comprehending the different psychology that underlay them.

Marc understood this, by Bergsonian intuition, from the moment he arrived. Swiftly he knew what he had to absorb from the French, but he also knew that his way was not their way. Cubism was obviously too cerebral; but even Fauvism was too programmatic for his taste. His discarding of the long tradition of perspectival realistic art was from his guts, his fantasy, not a planned revolution against whatever little was left of the Italian Renaissance.

With all his loving explorations in the plebe and pubis of Paris, he was limited, at first by linguistic limitation, to searching out and socializing with his compatriots.

The Russian émigrés in Paris were divided into Red and White. The Whites inhabited the bourgeois quarters of Passy or d'Auteuil. The revolutionary émigrés lived at the other end of the city, in the workers' quarters: at Gobelins, in the *alentours* of the Place d'Italie, at Montrouge. The Whites had opened restaurants and cabarets: La Maisonnette des Boyards, the Troika; the waiters here were likely to be Red, while a third, nonpolitical group danced the "lezguika," a Georgian dance, to amuse French clients.

On occasion, Marc might drop in to the Rotonde, where he would find Ilya Ehrenburg, who lived not far away in a hotel room on the rue Denfert-Rochereau. His first book of poems appeared at the end of 1910 in Paris. He had paid to have it set up by a Russian printer on the rue des Francs-Bourgeois who didn't care a hoot about the content of Ehrenburg's poems although the printer himself belonged to the Jewish Socialist Party—the Bund—and Ehrenburg's effusions were dedicated to Pope Innocent VI!

But of all the Russians in Paris, the most notable was Diaghilev and the whirling world of all the arts that swirled chromatically

around him. He was the Czar of Ballet. To his stepmother, he had coolly estimated his own qualities: "I am first a great charlatan, though with brio; secondly, a great *charmeur;* thirdly I have any amount of cheek; fourthly I am a man with a great quality of logic, but with very few principles; fifthly I think I have no real gifts. All the same, I have just found my true vocation, being a Maecenas I have all that is necessary save the money—mais ça viendra."

A year before Marc's arrival, the tall, stoutish impresario had presented *Le Pavillon d'Armide,* the *Polovetsian Dances from Prince Igor,* and *Le Festin* at the Théâtre du Châtelet; in 1911 he founded his own company with most of the choreography by Mikhail Fokine. The Parisians were dazzled by the technical brilliance of Russian dancers, based on a long tradition of the Imperial Ballet, especially Nijinsky, who with his low forehead, slanting eyes, and surly, sensual lips looked like a half-wild creature mysteriously catapulted from ancestral mists into the modern world. With sets designed by Bakst, Roerich, Benoit, Golovine, new violent colors, a refreshing highly self-conscious primitivism was suddenly seen on the Parisian stage. The Russians stirred up as much controversy in the field of scenic design as the two modern schools of painting then most talked about in Paris: the Wild Beasts (the Fauves) and the Cubists.

Third and most revolutionary of the Scythians was Igor Stravinsky, who in the years of Marc's first Paris sojourn was to compose *Firebird, Petrouchka,* and *Le Sacre du Printemps.* Just as the Russian artists had turned to folk art, woodblock prints—the *Luboks,* peasant embroidery, flaked old icons—so Stravinsky broke music free of traditional tonality and concert-hall rhythms, turning to Dionysian rites, erotic dance, pagan folklore, launching a career, like Picasso's in a companion art, fiery, renovative, and exploitative, looting the centuries from Gregorian chant to dodecaphony.

In June 1911 Marc went to see Bakst backstage during a Ballets Russes performance of *Le Spectre de la Rose.* Bakst was surprised to see his former student, whose talent he had never quite been able to appreciate. "You here?" he said, when the young painter made his appearance, moving lightfootedly and gracefully as the dancers themselves.

Bakst indeed had been the indirect goad that had brought Chagall to the City of Light. For when, in St. Petersburg, Marc had learned that Bakst was leaving for Paris—where he was to design for the

ballets *Narcisse, Le Spectre de la Rose,* and *Scheherazade*—Marc had begged to be taken along as an assistant.

"Do you know how to paint scenery?" Bakst had asked him, and Marc, who didn't know a scrim from a fly, unhesitatingly replied yes, accepted one hundred francs in advance, and botched the test. Bakst had gone to Paris without him.

And here he was now behind the scenes at the *Spectre,* one of Bakst's greatest triumphs. Marc saw the familiar red-haired designer approaching him, the familiar "red and rose smiling benevolently" at him. Nijinsky was there too; with a jungle bound, he was at Marc's side, affectionately embracing him around the shoulders. But the curtains were already parting: he was about to go onstage where the ballerina Tamara Karsavina awaited him. Bakst smiled paternally, murmuring, "Wazia, wait, come here," and rearranged his large cravat. Nearby, "flirting tenderly with Ida Rubinstein," Marc tells us, was Gabriele D'Annunzio, the priapic Italian poet, diminutive and elegant, who conquered sestinas and signorinas with equal ease, and was to conquer Fiume as well, become a national hero, and chant rhapsodic hymns in favor of war.

"So you've come just the same?" Bakst remarked brusquely to Chagall. Marc was embarrassed and felt that Bakst, for all his suavity, was equally so. Was it because Chagall had failed to repay the hundred francs which he had been supposed to use to perfect himself as a scenic designer? Was it because (and here the testimony of this encounter in *My Life* becomes surprisingly explicit) Marc didn't quite fit into this sophisticated world of *Mir Iskusstva,* this perfumed world of sophisticates playing at being ancient Scythians, or Greeks, or Persians, this world of high style, passions of a special kind, ultrarefined to the point of gaminess. The burly, busy hulk of Diaghilev bearing down on him was no more comforting: with Diaghilev he had never felt any true rapport. As for Bakst, oh, now he understood why Bakst, from Vilna with his red hair, and suave manners, and his golden rosy smile, seemed to be embarrassed to find Chagall here in Paris.

"And I thought: surely it is because I am a Jew and I have no country."

In a trice, he was not a Russian anymore.

Bakst promised to come see his work, and to Marc's surprise, he actually turned up one day at his studio on the Avenue du Maine,

looked at the explosions of his first Paris canvases—probably *The Studio* and *The Sabbath*—and proclaimed: "Now your colors sing."

That was the last time Marc Chagall ever saw Léon Bakst, who never returned to his homeland and died in 1923.

So, when he was not painting painting painting, at first in the studio rented from Ehrenburg, and afterward at La Ruche, Marc roved about the city in a lover's trance from museum to gallery, from salon to café. To him, as to all the Russians, Paris was the capital of the world. On the terrace of the Rotonde, turbaned Indians argued with long-jawed Macedonian mountaineers, Chinese students ogled the Night Blossoms yawningly preparing for their work; everybody was plotting revolution in one field or another—in the arts, in bed, in the chancelleries. Alongside the French papers, the kiosks of Montparnasse and Montmartre displayed a barrage of periodicals in Arabic, Polish, Russian, Czech, Portuguese, Yiddish, and Finnish. The Italian Futurist Marinetti, who had already been to Russia to spread his gospel there, declaimed: BURN THE MUSEUMS! to the fine-nostriled disgust of his fellow countryman, Amedeo Modigliani. In the fragrant blue smoke cloud, lips moved in every language under the sun, saucers clickingly piled up *l'addition.* Futurism wrestled with Cubism, Stravinsky was hissed or adored, the latest bourgeois inanity slashed or laughed to death. Paris 1910-14. It was a good place and a good time to be alive.

Soon he discovered that with all its cosmopolitanism, Paris was also a provincial city. Each of its *quartiers* had its own main street, its own shops, its own *bal musette,* tiny theaters. Everybody knew everything about each other in the *quartier*—or spoke as if they did—making sly allusions to personal habits that could only possibly be known to the habitué him- or herself.

On the benches, old women sat knitting knitting knitting—left over from the knitters at the guillotine during the Terror.

Over the grills of the Metro lay the *mecs,* warmed by the gusts of hot air belching up from the sewers and subways, the belly of Paris, and insulated against the upper cold by a quilting of newspapers.

Along the Seine, immobile in the eternal patience not of philosophers but vegetables, sat the fishers, more inert than their flexible bamboo poles, reading auguries in the dimples of the river. Tugboats glided by. Not only the buttresses: all of Notre Dame flew. A pink blush, negligée of cloud. Flesh-brown towers.

But with all this exciting carousel of the external city, he carried ever within himself another city. Paris and Vitebsk. Paris had not yet become *his* Vitebsk, as he was to sing exultingly years later. The themes of his painting were mostly all drawn from the images of his hometown, which he carried like a holy grail, careful not to spill a drop of the precious memories. He was still, especially before he moved to La Ruche, limited linguistically to fellow Russians and Jews. Sometimes, he ran into Ehrenburg at the terrace of the Rotonde. Ilya loved Paris but, like most of the Russians, was nostalgic for cold winters and a girl's warm hand in a muff. The Russians all had a mystical fervor in their homesickness. If Ehrenburg saw beautiful roses in France, he regretted the simple wildflowers of Russia, and mumbled their Russian names as he wandered along Gallic lanes odorant with wisteria. The French, he told Marc, were too polite, too little sincere, too calculating.

Here no one thought of pouring out his soul in cascades of Dostoevskian confession to a companion fortuitously met five minutes before at a bar. In the evening no one came to the window of a lighted room. Here the blinds were shut—like French lips—the Voltairean slit—the wary wing of an ironic smile. They drank but not out of nostalgia.

During Marc's first sojourn in the City of Light Tamara Nadolsky, with whom Ilya Ehrenburg had discussed, as Russians do, the *grands sentiments du but de la vie,* had, with the eyes of a somnambulist, achieved her final sleep by jumping out of the window of her mansard apartment. Tanya Rachevskaya poisoned herself. Thus some Russians in Paris discovered "the ultimate purpose of life."

Marc had very little money. Sometimes he just took a café crème with four or five croissants for dinner. But from time to time he got nostalgic for cheap Russian restaurants. There was one on the rue de la Glacière, frequented by a noisy lot of Social Democrats; and another, blessedly nonpolitical, but equally noisy and dirty, on the rue Pascal. The food was insipid, the clients pressed close against each other like herrings in a barrel. The waiters shouted their orders in Russo-French: *"Un borscht, escalopes avec kasha!"* A red-headed, owl-eyed young man, hopelessly drunk, was shouting hysterically that unless a certain "mission" were entrusted to him, he was going to shoot himself. Bolsheviks spat out their contempt of the minority wing of their party—the Mensheviks—the words "opportunist,"

"Lenin," "empirio-criticism" floated with self-satisfaction on smoke clouds: revolutionary cupids, hauntings of theological debates, the Marxist Middle Ages.

Lenin was indeed still in Paris and Ilya Ehrenburg had gone to visit him at his apartment on a little street near Parc Montsouris. What an appropriate name! For the revolutionary leader had greeted the young poet with the faintest sickle of an ironical smile. Ehrenburg heard him speak at several meetings too: without emphasis or elegance; his voice just pitched loud enough to be heard, sometimes rolling his *r's* a bit when his ideas coiled to strike, sometimes smiling that mocking smile. Writing many years later Ehrenburg thought Lenin's speeches were constructed like a spiral: that is, he went back to what he had already said to make certain he was understood, without repeating it exactly. Unlike certain speakers, says Ehrenburg, referring slyly to Stalin, who confuse a circle with a spiral. . . .

But Marc Chagall belonged to none of these Russian colonies: neither to the wealthy Whites of Passy, nor to the poor Reds who carried on their interminable squabbles in a library on the Avenue des Gobelins, nor to the moths and butterflies swirling around Diaghilev, nor to the older generation who met at the poet Balmont's apartment and talked about A. N. Tolstoy and M. A. Volochine, Russian writers who had lived long in Paris, nor to the scattering of Jewish Bundists and Zionists in the city.

His self-enclosure, his capacity to remain a loner dedicated to his painting and the furtherance of his career as a painter, was really put to the test when in the winter of 1911-12 he went to live at La Ruche.

*

When Marc came to La Ruche, the area was an ambiguous zone of misery—neither city nor country, near the slaughterhouses of the Vaugirard district. Here, after the closing of the Exposition Universelle of 1900, an academic sculptor appropriately named Alfred Boucher had the notion of buying up the picturesque barracks and using the material to construct a "commune" for artists on the terrain he had acquired so cheaply. Boucher was a Rodin imitator who had amassed a considerable amount of money setting up bewhiskered

generals in bronze and similar patriotic art all over Paris. Combining Fourierist utopianism with real estate speculation, Boucher's initial investment, for a very low price, was the Rotonde—the Pavilion of Wines—a structure in a very good state of preservation—circular as a beehive, three stories high, which he had dismantled and set up in the Dantzig alley. The entrance of this "beehive" was flanked by two cement caryatids taken from the Indian pavilion. Thus, the "commune" was founded toward 1902, eight years before Marc arrived. Officially founded, be it said, in the presence of the Undersecretary of State for Beaux Arts and to the tune of *La Marseillaise.*

Inside the Rotonde, along the circular corridors of the floors, all around the staircases as well, the doors were marked by letters in alphabetical order. Only the upper landing received light from an opening in the cupola; all the rest of the Rotonde was bathed in increasing degrees of darkness, as if one were descending a well. With increasing dark went decreasing rent, which was derisory at most—about 50 francs a year. Marc, who with his 125 francs a month, was a millionaire among the inhabitants, took a big studio on the top floor, letter A. But most of the narrow, upright, closetlike rooms set side by side on the curving floors were dubbed "coffins" by their very live inhabitants. Boucher, for all his bookkeeping rigor and rage at being cheated, was fundamentally a kindly idealist, eager to help the swarm of impoverished artists and writers who settled in his colony.

And what a swarm they were! The year Marc installed himself, there arrived Fernand Léger, the genial giant from Normandy; Alexander Archipenko, the Russian sculptor; Henri Laurens; Girard, Dupont, Durant, Thomsen, and many others. At one time or another during Marc Chagall's stay, the sculptors Ossip Zadkine and Jacques Lipchitz, the painters Jean Metzinger, Chaim Soutine, Kremegne, Kikoine; the poet Blaise Cendrars; the writer André Salmon; political agitators like Lunacharsky (later to become so important in Chagall's life) and Joffré, the left Socialist; Vaillant-Couturier; there was even at one time before the war the nephew of the Maharajah of Kapurthala who organized champagne parties in his sumptuously furnished shack; and Vladimir Ulianov, later known as Lenin; as well as down-at-buskins actors, bohemians, and the last famished gasps of erstwhile noble families—all these lived and worked either in the central twelve-sided Rotonde, or in one of the little houses which

Boucher had constructed around the immense beehive. The little houses had skylights, stingy windows, and haphazard doors above which perhaps a bas-relief might offset the poverty. The kindly concierge, Madame Segondet, often paid the rent for the more indigent tenants.

"—*Ah mes artistes! Mes enfants du Bon Dieu! Mes pauvres abeilles!* My poor bees! They cannot always give forth honey or when they give, it is often bitter! . . ."

The staircase ramp of the Rotonde, with its railing and finicky, overelaborate columnets, coiled around the central well-shaft. Sometimes, Marc wandered about the area called the "Zone" where town and country ambiguously met. Near the abattoires, the stench of death pervaded the entire zone. Clustered around the slaughterhouses were the wholesale butchers who bought the carcasses still streaming with blood, hanging on hooks; wrangling under every language under the sun.

Streets sprinkled with green powder against rats. Dirty hovels. Poisonous smoke of factories. A bistro every twenty meters.

Returning to his studio after grousing and dreaming around this pathetic area with its poor working-class wives stringing wash on the line, mangy dogs, drunken "assassins" from the nearby slaughter-houses, Marc would be greeted by the black gaping hole of the entrance portal of the Rotonde.

The wrought-iron gateway, 2 rue de Dantzig, giving on to an isolated passageway, seemed to be the paradoxical remains of what led once to a great château. In fact, this iron gateway had during the Exposition served as the entrance to the Palace of Women. Now during the day there were very few women indeed in La Ruche, since most of the wives or mistresses of the inhabitants worked as seamstresses or in whatever jobs they could find to supplement (in the luckier cases) their husband's income.

Wandering these streets of poverty and idealism, fervor and fever, Marc felt very far from and yet still enclosed in an enclave of Vitebsk. Since a great many of the renters in La Ruche were, like himself, Jews from Eastern Europe, the beehive had become a Pale on the periphery of Paris, a slum, a very special kind of hermitage. Here from all parts of the world had converged young men of every race and nationality.

Eventually there were to be in the "city" of art—the central

Rotonde and the adjacent skylighted little houses huddled around it—almost four hundred studios (in Marc's day about one hundred) extending from rue des Morillons on one side to the fortifications. It was a considerable chunk of land, with a very incongruous and picturesque lot of inhabitants.

Among the various national contingents—one thinks of the student "nations" in the University of Bologna during the Renaissance—the Russian and Polish Jews were destined to become the largest and most distinctive group in the beehive. Chagall arrived in 1910; Soutine in 1911; around those same years there lived for various intervals the painters Kremegne, Kikoine, Indenbaum, Jacques Chapiro, and the sculptors Archipenko, Lipchitz, and Zadkine. All these were to become part of what was later to be dubbed the School of Paris: a characterization less of place than of state of mind. Certainly if one includes in the School of Paris those who, like Picasso and Modigliani, lived in the Cité Fouguière up at Montmartre, or the other numerous foreign-born artists who lived all over the city, one is bound to ask: What made them a "school"? Merely the fact that they were all in Paris?

Indeed, the only quality they had in common was their disparity. Even among those who shared a common origin—the Pale of Settlement Russian and Polish Jews—those of the first rank were surely more marked by differences than commonalities. What had Soutine and Chagall in common with each other? Zadkine and Lipchitz?

Some of them must have felt, with sinking hearts, that swarming from the Pripet Marshes to this beehive, they had only exchanged one ghetto for another. Others, like Chagall, soon realized that moving to this noisome periphery paradoxically brought them closer to the center of the Paris art world.

Nor were the Eastern Jews the only foreigners in the famous School of Paris. Picasso was a Spaniard, and so were Miró and Juan Gris, Van Dongen was a Dutchman, Foujita was Japanese, Modigliani was an Italian. Pascin was a Rumanian Jew of Saphardic origin, Brancusi was also Rumanian. At La Ruche, especially, true-born Frenchmen like the genial giant Léger were exotic plants in this garden of the dispossessed.

But quite apart from the variety of its members' origins, the School of Paris was probably the most individualistic "school" in the history

of art. Each artist fanatically sought his own path, zealously guarded his discoveries. They shared nothing but quarrels and most of the "aesthetic" disputes were clouds of smoke.

While in the Russian ateliers, an insulted model was sobbing; while the Italians raised their voices in song to the sound of guitars; while among the Jews there were discussions—I, I was alone in my studio, before my petrol lamp. A studio crammed with pictures, canvases which were in fact not canvases but rather my tablecloths, my bedsheets, my shirts ripped to pieces.

Two, three o'clock in the morning. The sky is blue. Dawn is rising. There, in the distance, they were cutting the throats of the cattle, the cows are lowing and I paint them.

He was always in Vitebsk. He was at Lyozno as Grandfather approached the stubborn cow: "Come on now. Lie down. People need meat."

Concerning the "discussions" of the Jews, Jacques Chapiro, in his picturesque memoir on La Ruche, tells us that, in 1911, certain members of a group, including Marek Szwarc, Tchaikov, Epstein, and some others, had planned to found a publication of Jewish art. Their idea was that this publication would contribute toward determining in the plastic realm a style specifically Jewish, for such a style had not yet been sharply defined.

This idea, which was dear to Stasov, a celebrated critic of Russian art who was interested in Jewish folklore and in decoration of Judeo-Oriental inspiration, had by chance been introduced at La Ruche. Young painters—severely limited in their literary resources—launched a publication consisting exclusively of photographic reproductions pasted on pages of colored paper. This embryo of a journal was baptized *Makhmadim,* a Hebrew word with multiple meanings: desire, agreement, beauty.

Naturally that set off much buzzing in the beehive, but very little agreement or beauty.

Chagall, like Soutine or Zadkine, took not the least part in these apiary initiatives. A loner by taste and temperament, shy and yet very ambitious, he kept apart from the agitated, burning, and often miserable existence of the hive.

Chapiro says that Chagall might frequently have been seen

wandering through alleys and paths, or crouched in some corner, his curly head leaning against one of Sologoub's stone heads. "Chagall was always reading some symbolic work."

His hair in an aureole, as if it had never known a comb, his visage drawn, his gray eyes—wild, mobile, haunted with creative passion, in which there dwelt an expression sometimes infantile and sometimes similar to that of a very wise old man—the pupils, like grains of rice, sometimes lighting up with an enigmatic and demented fire, Chagall often remained at twilight seated on the debris of one of the statues or under a lilac bush, gesticulating, drawing his future works in the air. Miscarried canvases or those which had turned out badly, Chagall would simply hurl out the window or shove behind the piles of garbage. The garbage men carried them off with all the other filth. But it was Soutine's canvases that ran aground most frequently into the dustbin: there he cast one work out of three. . . .

The nights at La Ruche were brightened with rowdy meetings, songs, and music, or else tumultuous riots and squabbles fomented by the *"tueurs"*—the "killers"—of the neighboring slaughterhouses who penetrated into the area, wildly drunk, sowing terror. For these "killers," the artists were useless do-nothings. Every now and again, roused to a senseless fury, they would pile into one of the inoffensive idealists, their arms flailing.

The arrival of the good-natured Norman, Fernand Léger, often put a stop to these raids. One look at Léger's huge stature, his hamlike fists, and the "killers" retreated to their bistros. Léger rented a big studio in one of the shacks, wandered much around the factories of the area, soon to find their way into his special brand of industrial cubism: his tube-men, robots operating machines.

Against the decor of these agitated nights, Chagall, drunk with dreams and images, prey of a demented Dybbuk of inspiration, worked without a stop.

A light blazed in his window: a mysterious silhouette stirred against the candlelight, froze, stabbed like a fencer, disappeared behind the windowframe.

Thus night after night he painted till dawn, flushed and blue,

dimmed his lamp. Then instead of going down to buy on credit several warm croissants, he went to bed. Many of the artists at La Ruche slept till noon. But he couldn't sleep. Soon the morning somnolence was broken by the scraping of a violin. Red clamors of cocks. Marc heard colors. A goat bleating. Bellow of a bull. The proximity to the slaughterhouses was, as it were, the blown-up memory of his grandfather's barn. The stench of blood was always in the air.

He was in Paris, yes, but Paris was not simply a luminous perfumed light, an accordion swirl with a willing girl. It was also the desuetude of this banlieu, this filth and poverty and the ululations of cows whose throats were being cut. For Marc Chagall, love and death, poetry and pessimism, lyric affirmation and clownish humor are always on the brink of collapse into the abyss of despair and death. Critics who complain that the tragic sense is lacking in him or that this artist knows of nothing but making love in a bouquet have read his best work too swiftly.

Now amidst the parting cries of soon-to-be-slaughtered beasts he heard the inconsolable weeping of babies. Were they aware of the everyday slaughter of existence here? In the 1920s when a visitor asked how to find the studio of such and such an artist he was likely to be told: Take the Raskolnikov staircase and you'll get to Crime and Punishment.

The poorest starvelings in the hive were sometimes fed if not by the concierge, then by the generous family Ostroun. Chapiro recalls that Marc Chagall never availed himself of this assistance.

Scattered on the wooden table were reproductions of Greco, Cézanne, some crusts of bread, and the remains of a herring which he had divided in two: the head for the first day, the tail for the next.

At least he ate his herrings, he thought, not like Chaim Soutine, who had recently filched three fat carp from an unlocked "coffin," gulped one down, and kept on painting and repainting and repainting the other two until his still-life became a stink-life and his neighbors forced him to throw them out.

He tried to sleep.

But his head was a spinning color wheel. He heard colors. He ate colors. In the corner of the room there stood the boots he had just bought from a newcomer. Michel Kikoine: each boot was of a different color. That is what had fascinated Chagall, and he had

persuaded Kikoine, who had just found them in a flea market, to part with them. Kikoine came from Kiev; he was not poor; his family was middle-class, cultured. He told his friends proudly that his father had seven violins hanging on the wall.

Marc's neighbor, Marek Szwarc, recounts that when Chagall was weary of flying among his own images, he would lie down on a cot and stare up at the ceiling. On the poorly laid whitewash strange visions were projected which at dawn revealed themselves as fissures, seams, cracks in the plaster. Had not Leonardo discerned equestrian battles in wall stains?

Thus, night shadows, strange troubled reflections dancing about the room, cracks and stains in the ceiling were recomposed in the poet's brain. Chagall was inhabited by a seraphic flurr of colors, live souls out of Vitebsk and dead souls out of Gogol. The yellow light of the petrol lamp intensified hues, rendered them more vivid, more bitter, more unreal. When he saw, the next afternoon, these colors dictated by the night, they were the blazing colors of hallucination; he could not betray them by sense.

And, indeed, Chagall's color has nothing whatever to do with nature. His color relates to a world not seen by the eye; as do the colors of an icon, a *fond' oro* panel. Even in his writing, blue is not a color, but a state of soul.

So, nightly at La Ruche he wrestled like Jacob with the angel. "My lamp burned and I with it." He tells us he liked to paint naked. Why naked? Was his painting a kind of masturbation? He was alone alone alone. Bella was thousands of miles away. All day long there were the solicitations of the Parisian cocottes: Chagall, with the shyness of a *stetl bocher*, suggests that he refused them all. More than one, charmed by this curly-haired fawn with the slanting azure eyes, offered him her consolation gratis. He always refused.

Night after night in the Rotonde, Marc painted his visions. The magic of dreams coming alive in the lamplighted room. The curious metamorphosis of the colors the following morning when he rose toward noon and saw in cruel daylight the painted record of last night's pigmental orgy. The donkey head spitting white sperm at an upside-down Bride.

Sometimes—plague on his bones!—the indescribable Soutine would knock at the door. "Let me in! *Un croissant! un peu de pain!*" Bang! Bang! Bang! Worse than the blows of Ossip Zadkine, the stonecutter

on the ground floor of La Ruche, that Jewish Vulcan, whose mallet blows on the stone shook the entire beehive.

"A moment."

Hastily, Marc stowed away all his paintings: that which he had done last night, still wet like a lover who has just completed the act of love—stowed it away not only to conceal his private vision from Soutine, but also because that bandit's unspeakably filthy garments would surely brush against the wet canvas.

Finally he opens the door. The monster sidles in. His half-opened bestial eyes glance around: nothing but virginal backs of canvases, improvised from sheets, torn shirts serving as the ground of Chagallian dreams.

From the litter of last night's supper Soutine picked up a dry crust, grumblingly munched, his lazy half-opened eyes peering at the backs of the canvases as if he might unaccountably see through them to what was on the other side. Once or twice he made a tentative motion to turn or tip the canvas toward him, steal a glimpse. For every move Marc countermoved menacingly to protect his privacy.

After a bit of this speechless charade, Chaim left. Marc bolted the door, and went back to bed. He detested this strange creature. The rags that were his only garments were always as covered with pigment as his canvases. And those made Marc think of earthquakes, volcanic eruptions, explosions, ejaculations. The little wooden houses of the *stetl*, Chagall's isbas, the same little wooden cabins that appeared in the works of almost all the Jewish painters of La Ruche, were, in Soutine, ever in a state of dissolution, bursting apart under the blows of some cosmic catastrophe. The air was blood, the flesh of his occasional portraits indistinguishable from the flayed bulls and calves he had painted not so much in imitation of Rembrandt, but as if he were imitating the "killers" of the nearby slaughterhouses.

All day long one heard the bleating and neighing, the lowing and whinnying, the snortings and screaming of pigs, horses, goats, bulls. A daylong litany which brought him back always to his grandfather of Lyozno. Unlike Soutine's savage killings (he also slashed his unsatisfactory canvases, ripped them to ribbons) Marc's cattle were always painted with compassion; it wasn't a huge step to pass from the crucified cattle to the Crucified Jew. For Marc every slaughtering was a Crucifixion: a necessary sacrifice to give nourishment to the body or nourishment to the soul.

But there was none of this in Soutine's horrors. Blood as blood. Convulsions as convulsions. Although Chaim did not say it (he spoke little, and mumblingly with his palm over his mouth, when he did) Marc felt this creature's scorn for his sentimental compassion.

Privileged among the starvelings of La Ruche, insofar as he received a regular stipend, Chagall divided his money into thirty equal parts but never entirely spent his day's quota, so that at the end of the month he had some savings.

When other artists received a bit of money—Kremegne and Soutine almost never—they spent it the same day paying off the model, visiting a bordello, boozing, and continuing to starve. By contrast, the dreamer Chagall always coexisted with the provident Chagall. He was grasshopper and fox at once. While Marc hugged his Vitebsk to his breast, most of the other Jewish painters wanted only to obliterate their native land from their memories.

Sometimes Soutine or his companions in misery asked Chagall for a few sous. He gave it to them on condition that they should never pay it back. This was his way of protecting himself against new demands.

When Soutine had a few sous he slipped into a bistro and drank himself into melancholy. Then he hid so that no one might see him. By contrast, the theatrical Modigliani when drunk attracted a gallery of spectators.

Chaim Soutine, born in Smilovitz near Minsk in Lithuania in 1894, came from an area where the Jews were not Chassidic; there was no tradition of religion as a joyful leaping up to God. There he had grown up in grinding poverty, eating boiled potatoes, herring, and black bread. At sixteen, to the horror of his iconophobic family, he had enrolled in the Academy of Beaux Arts at Vilna, where he had met Kremegne. Friday, the poor students waited outside the synagogue to be invited to a sabbath dinner. This was when Soutine developed his eternal melancholy and Kremegne his ferocious hatred of the world. They were a pair of characters out of Dostoevsky— always together.

Soutine looked like a lump of clay pounded by blows before it has achieved the desired humanity. And indeed his temperament had been shaped by the very real blows he had received from his father for having violated the Mosaic injunction against making images of a living creature. Soutine had dared to paint a portrait (from memory

of course) of the rabbi of Smilovitz; as a result he had been locked in a cellar and treated like a heretic who had shown contempt for the fanatic faith of his forebears.

So Chagall from Vitebsk, Soutine and Kremegne from Minsk, Zadkine, Archipenko, Kikoine, Lipchitz from the Pale or the Ukraine or Galicia. Into the logical world of Cartesian France, analytic, geometric, cerebral, these Jews brought passion, fire, disorder, dreams, imagination. Thus from steppe and marshland and Baltic provinces was nourished one vital tributary of the School of Paris.

Later there was to arrive at La Ruche—transferred here from the other side of the city, from the hill of Montmartre—the beautiful Tuscan Jew, Amedeo Modigliani. Incredibly, he became constant companion to the mad Soutine.

A more incongruous pair could hardly be imagined: Soutine, twisted, grimacing, eccentric, ignorant, maker of images like clots of volcanic magma, resembling in his own person the earthquake world he conjured up. And Modi (whose very nickname suggested "mode") all style, style in dress, style in his art. Modi's line was the pure contour of an ideal. He transformed every model into a Madonna. Like most Italian Jews, he was more Italian than Jewish; he had absorbed Roman classicism and Christian imagery into his very handsome flesh, and he could not draw a line without it echoing centuries of classicism. His most erotic nudes were as lucid as a Brunelleschi church: tufts of pubic hair grew asymmetrically along one slope of the Mount of Venus; the model's contours were depicted with Apennines of outlines, the breasts rising like soft Tuscan hills, the color cool, most discreetly modeled.

And to think that this beautiful aristocratic young Livornese (like most of the Eastern Jews, Chagall thought of Modi as a "prince") should have chosen as his boon companion the unspeakable Soutine! Soutine, whose lava explosions of canvases, earthquakes of pigment, twisted huts, raw beef colors, catastrophic landscapes, mad staring-eyed portraits were diametrically opposed to Modi's refinements; Soutine, whose unbathed, suspicious person was cloaked like a beggar in filthy rags, whereas Modi, poor though he might be, always seemed meticulous in his velvet Apache jacket and red Communard's scarf.

Soutine never laughed, one never heard his laughter ring. A pale smile was the maximum he would consent to Modi's good humor.

This curious partnership was the La Ruche successor of the equally

curious pal Modigliani had chosen during his days up at Montmartre. Then it had been his fellow inebriate, the simpleminded Utrillo. Perhaps the Tuscan had found a historical echo in the concordance of *U's* and *L's:* Utrillo . . . Uccello. Paolo Uccello was one of his heroes: and he too had been seemingly simple, a fifteenth-century *naïf* with his wooden hobby horses and dense unmodulated color, his infatuation with perspective: *"Che bella cosa è la perspettiva. . . ."* Did Modi on the Hill of Martyrs, high on hashish, discern a reincarnation in poor Utrillo? And here at La Ruche was it simply the attraction of opposites which drew him to Soutine?

Modi was a lucid but tormented young man. His family background was in curious contrast to most of the Eastern Jews at La Ruche. Most of them could not trace their families back more than two or three generations. They were Jews of the *Galut.* Whereas Modigliani's family were leading citizens in the port town of Livorno: his brother an eminent Socialist who was to suffer for his anti-Fascism, his father a merchant, his mother a great lady. Everything in his background emanated class, education, culture, comfort. When drunk, he recited Dante, Petrarch, Carducci. He loved Italy, but he could paint only in Paris.

He had come there in 1906, settling in the Montmartre that was the other pole of the School of Paris. There he had lived for a while at another artists' colony, a barracks called Le Bateau-Lavoire, like a huge steamboat permanently and inexplicably moored—Noah's ark on Ararat—among the rooftops of Montmartre. Thus the Hill of Martyrs was complement to the Hill of Parnassus: together they formed the School of Paris. In Montmartre were to be found Picasso, Juan Gris, Max Jacob, Guillaume Apollinaire, André Salmon, Mac Orlan, Georges Braque, Van Dongen, Gleizes. . . . These had already presided over the birth of new forms in poetry, painting, sculpture, stagecraft. From these seeds were to germinate in Russia Meyerhold's theatrical renovations, Tatlin the Constructionist, the Futurists David Burliuk and Mayakovsky; even Kandinsky's nonobjective art and the Italian Futurists Marinetti and Severini.

*

The King of Montmartre, of course, was Pablo Picasso. Even in Russia Marc Chagall had heard his name and legend. The astonishing

collector Sergei Shchukin had been amassing works of the Spaniard
ever since 1908, when he had been introduced to him by Matisse,
whom he had earlier significantly collected, and who even came to
Moscow in 1911 to install his huge *Music and Dance* in Shchukin's
house.

Through Shchukin's and Morosov's tasteful and critical collections
(which were to become the core of the "French" collection at the
Hermitage) Russian artists had at their disposal a quintessential yet
sizable (over three hundred and fifty works) review of major trends
from Impressionism to Cubism. All of this was in Moscow, however;
and Chagall had not as yet been there. But certainly he had heard—
who had not?—about Pablo Picasso.

When he came to France Marc was eager to meet the legend. But
when he asked Apollinaire for an introduction, the poet—literary
picador of the great Torero's troupe—exclaimed: "Why do you want
to meet him? Do you want to be driven to suicide?" More than one
victim, especially women, had already experienced the Malagan's
destructive force, his capacity for hate which would suddenly trans-
form the face and figure of a ravishing mistress into a monster.

Three years before Chagall arrived in Paris, Picasso had painted
Les Demoiselles d'Avignon, jagged as shrapnel and as explosive,
painted not in memory of love in Avignon but of whores in a brothel
on Avignon Street in Barcelona. His studio at the Bateau-Lavoire was
renowned for its incredible disorder, which seemed to serve as loam
for Pablo's ceaseless fertility. His first mistress, Fernande, had already
set up her own apartment, nearby to be sure, while Pablo remained
with a menagerie of stray cats and dogs, a monkey, white mice, and a
retinue of Suit-of-Light polishers and sword-handlers. Marc indeed
was not to meet him until 1929. Marc knew that Picasso was a
genius, but he could not vibrate to his work which was—for all its
fire—cold, destructive of life.

Picasso is indeed the great Dismemberer. He takes apart the
Known and puts it together to create the Unknown. He makes one
think of Da Vinci gluing together wings, antennae, proboscides,
limbs of various insects to create a Leonardian monster-insect. To
birth the nonexistent he tears apart the existent.

Chagall's fantasy is equally free of realistic reference. But his
images arise from another emotional source: life-affirming always,
sentimental at times, mocking but not hating.

Picasso was then, and was to remain, the flaming leader of the entire generation. Squat, five feet two, with his blazing eyes, black lock falling over his forehead, a smoking Gauloise always dangling from his scornful lips, moving with the muscular combativity of a bull bred for the ring, always the center of a great commotion, he dragged his companions with him everywhere. He opened all paths, he feared nothing, he was already raiding the centuries for the raw material of new image-making. At the same time, he annihilated everything: the human person and objects.

Although some odd birds like Modigliani flew between the two hills, most of the new forms of expression were born up in Montmartre among the windmills and winding streets and under an immense sky stretched like a canvas, rather than in Montparnasse, which played a greater role after the war. And La Ruche was not even truly Montparnasse but a slum area at the periphery of it. There life was hemmed in between the slaughterhouse and the fortifications, and rivulets of blood did not · run only from the abattoires.

Inevitably, the bees formed groups. After Kremegne arrived in 1913, and Soutine the year after, these two palled together until the dour, sardonic Kremegne cut Chaim down from an attempted suicide . . . and never spoke to him again. For the short while of Modigliani's residence he became the new partner of the suffering Chaim. Others grouped in the studio of Indelbaum. The sculptors of course, and there were many, tended to stay together.

But Marc Chagall remained apart from all these artists. From the start he hugged his visions to himself, making use of every new art current that might be useful to him, but becoming subservient to none. At the time of his arrival, Cubism was the dominant mode and we see the influence of it in such works as *Homage to Apollinaire, The Poet, I and the Village, The Soldier Drinks,* and *Paris through the Window,* to take but a sampling of the more important works achieved during his first Paris sojourn.

But despite the disciplinary usefulness this Euclidian mode served, fundamentally the mathematics of Cubism was antithetical to his emotional nature. Color as the most immediate expression of feeling was more important to him than seeing all sides of an object at once. Chagall has the typical Chassidic distrust of rational procedures; and

Cubism with its monochromatic, muted tones, its architectural com-
position and structuring is above all rational. Cubism is analytic or
synthetic; and Chagall is lyrical. At best, he could make use of it to
formalize his visions, throwing nets over them as Dante encaged his
fantasy within the interlocking tercets or as Michelangelo in the
Sistine vault employed a complex architectural ground to contain the
overflowing of his imagery.

But Chagall is a poet. And from the very start of his career his
friendships veered toward poets, literary people, although he bridles
(and justly) when the word "literature" is applied to his work.
Living at La Ruche at that time, frequently to be found at the terrace
of Le Danzig, where one could get a meal for a few francs, was the
poet Blaise Cendrars.

Son of a Swiss hotel entrepreneur, Cendrars had run away from
home at the age of fifteen, since which time he had never stopped
running. Although about Marc's age when they met, Blaise had
already been around the world, had seen everything from the
Siberian tundra to Balinese brown-breasted maidens; bumming from
Scandinavia to North Africa, he had been in jail in Marseilles and
had peddled fake jewelry in Mongolia; he had celebrated Easter in
New York (whence the poem) and written *Panama or the Adventures
of My Seven Uncles.* His colorful experiences, no sooner engorged,
were spilled out hot with more vigor than art: Gallicized Whit-
manesque exultations of the open road. Cigarette dangling oblique
from a sardonic mouth, squinting eyes, boundless energy, he roamed
the planet and wrote *télégramme-poèmes:* a Pathé-news of the pen,
projecting jerky, nervous images of his vagabondage.

To Blaise Cendrars, La Ruche was a marvelous circus tent of
curious specimens, and this curly-haired sapphire-eyed Marc Chagall,
this light-footed Russian Jew who painted naked all night, wielding
his brush like a magician's wand, transforming objects before one's
eyes, was the most colorful specimen of all.

Their alliance was inevitable. Marc was considered by most of his
fellow painters as a fantasist, a strange creature with outlandish ideas,
a poet.

And when a painter is looked upon by his fellow painters as a poet
the compliment is ambiguous, implying some doubts about the
"purity" of his work. Chagall has been aware of this all his life. He

could ignore the coarse laughter of the French public at the several remarkable little canvases he had trundled over on a pushcart to the Salon des Indépendants of 1911. But that artists who came from the same world as he did could not fathom him made him feel his isolation more keenly. Most of the Russian and Polish Jewish painters worked in various modes of post-Rembrandt, post-Courbet realism, from the paintquakes of Soutine, to the Expressionist and Fauvist high color of Kikoine and Moise Kisling. But though they flapped their wings vigorously, none of them flew. They were earthlings in every case.

Thus while the painters clustered together in various and changing combinations, Marc Chagall was, if not allied, at least more at his ease with poets. Shapers of language do not compete with paint shapers. And though at that time his own French must have been still quite limited despite his swift acquisition of that subtle instrument, his singsong Russian cadences, his miming and grimaces, his tiptoe dancer's walk and crazy humor captivated Blaise Cendrars, who became his closest companion of those years. He was the first to visit Marc in his studio.

> . . . another light and sonorous flame, Blaise, friend Cendrars.
> Chromatic blouses, socks of different colors, bursts of sun-light, poverty, rimes.
> Threads of colors. Of flaming liquid art. . . .

Cendrars had a marked idiosyncratic character, a rough absolute frankness, natural, refractory to all convention. In whatever milieu he happened to find himself—whether literary or artistic—Cendrars decided everything, cut, reversed opinions, upset all applecarts, turned ideas, relationships, and activities topsy-turvy. He dominated those whom he approached and in most cases tried to influence those who were in contact with him, anchored as he was in his own certitudes. He sought to stamp Chagall in his own fashion.

> . . . then came Cendrars who consoled me just by the shining of his eyes.
> More than once he advised me, took care of me, but I scarcely ever heeded him, even when he was right!

He persuaded me that I could work tranquilly alongside the proud Cubists to whom I was perhaps a bit of nothing at all. . . .

Cendrars on his part has given us a portrait of Chagall at La Ruche in his *19 Poèmes élastiques,* beginning:

He sleeps
He is awake
Suddenly he paints
He grabs a church and paints with a church
He grabs a cow and paints with a cow
With a sardine
With heads, hands, knives
He paints with a bull's tendon
He paints with all the grubby passions of a little Jewish village
With all the exacerbated sexuality of a Russian province. . . .

He had to straighten up somewhat before Cendrars arrived. Marc always made the poet wait to give himself time to dress, clear a space amidst the mess of frames, empty soup cans, eggshells, cubist ladders of herring bones. Then burly, laughing Cendrars would globetrot into the studio whose native was as exotic as a Siberian, read his latest poems . . . "looking out of the open window and into my eyes; he smiled at my canvases and both of us roared with laughter."

It was Cendrars who suggested the titles for some of Chagall's pictures: *To Russia, Asses, and Others; I and the Village; From the Moon.* Often these are lively and apt, and Marc recognized this and was grateful. Cendrars' own poems, frequently influenced by Walt Whitman's long seaswell, were stenographic repetitive slangy musings full of airplanes eiffel towers women with sundisk stomachs charlie chaplin and brazilian pampas all flung together topsy-turvy in cubist fashion, somewhat akin to Chagall in their chromaticism and helter-skelter arrangement of images. His, however, is a kaleidoscope world, all surface: Chagall's fantasy springs from a deeper well.

Another writer, André Salmon, lived for a while at La Ruche, and perhaps served as Chagall's introduction to the circle centering around Guillaume Apollinaire. Chagall looked upon that giant of hilarity as nothing less than noble, the outrider of Cubism. Marc calls

him "that sweet Zeus." "In verse, in numbers, in tripping syllables, he traced a road for all of us."

Apollinaire's origins were indeed Zeusian, cloaked in clouds. When Salmon was questioned about his early years—whose *landsman* was he? Litvak? Galitsianer?—"By our discretion we guarantee bread to those whom Stéphane Mallarmé called '*les scoliastes futurs.*'" But at least one knew that Salmon was a Russian Jew, like so many of those living at La Ruche.

But Apollinaire! Even after half a century, the mysterious heritage of his paternity seems to have been attributable to some prelate in Rome, where he had been born of a Polish mother in 1880. His mother, the extravagant Madame Olga de Kostrowitsky, received his friends with hauteur, wearing the lingeries of the Belle Epoque. Among those privileged to meet her thus was the poet Max Jacob.

Apollinaire's mother, who claimed descent from Polish nobility, had been a *poule de luxe* at the casino at Monte Carlo. Guillaume was very fond of his mother, whom he used to visit regularly at her villa in Le Vesinet, on the outskirts of Paris, where she lived in stormy domesticity with her most persistent admirer, an Alsatian gambler named Jules Weil. The poet himself had a tiny bachelor apartment up in Montmartre near Picasso, for whom his admiration was total and without reserve.

Gertrude Stein, who had met Guillaume Apollinaire about 1906, said of him: "He was extraordinarily brilliant and no matter what subject was started, if he knew anything about it or not, he quickly saw the whole meaning of the thing and elaborated it by his wit and fancy...."

Apollinaire was the spokesman for the Montmartre painters, especially Picasso and the Cubists. A practicing art critic, he had already written in *La Phalange* about Picasso's Rose Period harlequins and, later on, about Matisse. But his trumpeting was not limited to Cubism. He was also a barker for the Italian Futurists and the Orphism of Robert Delaunay (who eventually became one of Marc's few close painter friends).

In 1913, when Marc Chagall painted his *Homage to Apollinaire,* the poet had just published his *Les Peintres Cubistes.* According to James Mellow, Apollinaire's artist friends took a condescending view of his art criticism without, however, disavowing its usefulness as publicity. In later years the artists he promoted claimed that he had

understood little of what he was writing about, that he had simply passed on observations they had made to him. "He never wrote penetratingly about our art," Braque maintained. "I'm afraid we kept encouraging Apollinaire to write about us as he did, so our names would be kept before at least part of the public." On his part, Apollinaire confided to a friend that he had championed Braque and the Cubists even when they were mediocre because he felt it was his duty to "promote newer developments."

Apollinaire was a wanderer of city streets in the tradition of Baudelaire, Léon-Paul Fargue, and so many Paris literati. For one paper he wrote a gourmet column; for another *la vie anecdotique*. Among his closest friends was the mincing wit Max Jacob, poet, watercolorist, mystic, clown, and (after a visitation by the Madonna) a Catholic convert. Which didn't protect him from being picked up by the Nazis as a Jew and sent to the German concentration camp at Drancy, where he died in 1944.

Apollinaire was at the center of everything literary, artistic, theatrical. He was a jovial companion; an endless stream of anecdotes poured from his lips; he ate enormously, drank enormously, lived enormously, and yet he was basically bland by comparison with the berserk globe-trotter Blaise Cendrars.

Apollinaire had become well known around Paris from about the beginning of the century. He had discovered and advertised the Douanier Rousseau, earned his living as a pornographer, critic, collected African sculptures, worked in a bank, contributed to avant-garde magazines.

In his third collection of verse, *Calligrammes* (1912-16), Apollinaire experimented with typographical artifices in order to create a "visual lyricism." Thus, employing the same image that began to obsess Marc in those years, Apollinaire makes a poem-picture of the Tour Eiffel:

Dismantling the Tower and Englishing it:

Hail world of which I am the eloquent language whose mouth
O Paris shoots and will always shoot against the Germans.

For their part, the painters—Chagall and Léger and Braque especially—introduced lettering into their pictures, breaking up the words, scattering and reassembling the letters. And just as Apol-

linaire made pictures, poems with words, Chagall began to employ the lyrical shapes of Hebrew characters as the armature for his compositions.

This was only one aspect of the general cross-fertilization of the arts typical of the period: the *Sprechgesang,* song-speech of Schönberg, the union of the arts in Diaghilev's ballet productions.

Although Chagall had known Apollinaire for some time, he hesitated to show him his work, which, despite some signs of influence, was far removed from the Cubist school for which the poet served as ardent spokesman.

One day they went to dinner together not far from La Ruche. Marc recalls that they ate salad, sauce, and salt—everything beginning with an *s,* the while he wondered whether the poet expected him to pay for the meal. Afterward they hoofed their way up to Guillaume's mansard apartment in Montmartre, and Marc timidly listened to the steady pour of wit, epigram, judgment. The place, crowded up to the ceiling with books and knickknacks and pictures by Picasso, was pleasing in its disorder; it was like his own studio. The side entrance was exactly like a small yard in Vitebsk. Marc felt he didn't even know what language the poet was speaking. All these glowing words, these flowing colors. He understood little. "To tell the truth, I was afraid."

Watching and listening to Guillaume, whose mouth never-stopped moving, whose eyes blazed and constantly rolled, whose corpulent body twisted and turned, laughing with eyes and chin and arms, then momentarily still only to become agitated once more, Marc had the impression that Apollinaire, famous for his gargantuan appetite, would swallow him whole and spit his bones out the window.

"He carried his stomach like a collection of complete works and his legs gesticulated like his arms."

About the time Marc Chagall met the portly poet-pornographer (a source of income), Gertrude Stein wrote one of her "portraits" of Apollinaire:

> Give known or pin ware
> Fancy teeth, gas strips,
> Elbow elect, sour stout pore, pour caesar,
> pore state at,
> Leave eye lessons I. Leave I. Lessons.
> I. Leave I lessons, I

This "poem," like Cubist painting and dodecaphonic music, is another example of twentieth-century art moving from conjunctive to disjunctive; an art of splintering, sundering, fragmentation, planned incoherence. Just as the Cubist painters were seeking to purge painting of associative values, Gertrude Stein was trying to strip language down to the same essential "purity." Frequently she succeeded: the "portrait" certainly communicates no meaning.

It was Apollinaire who talked about everything, knew everyone, pointed out blind Degas, painfully leaning on a cane, crossing the street. It was Apollinaire who laughingly dissuaded Marc from meeting Picasso, protecting him from self-destruction.

He had an incredible appetite for food and drink and seemed to sing as he ate, gurgling the wine, tinkling it in its glass, squishing the meat between his teeth. Meanwhile he greeted friends and acquaintances right and left, emptying one glass of wine after another in a swarm of elbows and brook-sounds.

Perhaps counting on the warm juices of benevolence stirred up at one of these Rabelaisian dinners, Marc timidly suggested that Apollinaire come to his studio at La Ruche. The poet had never been there before. He might meet Blaise in the corridor, his mouth round as an egg and his pockets full of poems. Or some young girls. And he could see the abattoires.

And he could see Marc's pictures.

As if to arm himself against the apostle of Cubism, puffing along with him up to the ramp of the Rotonde, Chagall interrupts his account of Apollinaire's visit with a long and quite inarticulate tirade against "scientific tendances" in art as opposed to "the honest heart." All that formal baggage is "like the Pope in Rome sumptuously garbed alongside Christ nude on the cross. . . .

"Apollinaire sat down. He blushed, snuffled, smiled, murmured: 'Surnaturel! . . .' " "Supernatural" was to become "surréaliste" for the first time in Apollinaire's farce *The Teats of Tiresias*, produced in 1917, laid in a Cubist setting with Cubist costumes, a music-hall play where characters spoke through megaphones, a newspaper kiosk talked, and a Parisian journalist spoke English and waved the American flag.

The day following Guillaume's ejaculation, Marc received a letter including the poem "Rotsoge," dedicated "To the painter Chagall,"

which he later used for the introduction of his first one-man show at *Der Sturm* in Berlin. It begins:

> Your scarlet face your biplane convertible into hydroplane
> Your round house where a smoked herring swims. . . .

*

Among the four makers and shakers honored in Marc Chagall's *Hommage* of 1911-12 is Riciotto Canudo, compatriot of Amedeo Modigliani. Canudo, whose literary goatee impressed Chagall as much as it horrified Modigliani, was the editor of *Montjoie,* a journal dedicated to modern art. He had given a series of lectures on Dante at the Institut des Hautes Etudes Sociales, rue de la Sorbonne. For this, Modi forgave him even his bourgeois beard. Modigliani, who shared the editor's admiration for the Poet and could declaim tercet after tercet of the *Divina Commedia,* especially when he wandered *nel mezzo* of his own hashish or wine-induced .Paradiso-Inferno, was tickled to learn that these conferences had bestowed on poor Canudo the doubtful title of Director of the Dante Institute—a nonexistent organization. Whenever Canudo appeared at his favorite café, the Closerie des Lilas, he was always greeted by his title, which didn't annoy him in the least.

Every Friday at Canudo's house one met Gleizes, Metzinger, de la Fresnaye, Léger, Raynal, Valentine de Saint-Point accompanied by his three young admirers; Segonzac, professor of La Palette, where Marc occasionally worked; André Lhote, Luc-Albert Moreau, and so many others. The atmosphere was smoke, noise, and fellowship.

Delaunay, especially, was what the Jews call a *tumler*. Chagall understood very little of what Robert was agitating about. At the Salon des Indépendants his canvases had struck Marc above all by their dimensions. Delaunay carried these enormous color wheels triumphantly to the end of the barracks, winking significantly as he did so.

Gertrude Stein also found Delaunay "amusing as a person" but negligible and overambitious as a painter.

We have not seen much of the Delaunays lately. There is a feud on. He wanted to wean Apollinaire and me from liking

Picasso and there was a great deal of amusing intrigue.
Guillaume Apollinaire was wonderful. He was moving just then
and it was convenient to stay with the Delaunays and he did
and he paid just enough to cover his board. He did an article on
Cubism and he spoke beautifully of Delaunay as having "dans le
silence creet (sic) something or other of the couleur pur."

Now Delaunay does conceive of himself as a great solitaire
and as a matter of fact he is an incessant talker and will tell all
about himself and his value at any hour of the day or night to
anybody, and so he was delighted and so were his friends.
Apollinaire does that sort of thing wonderfully. He is so suave
you can never tell what he is doing.

Undoubtedly an important factor in the Delaunay-Chagall friend-
ship was Delaunay's Russian wife, Sonya, just two years younger
than Marc and, like him, a Russian Jewish painter who had studied at
St. Petersburg. Sonya Terk had come to Paris in 1904 and had
married Robert Delaunay the year Marc arrived. Among the first
exponents of abstract art, the Delaunays developed Orphic Cubism
together, stressing color and dynamics rather than monochrome and
statics. The first to introduce the Eiffel Tower—to him the symbol of
modern civilization—into his paintings, Delaunay went on to create
large luminous asymmetrical multicolored sun disks. They didn't say
much to Marc, but it didn't matter: Delaunay was doing all of the
saying anyhow.*

Thus, through Canudo, Marc got to know everyone and was
everywhere. One evening the deracinated Italian even organized in
his living room a show of Chagall drawings: a scatter display all over
the furniture. Once in a café he boomingly informed Marc that his
head resembled that of Jesus Christ. Eventually, in his magazine he
hailed Marc Chagall as the greatest colorist of his time.

This did not help Marc to sell a single one of the portfolio of fifty
watercolors which he presented to a certain M. Doucet with a letter
of introduction from Canudo, brimming with praise. After a quarter
of an hour the portfolio was returned to the young artist by a
domestic who advised him in the name of his master: "We have no
need of the 'best colorist of our time.' "

* Eventually the sun disks were to wind up as the color armature of Chagall's Paris Opéra
ceiling.

Earlier, needing money, he decided to emulate a companion at La Ruche who was successfully palming off fakes. Chagall tried to concoct a Corot but gave it up when it persisted in becoming ever more a Chagall.

Apparently Canudo served as the Virgil in several nocturnal infernal explorations into the depths of Montjoie, where blinding rays of light played about the young men. An abyss where "flights of white gulls soared in formation like snowflakes to heaven."

It is not too difficult to surmise where all this psychedelic phenomena occurred. At any rate, in that mysterious place, the Russian and the Italian encountered "another light and sonorous flame, Blaise, friend Cendrars."

Is it to be wondered at, that among all those whom Chagall met during those years he should have singled out this quartet, *Cendrars Apollinaire Canudo Walden,* for the valentine naïvely appended to the corner of his *Hommage?*

Others he dismisses with a line:

> Here is André Salmon. But where is he?
> Here is Max Jacob. He resembles a Jew.

The valentine piques our curiosity; it has no bearing on aesthetics. A public love letter to an important drumbeater (Apollinaire), an avant-garde German art entrepreneur (Walden, whom, furthermore, Marc had met but once), a magazine editor who might help (Canudo), a brilliant self-and-friend-advertising poet (Cendrars)—all this is forgivable though its taste be questionable. Notice, there are no painters on the list. Marc Chagall was, like any young artist, desperately out to make a success.

The painting itself *qua* painting—self-consciously Cubist, cold, contrived—is curiously at odds with the sentimentality and self-seeking of the names around the pierced heart. The main dedicatee, Apollinaire, must have been pleased at what seems the art of a proselyte. For *Hommage* is the most Cubist of Chagall's paintings of those years, though all were affected to some degree by that style.

The bisexed Adam-Eve stands against a great color wheel rotating through red, gold, deep green, black, cloudy white. Although the circle—a form whose symbolic connotations are infinite—was later to become a dominant motif of Chagall's, this particular wheel might

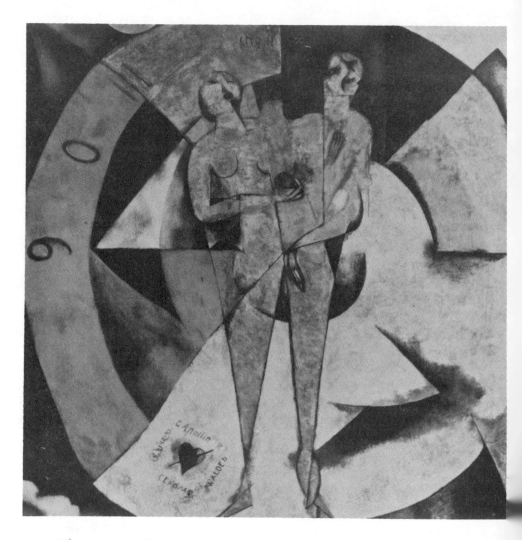

Hommage à Apollinaire, 1911/12.

have been inspired by the enormous chromatic sun disks Delaunay was painting at that time. If so, why isn't his name added to the valentine?

Cubism is apparent in the jagged interlocked triangles of figure and circle. The color wheel also suggests a clock face. Above the androgyne, Marc has juggled with the letters of his own name: once printing it in Latin characters, once omitting the vowels (as in Hebrew), once writing Marc with a Hebrew *aleph* and *beth*. Is there need really to read any symbolism into this playfulness other than a perfectly normal artistic disposition to treat letters, like everything else, as elements in a plastic design? Interpretations of *Hommage* have assimilated the joint figure against the wheel with the "medieval structural schemata" of Villard de Honnecourt, to which one might add the celebrated Leonardo drawing on the same theme.

Within the clock face the two hands are one: Man-Woman . . . in His image created He *them*. She holds the apple. His hand, swooping like a rollercoaster, becomes in this game of curves his penis, soon to be covered after the Fall. And the androgynous clock tells Chagallian time: 9 0 1 Nine? Ten? Eleven?—a segment only attempts to clock a life that is for the most part unquantified.

The pierced heart surrounded by his four good angels leaves us with an uncomfortable feeling. Is it naïveté? or obsequiousness cloaking calculation?

This two-headed Cubist Adam-Eve with its curious triple signature

 Chagall
 Chgll M c

 reveals the boy from Vitebsk plunged into France. Cartesian Cabala!

The colors are Léger-like but the irregular wheel rebels in its imperfection against the machine, and Chagall was soon to rebel against Léger machine-tooled colors also.

Here there is not yet the organic "chemistry" but the "chemistry" was already in his blood.

But though he was to make use of Cubism, essentially he was not conquered by it. Cubism, first enunciated about 1906 by the twin prophets Picasso-Braque who painted so similarly for a while that one

could only with difficulty tell their pictures apart, was undoubtedly
the dominant art mode up until the outbreak of the war in 1914. But
Chagall was hungering after another reality.

"Let them eat . . . their square pears on their triangular tables!"

His own art, he felt, even as he obsequiously paid obeisance to the
idols of the hour, was "flamboyant mercury, a blue spirit. . . ."

"Down with naturalism, impressionism, and cubist realism!"

Doctrines saddened him. Restrained him.

All those questions rolled out on the carpet—"volume, perspective,
Cézanne, Negro plastique," were hymns sung to . . . "technical art,
which deifies formalism."

No, he felt, this was not enough. This was folly. What was
needed was an "expiatory bath. A revolution in depth, not only on
the surface."

And then with exasperation: "Don't call me a fantasist. On the
contrary, I am a realist. I love the earth."

When he had accompanied the puffing Apollinaire to his studio at
La Ruche, they had passed along a corridor with many doors. At last
he opened his own.

He was always opening his own door.

> Personally I don't believe that the scientific tendency is
> happy for art.
> Impressionism and cubism are strangers to me.
> Art seems to me to be above all a state of soul.

In rejecting both Impressionism and Cubism—the two most signif-
icant movements of the nineteeth and early twentieth centuries—as
"scientific," Marc Chagall was expressing his own anti-rational, anti-
visual conception of painting. Realism, as he understands it, includes
the inner as well as the outer world. And by strictly plastic means he
creates a new reality—the reality of the unreal—which has little or
nothing to do with vision. Although Chagall never reasoned out the
roots of his objection to Cubism (and why should he?), he intuitively
understood that all this fuss about multiple views of the object
(whether static à la Braque or dynamic à la Balla, Boccioni, the
Italian Futurists) was essentially Giotto on a motorcycle.

That is, it was just the latest plastic reorganization of the physical
act of vision.

Retinal technology did not interest him a droshka. Illusionist

engineering was for the photographers. Had he not worked for photographers? All the great pictures of the first Paris period are acts of rebellion against Impressionist seeing and Cubist knowing.

A remarkable self-portrait of 1912 proclaims his uniqueness.
How could they understand him? He had seven fingers.
Not because he had discovered how to present dynamics in a static medium, simultaneities instead of sequentialities. He was not Juan Gris or the magician from Málaga or the housepainter's son, Braque, wriggling wood graining into succulent browns. He was not circulating around himself with compass and T-square.
No, Marc had seven fingers because.
Because why not?
Over his head in Hebrew letters he wrote *Pe' eri Russia* . . . Proud Russia. (In 1912 close to a hundred thousand Jews emigrated from "Proud Russia.") In the upper left corner a tiny view through the window of the Eiffel Tower against a black black sky. In the upper right, floating in clouds, Vitebsk.
The palette with its rings and triangles and blobs of brilliant color oddly suggests Chagall's head. Polychromatic ringlets.
The lessons of Cubism are here also. In the splintering planes.
Why seven fingers?
Why not?
The milkmaid is upset. She's flying up over the cow's rump, spilling her milk. Her head has flown completely off. She floats over a little church. Over the cross

All of Chagall's work during his first Paris sojourn shows how independent he was from all the powerful schools surrounding him and claiming the allegiance of a young painter. For one thing, he immediately demonstrated his utter indifference to the Impressionist masters whose works still exercised an influence on many Paris-drawn artists: that is, those who still felt that the picture was fundamentally the record of an act of seeing. But to Chagall, of course, the picture was an invented symbol of feeling, employing elements of vision as a vocabulary which he could manipulate any way he liked.
A comparison of Pissarro's Impressionist view through the window—his *Boulevard des Italiens* of 1897—with Chagall's *Paris through the Window* of 1913 dramatically illustrates the difference between

the picture as an act of seeing and the picture as an invented symbol of feeling.

In the tradition of French Impressionism—of Monet especially—Pissarro attempts to render the luminous image that strikes his retina. But as all things carried to extremes become their contraries, so Impressionist rendering of reality finally led to the very opposite: instead of serving as instruments of illusion, dots and blobs of paint become their own reality. Instead of suggesting, they *are*. Instead of negating themselves, they affirm themselves. So the search for new techniques to render light and atmosphere more convincingly resulted in an art of painting entirely anti-atmospheric. The picture itself became more *thingy* than it had ever been before: much thicker, more impasto, more blobs of paint, more *painty*—not painterly but painty. Monet's water lilies are the supreme example.

By the time Marc arrived in Paris he could see the ultimate contradiction: the Impressionist picture, intent on rendering subjects in light, had become itself an object. A technique of illusion had become itself a *thing*.

So the paradox: a slide projection of Pissarro or Monet is more *impressionistic* than the original painting. Photography is the true art of light, valid Impressionism.

Pissarro tries to tell you what he sees through the window.

But Chagall obviously doesn't care a hoot what he sees through the window. The senses are conveyor belts bringing raw material to be smelted, smashed, reconstructed. He employs his seeings and his feelings like a poet-engineer. Fragments of Paris are colored like Russian icons. A Cubist grid disciplines the fantasy. The imagery flies all over the place. If lovers are off the ground lovers always are. Chagall's is only another case of the space art of our century. Density, scrambling, interflow of subjective-objective, the destruction of the vector sense: uni-directionality, the possibility of reading the picture up or down, in any direction (Marc frequently turns his canvas upside down or sideways as he paints) as one might enter Proust's or Joyce's dense worlds at any point, read them forward or backward—all these are the qualities of the vital arts of the twentieth century. How uncomprehending were those (in Paris then, and elsewhere later) who looked upon Chagall as a cute primitive, a Russian *naïf*. He is no more naïve than Stravinsky in *Le Sacre du Printemps* and his paganism is just as calculated.

A psychological reading is one thing in Chagall and a purely

aesthetic reading is another; one may read him according to both systems separately or one may put them together. What, for instance, is the meaning of these various polarities?—that Janus-faced figure looking two ways: Is it Chagall looking two ways? Paris, you are my Vitebsk! And the human-faced cat? Are we in Egypt? Humanoid donkeys and man-cats. Is this his way of expressing the animal nature of man?

When Chagall paints girls who are girls but boys who are beasts, he lays himself open to the charge of "literature." Giant red cocks chasing after maidens are hard to interpret as pure aesthetics. Nevertheless, "literature" is a facile arrow to shoot against Chagall's art—indeed against all expressionist, surrealist, or fantastic art. The moment one employs recognizable images—no matter how splintered—capable of psychological interpretation, there is always the danger of the painting becoming "literature"—painted literature.

When you can say for every element in the picture, "It stands for this," then the picture is in danger: it is hemorrhaging outside its frame. Primarily, a picture must "stand for" *itself*. First of all it must exist *as a painting*. Its autonomy must never be in question notwithstanding all the symbolic arrows pointing to "life."

Chagall is very aware of this. "I cut off her head because I needed something in that space." Not altogether true, the comment is an irritated defense of the artist's autonomy. The painting must hold together as a painting quite apart from all symbolic equivalences. The upside-down railway train trackless in a world where gravity has been abolished, the two figures flying head on—male female—in a horizontal plane, Bella's bouquet, the phallic Eiffel Tower—all these must work as pictorial elements as well as symbolic, literary, philosophical elements.

But certainly by comparison with Pissarro's view—picture-making through the eye—Chagall's is picture-making through the heart: a construct of feeling built of reassembled visual materials.

Paris through the Window is one of the earliest instances of Chagall's humorous juggling with the categories of inside and out. Sometimes one may read his windows as looking out, sometimes the elements inside of, or beyond the window are forward on the picture plane. Naïve treatments of a similar problem may be found in Duccio's great altarpiece at Siena—an arm flagellating Christ on one side of a column, the body impossibly on the other. But Duccio's odd perspective was ineptitude; Chagall's is sophisticated playfulness. He

constantly juggles with spatial relationships. Sometimes windows are used as transoms through which you look and at the same time mirrors which reflect. He loves to play this game. He's very fond of the window as a kind of metaphysical spatial device, to fool around with categories of inside and out, Marc in Wonderland. Inside and out can also be read as inside Chagall's head and outside in the world. It's the subjective-objective mirror maze: the pictorial equivalent of Pirandello. Illusion and reality constantly being shuffled. But you cannot play the trick of illusion and reality if you eliminate every reference to reality. That is, total illusion is no longer illusion. In order to achieve the ambiguous interflow of illusion and reality, you have to preserve a certain amount of semblance. Otherwise it won't work.

Thus, Marc Chagall, not interested in semblances, has always clung perforce to a certain fixed vocabulary of semblances.

The Eastern Jew's scorn of the drunken Russian peasant offered Chagall a theme for several amusing drawings of drunkards whose heads are floating off upside down toward weightless bottles. Now in Paris in 1911 he tackled the theme again. *The Soldier Drinks* cubistically, chromatically. His blue cap flies in the air above his green greatcoat. He points to the teacup under the samovar spigot and his hand is mailed with Cubist plates of color as is the spigot itself. The pointing finger is incongruous with the straight-out stare at us. In the background the corner of an isba roof creates, probably inadvertently, a Union Jack.

But all these metallic clanks and clashes of color and shape calling attention to themselves serve merely as dramatic foil for the astonishing miniature couple dancing a *kazatska* in the foreground of the table. The scale reduction is dramatic and entrancing—and completely unexpected in a picture whose elements, no matter how strident, do not prefigure this.

We react as we react to the miniature saint in the corner of Parmigianino's *Madonna of the Long Neck.* Doll figures have suddenly intruded into an adult, if distorted, world. None of the other distortions have prepared us for this toy dance, these Lilliputian Russians.

Marc Chagall is one of the great humorists in the art of painting. Frequently his humor is self-mockery, the zany Jewish gesture

against incomprehensible fate. In this, as in so much else, the man is co-terminous with the artist. Edouard Roditi describes the conclusion of an interview in Paris 1958:

> It was at this moment that Madame Chagall came in to interrupt us, to remind her husband that he had an appointment at the dentist's. In the blink of an eye, with the rapidity of an acrobat, the great man stretched out on the blue divan was on his feet in the middle of the room, suddenly transformed into a sort of marvelous clown of the same type as Harpo Marx or Charlie Chaplin. While Madame Chagall asked him if he had enough money on him to pay for the taxi, he replied patting his pockets: "Yes yes, but where are my teeth?" Then tapping his jaws: "Ah! Here they are." Then he brusquely departed.

The Spanish poet Raphael Alberti, who visited Chagall frequently in the early 1930s, also speaks of Chagall's amusing personality, his clowning, his ironic improvisations, his miming, "putting on moustaches, cavorting. He was a comic actor. Better than Picasso."

Not infrequently Chagall's paintings are stage sets on which he grimaces, puts on colored wigs, blows old-fashioned auto horns, and smiles the melancholy smile of Harpo Marx.

In *Paris through the Window,* as in all his important paintings before the war, we can see how Chagall makes use of Cubism but is not conquered by it. His floating color is ennetted into Cubism, which splinters these lakes into manageable and composed planes; the color itself, derived in part from Russian icons, bursts into a new brilliance under the influence of Goncharova's and Larionov's Rayonism and Delaunay's Orphic sun wheels. But with all this "modernity" and despite the presence of the Eiffel Tower and parachutes Marc Chagall's vision was then and has remained pre-industrial, indeed pre-Renaissance. His parallels are to be found in artists like Sassetta or the Trecentisti whose angels chirp around a cross on a gold ground. There is a similar levitation and spacelessness in Chagall's Jewish transcendentalism and the Christian primitives.

This medieval-modern synthesis, the Russian-French fusion, is obvious in all Chagall's paintings of that period. *The Fiddler* of 1912-13 plays against a geometrical field of triangles, squares, rhomboids,

arcs, but the space is a nonspace, nonperspectival, and the scale of the personages is hierarchical, as in children's or medieval paintings.

Like the great Jewish comedians, Chagall knows that laughter is triggered by unexpectedness. The fiddler's face is green instead of the anticipated face color. If a green complexion were part of a universe of reversals, then it would be less surprising. So, like a good cook, Chagall ladles out his spices and emoluments: scale might be unreal, but each element within the scale system is real; colors might be an unreal dapple of black and white, but the violin begins by being violin color and ends by being egg-yolk yellow. The fiddler with the dark green face is a perfectly normal fiddler . . . except that he has a green face. He's huger than the houses, which he dominates like Gulliver among the Lilliputians, but the violin is the proper proportion to the violinist. Alongside him is a church which is almost perspectively correct . . . but the "almost" makes the difference between copying the church and building a new one. Staring up at the musician with wonder is a strange tiny dotted human creature with three heads one above the other and above the fiddler's hat a haloed bearded angel. Mysterious footprints hieroglyph the snow, the field of which stands straight up as a Persian miniature. Birds are pasted on the flat tree as children might depict them. But there is nothing childish about the church steeple which ends in a penis-shaped *lanterna* surmounted by a cross.

A lamp which stirred up similar connotations had already gotten Marc in trouble the year before when he had first exhibited at the Salon des Indépendants of 1911. At that time he had shown, among others, the painting which he entitles in his memoir *The Ass and the Woman,* later retitled *Dedicated to my Fiancée,* self-mockery becoming propriety (the original title is puzzling: there is no ass in the picture). The swelling glass globe of the lamp was interpreted as a phallic symbol. Chagall comments cryptically that the work was "arranged" to satisfy the censor. Apollinaire wrote a witty column about it in the *Paris-Journal,* the first mention of Chagall in a French paper: "The Russian painter Chagall has exhibited a golden ox smoking opium. The painting offended the police, but a little gold scattered over the offending lamp settled everything."

Perhaps the "little gold" had been scattered into police pockets? By Marc? He had very little then. There is nothing phallic about the lamp now, but certainly the picture is explosively erotic.

An upside-down female head, like a head on a playing card, blows a stream of spittle at a complacent bull-headed man. The picture is all burning reds (one wonders where Apollinaire got his "golden ox smoking opium"), all curves, dismemberment. The bull-headed man, reminiscent of African masks, Egyptian animal-headed gods, is obviously symbolic of the beast in man: especially in the context of the sex act. Again and again Chagall is to depict his male lover as ass- or goat- or bull-headed, but smiling, content in his bestiality, contemplating the rocketing passionate female—almost always the active element: swooping in her sperm-white veil.

*

He missed Bella. He was twenty-seven and he was alone in Paris and, unlike Modi, he didn't sleep with his models after he had painted them. In fact, his models were only in his head. He explored the city, like the body of his beloved, crossed the great space of the Place de la Concorde, the gardens of the Luxembourg. He gazed up at the gargoyles of Notre Dame and dreamt of riding astride one of these monsters, tracing his own path across the sky. Paris had become his second Vitebsk.

But he had to return to his first Vitebsk if only to capture a tangible bride. For with the years, and despite a steady spate of letters, the letters were becoming like those of Tolstoy's Natasha to André: too formal, too matter-of-fact for a languishing fiancée. He had been away four years. He began to fear that if he remained another year he would lose her.

And so he decided to seize the opportunity of the show which Herwarth Walden was setting up for him in Berlin for the summer of 1914. The indefatigable Apollinaire had been the middleman for this, as for so many another useful encounter. The previous March, "Zeus" had put the shy but very ambitious Vitebskite in touch with Walden, the flamboyant art-cum-literature impresario of Berlin. Two small rooms in the editorial offices of *Der Sturm* (prophetic title!) were to be the showplace for forty unframed canvases—the most important works Marc had achieved in Paris; and about one hundred and sixty gouaches, drawings, and watercolors were to be simply laid out on tables.

Marc planned to attend the opening in Berlin, swiftly detour to Vitebsk to marry his Bella, whisk her off with him to share his triumph (what else) in Germany, and then return with her to Paris.

He certainly had no intention of remaining with his bouquet-bride in herring-reeking Vitebsk.

"After us, collapse! We are ripe." The ominous declaration of a character in a Berlin play of 1913 sums up the spirit of the city to which Marc Chagall came in May 1914, lugging a huge roll of forty canvases and several cardboard suitcases full of gouaches, drawings, and watercolors.

Less than a month later, on June 15, just before boarding the train for Russia, Marc sent a terse postcard to Robert Delaunay: "It's hot. It's raining. Sauerkraut. German girls are quite extraordinarily not pretty."

His judgment no doubt was sharpened by anticipations of Bella. This first view of Germany did not set up sympathetic vibrations in him: the architecture was pompous, graceless, heavy; the faces potatoes. Too many Junker hairdos bristling like shoe brushes. Too many flesh folds at the back of the neck.

And although the seeds of exciting prewar Berlin were already sprouting—"the Weimar style was born before the Weimar Republic"—Marc didn't even stay there long enough to find out. He didn't even stay there long enough to realize that his show at *Der Sturm* would prove the heralding trumpet to his future fame. He left the day following the opening to get home in time for his sister's wedding, and to enfold as soon as possible his fiancée in his arms. He feared, on the evidence of the letters, that Bella was already drifting away from him at an alarming rate.

Thus it wasn't until after the war that he got to know Berlin. But although prewar Berlin had not yet achieved the importance it was to have as a cultural center in the 1920s, still it was cosmopolitan, lively, au courant in the arts, a vital part of the Western cultural community which young Chagall had already savored in Paris. Germany had attracted almost as many foreign artists as France. The Russian Wassily Kandinsky, who had learned from the French Fauves, reached his artistic maturity in Munich. When Marc arrived, Kandinsky was forty-eight years old, and had already been living and working in Germany for eighteen years. Like Chagall and so many other Russian exiles, he was soon to return to his homeland where he

became a teacher at the Academy of Fine Arts in Moscow.

To Germany came the American-born, Paris-trained Lyonel Feininger, who did his best work there. German art was open to the influence of the Norwegian Edvard Munch, the Frenchman Paul Gauguin, the Dutchman Vincent Van Gogh. The German Max Ernst, who was to find his ultimate artistic vocation in France, was then working in his homeland. From 1912 on the Italian Futurist movement had been drumbeating in Germany. Its chief ideologist, Filippo Marinetti, came to Berlin the same year as Chagall. Engaged in conversation everywhere, the would-be museum arsonist found Berlin enormously to his liking.

Thus there were two Berlins—the philistine, uncomprehending imperial city, thick-necked as Kaiser Wilhelm, ramrod-stiff as the troops goose-stepping along the Berlinalle facaded with ugly pseudo-classical buildings and Wagnerian kitsch and glitter. And there was that other Berlin of opposition: Berliner Bohemia. Here were to be found the artists, the rebels, the Expressionist painters and poets like Franz Marc and August Macke, both of whom were to be killed during the war; and others like Emil Nolde, whose vulgar lava swirls of violent color expressed the artist's equally vulgar anti-Semitism and subsequent enrollment in the Nazi party. To his shock, the brown-shirted Kultur gauleiters found Nolde's grimacing whores as unacceptable as the Red commissars were to find Chagall's flying droshkies.

After the German defeat and the founding of the Weimar Republic, Berlin was to become the *totentanz* city that fell swooning into the embrace of the Nazis. That final frantic fling was already under way when Marc arrived. And although he didn't like the city, he could not deny that Berlin was very much au courant, especially in the arts. The two most important groups were *Die Brücke* (The Bridge) and Herwarth Walden's *Der Sturm* (The Storm), the orthodox organ of Expressionism, run by the frantic psalmist Else Lasker-Schuler (who also called herself Tino of Bagdad and the Prince of Thebes). She was the jealous platonic friend of Franz Marc, the painter of "animal destinies," and her astral body was always in Palestine—"the mentally remotest land on earth"—where she ultimately died in exile.

> *Es pocht eine Sehnsucht an die Welt*
> *An der wir sterben müssen.*

A nostalgia knocks outside the world
Which will be the death of us.

Walter Mehring, the German poet whose ultimate exile proved to be in Manhattan rather than Palestine, has painted a feverish portrait of the entrepreneur who launched Marc Chagall in Germany:

> In the Cafe Megalomania, there sat enthroned at her side her second temporary prince consort, Herwarth Walden, the regent of Late Expressionism. This wood-sprite with his eternally restless, shifting, bespectacled eyes and his mane of straw-colored hair possessed the powers of a troll to bewitch and to produce treasures. Whatever he accepted and published—alchemistic essays by the gold-seeker, Strindberg; the satanist novel, *The Hammock,* by the Dane Aage von Kohl; a farce on the carnival of death which was the Russo-Japanese War; the painter Kokoshka's one-act satyr play, *Murderers, the Hope of Women;* whatever he exhibited—Kandinsky's *White Form;* Chagall's *Moi et le Village;* Marc's *Tower of the Blue Horses;* whatever he touched seemed to acquire immortality from the contact with his spidery, heavily beringed fingers.

A prodigal son of banker parents, Walden had peddled his *Sturm* on street corners in Berlin, Zurich, and Paris. The group of painters and poets who gathered around him were completely under his spell. He had them convinced that they were living in the Year One of the new millennium of art. The wrath and the ridicule of public and critics meant nothing to them compared to the curses Walden hurled at anyone who deviated by an iota or a brush stroke from his own aesthetic gospel.

Thus, having become the absolute monarch of the "Sturm Art Salon," Walden threw opulent banquets to which he invited art-loving officials of the state, general staff officers, and police censors, initiating them into the technique of the most advanced painting and linguistic alchemy. The banquets paid off: during the war, when even the arts were put to military uses, his important connections certified to his indispensability on the home front. In tune with the times, he added a patriotic eleventh commandment to his abstract laws of art: "Let everyone be a Prussian after his fashion—after his fashion—but

let him be one! For in earthly things the Prussians are artists."

Haughty to the last, he was expelled from his country by a dictatorship of dilettantes. By now gray and wretched, he sought refuge in Soviet Russia. There he continued to proclaim his Expressionism as "the highest ideal of the world proletariat."

But that was carrying folly too far. He was charged with "dissemination of counterrevolutionary, antipopular, formalistic false doctrines and incorrigible hermetism," and was liquidated.

To this "Regent" of Late Expressionism, then at the height of his influence, Marc had been recommended not only by Apollinaire but also by the German poet Ludwig Rubiner and his wife Frieda, who had become very close friends in Paris. Furthermore Walden, enraptured by what he had seen of Marc's work in Paris, had invited him to show in the First German Autumn Salon of 1913. To that show Marc sent three canvases: *To Russia, Asses and Others, Dedicated to My Fiancée* (the retitled *The Ass and the Woman*), and *Dedicated to Christ* (later renamed *Golgotha*). Guillaume Apollinaire, Bella, and Jesus Christ make an odd trio to have been chosen for "Dedications."

The great passion picture *(Golgotha)* was bought by the German collector Bernhardt Kohler and is now in the Museum of Modern Art in New York, where it has been renamed again: *Calvary*. This is Chagall's first major work dealing with the theme of Christ on the Cross, and, since it is dated 1913, indicates that long before the passion of the Jews under Hitler—and certainly long before his alliance with a "Christian" girl—Chagall was involved with this theme. After 1933 there can be little doubt that Christ crucified symbolizes Christ's own people crucified. The physiognomy of the tragic figure, the tallith and phylacteries he wears, the surrounding "angels," who are often Jews hugging the Torah, the burning synagogues, the Brownshirts, the menorah under the Cross—all this explicitly spells out, without a trace of doubt, the artist's intent.

But *Golgotha* is not an image of horror like the crucifixions painted during the rise of Hitlerism or after the Holocaust. This, rather, is a huge Russian icon, a splintered kaleidoscope of gay colors drenched strangely here and there with just the vaguest hint of the ominous.

Under the Cross an enormous bearded Jew (Joseph of Arimathea?) and a Mary are richly attired in Oriental finery. To the right a Scheherezade-like figure bears a bent ladder; in the upper right in an

interplanetary green space a circle with a V cut out of it like a chromatic pie or a huge closing mouth. The boat with its sail like a blue angel's wing suggests the Lake of Galilee.

But the picture lacks terror. This is the Crucifixion not as Calvary but as a Russian ballet staged by Diaghilev and Bakst. Christ's loincloth is radiant with flower-pulsating colors. On both sides of the Lake of Galilee futurist vegetation is growing. As in most Chagall, here too we find the clawlike missing-fingered hands. Thus if the Poet has one finger too many, the Joseph has one finger too few. Dream anatomy has its own laws of compensation.

Even in this early work the Cubist linear treatment acts as a binder cast over a chromatic explosion and, with its net of splintered pulsing color and connecting ligaments of irregular line slanting slashing looping, suggests the brilliant stained glass Chagall was to create fifty years later.

The odd scale relationships—especially the gigantic emaciated Joseph (or is it a John?) and the smaller Mary and the baby Christ—may have been germinated in Russian icons. Meyer interprets the scale difference thus: "The tall sorrowful figure of John reaches up into the mystery zone whereas Mary, being a woman, is forced to stay at the foot of the cross." Is that why Chagall has depicted Mary like a smug Russian nouveau riche, a bourgeois Maria? And as for the mysterious figure on the Cross, Chagall "explains" with deflective cabala: "In the exact sense there was no cross but a blue child in the air. . . ."

Certainly the theme of the Christ had seized his imagination long before the martyrdom of his people made almost imperative the recourse to that symbol. Chagall does not consider himself imprisoned within any creed, and he has taken his motifs wherever and whenever they set his imagination in motion. "I am," he is quoted as saying, "something of a Christian—in the fashion of Saint Francis of Assisi. I have an unconditional love for other beings. I give love and I demand love, like a child."

Naïveté, so self-consciously proclaimed, contradicts itself, and lays itself open to suspicions of calculation. This perhaps, aside from parochial zeal, may explain why Chagall has been attacked by pious Jews for his "Christian" stained glass in Christian cathedrals.

The sale of *Golgotha*—the first important work Chagall sold outside Russia—was either a sign of unusual prescience on the part of the

buyer, or a mistaken allocation of Chagall within the ranks of the Expressionists, then all the rage in Berlin, and whose chief spokesman was Walden, as Apollinaire was the spokesman for the Cubists.

Marc knew deep within himself that he was no more an Expressionist than a Cubist. The convulsive quirkiness, epileptic jerks, knife-slashed geometrism, blood-pour color of their violence, despair, *angst* had nothing to do with Marc's enchanted world. For Marc Chagall, even so Grünewaldian-hideous an event as the Crucifixion could be transformed into a cabalistic fairy tale. In Chagall's world there was joy. Perhaps this is why many Germans who came to the gallery didn't believe that Marc Chagall really existed. He was a mythical figure! To the German on the crater rim of war, joy did not exist. Chagall used colors not to intensify emotions but arbitrarily, strictly with reference to the closed universe of the picture he was making, with no reference to outside-the-frame optical or psychological verity.

Compared to the German Expressionists he was a formalist.

Back in Paris, Apollinaire read the laudatory German newspaper notices and echoed them in the *Paris-Journal*. In his review he mentions that "French" painting was represented at the *Der Sturm* show by Léger and Delaunay. Marc Chagall, "a young Russian-Jewish painter," he hailed as ". . . a colorist full of imagination who, although at times influenced by the whimsy of popular Slavic imagery, always transcends it. He is an artist of enormous variety capable of monumental painting, and not encumbered by allegiance to any theory."

Guillaume even managed to put in a plug about where Marc's work might be bought in Paris. Here was a friend indeed! If a letter of thanks was ever posted by Marc Chagall, it never reached the generous poet. Perhaps it was lost in the maelstrom of war that soon broke out. And when Marc finally got back to Paris eight years later, he learned that Apollinaire had died in 1918, two days before the Armistice, of influenza aggravated by the head wound from which he had never fully recovered. Chagall was not even able to attend the ceremony at Père-Lachaise whither Apollinaire's friends, following an ancient custom, brought to the gourmet, silent at last, an offering of fruit and wine, and also a cane.

Part Four
Russia
1914-1922

Chagall was not the only Russian artist to return to his homeland in 1914. That same year there also returned Wassily Kandinsky, who had gone to Munich as far back as 1884 and successively worked in Berlin and Dresden. Many returned from Paris at the outbreak of war. El Lissitsky quit his architectural school at Darmstadt and came home. Nor was Kandinsky the only Russian member of the Blaue Reiter group to leave Munich. The war became the occasion for an "in-gathering" of Russians. Antoine Pevsner, who had lived in Paris from 1911 to 1915, joined his brother Gabo in Oslo. Both returned to Russia in 1923, just about the time Chagall was leaving for the second (and last) time. Kandinsky had departed again for Berlin two years earlier. At the outbreak of World War I other foreigners of the School of Paris remained: some like Louis Marcoussis, Michel Kikoine, Moise Kisling displayed their gratitude to France by volunteering; as had Apollinaire, who was to suffer a head wound, Cendrars, who was to lose an arm. Canudo joined the Foreign Legion, asking only that he be sent to serve near the Italian frontier where he could hear the bells of his homeland. Modigliani had also attempted to join up, and when he was rejected because of

his poor health, turned bitterly anti-war, surely an odd motivation for pacifism.

In any event Marc Chagall's individual migrations to and from Mother Russia were almost always part of mass migrations. Rarely were these movements motivated by principle or idealism. The 1914-18 War shook everyone loose from his moorings. The most significant returnee, of course, was Vladimir Lenin but that historic event did not take place until 1917 when the famous sealed train chugged into the Finland Station.

He was "home." Or was he? Was this dismal town, this "unhappy town," this "boring town," the Vitebsk he had commemorated in rainbowed images? Perhaps Vitebsk was more desirable the farther away from it he was.

He thought he would remain only for a brief visit. But the outbreak of war cancelled all those plans. He settled down by the window and proceeded to paint "everything that fell under my eye." Within a year he had set down almost sixty "documents" as he calls them. These pictures—usually painted on cardboard or paper because of the impossibility of getting canvas—are surprisingly naturalistic images of his parents, his brother and sisters, his room, his neighbors, old beggars invited in from the street and transposed in Rembrandtian fashion into noble if somewhat grotesque Biblical patriarchs. For twenty kopecks the beggar set down his sack and put on Zachar's prayer shawl which Marc offered him. To Marc the figure uncomfortably posing was so tragic and so old that he had the air of an angel . . . but he dismissed the angel at the end of a half hour because of his uncelestial smell.

The great series of Old Jews, most notably *The Praying Jew* now in the Chicago Art Institute, grew out of this period. With phylacteries bound to arm and head, the model for the Chicago picture was probably a wandering Chassidic rabbi—"You never heard of the preacher of Slouzk?"—and the penetrating eyes and dignified mien are rendered with a profundity and compassion worthy of Rembrandt's rabbis. And how beautifully Chagall plays the black and white of the tallith and tefillin (made to order for Cubism!) against the rich black-gray beard. The jet thongs of the phylactery wind a spiral arabesque against the flesh of the forearm. The little cube on the forehead is a rectilinear contrast against the curving shadow to the left; black plays against white, square against volute—all combines

to form a beautifully harmonious and moving design. Of the few earth-moored Chagall paintings, this is one of the greatest.

*

He had rushed to see Bella as soon as he arrived. Black-haired, sinuous, long-necked, and elegant as Nefertiti, she was more beautiful than he had remembered, more sophisticated. In February, just a few months earlier, she had herself returned to Vitebsk after having completed her studies in history and philosophy at an institute for girls in Moscow where she had written a thesis on Dostoevsky; she had also studied dramatic art under Stanislavski. Marc, who had been somewhat worried by the seemingly detached tone of her last letters, and what seemed on his arrival to be a too-intimate friendship with Victor Meckler, was reassured by the passion with which the girl greeted him. In this blast, Meckler simply shriveled away like a letter thrown in a fire.

It was at this time that Marc rented his studio in the sergeant's house and Bella began her nocturnal bouquet-visits and early morning out-the-window departures. Surely the girl who had posed nude for him four years ago would have had no hesitation in sleeping with him now.

And so, despite the less than enthusiastic approval of the Rosenfelds, he found himself one rainy day under a nuptial canopy where his union with his beloved Bella was properly blessed.

But before that ceremony took place on July 25, 1915, there had been considerable opposition from Bella's family. After all, they owned three jewelry stores where multicolored fires glittered and sparkled from rings, pins, and bracelets. On every side, clocks and alarm clocks rang the hour. Marc sees the social contrast in terms of jewels versus herrings, "delirious" cakes versus "a simple still life à la Chardin," grapes versus onions; most of all, the grumbling opposition of Bella's fanatical grandfather who scratched around the apartment all day searching for Russian books, Russian passports, anything Russian to cast into the stove. Apart from this purgative activity, he did nothing but pray all day, and could not tolerate the thought that both Marc and Bella had attended Russian schools.

Furthermore, Bella's mother was dubious about a young man who

rouged his cheeks. What kind of a son-in-law was that? And a painter? What was a painter? How could he ever hope to earn his living? What would people say?

None of this mattered to the lovers. Bella continued her morning and evening visits, bearing cakes and grilled fish, boiled milk, bouquets, and passion. Marc had but to open his window and the blue air, love, and flowers came in with her.

So they were married. Even Zachar, who would have preferred to sleep, attended the wedding, which Chagall recalls as a subject worthy of Veronese. Frequently in his memoir Chagall likes to assimilate the small events of his family background to the great myths of European art. Thus Zachar was from Masaccio, and Vitebsk out of Giotto. In this way a mythic timeless dimension is decanted out of the *stetl:* Chagall's samovar is bubbling all the time: the alembic of metamorphosis, transformation is always going on: whether he is painting, writing, or simply playacting.

To Marc the wedding was like a severe gathering of sanhedrin.

It was performed by the chief rabbi of Vitebsk, an ancient sage, somewhat shrewd, surrounded by a "pleiade" of humble Jews whose intestines were grumbling in anticipation of the wedding feast. Under the red baldequin Marc squeezed the fine bony hands of his bride and dreamt only of fleeing with her to the country for embraces and laughter.

Soon enough the newlyweds were indeed able to escape to the wooded countryside outside Vitebsk for their honey- and "milk-" moon as Marc puts it: for every morning, cowherds of the Russian army passing in the vicinity illegally sold pailfuls of milk for a few kopecks. By autumn Marc, like so many bridegrooms, had fattened to the point where he could scarcely button his jacket.

Against all this domestic bliss a war was going on. Was Chagall aware of it? One wonders.

Cushioned in Paradise, assiduously painting away, "pursuing a goat who leaped triumphantly onto my canvas," Marc Chagall was naïve enough to think that now he might apply for an exit visa for Paris!

Instead, inexplicably, he found himself in the army! In a trainload of human-beasts jammed in a freight car, even clustered on the roof, headed for the capital. Would he be shipped to the front?—what was he supposed to do there? Stare at fields sky clouds blood human intestines?

Besides, wasn't he too skinny to be a killer? (He had already lost his honeymoon fat.) And weren't his colors—his pink cheeks, his celestial eyes—the wrong colors for a soldier?

Just before his unwelcome enrollment, signs of war had already come to Vitebsk. Cars from the front crowded with muzhiks in wool bonnets. Everywhere the stink of soldiers—herrings tobacco lice. Even the distant booming of cannon. And when one day a wounded German prisoner arrived in Vitebsk, so entirely circumscribed was the artist in his own ego-world that in the midst of a world war he could only wonder whether he might ask that German what had ever happened to Herwarth Walden and the forty canvases and hundred drawings that Marc Chagall had left behind in Berlin?

Irrevocably under arms, Marc applied to be assigned to a camouflage unit. After all, that was a logical place for him: he was an artist, and he had two round pink spots on his cheeks. But armies are seldom logical: he wound up instead as a clerk under Bella's brother, Jacov Rosenfeld, a successful lawyer who had recently been appointed director of the Office of War Economy. The fact that a Jew had been named to so high a post indicates that the Rosenfelds moved in orbits several stratospheres higher than the herring-barrel hoops of Marc's family.

Certainly Marc was totally incompetent in dealing with debits and credits. His sense of causality was not that of a bookkeeper. When he had been shipped to Petrograd in the jammed, profane, stinking cattle car, he had almost been pushed out of the train by his loving fellow soldiers on to the rain drenched swift flying grass. He arrived clinging on to the running board. "I flew, and the train flew with me." In his ego-centered world the priority was always Chagall, the cosmic order began with him. The train flew because *he* flew. Surely this was not a mental set calculated to deal with military economy.

The result was that the war Marc experienced was the war his brother-in-law waged against his fuddle-headed clerk. This cannonade was intensified by Jacov's desire to avoid being charged with partiality for the relative he had managed to get assigned to this bureau. Marc swiftly learned to solve all problems of military economics, and salve Jacov's anger, by simply juggling his bookkeeping: making up suitable figures. Juggling and making up was, after all, his unique talent. Soon he was removed to tasks in which his

supreme lack of clerical competence could not cause harm, such as perusing the newspapers.

So, as the guns boomed on the Western Front and the aimless butchery and incompetence began to eviscerate the Russian armies, Marc Chagall wearing no uniform returned home to his Bella every evening; and although they now lived in an unheated dismal furnished room, he even managed to find time for painting and dining out with friends and collectors. It was during this period that he met and fraternized with the poets Pasternak, Mayakovsky, Blok, and Essenin.

Oddly enough, nowhere in *My Life* in the section dealing with Marc's return to his homeland is there mention of the loving patron who had made his four years in Paris possible. Especially is this omission noticeable among the list of poets, critics, and collectors whom Chagall frequented when he was assigned to the War Bureau office in Petrograd. Maxim Vinaver was in the capital at that very time. Didn't Marc Chagall present himself to his erstwhile Maecenas? The prodigal returned: the ex-*stetl bocher* sophisticated now, speaking a fluent French with the grammatical gaffes and Slavic accent he was never to lose, familiar with the great art world of Paris, facile in the vocabulary of Cubism, Fauvism, all the latest isms? Did he not display himself to Vinaver: here is the product you helped shape?

There is no indication that he did.

For that matter Chagall writes very little about his family on the occasion of his return. He painted them—frequently, intimately, compassionately. A charcoal drawing of his mother, brooding, deeply felt; a tragic-weary portrait of his father; his brother David playing the mandolin; his sister Manya eating barley soup—all these are pervaded with love; nor does their basic realism indicate a return to Rembrandt so much as a catching breath, a touching earth. For lack of canvases most of these are painted on cardboard. He remarks sarcastically about aunts who exclaimed how big he'd grown. His world was obsessively limited to his painting: and Maxim Vinaver apparently was no longer useful in that sector. Perhaps he was too politically involved to concern himself with the career of Marc Chagall—or Chagall with him. During the Kerensky regime Vinaver was to become a justice in the Supreme Court of Cassation. In 1919

he went to Paris, publishing a weekly in Russian and French to combat anti-Semitism. Meanwhile he taught Russian civil law at the Sorbonne. He died in 1926 at the age of sixty, in France.

After moving several times, Bella and Marc finally settled into a smallish flat at 7 Perekupnoy Pereulok where the young couple remained until after the October revolutions.

Emblematic of his entire career is the fact that during this period when he was ostensibly in the army, a period of deprivation and war soon to erupt into the February and October revolutions of 1917, Marc Chagall continued painting, exhibiting, meeting critics and poets who were to serve as the outriders of his fame.

The number of works he showed during this period is truly astonishing. Chagall himself has characterized those convulsive years of war and revolution as ". . . one of the most productive of my life. In 1914 on my return from Paris I found in fact the atmosphere in Russia completely changed, especially in the Jewish circles that I had frequented before coming to France. The collectionists had become much more numerous." Almost immediately upon his return to Vitebsk he had started his campaign: writing to Alexander Benoit (as it turned out, in vain) and pleading that some of his pictures be shown in a *Mir Iskusstva* exhibition. The following March (1915), on the advice of the Jacob Tugendhold who with Abraham Efross was soon to write the first critical work on young Chagall (the first drops of what was to prove a torrent), Marc sent twenty-five of his Vitebsk "documents" to the exhibition "The Year 1915," in Moscow. Efross favorably reviewed the familiar folkish quality of the Chagalls. And in Petrograd, while still officially in military service, he showed sixty-three works in April 1916 in the Dobitchina gallery. In November 1916, there were forty-five Chagall works in the "Jack of Diamonds" avant-garde show in Moscow. The following year the same group included fourteen of his paintings and thirty drawings in a show of "Pictures and Sculptures by Jewish Artists." In November 1917, immediately after the Revolution, he had sixty-nine drawings and four paintings exhibited again at the Dobitchina gallery, whose proprietor he knew. Indeed young Marc Chagall was already well known to some of the leading critics and collectors of Russia—most notably the great collector Ivan Morosov, who acquired his first Chagalls at this time, and the engineer Kagan-Chabchay, who in a

short while purchased thirty, destined to become part of a collection of a new Museum of Jewish Art being planned in Moscow—a project destroyed by the Revolution.

Marc's military "service" was so elastic that he was even able to rent for several months a dacha in the country, where he painted on cardboard another view through the window—but this time looking out on greensward rather than a city court. Against Cubist green foliage Russian birches are treated calligraphically, their white and black bark vaguely suggesting Hebrew lettering. Most amusing and inventive is the placement of two heads—Marc's and Bella's—one atop the other as in a children's drawing squeezed into the lower right side against the frame, surmounted by a strip of mauve-colored cloth embroidered with peasant patterns. On the tipped windowsill—for nothing is level in Chagall's world, everything slides and slips—are four snippets of still life distributed with sophisticated naïveté almost perfectly equidistant from each other. Horizontal across the window-frame, incongruously the center of attraction, a white bedsheet hangs on the clothesline: erotically tangled, purplish with shadow.

So the Marc-Bella idyll—at any rate, the painted idyll—continues unaffected by war (the picture is dated 1915) as it was to be seemingly unaffected by revolution, the rise of Hitlerism, exile in America. In the tumultuous seas of our time these two constitute a self-enclosed bubble, floating with singular felicity.

Another project oddly commissioned while Marc was still technically enlisted in the Russian army was a series of murals for a Jewish secondary school housed in the same edifice as the chief synagogue of Petrograd. The murals were never executed but three sketches remain.

One entitled *Purim,* now in the Philadelphia Museum of Art, is Fauve in its patterned crimson, black, offwhite, sepia, purplish blue. Against these Matissean flat planes figures and houses are imposed as if an immensely talented child had rendered them with the arbitrary scale of the child and of the medieval man: size of figures varying according to their importance: hierarchal rather than optical perspective scale. The signature "Marc" in cursive Hebrew in the upper right of the picture echoes the curved arm and circular design of an adjacent peasant girl.

Playfully inserted into the triangular cut of sky, upper left, are

tiny figures balancing in a most unlikely fashion on the tall factory chimneys. In this instance, certainly, emotional "narrative" elements are subordinate to design.

In the spring of 1916, a baby girl was born and named Ida. Only a few curious paragraphs in *My Life* refer to this event: disagreements with his wife about the Russian habit of swaddling infants; an unnecessarily specific and odiferous account of his sister's baby's toilet habits (the two families shared a flat); Idotchka's refusal to drink sugared water in lieu of the ever more rare milk; Marc's incapacity to tolerate infants' cries; a premonitory dream Chagall describes (like a Rayonist painting) of little Ida bitten by a dog. He apologizes for not having seen the baby till the fourth day: he was expecting a boy!

More curious is the 1910 drawing, clumsy and amateurish, which Chagall selected to head up these paragraphs in the French edition of his memoir (1931). A bearded *male* figure, terribly drawn, lies nude in bed under a canopy ... with a newborn baby alongside him! Behind the canopy an ambiguous figure holds what seems to be a chamber pot.

During these tumultuous years Chagall painted a series of intimate pictures of his baby in a high chair or visiting her grandparents, as well as a number of landscapes around Vitebsk which he painted in company with his old master, Pen.

And since the ultimate themes of birth and death are always linked in Chagall's mind, just a year after Ida's birth he created what is, by his own judgment, one of his strongest works—*The Cemetery Gate*, a Cubist explosion of color and calligraphy, dating from 1917.

Over the architecturally impossible gate, Hebrew letters indite Biblical prophecies of resurrection, as indeed does the violent upward explosion of the picture itself, especially the green cones and pyramids and triangles of the Cubist tree. This is more of an explosion in a shingle factory than Duchamp's celebrated *Nude Descending a Staircase*.

The matching combination of explicit literature and implicit pictorialism is also found in the graphics he was exploring in those years: witty illustrations for the Yiddish writers Peretz and Nister, in which, design is frequently constructed upon the armature of a Hebrew letter. This device becomes a permanent design strategy in Chagall's graphics. Even as late as the *Dead Souls* series of 1924-25

we can see human figures derived not from observed anatomy but from the calligraphy of Hebrew lettering. On this typographical skeleton Chagall fleshes out his characters: stiff and cursive, a choreography of bony and boneless. So in the great *Dead Souls* etchings, how often Chichikov flings his arms and legs in a perfect *aleph!*

Meyer points out that Chagall's art differs from "all Western art" by its different origin: "As a boy he first learned the Hebraic alphabet, then the Cyrillic (used in the Russian language), and last of all the Roman. Accordingly, the graphic structure of his paintings and drawings appears to be influenced most by the first, less by the second, and least of all by the third."

The thesis, though intriguing, would require for its demonstration a quantitative formal analysis that ill befits the Chagallian dream world. Can we computerize a dream?

It is also possible that this intermingling of letters had some connection with the Cabalistic tradition, although I find not a shred of evidence that the anti-intellectual Chagall ever read a word of Cabala, nor is it likely that he "absorbed" these mystical and arcane notions from the stuffed-fish and herring-barrel environment of Tateh, Mamma, Uncle Neutch, and the butcher of Lyozno.

Chagall himself always insists that he is an "Oriental" painter. Certainly, insofar as he inherits the tradition of Russian painting which like so much Russian culture leaps directly from Byzantine to modern without a true Renaissance interval, we can "explain" the anti-Western nature of his images: the absence of horizon, the endless porousness of space, the floating weightlessness of figures and objects, the interweaving of calligraphic text into the image, the all-round reading of the picture, the absence of one-point perspective or the Renaissance geometric box, the non-naturalistic independent colors employed for their symbolic or emotion-rousing effect rather than descriptively, the game of in and out, up and down. Many of these characteristics are found in Chinese scroll ink-paintings, Persian and Indian temperas, and of course Russo-Byzantine mosaics and *fond' oro* icons with their distorted figures, flat planes, gold "thingy-ness" (the Chagallian *"chimie"?*)—magic-making incarnations rather than transcriptions and document.

Much modern art—and not alone Chagall—is a kind of technologi-cal medievalism: His pictures are magic to him: another "in-

gathering" of the Jews. And the image as magic, whether figurative or abstract, the picture wonder-working as a Tsadi; the picture as an icon, altar, meditation device, a phenomenological "bracketing"—all appeal more to the modern temperament than either the rationally planned and constructed Renaissance stage-set picture or Impressionist naturalism. Both such types of realism—encapsulated optics—had run their course by the middle of the nineteenth century. The invention of photography was the deathblow. Every click of the shutter was another nail in the coffin of realistic painting. The seeming revival in our day of the realistic painted image is parodistic: photography is used to paint pictures which look like photographs!

*

So alive (his "real" life) were Chagall's canvases that when the smell of mephitic gas finally wafted even into the military bureau on Lyteiny Prospect 46, where he was (by a stretch of definition) working (actually he had begun to while away the time by writing his memoirs), his pictures took ill. Suddenly they seemed dull, spiritless, sick.

One evening Marc went out alone for a stroll, the street was deserted. He heard distant shooting and when he drew closer to the disturbance, saw a gang of hooligans in military capes, their epaulettes ripped off, their buttons unstitched, roaming the streets, shouting against the war, seizing Jews and hurling them off the bridge into the Neva. He heard shots. Splashes.

Down lampless streets he passed the windows of butcher shops. Within the shops cattle were mooing alongside the hatchets and knives soon to dispatch them. Halted by a band of four or five ruffians, Chagall was challenged: "Are you a Jew?" He hesitated, silent. Inexplicably they let him go.

Cows piteously awaiting slaughter and pogromchiks prowling the streets—in Chagall's world such a juxaposition is not fortuitous but fated. An artist must *compose* even the reality he lives.

Whatever might have been the true sequence of the disorders, Marc had just witnessed preliminary rumblings of 1917. In February occurred the Revolution under the Social Democrat Kerensky; in October, ten tumultuous days managed to shake even Marc Chagall

out of his private world—the Bolshevik Revolution led by V. Lenin—
that bourgeois gentleman with the architectural cranium who eight
years earlier had been drinking bock beer on the Avenue d'Orléans.

Like almost all Jews, the entirely nonpolitical Marc Chagall
welcomed the Russian Revolution. For Jews the new order promised
full citizenship for the first time: the liquidation of the Pale, of the
numerus clausus in universities, the end of the internal passport
system. Some of the leading Bolsheviks were Jews: the brilliant,
acerb Trotsky, Kamenev, and, as I have pointed out, earlier under
the Kerensky regime, Marc's former patron, Maxim Vinaver, had
already achieved a high place as Supreme Court Justice of Cassation.

That juridical and constitutional ghettos could be eliminated by a
stroke of a bayonet or a pen in no way signified a simultaneous
elimination of the psychological ghetto. Centuries-rooted prejudice is
not so easily uprooted.

But for Marc Chagall, as for most Jews, the Revolution—both
February and October—meant the final collapse of a dirty war in
which every Russian defeat would be expiated by a new expulsion or
slaughter of Jews along the Russo-German front. Learning of these
forced expulsions, Marc had the desire to transport these victims into
his pictures, to place them in safety there. Corralled in that world of
his canvases he would be the creator; there he could provide solace to
all his creatures.

In the freezing winter of 1916-17, the Russian soldiers had begun
abandoning the front, abandoning the slaughter, the trenches, the
lice, the wrecked cannon, the arms and legs hanging abstractly on
barbed wire.

Fleeing the front in droves, they took trains by assault, smashed
the windows, and rode back to Mother Russia: famished, furious,
faggots for the revolutionary torch.

And as this army of tattered heroes poured back into Petrograd,
the word Liberty growling in their mouths, Marc like thousands of
others threw down his pen, spilled ink over the litter of bureaucratic
papers on his desk, and forthwith abandoned the Military Bureau. No
more soldier! Now he was enlisted in the Revolution.

His first reaction to the February Revolution was that he was done
once and for all with the passport official. Oh, those damned
documents which as a Jew had plagued him from his very first visit
to the capital!

Learning that the Volunsky regiment had been the first to revolt, Marc like thousands of others began running about the sprawling classic city from one huge square to another: from Znamensky to Lteynay to the Nevsky. Crackling of fusillades, boom of cannon. Shouts of "Long live the Duma! Long live the Provisional Government!"

He saw the artillerymen voting "for the people"; loading their cannon on flatbed trucks, marching, platoon after platoon swearing allegiance to the new order. Then came the officers corps and the sailors.

Jammed in the great throng in front of the Duma, Marc heard the stentorian voice of President Rodzianko: "Let us not forget, my brothers, that the enemy is still at the gates. Swear allegiance with us now."

Marc felt that he was living in a dream. Something new was being born. All birth was mysterious. But yet comprehensible: a baby, a bouquet of flowers. Whereas the squall of politics eluded him. He knew only that the Social Democrat Kerensky now inserted his fingers inside his tunic à la Napoleon and slept in the imperial bed . . . Social Democrats were succeeded by "demi-democrats" and after them by "democrats," by which Chagall probably means Bolsheviks. Meanwhile, General Kornilov was still trying to save Russia, and deserters were attacking the railway network.

In June Marc heard Viktor Chernov's speech at the circus in which he called for a "constituent assembly." And one day on Znamensky Square in front of the great monument to Alexander III, the rumor began to spread that Lenin had arrived. And some asked who that was and others said Lenin from Geneva had arrived from Germany in a sealed train and some cried it wasn't possible and others in a great burst of contrapuntal shouts:

"Long live Lenin! Down with the Provisional Government!"

"Down with Lenin! All power to the Provisional Government!"

In May of 1917, on the second "sealed train" through Germany, there had returned to Russia Anatoly Vasilyevich Lunacharsky, appointed Commissar of Enlightenment when the Bolsheviks took over. Lunacharsky was a Romantic Marxist, more Romantic than Marxist, of whom Lenin is purported to have commented: ". . . I am fond of him. He is an excellent comrade! He has a sort of French

brilliance. His lightmindedness is also French: it comes from his aesthetic inclinations."

Lunacharsky had also spent years in exile in France, Italy (where he stayed with Gorki on the island of Capri), and Switzerland. Marc had met him briefly in Paris; he remembered his intellectual goatee. Now Lunacharsky was to prove instrumental in converting Marc Chagall from a mere painter to a Commissar of Art!

Of course by 1917 Marc Chagall was no longer a "mere" painter. Although he was only thirty and without the assistance of his wife's family could hardly have supported his lovely Bella and his baby Ida, his reputation as one of Russia's leading young avant-garde artists was already quite established. If so shrewd and sensitive a collector as the engineer Kagan-Chabchay had already bought thirty Chagalls, and even the fabled Morosov had purchased his work; and if we consider the arduous exhibiting Chagall had been undertaking almost immediately upon his return three years before, he was well known especially in those circles that were now for a few febrile years to assume the helm of the new revolutionary order.

How illusionary was to prove their romantic equation: revolutionary politics equals revolutionary art: one avant-garde demands another! When they realized the true algebra and the QED began to tighten around their necks, the poet Mayakovsky blew his brains out, and a drove of artists—among them Chagall—fled the new Eden in a scattering of bitterness and disillusion.

But for four years through famine and civil war, intervention and chaos, birth pangs and death pangs, the murderous choreography of White and Red armies, pillage, vandalism, revolts and counter-revolts, the notion prevailed in all the Russian arts—in painting, sculpture, architecture, poetry, theater—that a new society demanded new forms and that formalist experimentation, like new technology, was in no way contradictory to art for the masses, a popular art. That this was supreme self-delusion should have been apparent from the start.

"As against representation of the visible world," writes André Malraux (Marc's future patron for the Paris Opéra ceiling), "artists try to create another world (not only another representation) for their personal use. Talk of a modern art 'of the masses' is mere wishful thinking: the expression of a desire to combine a taste for art with one for human brotherhood. An art acts on the masses only

when it is at the service of *their* absolute and inseparable from it; when it creates Virgins, not just statues."

Nevertheless, from 1917 to 1921, Russian artists lived in a state of intoxication, believing that they were creating Virgins: a new language not only for themselves but for society at large—for the "new masses." That not one sailor off the *Potemkin,* not one *tovarich* peasant out of a thousand would know what in the world their strange constructions, Suprematist white on whites could possibly signify, didn't even enter these enthusiasts' heads. The detested czarist regime had been toppled. A new world was bring built. And this new world was based on maximum utilization of machines. Socialism implied industrialization, "revolution plus electricity equals communism," Lenin announced with gnomic priestliness. The basic imagery of revolutionary artists was—especially in its abstract non-figural wing—based on mathematics, machines, speed. Even before the Revolution the Russian Futurists—like the Italian colleagues they imitated and admired—stressed dynamics, airplanes, speed, cyclists, motors, interlocking gears, the poetry of the machine age. Of course, out of the nihilism on the brink of war, this mechanical romanticism was combined with a crazy kind of indigenous Dada which expressed itself not only in absurd artifacts but outrageous behavior: Mayakovsky in his clown suits, striped in yellow and black; Burliuk with "I am Burliuk" painted on his forehead, and the wooden spoon he wore in his lapel.

Even from the distance of Paris, Marc had participated in some of the more important Russian shows: his great *Death* had lent a somber note to the "Donkey's Tail" exhibition in March 1912. He knew something about the leading prewar Russian movements and personalities: Larionov and Goncharova, who had left the country in 1915 to join Diaghilev; and Malevich, who, upon their departure, had assumed their role as leader of the Modernists—although Malevich swiftly became abstract whereas Larionov and Goncharova never abandoned the figure. Marc was especially familiar with Rayonism and Cubist-Futurism: Russian anticipations of Delaunay's Orphism and Léger's machine-tooled figures.

The Futurists combined scorn of the corrupt monarchy which presided over a backward agrarian society with boundless ecstasy for the machine age that was to succeed it. "The city is replacing nature and her elements. . . . Telephones, airplanes, express trains, elevators

... sidewalks, factory chimneys, massive stone buildings, soot, and smoke—these are the components of beauty in new urban nature."

Chagall of course has never been a poet of industrialization. On the contrary he is, if anything, pre-industrial. No matter how "modern" may be the architectonics of his image-making, the meaning-core of them remains rooted in an Eden without dynamos, a shabby grotesque Eden with outhouses rather than flush toilets. In this adherence to pre-industrial medieval folk imagery, Chagall inevitably became the target of that machine-age mystic, Malevich; as it was also later to reveal Chagall's limited comprehension of modern Zionism and the State of Israel.

So from the start, though he enlisted willingly in the Revolution, he was not only marching to a different drum but in another direction.

Far more hermetically than the iron curtain to come, the artillery barrage on the Eastern Front slammed down a curtain of fire that sealed off Russia from Europe after 1914. Thus unlike prewar Russia, which had been a caravansary of ideas from the West, the country to which Marc Chagall had returned was thrown in upon itself. And of course this cultural isolation was to be, if anything, intensified after the Bolshevik Revolution. Now the only Western items of import were invading armies. This situation of blockade—both material and cultural—lasted at least until 1921 and then only slowly did a certain dialogue with the West resume.

The artists immediately leaped into the fray. Moscow and Petrograd boiled with meetings, manifestos, polemics, performances. In entire cities fluttering with banners, in huge squares, on the sides of railway cars, in theater and cinema, the artists were going to help create the new Soviet man, the new society. Indeed soon brush and scalpel—the traditional arts of easel painting and individual sculpture—were looked upon as *ancien régime:* a collective society called for collective arts—posters in factories, poetry recited to thousands in a public square were more vital than self-expression on a square meter or so of canvas. The arts were turning from garden cultivations of the dubious Ego to directed churnings of the Mass.

Suprematists and Constructivists—the first movement under Malevich dating from before the war, the second headed by Tatlin, postwar—began a struggle for hegemony. Perched like a bureaucratic

saint atop this squabbling was the romantic idealistic Lunacharsky, resolved in his new post as head of Narkompros, Commissar of Enlightenment, to take no sides in the ever more bitter struggle.

"I always received the arguments of opponents with every attention and objectivity. . . . I almost never hold any position with the absolute resolution which is the prerogative of a genuine fanatic."

Only a Lunacharsky would have considered enrolling Chagall—set off from the start with all his Parisian veneer as a Jew, as anti-industrial, as a sort of *stetl* medieval mystic, as a wonder-working clown—into the ranks of the Revolution.

Of those fervid days immediately after the Revolution, Chagall recalls a meeting of actors and painters he attended at the Michailowsky theater. The purpose of the gathering was to found a Ministry of Culture. Suddenly to his astonishment he heard his own name nominated amongst the young artists being considered for Director of Fine Arts.

Yet he needn't have been so surprised. That young Marc Chagall was already well known among the avant-garde artists of Russia was the result of his own tireless productivity of remarkable works and self-advertising. Although there was very little Expressionist painting in Russia, in the sense of the then burgeoning German school, Chagall's work, together with some of the paintings of Larionov and Goncharova, shared an interest in the *Lubok* peasant crafts; some of his imagery was related to that of the Moscow Primitivists, and he had contributed to most of Larionov's exhibitions during the years 1911-14. When he returned to Russia he had established close contact with the school of Jewish graphic artists in Vitebsk as well as in Kiev and Odessa. One of the most vigorous and inventive artists of this group was El Lissitsky; all of these remained representational despite the rising tide of abstraction. Most effectively the Jewish graphic artists began to express folkishness and revolutionary ideas in delightful children's books, among the first typographical experimental works in this genre.

But although he was well enough known to be nominated for the new post, Marc Chagall had characteristically kept aloof from the violent quarrels, polemics, insults that—as was almost traditional in so much of Russian culture—had already broken out amongst the artists and critics.

Thus in December 1915, while Marc was walking down purple

roads with Bella flying like a Macy balloon above his head, an
exhibition entitled "O.IO. The Last Futurist Painting Exhibition"
opened in Petrograd. Organized by the returned émigré Ivan Puni
and his friends, this show was to be the first public showing of
Malevich's Suprematist works. But Tatlin, the Constructivist, vio-
lently objected to abstract art, which he considered to be amateurish
and useless. Whereas to the burly hot-headed Malevich and his
followers, pure nonobjective painting was a spiritual activity which
would free man of bondage to nature and lead to a new vision of the
world:

> Only when the habit of one's consciousness to see in
> paintings bits of nature, madonnas and shameless nudes [how
> Russian!] has disappeared, shall we see a pure painting
> composition.
> I have transformed myself into the nullity of forms and pulled
> myself out of the circle of things, out of the circle-horizon in
> which the artist and forms of nature are locked. . . .

All this spiritual redemption by way of nonobjective art was
nonsense to the Ukrainian Vladimir Tatlin, whose notion of art was
engineering.

Tatlin, who had earned his living on and off as a sailor up to 1915,
had traveled in Turkey, posed as a blind musician in Berlin, and
visited Picasso in 1913, where he had picked up some of the ideas for
his constructions. His father had been a technical engineer and Tatlin
had developed a theory of art that was integrated with the material
world; the artist was a kind of engineer who served society.

Before the show opened, polemics led to blows—not the first time
that this had occurred between tall thin Tatlin and Malevich, fifteen
years older but built like a stevedore and dangerous as a bear. The
compromise finally was to hang the works of the Constructivists in
one room and the Suprematists in the other. In order that there be no
confusion, Tatlin hung a sign over the entrance of the section set off
for him and his followers: EXHIBITION OF PROFESSIONAL PAINTERS.

Had Marc attended this boisterous exhibition he might have been
forewarned of his future relationship with Kasimir Malevich, that
unspiritual proponent of art as Pure Spirit.

* * *

When Marc told Bella that his name had been proposed for Director of Fine Art in the Ministry of Culture (what an honor—Mayakovsky for poetry, Meyerhold for theater) her immediate reply had been: "Let us go back to Vitebsk!"

Protective, maternal not only toward her baby but toward her husband as well, Bella was unalterably opposed to Marc's becoming embroiled in politics. Better than he, she realized where his talents lay, blossoming like an oasis in a desert of ineptitude for practical affairs.

But now all enflamed by the enthusiasm of the meeting, full of revolutionary fervor, Marc pleaded that he assume the post. He too yearned to play his part in the great national revolutionary effort. Bella wept.

So, in November they returned to Vitebsk. "She warned me that becoming involved in artistic politics would result in insults, injuries.

"And that's how it turned out.

"Unfortunately she's always right."

The·"unfortunately" casts an ironic light on Chagall's seeming subservience to Bella. The child-Mamma relationship to his wife (little Marc and Feiga-Ita) seems a public performance.

"When will I learn to obey her?"

What better shield than a skirt behind which to play one's own games?

Back in Vitebsk—". . . my town and tomb"—Marc and Bella lived comfortably in her parents' big house. Vitebsk was still a sleepy provincial town untouched by the Revolution and adequately supplied with food from the surrounding countryside. Marc went back to work and it was during this period, the first winter of the Revolution, that he produced the airborne lovers of *Over the Town* and *Promenade* and the stupendous *Double Portrait with Wineglass,* as well as the strange *Apparition* already described in the visitation of the angel in *My Life.* Flying lovers of course were already anticipated in the *Birthday* of 1915; but the *Double Portrait with Wineglass* with Marc seated on Bella's shoulders, drunk not only with wine but sex, covering one eye of his bride (the necessary blindness) and toasting

marriage as acrobats blessed by an angel—this is an entirely fresh
invention, and surely one of Chagall's greatest works: full of pictorial
brio and remarkably successful in composing a tottering vertical.

But one gathers that Marc Chagall was not entirely closed off,
even in the fine painting that he was then accomplishing, from the
wider world of social revolution. "Russia was all covered with ice,"
he writes, "and Lenin was turning everything topsy-turvy while I
had returned to my pictures." Madame Kchessinsky had departed
and Lenin was holding a discourse on the balcony, the factories had
stopped work, the world was then gathered under the red letters
RSFSR, listening listening.

And he had returned to his pictures.

Horizons were unfurling. Space, the void was unrolling. There
was no more bread. As every morning Marc looked at the black
letters of the bulletins listing the dead, describing the famine, he felt
a choking in his throat. Coup d'état, Lenin Minister of the
Sovnarkom. Lunacharsky, Minister of the Narkompros. The odd
letter combinations multiplied with every day of famine and civil
war. How could one decipher them? Better infiltrate letters without
meaning into one's works. Trotsky, Zinoviev, Iritsky are guarding
the gates of the constituent assembly. The world is being reshaped,
remade, reborn, torn down, built up.

And he was in Vitebsk painting pictures.

To be sure, they were great pictures. He knew they were great
pictures. Among his best.

And yet.

He felt he had to become involved. In something other than his
art.

Despite the fact that in the spring there had appeared the first
monograph on his art: a critical recognition of his place in the
Russian scene. In this work by the two art historians Efross and
Tugendhold, Chagall's *oeuvre,* both the Russian and Paris paintings,
is treated with admiration and sensitivity to the nonlogical irrational
elements in his production. Most penetrating from a biographical
point of view is Efross' description of the thirty-year-old artist:

> Chagall has the pleasant face of a young faun, but when he
> speaks the good-natured gentleness vanishes like a mask and
> then we think, "The corners of Chagall's mouth are like

arrows, too pointed, and his teeth, like those of an animal, too sharp-cutting and the gray-blue softness of his eyes flares up too often in a blaze of rare fire. . . ."

He must still have been addicted to the habit of painting at night as he had done at La Ruche. At least one may surmise this from the letter written in March 1918 to Nadezhda Dobitchina, at whose gallery in Petrograd he had several times shown: "Here I open in the evening and at night like the tobacco flower (which also opens in the dark) I am working, may God help me. . . ."

But painting was not enough. This was one of the few times— perhaps the only time—in his life when painting was not enough. Unaccustomedly shaken out of his ego by the winds of revolution, Marc Chagall came up with a project to found an art school in Vitebsk.

He might have spent his time painting, eating (he loved to eat as he loved to make love), sitting alongside the mill and lazily regarding the bridges, the beggars, the unfortunates, the porters twisted like the letter *lamed,* the little girl hopscotching like a *gimel.*

He might have loitered in front of the bath houses, watched the soldiers emerge and their wives with birch switches in their hands.

He might have roved along the riverbanks from the cemetery, which he had so magnificently painted in company with old Maestro Pen, stooped now and sad. Marc had already set in motion a scheme to honor his old master with a retrospective show in Vitebsk.

He might have attempted to push aside all of those who were shaking the world—his world—the out-of-time, out-of-place world of his levitated Vitebsk—those earthshakers: Vladimir Ilyich Lenin, that burning intellectual Jew Leon Trotsky . . .

But instead of blotting all this out, as had been his wont all his life; instead of living in peace and painting pictures, which is all he had ever aspired to do—Marc now found—despite himself, almost as if his action had been guided by some malevolent trouble-creating spirit, a *tumler,* a shaker-upper—that he had unwittingly drawn up plans for a School of Beaux Arts in Vitebsk, and had sent his program to Lunacharsky.

He, Marc Chagall, simply had to play his part in the general diffusion of enlightenment, if only in his hometown of Vitebsk.

What great happiness, he thought, to enlighten the masses.

What foolishness, thought Bella, rocking the baby.

While waiting word on his proposal, Marc went ahead with his project of organizing a big show of Vitebsk artists. Generously, although his own aesthetics had traveled far from the precepts of his first teacher, he set aside the big exhibition hall for hundreds of Pen's prosaic works, modestly reserving only a small back room for himself.

But insofar as the five pictures there exhibited—*Double Portrait with Wineglass, Promenade, Over the Town, Wedding,* and *The Apparition*—were among his most imaginative creations, to any discerning eye the pupil's five simply obliterated the master's hundred. Some works by another of Pen's pupils, Victor Meckler, were also included in the show.

To his surprise Lunacharsky responded with enthusiasm, and summoned Marc to Moscow to discuss the plans for his new art school. Lunacharsky, all on fire, had already opened a National Conservatory for Music in Vitebsk. His "first concern" as People's Commissar of Education was

> . . . the introduction of the proletariat to the mastery of all human culture. . . . If the leaders of the Russian revolution wished to take another path, they would have to appoint another People's Commissar, who would be able to ride off on a white—sorry, red—horse and liquidate the universities, and silence the unfortunate bourgeois Beethoven, Schubert and Tchaikovsky at all concerts—ordering the musicians to play only one "hymn" (not of course "God save the Tsar" but the "Internationale"), albeit with variations.

But Marc knew nothing of the Commissar's cultural passion, and he had not expected so prompt and sympathetic a response. He recalled his single meeting in Paris with Lunacharsky, who had come to his studio at La Ruche to do an art review for his newspaper, *Vpered,* organ of the anti-Bolshevik wing of the Russian Social Democratic Party. Marc had been struck then by the fawn-mask of his face, his neatly trimmed little goatee, his pince-nez—a typical Russian *intelligent.*

All Marc knew about his visitor then was that he was a Marxist of some sort. Chagall's own knowledge of Marxism, he tells us, was

limited to the fact that "Marx was a Jew and that he had a long white beard" (technically, Marx was born a Protestant—his father had converted—and Doktor Karl's enormous beard was black as jet). Chagall unconsciously has converted Karl Marx into a Prophet of the Old Testament!

One thing he did know: his art would surely not sit well with "Marxism." His timidity—as timidity frequently does—expressed itself in aggressiveness:

> Above all, don't ask me why I paint in blue or green and why one sees a calf in the stomach of the cow, etc. I like my pictures the way they are, and if Marx is so wise, let him come back to life and explain it to you.

It's doubtful that Marc Chagall, little given to direct onslaughts, master of obliquity and the clownish deflection, actually spoke as bluntly and unsubtly as this to Lunacharsky—who, besides, was a subtle cultured man who had never interpreted and was never to interpret the relationship of Marxism to the arts in leather-jacket fashion.

So, in Paris Chagall had shown the future commissar his canvases, flipping them swiftly in review under the smiling gaze of the Marxist journalist, who never uttered a single word, taking notes all the time.

Chagall was sure that Lunacharsky had, like himself, kept a sour memory of this encounter.

Hence he was surprised to receive a letter in August indicating instead a most sympathetic response to his project and summoning him to Moscow to talk further about it. And when he was ushered into the commissar's office in the Kremlin, there was Lunacharsky smiling at him even more warmly than he had smiled in Paris.

On September 12, 1918, Marc Chagall was officially appointed Commissar for Art in Vitebsk. He had in fact been given more authority than he had bargained for. His original plan envisaged only a school. Instead, according to the letter the pink-cheeked poet-painter whose administrative incompetence had been adequately proved in the War Economy office, was now to be in charge of organizing ". . . art schools, museums, exhibitions, lectures on art, and all other artistic ventures within the limits of the city and region of Vitebsk." He was indeed In Charge. To Bella's horror, he plunged

into his new self-assigned tasks with all the conviction of a convert. He was going to illustrate *Das Kapital* with flying cows.

Lunacharsky's appointment of Chagall was quite in line with the enlightened activities of the Commissar of Enlightenment. In his new post Lunacharsky had discovered almost at once that he was supposed to keep a team of unruly horses in the traces. In the arts he was attacked by the Arts Union, violent in defense of the autonomy of art and resentful of the intrusion of the commissar into their affairs; by the Futurists, who objected to his "mysticism" and defense of bourgeois culture; by Proletcultists and hard-boiled activists who considered him soft-hearted and even softer-headed.

He had been readmitted into the Bolshevik Party only shortly before the Revolution, and was never quite forgiven his twelve-year apostasy from the one true Party, his decade abroad, his sympathy with religion ("Revolution is the greatest and most decisive act in the process of 'God-Building' "), his open-mindedness and charity amidst the brutal ax-wielding of various factions in the arts as well as in "practical" politics.

Worst of all, Anatoly Vasilyevich much preferred the company of poets to politicians.

The fact that he had been among those who saw Lenin off at the Zurich Railway Station on April 1, 1917, did bestow upon him a certain orthodoxy. As the Lenin myth grew, of course that fact alone entitled Lunacharsky to a place among the apostles. Subsequently, he recorded his impressions with characteristic eschatological romanticism:

> In leaving, Lenin was composed and happy. When I looked at him, smiling on the platform of the departing train, I felt that he was filled with some such thought: "Finally, finally, that has arrived for which I was born, for which I prepared, for which I prepared the entire party, without which our whole life would be merely preparatory and unfinished."

It was perfectly logical that such a Commissar of Enlightenment should have chosen a Marc Chagall. It was also perfectly logical that both of them—Chagall after two and a half years, Lunacharsky by 1929—were ultimately to be defeated by Neanderthal aesthetics—art as a club.

For Marc Chagall the Revolution was a red dawn. In the full light of Marxist justice there would be no more pogroms, no more "special status." Oh, that "special status"! To be chosen by God seemed to involve being unchosen by everyone else!

That many young Jews joined the Bolsheviks or supported them is not surprising. For the Revolution promised to sweep away not only czarist obscurantism but Jewish obscurantism as well. The new world was to be a world of clean gleaming machines, chrome-bright in a hygienic sun, a world of just remuneration for labor, a singing proletariat—not muddy *stetls* and Talmud Torahs or praying Chassidim or Talmudic disquisition.

The Revolution was the ultimate Haskalah—Enlightenment. Marc felt this. Zachar did not. Nor could he be expected to. What was surprising is that most of the old Jews—the Zachars, grandfather at Lyozno—the non-Revolutionists, Chassids and Mithnageds alike, wonder-working rabbis and pious shoulder-shrugging destinarians, also accepted the Revolution. They accepted it not because it promised to build a glittering future without earlocks or synagogues but because now, in a free Russia, they would be permitted to be good Jews.

"We say *yes* to the Revolution," cries the narrator in Isaac Babel's tale *Gedali,*

> but why must we say *No* to the Sabbath? *Yes!* I shout to the Revolution, *yes yes!* But what does it do? It hides from Gedali and sends out only rifle bullets.
>
> The Revolution, it's wonderful! And then the Revolution comes to me and says: "Let me have your phonograph, Gedali. I must turn it over to the state!" "But I love music, Mrs. Revolution," I say to her. "You don't know what's good for you, Gedali," she says.
>
> But the Pole fired at me, kind Madame, because he was the Counterrevolution. And now you're firing because you're the Revolution.
>
> . . . I want an International of good men and I want every soul registered and receiving a first-category ration. Here, soul—eat, help yourself, get a kick out of life. It's you, Mr. Comrade, who doesn't know what people eat the International with.

They eat it with gunpowder . . .

The Sabbath was here. Gedali, the founder of the unrealiz-
able International, left for the synagogue to pray.

The quirkiness, the unpredictable leaps, the seeming illogic of the
logic, the folkish sophistication—how Chagallian all this is in this little
masterpiece of Isaac Babel, who, like most Jews, had accepted, albeit
with irony, the Revolution and was to die a victim of Stalin's purges
in 1939.

Marc was in the ranks neither of the ardent nor the passive
revolutionists. He was not a Communist: neither card-carrying nor
sympathizer; nor was he a pious Jew. He had welcomed the overturn
of the czarist regime as a spectator. He was about as political as his
box of colors. But like most Russian artists, he equated revolution in
politics with revolution in art. One avant-garde implied another. The
storming of the Winter Palace meant the storming of the academies.

Poor naïfs! Had they never heard that revolutions limp, that one
foot is always shorter than the other? That revolutions do not march
forward in iron geometry. That the ranks are serried not monolithic.
The taste of commissars was likely to be . . . not even reactionary.
Beyond that. Simply non-taste. Art? Suprematism? Inkhuk? Futur-
ism? Rayonism?

But the masses need bread and peace. Tovarich, first things first.

Certainly the Commissar of Commissars, slant-eyed Vladimir
Ilyich Lenin, had no time for art. Music made him uncomfortable, he
told Lunacharsky; and he always found an excuse to absent himself
from the weekly chamber concerts in Lunacharsky's house. These
were of an exceptional quality: sometimes the great basso Chaliapin
sang, or Koussevitzky performed or directed or a Stradivarius quartet
appeared. Lenin was almost always invited and always found a reason
for not appearing. He was too "busy . . ." "Of course it's very
pleasant to listen to music," he once told his Minister of Culture and
Education, "but imagine, it affects my mood. Somehow, I cannot
bear it."

How could he bear it? His life consisted exclusively of war and
politics. Music, art, poetry distracted him from his political tasks.
There is no record that he ever visited the Louvre when he was in
Paris or the National Gallery in London or any other gallery or
museum or exhibition of art in Switzerland or Munich or Berlin or

Moscow or St. Petersburg. He had no time. His taste in literature was for the nineteenth-century classics and he abominated whatever little Futurist poetry and painting he had inadvertently been exposed to.

"We toss reinforced concrete into the sky," wrote Mayakovsky. To which Lenin commented: "Why into the sky? We need reinforced concrete on earth."

So Vladimir Ilyich watched the peregrinations of his Commissar of Enlightenment with Slavic puritanism. "Shame! Shame!" he writes to Lunacharsky on one occasion. "Shame! These people should be hanged!" And why should they be hanged? Because they had neglected to put up *heroic* statues to celebrate the Revolution!

If for the most part Lenin was seemingly tolerant of Lunacharsky's humanism and open-mindedness, it was simply that Vladimir Ilyich had more important priorities on his mind. His approach to art was strictly instrumental. A story, a painting, a statue.—how many people would it affect? How clear was its message? What *was* the message? Any notion of intrinsic self-contained values in a work of art was simply beyond his comprehension. And Mayakovsky's revolutionary yelps, or Malevich's or Kandinsky's mystical formalism, or Chagall's violations of the laws of gravity were equally incomprehensible.

Eventually—and inevitably—Leninist aesthetics was to triumph in the banality of Socialist Realism.

But during the period of "heroic Communism" (when Marc Chagall assumed his task as Commissar of Art in Vitebsk, and even through the NEP, the arts in the Soviet Union were free in that peculiar way the Russians understand freedom: that is, everyone was "free" to cry for his opponent's annihilation, to question everyone's goodwill but one's own, to conduct debate in Manichean terms: the powers of light versus the powers of darkness: total godlike enlightenment on one's part, total diabolic darkness on the other; to vituperate, pronounce anathema, proclaim the Only Truth, condemn the Lie (anything outside of one's own Truth).

*

From September 1918 until May 1920, when Chagall left Vitebsk for good and settled in Moscow, his life was entirely bound up with his school, his museum, his efforts to bring art to the "people." He

was, in short, a dedicated Soviet official and ideologue in his own
very personal interpretation of that term. For more than a year and a
half, dressed in boots, red blouse, leather case tucked under his arm,
he had the "perfect look" of a Soviet official. Only his long hair, and
a few spots of pink which had rubbed off from his paintings onto his
cheeks, betrayed the painter . . .

The miracle is that he managed to paint at all amidst his
bureaucratic rounds—pleading with bigger wigs than himself at
Petrograd or Moscow for money to subsidize his school, money for
paints, supplies, equipment. Attending the Gospisbolkom meetings of
the Vitebsk town council to convince his fellow citizens—Jews and
Gentiles alike—that man lives not by bread alone. "But, Comrade,
what if there is no bread?" this with a provocative soft smile. A
question not easily disposed of. As a matter of fact, Vitebsk was more
fortunate than the rest of famine-stricken Russia: drawing from its
neighboring farms, the food rationing was less strict here than
elsewhere; and it was probably this—certainly a factor—that enabled
the indefatigable Chagall to enroll so formidable a list of teachers,
several of whom came from Petrograd or Moscow. Besides, he
offered a great deal of liberty to his colleagues. The result was that
the faculty of his academy included several leaders of the artistic
avant-garde of Russia. Almost all tendencies were represented there
from Impressionism to Suprematism.

When the school finally got under way, some six months after he
had begun his feverish activity, he had enrolled his first teachers,
including Dobushinsky, who had been his teacher at the Svanseva
school. But eager to avoid any trace of academic painting at his
"revolutionary" school, Chagall had not invited his old master Pen,
whom he "loved like a father." Pen's revenge was to parody a
celebrated canvas of the Swiss Symbolist Arnold Böcklin—who had
painted the *Isle of the Dead.* Pen depicted himself lying on his
deathbed; the features of the Devil lying in wait for his soul to carry
it down to Hell were precisely those of Marc Chagall!

That was only the beginning of what Marc himself terms a
"basket of crabs."

For although in subsequent recruitment, old Pen's bitterness was
somewhat palliated by his appointment to the faculty, others who
responded to Chagall's earnest appeal—"we need Revolutionary
painters! Men from the capital for the province!"—included Ivan
Puni (later in Paris Gallicized to Jean Pougny) and his wife Xenia.

At that time Puni was an ardent follower of Malevich's school of Suprematism, and it was he who induced Chagall to invite the burly Malevich to the school—eventually to prove Chagall's undoing.

His eyes "burning with the administrative flame," surrounded by kids and local artisans whom Chagall had resolved to transform into geniuses in twenty-four hours, fighting with the authorities to get his pupils exempt from military service, running to Petrograd and Moscow on errands of all sorts (in his absence Bella ran the school—and according to the Punis, not to the satisfaction of the faculty), Chagall's didactic and administrative flame proved surprisingly to be quite as hot as his aesthetics. He fought the president of the local Soviet, who purposely fell asleep during Marc's perorations, awakening only to counterpose with complacent mockery: Really, Comrade, which was more important—to repair a bridge or waste moneys for an Academy of Fine Arts? And whenever Marc, backed by Lunacharsky, received his subventions the president of the local Soviet threatened to throw Chagall in jail unless he submitted to his authority.

He was experiencing in germ what was to become the epidemic: the Zdhanov decrees, which established the fixed relationship of Soviet artist to Soviet commissar.

From the start of his administrative career, he had impressed politicians (other than Lunacharsky) as a clown. The pink-cheek makeup must have added to it. But the most spectacular demonstration of Chagallian clownish leftism came about immediately after he had been confirmed in his new post.

All over Russia great festivals were being organized to celebrate the first anniversary of the Russian Revolution. Since the shift from the Julian to the Gregorian calendar (as in the French Revolution, a calendar change lent, as it were, cosmic confirmation to the upheaval) the date was now November 6 instead of October 25. On that date, all over the country: in Kiev, Moscow, Petrograd, huge celebrations were being planned, and when Marc learned of these he was determined that his Vitebsk should not lag behind.

In Petrograd, still capital of the country, Nathan Altman was in charge. Marc heard that Altman had requisitioned the immense square in front of the Winter Palace ("making the streets his brushes and the squares his palette," as the poet Mayakovsky declaimed) and was planning to decorate the central obelisk with huge abstract

Futurist sculptures. Employing twenty thousand meters (*arshins*) of canvas, the buildings all around the square were camouflaged in Cubist and Futurist designs.

Elsewhere, sets in city streets were designed by Tatlin and Meyerhold while symphonies of factory sirens ululated their joy at the first anniversary of Proletaria, the new order, while trains decorated in Agit-prop slogans and posters rolled to all corners of vast Russia to make propaganda for the successful Bolsheviks.

Caught up in this fervor, Chagall resolved that his Vitebsk would not be outdone. From the communal craftshops and academy he had already organized, Marc mobilized all the local artists and artisans, and when this seemed to be insufficient for his grandiose scheme, managed to enlist others who came willingly from the capital if only to eat a decent meal or so while contributing toward a national act of piety. Designs were submitted—some by Chagall himself—to a jury selected in Soviet fashion, and executed in multiples. Among Marc's "revolutionary" designs was that of a tuba player astride a green horse.

When the great day came, Vitebskians awoke to find their peaceful provincial town transformed into a Communist Luna Park. Three hundred and fifty transparent red banners draped the streets, enormous red banners across all the major building facades. All the shops and trolleys had been newly repainted—and not only in crimson. To Marc Chagall purple, yellow, green were equally revolutionary. Red was not the only Marxist color. As in the Florence of 1515 greeting its native son Pope Leo X, in Vitebsk on November 6, 1918 triumphal arches constructed of wood—seven in all—were set up at the main crossways. Near one of them a gigantic banner, possibly by Chagall himself: HAIL LUNACHARSKY! The streets were explosive with marching cheering processions carrying flags and shouting revolutionary slogans: Chagall's bucolic urge proclaimed itself in the abundant stands of greenery while a curtain curtly entitled FORWARD he had designed for the Hermitage Theater was enlarged in another banner. At night there were fireworks, and constructions lighted up with lanterns or torches; several of these were especially set aflame.

Precedents for such a vast street spectacle are frequent in the Italian Renaissance. But "popular art" that grows out of the people, out of their own long-matured traditions is one thing; art that is

brought *to* the people is quite another. We don't know what the Vitebskite response to all this red hoopla may have been; but we can guess. The chance to march and shout and spend a day in the open—even a freezing Russian winter day—under fluttering flags was much more important than the substantive meaning of what one was marching and shouting about.

But to the commissars—budding and budded—and to a great many of the merchants, muzhiks, pious Jews like Zachar, and rich shop-keepers like Bella's family, Marc Chagall's decor must have seemed a prank, unacceptable alike to good bourgeois taste, Hebrew pietism, or Communist solemnity.

Marc thought he was bringing art to the "people." They understood his art, he felt, seeing how they marched along with great strides—*chagall*—under his multicolored beasts blown up with revolution, smiling as they marched, singing the International. Marc was sure they understood him.

But the leaders were somewhat less satisfied.

Why is the cow green and why is that goat flying in the sky? Why?

What has that to do with Marx and Lenin?

Even before the spectacular had taken place, the local *Izvestiya* had published an attack headlined: LET'S NOT MAKE FOOLS OF OURSELVES, dryly figuring out how many shirts or suits of underwear might have been made from the 45,000 feet of material used for the red banners and drapery. In a subsequent article, Marc's airborne livestock were described by a humorless Bolshevik as a "mystical and formalistic bacchanal."

So his troubles began. The local Sovieteers, including a nineteen-year-old military commissar and a strapping youth in charge of public works, could not overturn slender lithesome Chagall simply because he was securely seated astride Lunacharsky's shoulders—a bureaucratic post of importance. At meetings Marc took delight in slapping these peasant officials on the back—or on the behind. They, in turn, hastened to offset Marc's zany Marxism—closer to the Marx brothers than to hirsute Karl—by ordering academic statues of the founding father executed by inept art students to be placed in every public garden until poor Vitebsk pullulated with awful statues of Karl Marx,

frightening even the dour droshky drivers waiting for nonexistent fares.

But it wasn't funny. He was ashamed. His experience at the school to which he found himself giving more and more of his time, even resigning from other administrative duties, nourished growing convictions regarding the relationship between art and revolution.

These notions were to be programmatically expressed in an article by Marc Chagall entiled "Revolution in Art" published in *Revoluzionnoya Iskustvo,* a local journal which came out for a single issue only in the spring of 1919. His school had already officially opened, with Chagall as director, including along with regular instruction, special community studios intended to "transform ordinary houses into museums," and to apply avant-garde art decor to street and store signs, municipal lettering, and decorations of all sorts. There is something pathetic about Chagall's convictions that revolution in art and society ran on parallel tracks.

Indeed, his article was the result of growing head-on attacks by local Bolsheviks as well as traditional academic artists. The squeeze was already beginning.

"The art of today, like that of tomorrow, needs no content," Chagall wrote. "The real proletarian art will succeed with simple wisdom in breaking inwardly and outwardly with all that can only be branded as 'literature.' "

To this day Chagall bridles at the application of the term "literature" to his own work.

> Proletarian art is neither an art for proletarians nor an art by proletarians. . . . It is the art of the *proletarian painter.* In him "creative talent" is combined with proletarian conscience, and he knows full well that both he and his gifts belong to the collectivity. . . .
>
> In contrast to the bourgeois painter, who endeavors to meet the taste of the crowd, the proletarian painter never stops fighting against routine. He draws the crowd along in his wake. . . . The art of two times two equals four which is closest and most accessible to the crowd, is unworthy of our time. Ever since antiquity true art has always been in the minority. But now that is going to change. "Wait for the day of change! Then the new world will awake with us!" . . . etc.

The article is of course specifically an apologia pro vita sua, his art, Chagall's art, as well as an eloquent defense of every and any individual artist. The attack against visual literature is simply the reaffirmation of the form-content symbiosis that every true artist feels: the intuitive conviction that what is painted is precisely that which cannot be said; in Walter Pater's elegant dictum: an aspiration toward the condition of music, shared by all the arts.

So now, plunged in his "basket of crabs," he was being nipped from every quarter. First, Pen had "hated him to death" for having failed to enlist him in the first gathering of faculty. Then along came Ivan Puni and his wife, Xenia Bogoslavskaya. In later years when Puni went to Paris he changed his name as well as his style. The Jean Pougny whose "French" sense of color has been compared with that of Vuillard and Bonnard was in 1919 a severe Suprematist who backed Malevich in the internal power struggle that soon developed. At that time Puni and his wife taught the courses in "propaganda," that is, applied art.

Chagall was naïve enough to think that Suprematists and Constructivists, as well as academics like Pen and Victor Meckler, and various breeds of experimental artists could all be lodged happily together in his ark floating in the revolutionary deluge; actually, he was from the start heading swiftly toward shipwreck.

Although the Suprematists gave him the most trouble—Malevich backed by Puni and El Lissitsky—Chagall felt then, and subsequently, that Constructivists and Suprematists were only two phases of the same movement. As proof of this, he points to the career of El Lissitsky, at first "one of my disciples," then at Chagall's academy one of the most riotous defenders of Malevich's brand of abstraction, and subsequently a co-founder with Tatlin and Pevsner and Gabo of the Constructivist group.

Before the Revolution, Lissitsky had been the leader at St. Petersburg of a movement to revive Jewish art, and many of the graphic illustrations he did at that time strongly reflect Chagallian influence. In fact, one of his youthful works representing a Jewish subject and signed in Hebrew letters was sold in Germany after 1945 as an authentic Chagall.

But by the time he accepted Marc's invitation to teach at Vitebsk,

Lissitsky had evolved into an impassioned champion of that Russian brand of abstraction very analogous to the art of Mondrian and the Dutch Abstract artists of the De Stijl group. The initiative to invite Malevich, who after the 1915-16 exhibition was certainly one of the two most important leaders of revolutionary nonrepresentational art, came either from the Punis or Lissitsky or both.

But there is no question that once the burly polemical Malevich had arrived, the Vitebsk school split in two; there was a violent cleavage amongst the faculty which had been expanded by the late summer of 1919.

The two protagonists—Malevich and Chagall—stood for diametrically opposed philosophies of art, and, one might say, of the human condition. Kazimir Malevich had made his debut in 1900 as an Impressionist, then he had become in turn a Cubist, Fauvist, Rayonist; now he was the Supreme Suprematist. Whatever his plumage he was always aggressive, given to the promulgation of his "spiritual" ideas by brandishing his big fists or roaring like a lion.

To add to the normal in-built jealousy among artists, the internecine struggle took on passionate ideological coloring. Malevich, who had already written a *Manifesto of Suprematism,* was given to utterances as gnomic, ungrammatical, and vague as his painting was "pure," precise, and geometric.

Lissitsky, who had originally been trained as an architect and was now teaching architecture and graphic arts at the school, swiftly shed whatever Jewish folklore was left in his style, and became Malevich's chief proselyte. Eventually he proclaimed that all painting was only a transition to architecture.

This tallied of course with Malevich's ukase:

The principal element of Suprematism in painting, as in architecture, is its liberation from all social or materialist tendencies. Through Suprematism, art comes into its pure and unpolluted form. It has acknowledged the decisive fact of the nonobjective character of sensibility. It is no longer concerned with illustration.

Obviously orthodox Marxists who couldn't tolerate Chagall's frivolities would be equally distressed by a doctrine which purported to

"liberate" art "from all social and materialist tendencies"—that is, from the very tendencies for which the Bolsheviks had made a Revolution!

At any rate, this declaration was plain enough. But what was one to make of such Gertrude Steinian nuggets as the following, where meaning is limited to sonority:

"I have broken the blue shade of color boundaries and come out into white. Behind me comrade pilots swim in the whiteness. I have established the semaphore of Suprematism."

This was in the catalogue Malevich wrote for the Tenth State Exhibition of 1919, to which he sent his famous *White on White* series.

As a rejoinder another famous Abstractionist, Rodchenko, submitted to the same exhibition his *Black on Black* painting with an appended manifesto consisting largely of quotations: "As a basis for my work I put nothing" . . . "Colors drop out, everything is mixed in black" . . . "Murder serves as self-justification of the murderer, for he tries thereby to prove that nothing exists." Although the latter quotation was from Otto Weininger, it suggests the gratuitous crime of Gide's *Counterfeiters* and Dostoevsky's *Crime and Punishment.* Whereas the everythingness of nothingness anticipates Ad Reinhardt by almost half a century.

Actually just before he came to Chagall's school, Malevich, whose peregrinations all over Russia during the first four years of the Soviet regime had made him one of the best known of the avant-garde artists, had, in his one-man show at the end of 1919, programmatically abjured his Suprematist phase. Thus his Vitebsk disciples like Lissitsky, and more mildly, the Punis, were propagating for a faith which the founder himself had already announced as "dead." Indeed not only was Suprematism dead; one of its repeated forms, the cross, had become—as Malevich grandiloquently told Pevsner—his cross: "the death of painting."

From this time onward, at Vitebsk, later under NEP as a professor in the Petrograd Museum of Pictorial Culture, Malevich devoted his efforts toward new pedagogical methods which he disseminated in German published pamphlets dealing with his color and form inter-relation theories—all written in a language which according to Camilla Gray: ". . . is an odd mixture of the illiterate, the patriarch

and the genuine poet, but his highly illogical use of words, often in two or three senses in the same work, makes his writing of dubious value in explaining his ideas."

Thus split into two camps, the faculty meetings were riotous. Aesthetics threatened often to become athletics. The Punis tried to serve to some degree as mediators but their own inclinations leaned toward Malevich, and furthermore they were put off by what they considered Bella's exclusive concern for protecting at all costs and at all times the supremacy of her husband. In this she was a Suprematist! According to Xenia Puni this only added to the sufficient acrimony and jealousy in the Vitebsk school.

At one faculty meeting in the courthouse Chagall made a speech in which he argued that a triangle was as realistic as a chair: why then all this nonsense about art moving into psychic realms? Suprematism was no more psychic than—

And Malevich roaring his reply. And Lissitsky, the erstwhile Chagallian, backing him. And old Pen head in hand wondering what all the *Sturm und Drang* was about. Wasn't the art of painting simply the recording of optics plus feelings? And Victor Meckler sneering at everyone. And the Punis attempting to moderate the immoderate-ables. And Bella, who often came to these meetings, blackhaired, statuesque at the door, watching in Egyptian silence this mad husband of hers—this shy cultivator of dreams—now waving his arms, shouting through the thick wavering curtains of tobacco smoke, this political commissar, Tovarich Marc.

Who was he?

So Marc Chagall found himself squeezed between two monoliths of incomprehension: on the one hand commissars who couldn't understand why cows were green and why troikas of lovers floated over the Dvina; and on the other hand the various formalists like Malevich who found cosmic significance in a white square on a white square but no significance at all—certainly not Suprematist—in pink donkeys and green-faced fiddlers.

In post-NEP Russia, of course, private intellectual traders of the Malevich stamp were to be eliminated as ruthlessly as Chagallian dancers. The gray granite commissar won, hands down. The Cha-

galls (who were lucky or prescient enough) fled to the West before the guillotine fell. The Maleviches remained and (unless they turned commissar) had their heads chopped off. It is interesting to note how many heads fly off the shoulders in Chagall's paintings of those years.

Both trends of course (It is impossible to assign them positions on the Right-Left spectrum: Is formalism more right than canny naïveté?) are equally anti-"revolutionary" (in a political sense), anti-mass.

But swept by youthful fervor for the Revolution, which like most Jews he read as liberation from the Pale, Chagall failed to understand the essentially reactionary implications inevitable in the notion of art as propaganda, art in the service of a cause, the artist as a toolmaker for the political man. It was not Lenin who was standing upside down on the table (as in his subsequent painting *Revolution*), it was Marc Chagall. The knowledge of what the great liberating Revolution was to mean to him as an artist came bitterly, primarily as a result of the internecine warfare with Kasimir Malevich.

Although at the meetings of the local Soviet, Marc might permit himself the temerity of slapping the nineteen-year-old commissar on the backside, thus inducing respect for the arts in Vitebsk—that did not prevent, he says bitterly, the arrest of his mother-in-law together with all the other bourgeois of the town ". . . simply because they were rich."

Now the realities of the Revolution were beginning to be felt even in the hitherto peaceful enclave of Vitebsk. Food rationing tightened. He couldn't "bring art down into the street" when the people in the street were all out scouring around for bread. The hardship of everyday living, together with his woes at the school, harassed Chagall to the point where he even ceased to paint—for so obsessive a worker, the point of absolute zero.

The new state was already torn with civil war. And in his school Marc faced civil war. El Lissitsky's "apostasy" hurt him more than that of any of the others. For Lissitsky had considered himself his most zealous disciple, he had come to the Vitebsk school at Marc's invitation. His shift to Malevich's camp was a blow.

One gathers from the cryptic battlefront reports in *My Life* that a spiral of sex also underlay some of the lofty ideological quarrels. One of the female teachers (Xenia Bogoslavskaya?)

... amused herself flirting with the commissars of the town, willingly accepting their favors. When news of this reached me, I was furious:

"How is such a thing possible?" I feverishly asked.

"But Comrade Chagall, I'm doing this for you . . . to help you . . ."

Another professor was always surrounded by women enchanted by his "suprematist" mysticism. Marc cannot conceal his jealousy. "How he attracted them, I'll never know."

Malevich, indeed, was his arch-rival and not merely with regard to women. When Kasimir Malevich arrived in Vitebsk in 1919 he was already forty years old and had restlessly passed through a variety of art styles from Impressionism through Rayonism through various forms of Futurist-Cubism until the most recent Suprematism, which he had already repudiated. A huge man whose mere physical presence was intimidating, Malevich despite the lack of a formal education had read widely if sporadically, had great personal charm and humor, and when aroused was capable of physical violence. He had exhibited in the most important avant-garde shows from about the turn of the century on: the "Jack of Diamonds" (1910), the "Donkey's Tail" (1912), and various exhibitions of the Golden Fleece group. His works even in the long representationalist phase were always characterized by bold distortions, Cubist splintering and architectonics, and vivid nonrealist color. As if in ominous fore-shadowing of the battle they were to engage in in Vitebsk, Marc and Kasimir had both shown works at the famous "Donkey's Tail" exhibition in 1912. Marc, who was in Paris, had sent instructions to Bella to submit his *Death* to the "Donkey's Tail" exhibition—one of the earliest works that were to make him famous. The painting created something of a scandal with its linear, almost Futurist schematizations, and especially because of the figure of the defunct laid out between candelabra in the street in artificial perspective, as well as clumsy images of peasants and vagabonds, one of whom would seem to be the original ancestor of whole generations of Chagallian (and other) fiddlers on the roof.

That famous show, which brought together such disparate artists as

Chagall, Malevich, Tatlin, and Larionov and Goncharova, revealed goals that a great many of the avant-garde shared: they all wanted to achieve some kind of simplified pictorial language, peasantlike, *lubok,* "primitive," together with cerebral subdivisions and intersections of geometrical forms and elements, all painted in almost "pure" colors— unmodulated, flat.

But Chagall's sharing with any school—whether prewar Russians or Parisian Cubists or Fauves or Berlin Expressionists—was always tentative: a brief sojourn wherein he could absorb ideas which could nourish his own personal vision.

His only true friend was Lunacharsky. And, frequently, as internecine quarrels threatened to wreck the school, or because local thick-necked and thicker-souled commissars would not provide funds for paints, brushes, canvases, Marc would suddenly entrain for Moscow to receive comfort and enlightenment from his friend, the Commissar of Enlightenment. Despite his exalted bureaucratic post, Lunacharsky remained a pure heart.

Unlike most dour red priests, he was a romantic who wanted to share his happiness, his love of art with everyone, to accommodate all trends under his Madonna Misericordia greatcoat and outstretched arms of love. He was one of the most popular Bolshevik orators, speaking to crowds of thousands at factories and barracks and mass meetings. And he was so emotional that when, during the October Revolution, he had heard a report that St. Basil's and the Uspensky Cathedral had been destroyed in Moscow during the fighting, and that the Kremlin was being bombed, Lunacharsky had burst into tears and resigned on the spot. When he had withdrawn his resignation (after learning that the reports were false) Trotsky dryly commented: "Lunacharsky is not a militant politician."

Almost immediately, by December 1917, Lunacharsky was already being attacked because of the Futurists' adherence to Narkompros. An article by Zalevsky in *Izvestiya* on December 29 warns:

> The stronger the new socio-political structure in Russia becomes, the greater will be the number of intellectuals who try to fasten onto the proletariat. An especially abundant stream is expected from the ranks of artists. . . . The futurists, penetrating into the proletarian milieu, could bring the putrid poison of the

decaying bourgeois organism into the healthy spirit of the
proletariat."

Like Chagall himself, Lunacharsky headed up a commissariat
whose art department, IZO, was increasingly under attack by the
Proletkultists, who believed that the art of the working class should
be "beautiful form" reflecting "rich content." To these ardent souls,
government-supported proletarian art should smash both the "old
aesthetic junk" and the avant-garde "futurists." Actually it was a
preliminary division of the struggle between those who conceived of
art as propaganda and those who maintained in one form or other the
notion of the autonomy of art.

Art at the service of the state (or other institutions) is by no means
the invention of Proletkult. Plato, who stipulates in his *Republic* the
types of music that best serve to rouse martial valor, banning other
more emasculating modes; the Council of Trent (1545-63) laying
down "Zdhanov" decrees on acceptable and nonacceptable Christian
imagery; David as High Commissioner of French Revolutionary
painting—throughout history those in power have conceived of art as
instrumental, serving Church, Bourgeoisie, or Revolution. Only
artists themselves truly conceive of art as autonomous; their relation-
ship to patrons has always been a game of wits and subterfuge; and if
they think at all of the "influence" of art on society, it is only via the
more intimate psychological effects it induces in individuals.

So Lunacharsky sat atop a pyramid of quarrels: Futurists attacking
the old *Mir Iskusstva* group and the conservative academic artists;
Proletkultists attacking the Futurists as well as the academics . . .

Lunacharsky apparently sought sincerely to be above all this. He
was a Futurist and he was a Pastist. Victor Shulgin recalls:

The new filled him with ungovernable joy. . . . But . . . another
joy . . . was aroused by great works of art of the past. . . . There
was nothing monolithic in his world view. He was excited by
Levitan and Tatlin, Picasso and the 19th century Itinerants, the
circus and Tchaikovsky.

"But it is art all the time," Anatoly Vasilevich said, looking at
a canvas in whose center was poked a needle with a piece of
material hanging from it.

"Art?"

"Yes, new Art. You have to be able to understand it. I understand it."

Had he lived long enough, Anatoly Vasilevich Lunacharsky undoubtedly would have been able to understand an exhibit at the USA pavilion of the Venice Biennale of 1976 . . . a blank wall with a nail poked in the center of it. The cult of Total Acceptance, Hail to the New No Matter What cozily beds down in a bisexual embrace Russian Revolutionary Art of 1917 and American Capitalist Art of 1976—Dada as Yes yes and Dada as No no.

So Marc Chagall with his Jewish heart so already Gallicized, embedded in a Russian heart.

And the Russian heart whether in peace or war, czarist or revolutionist, is always divided between the iconoclasts and the devout. It is a Manichean soul: between the Light and the Darkness there is only the Void. There are no modulations; only leaps.

Every time Marc went up to Peter's city, soon to be renamed Lenin's City, he realized that the erstwhile window on Europe had been slammed shut. The war had slammed it shut.

From April to July 1919, he participated in the first State Exhibition of Revolutionary Art in the former Winter Palace, in Petrograd. Now, after his French experience, the wide prospects and crisscross rectangular grid of Petrograd made him think always of Cubism. But as in his pictures, the Cubist grid was superimposed on a Russian fantasy—the Western brain on the Eastern heart. So here, Italian neoclassical architecture was incongruously reflected in the Neva, and picturesque little Byzantine chapels, all alight with candles, dotted this "European" city.

The "fantasy" of Petrograd was in the writing of Andrey Biely as in the painting of Chagall. It is not Surrealism because it is not programmatic; nobody *resolved* to open the cellar door and let loose vaginal dragons and phallic serpents. Neither Freud nor Breton fathered this fantasy. Russian "fantasy" was perfectly "normal"—that is, normal to the Russian psyche, to Russian experience.

Where else but in Russia was it possible to link the loss of the Russo-Japanese War with the Jews and the Mongolian invasion . . . not to mention the machinations of the Masons? "Don't you realize," says a reactionary professor in Biely's novel, *Petersburg,* "that the

tracks of the Russian Jews and the emergence of the Boxers in China
are closely connected?"

Walking along the Neva river, Marc saw an enormous red sun,
the buildings of Petrograd dwindling away into ether, amethyst, lace;
the golden glow of the windows; spires transformed into spikes of
ruby, the Italian caryatids aflame, the blood-red palaces that Rastrelli
had built. It was all Chagall: a riot of splendid oriental color. The sky
had become waning lilac, beneath the windows of a yolk-yellow
house a plump lady black as the Queen of Spades was rolling against
the needle wind.

In this city incongruously cerebral, adventitiously cubist, Marc
Chagall deciphered many mysteries.

En route to the Winter Palace, bucking bitter blasts out of the
Baltic, Marc could understand why the hero of Biely's novel—Apollo
son of Apollo—was soothed by squares, pyramids, triangles, paral-
lelepipeds, cubes, trapeziums.

> ". . . did you get my little poem signed *Flaming Soul?*"
> "No, I haven't received it."
> "What do you mean, you haven't received it? Can the police
> be intercepting my letters? Oh! By the way, I just wanted to
> ask you something about the meaning of life . . ."
> "Excuse me, Varvava Evgrafovna. I have no time."

His triumph at the Winter Palace was his only solace amidst all
the administrative troubles at Vitebsk. The First State Exhibition of
Revolutionary Art was truly immense: almost 3,000 works by 359
artists . . . and out of this array Marc Chagall was honored by having
the first two rooms in the Winter Palace allotted to him, where he
exhibited fifteen large paintings and many works in black and white.
The government bought twelve of his paintings. Except for two
works acquired later, these were the last Chagalls purchased by the
Soviet State. Compare this with the fact that between 1918 and
1920, the Soviet government acquired twenty-nine works by Kan-
dinsky and thirty-one by Malevich. Swiftly the Chagallian star sank
as the Red Star rose.

The civil war prompted the shift of the capital to Moscow. So, by
the fall of 1919, Marc began traveling more and more often to

Moscow requesting money and moral support from the Minister of Enlightenment. Surely in these darkening times, enlightenment was more needed than ever! The country was riven with famine; civil war raged on all fronts; a White army under Yudenich was threatening Petrograd; the Soviet State, not yet two years old, seemed on the verge of collapse.

But amidst all this impending doom and notwithstanding his own manifold duties, Lunacharsky always found time to discuss the meaning of life or anything else with the young pink-cheeked art bureaucrat from Vitebsk. Their encounters were informal and warm; Marc always left with a comforting sense of support in high places. Paradoxically, now seated in the Marxist College of Cardinals, Lunacharsky impressed Chagall as less dogmatic than at the time he had come to interview him at La Ruche. Perhaps now that he was enrolled himself in the cultural apparatus—albeit in a lower echelon— Marc Chagall was more disposed to be tolerant of Lunacharsky's Marxism.

At any rate, Lunacharsky attempted always to placate the opposing camps in Vitebsk; to deal even-handedly with all of them.

Undoubtedly Lunacharsky could relate most amicably to Marc Chagall because he too, like the Commissar of Enlightenment himself, really stood outside the main lines of battle. For, not only at Vitebsk but in Petrograd and Moscow as well, the fundamental art struggle of those years was that joined by Suprematists versus Constructivists. The former school, led by Malevich, stressed individualistic art, the personal creative act; the latter, led by Tatlin and Rodchenko, stressed group, collective, anonymous art. The Suprematists, one might say, conceived of art as redemptive, mystic. Meditating black triangles or white trapezoids or floating dice of various colors worked on the soul of man as contemplating an icon does: *this* was the veritable revolutionary act. Whereas the Tatlins conceived of art as engineering, art as tangible intervention into everyday life. Tatlin's most astonishing contribution to Constructivism was his Monument to the Third International.

In 1919, just when Marc's troubles at Vitebsk were reaching their head, the tall rangy ex-sailor Vladimir Tatlin had been commissioned by Lunacharsky's IVO to plan for the erection of a monument in the center of Moscow which was to be a dynamic symbol to the victorious Revolution. Dynamism! that was the central meaning of

this modest construction which was planned to be twice the height of the not-yet-constructed Empire State Building!

An iron spiral framework was to enclose and support an inner segmented body consisting of a glass cylinder, a glass cone and a glass cube—that is to say, the three irreducible geometric forms to which Cézanne had reduced all nature. This tri-segmented body was to be hung on an asymmetrical axis, leaning like the Tower of Pisa. The inner glass Cylinder was to revolve on its axis once a year: here there would be lectures, conferences, and congresses—whirling no doubt with their ambiance. Once a month the Cone would complete a revolution: this was the appropriate site for the Executive. And once a day the Cube, on top of this Eiffel Tower drunk with Revolution and aslant with Futurism, would turn on its own axis as it blared forth news bulletins, proclamations, and manifestos by loud-speaker and radio broadcasts. At night the Motto of the Day would be projected against the clouds, always plentiful in stormy Moscow.

The Tatlin tower sounds like a construction for Stanley Kubrick's *2001;* the nightly mottoes projected in the clouds would be appropriate home movies for Orwell's Big Brother.

Of course Tatlin's monument was as utopian as the New Soviet Man. The monument never got beyond the various models which Tatlin and his assistants built of wood and wire during 1919-20.

But Marc Chagall's former disciple Lissitsky, who had once worked alongside Marc for a series of illustrations of fables, then became an apostle for Malevich; from 1919 on, he drew closer and closer to Tatlin and the Constructivists, perhaps because Lissitsky's original training had been as an architect. Even though Lunacharsky had appointed Tatlin head of the Moscow section of the Department of Fine Arts, he still apparently exercised fascination over Lissitsky now at Vitebsk. A collage by Lissitsky shows Tatlin at work on his monument in a Futurist world of quadrants, black space, and interlocking architectural components.

In the Vitebsk school, Lissitsky was playing a special role as a designer, which drew him ever closer to the Constructivists. Un-doubtedly Malevich resented such influence, and so began working on his series of *Planiti,* architectural projections which had succeeded his Suprematist phase. Thus Lissitsky was enticed momentarily back into the Malevich camp, the most riotous of his followers. Every time Marc thought of Lissitsky's Chagallian youthful works representing Jewish subjects and signed in Hebrew letters, he felt doubly

betrayed. (In 1945 occurred the third betrayal, "most unkindest cut of all": a Lissitsky sold as a Chagall!)

So Marc would come to the Commissar and lament. Chagall's head spun with all these *Planiti* and *Prouns,* morphological studies of material, the nature of technological man, the proper lines and structure indispensable for passage to the productive-architectonic phase, etc. etc.

What in the name of the Unnamable Name did his purple Yiddles with Fiddles have to do with all this?

What was the morphological-technical-theoretical-practical nature of a Bella-Marc-Idotchka trinity soaring in benediction over Vitebsk?

He had yielded to the goadings of Puni and El Lissitsky. Had he never invited Kasimir Malevich to join his faculty at Vitebsk his school would now be ". . . converting ordinary houses into museums and the average citizen into a creator." How pathetically naïve sound some of Chagall's effusions on his school, community studios, municipal museum: "Believe me, the transformed worker nation will joyously scale the peaks of culture and art which some nations have achieved in their own time but we can only dream about."

Instead of guiding happy workers, here he was a harassed Revolutionary director, accused of petty-bourgeois intimism, of continuing to make an art still tied to traditional form and content. That Marc's painted creatures ignored all the traditional rules of space, color, perspective, volume; that they moved as weightless bodies in a completely untraditional universe, in no way convinced cacophonous Kasimir. He hated Marc Chagall—as un Constructivist as could be— as much as he hated those who strove for a paralleling linkage between the productive process and Marxist culture.

His intolerance, his belligerence, his bull-in-the-china-shop tactics became more insufferable every day. Marc found himself entraining more and more often on the foul-smelling cattle cars that rattled their way across the great plains from Vitebsk to golden-domed Moscow.

On one of these trips to Moscow, Marc was driven to such a stage of desperation that he even went to see Maxim Gorki, who had been allied with Lunacharsky during their Capri exile.

As soon as Marc entered Gorki's apartment the atrocious taste of the pictures on the wall should have warned him that no help was to be expected from this quarter!

The famous writer was lying on his bed, spitting sometimes into his handkerchief, sometimes in a spittoon. He was soon to die of

tuberculosis, and Chagall was so appalled at the sight that he forgot what he had come to ask of the ailing Gorki, friend of Lenin, who treated him with respect but usually ignored his appeals for persecuted intellectuals.

The Gorki visit was sheer desperation. Nor could Lunacharsky help. He was himself embroiled, attacked from right and left, and not only in the visual arts. "Soft-hearted Anatoly," as he was called, had become embroiled with everyone—in theater, literature, visual arts— by his attempts to serve as liaison between the intelligentsia and the Soviet government. Gorki, who was later to become Stalin's darling, had at first disapproved of the October Revolution and had held aloof from Narkompros. But then he began to frequently visit Lunacharsky's office in the Winter Palace. In September 1918 after the attack on Lenin's life, Lunacharsky announced that Gorki had decided to cooperate with the Bolsheviks for the establishment of a publishing house. But whereas Gorki always felt that his prime loyalty went to the intelligentsia, Lunacharsky with all the zeal of a late convert to Bolshevism placed his prime responsibility with the government. After Gorki left Russia in the early 1920s relations between the two men became estranged.

Nor was that the Commissar's only trouble. He who had wept at the report of the destruction of the Russian monuments, how was he to react to these verses of the poet Mayakovsky in the journal *Iskusstvo kommony* (to which Marc Chagall also contributed):

> And why
> not attack Pushkin
> and other
> generals of the classics?

Did Anatoly weep also at this literary bombardment of a monument?

He wanted to offer free development to all trends, he was opposed to any "official art," even revolutionary, if it was dictated from above.

Poor Anatoly! "Impartiality" is always a no-man's-land. Mayakovsky's bullets from one line of trenches. Lenin's from another. For the Commissar of Commissars disliked the Cubist-Futurists' monuments that had celebrated the Revolution, considering them "straight-out mockery and distortion." He held Lunacharsky respon-

sible for all sorts of "Infantile Leftist" excesses such as celebrating May Day by painting in bright color (difficult to remove) all the trees in the Aleksandrovsky Gardens outside the Kremlin.

Ever more often, as Marc came to unload his bag of troubles on Lunacharsky's desk, he found the goat-bearded intellectual too busy warding off his own private hornets.

*

Returning from one such trip to Moscow in search of support, bread, paints, money, Marc learned to his horror that Malevich and his friends had fired the rest of the faculty and installed themselves as conquerors. Across the facade of the school building (a seminary had succeeded the ex-banker's mansion) a broad new banner provocatively flapped—SUPREMATIST ACADEMY.

Chagall's account of this palace revolution in his memoir is full of rage and lamentation. He charges that even the students had been dragged into the revolt against his directorship. "May God forgive them!" He also claims that a decree had been voted upon in his absence deciding upon his expulsion within twenty-four hours.

These cries of rage and pain may of course have distorted the gravity and actual sequence of events. But Chagall's grief, disappointment, and sense of betrayal were obviously still burning in him when he set down these pages in Moscow several years later.

Chagall accuses the "revolutionists" of dispersing the pictures he had collected for the Vitebsk museum, of abandoning the school and its pupils to "the hazards of fate."

He wanted to laugh in his grief. He felt that he had nothing to say, either to friends or enemies. They were all masks, broken pots, blockheads.

Asking him to decamp with his family! In twenty-four hours!

Removing his signboard, FREE ACADEMY OF VITEBSK, his posters, everything he had so painfully constructed. His dream of transforming the ordinary houses into museums, the vulgar inhabitants into creators.

Go ahead! Rip down his school. Rip everything down he has so laboriously constructed. He doesn't care. His enemies won't even remain in his memories.

But of course they did—as the pages of *My Life* attest.

And then amidst these Jeremiads and cries of betrayal, there crawls in a paragraph of curious infantilism. "If during several years, neglecting my own work, I have given myself entirely to the needs of my home town, it's not for love of you, but for my city, for my father, for my mother who lie there."

Curiously analogous was Michelangelo's furious letter to a ne'er-do-well younger brother while the Florentine Titan was painting the Sistine vault—"I cannot help but write you another couple of lines to this effect—for twelve years now I have gone about all over Italy, leading a miserable life; I have borne every kind of humiliation, suffered every kind of hardship, worn myself to the bone with every kind of labor, risked my very life in a thousand dangers, *solely to help my family.*"

How frequently artists misconstrue, either willfully or sub-consciously, the true motives of their actions.

Chagall suggests that the rebellion against his authority was led by a strange alliance: the ultra-abstract Malevich supported by the ultra-academic Victor Meckler. In an unfortunate simile he accuses Meckler of detaching himself from Chagall as gauze is detached from a wound. He accuses Victor of having stolen some of Marc's earliest school studies painted at the School of Fine Arts and passing them off as his own. He charges the friend of his youth with having attempted to seduce Bella while Marc was still in Paris.

Like all the others, Meckler was jealous of him. Friendship wasn't possible among artists. He suggests that another artist "no longer poor, even famous" had betrayed him.

Ach, the world is full of friends.

When it snows, he opens his mouth to swallow the flakes.

In rage and frustration, he tendered his resignation at once. Bella was entirely in accord. She had never been happy about the transformation of her Marc into a man of action. But while he had been so involved, she had stood loyally by his side: so loyally indeed as to antagonize Xenia and Ivan Puni, who, although they lived in adjoining apartments in the former seminary that housed the academy, felt a lack of warmth on the part of the Chagalls.

But the majority of the students were on Chagall's side. They urged him to withdraw his resignation, to return to the school. They

called a meeting where a resolution was passed, declaring that they needed Marc's leadership, promising to obey his directives, characterizing him as the "sole moral support of the Academy" without whom the school could not even exist.

Without withdrawing his resignation, however, furious Chagall immediately set off for Moscow in a cattle car, for lack of other rolling stock, to protest at the Ministry. There he was shown a dossier of unfavorable reports that had been sent in by Malevich and his friends, accusing him of being authoritarian, a poor comrade, and the like.

Obviously the "left" critics of Lunacharsky were also disposed to back the Suprematist rebels in Vitebsk; to his disgust, Marc learned that he had already been kicked out before the receipt of his letter of resignation! Amidst these charges and countercharges, a letter arrived from the academy in which all those supporting Chagall begged him to return to his duties.

So by the end of the year 1919 he was back in Vitebsk, triumphant as Malevich and Lissitsky prepared to depart. Did he actually, as one biographer claims, rub his enemies' faces in the dust by choosing this moment to appoint old Pen to teach a course in Realism?

He was not to remain in Vitebsk for long.

Russia was entering its apocalyptic year 1920. Civil war. Famine. That winter the snow seemed never to cease falling. Everything was falling. Who cared amidst deprivation and fear about Suprematists or Realists? Who cared about art? What was art—any brand of art—when there was no bread?

Even Marc found more and more of his vital energies deflected into the struggle for existence. His little family had been installed into two rooms which were part of an apartment occupied by a numerous Polish family. The glances they darted at Marc and Bella were a hail of needles.

"Just wait," said the little Polish children to their playmate, the four-year-old Ida, "Just wait. Soon the Poles will enter Vitebsk and kill your father."

Everyone lived near the barracks, buzzing like an Arab village with flies. Bella and Ida fell ill as a result of this buzzing pestilence. Soldiers marched constantly in front of their windows. Ragamuffins

played in front of the door; and out of pity, little Ida brought them silver forks as gifts! These dirty kids were an advance tricklet of the waves of orphaned children roving about wartorn Russia: thousands of homeless waifs, ravenous as packs of mongrel dogs.

Soon the Chagalls had to change quarters again, taking shelter with an old miser who thought Chagall, as director of the academy, could protect him against the equalitarian appetite of Madame Revolution. One night the dreaded Cheka came to perquisition the house, and Marc, after showing his papers, deflected the soldiers from searching the rich old man. "If you just draw near him, he'll drop dead. Do you want to risk that?"

Soon enough he did. And once again the Chagalls had to search for a place to live. Why did they not move in with Bella's wealthy family?

Because the fine brick house of the Rosenfelds had been wrecked a long while before. Vividly Chagall recalls the horrors of those days.

> One afternoon, seven carriages of the Cheka stopped in front of the sparkling windows and the soldiers began to help themselves to precious stones, gold, silver, watches, three stories full. They even entered into the Rosenfelds' apartment to search for precious objects. They even carried off all the silver which had just been brought into the kitchen from the dining room table. Finally they advanced menacingly toward Bella's mother, pointing their revolvers under her nose: "The keys to the safe or else. . . ."

Marc felt that his in-laws had suddenly grown old. All day they sat mute, arms dangling, eyes staring dead into the distance. They had been stripped of everything. Now Bella's father drank his tea diluted with tears. And that very night the Chekists returned again. Requisition! They ripped up the carpets searching for hidden treasures.

Although Chagall writes compassionately about the tribulations of his in-laws, he tells us very little about the fortunes of his own family during his tenure as commissar in Vitebsk. What devices did ingenious Feiga-Ita use to outwit the devils of war and revolution? How did this time of troubles affect the melancholy workhorse, Zachar? Chagall writes some words for himself alone (which he publishes). He reproves his sisters for not yet having put up the

monuments on the graves of his father, his brother David, his sister Rosine. He recalls that David died in a tubercular sanatorium in the Crimea. As for "my little father" . . . Zachar seemingly spent his last years loading trucks, scarcely earning his living. He was hit by a car, killed instantly. The letter announcing his death was "hidden" from Marc. Of the circumstances of his mother's death, all we are told is that Marc was not present. He feels that he could not have stood it. It would have meant the loss of his "last illusion."

And then he speculates that perhaps it might have been "beneficial" for him to have been forced to look upon the mortuary traits of his parents. The loss of parents intensifies the presence of the wife. Chagall is alone except for her. When he looks at her, he feels she is his "work." More than once she has saved his paintings. He doesn't understand people; he doesn't understand his own pictures.

"Everything you say is right. Direct my hand. Take my brush. . . . May our parents bless the conception of *our* painting. Let black be more black and white be more white. . . ."

His academy was dying, his teachers were fleeing (the Punis had already left because of famine), his museum was as dormant as a morgue: the state was unable to provide him with the pictures he had requested. Amidst all these troubles, Chagall managed as a final gesture of resistance to organize a big exhibition in Vitebsk, wherein participated such *éminences chromatiques* as Wassily Kandinsky, Kasimir Malevich, El Lissitsky, Marc Chagall, and hobbling along, bringing up the academic rear, old Jehuda Pen.

But when at last the camouflage of the long Russian winter had melted, and .Vitebsk's essential muddy drabness was revealed he could no longer fail to see the truth. His commissariat had collapsed. His school was a corpse, his museum an empty box, his family situation appalling. He knew he could not go on.

In May 1920, the Chagalls left Vitebsk for good, to settle in Moscow.

Malevich, who had stubbornly changed his mind about decamping after Chagall's reinstatement as director, now remained in charge of the Vitebsk Academy. He instantly revolutionized its program, renaming it UNOVIS—the College of New Art—and became inebriated with the writing of opuscules even more hermetic than his pictures. The *White on White* series, after all, did make its statement

as much as Kasimir's earlier *Chiropodist in the Bedroom* or his *Englishman in Moscow*. But the outer-space programs which Malevich promulgated during the rest of his presidium in Vitebsk (up until 1922) were written in a style compounded of prophecy, bunk, and science fiction, and since he spent most of his time setting down his pedagogical and aesthetic theories rather than painting, we are forced to judge him from this point on largely by his writings rather than by the few art works he created.

Up until 1922, when he left Vitebsk for Petrograd, Malevich busied himself in compositional schemes that were intended to be realized by "work collectives" together with his students. This art was supposed to function "outside of aesthetic laws" . . . "bringing us back to the objective phenomenicity"—a statement matching in its vagueness Husserl's philosophy of phenomenology. By nature always dissatisfied, Malevich moved over the years toward a mystical geometrism, issuing with all the zeal of a guru pronunciamentos regarding "pure visuality" and a "cosmic world without beginning or end" and "luminous space within which geometric symbols are diagrams of emotions."

As can be well imagined all of the abracadabra of this witch doctor prancing around a nuclear reactor left the men of the party absolutely indifferent.

They weren't even interested after his shift to Petrograd, when Malevich seemed to descend from his spaceships to an appropriation of certain Constructivist ideas (even inviting Tatlin to teach at his Institute of Artistic Culture, called Inkhuk!), now dreaming of the day when the inhabitants of modern industrial cities would live in an astral climate as if suspended in space according to construction plans of his *Planiti*.

But this futuristic mysticism proved no more acceptable than his earlier theories.

In 1927, after a series of conferences and shows at Lotz, Munich, and Berlin, Malevich precipitously returned to Russia without withdrawing the fifty paintings still on exhibit in the Grossen Berliner Kunsthausstelling. At the same time he entrusted his manuscripts to the Von Riessen family with a testamentary disposition that they were to be translated and edited twenty-five years after his death because "if they were published before, there could arise marked opposition in the way in which I defend the art that now (1927) they represent."

A presentiment of not only the arrest he would briefly undergo on his return to Mother Russia but also of the fatal cancer that would inexorably truncate his existence in 1935. He was buried in a coffin painted with Suprematist designs.

So between art as spiritual activity whose revolutionary purpose consisted in changing the soul of man, and art as engineering; between Malevich's astral life and Tatlin's tower, there was really little place for Marc Chagall.

Even during earlier trips to Moscow he had been in contact with friends involved in the Jewish theater, and one of the major motives of his transfer there was to become involved in theater. Before the Revolution he had had some experience with the Jewish theater in Petrograd. The world of theater attracted him. Was he not himself—with his spotlighted cheeks, his sapphire eyes, his fawn-footed way of walking—an actor? Were not his canvases stage sets of the Necessarily Impossible?

Fleetingly he had once entertained the notion that he might even manage somehow to continue to direct his academy at Vitebsk and work for the theaters in Moscow at the same time. But soon he realized that "evidently I could scarcely manage two marriages with a single asshole. . . . I didn't have the chance to paint many pictures while I was directing my Academy."

The marvel is that he managed to paint any at all! For more than a year now, he had expended his energy in smoking out funds from the government, occupying himself with problems of food rationing for his professors and students, sometimes even getting them exempted from military service. Making the rounds of all the art classes in the region under his jurisdiction, he came and went: a Chagallian creature flying in his red shirt. But miraculously he did manage amidst all this bustle to execute several paintings and drawings in which, notwithstanding his war against Malevich's doctrines, signs of enemy infiltration are evident in the marked geometricism of the imagery.

Repeatedly he was summoned to Moscow. How bleak. How grim. And how often, trampling the streets in search of kindling or food, did not images of Paris flicker through his mind. Paris? Where? . . . on the other side of the moon? He remembered only the Pissarro-dotted boulevards, the ample Seine, bosomy Renoirs, chestnut trees on the Boul' Mich'. And his pictures! Oh, the pictures he had left in

the keeping of Blaise. Where was he now? Time and distance performed their customary magic: even La Ruche lost its squalor; recalled in Moscow, the Rotonde was an authentic chalice of the bubbling French spirit.

And Guillaume Apollinaire, whose mouth never stopped: either to eat or to speak, that volcano-belching mouth. And that Italian—who?—oh yes, Canudo . . . yes, Canudo. Where was he?

Where were they? Swallowed up in war, in time, in distance.

Now in this too present Now, he and Bella lived in a single damp room with their Idotchka, flowering astonishingly in this wasteland: carrot hair, pink cheeks (like his), bud mouth, oblivious as only a child can be of the squalor and deprivation surrounding her.

Searching for better lodging, Marc thought that if he were only more audacious he might have been able to use some of the friends he had in high places to get certain privileges. But he stammered.

The room they now occupied reeked with humidity, Idotchka slept in mildew, the covers were damp, the walls ran with damp, his paintings were turning yellow.

With the help of four kind soldiers met in the street, Marc had managed to have carried up to the fifth floor a great heap of unsawn logs he had cajoled out of a wily peasant. If he had left the wood in front of the house it would have been stolen—as everything consumable, burnable, eatable, wearable was liable to be stolen in those birth years of the New Society.

At night, sleeping in that room crisscrossed halfway to the ceiling with a forest of kindling and logs, Marc heard wolves and foxes coursing through the rifled foliage, they were sleeping in the open under a melancholy moon.

In fact he was not entirely wrong. In the morning he found the child's bedcover sprinkled with snow that had fallen through a hole in the roof.

In Moscow it snowed even in May. The spring of 1920 was simply more winter, never-ending winter.

He tramped the streets. He had no money but who needed money in the Socialist Fatherland? There was nothing to buy anyway.

In Marc's fantasy, everything turned to color. Even misery. White frost-glazed streets, raw meat, golden steaming mounds of horse dung. Under the New Economic Policy a special commission was now awarding grants to artists. On the commission sat Kandinsky,

Malevich, Rodchenko—all Abstractionists. So Marc Chagall became a third-class artist.

Nevertheless, with this ignominious ration card he managed by ruse to secure an entire half-carcass of a cow. Helping to drag it up the steps, he thought of his maternal grandfather, the butcher of Lyozno. But now in the great famine of 1920, Marc had no Rosicrucian compunctions about the little cow in heaven. Nor Rembrandtian dreams of painting it. No, this was meat for his wife, his child, himself.

How red it was!

Everything became color. Flesh was transformed into color. His body was a paintbrush, his head a color wheel. He pulled up his wide flappy pants, his yellow smock, gift of capitalist Americans to starving Bolsheviks. He made the rounds. He went to meetings, poetry recitals, he hunted for something to eat besides herrings and kasha. Oh, he loved herrings, but herrings every day! And he loved kasha, but kasha every day! He had not received a letter from Papa for months. Over the Moscow river a herring swung its clock pendulum. Tock.

He trooped the rounds of meetings meetings meetings. Socialism seemed compounded of meetings cigarettes tea famine. He attended a meeting on international politics presided over by Lunacharsky, who was becoming hammered into a proper Bolshevik bureaucrat by blows from right and left. His little beard bristled with condemnation and defense.

He attended theatrical meetings dealing with the problem of theater for the masses, theatrical meetings at which actors raved more histrionically than ever on the stage; and Meyerhold, with his profile of an exiled Roman emperor, unsmilingly surveyed the scene. Now he wore a red scarf around his throat with as much chic as the Prince Albert he had recently worn at the Imperial Theater.

He heard Vladimir Mayakovsky reciting his poetry. Why did he have to fling his arms about like a drunken crane? And why did the booming bass voice have to shout so? When the poet spoke to thousands in the open air, one might understand the need to recite like a piledriver. But here in a hall? Did poetry really need so much noise?

Before the Revolution the Futurist Mayakovsky, with his lurid colored shirts, radish in his buttonhole, algebraic symbols painted on

his cheek, had roved about vast Russia with his gigantic Cossack friend the painter David Burliuk. David and his brother Vladimir were enormous men; for years during their Futurist phase they had carried onto the stage at all their poetry recitals twenty-pound dumbbells as well as bouquets of flowers. Powerful as draymen, they wore frock coats, magnificent silk vests, and a pearl earring, thus spoofing the Symbolists and other aesthetes descended from Oscar Wilde. The Burliuks were occasional poets as Mayakovsky was an occasional artist. Their need then was to scandalize the bourgeoisie. Now, there were no more bourgeois to scandalize but the psychology persisted. Mayakovsky had to create scandal no matter what the object. So he turned his vituperation on the defenseless past:

> I never want
> to read anything.
> Books?
> What are books?

Listening to these Russian poets, their rhetorical shouting and gesturing, Chagall could not but be reminded of the poets he had known intimately in Paris before the war: Cendrars (around what globe was he trotting now?); omnivorous Apollinaire; mincing Max Jacob, that clown in a *yarmulke,* taking communion.

These voices from the past, mouthing poems and *pommes frites,* remembered across barricades of war and revolution, tiny figures on a distant stage, seemed somehow more mellifluous, more subtle than this pack of roaring Russians. No matter how different they may have been one from the other, they wielded various-shaped rapiers, not axes.

Marc loved poetry and if he almost always painted his poems, he had on occasion, like David Burliuk, also written them. In Russia the two arts were always very intimate. In France too. When Marc had come to Paris the celebrated painter-poet alliances were Picasso and Max Jacob, Apollinaire and the Cubists . . .

But the French poets were more likely to serve as spokesmen, outrunners, drumbeaters, liaison men. They were the avant-garde of the avant-garde, spraying fiery words to burn away academic brush, clearing away for the new visual order. Here in Russia the two arts ran more in tandem. Mayakovsky had begun as an artist and still designed agitprop posters. David Burliuk wrote poems. And Male-

vich's and Kandinsky's pronunciamentos were certainly poetic flights into the empyrean rather than systematic formulations.

Of all the Russian poets Marc heard those days, the one he loved most was the peasant boy Sergei Essenin. Marc loved his smile, his strong yellow teeth, the tears in his eyes as he recited, striking his fists not against the table but against his chest, drunk with God not with wine. And if he spat, it was not against the others, but, unlike Mayakovsky, against himself, a true Dostoevskian, he spat into his own face. Essenin had been a naïve farmboy when he came to Petersburg from his native Ryazan. Praised by Alexander Blok, Essenin was soon the literary lion of the capital; but this was a lion not to be domesticated. He could not adjust to city life; and the poems he was now writing were full of nostalgia for the country.

> I am the last poet of the villages
> The plank bridge lifts a plain song
> I stand at a farewell service
> birches swinging leaves like censers. . . .

No wonder Marc loved him. What matter if his poems were imperfect. So was Marc's draughtsmanship. But according to Chagall, after Blok, Essenin's was the only "true cry" in Russia.

Sometimes to Marc's delight, Sergei would nod to him from the platform.

Then, as earlier in Paris—as indeed all his life—Marc preferred the company of poets to that of his own craft. Especially in that misery of Moscow 1920, Chagall knew the bitterness of being once again the outsider. Now he was in the ghetto of art, in the Pale of a no-man's-land between all the entrenched and embattled schools.

At the artists' meetings he found former students, erstwhile friends, ex-colleagues often in the Soviet saddle, from which eminence they looked scornfully down at him. They were professors. Everybody was a professor except Marc Chagall.

Once a leader of the Bubnowy Valet group pointed to a lamppost in Kremlin Square. "That's where you will be hanged some day!" he said, laughing. Chagall didn't see the joke.

The abstractionists, whom Marc considered utterly devoid of talent, shouted: "Death to Easel Painting!" Those who knew the least about the art of painting spoke most disdainfully about it. Figures like Marc's old friend Tugendhold, who had been proselytiz-

ing for Western art and had been one of the first to spread Marc's fame, were now madly in love with agitprop "proletarian" art. One announced the new revelation: henceforth he and his wife were painting only one subject—chairs.

At one meeting at which Marc was furiously defending his "soul," his opponent cried: "Fuck your soul! We need your muscles, not your mind."

To wretchedness of spirit was added wretchedness of body. Day after day he would issue forth to scramble with thousands of other Muscovites for food for his little family: especially milk for the baby. There was that legendary half-cow, all raw meat and bone. Another time a provision of firewood. Another time some starch in water which passed as milk. Another time a sack of wheat. Such was Moscow in 1920. In the Volga they were starving by the millions.

Where could they get butter for his Idotchka? Bella carried some jewels to the Soucharewka Market, hoping to exchange them for some butter. Baguettes for butter. To her horror she was rounded up with others by the militia for "black-marketing" and held in custody for a day.

A kind soul gave the family asylum in his apartment. In the enforced intimacy of socialist brotherhood, they all slept together in the same room: Marc, Bella, Idotchka, the bonne from the Rosenfelds of Vitebsk, and the "kind soul." With the necessary irony—shield against misfortune—Chagall recalls the smoking furnace, the chimney spitting wetness into the bed, the host consoling himself every night against the Soviet freeze with the bourgeois warmth of two girls to whom he had also given "asylum." So smiling crookedly, Marc chews his black Soviet bread until it is "absorbed in my heart."

An odd digestive system. But of course irony transforms anatomy: the black bread of affliction lodges in the heart. And so Chagall manages to survive the rigors of a Revolutionary winter amidst famine, laughing himself into warmth with that eternal Jewish laughter, the laughter of survival. Indeed many of the works, especially the drawings of these most dismal years of his life, are characterized by sardonic humor, goat leaps of fantasy, burlesques bleating and bellowing at once.

By that dismal winter of 1920-21, Marc Chagall knew more than ever how isolated his art was from all prevailing tendencies: those who fundamentally conceived of art, whether academic or Cézannean or various brands of Post-Impressionism, as systems of recording

visual experience; or those like Malevich and Kandinsky for whom art was magic or religion: the art object serving for spiritual regeneration; and those intent upon constructing news-bulletin towers or efficient futurist suits for the New Soviet Man.

No, he was out of all this. And indeed he had been from the start, and was to remain all his life, outside of all currents, schools, tendencies. Even amongst those rebels of 1912 who had thought to swipe a paint-laden "Donkey's Tail" across the fat face of the bourgeoisie, Marc's contribution had stood apart, his *Death* stubbornly affirming its own personality by the folklore of its figures, its odd combination of clumsy, popularesque, naïf, and sophisticated schematizations.

Chagall's relationship to that scandalous show (named after the episode of some French artists who, at the Paris salon, had presented a canvas painted with a brush attached to an ass's tail) was tentative. Indeed his relationship to all programmatic schools of painting was always tentative, one might even say exploitative. He took from every one what he needed, then went his own way. Among Russian circles he had very swiftly revealed himself as an "original." His work was less fashionably scandalous than provocatively popularesque with its figure of the defunct laid out between candelabras in a street with artificial perspective, as well as clumsy images of peasants and vagabonds, one perched with his violin on the roof of a house in the village.

So, even before the Revolution unleashed its own particular hornets, Marc Chagall's relationship to modern Russian painting was already tangential, marginal, peculiar.

He had already drawn attention to himself in several collective shows (in Petersburg in 1910 at the office of the magazine *Apollon,* with students of the school of Léon Bakst in 1911, at a manifestation of the Union of Youth; in 1912 at Moscow in the salon of Bolshaja Dimitrovka), striving to capture all the new voices that were stirring in various European countries.

Marc Chagall, however, very swiftly revealed himself extremely able to incorporate in a vision that was candidly ingenuous, infantile, and fabulous the most disparate formal structuralizations which had flowered from Neo-Impressionism to Cubism, from Expressionism and from Futurism. From the start he had preoccupied himself in achieving a sort of synthesis between Chassidic religiosity, images derived from Jewish cemetery monuments, Haggadah and Migillah

illustrations, peasant embroidery, *Lubok* woodcuts, icons, and folklore "naïf" art. St. Petersburg and Paris swiftly fused these elements with sophistication. When Marc came back to Russia he was entirely his own man, impervious to influences. Not even a Russian Revolution— not even a famine—could shake him loose from his private phantasmagoric chromatism, his fabulous irony.

There are drawings of those years which reveal Chagall's astonishing capacity to laugh amidst his tears. Because of the difficulties of everyday living, his loss of bureaucratic status, his pedagogical defeat at Vitebsk, his meager resources whether for food and lodging or for paint and canvas, much of Chagall's energy those years expressed itself in drawing and sketching out his ideas. Thus in 1919 he draws a full-moon face whose physiognomy spells out in Yiddish lettering: "To those who departed before their time." The cranium of this strange face is a little house away from which a horse and cart are flying diminutively in air. The theme would seem to be death: the treatment mockery.

Another marvelous ink drawing strangely efficient in its economical disposition of black and white, cubistically structured, is entitled *The Yard*, and dates from 1921, the nadir of Chagall's fortunes. The subject is an outhouse slightly aslant. A figure is entering upside down, his trousers already down. The black oval of the seathole awaits him. To the right, farm animals huddle tinily as ants. The major elements are rich velvety black enhanced by filigree touches, stippling, delicate cloud effects, a mumbled Yiddish inscription.

Zanily, the drawing laughs.

It reminds me of a story recounted by Zero Mostel who while attending to his needs in a New Jersey bus stop urinal, noticed the distinctive appearance of the man next to him, attending to the same needs. "You look like Marc Chagall!" Mostel exclaimed in Yiddish. "Ich bin Chagall!" The man smiled. "I am Chagall."

The earthiness of the encounter must have pleased him.

*

Through the critic Abraham Efross, who was serving as assistant to the director Alexis Granovsky, Marc Chagall was invited to join a group of ardent spirits working in the Jewish theater in Moscow.

Chagall was not entirely a newcomer to stage design. Even as a student in St. Petersburg he had been connected with the theater, having designed a set for a small anti-traditional private theater. His set consisted of his *Drunkard* of 1911 gigantically enlarged as a backdrop, and he had also designed the costumes for the actors, whose faces at Marc's instructions were painted green and their hands blue.

Later in Vitebsk he had designed the sets for three Gogol plays although they were never produced. But his theatrical ideas were widely known and praised. For the *Inspector General,* for instance, in order to create an ambience of instability, he erected poles and ladders entirely devoid of structural justification; and had a tiny railway car drawn diagonally across the stage on a crooked track. Another set and costumes which he later submitted to Stanislavski's theater for a production of Synge's *Playboy of the Western World* were rejected as too fantastic. Obviously, the Eastern world wanted no playboys. Judging by the sketch, only a painted backdrop could have solved construction problems of a stage design involving a goat floating behind a vertical ladder or a stick figure suggesting a Christ with one hand cut off, sliding headfirst down an oblique wire like a trapeze artist.

Chagall's notion of stage design was to toss everything: actors, direction, costumes, sets, props, into the crucible of his fantastic imagination. But Russia was already beginning to enter its NEP period, and economic conservatism was matched by a growing commissar-conservatism in the arts. Lenin issued his ukase against infantile leftism, and (not without Marc's pleasure) the Maleviches and Lissitskys who had tortured him found themselves bereft of commissions and in a new Pale of Settlement.

Luckily the freeze did not clamp down overnight. In 1920 and 1921 there was, despite auguries of the conservatism to come, still plenty of space for experimentation. So, when Marc came to Moscow he was swiftly enrolled in the ranks of the Jewish artists working for the Jewish theater. Among all these—Ryback, Nathan Altman, Lissitsky, Rabinovich, Tischler—who like himself became involved with the Jewish National Theater: the Habimah (in Hebrew) and the Kamereny Theater (in Yiddish)—Chagall felt that Issachar Ryback was perhaps the most talented.

The theater itself was installed in very small quarters—ninety seats in all—in a former "bourgeois" townhouse on Bolshoi Tchernishevski,

which had been gutted. Efross conducted Chagall into a shuttered dim room with the gesture of a Pope Julius indicating the Sistine ceiling to Michelangelo, and said: "These walls are yours. Do with them as you will."

"Down with the old-style theater stinking of garlic and sweat. Long live . . .!" thought Marc, enthusiastic. Alas! all the "Long Lives" of those revolutionary years did not live very long.

To work for the theater had long been his dream. In 1911 the critic Tugendhold had written that the objects in Marc's paintings were alive. He had suggested that young Chagall would make an excellent designer of psychological stage decors. He had even recommended him as a possible designer for a production of *The Merry Wives of Windsor.* Tugendhold's observation was perspicacious. Chagall's paintings are frequently puppet stages populated with the Real-Unreal.

With some bitterness he felt that having made his contribution to the Revolution in Vitebsk, introducing art and artists—both friends and enemies—to that provincial town, he was ready for new conquests. So he rejoiced to receive the invitations from Granovsky and Efross, asking him to come to work for the inauguration of the new Jewish theater.

Actually Efross had been the one who had insisted. Chagall's description of Efross is a marvel of laconicism:

> Efross? Infinite legs. Neither burning, nor silent. He lives. Mobile right and left, high and low. Everything sparkles: his spectacles, his goatee.
>
> Here, there, he's everywhere.

This verbal concision matches the white spaces of his graphics.

> Precise notations in a void. Echoings.

Through Efross, Marc met Alexander Granovsky, whom he had heard speak in St. Petersburg. As a faithful disciple of his master, Max Reinhardt, Granovsky had put on mass spectacles which enjoyed a certain vogue in Russia after Reinhardt's *Oedipus* was produced there. Now, Granovsky was intent on producing Jewish shows; he had enlisted the cooperation of the best "Jewish" painters,

writers, scenic designers in the Soviet Union. Before Marc's appearance on the scene the dominant style had been the realism of the Stanislavski theater.

When he had seen these shows, Marc could scarcely dissimulate his displeasure.

The Jewish theater which had originated at Petrograd as a small amateur theater had shifted operations to Moscow in November 1920.

Soon almost all the Jewish artists were enthusiastically involved with Granovsky's theater, including Marc's enemy Lissitsky. And from Petrograd there soon came Nathan Altman, famous now for his recent colossal celebration of the third anniversary of the Bolshevik Revolution. This time, Altman had staged a re-enaction of the storming of the Winter Palace so realistically as to set the Soviet authorities atremble afterward at the possible consequences. For Altman, without bothering to get any official permission, and without informing the commander, had simply borrowed an entire battalion of Red Army men, together with their equipment, enlisted thousands of Petrograders, lighted up the huge square with giant arc lights, and placed fifty identical puppet Kerenskys on a platform performing fifty identical gestures over and over to symbolize the White Army. Then the Red Army (a real live Red Army!) was ordered to drive the White Army puppets from their eminence. This was accomplished without much difficulty and lots of noise, after which the masses of spectators followed the victorious battalion as it surged through the gates of the Czar's palace with roars, whistles, sirens, trumpet blasts, and high-decibel proletarian jubilee.

This combination of medieval morality play and hyper-realism made Altman famous, terrified the Petrograd authorities, and caused the battalion commander almost to lose his neck.

When Marc heard about this incident he recalled his own celebration at Vitebsk two years ago. Now Altman was also at Moscow at Granovksy's theater, and meeting him, Chagall felt more than ever that he had been rejected, he was at the periphery, back in the Pale, Russia had no real place for him.

Perhaps in the theater he might salvage something: bread and the fulfillment of his artistic ambitions. Besides, Bella's former ambitions to become an actress were stirred up by Marc's new theatrical associations. She began again to take acting lessons until a fall during rehearsal immobilized her for months.

The scenic designer Marc Chagall worked as passionately and eccentrically as the painter. He stretched his huge drop-canvases out on the floor. Workers and actors walked over them. And with brush in hand, his face close to the image growing below him, Marc felt that joy he had felt under the bed, that womb comfort, that pleasure of being hidden. Surrounded by workmen bearing tools or planks of wood, amidst a shower of tossed cigarette butts and crusts of bread mixing with his colors, Marc felt close to Mother Earth to whom he could whisper his hopes and his fears, his disappointments and his prayers. He thought of his great-grandfather painting the walls of the synagogue at Mogilev and implored his heavenly intercession: "Oh bestow upon me, my bearded grandfather, one or two drops of Eternal Truth!"

To reinforce himself after one of these emotional binges on the floor, wrestling with his muse, Marc would sometimes ask the theater concierge Effraim to go out and see if he could rustle up some real milk and honest bread.

Invariably Effraim returned with milk that wasn't milk and bread that wasn't bread. Water thickened with starch, it was the same liquid (or worse) that Bella had to urge (unsuccessfully) little Ida to drink.

He ruminated the straw bread. He gurgled the white blood. Or was it piss? or slaked lime?

Or perhaps true milk drawn from a revolutionary cow?

And there, gaping at his sumptuous repast, stood Effraim. This Effraim possessed a melancholy nose, was beggarly poor, and in addition stupid, lazy, and fly-bespecked. He was the only representative of the victorious proletariat in the Jewish theater.

Slack-jawedly he grinned at the frenzied hungry artist on the floor.

"What are you laughing at, imbecile?"

Marc had had enough of workers who didn't work and bread that wasn't bread and milk that wasn't milk.

Chagall soon struck up the most amiable relationship with the director Granovsky. While the theater was being readied there was very little work. Marc often went into Granovsky's narrow little office, which reminded him of the coffins at La Ruche, and found him lounging on a cot littered with sawdust. The manager had a dual

personality: sometimes his words were barbed wire, sometimes plush and scented as the thighs of a ballerina. Sometimes male, sometimes female.

 ˙ He smiled a lot. His smile was Effraim's milk. Not very reassuring.

Especially when Marc made clear almost from the start that he was no more sympathetic to realistic theater than he was to realistic painting. Just as he had subverted French light and color to his own uses, which were not illusionistic reproductions of "real" light and color, so now in the theater he carried chromal autonomy a stage further, employing it instrumentally. Instinctively he distinguished between color in applied arts, especially in theater decor, and color in painting.

> Light in the theatre is not that of nature, and one can permit oneself in scenery contrasts more gaudy than on a canvas, where there are neither movements of actors or dancers, nor projectors to suddenly show a detail spotlighted while all the rest is left in shadow. A canvas demands a harmony of colors and light, a unity which is no longer that of theatre decor where one can permit oneself more contrasts.

But the very things the French had admired in Bakst's sets and costumes for the Ballets Russes—the wild unrestrained color, the irrational verve—were soon to run aground in the land of their birth.

Marc wasn't even sure at first that Granovsky, with his self-convinced manner, somewhat mocking, and schooled in the Stanislavski tradition of realistic theater would take to Chagallian fantasy.

Yet it was precisely Granovsky who asked Chagall to design mural paintings for the auditorium and sets for their first show: three short plays by the great Yiddish writer Sholem Aleichem.

Chagall seized this opportunity to revolutionize the traditional Jewish theater with its naturalistic psychology.

His murals were the biggest paintings he had undertaken till then, and anticipated his later monumental music wheel for the ceiling of the Paris Opéra, the Musée Biblique, the Jerusalem windows—first tidings of the epic Chagall to come. Painted in oil on canvas and attached to all the walls of the auditorium, one canvas alone measuring over twelve by thirty-six feet, Chagall unleashed here all

his fervor in color and free-floating forms fitted to the architecture of the auditorium. In the huge panel entitled *Introduction to the Jewish Theater,* Chagall depicted himself borne in the arms of his friend Efross; Granovsky in particolored tights is an ancestor of thousands of subsequent Chagallian trapeze artists; the famous actor Salomon Mikhoels dancing with Chassidic frenzy appears several times (as in Italian *trecento* frescoes). Other panels depict a Torah scribe, a jester at a wedding, a dancing housewife, and a dreaming poet as predecessors of the modern theater. These works range in style from the almost abstract *Love on the Stage* to cubist-splintered figures, marvelously constructed in overall free designs symbolizing Music, Dance, Literature. *Dance,* especially, reveals memories of Léon Bakst in its curlicued dress-pattern but the combination of grotesquerie, clumsiness, and grace is vintage Chagall. When the theater moved to larger quarters, these murals were shown in the foyer. Today they have been relegated to the stockroom of the Jewish Theater, and are shown only at the demand of foreign visitors provided with the necessary bureaucrat-bending *cachet.*

Unfortunately we can only project the sketches (in the artist's possession) on the mind's screen to imagine their original effect.

Covered on all sides up to the timbered roof by these paintings, the auditorium in the little theater must have pulsed so with color and *joie de vivre* (an ebullience especially astonishing in view of those famine-stricken years) that it was difficult to attend strictly to the goings-on onstage.

But that didn't matter to Chagall. In fact, he had appropriated the stage as he had appropriated everything else.

So infectious was Chagall's enthusiasm, his energy, his innate theatricalism that before long he was actually the director; everything about the show revolved around him, his images, his concepts.

One of the first to fall under Chagall's influence was the actor Mikhoels, who now obeyed Marc's every wish as if Chagall were the director, author, producer, all rolled into one. When the artist suggested that Mikhoels close off one eye to complete his mask, the distinguished thespian immediately responded like a puppet. If Chagall had ordered him to play blind, he would have done it.

Soon the actors, the director, everyone had become Chagall's creatures, hypnotized by the manic light in his sapphire eyes, his devilish energy, his importunings. Topsy-turvy to traditional theater,

he cried, snapping his metaphoric whip at them, a circus manager. Everything must be stood on its head.

He felt that the actors loved him. And that he be loved is an eternal anxiety of Marc Chagall. He wonders always if he is "loved." If he is not "loved," he is in despair. The phrases "He loved me" . . . "I felt I was not loved" . . . "Would they love me?" . . . recur on page after page of his memoir.

The actors loved him. They regaled him with crusts of bread, bowls of thick hot Russian soup for his flesh, and smiles more important for his spirit.

Chagall's magic even enticed Granovsky away from Reinhardt and Stanislavski—his previous theatrical mentors—toward a more vivid, more imaginative world. In Chagall's presence, surrounded by his fantastic sets, the troupe of actors with their noses painted green and their odd clown costumes, personages who had stepped right out of Marc's pictures, even the down-to-earth Granovsky felt rewarmed, transformed, transported to another realm: a Yiddish circus, a Chassidic whirl.

The gaiety emanating from the Kamerny Theater on narrow Tchernitchevsky Street was indeed a *hora* in the horror of Moscow 1920-21.

But soon all of these Chagalleries "ran afoul." Carping critics condemned these representations "in high Jewish colors," these "preposterous" decors treated in right (or infantile left) angles, this violation of good sense, anatomy, and symmetry. Some of the more conservative in the Jewish community considered even Sholem Aleichem's characters as outrageous as Chagall, which indeed they are. Perhaps that is why Chagall had captured their essential meaning in his sets and costumes.

All this pictorial richness, sharply tinted with Jewish folklore and inspired by foreign art, was not understandable to the Jewish public at large. Indeed Chagall was accused of anti-Semitism, of caricaturing basic Jewish traits. Nevertheless Jacques Chapiro, an artist who lived in Russia in the 1920s and subsequently emigrated to Paris where he lived at La Ruche, writes that Chagall's wild theatrical ideas were a great success, "vigorously affirming, as in the Commedia dell' Arte, true principles of scenic art. I was myself at that time in close relationship with the artistic activity of several Muscovite theatre groups, and Chagall's directives played a great role in forming my own expressionist style at that time."

Chapiro recalls the theater foyer with Chagall's mural covering an entire wall. The depiction of Efross (Chapiro says Granovsky) lifting in his arms "a tiny character who was Chagall himself," leads Chapiro to wonder whether "Granovsky is still carrying him, in his arms or in his heart, here at la Ruche? . . . I don't know but I imagine that this fantastic poet, full of ideas, was indeed flying over all of us."

Inasmuch as Jacques Chapiro came to La Ruche in 1925, long after Chagall had left—eleven years later—the "flying over all of us" is obviously intended metaphorically.

But the vibrations of the Vitebskite worked their magic at long range: especially on "Jewish" artists, whether in Moscow or in Paris.

In 1920 Lenin published a 30,000-word pamphlet, *Left-Wing Communism: an Infantile Disorder,* condemning "the puerilities of the leftists." A regular campaign ("organized indignation") against the leftists began. The Futurists were a useless growth on "the artistic community" of Soviet Russia and they were invited to "rebuild themselves."

Marc read all this with a bitter smile on his mouth. So now all those who had scorned him were themselves being scorned. The honeymoon of the leftists—whatever name they took—had lasted only a few years. They had seized the Revolution as their legitimate bride, taken her by force, stormed the Bastille of the Academy, replacing the Imperial Academy of Art by the Free College of Art, renaming the Moscow School of Art, *Vkhutemas*—a composite word standing for "Higher Art Workshops." And after having ejected the academic professors they had ejected the Marc Chagalls as well. For two or three years, the leftists had it all their own way.

But now the Commissar of Commissars said *Nyet: No* to projecting the New World in three-dimensional objects; *No* to Suprematists "standing on the borderline of transition from the physical plane to the astral"; *No* to those whose open declaration that "Dematerialization is the aim of the world" was hardly likely to arouse Lenin's enthusiasm; *No* to the Rayonists, the Analytic Painters, the Subjectless Painters, the Intuitivists, the Neo-Primitivists. *Nyet* to all of them, lumped together in the official mentality as "Futurists." Even those whom Marc called the "Cézanneans," that is, David Sternberg, Robert Falk, and Nathan Altman, who were still at the head of the

National Academy of Beaux Arts at Moscow, no longer dared say anything when the up and coming theoreticians of Socialist Realism condemned their art, which they considered as formalist or bourgeois as Chagall's or any of the other heretics. Little by little everyone began to feel the artistic reaction which would subsequently characterize the Stalinist regime. Even his chief enemies, the Suprematists, could not continue to persecute him in Moscow. After 1920, the Constructivists and Suprematists were also being pushed into the dogmatic doghouse.

And although Marc belonged to none of these groups, and had himself been eased out of his prestigious position in Vitebsk, he realized that soon there would be no place for him in what was clearly coming: that theory and practice of art which was henceforth, especially under Stalin, to dominate the Soviet scene. To the Socialist Realists, Chagall was as much of a Deviationist—and therefore as damned—as Malevich or Tatlin or Lissitsky. If the latter were, in Lenin's terms, infantile leftists, Marc was an infantile rightist. As far as the New Academics were concerned, Marc Chagall, like any other avant-garde artist, exalted form at the expense of content.

And this, indeed, was true, for any true artist "exalts" form until it *becomes* content. Artistic anguish is the struggle to *embody* a concept, not clothe it: incarnation is not illustration.

Whereas the art of the commissar is Madison Avenue in the Kremlin: a sales pitch, red huckstering.

Outside in the streets and squares and vast plains, the three-year-old Soviet Republic was bleeding and starving. Four days after his fiftieth birthday, April 10, 1920, Lenin, already an old tired man, completed his ukase against the infantile lefists, only to commit that same year the infantile leftist gesture of invading Poland under the illusion that Polish peasants and workers would greet the invading Red Army with a fraternal Communist uprising. In February 1921 occurred the revolt at the Kronstadt naval base in the gulf of Finland; the rebel battleships frozen in the ice assaulted by artillery barrages, as camouflaged against the snow, white-sheeted Reds under Trotsky ruthlessly suppressed the revolutionary sailors drowning by the hundreds in the shell-splintered ice. As a result of Kronstadt and the stubborn refusal of the vast majority of the peasantry to cooperate with the regime, the Tenth Party Congress in March 1921 was to revive limited capitalist enterprise not surreptitiously but as a New

Economic Policy, the famous NEP, designed to plug up some of the holes in the sinking ship of state and get it through this storm.

Such was Russia those apocalyptic years. A Petrograd writer, Viktor Shklovsky, writes in his *St. Petersburg in 1920:*

> I burned my furniture, my sculptor's stand, bookshelves and books, books beyond count or computation. If I had owned wooden arms or legs I should have burned them and found myself limbless in the spring. . . . Everyone gathered in the kitchen; in the abandoned rooms stalactites grew . . . the Arctic Circle had become a reality and its line passed through the region of the Nevsky Avenue.

And inside the Chagall-emblazoned walls of the theater in narrow Tchernitchevsky Street a little group of Jews danced and sang with irrational Chassidic joy.

The merest review of Chagall's work during those dreadful years, especially his theater designs, is enough to expose the absurdity of oversimplified sociological aesthetics. The more Russia weeps the more Chagall laughs. Civil war, famine, political repression aroused his most clownish response. But not infrequently, as in the baleful silhouette of the huge bearded peddler flying *Over Vitebsk,* the laughter is a special mode of terror.

The lead actor of the company, Mikhoels, became his chief disciple. Famished like everyone else in Russia then, he would wait upon Chagall's fantastic directives. Mikhoels had great protruding eyes, bulging brow, flying hair, short nose, thick lips. Like all actors his body was his instrument; his thoughts took the form of jerking elbows, tilt of neck, lift of eyebrow. He listened attentively as Marc outlined his latest idea, and immediately gave it bodily form in a *lamed*-thrust of leg, an *aleph*-curve of his supple torso, a nod that was a *yod.*

In this protean presence, taking unforeseeable shapes, Marc felt that his paintings were talking, chuckling, roaring with laughter. Mikhoels loved to contemplate Chagall's paintings, acquaint himself with these bodily positions, touch them, kiss them. He begged Marc to lend him sketches.

And after having studied them for several months he announced

joyously that now he could interpret any role: henceforth he would know how to play upon the actor's instrument: his own body, himself. With this man Chagall felt a warmth of conspiracy. He and the actor understood what had been the source of Mikhoels's revolutionary change in style. But nobody else knew.

They smiled at each other.

The production of the Sholem Aleichem trilogy went ahead with great difficulties. They even lacked material for the costumes and decors. The other actors tried to comprehend what Chagall wanted. Timidly they also studied his paintings. Hanging on ladders they grouped around him and his work, listening as Marc explained, as Mikhoels explained. Even Granovsky listened. Chagall was the director.

Everyone onstage had to become a character in his painting. He wanted to swallow them all up in his canvas. Now the stage was his canvas.

Just before the opening Marc in desperation had to make do with used material; in the pockets of old costumes he found crusts of bread and cigarette butts.

On the eve of the opening Marc couldn't even enter the auditorium, so paint-besmeared was he. Just a few seconds before the rising of the curtain he ran out onstage to touch up some props at the last minute. As they were, he found them unbearably naturalistic: a chair, a hatrack. Unbearable. He ran out onstage and painted them in circus colors. He just couldn't tolerate "realism."

But suddenly there was a collision.

Granovsky had dared to hang up a real feather duster in the kitchen.

At the last minute he had to affirm his status as director.

Of course to Marc Chagall the opening performance was tarnished by some few Granovskian touches of naturalism. But in the main, he was not displeased by what he had wrought.

However, tensions with Granovsky and what was more important, the total absence of any salary, induced Marc Chagall to transfer his theatrical activities to the Habimah Theater. An offer came for him to do the sets for the Ansky play, the *Dybbuk,* an offer which the author himself had made to Chagall several years earlier.

At first Marc was troubled. Both theaters were at war with each

other. Furthermore, he couldn't tolerate the style of Habimah acting. They weren't playing. They were praying. Even more than Granovsky's troupe, the Habimah carried out Stanislavski's ideas. Marc felt that he was even less likely to influence Wachtangoff, director of the Habimah. What was worse, Wachtangoff was at the same time a leading actor in Stanislavski's theater where he also was creating stage sets. Anxious for love, admiration, Chagall admits himself that he could not work well in an atmosphere of doubts, hesitations. At the early rehearsals, listening to Wachtangoff, Marc was certain that the Georgian would find him "incomprehensible," that he would "read in [his] eyes all the chaos and disorder of the Orient, foreign."

Chagall's prickly sense of alienation here is especially curious aroused by a "Georgian" (as "foreign . . . oriental" as Chagall!).

What was the point, he thought, of attempting to convince this man, fix him with a piercing glance, when what he really wanted to do was inject him with a drop of poison.

The Habimah project never went through because of Wachtangoff's opposition to Chagall's notions. All distortions, all deformations were repugnant to this director, deviations from the true line of Stanislavski. Russia was the land of "true lines."

Few, certainly not Chagall either, were prepared to admit that someone else might possibly possess a glimmering, if not the entirety, of a "true line." After a violent quarrel in which Chagall hotly defended stylized anti-realism, he stormed out of the theater.

A year later Chagall claims he learned that Wachtangoff had been attentively studying his murals at Granovsky's theater and instructed his scenic designer to paint "à la Chagall." And that even Granovsky was now mounting productions that outchagalled Chagall.

But these were only the last flares of dying avant-gardism, even of the Chagallian variety. After Lenin's 1920 blast all such gestures were doomed; they were dancing a *hora* on the lip of the grave. Green noses were no more comprehensible to authority than green donkeys.

Already conservative forces were regrouping to form a new academy—Socialist Realism, henceforth to dominate all the Soviet arts. Even more than easel painting, the theater was indispensable as a means of mass education. And since the theater was a setting for the human body, which lives and moves on its stage, a certain degree of realism had always been and always had to be preserved. "It is not possible," wrote one of the orthodox critics, "to alter the figures of

human beings. While every style can be subject to any alteration, to any grotesquerie, there is nothing one can do with the human body. There is nothing left for the innovators but to agree to a compromise. ... Occasionally one sees sketches for leftist stage settings in which costumes are entirely impossible of realization; as, for instance, the head placed somewhere to the side, in back of the shoulders, etc."

The "etc." was menacing.

*

While still working in the theater, Chagall had moved his little family to Malachovska, a small town in the country, not far from Moscow. Nevertheless, every trip involved lining up for hours, struggling to get onto the train, his thin undernourished form in floppy pants and billowing smock shoved and pressed by the workers and peasants. He and Bella had made the move because life was somewhat cheaper there; perhaps they might get milk for their child; besides, Chagall hadn't received a kopeck for the work he did for Granovsky.

On those tortuous train journeys Marc Chagall came to know what it really meant to be part of the masses. Milkmaids stepped all over his feet and pitilessly stuck their iron pails into his back. Peasants redolent with dung and vodka jostled sovietically against him. And whether standing or stretched out on the floor everyone was busily engaged in hunting lice. Crackling pumpkin seeds in their urine-colored teeth they spat a spitty spray into Marc's aesthetic face.

In the evening the little train chugged home under a plume of red smoke. Plaintive Russian songs. Peasants eternally crossing themselves and spitting pumpkin seeds. Then across the dark icy fields to his cottage, fearful of wolves that turned out to be the howling of chained dogs.

Next morning he had to depart before dawn to catch the Moscow train. The only compensation for his painter's eye was the lilac-blue sky of approaching dawn, a wet-on-wet aquarelle diffusing over the vast flat plain the striped emergence of his beloved birches.

Once in the rush to grab seats, Marc saw a peasant hurled under the wheels of a moving freight train, screaming, the violet blood of his fractured leg staining the snow.

Soon he was spared these horrendous train journeys when he was

assigned as a teacher in the Malachovska and Third International colonies for homeless children.

After the Revolution thousands of orphan children roved about the New Soviet Republic: pillaging, begging, reduced to the state of savagery. They had witnessed terrible sights: their parents' throats slit open by knives, the hiss of bullets, the boom of cannon, the crash of shattered windows. They had seen their grandfathers' beards pulled out and watched dumbly as soldiers violated their sisters and their mothers.

Covered with vermin, shivering with cold and hunger, they wandered like packs of wild dogs, hanging onto the trains.

Finally the government began to round up these little savages created by revolution and civil war and placed them in Boys' Towns where it was hoped to restore them to civilization through the most advanced pedagogy. Each of these colonies usually consisted of about fifty orphans.

One such colony had been set up for these unfortunates in the vicinity of Malachovska and Marc was invited by the Narkompros to teach art there. The colony consisted of a group of wooden houses run by the boys themselves. Self-governing, they prepared their own meals, baked their own bread, carted their own firewood. They also had their own Soviet, and Chagall was fascinated as these boys, half-nude in their rags, barefooted, scratching their skulls shaved to zero against fleas, shouted in true Russian political fashion, judged each other and their professors, and sang the *International* gesticulating and smiling.

Only their eyes never smiled.

They loved Marc. He proved a gifted teacher. They clustered around him and cried from every side *Comrade Chagall!*

And he loved them. Enthused by his words and demonstrations "they hurled themselves upon colors like wild beasts on meat."

Art was food for their famished souls.

One of the boys seemed to be in a continuous state of delirium. Delirious with the act of creation. He painted, he composed music, he wrote verses.

Another tranquilly constructed art like an engineer.

Some of them naïvely produced pure abstract art which reminded Marc of medieval stained glass windows in Notre Dame.

They were Constructivists and Suprematists, Rayonists and Impressionists, Fauves and naïfs. They were even Chagallians.

As Marc examined the drawings of these erstwhile wild boys, ecstatic at the purity of the vision, the little artist being judged would stand, head cocked in inquiry, the great sad eyes round as a moon in a prematurely adult face. Marc thought their painting was inspired babbling. Like Larionov and early Malevich, Chagall had always found inspiration in the work of primitives, children's art, even the art of madmen. The work of these boys was like the *Lubok* which had earlier been one of the sources of the new modern art movement in Russia.

In order that he might more efficiently work with the Boys' Town, Chagall was finally assigned a little isba near the colony abandoned by its proprietors. There, in a room littered with empty medicine jars and stinking still with the dung of cattle who had once shared the place with the earlier tenants, Marc and his little ménage passed most of 1921 and the winter and spring of 1922, all sleeping on a narrow iron bed, while his plans slowly matured.

He had to leave Russia. He knew that now. Russia was no place for him. It was no place for his family. He didn't want his Idotchka to grow up in an atmosphere of idealistic squalor.

Once, as she was putting bread into the oven, the round chunky peasant woman who now served them as housekeeper told how during the famine she had managed to round up some sacks of flour which she had dragged into a freight car ... only to find a patrol of twenty-five soldiers in the car. Informed of the "illegality" of hoarding flour, she had calmly lain down and permitted each of the twenty-five soldiers in turn to take their pleasure with her.

In exchange she had kept her sacks of flour.

Listening to this tale, told with smiling big yellow teeth, in a booming complacent voice, Marc stared into her mouth and decided Russia was no place for his family.

Soon the peasant woman left him to live among the foresters. Marc saw her later, pregnant, bearing God-knows-whose child, spitting on her hands as she swung an ax.

The Pevsners went. Puni and his wife had already gone. Ilya Ehrenburg took off for Berlin. Within a few years the re-exodus of Russian writers, artists, and musicians to the West reached flood proportions. Some thought they were going temporarily to spread the Gospel, only to find their Gospel was no longer orthodox back in the

Holy Land. Some left with no intention to return. The New
Economic Policy in a temporary reversion to limited forms of
capitalism, that is, economic conservatism, was accompanied by a
new conservatism in the arts. Now the Maleviches and Lissitskys
who had unsaddled Chagall found themselves in turn tossed to the
heaving Russian earth. Lissitsky also soon went off to Berlin to teach
at the Bauhaus. Malevich lost control of the Vitebsk school, returned
to Moscow, where he found himself in increasing conflict with the
art of the political commissars.

By 1923, even Proletcult, most venerable of Communist art
groups, was abolished by the Kremlin. In Louis Fischer's witty
phrase: "The Proletcult, by proving that a proletarian culture could
not exist in NEP Russia, proved that the Proletcult should not exist
in NEP Russia."

For two years Marc Chagall had haunted the offices of
Narkompros, trying to get paid something at least for the murals he
had done for Granovsky. The state repaid him with the usual
abracadabra of bureaucracy, forms to be filled out, the majestic
approval of Lunacharsky. Granovsky recompensed him with a cat-
smile. Chagall's total earnings turned out to be an inflammation of
the lungs.

Back in a small flat in Moscow, pushing ahead the memoir he had
started several years before, Marc reviewed his situation and tasted
only ashes in his mouth. If only his God-given talent were accom-
panied with a build like Malevich's, or a voice as booming as
Mayakovsky's. His paintings alone were insufficient. One had to
possess a certain aggressive corpulence, commissarian brass. He,
Marc, was too sweet. His expression was too gentle. His voice didn't
boom enough.

No, he had to leave. Russia obviously didn't need him. He
wandered the streets of Moscow. One day he saw Trotsky descend-
ing from his carriage in front of the vast door of the Kremlin.
Trotsky seemed tall to Marc; his nose was purple in the cold. With a
heavy but firm step he walked through the gate to his apartment in
the Kremlin.

Perhaps, Marc thought, he might get some assistance from the poet
Demyan Bedny who also lived in the Kremlin and whom Marc had
known during the war when they had both "worked" in the War

Economy Office. Perhaps through the influence of Bedny and more important, Lunacharsky, he might get a visa permitting him to leave this Workers Fatherland. Surely there was no work for him. He'd had enough of being a teacher of wild boys, a director of wild artists.

He wanted to paint pictures, again, that's all.

And he thought of all the pictures he had left behind: with Blaise Cendrars at La Ruche, with Walden in Berlin. He thought of his studio at La Ruche full of canvases sketched in, waiting to be completed.

During the last year of the war, he had received a letter from Germany written by his friend, the poet Ludwig Rubiner. His wife, Frida, was a close friend of Bella; and the poet had recommended Chagall to Walden before the war, reinforcing Apollinaire's enthusiasm.

"Are you still alive?" wrote Rubiner. "The rumor here is that you were killed in the war.

"Do you know that you're famous here? Your paintings created Expressionism. They're selling for big prices. However, don't count on the money that Walden owes you. He won't pay you. He maintains that fame will suffice for you."

He had to get to Berlin, wring money out of Walden. And then he would go back to Paris. Or perhaps, who knows, perhaps to Holland, or to the south of Italy or to Provence. He would strip off his Russian blouse, his Russian boots, his Russian pantaloons, and announce to his friends in the West: "You see, I have returned amongst you. I am mad in Russia. The only thing I want to do is make pictures."

That's all.

In Russia he felt he was misunderstood: an outlander.

"I am certain that Rembrandt loves me."

And Marc Chagall had to be loved.

In 1921 "old" Zachar—he was only in his mid-fifties—was run over by an automobile. A portrait which Marc did shortly before this tragic event offers little documentation about his father's appearance at that time. Executed for the most part in palette knife, its outstanding feature is the omission of one eye and the treatment of the nose in profile against the frontally viewed face. The eye barely sketched in like a cartoon, the lemon yellow beard and sad crimson

lips stand out garishly against a ground and garb somberly Rembrandtian.

What provisions did Chagall make for his mother and sisters before he left the Soviet Union in 1922? As the eldest son, Zachar's death thrust onto his frail shoulders the full responsibility of maintaining his mother, his brother, and numerous sisters. We can only deduce that whatever money was left of the Rosenfeld fortune might have been tapped for this purpose.

Certainly the death of his father, his brother's tuberculosis that was to carry him off within a few years—these family misfortunes only added more drops of bitterness to a cup already overflowing.

Although Bella's injury would not permit her and the child to accompany him, Chagall proceeded now to employ the influence of his high-placed friends, especially Lunacharsky, to get a visa that would permit him to leave his beloved Russia.

He was confident that he would get the necessary documents for his wife and child to follow him. Russia at that time had too many mouths to fill, and too much economic and social turmoil to confront, to think about putting obstacles in the way of those who wished to leave.

There was still the tolerance of chaos, not yet the insecurity of tyranny.

Let the locomotive of history shake off the faint-hearted! The central metaphor of Communism was not yet the Wall.

*

While waiting for his visa, Marc continued to work on *My Life,* some ideas for which he had already jotted down in Jacov's office as his contribution to the war effort.

"These pages have the same meaning as a painted surface."

So Marc Chagall begins the epilogue of his memoir, conceived as parallel text and illustrations. Dated Moscow 1922, the actual writing must have been done precisely during this most trying time of Chagall's life: in 1920 and '21 when his little family was barely surviving in cold famine-struck Moscow. And that a young man in his early thirties, desperately involved in finding sustenance for his wife and baby, burning with ambition to make his way as an art commissar or personage in the theater, should still manage amidst all

that turmoil to create easel paintings or sketches full of puckish humor and grotesque formal inventiveness is surely an indication of unquenchable *esprit*. But that, additionally, Marc Chagall should have set about writing his memoirs is an astonishing act of narcissism.

Did he begin writing because he was at the bottommost pit of Hell? Was it his way of climbing to the stars moved by love? Was it an outlandish—and hence typical Chagallian—gesture of supreme ego? He has not yet reached the middle of his life, and already he is setting down the events of scarcely more than three decades, as something possessing historical significance.

As indeed it does. But did he know that? A young man of thirty-three summarizing his life? transforming his life into a Life? Had he not indeed begun setting down some of these notes in 1911—when he was twenty-four!

Marc Chagall is a canny cultivator of his own ego. He plants in it, he reaps out of it. He paints out of it. *My Life,* written in Russian on plain poor pages, was about three-quarters completed when he left Russia. Sentimental and brilliant in turn, hopping from episode to episode in a kangaroo style of stenographic pointillism, frequently deflective, the memoir, as the artist himself admits, is *ex post picturam:* that is, to be interpreted as written painting. And savorous though it be, this font of dubious documentation covers only one-third of Chagall's long life.

Even in 1958, thirty-six years after his departure, Marc Chagall insisted that political reasons played no part in his decision to leave the Soviet Union. "I had already had equally good political reasons for expatriating myself in 1910, but this time I left Russia for purely artistic reasons."

It is difficult to know what to make of this. "The equally good political reasons of 1910" might refer to the conditions of the Jews at that time. But surely the glacier that was inexorably grinding all artistic expression to the gravel of Socialist Realism, Chagall's expulsion from the Vitebsk school and the incomprehension and criticism he had encountered in the Moscow Jewish theaters, not to mention the dreadful economic and social conditions of Soviet Russia in 1921-22—surely all these are "political reasons" infinitely more compelling than the Jewish restrictions of 1910.

"I came to France because I felt that this country was my true homeland, because only in Paris or France did I feel free as a painter

of light and color. Look, in Russia painters have only very rarely developed a true sense of color."

But Chagall's sense of color is certainly more Russian—more iconish, symbolic, expressionist—than French Impressionist. That he felt freer in Paris cannot be gainsaid. But he felt free to be more Russian not French. He is not a painter *of* light and color, but a painter *with* light and color.

The ambiguity with regard to his departure is typical of many Russian expatriates and exiles, although it is more unusual among Jews. When he left Russia and for many years later, Marc Chagall was always reluctant to ascribe political reasons for leaving the Socialist fatherland.

Even his former son-in-law and exegete, Franz Meyer, writes: "His departure did not, however, signify an inner severance. Decades later he felt as close to Russia and its 'soil' as on the day he left."

Marc Chagall was not to see his beloved Russia again until 1973, when he was promised by Madame Furtseva, then Minister of Culture, that several of his greatest works, including the murals for the Jewish theater, and *Double Portrait with Wineglass,* would be sent on loan to the Paris Museum of Modern Art. More than a year later, on December 17, 1974, *Figaro* reported Chagall's rueful remark that if he had to live his life over again, he would want to be a Communist. Evidently this statement did not help release the paintings which are still in the vaults despite the fact that the Maestro had been asked to autograph them when he came after fifty years with tear-dimmed emotion to the land of his birth.

But there is more than a trace of ambiguity in all of this avowed love, as perhaps there is in all avowals too ardent and too often reiterated.

Although all the signs already pointed to the cultural neanderthalism soon to come with the accession of Stalin, 1922 was still relatively free. Despite the violent polemics that had gone on since the Revolution, those who were defeated could still abdicate from the field, with honor and even with dignity.

The frontier which had been closed by seven years of war and Revolution was open again, and Marc's decision scandalized no one; nor did it necessarily signify, at that time, an irreparable break with the young revolutionary state.

Indeed, as I have already said, in Chagall's flexible judgment no

such definite break was intended, even though his assertions that no political reasons operated in his case are rendered somewhat dubious by the marked bitterness of the final pages of his memoir, written in Berlin although dated Moscow 1922.

He wants to conceal his writing in the hiding place of his paintings. Or perhaps he might paste them onto the backs of one of his characters or on the pantaloons of the Musician in the Granovsky Jewish theater mural. God knows what he might write on there!

And with rather grim pride he boasts that his "plastic presentiments" foretold the present situation in the Soviet Union: Wasn't everything up in the air? Didn't everyone suffer from a single sickness: "the thirst for stability"?

Through the intervention of the high-placed Lunacharsky, Chagall received his visa and passport. Bedny, his former colleague in the War Economy Board, now close to Lenin, may also have played some part in greasing the bureaucratic wheels. Another friend, the poet Jurgis Baltrusaitis, who had been appointed Soviet Ambassador to Lithuania, permitted Chagall to send a batch of oil paintings, gouaches, sketches for the theater drawings, as well as the manuscript of *My Life* by diplomatic courier to Kaunas, a town on the Lithuanian frontier.

Even amidst the rigors and confusion of his brief stay in Kaunas, Chagall's friends and admirers managed to organize a show of his works at the Authors' Club. The catalogue lists sixty-five items in all. And one special evening during the exhibition was set aside for a reading by Chagall of part of *My Life*.

In May 1922 he arrived in Berlin.

Part Five
Berlin
1922-1923

Of course the first thing he did when he arrived in Berlin was to search out Herwarth Walden. *Der Sturm*—both gallery and publication—was even more influential in the German art world than it had been before the war. During the turbulent years of war and revolution, Marc had always been aware of the many works he had left behind in Paris and Berlin. Even in 1919 he had attempted unsuccessfully to run a check through the aegis of Narkompros on the works he had left with Walden.

So he had come to Berlin not solely because of Rubiner's letter: "Come back to Europe, you are famous here." Rubiner had died in 1920, but his widow Frida, who was a good friend of Bella, greeted him; through her and other friends it was not difficult to track Walden down.

To his horror Chagall learned that all of the forty oil paintings and one hundred and sixty gouaches he had left at *Der Sturm* had vanished. Walden had continued to fan the embers of Chagall's reputation after his departure in 1914, organizing shows in Berlin and other cities. Technically, once Germany and Russia were at war, Chagall was an enemy alien and his pictures could be seized. Indeed for Walden to promote his art involved a combination of nerve and con-

245

viction. The magazine *Der Sturm* had regularly published reproductions of Marc's work. An entire picture book had been devoted to him. The "junk" artist Kurt Schwitters wrote a poem to Chagall after seeing one of his drawings at *Der Sturm*. Max Ernst was influenced by this folkish fantasist from Russia. So famous was he already in Germany that an imposter in Dresden assumed his name (after all, nobody had any idea what Chagall looked like), milked the bourgeois progressive art lovers, and disappeared.

The result of all this hullabaloo about the Vitebskite was that Walden had found no difficulty in selling to private collectors the bulk of Chagall's work. And quite meticulously, he had deposited the sums of these sales with a notary, awaiting Chagall's return. Apparently he wasn't even sure that Marc would return, because rumors had long been current in Berlin that Chagall had died during the war or the Revolution.

But not all the paintings had to gone to private collectors. A number of the more beautiful works had been acquired by Walden's Swedish wife, Nell. This was explained as a stratagem to prevent seizure of the paintings by the German police as enemy property. These moneys were also duly deposited with the notary or a lawyer.

Chagall was infuriated, in a state of incandescent rage—which is still likely to erupt whenever this episode is brought up. He demanded the money for his work and Walden promptly withdrew it and offered it to Marc. But the mark that was now being offered to Chagall had been inflated to worthlessness: a suitable monetary symbol of the worthlessness of everything. In Berlin those days one papered one's walls with paper money or trundled a wheelbarrow full of marks to do one's shopping. The total amount of Walden's sales in terms of that grotesquely depreciated currency came to about enough to pay for a pack of cigarettes. Marc screamed, Walden promptly raised the sum to a million Reichsmarks—very little indeed in view of the fact that a single Chagall was then being auctioned in the capital at one hundred times that amount.

Naturally, Chagall refused to accept the offer and demanded the names of the purchasers of his works. Walden refused to release these. Relations deteriorated to the point that Chagall finally hired a lawyer and filed suit. Although Walden was ordered by the supreme court to name the purchasers as well as to increase the amount of remuneration, Chagall's demand that his pictures be returned was rejected.

After dragging on for years, the case was finally settled out of court in 1926: Nell (who had meantime divorced Walden and remarried) gave Chagall, in return for dropping the suit and all demands for financial remuneration, the choice of selecting three paintings and ten gouaches from her collection. For the oils, he chose three of his best works of the prewar period: *To Russia, Asses and Others; I and the Village;* and *Poet.* But his bitterness was not then and has never been assuaged.

The loss of these pictures, joined with others, contributed to the formation of a hidden iceberg of bitterness in Chagall's character. From this submerged sense of loss also derived the obsessiveness with which he went about replacing his disappeared *oeuvre.*

The distinguished art historian Dr. Meyer Schapiro told me that when he was in Berlin in 1923, Walden spotted him as an American "just by the way I was dressed or walking." The enterprising dealer invited Schapiro up to the *Sturm* gallery to correct some English translations for a show ("the text was full of mistakes").

At that time Schapiro saw some "little Chagalls," none of which he remembers clearly. But when he told the artist about this many many years later (probably during the Second World War when the two became intimate friends in New York) "Chagall hit the roof and became very angry. He wanted to know which paintings they were, and so on, because these were presumably some of the works which had disappeared."

Every artist needs to create new works in an atmosphere of resonance, a preceding body of work. In Chagall's case because of several catastrophic losses, real or imagined (and if imagined intensely enough, *real),* that echo chamber has had to be painfully reconstructed—hence the many versions of early works.

And on a less aesthetic level, there is the merchant's need for stock.

A decade later Walden was to disappear like Chagall's pictures. Chief drumbeater for Expressionism, he had reached dizzying success in the German art world before and even during the First World War.

Expressionism, which he so tirelessly and spectacularly espoused, was the first art to be declared "degenerate" by the Nazis. Before their assumption of power, however, Walden had been one of the few German anti-Nazis who had followed his convictions eastward. Apparently, he felt that the Soviets would prove sympathetic to his

notion of Expressionism as a cultural crusade: an awakener of the true moral nature of man, a reaction against purely decorative art, *Jugendstil.* The Stalinist response was that Expressionism was the ultimate of bourgeois decadence and corruption. In the 1930s Walden was swallowed up in the vast spaces of the Soviet Union and was never heard of again.

The unpleasant bile-bitter Walden episode was acted out against the background of a Berlin that was itself like an Expressionist picture by Nolde. Eight years had passed since he had last been here: eight years that had brought forth fruits sweet and bitter: his marriage and the birth of his daughter, the idealistic dedication of his first years as commissar and then swiftly the acrid disappointments. The commissars who couldn't understand that to make a true revolution one had to learn to drive a droshky in the clouds. And on the other side, inhuman as a glacier, the huge mass of Malevich, crushing every flower in his path.

No, Russia was no place for him. And so, thanks to Lunacharsky, he was back in Berlin. Bella and Ida soon joined their chromatic peripatetic husband-father and the family was to remain in Berlin from the summer of 1922 to the fall of 1923, save for several vacation trips to the Black Forest and Thuringia. They had a number of friends there, including the famous Yiddish writer Chaim Bialik; and Chagall in his usual enterprising manner soon was well acquainted with several important dealers, art critics, and more selectively, artists.

The city itself did not seem very different. World War I had not resulted in the physical destruction it was to undergo in the Second World War.

If anything, defeated Berlin was gayer, more volatile, more exciting than it had been before. It was no longer the political capital, which had hopefully been shifted to Weimar as if by magic the transposition would replace Wilhelmian militarism with Goethean humanism.

All the promises of the avant-garde had now come to fruition, and whereas prewar Berlin had to compete with sister cities like Munich, Frankfurt, and Hamburg for the patronage of the new artistic movements, now all drifted inevitably to Berlin.

Like sewage pouring down a drain, Marc thought sometimes, as he

watched the painted boys promenading along the Kürfurstendamm, swinging their tight-waisted hips. High-school students sold themselves for money. Stefan Zweig has written:

> Berlin transformed itself into the Babel of the world. Bars, amusement parks, pubs shot up like mushrooms. . . . The Germans brought to perversion all their vehemence and love of system. . . . In the darkened bars one could see high public officials and high financiers courting drunken sailors without shame. Even the Rome of Suetonius had not known orgies like the Berlin transvestite balls, where hundreds of men in women's clothes and women in men's clothes danced under the benevolent eyes of the police. Amid the general collapse of values, a kind of insanity took hold of precisely those middle class circles which had hitherto been unshakable in their order. Young ladies proudly boasted that they were perverted; to be suspected of virginity at sixteen would have been considered a disgrace in every school in Berlin.

And yet Berlin was *the* place to be. Together with its prostitutes and transvestites the city was the center of German culture—of art, of literature, of music. There were magnificent symphony orchestras conducted by such worthies as Bruno Walter (a native Berliner), Wilhelm Furtwängler; the State Opera which had premiered Alban Berg's *Wozzeck* based on a text by Georg Büchner, one of the great nineteenth-century writers revived in postwar Germany. There were one hundred and twenty newspapers and forty theaters.

So he was not surprised to find again, in the feverish atmosphere of inflation and the painful beginnings of the Weimar Republic, many of his friends and enemies from Vitebsk, Petrograd, and Moscow.

Among these there was even the ubiquitous El Lissitsky, who had given him so much trouble in Vitebsk. Now he was propagating his Constructivist doctrines among the Germans. There was even an avant-garde review which Lissitsky and Ilya Ehrenburg directed in Berlin in 1922. This review, *Objet-Viesych-Gegenstand,* was published in three languages: French, Russian, and German. Among the collaborators were Picasso, Le Corbusier, Archipenko, Ozenfant, André Salmon, Mayakovsky, Essenin, Tairoff, Meyerhold, in sum, a veritable international Parnassus of the 1920s.

After the war [Chagall told Edouard Roditi], Berlin had become a kind of caravansary where one met all those going and coming between Moscow and the West. Later I knew a similar tower of Babel in Montparnasse up to 1930, then in New York between 1943 and 1945. But in 1922 in Berlin I had the impression of living in the midst of a dream, sometimes in the midst of a nightmare. Everybody seemed to want to buy or sell pictures, and one already calculated the price of a roll at millions of marks. In the apartments of the Bayrischer Platz quarter, there were almost as many samovars and theosophists or Tolstoyan countesses as there had been once in Moscow. In the basements of the Russian restaurants of the Motzstrasse, there were more Russian generals and colonels, now become cooks and dishwashers than in a garrison town. As for me I've never seen in my life as many wonderworking rabbis as in Berlin in 1922.

If the rabbis sought to work wonders, the workers sought less magical and more efficacious means to attack the Saturnalia of corruption, exploitation, and despair. A powerful Marxist political movement arose. And Marc Chagall, fresh from the first Communist state, must have grimaced ironically at the Socialist-Realist art of Nagel, Otto Dix, George Grosz—grimaced not at what it attacked but at the spurious hope behind it all. Did he, perhaps—a refugee from the Workers' Fatherland—quarrel with idealists like the great Käthe Kollwitz? Did he point out, from bitter experience, that social revolution did not imply the corollary, artistic revolution? Perhaps the more academic Kollwitz, with her working-class mothers and staring-eyed children, enclosed in velvety womb-shapes of lithographic black and white, would not have as much difficulty with the commissars as had he, Chagall. They would understand her: she was, after all, a conservative artist. As was essentially George Grosz, despite the savagery of his caricatures: his evocative scratchy line cutting like a scalpel into the fat flesh of German militarists and factory owners, sucking on penis-cigars as they fondled fat-buttocked naked prostitutes.

Like Chagall himself, Grosz was to emigrate later to America where he painted lyrical sunburst views of New York harbor in

watercolors for want of familiar targets of his scorn. But these works, though charming, are markedly inferior to his German drawings; Grosz's art needed the provocation of hatred. *A Little Yes and a Great Big No* is the poignant title of his autobiography.

All the artists of the German left were essentially conservative compared to Marc Chagall. His affinities lay rather in prewar Berlin—with the garish colors, skeletal simplifications and distortions of the Expressionists. If he was not historically "the ancestor of Expressionism" as Boris Aronson was to write, he certainly shared its conviction that image-making was not the fixing of vision but the language of emotion. His prewar show at the *Sturm* gallery served to confirm to the Germans that they were on the right path. So it is understandable why Ludwig Rubiner had written that Chagall's paintings had really "created" German Expressionism, and were fetching the highest prices.

How deeply did the German painting of that febrile epoch influence his own more lyrical art? The fact that certain characteristics of his style are common to Chagall and many of the German Expressionists—the blue horses of Franz Marc and the green donkeys of Marc Chagall—proves only that the generally anti-realistic spirit of the European avant-garde transcended national boundaries. Chagall's "Expressionism" was an independent growth fed on non-German sources. And prewar German Expressionism existed before Marc entered that scene, although subsequently, exposure to his art stimulated the native growth.

The line of "influences" is always murky in the case of artists with a strong personality. Their minds possess built-in selective apparatus, neural geiger counters, which are constantly absorbing and rejecting. The images (raw visual material) do not enter solely or even most significantly through the retina. And what is rejected or retained is only subject to *ex post facto* unraveling which has more to do with the exigencies of clear narrative in art history than with the jumbled nervous knots that are the true psychological situation. The creation of art history should never be confused with the creation of art.

Marc Chagall was a "natural" on which various influences played. But he was always his own man. That is why he cannot be fitted into any categories, tempting as such categorizing always is to scary mentalities seeking bomb shelters against existential chaos.

In his youth he had drawn heavily from Russian folk art, icons,

wooden toys, linen embroidery, *lubok* images. In St. Petersburg he had (perhaps) picked up some of Bakst's lyricism and perfected his craft. His first Paris sojourn had been an avid almost frenetic opening to all the leading art movements—the famished Russian from the provinces suddenly loose at the table set with the great feast of French art from the Impressionists on, not to mention the sanctified past enshrined in the Louvre.

Now in Berlin again after his Russian Communist interlude, he found himself in the spooky atmosphere of *Dr. Caligari* and the early UFA films, the lurid paintmares of Nolde (reminding him somewhat of Soutine's hysterical tremors), the fantasy bestiary of Franz Marc, the jerky eroticism of Kirchner, the allegorical Max Beckmann and Grosz's graffiti.

All this played upon a style already embarked on its path, a soul already fashioned. The rejective system of his mental radar was stronger now than the acceptive. Most likely he refused to be influenced more than he was prepared to be influenced.

Maturity is a certain self-sufficiency, an acceptance of self, of one's own personality.

The artist Marc Chagall of 1922 was mature.

*

One Russian, Wassily Kandinsky, was propagating his mysteries at the Weimar Bauhaus. Another, El Lissitsky, was busily converting as many German artists as he could away from the Weimar Bauhaus. His *Prouns,* which he had defined in a lecture as a "changing-trains between painting and architecture," were creating a great stir in Berlin. In these he synthesized Dadaism and the German school of Neue Sachlichkeit (New Objectivity). In 1922 Marc Chagall could not but be aware of the triumph of his former disciple in modern typographical design, with the publication in Berlin of Lissitsky's *Story of Two Squares* designed in Vitebsk just about the time Marc had abdicated. This was a book of ten pages of geometric shapes, letters, and numbers in Constructivist layouts and with the following text:

1. About 2 Squares. El Lissitsky
2. To all, to all Young Fellows
3. El Lissitsky: A Suprematist story—about Two Squares in 6 Constructions: Berlin, Skythen, 1922
4. Do not read: Take—Paper Fold
 Blocks Colour
 Pieces of wood . . . Construct
5. Here are—Two Squares
6. Flying towards the Earth—from far away—and
7. and—see—Black Chaos
8. Crash—all is scattered
9. and on the Black was established Red Clearly
10. Thus it ends—further

Thus both Chagall and Lissitsky were flying in Berlin at the same time but on very different astral planes. One need but compare Lissitsky's abstract text and graphics with Chagall's human-all-too-human etchings for *My Life,* printed in the same city the same year. Thus in Germany, the classic land of graphic art, Chagall had his first encounter with a medium in which he was to accomplish some of his greatest work. In fact with the exception of some watercolors painted on vacation in the Black Forest and in Thuringia, he devoted himself entirely to graphics during his year and a half in Germany.

Lissitsky meanwhile was busily involved in editing the international Constructivist magazine *Objet-Viesych-Gegenstand,* with Ilya Ehrenburg, already well on his way to becoming the official bad boy of the Soviets, the acceptable gadfly (a role the poet Yevtushenko now fills). A skillful weathervane, Ehrenburg swung without creaking to every new doctrine blowing from the east. He seemed to have fathomless sources of ideological grease. In the Berlin art and literary world this future philosopher of freeze and thaw helped Lissitsky promulgate the aesthetics of the "object," bringing together in their multilingual magazine various European schools of functional design. Thus, with the lifting of the Allied economic blockade, cultural commerce East and West resumed. A German critic came from Berlin and lectured in Moscow the same year Lissitsky went to Germany. Russia, with her brand-new Tatlin-designed functional boots, was still pursuing Marc Chagall.

Indeed during his stay in Berlin occurred the most significant

event signalizing the return of Russia into the European art world. This was the comprehensive exhibition of various Russian schools of abstract art presented at the Van Diemen Gallery in Berlin 1922, later in Amsterdam. Covering the modern movement in Russia from the *World of Art* at the end of the nineteenth century to the latest Constructivists, the show was dramatic both in content and display. El Lissitsky's designs for gallery and arrangement employed the wall spaces themselves as part of his display.

Chagall, who had had a one-man show at the Van Diemen Gallery in 1922 and was to have another the following year, was not included, of course, in the abstract show. Lissitsky's decor reminded him vividly of its source: the Moscow Café Pittoresque where Tatlin and Rodchenko had installed similar constructions: metal and cardboard triangles, and polyhedrons. The purpose of these "real materials in real space" was to destroy the real space of the little room, inflict Euclidean wounds. For the rods, twists of cardboard and metal, geometric cutouts hung from the ceiling, squatted in the corners, splintering the real space; even the lights flickering through construction lamps split into jagged rays in dynamic shifts.

The Real was being liquidated by the Real.

It was at this café that Larionov and Goncharova, those Dadaist lovebirds, might flutter in with their painted faces, seashells in their ears, or wearing grotesque masks. Or there might be Mayakovsky, huge as a truckman, spoon in buttonhole, bellowing out his rhythmic contempt of the bourgeoisie, his bass booming, his face purple as his shirt.

All this—decor and actors—amused Marc, harmonized with his own sense of mockery and whimsy. But inevitably these jesters had to pragmatize their humor—and at this point Marc departed. He distrusted this Russian need to forge cannon even of their jokes.

He may have left Russia but Russia had not left him.

The artist Ludwig Meidner, who met Chagall in Berlin at that time, commented: "Chagall looks very strange, like a man with occult powers, not a bit intellectual. . . ."

Joined by his wife and young daughter, Chagall remained untouched by the orgy of Berlin. Within the protective bubble of work and family, he could always isolate himself against the stormiest seas. And his reputation in postwar Berlin was such that soon several very

important exhibitions of his works were organized at the Van Diemen Gallery. The monograph by Efross and Tugendhold was translated from the Russian by Frida Rubiner. A number of other shorter monographs on his work soon appeared.

Among them was a remarkably perceptive little pamphlet by Boris Aronson, then a young painter of twenty-five, who had already met Chagall briefly in the world of the Jewish theaters in Moscow and was to be his familiar again later in Paris and New York, where Aronson became one of Broadway's leading scenic designers.

I interviewed Aronson in his New York studio-apartment. His eyes, memory-glazed, were in counterpoint to the sharp, critical evaluations of Chagall the man and Chagall the artist with which he laced his recollections.

"I decided to write my little book on Chagall because of something which I had read in a Russian anti-Semitic publication in which an untranslatable Russian word—*Tchutz*—was applied to the painter from Vitebsk.

"I came to his place and read my book to him. It was very very favorable. But when I finished reading it, Chagall said he would be happy if it were never published. It was too *intimate*. It was as if I had entered the room where he slept with his wife. He even offered to *pay* me not to publish it!

"Of course when he told me that, I ran to publish it!"

Translated into German and Yiddish, the booklet was sincere in its admiration of Chagall's art. But according to Aronson, Chagall didn't want the truth exposed in that manner. "He didn't want intimacy expressed in a way he couldn't deny.

"Now he is not the fine artist he was then. Today he is a mixture of Dufy and Vitebsk. He is a very complicated person, terribly involved in being the greatest. Chagall had fantastically great gifts as a painter. On the other hand he was a merchant. I was at his house and I didn't like what I saw. The way he went about selling his pictures.

"And as a designer he is doing *Fiddler on the Roof* all his life.

"He is a little man who made it big and can't take it. That part is very ugly. Yet in his time he was a very great graphic artist and a very great painter. He accomplished very beautiful work in many fields. His Hadassah windows are original, fresh.

"Even back in the twenties when Jewish artists were just emerg-

ing from the Pale, the problem of identity arose—one of those false problems which so agitate critics and leave artists indifferent. They know who they are."

Aronson differentiates between two kinds of artists: the Cézannes who create a classical style, and the Redons who relate to certain intimacies, a temperament rather than a style.

Chagall belongs to this latter group. His recent work is just a repetition of his dreams. By comparison with Soutine, Chagall is decorative. "But he has painterly qualities in his decorativeness."

Aronson says that Chagall "hit the roof" (and not in one of his poetic erotic ascensions) when he made these observations back in the twenties in Russia and later in Berlin and Paris. Then as always Chagall hated to be criticized, kept himself aloof from commitment to any fashionable or particular art style.

There is no such thing as "Jewish art. A Jewish cloud is a French cloud. Or a German cloud. Or a Russian cloud. There are Jewish subjects but that doesn't make Jewish art. Chagall uses Jewish subjects. But Soutine paints a chair and it's sad, it's melancholy, it's *Jewish.*"

Aside from the fact that the equation *Melancholy equals Jewish* is dubious, Chagall himself has publicly expressed himself on the question of "Jewish art." He dislikes being considered a "Jewish" painter; one of the reasons for his antagonism to those who frankly accepted the appellation, Mané-Katz, for example.

Aronson feels that the influence of icons on Chagall is very real, not artificial. Additionally he discerns in his work marked elements of *lubok,* the folk art found on wallpaper, embroidery, towels, paintings, wooden toys, trays. Decoration of this kind was a very rich source of new images, as were the icons. When Matisse was in Russia he said: "Why do the Russians go to France when they have all the icons?"

Out of this grew *Mir Iskusstva (World of Art)*, in rebellion against the academic school, the history painters, etc. The graphic artists were the Jewish *Mir Iskusstva.*

"Chagall instinctively had it. But then he began to exploit it. He is like a woman who is charming, nobody knows why she is charming, it is beyond explanation. Then when everybody tells her she is charming, she begins to use it, consciously. But when charm becomes a system, the magic is gone. That is late Chagall.

"As for Chagall in the theater we must remember that scenic

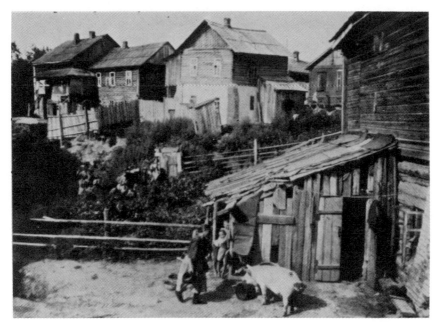

Chagall's grandparents' house in Vitebsk: The "romantic" *stetl*. Alchemy transformed such drab towns to dream towns.

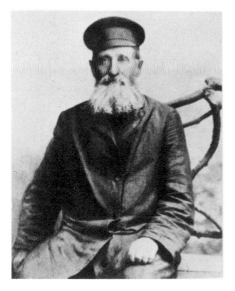 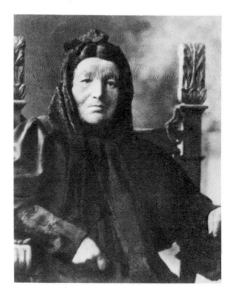

Chagall's grandparents.

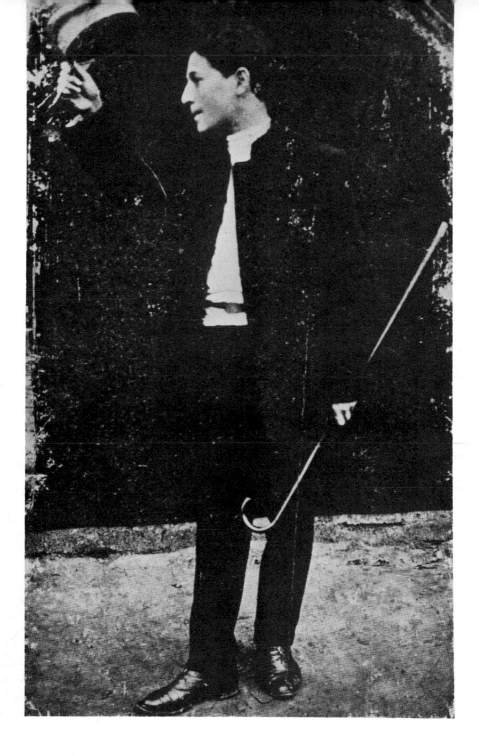

Left: Young Marc Chagall as a student in Vitebsk. His histrionic gifts are already apparent. Probably about 1908, when the artist was twenty-one.

The Chagall family. Marc Chagall is second from the right, standing behind his grandmother. Photo before 1910.

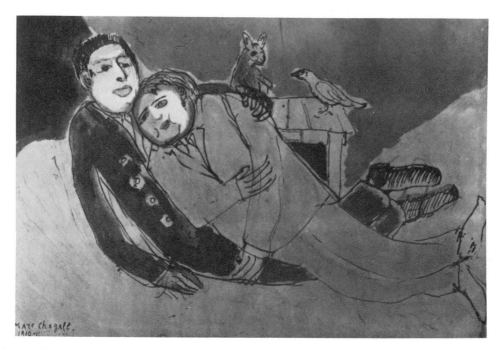

Left: *Apollinaire and Chagall.* Gouache. 1910-11.

Caricature of the Svanseva School exhibition in 1910 (nos. 1 and 5 are paintings by Chagall).

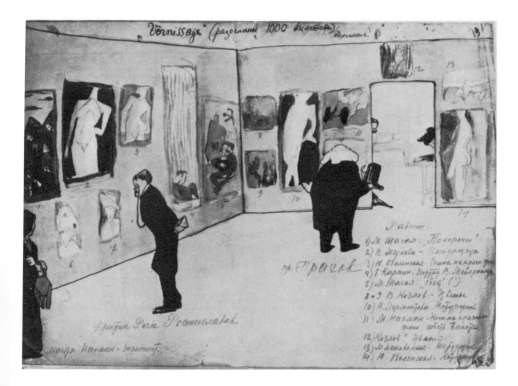

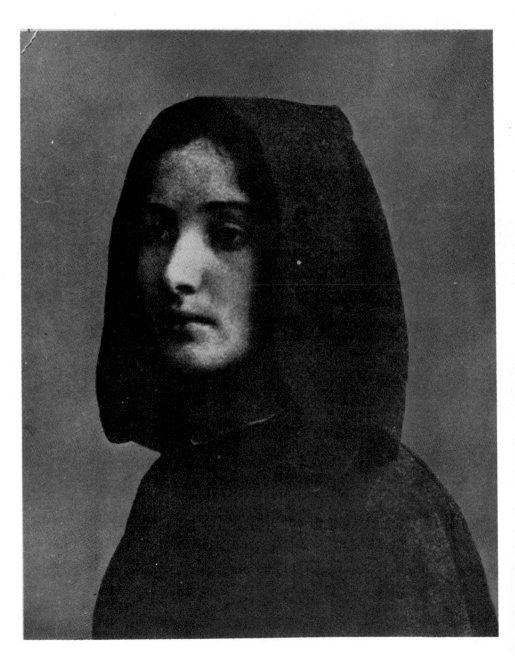

Bella Rosenfeld. A brooding introspective portrait of Chagall's fiancée about 1909. They were married in 1915.

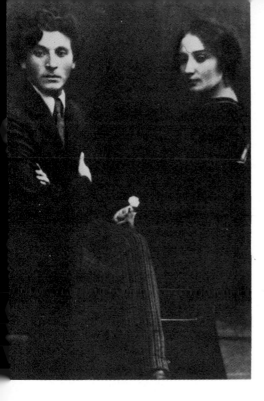

Left: Chagall and Bella shortly before his departure for Paris.

Chagall, Bella, and Ida, 1917.

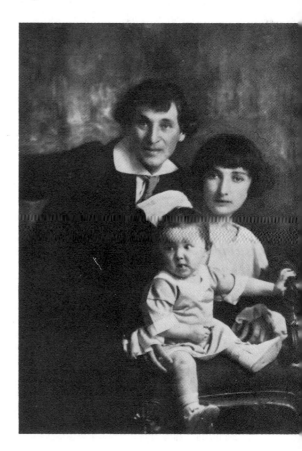

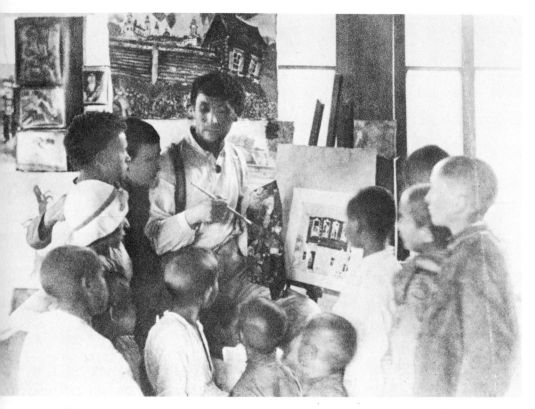

Chagall with his students at the "boys' town" at Malachowka,
1921. Their eyes never smiled.

1924. Ida, Bella, and Marc Chagall in the studio at 101 Avenue d'Orléans, Paris. The happy trio is photographed against several of the artist's great paintings; *The Praying Jew* (1914), *Birthday* and *Poet Reclining* (1915), a small gouache after the big oil *I and the Village*.

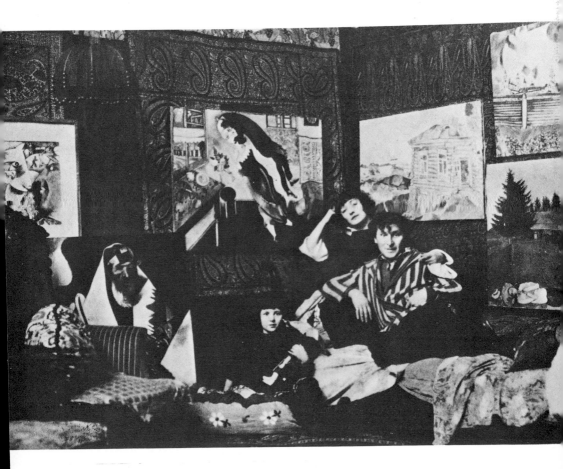

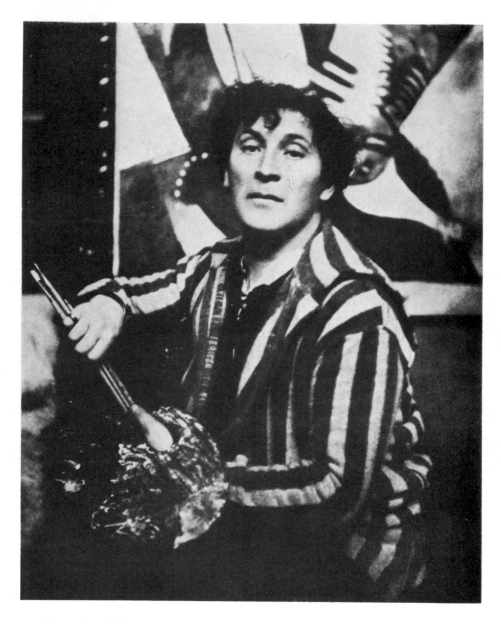

The striped blazer and bottom half of *The Praying Jew* would date this portrait 1924.

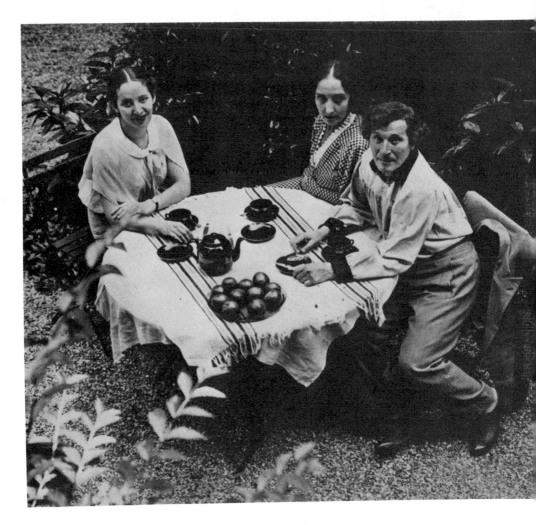

A happy trio—Ida, Bella, Marc—in the garden of the small house on the estate of the Villa Montmorency, near Paris, 1933.

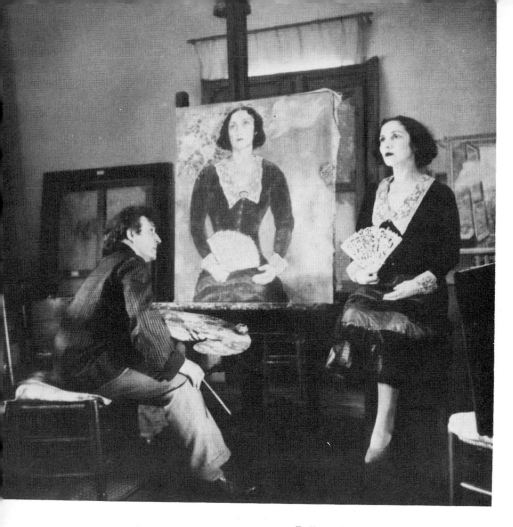

Bella posing for *Bella in Green*, 1934.

"Artists in Exile," from the show mounted by Pierre Matisse in New York, 1942. From left to right, first row: Matta Echauren, Ossip Zadkine, Yves Tanguy, Max Ernst, Marc Chagall, Fernand Léger; second row: André Breton, Piet Mondrian, André Masson, Amédée Ozenfant, Jacques Lipchitz, Pavel Tchelitchew, Kurt Seligmann, Eugene Berman.

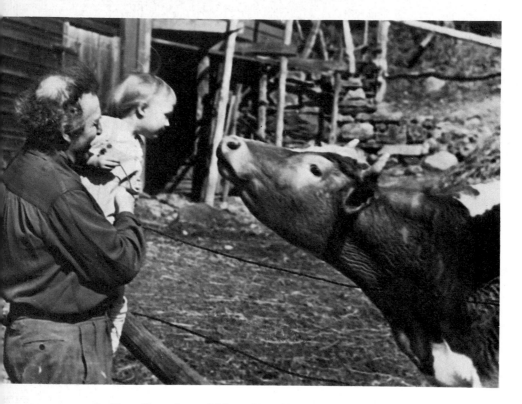

A Chagallian view of Marc Chagall and his son David at High Falls, New York, 1948, when the artist was sixty-one years old.

Right: Virginia and Marc Chagall at High Falls, New York, 1948.

Below right: Virginia, Jean, David and Marc at High Falls, New York, 1948.

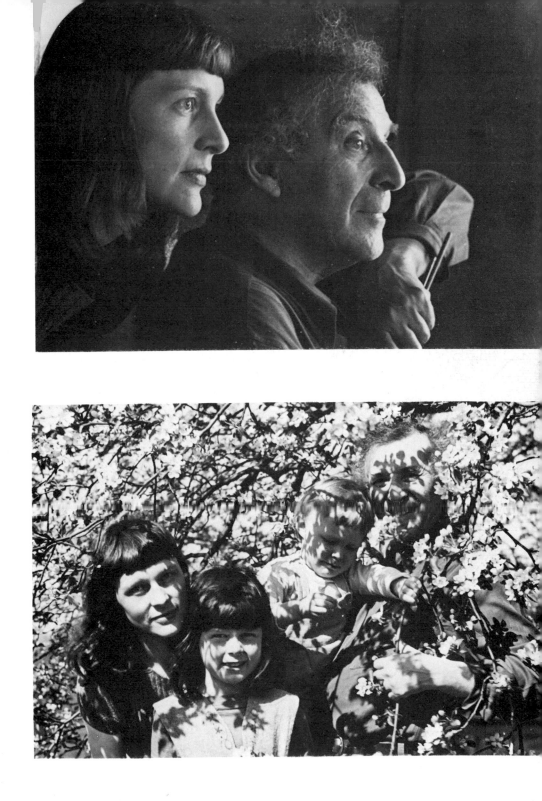

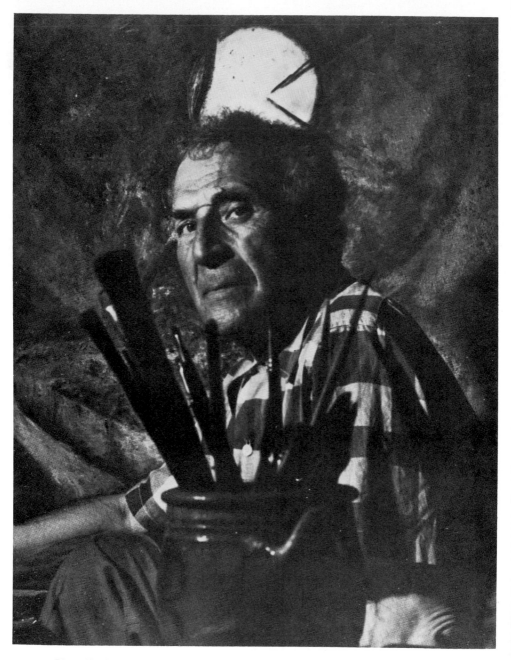

Chagall, the tireless worker totally dedicated to his art, is captured in this study of the artist in his middle years.

designers in Russia were not specialists. The feeling was that they were first of all artists—which meant that they can illustrate a book, paint a mural, do sets."

Listening to Aronson expostulate on this theme, I was struck by the paradox that the Italian Renaissance notion of artist as *Uomo Universale* should have come most alive in that very country which was least influenced by the great revival of the fifteenth and sixteenth centuries.

In the Jewish theaters there was a reaction against Stanislavskian realism. Stanislavski, of course, had himself been a revolutionary against the older pompous rhetorical style. He had produced Chekhov, Ostrovsky with the fourth wall removed. Now Alice Tairov, a Jewess, rebelled against the naturalism of Stanislavski. Also Alexandra Exter did *Romeo and Juliet* in a highly stylized fashion. Boris Aronson recalls one occasion when Exter, his Maestra in the art of theater design, showed him a set design for *The Tempest* employing many mirrors. He did not understand the significance of the mirrors until he was told that they were water.

This kind of freedom from realism was exactly right for Chagall. And in this free-flying style Chagall accomplished wonderful sets, scenery, costumes for the Yiddish theater. Aronson met the artist for the first time during those days when he was working on sets and costumes. Chagall immediately impressed the young scenic designer. "I tremendously admired his work. But he was even then a mixture of a man—on the one hand, extremely ambitious, involved in making it. On the other hand, a great artist."

Although youthful idealists may be disturbed by the "mixture," such a combination of business acumen and great artistic gifts is by no means rare in the history of art, nor is it necessarily self-destructive. In more than five hundred letters Michelangelo speaks more often about ducats than art. Rubens advertises his "naked girls painted by my own hand" like an entrepreneur of strip-tease shows.

"He was extremely businesslike. In Paris he would sit at a café drawing on a napkin. If someone would ask him for the napkin, Chagall would carefully tear it to pieces.

"Bella had her own quality. Her influence on Chagall was a good one. In the *Querschnitt,* a German magazine, there was a picture of Chagall in Berlin with Bella and Ida. The little girl is nude. Chagall was highly criticized that a father would publish an intimate thing

like that in a publication. But this is so characteristic of Chagall. Anything for *réclame*."

This remark by Aronson would seem to be in flat contradiction to his claim that Chagall offered to pay him in order that he not publish his "little book" because it was "too intimate."

"There are two kinds of intimacy," he rejoined, "profound intimacy and cheap intimacy. Chagall wants to be a legend. His main objection to my book was that if you are a charmer, you don't want people to know that your charm is calculated. My book indicates that he is very talented but that his charm is put on. Chagall preferred such critics as Waldemar George who were not painters."

The "intimacy" of his work—the way he put in the charm, the naïveté—he wanted that kept secret. He didn't want that known.

Picasso and Matisse are designers. Chagall is a storyteller. A storyteller, but that doesn't necessarily mean literature. Chagall is a painter, a real painter. He doesn't make literature. But he is a storyteller as a painter and a painter as a storyteller.

"Chagall is organized inspiration."

"Organized inspiration." How well that synthesizes the two sides of Marc Chagall: his childlikeness and his shrewdness, his intuitive anti-intellectualism and the self-conscious formal organization of those intuitions, one might say his bookkeeping of dreams. Similarly, the Cubist grid that he superimposed (especially during his first Paris period) on amorphous washes of color served a psychological and pictorial function: containing and articulating what might otherwise blur away into meanderings: childish figures artfully clumsy, flying in that sentimental bath, calculated even as it was improvised.

Read today, after more than half a century, Boris Aronson's "little book" is sharp, just, and prescient. The style itself in its vivid color, ellipses, and Russian leaps is not unlike Chagall's painting and writing of those early years.

Chagall belongs to the Kom-Komlikas, the So-Soers, the last of the Just-Justs. Is he a story teller? a philosopher?

Chagall is a Russian Jew, a Chassid, a student of French modernism.

Is Chagall from the literati? intelligentsia? philosophers?

Surely this painter is a psychologist through and through in the creation of his primitive work.

Chagall creates even out of the primitive Russian.

Where did he learn to fly?

Where did he learn to decapitate his figures?

A great scholar he is not. Wars, revolutions are to him pettinesses.

The phases of Rozinoff might be a clue to Chagall. Chagall says—"May God forgive me for not putting into my caricatures the calf's love of people! But my relatives are holy!"

In Paris he did not forget his aunts and his uncles. There he loves them.

He is however a lover of small things *(Kleinigkeit)*. In Paris as in Vitebsk on the Eiffel Tower he sees children's diapers and panties hanging. He looks through the window and sees Vitebsk, the little street, the children, the religious schools *(cheders)*, and he is in Paris but he sees Vitebsk!

He keeps Vitebsk always within himself.

He does not really see Russia. He says he has not seen enough of Russia. Only Petersburg and a bit of Moscow.

Ah Vitebsk!

Chagall says—If I weren't a Jew I wouldn't have become an artist. It is clear that such painting is through and through artistic *(kinstlerish)*.

He writes especially about the artist and his creation *(schaffingen)*.

He is sometimes monumentally friendly but he is tense *(angestrengt)*.

Chagall is a Russian Jew, a Talmudist (sic), a student of French painting.

And again there is the Chagall derived from literary fantasy and philosophy. Chagall stems entirely from Yiddish fantasy and folk simplicities. *(Chagall bestet durch und durch von Yiddische fantasia und volk einfachkeit.)*

Most significantly, the stay in Berlin introduced Chagall to the art of engraving and etching in which he was to achieve some of his greatest works. His two shows at the Van Diemen gallery not only relieved him of financial pressure but brought him to the attention of

the progressive publisher and art dealer Paul Cassirir. Even before
the war, Cassirir had been collecting primitives such as the Douanier
Rousseau; now he became intrigued with Chagall's "primitive" style
in *My Life,* then being completed, and wanted to publish it with
illustrations by the author. With this end in view he referred Marc to
a well-known German engraver, Hermann Struck, who gave Chagall
his first lessons in intaglio printing.

Mastering this exciting new craft with characteristic speed and
employing it from the start with unorthodox techniques necessitated
by his unique style, within three weeks Chagall had prepared fifteen
plates for his memoir; then he added five other works, some in mixed
drypoint and etching. Since the "naïve" text proved too sophisticated
for the German translator, the portfolio entitled *Mein Leben,* put out
by Cassirir in 1923, consisted of the illustrations alone: twenty prints
in an edition of 110 numbered examples, 26 on Japanese paper and
84 on handmade paper.

Thus fittingly, Chagall the printmaker was born in Germany,
which from the fifteenth century onward, with Martin Schongauer,
Albrecht Dürer and Lucas Cranach, has been the classic land of
graphic art. Even the Expressionists with whom Chagall was styl-
istically associated had made extensive use of wood engraving and
etching. During his German sojourn Chagall also began working in
wood engraving and lithography.

Thus launched, Chagall's achievements in graphics were to con-
tinue henceforth in tandem with his painting. His printmaking
indeed is extremely pictorial. From the outset, he employs burin and
needle, linear accent and hatching in a wide range of eloquent
articulations and silences. The line sweeps along and hesitates, dances
and stammers, abruptly vanishes in a froth of dots, scratches,
pinpricks. The omissions speak as eloquently as the commissions.
Quickly learning how to wipe the inked plates, sopping the ink up
out of the deep furrows of plowed line, he achieves marvelous fuzzy
effects; Chagall's plates have a tremendous range of "color" in the
blacks and grays.

Most of the prints of *Mein Leben* are variations of themes already
dealt with in paintings or drawings (and of course in the text):
Grandfather sits munching on the roof; a fire accompanies Marc's
birth; a horse and cart float most matter-of-factly past the windows of
a Vitebsk isba; Zachar lies calmly in his grave at right angles to the

tombstone on which under a Star of David is simply written *Yitzkol Chagall;* Bella floats up from Marc's uplifted hand during a promenade; an auto-cellist plays on himself. All is besplattered with dots of varying sizes like stars of varying magnitude. The wise smudges, white spaces, and most of all, the line leaping like Nijinsky, then splattering away in a heap of hesitation, here sure, here obscure, create, as in the paintings, a world of perpetual metamorphosis: every form is on the verge of becoming something else.

But no matter how well his career was finally sailing along in Germany, he wanted to get back to Paris. And when unexpectedly after years of silence he received a letter from Blaise Cendrars, saying that the famous dealer Ambroise Vollard wanted to commission Marc for a big project, he decided to leave in the late summer of 1923.

As naïvely as he had previously believed in 1914 that to leave Russia all he had to do was buy a railway ticket for Paris, so now he ran into difficulties securing a visa. Marc and Bella Chagall were still Soviet citizens and as such were not allowed to enter France. The presentation of his 1914 certificate from the prefecture of police apparently convinced the officials at the French consulate that since he had once been resident in Paris he might now return there. The logic was as mysterious as all bureaucratic logic, but Bella's and Marc's visas were duly stamped.

On September 1, 1923, Chagall and his little family steamed into the Gare de l'Est in Paris to enter upon an entirely new period in his chromatic and choreographic life.

Part Six
France
1923-1941

He was thirty-five years old, in the middle of the journey. But his inferno and purgatorio were already behind him. The next eighteen years of Chagall's life were such an unclouded success—artistic, familial, financial—that the biographer is hard put to discover those germs of conflict, those abrasive cacophonies so essential for true drama. There is indeed little drama in beatitude, the only word to describe Chagall's life and career in France from 1923 to the outbreak of the war.

However, one must qualify, his personal joy was increasingly beclouded in the thirties by Nazi anti-Semitism with its repercussions on Jews everywhere. That Chagall, for all his egocentricity and commercial ambition, was not indifferent to stormheads rolling up from Germany is proved especially by the darkening tone of his paintings in the late thirties, and obsessive recourse to the Crucifixion theme.

Even the commencement of his happiest decade began with a shock.

As soon as possible after their arrival, he ran off to La Ruche to retrieve the paintings he had stored there seven years before, locking his studio with a twist of wire.

The wire was long since gone. The studio was occupied not by an artist but a poor pensioner moved in by the French government during the war. And all the paintings were gone! It was the second great blow since his exit from Russia. Forty oils and a hundred and sixty other pictures left in Germany; over one hundred and fifty at La Ruche; plus those which had been sold in Amsterdam in 1914 and for which he had not received a sou—his entire prewar *oeuvre* wiped out! He reeled with the shock of it.

In 1915 a government decree had ordered that refugees from the north of France be resettled in the by then largely deserted "coffins" and studios of La Ruche. Marc's old studio door had been forced, the paintings stored in an attic, from which subsequently over the next few months they disappeared. Chagall, who still flares into incandescence when he recalls this grievous greeting to his "true homeland, Paris," believed that his old pals at La Ruche simply helped themselves to the paintings and sold them when they needed cash.

According to Jacques Chapiro, a painter who lived at La Ruche during the war, the occupants began abandoning the great beehive with the outbreak of hostilities. All became dark, gloomy. Many foreigners returned to their homelands. Others enlisted in the French Foreign Legion. Some had left not because of the war, "but in order to further their artistic careers: Chagall, Fernand Léger, Zadkine, Lipchitz, Laurens." French citizens, of course, were called to the colors.

It is told that when a studio was thus abandoned by its tenant, Boucher would have the premises cleared out of all that it contained: all the objects, works, storing everything away elsewhere, sometimes in a corner of the deserted theater. Often the owners had simply abandoned their possessions to the grace of God and the risks of fate. Naïve as he had always been, Boucher counted on the idealism of others and the respect he thought people felt for artistic creations. Thus it was, writes Chapiro, that Chagall's canvases underwent the fate shared by all unclaimed canvases.

The concièrge of the compound—no longer Madame Segondet—not knowing how or with what she might cover a certain rabbit hutch which she had built, found nothing better than to utilize Chagall's works which seemed to her particularly suitable for her purposes: weren't these canvases impregnated with paint and therefore impermeable? Only many years later was it discovered where some of Chagall's pictures had wound up. Certainly it was an act of

vandalism due to the concierge's ignorance of their value or more simply to the scorn which she felt with regard to objects which in her eyes had no practical use. It must be added, continues Chapiro, that Chagall's canvases, which had submitted to this disrespectful treatment (being used as rabbit hutch roofing), hadn't suffered very much from it, thanks to the thickness of the linen and the fact that it had been tightly stretched on the frame and well nailed. That is, an ironic trick of fate resulting from Chagall's careful sense of craft. There is no means of checking the authenticity of Chapiro's report. But there is no question that the works had disappeared without a trace. The shock of his loss beclouded the joy with which Marc had returned to the city which he now felt to be his "true homeland." He even contemplated legal action and consulted a lawyer. But too many of his friends were involved.

Among them, unkindest cut of all, Blaise Cendrars. The poet, apparently just before he had entered the army (where he was to lose an arm), had signed his name to the certificates of authenticity on many of the canvases purchased in good faith by the critic Gustave Coquiot. Like most others in Paris during the war, Coquiot believed that Chagall had died during the Russian Revolution.

At any rate, Chagall broke abruptly with Cendrars. Accounts of witnesses vary about where justice lies. The episode is not even mentioned in T. Sestevens's biography of the poet. Indeed Chagall nowhere figures in this recent life by Cendrars's closest friend. Much of the book is a loving demythification, suggesting that the globe on which Cendrars trotted was mostly his own skull. Cendrars himself says almost nothing in his extensive memoirs about his youthful friend, the eccentric Russian whose zany images inspired him to zany poetry. A bitter reference ". . . that was when Chagall had genius, before the War of 1914"; an oblique slash at ". . . all those painters—millionaires today—who are still indebted to us, to *us*, poor poets—" these were the ashes of their friendship. For almost half a century the two men had no relationship, and grimly refused to discuss the cause of their quarrel. Then in 1960 just a few weeks before Cendrars's death, they met again through the intervention of Chagall's dealer, Aimé Maeght, for a brief and touching rapprochement.

So in bitterness and rage his second Paris sojourn began: his main body of work gone, wounded by what he felt was the treachery of his friends. Paris had changed, but so had he. The unknown Russian

youth was now a mature hard-driving man of thirty-six, with a world
of experience and achievements behind him: his name was known in
France, Germany, Russia; he was famous if not rich, and he had
accomplished a notable body of work, though much of that work had
vanished.

One of the major tasks therefore that he set about was to recreate
this work. Whatever time was left free from the graphics which
occupied him for the next two decades was devoted to obsessively
redoing the canvases that had been dispersed in Berlin and Paris.
Whenever possible he borrowed one of these early works from its
proprietor and copied it. Of course it soon became apparent that the
existence of a copy—even if somewhat varied—depreciated the value
of the original work; and some collectors and dealers refused to
permit Marc to copy their Chagalls. Katia Granoff, for example, for
three years his dealer, obstinately refused to let Chagall have her
'Chagall.' In such cases he employed photographs or worked from
memory to bring back to birth a lost painting. The more replicas and
variations appeared, the more appalled were many collectors of
Chagall.

This habit of recopying his old work became deeply rooted. In
New York City Mrs. Leah Goldberg, widow of a well-known
Yiddish journalist and daughter of the celebrated short-story writer
Sholem Aleichem, showed me a gouache which Chagall had given
her husband when he was in America during the war. "For years
after that, every time he visited our apartment he would offer to
make an exchange for that work. When I told him I didn't want to
exchange it, he became very pesty about it. . . ."

Claire Goll, who with her husband the poet Ivan (Yves) were to
become intimates of the Chagalls in France, describes in her recent
memoir Marc's return to Paris. Searching for an apartment, he came
to Goll and performed like a clown, his favorite defense against
malignant fate, fey, winsome, and weeping. "I am a poor painter, just
emigrated from Russia with his wife and child. I am not rich for they
have robbed me of everything. . . . I need only a tiny apartment, not
too expensive."

The only thing he never joked about, remarks Claire malignantly,
is money.

Goll asks Chagall why he failed to get receipts from Herwarth
Walden for the paintings he had left with him.

"Can you see me, me Chagall, a little Jew from Vitebsk, doubting the word of the celebrated Herwarth Walden, asking a big dealer for a complete inventory signed before a notary? We painters are satisfied when a dealer just bothers with us."

At which Goll remarks that because artists are humiliatingly treated like beggars during their early years, when they attain glory and success they take revenge "with a dry heart, . . . losing all pity and all generosity."

The Golls and Chagall talked about current trends in painting. Expressionist works were no longer in vogue; Picasso had returned to classicism; Derain, Vlaminck were also turning back toward traditional art. The bourgeoisie were tired of being mocked at.

Och, says Chagall, Cubism is finished. Expressionism is finished. It's necessary to find something else.

At that time, according to Goll, he lived near Place d'Alésia in a sort of garage. The first months in the City of Light were certainly grim. For a while the Chagalls occupied rather grubby quarters in the Hôtel Médical, 28 rue du Faubourg St.-Jacques, a surrealist combination of clinic and rooming house for foreign artists: supplementing with sick purses the quarters unoccupied by sick bodies. Finally, early in 1924 Chagall and his family moved into the studio of Eugène Zak at 101 Avenue d'Orléans where he lived until 1927. There it was that a lovely photograph was made in 1924: Marc elegantly winsome in a painting overall that looks like a blazer, leaning against his attractive Bella, herself resting a tilted knowing head on her arm; the child clutching a parasol. In front of the happy trio, gaily colored and striped and patterned, pillows and shawls are scattered. The happy trio is photographed against a background of some of Marc's great paintings: the *Praying Jew* (1914), the swooping *Birthday* and post-matrimonial *Poet Reclining* of 1915, a smaller gouache after the big oil *I and the Village,* a Russian isba in gray. Amidst this chromatic splendor the little family poses with nonchalant assurance; one feels that they are all content (even Ida, then eight years old) to be the Chagall family. They have arrived in *Geneden.*

Either out of naïveté or poetic innocence or a simple inability to anticipate Marc's volcanic reaction, Blaise Cendrars apparently had never felt any sense of guilt over his role in dispersing the La Ruche stock of Chagall, if indeed he was the culprit. At any rate, the fact is

that he had written to Marc in Berlin in an entirely friendly fashion, preparing his old friend, so to speak, for his reentry into the Paris art world. This particular letter informed Marc that Ambroise Vollard, the renowned art dealer and publisher, was anxious to meet him. Written not too many months before their quarrel, the letter proves that Cendrars still considered himself Chagall's friend and was eager to promote his interests.

This meeting with Vollard was to prove the spur to Chagall's amazing production in the field of graphics for the next decade. Vollard was a portly bourgeois gentleman whose somewhat grim tight-bearded mask concealed an altogether unpredictable sense of humor. He was avaricious as a Wagnerian gold-goblin, and combined total insensitivity to the persons of his artists with total sensitivity to their products both as art and merchandise. Shrewd, with a nose for the market, he had launched Cézanne, the Fauves, given Picasso his first show, bought out the entire studio of Derain and Vlaminck for a pittance.

Once before the war, Chagall had met him sitting like a goblin in his dark shop surrounded by his pictorial gold, and been frightened by him. An obsessive collector, by the time Chagall returned, Vollard like a miser was heaping up his house in the rue de Martignac and his shop on the rue Laffitte, with priceless works which he sold reluctantly, bit by bit, only when he needed money. Of course this tight fist on the tap simply resulted in making each drop more costly. Yet Vollard was not simply a speculator. Chagall himself says: "Vollard loved possessing with a kind of sadism. When you didn't work for him, he couldn't stand it. When you did work for him, he stored everything you brought him in his basement. He never even looked at the engraved plates which I brought him, one by one, as they were finished."

These were the plates for *Dead Souls* which finally amounted to 107 full-page etchings carried out between 1923 and 1925. Like other series executed for this strange man—the *Fables* of La Fontaine and the Bible—the plates were not actually printed until after World War II.

Chagall of course had always been a great black-and-white artist; and in his Russian phase had been part of what Aronson calls "the *Mir Iskusstva* of the Jewish artists," employing a bracing freedom from drab naturalism, and various Futurist devices to make revolu-

tionary propaganda—and incidentally great art. The turn to graphics therefore signalized by the etchings for *Mein Leben* in Berlin was a natural and easy development for Chagall.

The graphic media proved that Marc Chagall was born to cavort like a dolphin in acid or lithographic ink. *Dead Souls* was his first real experience in etching, since almost all of the *Mein Leben* prints were in drypoint. But whatever the graphic medium, he soon performed astonishingly in it. In his hyperbolic way, Chagall has said:

> From my earliest youth, when I first began to use a pencil, I searched for that something that could spread out like a great river pouring from the distant, beckoning shores.
>
> When I held a lithographic stone or a copper plate, it seemed to me that I was touching a talisman. It seemed to me that I could put all my sorrows and my joys into them . . . everything that has crossed my life in the course of the years: births, deaths, marriages, flowers, animals, birds, poor working people, parents, lovers in the night, Biblical prophets, in the street, in the home, in the Temple and in the sky. And as I grew old, the tragedy of life within us and around us.

If sometimes in painting, especially in the last twenty-five years, his boisterous fancy slips into tutti-frutti sentimentality, fairy-tale kitsch, Russian mother-gooseism, this almost never occurs in his graphics. The scraping needle of drypoint, the delicate furrow manipulated for poetic blur, the hatchings achieved with a burin, the tricky control of repeated acid baths and wipings, the scuffle and scubble and liquefication of *touche* on the lithographic stone—all these served to discipline, control, tighten Chagallian elfishness. The very resistance of these media firms his fancy, as he himself has recognized. Furthermore, the absence of color is a necessary restrictive element although later he was to demonstrate, especially in the *Circus* series, his skill in colored lithographs.

And just as the egocentric Chagall could not subordinate his scenic design to mere theatrical exigencies, so from the start he is never an illustrator of a text but a collaborator. Indeed this is even true of the *Mein Leben* drypoints, several of which have nothing to do with the text; and others, as I have suggested, are the progenitors rather than servants of the word.

In *Dead Souls* his vision takes off with verve and freedom from Gogol's text. One might say he uses texts—even the Sacred Scripture—as a trampoline to set him off on his own acrobatics. In that realm of graphics, to which he was to devote a major part of his efforts between the wars, Chagall proved one of the greatest artists of the century. The variety of touch, the supernal bursts of light, the odd spacelessness, the merger of folk crudity and naïveté with the most sophisticated technical resources—all these are employed not to illustrate but to re-create an autonomous pictorial world. He is a master of the incisively hesitant, the precisely dubious. His wit bites like acid. Chichikov with a kerchief bound around his cheek may suggest—even illustrate—a toothache. But the wild wiry coil of scratched line over his head *is* the toothache. We look at it and feel a dental drill. Gogol's account of Plyushkin's ubiquitous single pair of boots which all the servants had to use is hilarious. Chagall metamorphoses the boot into a Torah curtain on which his own name is written four times, forward, backward, in Hebrew, in Russian. Dressing tables rocket in an earthquaked world, discarded trousers are phallic tubes as are bedposts. Dots, scratches and scribbles summon up and extend Gogol's world of bought-and-sold dead souls, drunken landowners, and cockroached inns.

So Vollard, that sleepy fox, somnolently cunning, himself a character out of *Dead Souls,* buying up live plates which he stored in the cellar!

Although he had come "home" to Paris for good, he continued to reside in the inner city, Vitebsk. The cityscape of Paris becomes as familiar to him as that of his native town. And yet it remains the outer city. There is no true symbiosis, but rather extro- and introspective vision. Even later when he was in exile in New York, he declared that "it was almost Paris rather than Vitebsk which I saw in my dreams."

The "almost" is the infant hand still stubbornly gripping the maternal dug.

Yet joyful as he was to be back in France, to some extent the atmosphere had changed. The ebullience of prewar Montparnasse had now given way to a more hysterical postwar atmosphere. He could not introduce Bella to the Paris he had known before the war. That world had been destroyed by the war. Apollinaire was dead;

Max Jacob, a monastic clown, was hidden away in St. Benoit; Prince Modi was in the grave; now his old pal Soutine was the prince: monstrous Soutine who, thank God, was usually out of Paris, living for the most part in splendor on the Riviera, supported by his rich American patron Dr. Albert C. Barnes.

And despite his nonpolitical stance, events within the Soviet Union continued to affect Chagall's life, and not solely in the realm of ideas or emotion. For example, when he had left Russia, Kagan-Chabchay, whose collection had not yet been nationalized, entrusted to Marc's safekeeping all the canvases that he had bought from Chagall. This was to permit them to be shown in Paris. Soon after Marc's arrival the immigrant relatives of Kagan-Chabchay told him that he had authorized them to sell the pictures that he had lent Chagall. Marc had no choice but to let them do it. Then the Soviet state in the name of the heirs living in Russia seized the last canvases which had not yet been sold after the death of Kagan-Chabchay. These three pictures then remained under sequester more than twenty years while waiting for a decision by the court.

When finally they were placed on sale at the Salle Drouot the émigré heirs realized more than twelve million old francs, a good deal more than they could ever have obtained in 1922; Chagall had originally sold them to Kagan-Chabchay for the equivalent at most of several thousand franc notes.

The state of affairs in Russia intruded frequently into his French refuge. All through the twenties and thirties cultural commerce between the two countries was frequent; and Marc met again his old friend the actor Mikhoels, who came with Granovsky's company to Paris in 1927, and the director Meyerhold. Soon Ehrenburg had drifted back to his old haunts; he had readily become a master propagandist for the Stalin regime while in private expressing his scorn for the hog-butcher mentalities now controlling the Workers' Fatherland. From these visitors, Marc picked up scatterings of what had happened to the canvases he had left behind, some with friends, some in little collections. Often the owners had been reduced to selling them in the Moscow free market which is a sort of flea market. Other clandestine collectors grabbed a Chagall whenever they could. This was the period when George Costakis, the Greek collector, who has lived most of his life in Russia, was building up the world's greatest collection of "modern" Russian paintings, buying as

he himself has said: "this kind of art—including Chagall and Kandinsky ... at a very low price.... Here, [in Russia] their paintings were available, if you could find them, for $135 to $160. I found paintings in barns and under tablecloths, and I paid very little for them."

Costakis eventually built up in his own apartment a fantastic collection of 380 paintings from the critical years of the Russian avant-garde, 1910-25, including Wassily Kandinsky, Kasimir Malevich, Alexander Rodchenko, Vladimir Tatlin, El Lissitsky, Marc Chagall, Linbov Popovaetz. He owns about thirty Chagalls, including some of the most adventurous images of his youth.

All of this art of course was anathema to the Kremlin, especially after Socialist Realism became the official dogma during the years of Chagall's return to Paris.

So, in the depths of his consciousness, from the time he arrived in France for his second long stay, was the feeling that he had achieved a certain status in Russia, in Germany, in France; his own voice in the chorus of European art, yet he had almost no works at hand to prove it. This curious situation, to be famous and admired for a body of work mysteriously scattered about in Russia, Germany, Paris, Amsterdam—none or little of which he had been paid for, built up in him a new frenzy of painting. He had to, as Meyer says, "equip himself with what he felt was his own," that is, his own imagery, the imagery he had invented and to which he owed his fame. So began the fury of remaking, the recourse to photographs of his old works, borrowings whenever possible, replicas, slight or very free variations.

And hence too the fury with which he reacted to any artist who seemed to be intruding into his field. Thus it was with the amusing perambulating Russian Jewish artist Mané-Katz, who coming from a similar background (albeit in the Ukraine) and dealing with (on the surface) similar themes, proceeded to paint his Dufyish Jewish weddings and dancing rabbis by the hundreds, traveling all over the world to paint on the spot the sure-to-be-sold pictures to the resident Jewish community. Chagall hated this wispy funny witty little man; and hated even more to have his name bracketed with Mané-Katz's as a "Jewish painter."

The paintings which Chagall was to accomplish during this new French period are in general sweeter, more fluid, goodnatured rather than savage in their wit. *Ida at the Window* is an example of Chagall's

lyrical and happy state of mind. There are few distortions here, except the cloddish feet as if the artist wished to remind himself that even his lovely daughter had roots in the earth; these are peasant's feet. The child is oddly, almost aggressively, mature, frowning at the window. For the most part, the picture is a flowing vegetal hymn, all green and sunshine.

In 1924, the Chagalls celebrated their daughter's eighth birthday with a big party in their studio-apartment on the Avenue d'Orléans. The roster of guests is a clue to the circles in which the Chagalls already moved at that time: old Russian and new French friends and acquaintances, many writers, fewer painters. At the party were that explosive pair of writers, Ivan and Claire Goll; the collector and critic Gustave Coquiot; the painters Louis Marcoussis, and Robert and Sonia Delaunay; the ballet critic André Levinson and even Marc's old teacher Léon Bakst. Poor Bakst! Set aside by Diaghilev in favor of the more revolutionary Picasso, the ex-scandalizer who had once scorned Marc was now boasting all over Paris that he alone deserved the credit for Chagall's success. Also present was Marc's former patron Vinaver, now Professor of Russian Law at the Sorbonne. What pleasure and pride he must have felt to see how far his stipend had propelled the pink-cheeked young artist he had known and befriended in St. Petersburg.

Thus, like the Paris he had known before the war, the City of Light was again full of Russians. But this new Slavic contingent was unlike the old, more often politically exiled: very few of them felt that they would in time return to their homeland, serving once again as culture carriers East and West. These were the days when Russian princes began to drive Parisian taxis: hardly a cultural exchange.

For the second time, the encounter with France was a catalyst: precipitating a new burst of Gallo-Slavic images. Psychologically now he was in a calm after the storms of war and revolution; settled with his beloved wife and child; happy in a modest house and garden in the Bourgogne (after 1927), surrounded by legions of friends (mostly literary, to avoid the inevitable squabbling and competition so common among artists), the contracts from Vollard provided a steady source of income, and his paintings were now being shown at several galleries in Paris and London; in 1926 he had his first exhibition in New York City under the auspices of Pierre Matisse.

These are the years which found him driven, almost riven by a creative impulse that sought expression in an endless flood of pictures. Now he became acquainted with the French countryside, and began with his family to make a series of trips all over his adopted homeland. Unlike Picasso, sedentary, hating to move, Chagall is the typical wandering Jew: after three or four months of febrile production, he must seek inspiration in a change of environment.

The encounter with nature, rendered more direct by his sojourns in Brittany, Montchauvet, and Mourillon, is an authentic revelation: flowers and landscapes appear in his canvases as if caressed by the feathery vaporous stroking of the brush, in a harmony of pure delicate colors, bathed with transparent light. The simpler and fresher the theme, the higher is the pictorial quality, as in *Flowers in Mourillon* or *Ida at the Window,* already mentioned, where the dialogue linking the child to the landscape is intimate and spontaneous.

And of course he has not abandoned (nor is he ever to abandon) the Russian motifs which continue to be expressed either in new versions of old pictures or in the illustrations for the *Dead Souls* etchings. Certainly in these Marc replunged into his Russia; creating a stupefying gallery of characters which are not mere illustrations of the novel, but a novel in scratches, dots, exclamations, compositions often based on the armatures of Hebrew letters, a new novel in pictures worthy to be set alongside Gogol's, neither subordinate to the text nor indifferent to it: a dignified cousin relationship. Chagall's "illustrations" are the supreme example of his ability to create picture-poems. These are not literature, they are above all pictures in which the narrative has been transformed into the visual medium. Hence I would question the term "illustration" for Chagall's best work in this field. His graphics, beginning with *Dead Souls,* confirm that too much has been made of Chagall the colorist (not least by the artist himself) and too little of his endless inventiveness in black and white: his fusion of the naïvely literal (objects, ideas, emotions coexisting in the same picture-space, everything in literature finding its visual correlative, so to speak) and fluid nonrealistic composition.

So one *reads* Gogol; one *sees* Chagall. In both cases, one is immersed in a marvelous world of characters and situations bringing to life all that is pathetic, amiably ironic, humorous, humanly struggling in the Russian provinces.

From this time on, for more than a decade Chagall is a cornucopia

pouring forth an uninterrupted feast: all the themes of his preceding
production, those works long meditated, those experimented with and
worked on, those of Russian and Jewish and Parisian inspiration; in
this peak period of his art Chagall seemed to rediscover his entire
world with a new sensitivity, to resuscitate it exalted and decanted in
a new maturity of language.

Only the tediously teutonic need keep a bookkeeping record of
Chagall's astonishing fertility. These years especially, in brush and
burin, painting and plates, he gushed forth like an exploding geyser
an endless rainbow jet of images: a humorous scintillating gymnastics
of poses; rhythms now jerky, now melodic; characters of the circus,
equestrians, the young acrobats who had already interested him in
1914 and during the Russian period. Among the picket fences and
green meadows there still jut forth the saw-toothed roofs of the old
log houses of Vitebsk, or Mediterranean landscapes blazing in the
blasts of light. And always above Vitebsk or the Vosges, isbas or
Eiffel Tower, there are the intertwined Marc-Bella, that androgyne
soaring through all his dreamscapes. Enwrapped, enchanted, en-
twined they fly between heaven and earth, carnal lovers yet shaped
not of flesh but air, flame, luminous and irradiated in their embraces.
Erotic always, this twin-image glides for the most part successfully
between pornography and kitsch. Masses of flowers burst into flame
at their passing.

*

So, after seven years of war and revolution, the Paris to which he
had returned seemed to him Eden. Now here with wife and child, a
European-wide reputation (based on lost works) and a financial
position continuously made more reassuring by Vollard's commis-
sions and steady and continued sales, Chagall had returned to a Paris
still in the field of painting under the trinitarian domination of
Picasso-Matisse-Braque. The lesser figures—the so-called Ecole de
Paris (composed mostly of non-Frenchmen)—were in the next
decade or so to make their own affirmations. Among these the
Russian Jew from Vitebsk loomed ever larger.

In a sense postwar Paris was more likely to be responsive to
Chagall than the city he had experienced in 1910-14. For the Great

War, like all wars, had been an explosion of irrationality. Since the spectacle of millions of men butchering each other·for four years out of ambiguous motivations and for mist-shrouded goals could hardly be "explained" in any rational terms, and since words like "honor" and "glory" and "patria" had long been drained of meaning, the time was ripe for new affirmations: plunges into the subconscious or flights into the superconscious. A plunge into the dark slimy depths below the mind-illumined surface or a mystic flight above it. In postwar Europe the irrational made sense because nothing else made sense.

Hence in the Roaring Twenties the vogue of D. H. Lawrence's gush and spasms; Dr. Freud's marvelous tri-part mechanism of id, ego, and superego; Rudolph Steiner's astral planes; Hemingway's mystique of athletic mindlessness; T. S. Eliot's mitered and sceptered Wasteland; Henry Miller's phallic effusions and confusions; Ezra Pound's vigor without rigor; the cult of ejaculation as High Art. And hence also Cubism, which to Marc had always been too "realistic," too "physical," and which was certainly cerebral, had been blasted from its eminence by the war. In 1916, in Zurich the anti-rational revolt received explicit form in the very same café with the enlightened name of Voltaire which was the headquarters of Lenin and his Bolsheviks in exile. In that café at six o'clock in the evening on February 8, 1916, a Rumanian Jew named Tristan Tzara opened a Larousse dictionary at random to find a new name to christen his anti-literary anti-artistic anti-everything movement. He came across the word *Dada*, which to him meant nothing; soon there was a Dadaist bulletin in Zurich and later in Paris.

Such at any rate is the textbook tradition. Actually, as the poet Claire Goll correctly points out, "exact dates" of this kind are invented *ex post facto* by the professors: Goll, who was at the center of the Zurich art world at the time, says that Dada was only a peripheral trickle of the cultural whirlpool; its subsequent notoriety was due to the promotional genius of Tristan Tzara, later (like the French Dadaist-Surrealist Louis Aragon) to become an orthodox Communist.

In the French capital Dadaism soon attracted such writers as Philippe Soupault, André Breton, Louis Aragon (who became its leaders), with Paul Eluard, Drieu la Rochelle, Raymond Radiguet, Blaise Cendrars, Jean Cocteau more or less closely connected. Among the painters Picabia was the *enfant terrible* of the group and

published his own magazine wherein Marcel Duchamp improved the *Mona Lisa* by painting a moustache on that dewy, somewhat fatuous face.

"Dada doesn't mean anything" is the title of one of Tristan Tzara's famous manifestos. "The work of art is dead. . . . Logic is always false. . . . There is a great destructive negative work to be accomplished. . . ."

Apparently the Battle of the Marne had not been sufficient.

Another manifesto is entitled "Dadaist Disgust."

Everything produced by disgust capable of becoming a negation of the family is *dada;* protest with the fists of all its being in distructive action: DADA; knowledge of all the means rejected up to now by the bashful sex of convenient compromise and politeness: DADA; abolition of creation: DADA; of all hierarchy and social equation installed as values by our valets: DADA; each object, all objects, feelings and obscurities, apparitions and the precise shock of parallel lines are the means for combat: DADA; abolition of memory: DADA; abolition of archeology: DADA; abolition of the future: DADA; absolute and undiscussable belief in each god immediately produced by spontaneity: DADA; elegant and unprejudiced leap from one harmony to another sphere; trajectory of a word hurled like a sonorous sounding disk; respect all individualities in their folly of the moment; serious, fearful, timid, ardent, vigorous, decisive, enthusiastic; to strip its church of all useless stupid accessories; to smash like a luminous waterfall disobliging or amorous thought, or to fondle it—with the lively satisfaction that it doesn't matter—with the same intensity in the bushes, pure of insects for well-born blood, and the gold of archangels' bodies, for its soul. Liberty: DADA DADA DADA, a howl of irritated colors, an intermingling of contrarities and of all contradictions, of grotesques, of inconsequences: LIFE

The last phrase might be a description of one of Marc's paintings: ". . . irritated colors . . . grotesques . . . inconsequences . . ." and it is not surprising that he should have been courted by Dada's immediate descendants: the Surrealists. In 1920 the Dadaists had created a series of noisy scandals: poetic musical artistic demonstrations that fre-

quently ended in shouts, booing and culminating in fistfights, to the accompaniment of the new American jazz then invading Montparnasse, and the taxi horns that were to figure in Gershwin's *An American in Paris*. Nauseated by Western society that had demonstrated its civilization in four years of slaughter, disgusted by the bourgeoisie, these literary and artistic gunmen shot up the works in a France whose collapsing franc added a lacy financial fillip to the naked thighs which La Madeleine dangled in front of a horde of American exiles, some talented and others merely alcoholic, that soon became a familiar sight on the terraces of the Dôme and in the *boites* of Montparnasse.

This was the Paris to which Marc Chagall returned in 1923. Not a single name on his Valentine *Hommage* now figured in his life: two days before the Armistice, the dionysian Apollinaire had died during the influenza epidemic, probably aggravated by his head wound. Cendrars and Walden were now Marc's mortal enemies. Canudo had simply disappeared.

Marc had returned only three years after Modigliani's death. The beautiful Italian Jew had been buried at Père-Lachaise "like a prince" according to the instructions wired by his brother from Livorno; and on her return from the cemetery his pregnant mistress jumped out of a fifth-floor window to join her beloved Modi.

An epoch had ended: an epoch of incomprehension, poverty, hunger, desperation. Everything was rapidly changing: the myths, even the places wherein those myths took root and flourished. Montparnasse had now superseded the *butte* of Montmartre—the mount of Parnassus had superseded the Mount of Martyrs. All the leading Montmartreans had departed. Max Jacob had converted from Judaism to Catholicism and was now living in a Benedictine monastery at St. Benoit, his *laboratoire central* where he blended in retorts Mariolatry and farce:

> Il y a autant de boutons
> à la Robe de la Sainte Vierge ...
> autant que péchés sous ma veste.

Picasso was married to a young Russian ballerina, Olga Koklova, and had crossed over to the Right Bank, living the grand life there and at fashionable resorts in the Midi. He was now painting in a

neoclassical style which Marc found even less to his taste than the Minotaur's earlier Cubism.

New faces dominated the Montparnasse scene. The artistic and social center was the studio of Moise Kisling whom Chagall had vaguely met in prewar Paris. Like himself Kisling had arrived in Paris in 1910, a twenty-year-old Jew from Kracow, Poland. Son of a tailor, he could depend on a stipend of thirty francs a month, much of which he gave away to his indigent comrades. From 1913 on he had achieved success; the opulent nudes of his favorite model Kiki, sex-dolls colored like Polish wooden toys, were sensual, amusing, and popular; during the war he had enlisted in the Foreign Legion and become a French citizen. As before the war, his studio on rue Joseph-Bara was open day and night, where Kisling, fat and melancholy, reigned over a bedlam of models, painters, poets. Marc never felt at home there. He never felt at home anywhere except at home. And although in his own way, he shared the cult of Woman that dominated the Paris scene of the twenties, his aerial androgynes, even his marvelously strong portraits of Bella, had nothing in common with Kisling's pneumatic naked Kiki, or Van Dongen's *haut monde* ladies, long lean and languid under their gauzy gowns in a belated Art Nouveau style; or Pascin's melancholy fat whores drawn with incisive yet fuzzy iridescent pity; or the Japanese Fujita's Western nudes in Eastern colors; or Picasso's women, now warm billows, now a bear-trap. The dominant motive certainly was Woman, aristocratic or plebian, wife, model, prostitute, always naked even when she was dressed; always available and remote, naked idol, obsession, goddess. Much of the frenzy of Montparnasse centered around Woman: pursued painted possessed.

Marc felt out of this. Montparnasse had become noisy, vulgar, mirrored and electrified. On several occasions he visited La Ruche, still a center for artists, though on a much smaller scale. Climbing the circular ramp of the Rotonde again, peering into the "coffins," he remembered with an upsurge of bitterness the pictures he had left here. None of his fellow "bees" were buzzing around that noisomeness: but kids still played games in the scrubby wash-fluttering lots and there was no giant Léger to stand off the "killers" from the slaughterhouses which still stank up the neighborhood. Bulls, on the brink of slaughter, lowed their litany.

He had moved very far from this world.

Indeed everything had changed in Paris. The war was the Great
Divide. He went up to Montmartre to find that the Lapin Agile was
now a hutch of tourists. It had been supplanted by the more
bourgeois Dôme and Rotonde at the crossing of the boulevards
Montparnasse and Raspail. These cafés now became the meeting
place of all those without a country, exiles, fugitives, fakirs and
fakers: some few really working at making art and books, and a great
many playing at being painters and writers.

There was a desire—a need—to live at any price; to seize the
moment. The Roaring Twenties were slipping into high gear. To
the pop pop pop of Fitzgeraldian champagne corks, the flapper
decade zoomed on to the crash of 1929; after which the Americans,
dazed and disillusioned, picked themselves up off the lonely sidewalk
cafés and stumbled back home, while the French and the neo-French
(like Chagall) withdrew into the bomb shelters of their craft and
parceled their purses. The thirties were to be a grimmer decade,
shivering with depression and heading toward war. One decade ends
with Wall Street brokers falling faster than their stocks from
skyscraper windows. The next ends with the metastasis of Nazism,
irrupting into Poland. And these were precisely the decades of Marc
Chagall's greatest triumphs. In the twenties he sings his love songs
against encroaching financial collapse. In the middle and late thirties
his palette darkens, his bouquets wither, he paints the Jew on the
Cross.

But in 1923, there was an air of general absolution, of plenary
indulgence. Everybody came to Paris, the capital of Everything, the
place where everything was permissible. Even the *peintres maudits*
were selling. To patient and somnolent art merchants like Vollard
who was accused of storing his pictures in the cellar like rare wines,
or to pathetic desperate merchants like Zborovsky (good angel to
poor Modi). Or to characters like Guillaume and Rosenberg (sharing
the name Paul but otherwise competing), who combined a taste for
culture with a nose for business; and other picture dealers who bereft
of the former were well endowed with the latter. And certain picture
speculators like Cheron, who boasted that he had bought only those
painters quoted at low prices: Modigliani, Fujita, Utrillo, Soutine . . .
recommending them without false modesty as good investments.

Everybody was buying pictures in Paris in those days. Even police
functionaries among whom was the Commissaire Zamaron who was

to become famous for filling the walls of all the offices at the Police
Préfecture with paintings which he had patiently bid for at café
tables or from behind his desk at the Commissariat. And now along
came the American collectors, steaming in to the rhythms of Negro
jazz and Gershwin—most dramatically the great American collector
Alfred C. Barnes who was to rescue Soutine from poverty and add a
grotesque snobbism to the other grotesqueries which Chaim already
possessed. Just a year after Chagall's return, Barnes, looking for
"geniuses," was recommended by his dealer Paul Guillaume to the
Galerie Zborovsky. Zborovsky showed the American works by
Derain, Utrillo, Kisling but Dr. Barnes, who had made his fortune by
inventing Argyrol, a medicine for the protection of the newborn, was
looking for a newborn genius whom he could invent. Finally he
picked up a dusty Soutine abandoned in a corner.

"Have you others by this artist?" Enthusiastic after seeing other
Soutines, he cried: "Why here is the genius I've been searching for
all these years!" and purchased one hundred Soutines on the spot.
The collector of course wanted to meet the artist. After a frenzied
search, Soutine was finally discovered waiting for a handout on a
bench in front of La Rotonde; immediately he was bundled into an
auto and presented in all his redolent rags to the good doctor, who
smiled benevolently, sent Chaim off for a bath, had a suit made for
him by an English tailor, and finally installed him in a rented villa in
the Parc Montsouris where Braque, Lurçat, Fujita, and Chana Orloff
were already living. Soutine refused to pay the rent although he had
already received money for it from Barnes. He was afraid of
spending his unexpected fortune.

Once rich, Soutine never saw his old friends again. Marc met him
once four years after he had struck the Barnes Eldorado. He found
him even more intolerable than before, now that he cleaned his nails
and gave himself the airs of a grand seigneur. Indolently fingering his
flowered silk tie, he denied to Marc that he had ever been born in
Vilna. Chana Orloff reports that Soutine told her that he had entirely
forgotten Russian, he had blotted out Smilovitz, Vilna, even La
Ruche. Chagall cherished, nurtured, even rainbowed his Russian
Jewish past; Soutine tore it up as savagely as he had slashed his
unsatisfactory canvases.

How painful it must have been for Marc Chagall to share a show
with his antithesis in 1945 at the Institute of Modern Art in Boston:

"Soutine and Chagall"—which might perhaps have been subtitled: Blood and Bouquets.

Paris in the twenties was crucible, seedbed, showcase, caravansary, culture capital of the Occident. Ideas, personalities, events are interwoven and leap like the shuttle of a loom, spurred by a continuous new influx of personalities, ideas, events.

If one merely scoops a thimbleful out of the ocean of arts foaming in Paris in the years immediately preceding Chagall's return, one might have a feeling of the cultural density of the medium in which the now twice-exiled Russian Jew was to steep himself. In 1920 there had appeared the first volume of Proust's *Le Côté de Guermantes;* Dufy made the lithographs for the Madrigaux of Mallarmé, and the scenes for *Le Boeuf sur le Toit* by Cocteau (if Chagall's grandfather could munch a carrot on the roof, why not a bull on the roof?) with music by Darius Milhaud, one of the "Six"; Tzara arrived from Zurich; Picabia published a Dadaist journal entitled *Cannibal.* Man Ray, Max Ernst, and Duchamp appeared in a Dadaist show which ended in a hail of hurled tomatoes.

In the following year, Fujita began to attract much attention at the Indépendants show; Matisse utilized Moresque and Oriental motifs; Marie Laurencin illustrated Gide; Ernst showed his collages for the first time in Paris; Picasso and Larionov did sets for Diaghilev's Ballets Russes; Léger for the Swedish Ballet; Proust published two more volumes of his centipedalian *A la Recherche du Temps Perdu.*

The following year Benoit and Goncharova did sets for the Ballets Russes; Max Ernst definitely shifted his headquarters from Cologne to Paris, and in collaboration with the poet Paul Eluard, published two books.

And in 1923, the year Chagall arrived, several of Picasso's monsters burst like nightmares out of his neoclassical dream; the Dutch abstractionists of the De Stijl group were shown; Man Ray produced a Surrealist film; Diaghilev produced Stravinsky's *Les Noces;* Léger designed sets and costumes for Milhaud's *La Création du Monde* presented by the Swedish Ballet.

The Paris of the beginning of the century, that of the *buttes* of Montmartre, of the Cité Falguière, of the Bateau Lavoir, of rue Ravignan, of Utrillo, Modigliani, the first work of Van Dongen, of

Picasso and his band of picadors had offered everyone adventure, promised them glory, and given them poverty.

The Paris of the twenties, that of Montparnasse, still offered adventure and promised glory, and to many—including Chagall—also gave them riches.

Thus, as before the war, they streamed back to Paris from all over the world: from Spain and from South America, from the Nordic countries and in greater and greater numbers from the ghettos of Eastern and Central and Balkan Europe: Fujita, Pascin, and Kisling were still there; Kremegne, Mané-Katz, Puni (now Pougny), Kikoine, Chana Orloff, Larionov and Goncharova, Naum Gabo and his brother Pevsner, Zadkine were back, as were Lipchitz, Tchelitchew, Sert, Gargallo . . .

Marc hated the newly restored Dôme and Coupole, glittering with electric bulbs and tourists. Obsessed with his work and now that Bella was with him, he ceased for the most part frequenting his old cafés, especially after he had moved to the Boulogne, an hour trip from Montparnasse.

For a while he did continue to meet old friends and acquaintances regularly at the café Parnasse; but purely social excursions into the city became more and more rare. Edouard Roditi describes Chagall presiding over a sidewalk café session during those years:

> I had met Chagall the first time toward 1930 at a table of the Terrasse of the café du Dôme at Montparnasse. That evening he was in the company of an entire group of artists and intellectuals from central and eastern Europe. If my memory does not betray me—but perhaps I have merged into a single evening my recollections of two or three meetings of that period—Chagall was accompanied by the sculptor Ossip Zadkine, the Yiddish novelist Sholem Asch, the Soviet publicist Ilya Ehrenburg, and the German cinema and theater producer Erik Charell, celebrated at the time for his *Auberge du Cheval Blanc* and his *Congrès s'amuse*. There were also others at that table where they were speaking Russian, French, German and Yiddish. I only remember in all that coming and going some of the celebrities who at the time had dazzled my twenty years.

Although Chagall was not to become actively engaged in theater design again until 1949 in Mexico, he was by temperament and by the nature of his art, very much in vibration with the theater-oriented Paris scene. For his paintings had been related to theater even before he had been a working member of the Moscow Jewish troupes. Every painting is a *performance*. And this not in the sense of the Renaissance "box"—the canvas as a miniature stage set—for Chagall instinctively violates all of the "laws" of perspective so arduously elaborated from Paolo Uccello on. His painting is a performance not in the sense of being a setting for the "real" world, but in positing a new reality. The paint leaps and gestures, the colors dance and mime, the pictorial elements are themselves dramatic.

This overflow of the arts—synaesthetics—into supertheater was a logical culmination of Baudelaire's "Correspondences" and Rimbaud's colored vowels. Thus Stravinsky ironizes against

> those who listen to music with their eyes closed, without participating in the movements of the executors. The sight of the gesture and the various parts of the body which produce it, is an essential necessity if one wishes fully to grasp the music. ... Music has need of an intermediary, an executor. And since this is an inevitable condition, without which music cannot reach us, why ignore it or try to ignore it, why close one's eyes before this fact which is of the very nature of musical art?

Why close one's eyes? And so the theater now with its music, its scenography, its costumes, its dance, its mime, its literature became the grand convergence of all the arts of the epoch.

Wagner's Bayreuth had been of course the glutinous affirmation of supertheater. But marinating in Teutonic mysticism, this had swiftly degenerated into a nationalistic-sexual-religious cult: the visual (and olfactory) elements serving primarily as *Vorspeise* for the grand seduction: the Master in silk robes waving a phallic baton in his incense-drenched Jugendstil bedroom; the Lady: huge, slugwhite, Valkyrian, swooning on a bearskin. Most of the audience kept their eyes closed during the Liebestod. Naturally.

Between the wars then, those hilarious and brazen years broken clean across the spine by the stock-market crash of 1929, the theater

played the determinant function in the evolution and promulgation of new aesthetic ideas. In Paris especially it served as the catalyst of difficult combinations. Directors like Jacques Copeau, Charles Dullin, René Clair; companies like that of Georges and Ludmilla Pitoëff; but particularly personalities like the indefatigable Diaghilev of the Ballets Russes and from 1920 on, Rolf de Maré of the Swedish Ballet.

The theater was the place of live contacts. All those new modes of representing the world of reality which might seem bizarre, grotesque, distorted on the walls of a gallery became tangible in the magic of the stage. Even those critics who were reluctant to accept, or outrightly antagonistic to the new pictorial ideas found them palatable, even pleasurable, when they were bodied forth as stage design, costume, lighting in a total theatrical experience. The theater drew the artists and their works out of isolation. Thus the theaters, the new cafés: the Sélect and the Coupole; dancers like Isadora Duncan; actresses like the divine Sarah Bernhardt; models like the superabundant Kiki, painted so often with voluptuous strokings of the brush, especially by Kisling; singers like Mistinguette and Chevalier; the choreographer Balanchine; the black pearl Josephine Baker—this was Paris between the wars. By the thirties a stream of German intellectuals poured into Montparnasse: anti-Nazi writers and artists, mostly concerned with securing visas to the United States. Meanwhile they sat at café tables, lamenting their past glories, unknown to the franco-centered French even when their names were Brecht, Piscator, Heinrich Mann, Ernst Bloch. They added a lugubrious current to the Parisian whirlpool.

Calling the roll of all these names of the twenties and thirties one is struck by the internationalism of it all: what Chagall was to call a "caravansary." In his lifetime he had experienced three such places and periods: Berlin immediately after the First World War, Paris between the wars, New York City during the Second World War. Out of such cauldrons, such anguish and exile arose most of the great art of the twentieth century: that most Irish Joyce in Trieste, Zurich, Paris; that most Russian Stravinsky in Venice, Paris, New York; that most Spanish Picasso in France; that most Viennese Schönberg in California; that most Russian Jewish Chagall in France, in Berlin, in the United States. Surely in our global village, national and ethnic purism is as mythical as the Aryan race, absurd as Hitler's moustache. Yet the paradox persists: globalism, expatriation, exile,

deracination frequently result in intensifying a certain savor, a unique cultural flavor.

*

In 1924 Dada was reborn under a new name: *Surrealism*. The name had been discovered in the writings of Guillaume Apollinaire; hearing this new hullabaloo Marc could not help but recall the poet's exclamation of "Supernatural" when confronted for the first time with Chagall's paintings. Most of the former Dadaists participated in the new movement and contributed to a periodical entitled *La Révolution Surréaliste*.

Basically, Surrealism, for all its stress on automatism, the free flow of the subconscious, is Dada fitted out with a philosophy. Artistic anarchists incongruously organized . . . against order. Dada was non-sense: Surrealism is nonsense taking itself seriously. Dada died laughing. Surrealism became a church, its pope, Breton, issued bulls, hurled anathema; as in all churches heretics inevitably arose; challenge became schism, and Surrealism dissolved in a fury of splinters.

Dada had poked fun, outrageously dropping its drawers right in the face of the bourgeoisie. Surrealism also flaunted its pudenda: but delivered solemn lectures about the significance of these folds, hollows, and protuberances. A literary movement above all (as was Dada) led by André Breton and Louis Aragon, Surrealism presumed to be a new transcendentalism, exploring by means of hypnotic or *pensée onirique*—dream language—or automatic writing the realms below (or above) the conscious. For its dive into the subconscious Surrealism borrowed the psychoanalysis of Freud, for its new discoveries of dimensions beyond realism it presumed to be applying in the arts Einstein's relativistic physics.

Certainly many of the values expressed in Breton's *Manifesto of Surrealism* (1924) had long been manifested in Chagall's art. With the Surrealists he shared a distrust of excessive reliance on the rational (hence his objection to Cubism), on physical realism, or abstract intellectualism, a faith in intuition, a giving over of oneself to the nudges and suggestions of the subconscious, a conception of the artist as divinely seized rather than cerebrally directed, a sympathy with primitivism, folk art, children's art.

So it was not surprising that the Surrealists, employing as their proselytizers Max Ernst and especially Paul Eluard, the poet who was a good friend of the Chagalls, and his wife Gala, sought eagerly to have Chagall publicly declare himself in favor of the new cult.

But he refused. Always suspicious of "movements," or programs, groups, his essential loneliness had been reinforced by the collectivism he had experienced in Russia. Furthermore, Chagall's irrationalism was a natural growth: it was Dostoevskian and it was Chassidic. Whereas the Surrealists, for all their stress on the irrational, were in the purely French tradition rebelling against the excessive Cartesianism of French culture in a very French way: by issuing reasoned manifestos against reason, à la Henri Bergson, the philosopher who had demonstrated with impeccable logic the limitations of logic.

What is more, Marc was in utter disagreement over the Surrealist emphasis on "automatism." For although he employed images which welled up obsessively and hallucinatorily from his subconscious, his *organization* of these images, their disposition on the canvas, the precise degree of saturation in color, the stippling and dappling and manipulations of the "painting skin" calculated to achieve the exact kind of epidermal spatial tensions he wanted—all this involved a highly conscious series of *choices.* Thus the raw materials, so to speak, of his images may have spontaneously presented themselves, but he *made* his pictures. The notion that a picture or a poem could automatically create itself was nonsense to Marc Chagall. Profoundly he felt this was a demeaning of the role of the artist. A painter of dreams does not dream as he paints.

Thus his childlike images are never childish, his naïveté is sophisticated, his primitivism is highly cultured because he "works" it into a plastic structure. Hence his fury at those who consider him "literary"; and the Surrealists' approach to the plastic arts was primarily literary.

Chagall's refusal to join their ranks led almost immediately to attacks against him as a "mystic"—which perhaps he is but which has little bearing on his qualities as an artist.

Chagall has described himself as "an unconscious-conscious painter."

Our whole inner world is reality, perhaps even more real than the apparent world. To call everything that seems to be illogical

a fantasy or a fairy tale is to admit that one does not understand nature.

In fact, Chagall's instinct to keep himself apart from any schools was profoundly correct. His art differentiates itself completely from the symbolist current which spread all over Europe at the beginning of the century. All of these movements leaned on a literary or mystic-philosophical culture. Chagall never sought a symbol *a priori* to make use of it. The symbol rather grew in his hands at the very moment he was struggling to give form to some image flickering in his mind. His colors and shapes and perspective are symbolic and evocative not according to a pre-established scale of significances, but with reference to the real object which has evoked in the Chagallian eye this particular emotion. In some sense, he was always relating to a "real" world if only to fly out of it. But the substratum of realism is there. His unique symbiosis of symbolic realism had manifested itself as early as the *Death* of 1908. Every element in that work—the characters, the sharp foreshortening, the objects—is derived from daily life, the life most familiar to the artist; yet the atmosphere palpitates with mystery, the figures are disposed according to an artistic inner logic rather than to a Renaissance convergence grid (the perspective is *instead of* rather than *as if*); everything pulsates with the mystery of death, that ineluctable destiny, a grief that is almost comic: the absurdity of our end: to be placed in a box and have heavy dirt dumped over one.

Another difference between Chagall's fantasy and that of the Surrealists has been sharply stated by Roy McMullin:

> The typically Surrealist picture space is not governed by the presence of a specific dreamer; it implies instead that it is intended to be perceived through the eyes—from the psychological point of view, that is—of a spectator out in front of the canvas. In other words, however many symbols of a presumed unconscious it may contain, in spatial terms it is more theatrical than dreamlike.

Certainly Chagall's dream pictures are not theatrical representations. One doesn't look *at* them, one creeps into them. The pigment skin is organic, inviting touch; the spaces are prehensile: they seize

and devour, the artist has often said that if there were a hiding place in his pictures he would slip into it, and the spectator is invited to do just that. That this *participative* vision—vision that is always urging itself to tactility—can be combined with the necessary distance of irony and humor—a marked component of Chagall's art—is some kind of a miracle.

Furthermore, this creeping into the pictures, this participation, so to speak, with the very pigment, with the substance, makes for a second paradox: that an art so very "physical" expresses the spiritual; "thinginess" is at the service of mysticism; tangibility incarnating the intangible.

In all this certainly Marc Chagall is in the tradition of a mysticism not transcendental but immanent, pantheistic, permeated through and through with the divine.

One can understand the painter's deep-rooted refusal to be categorized a Surrealist, as in Germany he had refused to be categorized an Expressionist, or to be neatly placed in any of the boxes that swirled like coffins in the whirlpool of the Soviet Union.

Only in 1945, re-editing his *Surrealism and Painting,* did André Breton (then, like Marc, in exile in the United States) publicly acknowledge the injustice of his anathema, hailing Marc's work as "The triumphal appearance . . . of the metaphor in modern painting. . . . No work was ever so resolutely magical. . . ."

Breton's observation is just, but requires differentiation. *All* art is metaphor; *all* art results from transformation of the real. What sets off Chagall's pictorial metaphors from, say, Soutine's is that the former explicitly violate "common sense," the latter stretch it to the breaking point.

Chagall's metaphor expressed his life not in the simple one-to-one sense of reflections in a mirror, a painting journal. But like Picasso (with whom he has otherwise very little in common) the *formal* qualities of Chagall's imagery are more significant of his psychological state than the separable content of those images.

Thus we can see in the steady stream of "happy" pictures that flowed from his brush all through the twenties not only a secure mastery of his craft, but a quiet sense of having arrived in harbor, galleons full. The main subject of these years is love: love for Bella, for Ida, for France, for flowers, for the art of painting. Now too the circus—love reflected in a distorting mirror—begins to appear, partly

because Vollard had a season box at the Cirque d'Hiver and was shrewdly enticing Marc to eventually do a series of lithographs which were to eventuate in the Vollard *Circus* series of 1927. Partly also, because the circus was a lovely place to take his daughter. Marc was as childishly delighted with it as Ida. The distortions, the violations of normalcy, the clowns (Was he not himself a clown with his grimaces, pale cheeks, flicking movements?), the equilibrists, flying angels, pathetic monsters—all these creatures seemed to have crept out of Chagall's pictures into the ring. They were naturally Chagallian. To divest them of Vitebsk greatcoats and peel onto those lean shanks the particolored hose of the equilibrist; to take Grandpa off the roof and balance him on a high wire—all this was easy Chagallian magic.

After all, had not his Vitebsk Academy been a circus? Nathan's storming of the Winter Palace? His experiences at La Ruche? His wedding?

Besides, Chagall is a strategic clown. He cultivates the white powdered gamin face, the unexpected swift dancelike movements, he looks not infrequently like Charlie Chaplin or Harpo Marx. He enters a room swift as a fawn, parries direct questions with uplifted eyebrow and witty sarcastic deflection, he is as hard to pin down as a Chassidic butterfly.

Distrusting logic and coherence, he coherently employs illogic in defense as a shield. He guards his world by pretending inconsequence; he is a calculating mystic, a mixture of Mithnaged and Chassid, of the rule of law and the virtues of lawlessness, of conservation and abdication, of head and heart.

His painting during that halcyon decade—dancing at the edge of an abyss—tended to become more fluid, the colors sweeter, the contours softer, the rhythms more feathery. The Cubist grid softens, wavers, disappears. In certain gouaches, even in the astonishing ever more subtle graphics he was steadily producing then, line gives way to a cloudy nuance, statement to suggestion. One might say Chagall is moving into a Verlaine kind of image-making with his dots and dabs, omissions, suggestions. . . .

Thus as he swiftly mastered etching, engraving, lithography, he began to bend these graphic media to his own more pictorial purposes. The gouaches for the *Fables of La Fontaine*, with which he

was concerned from 1925 on, are more painterly than the *Dead Souls* etchings.

Even the *scandale* over Vollard's commissioning of a foreigner, a Russian Jew, to illustrate that classic of French letters, La Fontaine's *Fables,* served to magnify Chagall's fame. The fuss over assigning La Fontaine's moralizing bestiary to Chagall was first aroused by the exhibitions of the gouaches. But so chauvinistic was postwar France that the affair was even debated in the Chamber of Deputies where Chagall was characterized as a "Vitebsk sign painter."

Vollard, who had a literary itch, replied at length and with quiet wit to all these attacks, pointing out that the *Fables* being of Oriental origin: Aesop, Arabian, Persian, even Chinese sources ". . . gave me the idea that an artist whose birth made him quite familiar with the magic of the Orient could not but produce a plastically sympathetic rendering. . . . Now if you ask me: 'Why Chagall?' my answer is, 'Simply because his aesthetic seems to me in a certain sense akin to La Fontaine's, at once sound and delicate, realistic and fantastic.'"

In preparation for the *Fables,* which he felt had to be drenched in color, Marc and Bella spent much time during 1926 and 1927 in the countryside at Mourillon near Toulon and later in the Auvergne and a first trip to the Riviera where they stayed with Georges and Marguerite Duthuit-Matisse. The sapphire (as yet unpolluted) Mediterranean, the brilliant blossoms which Bella brought home from the market, the presence of barnyard animals which reminded him of Vitebsk—all this was necessary silage for his bestiary, even though his original notion of doing the *Fables* in brilliant-hued gouaches transcribed into colored graphics proved a failure, and he had to redo them all in black and white. These plates also were buried away in Vollard's dusty basement with the other *Dead Souls,* not to be resurrected till many years later, after the war. Even before their completion, Vollard with the intuition of genius had already proposed that Chagall do illustrations for the Bible, which was to prove his masterpiece in the field of graphic art.

In general, one might say that during the twenties his paintings— unlike his etchings and engravings—tended to grow sweeter, more content with themselves, a certain fuzziness crept into them, a weakness of structure, a plastic and compositional sogginess close to sentimentality: too many lovers were now reclining in too many beds of flowers. But these kitschy lovers were soon to be startled out of

their rainbows. From the thirties on, the Nazis goose-stepping steadily on toward another world war, the rising tragedy of the Jews, harshened Chagall's colors, stiffened his lines, brought body again into pictures that were threatening to become* amorphous, mere exercises of a too expert hand.

But as yet the brown cloud was still on the horizon. The explosions of the twenties were not bombs but champagne corks. Never had he known such success. He could not keep up with the commissions pouring in. Dancing toward the abyss, everybody seemingly wanted a Chagall picture. The first retrospective exhibition in Paris at the Galerie Barbazanges-Hodebert in 1924 was followed that same year by a big show in Brussels at the Galerie du Centaure, and in successive years by exhibitions in New York (1926), and eventually a great retrospective at the Kunsthalle in Basel, Switzerland (1933). By that time Marc Chagall was considered one of the leaders of the School of Paris and participated everywhere in collective shows as a French artist.

Immediately after his exit from Russia began the first publications of what was to prove a gusher of monographs and articles on his art, initially in Germany, then in Paris: Th. Daubler (1922), K. With (1923), Boris Aronson (about which I have already spoken, 1922), Lichtenstein (1927), André Salmon (1928), Waldemar George (1928), Paul Fierens (1929), R. Schwob (1931). Special issues of art magazines were devoted to him. His secure position in the art world of Paris was succinctly summarized by the formula: "Picasso is the triumph of intelligence, Chagall the glory of the heart."

*

Among the literary friends frequenting the Chagalls during those halcyon years was the poet Jules Supervielle. One July day in 1931 he brought along with him a young (but already famous) Spanish poet named Rafael Alberti.

That summer afternoon at the Chagalls still glows in Alberti's memory as if he had strayed into a pagan Eden, a bucolic idyll out of Theophrastus.

I interviewed the poet in 1976 in his apartment in Rome near the Via Giulia, the Arch of the Portuguese Ambassador, the ancient

quarter in Trastevere where another Raphael (the Renaissance artist) had once set up his mistress, the Fornarina.

One entire wall was lined with knickknacks, shells which the poet's wife, the actress Maria Teresa, collects; many Picasso drawings inscribed to Rafael and Maria Teresa; lithographs by Miró, portraits of Picasso and Neruda. The baronial sunbathed room was floored in blue Spanish tiles ("They were here when we took the apartment!"). Alberti, well into his seventies, spoke in a lively youthful manner Spanish-tinted Italian—*como* for *come, yo* for *io*—while his wife attended with a faded flowery noctambulist air, a sweet vagueness.

After the Spanish Civil War, when Alberti's poems were carried in the knapsacks of Republican soldiers, the poet had dwelt in exile for a quarter of a century in Argentina, and now ten years in Rome.

Still vivid as an orchid in this thicket of memories is his first encounter with Chagall:

"It was the first year I had come to Paris—1931. I was a friend of Jules Supervielle who was very close to Picasso and also to Chagall. In fact he had dedicated some poems to Chagall. And he had great admiration for him. One late afternoon he brought me to Chagall's lovely little house with a pavilion and a garden.

"It was about five in the afternoon. There was still sunshine and shadow in the garden where Chagall was painting his beautiful daughter Ida completely nude in the woods under a tree."

Alberti's eyes grew misty.

In 1931 Ida was fifteen. Undulant, full-figured, she had reddish hair, her father's green-blue eyes, a ravishing smile.

"Oh, that girl was so beautiful it was a spectacle to see her under the trees that way. Certainly there was nothing erotic about it, nothing improper. One saw her as a model—perhaps too young—posing for her father. And her father had no false shame about it and neither did she. . . ."

Chagall laughed, Alberti remembers. "He was a bit pagan, you know, a bit of a fawn, a satyr. He certainly wasn't religious in any sectarian sense. No. He was a man truly open, free. He just laughed."

Alberti spoke about the famous photograph published in *Cahiers d'Art* showing the adolescent girl posing nude for her father. "Oh, he did that purposely. It created some scandal but Chagall didn't care; he just laughed."

(I thought of Aronson's remark about a similar photograph of a six-year-old nude Ida published in Berlin, and wondered whether this would have created a scandal in the Berlin of those days!)

Alberti visited five or six times that summer, at first with Supervielle and afterward alone. Two years earlier, the Chagalls had bought the little house which was on the estate of the Villa Montmorency; at that time many Russians resided in the neighborhood and Marc and Bella felt very much at home there. Thus Alberti encountered the Chagalls at one of the happiest periods of their lives. The poet felt an immediate sympathy for the painter. "I am an Andalusian and we have a certain joking character, not always *allegro,* dark at the root perhaps, but still we laugh. And Chagall was a good Slav: ironic, very amusing, always caricaturing himself as well as others. We took to each other right off."

He was obviously taken with the daughter as well from the moment he had seen her *au naturel* in the garden. "Ida had a great sympathy for me and I for her and we became good friends. Every time I visited, she was very sweet, very tender."

As Chagall cavorted, mimed, performed in his Chaplinesque way, Alberti was aware, always in the background, of Bella "a small woman, dark, with a bird profile, very sweet, very lovable."

"Did she speak much?"

"Yes, she spoke. . . . But look, Chagall was completely absorbing. He took over. Only *he* spoke. He made jokes. All kinds of things. And then because it was summer, we had tea in the garden, that classic Russian tea that they drew from the samovar, everything Russian. Marc and Bella spoke French but with a strong Russian accent. . . ."

The friendship continued over the next few years until Alberti and his wife returned to Spain at the outbreak of the civil war. The poet had met the painter "in his golden age": Chagall was in his early forties, robust, vigorous, successful, at high tide in art and life.

"He liked very much to play the actor, a bit like Picasso. In fact he did it better than Picasso. Oh, Picasso was a very good actor. But Chagall had a certain sense . . . the perfect timing of a comedian. Very amusing. And he did all sorts of things. Put on moustaches. Improvised skits in the garden. Whatever came into his head. Like his paintings. And everybody laughed. I never heard so much laughter.

"All this left in me a memory so beautiful that it was never

cancelled by any other image. For me, all my life Chagall was that garden, that first afternoon with the nude girl, his facility in joking, in improvising scenes as if life were a *commedia dell' arte*. That was Marc Chagall in the flush of his youth, full of invention."

An article by Alberti published in *El Sol* (Madrid) on August 2, 1931, celebrates this first encounter:

> When, accompanied by the poet, Jules Supervielle, we entered the house of the painter, Marc Chagall, we noticed that a cow had opened the door. Within, cows everywhere: on the wardrobe, on the dining room table, on the windowsills, on the books. . . .

The artist, too, Alberti thought, with his "green luminous eyes" was like an Andalusian bull. Chagall tells him that "the frozen moon of Russia is full of cows." They fly from the "humid and snowy stables" down the Milky Way. There were blue cows in the Caucasus, and during Christmas in the Crimea promptly at midnight the cows rang the bells in the belfries.

According to Alberti, Chagall recounted how "the innocent people in Russia," celebrated the birth of the "Baby God" by wearing horns. One wonders whose horn was being pulled.

Chagall sees cows and bulls reflected in his tea. They pursue him in his sleep. He sees them ascending elevators, coming down chimneys, atop the Eiffel Tower, strolling down the halls of the Louvre.

> Yes cows cows everywhere. People do not exist in the world. Only cows. . . . In fact, at that moment a cow with green eyes stepped out of a Ford and crossed the garden. "Muuu" I said, shaking her hand. She mooed melancholically.
> —Vacas, vacas, vacas, nada ma' que vacas.
> —Si, es verdad.
> —Vacas.

That article, said Alberti, "was a scene inspired by his paintings. All the people in the garden that day became cows or horned bulls. Everybody. Ida, Chagall, Supervielle . . . animals flying. . . ."

Obviously the mode of Surrealism then dominant in literature, as

well as Alberti's native tradition of bullfighting, also helped create that taurine bovine bucolic afternoon.

Alberti had come to Paris the previous year with the actress Maria Teresa (later to be the directress of agitprop theater in Spain during the Civil War). At that time they were studying avant-garde theater groups in France. Then they went to Germany at the frightful moment Hitler came to power.

When Alberti returned to France there were new shadows in the garden. Soon the Spanish Civil War was to break out. He saw Chagall several more times before returning to Spain. I asked Alberti whether during all those years of their friendship, Chagall had ever spoken of his political experiences in Russia, or indeed of politics in general.

"No. This was a calm period for him. He was still young. Younger than Picasso. In the full tide of his golden years. His Russian experiences were very far away. He was already a very great success. To me Chagall seemed a Russian fawn. He was beautiful. Astonishing eyes. I never thought of him for a moment as Jewish. Instead, his wife, with all her expressiveness, had something different, more inward, somewhat dryer, much less extroverted. While Chagall was very extroverted. He did all the talking. We would arrive and he would start right off, telling us all sorts of stories, most amusing inventions. Those visits were lots of fun.

"Instead, his wife was, yes, very lovable, smiling . . . but somehow more serious, somewhat dryer. As for the daughter, well, she was just a girl at that time. She poured the tea. She laughed at her father's jokes. She obviously admired her father very much. And her father had a great admiration for her. That garden. . . ."

Alberti could tell that Chagall was an artist by his Russian expression. Profoundly Slav. Those eyes. Everything. His character. "Because whenever I am with Slavs there always comes a moment when one doesn't understand anything and I always say '. . . Sont les mystères de l'âme slave.' I always used to say that to Ilya Ehrenburg, who was a great friend."

Although the poet and journalist had already met in Spain, Alberti doesn't recall ever seeing Ehrenburg at Chagall's during those years. Once Henri Michaux, the poet-painter, was there. This introduction also came through Supervielle, who was Alberti's closest French friend. And it was Supervielle who introduced Alberti to Picasso, both Andalusians meeting for the first time in 1931.

When I asked Alberti if Picasso had ever come to Chagall's house, he smiled:

"No. I don't know. . . . But I don't think so. You know how artists are . . . they're so terribly jealous of each other. Their mentality is a bit *asiatique.*"

And were writers more benevolent toward each other?

"Oh yes. Writers are more benevolent. . . . At least, they're capable of seeing you. . . . But afterward, they're more perilous than painters. Because when they write! . . . And I write and I paint! . . . I limit myself to that garden, that impression of freshness . . . of youth that Chagall had . . . that springtime. In that silent quarter of Paris."

He recalled that Chagall gave him a dedicated copy of *Ma Vie,* the French version of his memoir published in 1931, and he was struck by the fact that the so-Russian Chagall should have written that the Russians would never understand him but that Rembrandt would. "Naturally, since he was also a Jew."

"Rembrandt wasn't a Jew."

"He *wasn't?* . . . But all those Jews he depicted? . . . All those Old Testament scenes?! . . ."

I pointed out that Rembrandt, with historical sense unusual in painters, populated his Biblical scenes (both Old and New Testament) with "Jewish characters" he found in the ghetto of Amsterdam, although the ambiance remained Dutch and the artist remained a faithful member of the Dutch Reformed Church.

To add to the poet's ethnic confusion, the atmosphere in the Chagall household was "fundamentally pagan, Bacchic, joyful . . . there was none of that sadness so many Jews have . . . that feeling so deep . . . so dolorous. . . . The Chagall I saw under the trees with his hair flying . . . that poet so fawnesque . . . so genial . . . there was nothing Jewish about him. . . .

"Only his wife Bella was more serious. More melancholy. And she dressed a bit like a lady of the last century, all swathed in a long silken shawl, like a bullfighter's veronica . . . very curious . . . the sort of thing one sees in portraits by Goya."

*

In the spring before Alberti's visit, Chagall made his first trip to Palestine. Although Chagall says the immediate spur for this voyage

was Vollard's contract to illustrate the Bible, it would be more correct to say that the contract was an excuse. Surely Chagall did not need field observation to accurately depict the Holy Land.

And the shrewd Vollard knew it. "Why not the Place Pigalle?" he remarked dryly when the artist told him of his plans to visit the Holy Land to soak up atmosphere for the Bible illustrations. Putting aside the malicious import of the dealer's remark, the fact is that Chagall's Biblical scenes bear as little relationship to real place as the Italian settings for annunciations and crucifixions by Renaissance artists.

But now that he was considered one of the leading artists of the School of Paris, and could count upon a good steady income from his contract with the dealer Bernheim-Jeune, the wanderlust which had already taken him all over France had stirred in his essentially restless nature a desire to travel.

In 1924 the Chagalls had gone to Normandy and Brittany, in 1925 to the Ile Adam on the Oise and Monchauvet.

Almost all of 1926 they were away from Paris: at Mourillon near Toulon and in the Auvergne as well as Nice; in 1927 again to the Auvergne where Bella and Ida recuperated from an attack of blood poisoning. That autumn Marc took a motor trip with Robert Delaunay, in an open Willy's Overland convertible, wearing according to Sonia Delaunay ". . . three outfits one on top of another. . . . He had jammed a fur toque onto his wiry hair, giving him a somewhat ambiguous appearance and causing him to be taken for Robert's wife in hotels along the way." In 1928 and '29 he had explored the Pyrenean coast, looking as he did now on all his trips, for a piece of land on which to build a house . . . which he never did.

This restlessness was to continue for the rest of his life. Unlike the sedentary Picasso, Chagall is the wandering Jew. After three or four months he feels a need to change place, see new sights, hear new sounds. The effect this has on his art is rarely descriptive of course, but one can discern varying intensities of light and sea, densities of earth and foliage in his painting as he wandered about the French provinces from 1924 to 1931. He never returns to the realism which dominated his work for a brief period on his return to Russia. Paradoxically many of these paintings inspired by primitive hamlets, shabby farmhouses surrounded by chickens and barnyard animals remind him of Russia, as did the snow in the mountains of the

Vosges in Savoy where he returned quite regularly winters. But Russian or French in imagery or light, they are never landscapes, always "inscapes." The particular flavor of that inscape has perhaps been determined by the experience of a landscape. But the relationship is indirect, at most, cousin. Similarly, Chagall never goes for a walk without carrying with him small pocket sketchbooks in which he scribbles, seemingly looking all the time. What is in the notebooks rarely has any relationship to what he seemed to be looking at. For this kind of artist the visual is essentially a trampoline.

Thus all the talk about the "light" of the Holy Land infusing a new light into Chagall's gouaches or the Bible illustrations is hardly convincing. Chagall's "light" is strictly interior; the light that never was on land or sea. A similar judgment could be made of the critical writing on the effect of Chagall's voyages to Greece in 1952 and 1954. These are alleged to have resulted in a new sparkling Hellenic light but one may find exactly the same light in Chagall's works accomplished long before those voyages.

But the psychological effect of the Palestine trip cannot be underestimated. Although Chagall certainly knew that he did not "need" the Palestine trip to "document" his Bible etchings, he felt intuitively that such a visit could not help but be inspiring to the images already bubbling in his mind. Besides, although he had never been a Zionist, he had always remained very much a Jew, and followed avidly in the Jewish press and through personal contacts the drama of national resurrection already under way in the Holy Land. There is no reason to believe that Chagall's knowledge of the Bible was (or is) particularly profound. He was familiar of course with the stories, the prayers, the commentaries, the traditions, as much and no more than any Jewish lad raised in the Eastern European Pale. His boyhood command of Hebrew had been just sufficient to recite his Bar Mitzvah and ask the Four Questions at the Passover ceremony and avoid getting rapped on the knuckles by the old-fashioned *cheder* teacher. Despite Zachar's orthodox frequenting of the synagogue, undoubtedly abetted by a desperate need to spend at least some hours of his miserable life in a loftier ambiance than a herring warehouse; despite the year-round ritual of religious holidays followed by his family (poetically described in Bella's *Burning Candles*); once young Marc began to frequent the enlightened Thea Brachman circle in Vitebsk, and especially after his Petrograd and first Paris experiences,

he typically shed whatever ritual habits he had acquired and certainly never followed religious law or attended synagogue. Like many of his generation of Russian Jewish youth, some by ·way of Socialist or other political affiliation, some by way of literary enthusiasm, some by way of nonreligious Zionist nationalism, he (and Bella too) slid comfortably into a fundamentally secular way of life, no matter what folk patterns may have tinctured his Russo- and now newly acquired Francophilia. Virginia Leirens recounts that during his American exile, Chagall was prevailed upon once by his close friend, the Yiddish writer Joseph Opatashu, to attend synagogue on the High Holidays, but he never went again. As for his "mysticism," "religious sense," that is another discourse entirely, a question of temperament, not creed.

At any rate, the portly dealer's mockery did not dissuade him. Early in 1931, Chagall with his wife and child set off on this first of what were to be many long trips abroad in the 1930s. The trip lasted from February to April. On board the SS *Champollion* they encountered the famous Hebrew writer Chaim Bialik and Edmond Fleg. Stops at Alexandria, Cairo, a visit to the pyramids, and Beirut, lent touristic glamor to the voyage. And the reception they received when they finally arrived in Tel Aviv overland from Beirut proved an unexpected triumph. A guard of honor consisting of a fire brigade—the only uniformed Jewish "soldiers" the authorities could muster in the British protectorate—greeted them at the railway station. The mayor of Tel Aviv, Meier Dizengoff, had met Chagall the year before in Paris and had invited the artist to come to the Holy Land for Purim to lay the cornerstone of the new art museum.

Marc and Bella were entranced with Palestine. The brilliant light, the panorama of Jerusalem viewed from the Mount of Olives: the sepia crenelated walls of the Old City crowned by the gold and silver mosques, the purplish undulant shadows of the Judean desert, the idealism and courage of the pioneers, the *chalutzim.*

And in the small town of Tel Aviv clustered around café tables, sipping hot tea from glasses through a dice of sugar held between the teeth, wrangling over politics or cultures, he rediscovered much of his old Vitebsk. The majority of these early waves of settlers had come from Eastern Europe, especially Russia and Poland. They spoke Yiddish as well as (and usually better than) Hebrew! At that time there was still a strong Yiddish artistic and literary movement in Palestine. Yiddishkeit still affirmed itself against the attacks of the

Hebrewists who considered Yiddish a shameful heritage of the *Galut* or Exile. Hence, despite his strong identification with Russian culture and his top strata of French, Chagall felt very much at home in Palestine.

At that time there were very few painters in Israel; and certainly the first three waves of the *aliya* (immigrants) had not carried art collections with them. There were brawny-armed pioneers who looked upon the art of painting pretty much as had the local commissars in Vitebsk. Even though Marc had been invited to lay the cornerstone for a museum, most Jews in Mandate Palestine had other concerns on their minds. At any rate, he experienced none of the annoyance he was to feel on his next visit, twenty years later, when he furiously rejected being hung on the same wall with Mané-Katz or Reubin Rubin as a "Jewish" artist.

During this visit he did some *pleine air* painting (rare for him) on windy barren hillsides, or in the lavender Judean desert outside of Jerusalem, the wild *chamsin* blowing his abundant ringlets. A photograph of 1931 shows him staring somewhat grimly at the camera, an unaccustomed hat drawn tightly down over his ears, against the background of a white Arab town, a single cypress on a rocky hill, the canvas almost blowing off the easel. He had hung his harp on the willows of Jerusalem. The bright crystalline atmosphere, a line of Bedouins leading pendulous camels near the Dead Sea, the golden sunbaked bricks of Safed—everywhere he saw—rather envisioned— Elijah, David dancing, Jacob sacrificing, Rachel at the Well. As in Vitebsk *his* reality soon superseded the evidence of his senses. So for Chagall Palestine was the Holy Land of his dreams populated with Biblical characters rather than with Zionist pioneers, Arabs, British police stations, an explosive raw political state in the making.

And although the inevitable challenge was put to him by fellow Jews from Vitebsk and Vilna, from Bialystok and Dvinsk: "When are you coming to stay? Why don't you settle here? This is *our* land. This is where you belong. You are not a Russian. You are not a Frenchman. You are a Jew. Within a few years, the British protectorate will be lifted, removed. Then this land will be ours juridically. Come. This is where you belong," he was not tempted. His career was in France. His future lay in France. His true homeland was where he could best make and sell pictures. *Ubi bene ibi patria.*

Bella also felt the Zionist tug, perhaps more than he. Frequently

during that visit Marc became aware of a deep undertow in his silent Bella.

In addition to the bony landscape which he found as attractive as good bones in a woman's face, Chagall did some paintings of synagogue interiors in the Galilee town of Safed and in Jerusalem.

The *Synagogue at Safed* in the Stedelijk Museum in Amsterdam (1931) is, in many ways, outside of the Chagallian universe of topsy-turvy. It is rather a straightforward, if Expressionistic rendering of the whitewashed-walled interior of a little synagogue with the major attention, of course, lavished on the Ark: three red accents against the overwhelming swiftly brushed warmish whitish gray. The tones are pure, the colors clean, the sunlight glaring.

There seems to be something incongruous in the notion of so sunny a space serving religious meditation. Religious architecture in France, England, the north generally, and by extension the United States, has habituated many of us to the notion that gloomy interiors are propitious for bars and churches, assignations and meditations are best served in shadow.

Even so-called Italian Gothic—such as Santa Croce in Florence or the cathedral in Milan—seems in the rational light suffusing those spaces to be thoroughly untranscendental, of this earth, despite certain upward thrusts of the architecture. Similarly, religious structures such as the Blue Mosque and Hagia Sophia in Istanbul are flooded with light. Indeed, in these cases, the mysticism *is* light. "... the vaulting is covered over with many a little square of gold from which the rays stream down and strike the eyes so that men can scarcely bear to look," wrote the poet Paulus on the occasion of the dedication of Hagia Sophia in AD 532.

Thus, "light like the radiant heavens ..." is by no means incompatible with mysticism. Conditioned by Gothic gloom, we tend to find the very notion of a sunny religiosity as somehow heretical. Yet sunny religiosity is precisely Chagall's brand. The Chassid dances, sings his praise of God. In this respect the noncultist, nonpracticing Chagall is Chassidic. Later when he turned to stained glass he discovered the perfect medium to express his religious sense: light and color emanating from within.

By 1932 Chagall had completed thirty-two plates of the Bible etchings. Two years later Jacques Maritain published an essay on the

Genesis cycle (forty plates) in *Cahiers d'Art.* When Vollard died in 1939 just before the outbreak of war, Chagall had finished sixty-six of the plates. A batch he had started working on that same year were to be interrupted by more than a decade of war and exile; he was not to resume work on these until 1952 when he was again back in France. Thus the entire series, finally totaling one hundred and five etchings, was not completed until 1956, and published by Tériade the following year.

The Bible (more strictly the Old Testament) series set the final seal upon Chagall's stature as a printmaker. Long before its publication, he had become a complete master of various graphic techniques, which he expectedly manipulated to serve his own purposes. He added drypoint or aquatint to etching to lend a "painterly" look to his engravings. He liked the artisan atmosphere of printshops, and got along well with the master craftsmen. He swiftly appropriated for his own usage those techniques which he needed, and just as freely rejected traditional practices which were of no use to him. Although Chagall is undoubtedly one of the greatest technical masters in twentieth-century printmaking, he never fell into the trap which printmaking seems to set, more than any of the other visual arts, for its practitioners: his poetry is never swallowed up by technology.

Although now and again, as in *Jacob* and *Rachel at the Well,* one sees Bedouin types such as Chagall undoubtedly saw in Palestine, or Palestinian backgrounds—David's Tower and the walls of Jerusalem in the marvelous light-flooded *King David* engraving—most of the patriarchs and prophets reside in Vitebsk. With all the Chassidic swirl of luminous angels (in the *Vision of Elijah*) or the four beasts seen by Ezekiel, these Biblical visions are entirely of this world; they are poetic not mystical renderings of reality; there is nothing transcendental about them. The magnificent *Lament of Abraham for Sarah* is Chagall's memory of a mourner in Vitebsk, translated (as he had in his early painting *Death*) into his own peculiar style. The statement here is made entirely in a dramatic contrast of blacks and whites, the white horizontal rigidity of the corpse against the black vertical mass of the mourner. The ground is scratched in a spiderweb of cross-hatchings; the plate has been reworked dozens of times, drypoint scratches with a needle added to the acid-bathed burin engraving to achieve luminous tones within the gloom, bursts of light as in Abraham's beard, and in the clumsily eloquent hands covering

the weeping face. This grief is not simply that of Abraham, of any old Vitebskite. The earthen mass of the mourner lends monumentality and universality to the image: it is everybody's grief. And throughout the series—in the awkwardly drawn upper arm of the curiously naïve *David as a Shepherd Boy;* in the calculated clumsiness of hands, especially; in violent slants of light and the superimposition of irrational crisscrossed spaces—one feels again that Chagall has applied the entire battery of twentieth-century visual technology to a temperament like that of Sassetta, the fifteenth-century Sienese artist who also created lofty religious poetry out of folk materials.

A year after the Palestine trip, Marc and Bella visited Holland. Considering that the name Rembrandt was "a household word," as Raphael Soyer puts it, among almost all Jewish artists, it was a voyage *en famille.* A Chagall self-portrait of 1909 depicts himself wearing the same type of beret that Rembrandt wore in one of his youthful self-portraits. And now, like the venerated Dutchman, Marc was also illustrating the Bible—with "Jewish" characters!

Several years later the Chagalls went to Spain, in 1935 to Poland, in 1937 to Italy. Thus, established as an artist, and financially secure (even after the crash of 1929), Chagall traveled regularly within the confines of his adopted country, and every few years took longer trips abroad.

From these years also—the late twenties and early thirties—date Chagall's close friendships with many of the leading French poets and writers, including Paul Eluard and Jules Supervielle. I have already mentioned Jacques Maritain, into whose circle Marc and Bella were introduced by René Schwob, who wrote a book at that time entitled *Chagall et l'âme juive (Chagall and the Jewish Soul)* in which incessant agitation and a dream of collectivity are set forth as characteristics of this particular brand of soul.

From the late twenties until the war, the Chagalls and Maritains became very close friends, meeting regularly with the circle of writers, artists, and converts who gathered around the Catholic philosopher at Meudon every Sunday afternoon. The fact that Maritain's wife, Raissa, was of Russian Jewish origin undoubtedly helped draw the two couples together. The book that Raissa subsequently wrote about the artist *(Chagall ou l'Orage enchanté,* Geneva,

1948) is, like its poetically perceptive title, *The Enchanted Storm,* a compost of incense and insight.

The book carries this poem as epigraph:

> Chagall est venu à grands pas
> De la Russie morose
> Il a dans son bagage
> Des violins et des roses

"Chagall has come with great strides" (the familiar pun on his name) "from morose Russia, bearing violins and roses in his baggage." Raissa asks Marc what struck him most at first contact with Impressionists, Fauves, Cubists. *"Their realism,"* he replies at once *sadly.* ("Melancholy," in Maritain's little book, is an inevitable attribute of the Jew.)

"All these conceptions seemed too terrestrial. . . . I want to concretize in a human manner man's impotence before nature. I do not seek to wreak vengeance but establish an effort parallel to nature. . . ."

Here Chagall's odd formulation reveals an intuition felt by all true artists: one doesn't imitate Nature. One competes with her.

As for Jewish melancholy-in-the-blood, Maritain soon contradicts herself when she lists Chagall among the rare painters of joy. Pure joy—not pleasure, laughter, irony—but pure joy is rare in painting. Rubens, Renoir, Chagall: the first two: realists of joy; Chagall: the surrealist of joy.

"One could say of Rouault that he is the painter of original sin. But the universe created by Chagall ignores sin, it knows nothing of hatred and discord; it bespeaks grace and joy, fraternity and love. . . ."

The world's grief is also present under the signs of a grave and melancholy contemplation; but the symbols of consolation dwell always with it. If there is a poor man in the snow, at least he plays a violin. If a Rabbi holding the Torah in his arms is plunged in a doleful dream, the presence alongside him of an innocent white cow expresses also the tranquility of the universal. . . .

In a Chagall gouache of *The Descent from the Cross,* one of Christ's friends, who helps take him down, has a bird-head. This, according to Raissa Maritain, stands for the "universe of innocent beings."

Raissa had married Jacques when he was still a student at the Sorbonne. Jacques was a cradle Catholic who had fallen away from the faith; Raissa was a Jewess. Born in Russia at Rostov-on the-Don, she had come to Paris at the age of ten and was now very French indeed and a very devout and practicing Catholic.

Five years before Chagall's first arrival in Paris, Raissa and her young husband had read Léon Bloy's *Le Salut par les Juifs,* whose central doctrine is a development of Paul's remark in his Epistle to the Romans IX:5: From the flesh and blood of the Jews came Christ; that is, *Salus ex Judaeis est:* Salvation comes from the Jews. So affected were the Maritains that they paid for a new edition of Bloy's book which was dedicated thus to Raissa (before her conversion!)

A
Raissa Maritain
Je dédie ces pages
écrites à la gloire catholique
du Dieu
d'Abraham
d'Isaac
et de Jacob

From June 11, 1906, when Raissa and her husband were baptized together with Léon Bloy as godfather, in the appropriately named church of Saint-Jean l'Evangéliste, in Montmartre, the Maritains were indefatigable proselytizers for the Roman Catholic Church. They were in touch with many of the great names of French art and letters: Raissa's fellow convert Max Jacob ("souffre-douleur de génie . . ."), the religious Rouault ". . . similar to certain of his pierrots or clowns: long ivory-pallid features . . . a bit melancholy . . ." (and one might add, jealous that the Bible etchings had been assigned by Vollard to the Jew Chagall); they were to convert Pierre Reverdy and Jean Cocteau, who wrote to Maritain: "A priest has struck me with the same shock as Stravinsky and Picasso. . . ."

But apparently the Maritains had no effect on the Chagalls' "Jewishness"; Marc and Bella were never to join the procession of French intellectuals whom the Maritains led to the confessional. That Marc was always scornful of "Les juifs assimilés" did not in any way

seemingly affect his friendship with the pious Maritains. Even before Jacques wrote about Marc's Bible etchings, and Raissa published her perspicacious yet sentimental *Enchanted Storm,* the philosopher was to engage in amiable theological controversy with the painter. In 1929, responding to a provocative statement by Chagall: "I am not and I have never been religious," Jacques Maritain replied, "Chagall knows what he is saying but perhaps he is not aware of the implication of what he is saying. Saint Francis could have taught him, just as he taught the lark."

To which Marc might have replied (but didn't): "Yes, but the lark sang the same song even after Saint Francis preached to him. Saint Francis didn't teach the lark to sing."

Considering their triumphs as proselytizers, Chagall's charm must have bedazzled even the Maritains from recognizing that he was taking them in most of the time. The subjectivity of witnesses is evidenced by Rafael Alberti's stress on Chagall's "paganism" at the very period when Jacques Maritain is projecting the image of Marc as a religious mystic despite himself.

This close association with the French literati led to the new French version of *My Life.* First André Salmon was entrusted with the translation from the Russian text but failed, according to Bella Chagall, to capture the very personal idiom of Marc's fable-auto-biography; Salmon's version was "too French." In close collaboration then with her husband, aided by Ida's French teacher and the advice of other friends, a French version was finally achieved. The first edition, published in 1931 by Librairie Stock, listed Bella as translator, with thirty-two of Chagall's Berlin etchings included, and an introduction by André Salmon, declaring that Chagall is untranslatable, that his Russian is not true Russian, and that the French version would probably offend purists. Of course, even if Salmon's admission was made out of injured pride, to admit that a text is untranslatable is to define it either as nonsense or as a poem. Of this first Stock edition, 1,607 copies were printed. The fact that a second edition did not appear until 1957 simply indicates that Chagall's drolleries in autobiography failed to attract as admiring an audience as his more significant pirouettes in painting. Subsequently, Hebrew, German, Italian, and American editions appeared.

Although the entire work had been published serially (1925) in Yiddish in several issues of *Die Zukunft,* New York, no Yiddish book

publication has yet appeared. More than a hint of Chagall's ambigu-
ous relationship with Yiddishists is suggested by this surprising
lacuna.

*

In 1934, Ida, eighteen years old, radiant and curvaceous, blue-eyed
and charming, married Michel Gorday, a young lawyer also of
Russian Jewish descent, not much older than his budding bride. A
beautiful ambiguous painting resulted from this wedding of the
Chagalls' only child: *The Bride's Chair.* The scene depicted is simply
a white-shrouded tall, rather regal armchair with the bridal bouquet
resting in its lap as if the warm occupant had just departed, leaving
her spray as a memento. To the right and left of the armchair are
heaped bunches of white roses. A warm brown rug leads the eye
obliquely from floor to the portentous chair and up the wall. On the
white linen tablecloth, far left, a three-armed silver candelabrum with
one lighted candle, next to it another pot of white flowers embedded
in green leaves. Above the table Marc's painting *The Birthday,* as if
to pass on to his beloved daughter as *envoi* his own felicitous
marriage.

Reality would seem to be quite straightforwardly depicted here;
for Chagall surprisingly straightforward; it's a real room, and all the
furniture stands on the floor, if somewhat atilt. But for all its realism,
there is certainly ambivalence here: to paint a *nature morte* for so
living an event! Considering that marriage is a rite dedicated to the
continuation of the race, the dramatic ban of all living human beings
(unusual in Chagall) from so ostensibly celebratory a picture is
revealing of the artist's deeper feelings. There is indeed a funereal air
in this wedding picture: a sense of desertion, loss, almost death. An
Italian critic speculates that in the Vitebsk of this childhood, Chagall
had become conditioned to the association of white on occasions of
penitence and grief (the rites of Rosh Hashanah and the fast of Yom
Kippur). But I would say that she pushes her symbolism too
selectively here: the same white prayer shawls are also worn in the
synagogues on days of rejoicing such as Purim. The fact that white is
". . . in the Far East the color of mourning" is a farfetched compass
reading both geographically and symbolically: Chagall is hardly a
Chinese.

Similarly I would reject as too narrow her Freudian reading of the candelabrum with one lighted candle adjacent to "... the tiny head of the central bulb projecting from that little body with curved rising arms" and her Jungian reading of the "collective unconscious of nuptial grief" which this critic finds in both Chagall and Stravinsky's *Noces.*

With all that, the atmosphere of the picture is less one of celebration, joy than solitude, grief.

Undoubtedly, Ida's wedding must have reawakened memories of his own wedding: the opposition of Bella's family, the Sanhedrin waiting for him in the bride's house. "It seemed to me that if they had placed me in a funeral parlour, my lineaments would have been more relaxed, less rigid, mask-like than the mask which was seated alongside my future bride. . . ."

The same choice of white to signify grief appears in *White Crucifixion,* painted in 1938, the first of a new series of crucifixions entirely different from the few he had earlier essayed. For crucifixions such as the *Golgotha* were less iconographical than decorative; they were part of Russian folklore; they helped set his Slavic scene rather than evoke emotions.

But the crucifixions Chagall was to paint increasingly and obsessively over the next decade were explicitly intended to arouse emotions. The central symbol of Christianity is employed to cry out the artist's anguish over the Nazi persecution of the Jews.

In 1935, at the invitation of the Jewish Institute of Vilna, Chagall and Bella went to Poland as guests of honor. Vilna was only two hundred miles from Vitebsk. Thus, from a safe distance and through a juridical corridor he could draw nearer to his hometown and yet remain far enough away to preserve its mystic contours in his head. Once again the ambiguity of his Russianism peers through the gesture. For had he been willing to accept the Stalin regime, a return to his "beloved" Vitebsk would not have been impossible. But already in 1933 he had applied for French citizenship. The matter was still undecided. For, when the French authorities discovered that the applicant had once been a commissar in the Soviet Union, his request had been left hanging in the balance. No matter that poor Chagall's "commissariat" had been in the field of art, in Vitebsk! Uncertain of the nature of his pro-Russianism, French authorities were suspicious. And in the Soviet Union, the question was undoubt-

edly raised, now in the era of Stalin: Why would one who loved his Vitebsk so much have applied for French citizenship? Why didn't he simply return to his native homeland? No, he preferred loving it from a safe distance.

Indeed, in 1934, a year after his application, Chagall wrote the poet Brodsky: "The title 'a Russian painter' means more to me than any international fame. . . . In my pictures there is not one centimeter free from nostalgia for my native land."

Are we supposed to take this seriously? Artists not infrequently are the least reliable geologists of their own terra incognita. Thus in a letter Michelangelo asserts that his chief motivation for painting the Sistine vault was for the "honor" of his "family" and "to set his brothers up in the wool business"; no more believable than other assertions by the artist that his chief motivation was an assignment from the pope which he could not refuse, and eventual payment of 10,000 ducats.

Motivations lie in layers like archeological strata. Despite his ringing declaration, Chagall is no more a Russian painter or a French painter than a Jewish painter. He's a Chagall painter.

Such juridical floating may have been perfectly consonant in a Chagallian pictorial universe, but it hardly soothed his state of mind. World events had darkened notably since Hitler's accession to power. The Germany where he had been hailed as precursor to Expressionism was already removing his works from the walls and burning them as "decadent Jew art."

In Poland Marc and Bella visited the Warsaw ghetto; there they heard and saw premonitions of the holocaust to come. But once in Poland, signs of racial tension and brooding violence manifested themselves.

Marc and Bella were shocked to see respectable Polish citizens attack the son of the great scholar Dubnow, calling him a "dirty Jew." The sounds of Yiddish, the cantillation of Chassidic chanting, the sights of Polish Jewry in their long black caftans and bobbing earlocks, the contrast between the rich Jewish bourgeoisie of the big cities, and the poor Jews in the *stetles,* vividly replunged the Chagalls into the world of their youth. In Vilna Marc painted the interior of the synagogue, perhaps stimulated by a desire to "document" what he already sensed would soon be destroyed forever: the old country of Eastern Jewry. A similar motivation may have suggested to Bella on this trip the memoir of her childhood that she wrote in 1944 in

Yiddish—the language of her childhood but one which she and Marc as typical Russian intelligentsia almost never used in their domestic discourse. On this trip friendships were initiated with several Yiddish writers—the poet Abraham Sutzkever, the critic Talpiel—which were to be resumed in 1952 in Israel. One could say the Polish trip strengthened the Yiddish component in Chagall's Russo-Franco-Yiddish amalgam.

Another picture painted at this time depicts a Jew praying in front of the Ark: his head bent as if in sorrow, he cradles with pride, close to his chest, the Scroll of the Law. Everywhere on this trip, Marc and Bella became aware of growing tension.

Some critics have discerned a gradual darkening both of theme and color in Chagall's works in the thirties, corresponding to the darkening of the international situation. But a close examination of Chagall's output during these years makes this one-to-one thesis a bit too simple.

That the growing repressions of the Jews in Germany, the Stavisky affair and the Popular Front agitation in France, the outbreak of the Civil War in Spain, the anti-Semitism Chagall had personally witnessed in Poland—that all this certainly affected Marc's spirit cannot be gainsaid. For all his egocentrism, his air of a curly lamb, as Salmon describes him, the effervescence and gaiety that Alberti noted, his growing European fame, the economic security which had even enabled him to float safely through the shoals of depression on the raft of Vollard's commissions, his tidy domestic cocoon in which he could take refuge from a tragic world—despite all this, the artist was by no means unaware of the storm brewing outside, nor was he unconcerned. Basically apolitical he might have been (and his experiences in the Soviet Union had surely not inculcated in him a growing respect for politics as conducive to happiness or enlightenment), nevertheless Marc Chagall was a highly intelligent, sensitive, and sophisticated man strongly attached to the Jewish culture in which he had grown up and increasingly troubled by the threat German expansion posed to all Jews everywhere.

We have no evidence to indicate how closely, if at all, he maintained contact with his Russian relatives. He never speaks about his mother or sisters in any published statement made after *My Life;* yet when he had left Russia in 1922, Feiga-Ita and his six sisters were alive, dwelling in that very zone which was so tragically to be destroyed by the Nazi invasion of June 1941.

But if it would be difficult to point to neatly parceled "phases," we can indicate a number of important pictures painted during the middle and late thirties that do display a more somber palette, a brooding earthbound anger or melancholy solemnity; or, in the graphics that were his major concern during this decade, he makes frequent use of a line by no means caressing but scratchy, harsh as barbed wire; a George Grosz line that drew blood.

This tragic side of Chagall has been too readily ignored by some critics who take Chagall seriously as an artist only in his pre-World War I and Russian revolutionary phases. After that they see nothing but bouquets, lovers, tutti-frutti colors, Vitebskian valentines, sweet-meats and sentimental jokes. Some of this is true. Every artist, especially one who lives to a great old age, and whose output is astronomical, is bound to produce all too many inferior or even poor works: works in which the skilled hand functions as it were automatically with little involvement of mind or heart.

But in Chagall's case, these are more than offset by the numerous tragic paintings of the prewar and war years, not to mention some of the monumental achievements afterward: the Knesset tapestries in Jerusalem, the Paris Opéra ceiling, the Musée Biblique at Nice, and especially the innovative and imaginative stained glass at Jerusalem, Metz, Reims, Zurich, Pocantico Hills, and elsewhere.

Most of Chagall's paintings of the twenties are characterized by feathery brushwork, pastel rainbowed colors, the tints of *la douce France* whose countryside he was then discovering in various summer explorations and winters in Savoy. Domestic happiness merged with love of France, which had treated him so kindly after years of deprivation and ideological struggle in the Soviet Union; and the enormous influence of Bella: wife, lover, mistress-*nishoma* (soul), guide, manager, counselor, abiding presence gave rise to a series of love pictures: love of Bella, love of France.

But soon in the graphics, first in the sarcasms of *Dead Souls* and in the grotesque animal farm of the *Fables* and then in the brooding religiosity and primitivism of the Bible etchings a new darker Chagall manifests itself. The prescribed subject matter of "illustrating" left him free to concentrate on purely formal qualities of line, depth of bite, exploitation of the "plowshares" of drypoint to create pictorial fuzz, enriching the range of blacks and whites by repeated immersions of the plate in the acid, lacquering already bitten line, and

sanding. In graphics he displayed a complete freedom from tradition, mixing etching and drypoint, treating contour not as line but shadowy blobs, stippling, scratching, to achieve effects of varying depth, and in general treating black and white as a marvelous palette of color.

In 1936 the Spanish Civil War broke out, an event which was to have the unlikely effect of bringing about a momentary closeness between Picasso and Chagall. Although they had met on several occasions in the apartment of Christian Zervos, the editor of *Cahiers d'Art* (which had published the "scandalous" photograph of Chagall painting his daughter nude), they had never been very friendly. Their personalities were utterly opposed. Chagall kept the world at a remove behind his mask of ingenuous innocent, sweet prancing clown. Picasso was an entire corrida: matador and wounded bull at once. His brutalities to women, fellow artists, innocent bystanders were notorious. He produced as much art out of hatred as out of love. But hatred does not exist in the Chagallian repertoire: anger, yes, sarcasm often, witty ridicule even more often, but slashing murderous hatred never.

But now a certain shared political concern made it possible for the two men to communicate when they met occasionally at various haunts in St.-Germain-des-Prés: at the Café de Flore or Lipp's or at the Deux Magots. The Spaniard had recently had an important show at Rosenberg's, was in the midst of litigation connected with his separation from his legal wife Olga while simultaneously shuttling between two mistresses, Dora Maar and Marie-Thérèse Walter. Civil War in Spain galvanized him from the bed onto the public arena—he declared himself for the Republic, which in gratitude named him director of the Prado, a post which he never actively fulfilled.

So Picasso, troubled about Spain, and Chagall, troubled about racial persecution, could maintain certain lines of communication until the outbreak of the war. Their few contacts after Chagall returned from America to France were disastrous.

But more significant than their occasional conversations in the smoky talky cafés of Montparnasse was the work whereby both these very different artists expressed their reaction to Nazi brutalities.

About a year after Picasso had painted his huge *Guernica* in

response to the German terror bombing on April 26, 1937, Chagall painted his *White Crucifixion,* a large composition in which the persecution of Jews under the Hitler regime furnishes a martyrology swirling around a Christ who is no longer the decorative iconic child of the *Golgotha* of 1912, but clearly and explicitly a Jew wearing a tallith across his loins. To further emphasize the Jewishness of this Christ is the seven-branched Menorah at his feet, the halo of its burning candles echoing the halo behind Christ's head. And floating in the halo INRI (the Latin initials of what is written out in incorrect Hebrew: Jesus the Nazarene King of the Jews).

Unlike medieval crucifixions, which occur out of history and out of place (hence the gold ground), or Renaissance crucifixions, which occur in an optically real space, this one occurs in *history,* in twentieth-century history. A brownshirt smashes into a synagogue and sets it ablaze; a Jew with a sack on his back runs to rescue a blazing Torah scroll; elders float like angels above the Cross, disputing and bewailing; in the lower left corner an old Jew wears a breast cloth on which was originally inscribed in German "Ich bin ein Jude," later cancelled by Chagall as unnecessarily explicit. Above an upside-down village storms an army with banners. Is it the Red Army heading toward the Cross to free the Jewish Christ?

From the evidence of this picture it would seem that the terrible threat of Nazism had revived in Chagall his earlier support of the Soviets. In this picture the Red Army certainly figures as a liberating power. Indeed, in France the Front Populaire proclaimed just such a faith in the Russians as loyal allies against the Germans. Most French intellectuals, many of them friends of Chagall, were now either active card-carrying members of the Communist Party or sympathizers whose complexions ranged from fellow traveler's puce to ever-virgin's blushing pink. That most dogmatic of Surrealists, the elegant Aragon, had already begun his career as a dogmatic literary pope of the French Communist Party. Emotional Eluard was swept into its periphery. Léger also was to join the Communist Party which was not surprising; to reduce man to stovepipes and chromium tubes led inevitably up that garden path to doctrinaire determinism. In such an atmosphere of solidifying ranks against the growing threat of Nazism, even the eccentric Erik Satie became a member of the party. And of course eventually the most-bruited convert was to be Pablo Picasso, whose adherence was publicly announced in October 1944,

soon after the liberation of Paris; Picasso was already well en route to become the wealthiest Communist in the world.

All this faith in the Russians and that particular one of their various long arms called the French Communist Party was of course ultimately shattered by the Russian-German pact of 1939 after which the French Communists, like all Communists everywhere, flipflopped overnight to the crack of Stalin's whip.

But Chagall's ambiguous relationship to the Russians did not need a Soviet-German pact to proclaim itself.

At about the same time as *White Crucifixion* he was bringing to a close a very large composition dealing with the October Revolution. Eventually he was to destroy this work because of dissatisfaction with it, but he kept a fully developed sketch of it.

At first glance *The Revolution* seems to belong to the *Circus* series. A figure stands upside down on a table, balancing on one hand, urged on by a shouting applauding crowd. But the balancing figure is none other than Vladimir Ilyich Lenin! With his free hand he points to a red flag lying on the ground on which is the first letter of the Hebrew alphabet—*aleph*. Between his legs the equilibrist Lenin waves a French tricolor. Was Marc mocking the Revolution for the benefit of the French Communists? Meditatively leaning his elbow on the very table on which the acrobat Vladimir Ilyich is displaying his virtuosity is a bearded Jew, Torah in his arms and phylacteries on his head. An open book is on the table, a yellow samovar in the path of snow which divides the picture into two realms. Seated in a chair is a donkey watching with wary admiration Lenin's trick. The mob urging on the revolutionary leader waves red banners, gesticulates weapons and sticks, shouts, quarrels among itself. Some have been knocked to the ground. On the right of Lenin (are right and left also allegorical here?) lovers on the slanting roof of an isba, a typical wayfarer peddler with a sack, an upside-down floating musician, an auto-cellist playing on his own body (frequently a symbol of the artist), a domestic barnyard. The dominant colors of the revolutionary crowd to the left are deep bloody reds and venous purples; to the right—the domain of art, love, religion, folk—dream blues. The red flag with the mysterious *aleph* penetrates into this nonrevolutionary realm.

As in all allegories many readings are suggested, in this case too many for successful composition: the picture is scattery, ill-resolved,

which is why the artist eventually cut it up in 1943 and repainted two of the fragments as independent works.

Certainly Chagall is making an explicit statement here: the Soviet Union is a circus whose star performer is the Commissar of Commissars. By 1938 when Marc was still trying to pull the spotty painting together, Lenin's ritual image in bronze, in stone, haranguing the crowds, arm rigidly pointing to the Truth was already superabundant in the Soviet Union.

That Marc Chagall could stand this red priest upside down on one hand was a delicious act of ridicule.

Nor is it difficult to discover the artist's preference by interpreting the imagery in the revolutionary and nonrevolutionary zones.

Perhaps indeed it is the very specificity of the symbols, even more than the unsuccessful design, that led to Chagall's dissatisfaction and destruction of the work. As an artistic statement allegory is always weaker than symbol; the very particularity of spelled-out visual signs makes for literature; whereas the symbol is form-language suggesting more generalized meanings, as in music.

One may see the difference by comparing Michelangelo's powerful storm-laden Prisoners for the Tomb of Julius II with the more ambiguous Hamletism of the Medici tomb allegories where, especially in the figures of Night and the Dukes, the strong primary meaning of the form is weakened by an overlay of allegorical props.

So in Chagall's *Revolution* the multitude of allegorical meanings tends to bleed the picture outside its frame, weakening the formal meanings within the frame. The "real" world intrudes into the made world of the artist—and the latter is where his "meanings" belong.

Nevertheless, even so seemingly explicit an allegory as the *Revolution* can be interpreted rather astonishingly:

> . . . Lenin's handstand does not signify a criticism of Lenin, but symbolizes his revolutionary impact in an entirely positive sense. Standing upright on one hand, this central figure is like the pointer of a scale marking the equivalence of the two sides— the political revolution and the artistic-human revolution— according to Chagall's dream.

Meyer believes indeed that Chagall destroyed the large picture because it tried to say too much, not because he "repudiated the idea of the revolution . . . in his own sense of the word."

*

On the first day of September 1939, less than two months after Josef Stalin performed his flip-flop (even more spectacular than Lenin's handstand) the not-unexpected war broke out with the German invasion of Poland.

The war caught Marc Chagall at the peak of his career: he was fifty-three years old, in perfect health, affluent, productive, fecund, flowing with the tide. He had just received the Carnegie Prize, only six years after his large retrospective at the Kunsthalle in Basel. That show indeed had effectively placed him among the masters of the twentieth century, in the ranks of Picasso and Matisse, who had had their retrospectives in Zurich in 1931 and 1932, the years immediately preceding Chagall's show.

A celebrated artist, a Frenchman juridically (he had finally gotten his citizenship in 1937 after four years of bureaucratic webbery), he and Bella had been, in recent years, prominently present at every important opening. A box was set aside for them at the Ballets Russes. Every visiting Russian artist hastened to his door. His friends were numbered among the intellectual elite of France; he had traveled to Holland, to Spain, to Italy, and had many friends and admirers in all those countries.

Then on August 23, 1939, when the Chagalls were living in the wing of a rented farmhouse on the Loire, Comrade Molotov shook hands with Herr Ribbentrop and announced to the world that:

In the last few months such concepts as "aggression" and "aggressor" have acquired a new concrete content, have taken on another meaning. Now it is Germany that is striving for a quick end to the war, for peace, while England and France, who only yesterday were campaigning against aggression, are for continuation of the war and against concluding a peace. Roles, as you see, change. The ideology of Hitlerism, like any other ideological system, can be accepted or rejected—that is a matter of one's political views. But everyone can see that an ideology cannot be destroyed by force. Thus it is not only senseless, it is *criminal* to wage such a war as a war for "the

destruction of Hitlerism," under the false flag of a struggle for democracy.

The Soviet-German Non-Aggression Pact sent a shock wave around the world, shaking thousands of fellow travelers off the locomotive of history. For twenty-five years in the alembic of self-delusion, Stalin's crimes had been transformed into political pap. All over the world a huge literature of exculpation had been heaped up to "explain" the twists and turns of Russian policy, and to realign it ever with orthodox Marxism.

During all these years Chagall remained barricaded behind his easel. Whatever "revolutionary" notions he had ever possessed had been brutally squelched by his experiences in Russia after 1917. Thus during the Popular Front years when many of the leading writers and artists working in France—Picasso, Léger, Eluard, Aragon, Claire and Ivan Goll, many of them Chagall's friends—had publicly proclaimed their support of the Soviet Union, in some cases by joining the French Communist Party, Chagall had signed nothing, participated in no manifestos, marched in no demonstrations. His feelings about the darker political scene are expressed, if anywhere, in the new somber tonality of his work, the increasing number of crucifixions that were to follow for more than a decade in a tide of woe the *White Crucifixion*. And in the typical centripetal whirl of his psyche, Christ on the Cross was not only the martyrdom of the Jews but the martyrdom of Marc Chagall:

> Nuit et jour je porte une croix
> On me pousse, on me traine par la main
> Déjà la nuit autour de moi
> Toi t'éloignes, mon Dieux. Pourquoi?

he writes in one of his poems, probably dating from this period.

> Night and day I carry a cross
> I am shoved, dragged by the hand
> Already Night surrounds me. And You
> Abandon me, O God. Why?

Christ (Chagall) is carried by a yellow bird-faced man, which led to some rather farfetched symbolic pirouettes by several critics, especially Raissa Maritain.

Yet with all his disillusions about the Soviets, Chagall remained always—and still remains—sympathetic to Russianism: to the language, to the culture, to the feeling-tone. And it is this typical ambiguity that explains the salvationist notion of the Red Army in *White Crucifixion*. Artists are not "thinkers"; they are "feelers." And Chagall is even less of a "thinker" than most.

His reaction to the obscene pact was in marked contrast to that of his wife and daughter. For Marc a pit had opened, it was "the end," the bottommost pit of Hell, and the Soviet Union was the three-tongued Satan: the tongue of Hitler, the tongue of Stalin, the tongue of the Communist parties serving as Russian extensions throughout the world.

But Bella and Ida were cooler. The pact was simply deflective strategy. The West had been seeking deviously for years to turn Hitler's hordes against the Russians. So the Russians had now turned the tables, and sent the Germans against the West.

The pact was the first mighty thunderclap of impending storm. The air of late August was tense, hung with menace. Everyone's nerves were at breaking point. One day a quarrel broke out between Chagall and the farmer from whom he rented. Refracted in this atmosphere it took grotesque proportions. Chagall imagined that he was being physically threatened by the farmer and barricaded himself in his quarter of the farmhouse. Perhaps the farmer had expressed his rage at the betrayal of the Russians and here was a Russian in his own house. Perhaps there had been some violent expression of the latent anti-Semitism that was soon to spring forth in France.

At any rate, just before the outbreak of the war, the Chagalls decamped in haste to the home of a friend at Saint-Dié-sur-Loire where he remained during the period of the Phony War. On rare occasions he went up to Paris, once in January 1940 for a big show at the Galerie Mai where his ironically titled *Revolution* was hung in a back room under the nonironic noncommittal title of *Composition*. Thus even though the Russians were now passive alies of the Nazis, Chagall seems to have been reluctant to attack them openly.

On another occasion, just before the big German offensive in the

spring, Chagall moved most of his canvases, removed from their frames, from his Paris studio to Saint-Dié. A few unfinished oils and some cartons of gouaches and drawings were ransacked by the Germans.

Once the German offensive began in May, France—betrayed by its Communists who were now zealously boycotting the anti-Fascist war for which they had been drumbeating during the Front Populaire—collapsed in six weeks. By June the Germans had blitzed their way to Paris, which had been declared an open city; Hitler danced his jig under the Arc de Triomphe. The government had fled together with millions of Parisians and other refugees all streaming southward. In another few days Pétain signed an armistice, dividing France in two.

Although he was now living in Gordes, in Provence, the South of France which remained as yet unoccupied, it should have been manifest to Chagall that he would have to escape from France. How could he, a Jew, even conceive of staying with the Nazis next door?

And yet either out of sheer ignorance of the situation or stubbornness or innocence (most likely a combination of all these) Chagall seemed to have no real idea of his imminent danger.

At Easter 1940, urged by his friend André Lhote's enthusiastic reports about Gordes, a beautiful stony village near Fontaine de Vaucluse, Chagall and Bella had driven there, been enchanted by the site, and first rented, later bought a house that had formerly been a Catholic girls' school. Its big rooms were ideal for a studio. They sealed the deal the very day the Germans invaded Holland and Belgium, flanking the Maginot Line. But the Maginot Line of Chagall's naïveté remained unflanked.

Although the illusion of the Phony War was now shattered, Chagall went ahead with his plans to settle in Gordes for a long while. He hired a truck and moved all his pictures from Saint-Dié to Gordes, where he remained for a year, seemingly oblivious of the war, contentedly painting away at canvases he had already begun or still lifes and studies of the area. Delighted by spring in Provence— the angular choreography of olive groves, peach trees in bloom, ochre prehistoric *bori* employed as tool sheds, Chagall seemed to be totally oblivious of the tragic consequences of France's shamefully swift capitulation and the German occupation of the entire northern half of the country including the Atlantic coastal zone.

All this while Chagall went on blissfully exploring the countryside and painting still lifes of baskets of fruit.

But such an out-of-phase relationship between external events and the art produced at the time is by no means unusual. While the German panzer divisions rolled into Poland, Picasso continued work on his huge lyrical *Fishermen at Antibes*. There is a certain autonomy in picture-making: the hand may continue to work in an accustomed mode, while new feelings are being stoked into the stove, to be ignited later.

Gordes is situated in a spectacular landscape where the almost steady Mistral has bent all the trees northward. For all its abundance there is a harsh lunar aspect to these spiny hills and plains bestrewn with rocks, which is intensified as one approaches the Alpilles. Today the Renaissance château topping the town has been taken over by that master Op artist Vasarely as a private museum. But when the Chagalls were there, the village—thirty-four miles from Avignon, the nearest big city—had not yet become a tourist attraction although Marc's friend Lhote was eagerly seeking to transform Gordes into an arts and crafts center and was delighted that Chagall had decided to settle there.

The relative isolation of the village has been adduced as an explanation for Chagall's seeming indifference to the Nazi occupation; but I should say that the real isolation was that of his mind. He was then painting more and more still lifes—relatively rare in his oeuvre—as if obsessed by the wartime shortages of food. (Picasso, after he returned to occupied Paris in August, was similarly obsessed.) Frenchmen—Jews and non-Jews—were already being rounded up by the Nazis and sent to work or concentration camps. Marc went on painting figs and grapes.

In the winter, a big American car rode into the village, creating a sensation. Marc's visitors were Varian Frey, head of the Emergency Rescue Committee, and Harry Bingham, American Consul General in Marseilles; the two men were bringing the artist an invitation to come to the United States. Similar invitations were being offered to Matisse, Picasso, Rouault, Dufy, Max Ernst, and André Masson.

Chagall was oddly unimpressed by what he thought was the excessive concern of his visitors. How could he go to America? Were there trees and cows there? According to Chestelle he also declared

that the Germans wouldn't dare touch him—he was too famous; an incredibly naïve misreading of German respect.

During the spring when the German blitzkrieg had shattered the armies and defenses of Holland, Belgium, Luxembourg, Britain, and France, Picasso and Matisse had been in Paris, placing their paintings in adjacent strong rooms in the Banque du Commerce et de l'Industrie. And although Matisse was to get as far as the frontier with a passport in his pocket and a boat waiting to take him to Rio de Janeiro, at the last minute he decided to stay and sit out the war in Vence. Picasso also could have gone to the United States or Mexico or Brazil. He too decided to remain. Certainly their motivations were different; Picasso perhaps acted out of sheer bravado (especially his return to occupied Paris) or a pathological aversion to travel; Matisse out of a patriot's conviction that to leave would be the act of a deserter. "If anything of any worth runs away, what will remain of France?" he wrote to his son Pierre.

But Chagall's situation was altogether different. Despite his joking reference to fame, he certainly was not yet on the same Alpine level of celebrity as Picasso and Matisse. Most importantly, he was a Jew. Jews were already being rounded up in France. Among them many artists. Eventually eighty Jewish artists were to die in the Holocaust. A poem which Chagall wrote in 1950 to these artist-victims of Nazism is now inscribed in bronze on the walls of the Israel Museum of Jerusalem.

TO THE MARTYRED ARTISTS

Did I know them all? Was I
in their studio? Did I see their art
close up or standing off?
And now I pass from myself, from my own being;
I go to their unknown grave.
They call me. They drag me into their
pit . . . me, innocent-guilty.
They ask me: "Where were you?"
. . . I ran away . . .
They were taken to the death baths
where they got the taste of their sweat.
That was when they saw the light
of their unpainted pictures.

They counted the unachieved years
which they had saved up and looked forward to
for fulfilling their dreams, their dreams . . .
unslept, unsleepy.
They tracked down inside their head
the children's corner, where the star-circled
moon bade them a bright future.
Young love in the dark room, in grass
on mountains and in valleys, the chiselled fruit,
milk-molten, flower-sprayed,
promised them Paradise.
Their mother's hands, those eyes of hers
accompanied them to the distant-bound train.
I see: now they drag themselves along in tatters,
barefoot on mute roads,
Israel's brothers, Pissarro's and
Modigliani's . . . our brothers . . . led along by
ropes by the sons of Dürer, Cranach
and Holbein . . . being led to death in the crematoriums.
How can I, how shall I shed tears?
They were long since soaked in salt . . . from
my eyes.
They were dried with scorn, so that I
should lose my last hope.
How shall I weep
when every day I heard:
the last planks are being torn from my roof,
when I am too weary to wage
war for the bit of ground on which
I've been left standing, in which
later I'll be laid to sleep.
I see the fire, the smoke and the gas
rising to the blue cloud and
turning it black.
I see the plucked hair and teeth.
They cast a turbulent pall on me.
I stand in the desert before piles of slippers,
clothes, ash and rubbish murmuring out a single
Kaddish.
And as I stand thus . . . there descend to me

from my pictures the painted David with
his lyre in his hand. He wants to
help me weep and play chapters of
Psalms.
After him descends our Moses
saying: Do not fear anyone,
he says that you should be quiet
until he carves out new tablets
for a new world.
The final spark dies,
the last body vanishes.
It becomes still as before a new deluge.
I get up and take leave of you,
I take the road to the new Temple
and there light a candle
for your picture.*

Nevertheless, even when all of Europe was being crushed by the
Nazis, he continued peacefully painting in rocky windy Gordes.
Only when France adopted under German pressure the anti-Semitic
legislation which stripped Marc, Bella, and Ida of their French
nationalization, did he become aware of the danger. Reluctantly he
was convinced to secure an exit visa, and in April 1941 moved with
his family to Marseilles in preparation for departure. As far back as
1939 certain friends such as Claire and Ivan Goll had already
departed for the United States. Léger, Maritain, Breton were already
there. But even at this late date, while applying for the exit visa,
Chagall insisted that all his papers be in order for re-entry into
France. His concern over such bureaucratic details even at the risk of
delaying his departure may have been motivated not only by love of
France but memory of the difficulties he had had in 1922 when he
had left the Soviet Union. A flood of such memories must have
thronged to the surface on this occasion. Once again he was at a
turning point in his life. Once again he was being the wandering
Jew—another stage in a perpetual exile. First it had been from
Vitebsk, now it was from Paris. Now Paris was indeed his Vitebsk!
 'Vhile waiting out the interminable arrangements at Marseilles

* A beautiful example of Chagall's poetic Yiddish, translated by Moshe Kohn.

Marc and Bella were arrested during a raid at the Hôtel Moderne, where he had foolishly chosen to stay. The hotel was the center of the German "armistice" commissions; round-ups were frequent. Luckily, the Chagalls were swiftly released after the intervention of Frey and Bingham, as well as the presentation of his Carnegie Prize diploma which perhaps impressed the art-loving police. After that hair-raising experience, Chagall no longer had any hesitation. On May 7 he crossed the Spanish border at Canfranc whence they went on to Madrid. Bella, in the tragic mood which she had increasingly displayed, solemnly announced that she would never see France again. In one of her last letters before they left their beloved adopted country, Bella wrote that she felt "sentenced to death."

Through a complicated series of maneuvers and operations carried out with great skill by Ida and her husband, Chagall had managed to have shipped into Spain, awaiting transhipment to Lisbon and America, trunks and packing cases containing most of his output in recent years: hundreds of gouaches and oil paintings, portfolios of drawings. Estimates of the total vary from 3,500 pounds according to Meyer and 800 pounds according to Chastelle who also estimates that there were 500 paintings in the lot. At any rate, the German Embassy in Madrid had the cases impounded by customs (probably as a last attempt by the Gestapo to get their hands on the paintings) and only through the intervention of a curator of the Prado were the cases freed. As soon as they had completed arrangements with a shipping agent to send the luggage on after them (another naïve error, as it turned out) the Chagalls immediately entrained for Lisbon, arriving on May 11, from which they sailed to New York.

Part Seven
United States
1941-1948

Marc and Bella Chagall landed in New York the very day the Nazis invaded Russia—June 23, 1941. This was surely one of the factors that served to provoke a peculiar stirring up of Chagallian layers of consciousness. The longer he stayed in America, the more Russian he became. Despite seven years in the United States, he never even attempted to learn English, passing it off with the quip. "It took me thirty years to learn bad French, why should I try to learn English?" His conversations with his wife and daughter were almost entirely in Russian, and here in the summer cauldron of New York the rat-tat-tat of rivets obliterated the chirping trill of his adopted French. Indeed French no longer sounded sweet to his ear. The Madeleine with whom he had fallen in love had turned out to be a whore. The Phony War and the six weeks of real-enough defeat, the shocking emergence of French anti-Semitism which served to hasten the swift capitulation to the Germans, the temporizing Vichy government—all of this had served to sour somewhat Chagall's infatuation with la belle France.

And so here in New York which frightened him and fascinated him by its scale and furious energy; this vertical city, in the canyons of which he fancied he could see his phantasmic flying lovers,

completely blotted out the City of Light. The City of Light had become the City of Darkness and Shame. Manhattan, day or night, sufficiently outblazoned Paris across the sea. It was a psychological as well as real blackout.

Vitebsk of course had always coexisted with Paris. Over the past decade Paris, indeed, had become "my Vitebsk." That is to say, Parisian elements had happily infiltrated into, and coexisted with Vitebskian imagery. And since "my Vitebsk," whether with the Eiffel Tower or not, bore to the real Vitebsk only the relation of dream to waking life, even after the outbreak of war and the fall of France, his *stetl* of the mind could not be bombed.

The German invasion of Russia served to stir up more tangible Russianisms: France was simply blotted out now. His real Vitebsk was really being burned. The Chagalls listened to the news from the Russian front with anguish and hope, struggling to understand the English-language broadcasts.

Greeting them at the pier was Pierre Matisse, son of the artist: young Matisse had already served as Chagall's American dealer; a relationship that, with the exception of a ten-year period, has continued to this day.

Matisse recalls the bewilderment with which the Chagalls encountered America. "Bella was a quiet beautiful intelligent woman. Chagall has never handled his own practical affairs. He left all that to Bella, a wonderful woman; or to his daughter Ida, or later to Vava." When they arrived Bella seemed depressed but resolute; Chagall's remarkable font of energy and resourcefulness almost immediately manifested itself.

Matisse helped the Chagalls move into the Hotel St. Moritz on the corner of Sixth Avenue and Fifty-ninth Street, overlooking the green rectangle of Central Park.

Adding to his general disarray resulting from the recent months of flight, arrest, uprooting was the shocking discovery when he arrived in New York that his precious luggage was still impounded in Spain. Instead of his trunks, there was a notice from Spanish customs advising him that since his possessions had to be personally identified before shipment, the agent to whom they had entrusted this task could not act. It was one of those typical bureaucratic mazes

intensified by the confusion of the war; the efforts of the Germans to seize Marc's paintings may have also played its part.

Chagall immediately wrote to his daughter Ida, who was still at Gordes with her husband. The young couple set off for Spain at once where Ida played the bureaucratic harp with skill and persistence, pulling all the proper strings until the vital shipment was loaded onto a cargo ship in Lisbon. With her young husband, Michel Gorday, who had just managed to escape being sent to a Spanish concentration camp, Ida accompanied the crates across the Atlantic in a forty-three day gruesome crossing to join her parents. The act was emblematic: for if ever there was a daughter totally devoted to her father, that daughter was Ida Chagall.

To permit Chagall's entrance into the United States, the Museum of Modern Art had gotten in touch with several of his friends and acquaintances already in New York, requesting that they sign as guarantors of the new immigrant's maintenance.

Among these was the scenic designer Boris Aronson, who if not ever in the very constricted inner circle of Marc's friends, had met him during his Moscow Jewish theater days and afterward in Berlin (where Aronson published his little book) and Paris.

"Here is a man who had to flee Europe because of Hitler," Aronson recalls. "Well, the minute he arrived I telephoned. The first thing he said was: 'Who are you?' and then 'How did you get my telephone number?' "

Recalling the episode, Aronson still explodes. "I never spoke to him again after that. Such silly behavior! I had been a visitor to his house many times; my place is filled with etchings and drawings dedicated to me. And that idiotic suspicion!"

Chagall's normal distrust of even his benefactors must have been intensified by the strains and rigors of flight. Everyone who has known him intimately comments on the diffidence with which he faces the world. Together with this innate suspiciousness hidden under the mask of charm and wit of a true performer, Chagall has not unseldom confided his trust in those who turned out enemies and distrusted his truest friends. His jealousy of fellow artists is of course not at all unusual in the history of art. Painters and sculptors are after all petty bourgeois entrepreneurs. They make unique objects and

compete with their fellows in the craft for the available customer. True in the Renaissance as it is true today, none of this has any fundamental bearing on the worth of the artist. Aronson is the first to admit this. "He was a great artist a long time ago."

Once set up at the St. Moritz (later at Hampton House and finally at the Hotel Plaza on West 57th Street near the park) Chagall began to explore the city which fascinated but repelled him. Soon he was haunting the various art galleries, and his aureole of dancing hair, his sea-blue eyes and puckish gestures, his clown-clasping hands and grimaces, his velvet jacket and checked shirt became a familiar sight in the art world.

One day he visited the ACA gallery. The young artist whose work was being shown was thrilled to see the great Chagall bound from picture to picture in his buoyant dancer's way, peering, cocking his head, hands clasped behind his back in Eastern European fashion.

Then when Chagall was about to leave, the artist ran over to him and caught him at the door, asking breathlessly: "What do you think of my work, Maestro?" To which Chagall replied in Yiddish: *"Die kunst is sehr schwer ...* [Art is very difficult]," and swiftly departed.

Manhattan, moored like a great ship bristling with masts, on the brink of perpetual departure and yet never departing, was difficult for Marc to comprehend. It was full of Europeans but it was not Europe. Paris had also been full of foreigners but at least those like Chagall who came there carrying a certain mystical Paris in their minds, succeeded in soon achieving an equally mythical patina of "Frenchness." But that did not seem possible in this glass and steel jungle. Becoming an American or even Americanized involved a more ruthless tearing up of roots.

In New York they resumed their friendship with the poets Claire and Ivan Goll, who had from the early twenties been part of their inner circle. Marc had illustrated their *Poèmes d'amour* and did several portraits of this eccentric couple—she German, he Alsatian—who had emigrated from France to the United States in 1939. Erotic and violent, they were even more political-minded now than they had been. Ivan Goll's unctuous pronunciamentos on "revolutionary duty and political tasks" reminded Marc of Soviet commissars. At the same time Goll was writing surrealist mystical poems like his *Deuxième Elégie d'Ihpétonga:*

Frère Vimor, demi-demon, toi qui partages la demeure de ma
 carcasse
Que j'entends remuer dans les décombres du passé
Brisant les ailes de mes chimères et les béquilles de mes rêves
Puis éclatant de rire à la vue de mon papillon de mort.

Brother Vimor, half-demon, co-tenant of my skin's house
Whom I hear fidgeting in the rubbish of the past
Scorching the wings of my chimeras and the crutches of my dreams
Then bursting into laughter at the sight of my butterfly of death.

An odd pair, the Golls, coupling like short circuits hissing and
steaming; ricocheting away from each other for prolonged affairs
with other loves, then returning to hiss and burn again. By contrast
with this screaming jungle Marc and Bella were a garden of fidelity.
If bouquets were the proper symbols of the Chagalls, paroquets and
jaguars were emblematic of the Golls.

In her memoir, *La Poursuite du Vent,* Claire Goll vividly depicts
the situation of the European exiles in New York.

With the tragedy of June 1940 and the defeat of France, Hitler's
delirious prediction of a thousand-year Reich seemed about to be
realized.

Soon the bulk of the intellectual battalion arrived in New York:
Max Ernst, André Breton, Chagall, Yves Tanguy, Léger, Kurt
Seligman, Lipchitz ... "They had been preceded by Salvador Dali,
already installed in California, nearest the biggest fortunes," and by
the German publisher Kurt Wolff who, for his part, was preparing to
relaunch a publishing house.

"New York became a lunar city haunted by forgotten legends.
Some [of the refugees] set about learning English in order to reinsert
themselves into life. Others, like André Masson, buried themselves in
their work." Cut off from his terrain and the patiently woven web of
his career the emigrant intellectual became *Jean-sans-terre,* the John
Homeless of Ivan Goll's poems.

Each refugee confronted his situation according to his character.
Chagall, claims Claire Goll, declared that inasmuch as there were
many Jews in the United States, he already had "an American
clientele" but it would "be necessary to develop it." Her account
rattles like tin: a brash pejorative sound. Chagall, she says, was laying

plans like a good merchant to capture the American Jewish market.
He had competitors, notably Mané-Katz. He had avoided Mané-Katz
in France, fearing to be characterized with the lively witty little
globetrotter as a "Jewish artist." Even his name sounded absurd to
Marc's ears. And here he was in New York! Claire Goll dips in
venom:

> Chagall's strategy was clear: to play the persecuted to
> conquer the New York Jews and become their exclusive
> supplier. Max Ernst, who struck out against all suspicions of the
> fact of his German origin, resolved his problems by marrying a
> millionairess, the collectionist Peggy Guggenheim. In one blow
> he obtained money and American nationality. But the forced
> labor was too rude for the seductive Max Ernst, who soon
> abandoned his post, leaving it to more hardened specialists.

However, his own shows, one after another, were complete failures.
The time was no longer propitious for that which was scornfully
called "Parisian surrealism."

Time and space, before the war and across the Atlantic, clove the
refugees' lives. Past passions seemed present follies. Had they really
sat around the tables of the Sélect or the Coupole discussing the
exclusion or inclusion of this or that poet or painter from the
Surrealist group? Seen from New York, what futility!

"To speak of language, culture, poetry, is to speak of man.
Opposition to Hitler and his clique must be our strategy. One cannot
elaborate a counterattack without having an idea of man."

Goll's preachments were hard for Marc to take. He agreed with
almost everything the man said. But he could not tolerate how he
said it. It all smacked too reminiscently of the commissar talk he had
heard in Russia. There was a priestly halo of righteousness about
these revolutionaries which Chagall could not abide. His humor, his
sense of the absurd, his native distrust of dogma kept him at a remove
from Ivan Goll. Elfishness could not dance in a cement factory where
doctrine was turned out in slabs and where all the workers wore iron
haloes.

"Is this the moment to evoke the spectres of the unconscious?"
(The judgment from the mount referred to Max Ernst.) "There is
nothing phantomatic about the veritable monsters. They are acting in
Berlin and ravaging Europe."

Some of the refugees did very well in America. Fernand Léger, for example, Marc's old companion of La Ruche days, was now a professor at Yale University along with André Maurois and Darius Milhaud. His teaching obligations left him plenty of free time. And even if he didn't find public enthusiasm for his art, at least his daily subsistence was assured.

"*Ah, voilà mon petit pote!*" he would boom when he met Claire or Marc. They were all "little pals" by contrast with this tall heavyset clumsy man planted on the earth like an oak. Unlike some of the more sensitive transplants he refused to be upset by exile.

"What do you make of this New World?" one of the exiles asked him one day.

"*Mon pote*, you know well that I'm not sentimental. The picturesque doesn't interest me. Paris or New York. It's all the same. I'm not a landscape artist."

Impermeable to his surroundings, Léger's certitude dwelt behind a coat of armor.

"The important thing, you see, is what one has in one's head. Exoticism, that's all right for a Gauguin and his Tahitians. For me, a yellow, a white, a black, it's only color. Behind it I see there the same man. There isn't one truth for Europe, another for America, isn't that true, *petit pote?*"

Such generalizations of course are perfectly consonant with Léger's pipe-and-machine-part figures. His "universal" images express a conviction—typically antihistorical—shared by many sociologists and anthropologists: that samenesses are more revealing than differences. This is what I would call the reductive illusion; common denominators (the basic drives for food, shelter, sex) may be fundamental, but they are also banal. What is revealing is the varying pattern of these "fundamentals."

Léger's huge figure compositions fit neatly together like well-made gadgets. No wonder he took such delight in New York's luminous geometry. Like Mondrian he loved the Euclid of windows, the spectacle of the street, the manikin walk of signs, the poster-bright colors, "Negroes with green shoes." But with all his vaunted artistic eye he saw what he was prepared to see. "Not a tree, not a horse in the entire city." Central Park? His thesis blinded him to its existence. "Here, *mon vieux*, is a civilization made for the eye." (Yet Léger had been boasting that he doesn't care what he sees. He is not a "landscape artist"?) "What magnificent barbarism."

The Golls like the Chagalls—like the Jews everywhere—were not unaccustomed to these periodic uprootings. So Ivan Goll was deepened by exile. He was now writing his best poems in the United States. After all had he not been born a *Jean-sans-terre*—a Boche in France, a Frenchman in Germany? Like Claire he had neither roots nor home. Sometimes they had cast anchor in Zurich, in Berlin, in Paris. ... Now they had run aground in Brooklyn, in Columbia Heights, where they lived in a superb apartment house with one of those incredible views of the skyscrapers of downtown Manhattan. The Brooklyn Bridge soared in front of their windows, a giant harp; and the Statue of Liberty abruptly gone when the lights-out siren sounded from the destroyers moored in the harbor.

Many of these exiles worked at the Office of War Information. Chagall's son-in-law, Michel Gorday, was also employed by the government broadcast service, Voice of America; through him Marc and Bella could keep in touch with the Free French movement although Chagall's resentment and suspicion of French betrayal was not to be lifted entirely until the Liberation. Meanwhile his prime interest was focused on the Eastern Front from the moment the Nazis had invaded his homeland Russia.

The Office of War Information was intellectual and artistic Europe in a skyscraper on 57th Street. Those Americans like myself who worked there in 1942 and 1943 knew the thrill of meeting many of the shapers of between-the-wars avant-garde art. There, struggling with cables, was the polyglot Eugene Jolas, editor of the international journal *transition*, Joyce's exegete, poet in four languages not to mention Amer-Indian. One day Jolas announced that he had finally discovered the crown of cities, the jewel of America, the culmination of twentieth-century civilization. "And where is that paragon?" I asked. "Bridgeport, Connecticut," Jolas triumphantly announced. "Paris Vienna Berlin London ... all that is finished. Europe's gone down the drain. The future is here. The vortex is here." (Is that what he meant by "drain"?) "And the vortex of vortices is Bridgeport, Connecticut."

As soon as the war ended, Jolas flew back to Paris to deprive himself forever of the aesthetics of Bridgeport, Connecticut.

So the patterns of these cultural waifs varied. Their café wars spluttered out unnoticed amidst the Big Bang of World War II.

Working under the direction of Pierre Lazareff, the poet-journalists stole time from their war effort to plan and create new literary magazines such as *Hemispheres* or *VVV*.

In New York André Breton resumed his role of Pontifex Maximus of the Surrealist movement. At this time he decided to forgive Marc Chagall his "mysticism" and wrote his celebrated absolution:

> For a long time one serious failing at the roots of those movements—Dada, Surrealism—which were to achieve the fusion of poetry and visual arts consisted in underrating the importance of Chagall. Yet the poets themselves were deeply indebted to him—Apollinaire for his "Across Europe," possibly the freest poem of this century, and Cendrars for the "Transiberian"; even Mayakovsky and Essenine echo to him in their most convulsive moments. The poet's resistance came later; it was based on the suspicion, no doubt partly justified, that Chagall had turned mystic (and in the twenties and thirties any such suspicion brought an automatic and final condemnation). Today it is possible to situate Chagall's work more fairly. His complete lyrical explosion dates from 1911. It marked the triumphal appearance, through his work and no other, of the metaphor in modern painting. In order to consummate that shuffling of the spacial plane which Rimbaud had prepared us for many years earlier, and, at the same time, free objects from the law of gravity, tear down the barriers of the elements and kingdoms, in Chagall's work the metaphor immediately found a visual support in the hypnogogical image and in the eidetic (or aesthesiac) image, which only later came to be endowed with the characteristics that Chagall had bestowed upon it. No work was ever so resolutely magical: its splendid prismatic colors sweep away and transfigure the torment of today and at the same time preserve the age-old spirit of ingenuity in expressing everything which proclaims the pleasure principle: flowers and expressions of love.

For some, therefore, America was a liberation. For others, Europe remained locked and unaltered within them. Claire Goll relates that as soon as she landed in New York immediately after the war had broken out in September 1939, she felt a happiness such as she had never known. "Everything seemed possible to me. I could have,

without feeling myself humiliated, sold newspapers or shined shoes. In Paris I would never have dreamt of doing such things. But the American atmosphere released such dynamism that nothing appeared degrading there."

Although America, avid for fresh blood and new ideas, opened opportunities to this cultural infusion, the poets bound by their language had a more difficult time than the painters or sculptors or musicians.

Much of the Berlin contingent which had fled to Paris in the thirties had now crossed the Atlantic. Claire met George Grosz in New York. He didn't think he would ever return to Berlin any more than the Golls thought they would return to Paris. Brutal, gross as ever but with ardor somewhat dampened, Grosz's brilliant barbed-wire drawings were the result of his hatred. "I have discovered my style in the graffiti of pissoires; nowhere else do I find a better résumé of human ugliness."

Poor Grosz! America had no pissoires, no Junker officers, no thick-necked German bourgeoisie. He began painting romantic chromatic watercolors of New York Harbor.

When the Golls returned to New York from Cuba (where Claire gorged herself on mangoes and Ivan on Negresses) Mondrian was the first to visit them. He arrived from London where he had thought he would find the necessary tranquillity to perfect his squares. But the bombardments had troubled his meditations.

On the boat during the entire crossing, he told Claire, "I asked myself whether it was necessary to put a red dot in the yellow square or in the square to the right."

(The American painter Ad Reinhardt, whose saturated and subtle Zen black canvases outmysticed Malevich's whites, once told me with great pride that he had just returned from a voyage around the world wherein he had taken thousands of photographs. "Not a single one of a human being. Not a single one.")

Mondrian settled down in an apartment on 52nd Street, living very much alone, far from tumult. Cases served as chairs and table. In his imperturbable way he was quivering with excitement at being in New York. He was certain that he was going to discover something entirely new there.

Unlike Chagall, Mondrian adored New York and took joy like a child on his daily walks. Typical of the European who likes to play

up the technological "barbarism" in American life, Mondrian was convinced that the Americans were those who had left all their troubles on the other side of the ocean. There was no "interior life, no drama, no sadness. ..." Everyone ought to live like that, he thought, on the surface of life, on the surface of things. In old Europe the interior counts too much: hidden secrets, the heart, sentiments, man wants to understand himself. Here one tries to understand what's happening outside this instant. Tomorrow the world will be like Broadway, all the lights on the facade. Like jazz, or a new noise. No more nostalgia or regret.

He found New York marvelous. It was never night. Sometimes he stretched out a piece of oilcloth on the parquet floor and danced.

He adored modern dance.

New York was his dream: "To find a world as immobile as his squares, without morning or evening, without hate or love, without sadness or gaiety. ..."

Mondrian's *Broadway Boogie Woogie* of 1942-43 is an instance of this astonishing misunderstanding of the American Dream.

*

But Marc's response was not Mondrian's or the Golls' or Breton's. Although he enjoyed many aspects of the city—especially his walks in Jewish neighborhoods, around the Lower East Side where he felt abruptly thrust back into the Vitebsk of his youth—he never was able to habituate himself to the rhythms of this American megalopolis.

After having lived in several hotels, Marc and Bella escaped the New York heat for several weeks in New Preston, Connecticut, where they met the ebullient Alexander Calder who lived nearby. Calder was to become one of their close friends for the next few years. His booming presence, his boisterous humor and bluntness was to the Chagalls America personified, although Sandy Calder had already spent many years in France and was to shuttle all his life between Connecticut and his home at Saché in southern France. In September the Chagalls moved into an apartment at 4 East 74th Street, which they decorated with hangings and Marc's paintings to look something like the Paris studio. Here Chagall began reworking some of the canvases he had brought to the States, and after a day's

work would walk for miles in this great liner permanently anchored in the bay, that was the island of Manhattan.

Chaim Gross, the sculptor, recalls that Chagall quite often used to drop into his studio at 63 East 9th Street. The two artists spoke Yiddish together. They had met for the first time in 1943 at the Perls Gallery.

Gross, a vigorous handsome man, now in his early seventies, is another example of the Eastern European Jew whose emigration (in this case from Galicia, Austria) to the West had added a new vivid touch of color to the culture spectrum of the land of his choice. Simple and unassuming in manner, like Chagall a touch of Harpo Marx in his soulful brown eyes and somewhat self-deprecating smile, Gross was the assimilated immigrant, Marc the exile.*

"He would stand and watch me wood-carving and murmur: 'Nu, I see you're a worker like me. *Arbeit arbeit* . . . Work work . . . that's all I do.' "

Indeed Chagall's work obsession was obviously his bomb shelter against the war, against exile, the difficulties of adjusting to this strange land. Like Picasso, whose productivity he rivals or even betters, Chagall solves—resolves—all his personal problems within the bounds of the canvas. That is his universe wherein the sprawling chaos of the quotidian might be composed as he wills it. Composition involves conquest.

"He talked mostly about himself. Not in a bragging way but his interest was entirely ego-focused." (In Chagall's home at Vence, which Chaim Gross and his charming wife Renée visited in 1971, all the works on the walls were Chagalls except two: a Renoir and an African piece.)

In later years Gross occasionally met Chagall at parties "where he was very friendly but where Vava [his future wife] spoke only French and preferably to Pierre Matisse, the dealer. Usually Chagall spoke only about art. Himself and art. Nothing else."

Eventually Gross did five sculptures of Chagall. He sent photo-

* Indeed, the *double* exile! Harold Rosenberg makes a good point when he contrasts the immigrant artist who ". . . did not come to New York to become an artist. He came . . . to become an American . . ." with a figure like "Chagall in Paris [who] could combine Russian-Jewish folklore with advanced Left Bank ideas in painting and retain both elements in his work. In regard to his background, the immigrant as New York artist has been strictly of New York in its changing relations to world art." (Harold Rosenberg. *The Anxious Object.* New York, 1973, p. 208.)

graphs which Chagall acknowledged receiving, but he said nothing about the sculptures.

"He has eyes blue as the sky of Vence," said Renée Gross. She found him a "lovable man." "Embraceable" was her favorite characterization for him. "He has the skin of a child, clear, with bright pink cheeks. He looks very much younger than his actual age."

When the Grosses visited Chagall's home at St. Paul de Vence in 1970, they brought candy. Chagall's eyes lighted up like a child's. *"Oy gut gut gut!"* he murmured excitedly, rubbing his belly. He loves sweets. Their home at Vence "is like a big bouquet of flowers," said Renée. "The door was opened by a beautiful maid; then Madame Chagall ushered us into Chagall and left us. Exactly an hour later she marched in again to remind Chagall that he had another visitor coming."

On this occasion Gross did a drawing of his distinguished host. Apparently it didn't entirely coincide with the Maestro's self-image, for he made corrections on it: thickening the feathery baldness of Gross's sketch to a rich crop of youthful ringlets, and elongating and slanting the eyes to give himself a mischievous semi-Oriental fawnlike look.

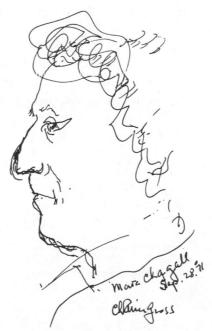

Another friend Chagall acquired during his New York period was Professor Meyer Schapiro, the art historian who was then midstream in his long and distinguished career at Columbia University. The two men have an astonishing resemblance to each other. They have often been taken for brothers. Schapiro laughingly told me of a time when, dining with Chagall at the Four Seasons, a boy came to their table and presented him with a book to be autographed, confusing him with the artist.

Schapiro first met Chagall about 1942, and soon he was frequently visiting the Chagalls in their apartment. Bella was ". . . a very vivid, outgoing, very warm and intelligent person." When I commented that the "outgoingness" is somewhat at variance with other accounts we have of Bella; that Marc himself writes about her famous "silence" or her general air of reserve, Schapiro said: "Well, she was more reserved than Chagall of course who was extraordinarily outgoing. But Bella too was a lyrical person, full of high spirits, a very outgoing woman." He recalled with great warmth that Bella always did ". . . a very Russian Jewish thing when guests came to the house. She would always serve a huge tray filled with sweets and nice things to eat."

Chagall and Schapiro didn't talk very often about pictures despite the fact that one was an artist and the other an art historian who, apart from his specialization in medieval Christian art, was interested in and also taught and wrote perspicaciously about twentieth-century art. Of course they spoke about contemporary painting when it happened to come up in the conversation. But as Schapiro put it: "I avoided acting as if I were interviewing him. It was a friendship and I didn't want him to feel that I was trying to find out his ideas or anything like that." But of course they talked about pictures. Schapiro remembers that Chagall said that "El Lissitsky had a great brain." Chagall also spoke with tremendous admiration for Bonnard; and disliked the current mode of abstraction, Kandinsky for example, which he called *peepee*. The two men usually spoke in French, sometimes in Yiddish. Schapiro had spent a number of years in France. Again, as in the case of Gross, the immigrant to America (Schapiro came to the United States from northern Lithuania not far from Riga at the age of three) was an American Jew of Eastern European heritage; the immigrant to (now refugee from) France was a Russian Jew, juridically French. In the one case a typically American brew of assimilation spiced with hyphenization, in the

other, a remarkable suspension and coexistence of various cultures.

Chagall's personality was extremely warm. "Not an intellectual but he is certainly very intelligent. He has the consciousness of a craftsman about what is being done. He was nostalgic for France at that time, I thought. He had great feelings about France." When they spoke about why he had left Russia, Chagall more or less indicated what Gabo told Schapiro later: namely the real reason so many artists and writers had left the Soviet Union in 1922 and '23 was less out of political disagreements and more because of the terrible years of privation—no heat, no canvas, no paints, no food—that they had gone through in 1920 and 1921, or even earlier. Not ideological differences but purely materialistic reasons had driven them out.

As for Chagall's judgments of artists, aside from speaking with tremendous admiration for Bonnard and against Kandinsky and current modes of abstraction, Marc expressed an enormous admiration for Titian. Which is not surprising since Titian has that rich surface texture, that *chimie* or skin that would appeal to Chagall. Whenever the talk turned to Picasso, "Chagall always spoke with guarded and wary caution. He was always very very careful in what he said about Picasso."

Schapiro thought that Chagall possessed a great deal of "common sense." He was not given to theorizing. He was very conscious of his work. He was very craft conscious. And he was a thoughtful artist. "He didn't just spill these things out, no matter how free and loose they may look. They're very carefully thought out and composed."

Schapiro, though a medievalist, gave the first graduate course in art history at Columbia and was acquainted with a great many contemporary artists. He was in contact with that world and so he and Chagall could get on well together.

In later years, Schapiro was to write a sensitive introduction to the publication of the Bible etchings, in a double issue of *Verve* 1959. Chagall was very pleased with this and sent five of the etchings to Schapiro. Then, when he came to visit he saw one of his old etchings which Schapiro had bought right after the war. Marc insisted that he take this etching out of the frame in order that he might inscribe it to Schapiro. "And then he made a nice slip," as Schapiro put it. The dedication was to Meyer "Chapiro" so that "my name and his both began with *Ch.* . . ."

During the war there was a movement in the United States to

build new synagogues. "The pity of it was that with all the great wave of building, the aesthetics were abominable. Most of the new synagogues were simply dreadful from an artistic point of view." Schapiro discussed this with Louis Finkelstein of the Jewish Theological Seminary, and told him that he thought it was a pity that more beautiful "more artful" synagogues were not being built. And he suggested that the architect Percival Goodman should make a small model of a synagogue and Lipchitz and Chagall prepare designs for "emblematic stained glass, tapestries and sculpture."

This was before Chagall had ever done any stained glass. Lipchitz, Chagall, and Goodman were brought together. Schapiro observed immediately that Lipchitz and Chagall would never get along. "Lipchitz just hated Chagall. I don't know why. It was just another typical example of the competitiveness of artists. They just didn't get along at all. And then while these discussions were still going on, there came the news of the Holocaust and the demands for relief were so great that the project was dropped."

After the war—this is after Chagall had already returned to Europe—a Rabbi Brande in Providence, Rhode Island, picked up Schapiro's idea of building aesthetic synagogues. The rabbi wrote to various artists suggested by the art historian: Chagall, Adolf Gottlieb, Lipchitz, and so on. Later Brande told Schapiro that "Chagall was out of the question. Lipchitz would ask for reasonable prices but Chagall's prices were astronomical. It was impossible to get anything." For this reason and various other difficulties the postwar "aesthetic synagogue" project also failed to be realized.

Even in those trying times of his second exile, Chagall's essentially joyous nature bubbled forth. The artist has what Schapiro beautifully calls "a capacity for elation."

"Even in New York I remember seeing him walking along the street, sometimes with his head bobbing back and forth, talking to himself. And it made me think of a poem by Baudelaire about the poet who is so full of his poetry that he walks crookedly." Chagall has a certain quality of an actor, of a clown. "He makes fun of himself. He laughs at himself. Which is very charming."

Once by extension, Chagall got very angry at him. In 1957 a writer asked Schapiro where Chagall got the idea of having these people flying over the cities. And Schapiro said, "Well, in Yiddish, one says of a peddler: *Ehr geht uber die hauser.* Which means

literally: he goes *above* the houses. . . . But it really means 'He goes through the town.' A peddler is one who goes through the town, that is, *uber die hauser.*" The writer dutifully quoted Schapiro as stating that Chagall had derived his air-borne creatures from Yiddish sayings of that kind—*luftmensch* and *geht uber die hauser.* And when Chagall read this he got furious. "He really got very angry."

At which point I commented, "Of course, he gets angry and I think justifiably so when anybody calls him 'literary.' He's afraid people will think he's an illustrator."

Schapiro smiled a quite Chagallian smile and replied: "But he *is* an illustrator. And I, as a medievalist, have no objection to illustrators. The important thing is not that he's an illustrator but that he's a *great* illustrator." He added: "Medieval art is all illustration, illustration of sacred legend. And Chagall shouldn't object to this. What's wrong with illustration? The question is simply an aesthetic one."

Of course one might question whether arts derived from the same font (Sholem Aleichem stories and Chagall paintings) can be considered "illustrations" of each other. But at any rate, one can understand Chagall's sensitivity on this point. His anger is an assertion of the autonomy of the picture, a declaration of independence of the art from whatever literary matrix may nurture it.

*

Chagall's paintings on the walls of their small apartment at 4 East 74th Street created the illusion of being back in Paris. Illusion was the world of the exile which Marc and Bella were to experience in America. Exile always implies a desire to return; they had never experienced this desire in France. But the United States was too big, New York too blustery, the changes of weather too violent. Marc was happiest in the country. Cows were cows—whether in Vitebsk, Normandy, or Connecticut.

Like most exiles he sought comfort in the company of familiars. Even a familiar enemy was preferable to an unfamiliar stranger. So he sometimes might be found in Kisling's studio in Greenwich Village—the Moise Kisling whom he had studiously avoided in Paris, and who was now throwing the same wild parties frequented by models, ladies of the evening, journalists, and many of the old crowd

who had attended his parties in Montparnasse. And after his absolution Marc became reconciled with the High Priest of Surrealism, André Breton, who was gracious enough to make public acknowledgment of the fact that he had forgiven the heretic.

Amédée Ozenfant's studio near Columbia University (where he taught) was another favorite gathering place of exiles. There the Chagalls might meet Zadkine or Léger or Jean Hélion. Sometimes Meyer Schapiro would be there; or the Italian critic Lionello Venturi, who was later to write a perspicacious study of Chagall's work. The Maritains were also among his closest friends in New York. There as in Paris the Chagalls maintained their warm friendship while turning a deaf ear to Raissa's prosletyzing.

Most of the refugees had arrived in New York without money or even the tools of their art. Zadkine had to find a smithy on 100th Street which could forge pliers for marble or granite. Once he had these in his hand, he felt he could forge not only statues, but a new life, a new career in this strange land. Léger opened a school, and photos of him in his New York studio reveal a calm self-contained man, not at all dispossessed in the New World. His work too underwent a change—it is in general more abstract and the individual forms are more organic, the pipe-men and chimney-pot women, though still bolt stiff upright, posed somewhat dismantled (machine-part legs and arms not yet assembled) in front of their bicycles like figures in a daguerreotype, were more organic, curvilinears were replacing rectilinears.

Kurt Seligman, who had introduced Meyer Schapiro to Marc, taught painting and engraving. A certain osmosis began to permeate between young American artists and these more famous Europeans—the results of which were to manifest themselves only many years later.

Closest to the Chagalls during that first American period were the Maritains, Lionello Venturi, Pierre Matisse (who was to mount a Chagall show in New York as early as 1941), and the Yiddish writer Joseph Opatashu.

The confluence of such friends was emblematic. Here in exile in the United States, a country founded by exiles, were the Russian Jews like Marc, Bella, and Raissa Maritain who had found a new country in France, and in the case of Maritain, a new religion; the Italian Jew Venturi; and the Russian Jew, now an American citizen,

Opatashu, one of the leading practitioners of Yiddish fiction in the United States. "Sentimentality," wrote Opatashu, "has to be smoked out. Among our Yiddish writers, the trees swayed too often in afternoon prayer, the sky was too often enveloped in a prayer shawl."

Yiddish fiction had been modernized and internationalized after the First World War: and Opatashu represented in his writing a similar mixture of provincial strength and modern techniques and themes that one finds in Chagall. The writer and the artist had an elective affinity. Opatashu's prose was thick, sometimes coarse, vivid, erotic like Chagall's painting "skin." "The secretary took tiny steps like a cat about to embark upon theft . . . the secretary's wife, fat and still spreading, met Friedkin with a greasy smile . . . he spread out on the chair. . . ."

And just as Marc, after more than twenty years in France, was still painting Vitebsk, so Yiddish writers like Opatashu who had arrived in the United States in their mature years still wrote best about "the old country." For although these writers "would often make an effort to engage themselves . . . with Jewish experience in America . . . the contours of their imagination had already been shaped, they were far more at ease in rendering places they remembered than those to which they had come." Irving Howe's judgment would apply equally well to Chagall in France, although the places he remembered were a geography of the soul.

Thus exile in America—especially during the first few years—served paradoxically to draw Chagall closer to his Russian Jewish background. The earthquake of war shook up the various strata of his being: his Jewishness, his Russianness came to the fore; his Frenchness receded. The French collapse in six weeks had inculcated serious doubts about French will to resist the Germans; Nazi occupation had stirred up the muddy bottom of latent anti-Semitism in France; Marc wasn't at all certain that Pétain's Vichy government was not supported by a majority of the French.

In New York at this time, certainly, he was much more interested in the progress of the war on the Eastern Front than in conditions in France. German armies were now raging through the lands of his youth; Vitebsk—the Vitebsks by the thousands—were being physically annihilated. The Holocaust was blazing at its full. Now more than ever he felt profoundly Jewish—Jewish to the core—suffering the

Passion of his people, their Golgotha of gas chambers. And now Marc Chagall was painting that series of "Jewish" crucifixions that had been initiated by the *White Crucifixion* of 1939.

That same year the Yiddish novelist Sholem Asch, whom Marc had known well in Paris, published *The Nazarene*, a fictional life of Christ. Inevitably this set off bitter criticism and charges in Jewish circles that Asch was about to be *geshmat,* converted to Christianity. Although this wasn't true, Asch's timing was unfortunate no matter how ecumenical may have been his intentions. For his trilogy on Jesus, Paul, and Mary appeared just when the war broke out, and the physical annihilation of six million Jews was attaining the proportions of Gehenna.

Chagall himself referred contemptuously to Asch as *un juif assimilé.* Marissa Goldberg, the daughter of Sholem Aleichem, told me that Chagall and Asch were always quarreling, that they didn't "click," they "clashed about art, and everything else." At one point they fought over exchanging a book for a picture. "They had the same character."

According to Marissa Goldberg, Chagall was not at all well liked when he was in the United States. He didn't "mix with artists, more with writers." Perhaps that is why "he came to our house almost every day." Sholem Aleichem's daughter was married to B. Z. Goldberg, a prominent Yiddish writer who contributed frequently to the most "literary" Yiddish-language journal, *Der Tag.* Yet although Goldberg was an ardent Yiddishist, Chagall always spoke to him in Russian "which my husband spoke poorly."

Mrs. Goldberg showed me a Chagall print of a swooping bride signed by Chagall and dedicated to "Marissa" written in Russian characters.

On another occasion Chagall acted ". . . peculiar. I have this old drawing which he made of my father and another of himself—early sketches of the writer and the painter. Chagall wanted them back. He said he wanted to put them together. I refused. He got mad. Offered to buy them. I refused to sell."

Chagall never actually met her father, the famous Sholem Aleichem. "But when he was eleven years old in Vitebsk, he saw a sign that Sholem Aleichem was reading one night behind the gate of the mill. Admission was forty kopeks and Marc didn't have forty kopeks. So he peeked through the tent. All he remembers are his

shadow and his hair.... This portrait was done from memory and photographs."

Sholem Aleichem emigrated to the United States on December 2, 1914, and died there in May 1916. Even then, says Marissa Goldberg, "everybody in the Yiddish world already knew who Chagall was."

Once she met Bella at a hotel amidst a small circle of friends. "She wasn't very friendly, but she was certainly very intelligent." As for Ida—"Oh, she was in love. She was always in love."

During those difficult days of readjustment, "we took him into our house like a member of the family. He's charming. Very very handsome. Brilliant blue eyes. We looked for an apartment for the Chagalls. He was talking then of moving up to the Catskills."

Despite his great reputation in France, Chagall was almost unknown to the art-loving and picture-buying public in America. Nor did most American artists consider him much more than a folklorist, a Surrealist with a Russian Jewish fairy-tale brand of imagery, a vendor of a special kind of bagel. American art had already broken free of the domination by the School of Paris. This declaration of independence marched in several directions: abstraction that was not cerebral à la Mondrian or mystical à la Kandinsky, but highly emotional, sometimes even violent (what was to become the New York School of Abstract Expressionism: Jackson Pollock, Franz Kline, Willem de Kooning, Philip Guston, Mark Rothko); incipient Pop which was Dada in Red White and Blue, and in another sense had developed out of caricatural elements already present in American regionalism of the twenties and thirties—Thomas Hart Benton's rubbery figures, or Grant Wood's American Gothic. Although there were of course a plethora still of Europeanized American artists—fledglings of all sorts of nineteenth-century schools, even the last splatterings of Impressionism—the main direction of American painting was already shaking loose of Europe: a pictorial decolonization, one might say, was taking place.

Consequently, although Chagall found buyers aplenty, especially among the Jewish community, his critical status was not high. Ted Fried recalls that when he recommended Chagall for membership in the Federation of Painters and Sculptors, his suggestion met with ridicule. "Chagall is not a modern artist!" he was told. Furthermore,

Fried, himself a new member of the Federation and a recent émigré from Czechoslovakia and France, could not possibly judge what modern painting signified to a group of American artists.

Fried had lived in France from 1925 to 1936, and had participated with Chagall in several group shows in Germany. For a while he resided near the Chagalls at Passy "but I never spoke to him then. He was older, famous." Even in France "when many artists were members of Front Populaire groups such as the Maison de la Culture, directed by Aragon, Chagall remained unaffiliated always. In New York, too, he steered clear of other artists and artists' groups." As in France his success in sales stirred up the usual envy, backbiting, and irresponsible gossip among painters. "In France I remember he had a reputation for avariciousness. He wouldn't give away napkins on which he'd sketched an idea for one of his pictures. Instead he'd sell it for 2,000 francs as an 'explanation' to a gallery owner or a critic. Well, soon he had the same reputation for stinginess in New York, though nobody ever saw him sketch on napkins. In fact he wasn't seen much by the Americans."

There was much excited talk, especially among the Jewish artists, when all those crucifixions began appearing in Chagall's work. Since the *Golgotha* of 1912 had not yet been acquired by the Museum of Modern Art in New York, these artists most likely were ignorant of Chagall's long infatuation with the theme. But during the war years how could anyone fail to understand the obviously Jewish sacrificial nature of Chagall's crucifixions?

More comprehension of Chagall's art was expressed by the artist Raphael Soyer, who met Marc on several occasions, "always at parties or gatherings, never privately. He's not a Cubist or an Expressionist. He's a phenomenon, a *samorodok*—'born of himself.' And Chagall is right in not considering himself a Jewish artist. He's a universal artist."

Pierre Matisse had been the first to greet him in the strange new world of America, and during the six years of Chagall's stay in the United States, the art dealer mounted numerous shows for him and was in steady contact. Matisse is a canny and balanced observer of artistic temperaments. Son of the great Henri, associated as dealer with many of the most celebrated figures in the world of art, Pierre Matisse's judgments regarding the ways and woes of artists are based

upon intimate associations. His many years in America have if anything intensified his Frenchness, an air of sympathetic irony pervades his cautious observations. He smiles wisely, surveys one shrewdly: "I don't stick out my neck."

Chagall's sense of exile, says Matisse, was typical of all the Ecole de Paris artists who found themselves in America, especially in New York during the war years. On the island of Manhattan, inhabited by all the world and yet unmistakably American in its tone, its energy, its violence, its air of anything-is-possible, the refugees huddled together like sheep in a fold, typical of all immigrants to the New World, isolated from the American scene less by their lack of English than their inability to divest themselves of centuries of corseted habits. How could they adjust to a city without outdoor cafés? How could one amble down a windswept canyon? Melancholically they shared (or sometimes treasured) information about restaurants where one might dine in a civilized fashion rather than furiously refuel the human engine *à l'amèricaine*.

In February 1942 a remarkable set of artists assembled for a photograph which was to be printed in the catalogue of the show mounted by Matisse entitled "Artists in Exile." The artists were: Marc Chagall, Matta Echavren, Ossip Zadkine, Yves Tanguy, Max Ernst, Piet Mondrian, André Masson, Amédée Ozenfant, Jacques Lipchitz, Pavel Tchelitchew, Kurt Seligman, and Eugene Berman.

With amusement, Pierre Matisse recalls the day of the photographing. "They were all cat-walking around. *Ssss! Ssss!* until the photographer (George Platt Lynes) clapped his hands and shouted: 'All right! Everybody in place!' Then they smiled. And after the photo they began cat-walking again. *Sss. Sss.* Artists are terrible!"

Next to the handsome Ernst—"and he knew it too"—Chagall gazes at us with assurance, a strong vigorous man. He was then fifty-four years old. There is nothing in this photograph of the fragile fawn, the dreamy dancer of Vitebsk, the cloud-navigating poet. Instead, Chagall strikes us here as a man who has arrived at a certain position and means to hold it. He is as burly as Léger alongside him.

After the war, Yves Tanguy remained in the United States. All of the others returned to Europe, though Lipchitz and Berman were later to come back to America and take out citizenship.

Five of the group were Surrealists who wanted Chagall to join them. "But he refused. He was always an individualist. Their

reactions to exiles were varied. All however felt gratitude to France where their art had been nurtured or stimulated."

"It is understandable," Matisse later wrote to me, "that away from their normal and respective European environments they should experience at times uneasiness and nostalgia. However, the feeling of security compared to the fate that would have been theirs had they failed to escape must have largely compensated their unhappiness.

"Most of the artists in George Platt Lynes's photograph had little in common and only a few did see each other regularly. To have found themselves in the close quarters of the photographer's studio must have seemed very strange to them."

Chaim Gross got to know several of the refugee artists during the war years. "Léger was very unhappy here. Bella and Marc Chagall talked only of the possibility to return to France. Zadkine felt he was neglected. Only Jacques Lipchitz was happy in the United States, treated as the favorite son by the museums and galleries."

Obviously Léger presented one mask to Chaim Gross and another to Claire Goll. The pragmatic test is the speed with which most of the refugee artists returned to Europe as soon as the war was over.

The catalogue to the show "Artists in Exile" which was held at the Pierre Matisse gallery, 41 East 57th Street, New York, from March 3 to 28, 1942, contained two presentations: one by an American entitled *Europe,* and one by a European entitled *America.* The preface by James Thrall Soby pointed out that the presence of talented Europeans might

... mean the beginning of a period during which the American traditions of freedom and generosity might implement a new internationalism in art, centered in this country. Or it can mean its reverse: ... that American artists and patrons may form a xenophobic circle and wait for such men to go away, leaving our art as it was before ... it would be disastrous to apply rigid standards of nationalism to the arts. ...

Rejecting the isolationist viewpoint whether in politics or in the arts—*Regionalism* and the *American Scene* movement—Soby declared that:

... art transcends geography. ... While remote and solitary creation benefits an occasional American painter, many of our best artists mature by working with full comprehension of contemporary European movements, accepting or rejecting the tenets of these movements with confidence and sensitivity. ... The arts are the only currency left which cannot be counterfeited and which may be passed from nation to nation and from people to people.

As his contribution, Nicolas Calas outlined in rather pedantic fashion the contradiction between the United States—"The first country of pure Protestant background to become an important factor in the cultural life of our times"—and Europe, where even most Protestant countries "never succeeded in entirely breaking away from the influence of Catholicism. ..." The Protestant is more interested in Truth; the Catholic in Beauty. "But whenever there is a crisis in culture the need to reconsider the accepted point of view is felt." Calas's categories could only dubiously be applied to a group of fourteen painters, six of whom were neither Catholics nor Protestants but Jews of varying degrees of religiosity and observance. Similarly Chagall's contribution to the show—*The Dream* of 1939—fitted uncomfortably into any of the major categories of modern European art outlined by Calas: Cubism, Surrealism and Neo-Romanticism. The red cock floating in the clouds was certainly Surrealist, but there is a Cubist webwork in the picture and a dreamy air quite akin to some Neo-Romantic works.

Matisse mounted Chagall shows in November 1941, October-November 1942, October 1944, June 1945, February 1946, April 1947, and November 1948, the last after the artist had returned permanently to France.

Although successful from a sales point of view, Chagall did not at first make any real critical dent in America. In 1945, his friend Lionello Venturi wrote an article deploring that prejudices are more tenacious in matters of painting than in poetry. Venturi expressed the fear that a long time would be necessary before the public would "know how to distinguish Chagall's creative purity from the cerebral, rhetorical, and erotic productions of so many others."

Even as late as 1946—when, after five years in America, Chagall had already been honored by two important retrospectives—the Museum of Modern Art in New York and the Art Institute of Chicago—the New York critic Henry McBride wrote:

> Chagall has been understood with much more difficulty in New York than in Paris where he was accepted from the start and where he has been given an eminent place. In New York at first he aroused a slight hesitation due to the violence of his color and lack of refinement of the symbols which are found in all his canvases. These symbols still exist; the horse, the drunken violinist, the cock are still there; but no one today is put off by them. They are even accepted in a way which resembles affection. This comes in part from the fact that we are used to them, but it is impossible also not to perceive that something new resulting from maturity, facility and refinement has entered into the painter's work. One might be tempted to believe that we have given this to a refugee; that America has refined what was formerly crude; but that would be to delude ourselves, because Chagall has lived as isolated in New York as in Paris. From his earliest youth he has selected some symbols and escaped from the world in order to take refuge in his dreams where he still lives content. One can therefore suppose that his new grace comes only from his own development.

McBride's supposition that a new "maturity, facility and refinement" were to be found in Chagall's paintings of the American period can hardly be justified. These qualities had been developed long before—indeed before Chagall returned to Paris in 1923!—and were made more or less manifest according to the artist's intention. He didn't always *choose* to be "refined," his clumsiness is almost always calculated; he draws "badly" in order to speak well: to make his images say exactly what he wants to say; he is most consciously "childish," maturely "infantile." This chordal coexistence of contrary qualities is of the very essence of Chagall's style and surely was not acquired in the United States. And most assuredly residence in America was less likely to refine than to roughen. De Kooning is a case in point.

Venturi, in a perceptive little book published in 1956, takes issue with McBride on the allusion to symbols.

> When one says symbol, one implies a precise content. Now Chagall's so-called symbols do not have that. They are pretexts which he employs to take refuge in his fantasy, when the high tide of passion overflows; these are spiritual or sentimental distractions. Gifted with an imagination that is both boundless and at the same time ineffectual against external events, what can this child do, lost as he is in a world more and more alien to him? He replies to war, massacres, martyrs by his painting—the only language of which he is master—by a defiance ever more obstinate. He conjures away the spirit of evil by tenderness and hopes that are sweeter as they are more unrealizable. Thus he escapes into his poetry as in a refuge to find himself in losing himself.

I should say that Venturi—for all the poetic sensitivity of his judgment—overstresses the automatism of Chagall's aesthetic; this artist is not—never has been—a somnambulist. He dreams, yes, but with his eyes wide open.

*

Surprisingly the American exile turned out to be his first opportunity to work in ballet. In France Diaghilev, although presenting him with a free box at the Ballets Russes, had never given him a commission.

In New York, however, the Ballet Theatre commissioned Chagall to do scenery and costumes for the ballet *Aleko;* and soon to the music of Tchaikovsky on the record player, Marc and Leonide Massine, the choreographer, were happily at work. Because of union rules which forbade Chagall to work onstage inasmuch as he was not a member of the stage managers' union, he could not complete his sets in place. Chagall felt he had to be able to do this in order to judge the effect of the sets *in situ.* Unable to budge the union officials, Massine, furious, in August 1942 transferred the entire

troupe to Mexico, where for a solid month Chagall plunged ec-
statically into the make-believe world of ballet which he had always
loved. The Germans were knifing deeply into Russia; Marc and
Bella's homeland was a heap of blackened ruins and corpses; the final
solution of the "Jewish Problem" was now under way.

Against this tragedy, against the vivid color of Mexico, the high
and daring chromatic folklore art stirred up in him memories of
Russian *lubok*. Both in New York from the start and in Mexico he
worked closely with Massine. Whatever might be the circumam-
bience—the gothic forest of New York or the tropical forest of
Mexico—the two Russians were plunged now in the Russianness of a
ballet based on a piano trio by Tchaikovsky and a poem by Pushkin.
Chagall painted the backdrops with his own hand, and Bella took
charge of the costumes, supervising a group of Mexican seamstresses.
In many cases Chagall touched up the costumes to get the colors
exactly as he wanted them.

The premiere of *Aleko* was a triumph, especially for Chagall. Since
he had been consulted on every detail of the production—dance,
scenery, set, costumes, lighting—there was a Chagallian unity to it
all: fabulous, highly colored (perhaps even more than usual because of
the Mexican influence), anti-realistic.

From his first contact with the Yiddish Moscow Theater in 1920,
Chagall had gone into his own outer-space orbits; even then he went
beyond the anti-realistic stylized theater of Meyerhold by insisting
that the actors be made up with green faces and blue hands. Chagall
had always envisaged the theater as the realm of poetry: free,
metaphorical, never as a representation of the real world.

Although he and Bella were never able to make the trip to
Yucatan they had dreamed of, a few short excursions outside of
Mexico City resulted in a set of Mexican gouaches, in which animal
bodies glow like Indian jewelry and turquoise and brown earth figure
as prominently in his palette as in the frescoes of Orozco and Rivera,
who were among the enthusiastic audience at the premiere of *Aleko*
on September 8, 1942. There were nineteen curtain calls.

The libretto of *Aleko,* derived from Pushkin's long poem *The
Gypsies,* tells of a Russian youth who, bored with life, joins the
gypsies. He falls in love with Zemphira, daughter of the gypsy king,
is betrayed, and in a fit of jealousy kills the fickle girl and her gypsy
lover.

Less than a month (October 6, 1942) after the Mexican triumph
the ballet opened at the Metropolitan Opera House in New York. As
in Mexico, Marc was called onto the stage together with the dancers,
choreographer, and director. The cheering audience understood that
the work was permeated in all its synaesthetic parts by Chagall-
liana.

Since all the gouache studies remain, we can easily project the
effect they must have had unfurled as huge backdrops. The gouache
study for Scene I, "Aleko and Zemphira by Moonlight," is almost
identical with the *Dreamer* of the Matisse show; the two lovers float
amidst mysterious moonlit clouds, a red cock (whose import is
obvious) heading in a turbulent sky toward a full moon. This moon
and red cock appear also in the sketches for Zemphira's costume;
Chagall is incapable of simply making "pragmatic" images; entirely
superfluous here from the point of view of costume design, the moon
and rooster clearly answer to a psychological need.

The sketch for Scene III is very powerful in its reduction to a few
elements: two huge blood-red suns, one in rays, the other a bull's-
eye, in a yellow sky against a wheatfield, with a sickle projecting
above it, a man in a blue boat, and an upside-down tree.

"I wanted to penetrate into *Aleko* without illustrating, without
copying anything," said Chagall. "I want the color to play and speak
alone. There is no equivalence between the world in which we live
and the world we enter in this way."

Certainly his backdrop for the "Fantasy of St. Petersburg," Scene
IV, has little to do with the story with its flying white horse, golden
candelabrum, red St. Petersburg. Chagall's sets are not really settings
at all: rather than being subordinate to the play, they tend to dwarf
it. After the New York premiere of *Aleko,* John Martin, dance critic
of the *New York Times,* wrote:

> ... It is Chagall who emerges as the hero of the evening. He
> has designed and painted with his own hand four superb
> backdrops which are not actually good stage settings at all, but
> are wonderful works of art. Their sequence is independently
> dramatic and builds to a stunning climax. So exciting are they
> in their own right that more than once one wishes all those
> people would quit getting in front of them.

*

Stripped of their surface French skin by war and exile, Marc's and Bella's identification with their deep-rooted Russian Jewishness had been intensified from the very start of their stay in America. First there had been the coincidence of landing on the very day the Nazis had demonstrated their capacity to outsmart Stalin by invading the Russians before their erstwhile pact partners could invade them.

Marc did not weigh all the political morality of whose the guilt and whose the innocence. Once the Germans had invaded his homeland, he and Bella followed the news breathlessly. It was *their* Russia that was being overrun now. *Their* Vitebsk that was being burned. *Their* Jews who were now being massacred in the gas ovens or shot in droves at the lips of graves they had just dug. Marc was not a political analyst who was capable of weighing all the niceties of fallen angels versus devils. Although he was certainly not a Communist, he was just as certainly a Russian, and became more so every day.

Perhaps Chagall's lifelong habitation in his own topsy-turvy world made the flip-flops of Russian-Western relationships, if not easy for him to understand, at least a medium in which he knew how to maneuver; "understanding" in a logical sense being unnecessary, indeed irrelevant. He was simply emotionally a Russian patriot. So when the Soviet Union started sending delegations to the United States, Chagall enthusiastically offered his services. On one such cultural mission he met again the actor Mikhoels, whom he had so inspired in the Yiddish Theater in Moscow 1920, and the poet Itzig Feffer, whom he had known since the school at Malachovska—both of whom he had not seen for about twenty years. With their arrival, Marc was suddenly back in Russia, the old days. He saw Mikhoels and Feffer almost every day; and when they returned to Russia, he gave them two paintings to be donated to Soviet museums. Together with the gift was a letter to his "Russian friends" in which he dedicated the pictures "to my fatherland, to which I owe all I have done in the last thirty-five years and shall do in the future. . . . Was it not my fatherland that put colors in my hand? Is it not the voices of my parents that call to me from out of the earth of my hometown?"

We have no documentation of how this passionate avowal, attributing to Mother Russia the merits of all of Chagall's past and future painting, was received in his homeland. The paintings apparently joined other Chagalls in the vaults of the Tretyakov Gallery, where they still remain in quarantine to prevent contamination of the proletarian purity of Soviet spectators.

Eventually both Mikhoels and Feffer, one an opportunist, the other a loyal Communist, were liquidated by Stalin—the actor killed in Minsk by the KGB; Feffer implicated in a so-called plot of Jewish intellectuals and shot.

If New York evoked no Slavic equivalent, the American countryside especially intensified Chagall's Russianism. After all, cows, chickens, greenery, meadows, clouds are universal. In Connecticut and up in the Adirondacks at Cranberry Lake, especially in winter Marc and Bella could fancy they were back in Russia: black and white pencilings of birch stands; forests, frozen lakes, snowy meadows. All that was missing were the isbas.

They were at Cranberry Lake when they heard the news of the Liberation of Paris. Their son-in-law, Michel Gorday, telephoned from the Office of War Information, where he worked. A running commentary had been received at the OWI from the Hôtel de Ville in Paris. Breathlessly Marc and Bella followed the Free French news reports—struggling to understand the English broadcast of the progress of the Allied troops entering Paris. In December 1944 a "Message de Marc Chagall aux peintres français"—written jointly by Marc and Bella, and dated October 14—was published in *Le Spectateur des Arts* in Paris.

Bella wanted to return to France immediately. She had been even less happy in the United States than had Marc. No matter where he was, no matter the circumstances, Marc could always take refuge in his work against the inimicably alien. But Bella, his alter ego, his Muse, his guardian angel, could nevertheless walk only on the outer bastions of his fortress: she could not (as he did) immure herself in his work. So she had suffered homesickness for France more than had Marc. And now as they listened to the excited radio commentary, guessing at best what was being described in English, their hearts beating with the tolling bells of Notre Dame, Bella shivered with excitement. She was ready to pack at once. They planned to leave the Adirondacks for New York on the third or fourth of September.

On September second Bella was dead. Six weeks after the Liberation.

The true story of her death—absurd, shocking—is difficult to unravel.

Meyer's account, obviously tooled to the desire of the family, is succinct:

> The Chagalls planned to leave the Adirondacks and return to New York on September four or five. But a few days before that Bella fell ill. She was taken to the local hospital but the gravity of the trouble, a virus infection, was underestimated. She died on September two. . . .

Crespelle cites a *Time* magazine article as his source for the following story: Bella had come down suddenly with what she thought was a sore throat but which turned out to be a streptococcus infection, was sped by Marc to a local hospital where she was refused admittance on the ground that the admission hour was over.

> . . . actually, the truth is quite different. Under the grip of fever, perhaps, Bella had lost all judgment and refused to enter the hospital. She had seen nuns in their white habits, and seized by an old phobia, she implored Chagall to take her back to the small, isolated farmhouse they had rented for the summer. The next day, her pain and state of exhaustion required urgent hospitalization, but it was too late. It was impossible to save her. The hospital was poorly equipped, with no penicillin, which in any case was still rare, as its use was reserved for the army.

I have found no article in *Time* magazine concerning the hospitalization. There is a *Time* obituary of September 11, 1944, as follows:

> Died: Bella Chagall, 48, wife and only model of Russian-born, Paris-loving Artist Marc Chagall, now painting his bucolic, sentimental fantasies in U.S. exile; of diabetes; at Tupper Lake, N.Y.

In her memoir, *La Poursuite du Vent,* Claire Goll, who had also recently lost her spouse, repeats Crespelle's story with some varia-

tions. One of "the most touching" condolence letters she received came from Chagall "who had known a similar fate." One day after bathing in the lake, Bella came down with an *"angine"* soon followed by septicemia. "Chagall ran to the pharmacy but that tiny shop only carried purgatives and sun lotions. Penicillin was needed. When the medicine arrived by plane, it was too late."

Ida arrived just in time to witness her mother's death at six o'clock in the evening during a violent thunderstorm which had sprung up as unexpectedly out of a calm sky as had Bella's death itself out of a blue and blissful existence.

The *New York Times* obituary (September 4, 1944) is headlined

MME. M. CHAGALL
WIFE OF ARTIST, 48

and reads as follows:

Mme. Bella Chagall, wife of the Russian-born painter, Marc Chagall, who lived for many years in Paris, died Saturday at Tupper Lake, N.Y. where she had been on a vacation. She was 48 years old.

Mme. Chagall, who had been her husband's only model and had strongly influenced his work, completed, a few days ago, her memoirs, which will be published soon. She was well known in art circles of Paris during the years between the two wars. She was acquainted with the artists and writers of the period, including Picasso, Matisse, Maillol and Maritain, was a writer of poetry and translated her husband's autobiography "My Life," from Russian into French.

Vitebsk, Russia was the birthplace of the Chagalls. They were married there in 1915. They fled Paris in 1940 and after nearly a year in southern France, came to the United States under the sponsorship of the Museum of Modern Art. At Mme. Chagall's death her home was at 4 East Seventy-Fourth Street.

Besides her husband, she leaves a daughter, Ida Rappaport-Chagall, and a son, Michel Rappaport-Chagall.

The age ascribed to Bella at the time of her death is obviously in error, since this would mean that Bella was only thirteen years old

when she and Marc had met in 1909. The Chagalls have always been extremely loose with dates.

Her correct age was probably fifty-two or -three. The obituary also contains a number of other errors and variations—"son" instead of son-in-law, former name of Michel Gorday, Tupper Lake instead of Cranberry Lake—but makes no reference to the local hospital or the cause of death.

It is difficult to determine the truth of the circumstances surrounding this shocking and absurd death. Streptococcus today is easily checked by antibiotics; in those days it was a killer. Was the hospital equipped with antibiotics? (Penicillin, developed during the war, was, in view of limited supply, not released for civilian use.) And what are the facts regarding her failure to be admitted to the hospital? Schapiro wrote me the following:

> One episode comes back to mind whenever I think of Marc and Bella. They were spending the summer in the mountains in up-state New York when Bella was suddenly taken sick—if I remember right, it was a streptococcus infection. She was brought to the nearest hospital which was a Catholic institution. As a Jew she was refused admission and died soon after. You can imagine the feelings of Marc and their daughter Ida who were close friends of Jacques and Raissa Maritain. I was horrified by the story, and my wife—a physician and professor of medicine at the New York University Medical College—wished to make a public protest. Marc and Ida begged us not to. It seems that the Mother Superior who ran that hospital had come to them and apologized, saying it was all a mistake, an inadvertence. This is my memory which you must check, however, with Ida whom you will probably consult for other information about her parents.

When I wrote to Madame Ida Chagall, to check this information, her reply was a refusal to discuss the painful subject. Madame Ida simply referred me to her former husband Franz Meyer's "official" account, which of course had been written many years later under the tutelage of the Chagall family. Schapiro's recollection of the circumstances have been corroborated in the main by other friends and acquaintances of the Chagalls at that period. The artists Chaim

Gross, Raphael Soyer, the historian and journalist Max Lerner, Mrs.
B. Z. Goldberg and many others have substantially repeated what
Professor Schapiro told me.

Barring a direct statement by Chagall or his daughter, the most
likely account was related to me by Virginia Leirens:

> Marc once spoke to me of the circumstances of Bella's death.
> They had been staying in a lavish hotel at Beaver Lake. One
> day Bella noticed one of those signs which indicated, couched in
> polite terms, that Jews were not welcome. An exception
> obviously was being made for the famous artist Marc Chagall
> and his wife.
>
> A few days later Bella fell ill. Marc kept making hot tea. She
> said her throat was burning. Finally they went to the hospital.
> On the admission form she was asked to indicate her religion.
> In her high fever and hypersensitive state, she refused. And
> when she saw some of the nuns floating around, she became
> hysterical and told Marc to take her home.

Leirens believes that Bella was admitted the next day or the day
after, but it was too late.

There is no way of documenting the episode inasmuch as hospital
records (at that time) were not preserved for more than eight or nine
years.

The variations in the various stories probably result from Marc's
and Ida's desire not to publicize whatever had happened at the
hospital. As wartime guests they most likely felt it ill-befitting to
protest publicly about anything in the United States.

Certainly to judge by the last photograph of Bella taken at
Cranberry Lake in August, a few weeks before her death, she was
struck in the full flower of her being. In the photograph (with Marc)
she looks young, beautiful, healthy—the thought of her dead within a
few weeks is unspeakable.

Renée and Chaim Gross attended the funeral in New York.
"Chagall was completely shattered. Crying like a baby . . . uncon-
solable. It was terrible to behold that strong man weeping weeping."

Claire Goll writes: "At the funeral I saw him shattered, broken to
bits, tragic."

Joseph Buxenbaum, an old friend of the Chagalls, recalls: "Marc

just cried and cried. It was heartrending. I thought he'd never get over it."

Unaccountably, beyond comprehension a blow from the blue had transformed him into the man from the land of Uz whose name was Job.

I was at ease, but he hath broken me asunder . . . I have sewed sackcloth upon my skin, and defiled my horn in the dust. My face is foul with weeping, and on my eyelids is the shadow of death.

Not for any injustice in my hands. . . .

For twenty-nine years Bella had been to him all women in one woman, his Muse, his patron, his critic, sharing his laughter and grief, co-builder of his career, his companion by sun and by moon.

He consulted her on his paintings, and though he might explode with fury at a criticism which did not please him, he always hearkened to what she said, returned to make the recommended changes though he might just have burst out of the studio in fury, slamming to the wall in eternal refusal the picture wherein Bella had suggested that a certain blue be exorcised or a yellow excommunicated.

Across a long and variegated life, from Vitebsk in 1909 to Moscow to Paris and all over France, to Palestine and Poland and Holland and Greece, from old Europe to new America, through sun and storm, flights physical and phantasmal, triumphs and frustrations, through poverty and wealth—Bella had always been there, by his side, a bastion of his spirit. Life without her radiant presence was as inconceivable as the idea of her lying motionless in that box on which the hard clods of earth were now falling in drumbeat of doom.

He wasn't even aware of the chief rabbi making the ritual cut in his garments.

After this shocking death, Ida, not wishing her bereft father to remain alone in his apartment, persuaded Marc to move with her and her husband to a new huge double apartment at 75 Riverside Drive with a beautiful view of the Hudson River and the green Palisades cliffs of New Jersey. Although he was sharing the place, the

apartment was rambling enough to permit him complete privacy, an ample studio and bedroom. Here he sat for hours on end staring out at the Hudson and seeing the Seine and the Dvina.

"Everything had turned black before my eyes," writes Chagall. For days on end, this strong man of fifty-seven who had never stopped working, moving, dancing, sat staring into space like an Egyptian monolith, unable to move, catatonic in grief, bludgeoned by fate into immobility, hopelessness. It was a reaction which this effervescent man was to demonstrate on several other crises of his life.

Then as if to remain in living contact with his dead wife he began with Ida's assistance to help translate Bella's memoirs from Yiddish into French. Ever since her return from Poland in 1939, impelled by the need to preserve a world which the Nazis could not burn, Bella had been writing memoirs of her youth. Significantly enough she had felt the need to write in her *mamaloschen,* her baby tongue, Yiddish, though she and Marc had spoken Russian more often than not to each other. "A strange thing," she writes in the preface dated Saint-Dié 1939, "I have had a desire to write, and what is more, in my stammering maternal tongue, which I have almost never had occasion to speak ever since I left the house of my papa and mama.

"The farther away my childhood years have slipped from me, suddenly they have returned to me, close, ever more close—so near that they could breathe in my mouth."

Everything floats before her eyes like the deep waters of the Dvina.

"My old house is no more—"

In his postface written two years later in New York Chagall himself writes that Bella's exile had stirred up anew in his wife her "Jewish soul" and hence her language had to become the language of her parents.

Her style, he says, "is the style of a Jewish fiancée in Jewish literature."

He remembers the last days: how many times he found her sitting up late at night reading Yiddish books in bed. . . . And just several weeks before her death—beautiful as always—he had come across her in their bedroom putting her manuscripts in order—finished work, sketches, copies. And Marc, stifling his fear, had asked:

—Why so much orderliness all of a sudden?

And Bella with a pale smile— Then you'll know where to find everything—

Ever since their departure from France she had had a presentiment of her early death. And so she had sought to cancel not one, but two exiles, skipping over her proximate past in France to return to the Jewish world of her childhood. Immersion in the past must have been very dear to her. Chagall describes her sitting at the shore of the lake, waiting, listening to the sounds of an unknown world. Ever since she came to America her mind had flown off from the present in two directions: into the distant past, and into the unthinkable future. According to Marc, her last words were: "My notebooks."

And with the thunderstorm that accompanied her departure (as in the death of Beethoven) Marc knew that he had entered now irrevocably into his third and most bitter exile—exile from his beloved Bella.

One of those who frequently dropped in to visit him after the funeral was the sculptor Alexander Calder. Once he even brought Marc a gift of a little mobile, gay-colored and witty, one of the few non-Chagallian works of art in Chagall's house. A letter which I wrote to Calder for details of Bella's death elicited the following reply written in his own big childish hand:

15 Jan 76
Saché
I.et L.
France

DEAR MR. ALEXANDER

It's quite true that I went to Chagall, and sympathized with him at the time of Bella's death. I also went to Bella's funeral. And I was interested in the fact that the "Kantor" cut notches in Chagall's tie, and in Ida's (the daughter) veil.

However, Chagall's attitude toward other artists changed totally, and we have never been friends since. I have tried to be friends, and I made him a little "mobile" with a mans (sic) body, with head of a goat. He refused to accept it, but Ida liked it, and adopted it.

I am very sorry, but I would not be able to enumerate my reasons for not being friends with him.

Cordially yours

SANDY CALDER

Another letter sent to me by Edouard Roditi reads in part:

Memories of Bella? I remember nothing very specific, only a few meetings, in Paris before 1937 and in New York during the war. One, in particular, at the home of Henry Hurwitz in New York, with Marc, of course, and André Spire. She was charming, as usual, and struck me then as very serene, while Spire and Chagall and Jules Romains (who was also present) spoke less reasonably about the dreadful news we were discussing, from occupied France and elsewhere in war-torn Europe—Not that she was flippant—only somehow more confident perhaps of final victory, less prone to believe what might have been mere rumor, in fact more realistic too. She was a great lady.

As ever

EDOUARD RODITI

P.S. I remember now: the meeting was *after* the liberation of Paris, when Sartre and others had come to New York—·Romains in particular spoke sheer nonsense about the French resistance, Ivan Goll too!

Warm understanding and intellectual distraction also came from Max Lerner, whom Marc met just about this time, after Bella's death, when he was in the slough of despond.

We saw each other frequently. He was troubled at being uprooted from Europe, and what was happening as a consequence of both totalitarianisms—the Nazi especially. His mind dwelt on Jewish topics for his paintings. He also felt lonely, without a wife. . . .

We were close to Ida who watched over him. So did Becky and Bernard Reis. The language problem troubled Marc. He couldn't speak English, and most of us had little French. He and

I managed to converse in Yiddish. We continued to do that when he returned to France, and we even exchanged a few letters in transliterated Yiddish. He always wanted to discuss world politics with me—during his New York years about Hitler and the war; during the post-American years about the Soviets, and Jewish life there.

<p style="text-align:center">*</p>

But grief—even so iron-fanged a grief as this—could not hold permanent purchase on the soul of Marc Chagall. The man's powers of recuperation were enormous; his basic font of joy-in-the-world too bubbling to remain forever enstopped.

After several weeks, green tendrils appeared on the monolith, he began going out again, his wonderful crescent smile blossomed at the sight of friends. Pictures he had turned to the wall, thinking that he would never paint again, were turned around, re-examined, re-worked, cut in half. With the brush once more in hand, the miracle of image-making served to reawaken all his latent force. Painting again he was living again. As the images blossomed so did his essential life–affirmation blossom with it. He cut a large picture in two—the *Harlequins*—which had lain about unfinished since 1933. The left side became the elegaic *Around Her*, a memorial to Bella, now in the Museum of Modern Art. As in a palimpsest, elements of the earlier picture were metamorphosed: the upside-down head became the artist at his easel, the book a palette; Bella weeping leans against a huge luminous circle like a conjurer's globe in which one sees the past: the isbas of Vitebsk. Above the glare, upper right, bride and groom in nuptial flight, the long white trail of the bridal gown reaching down to weeping Bella's shoulder; upper left an acrobatic androgyne and a cock holding a lighted candle. The symbols are all familiar, part of the alphabet Marc had used thousands of times, but the total image now is grief-stricken: a bluish-black tonality suffuses the scene, there is a lunar remoteness to this elegy, a frozen dream.

The second half of the picture became *The Wedding Candles:* irrepressible affirmation of Chagall's body and spirit. With Bella dead he evokes again their long-ago wedding; a beautiful winged goat is preserved from the incomplete canvas of 1933. The bridal couple under the flaming candelabra are bathed in dream-melancholy.

If the buds had appeared on the monolith, the miracle was not entirely from within himself. During nine brooding months—gestation of a rebirth—he felt his soul, his *nishoma,* was gone. This alchemy, the *chimie* that for twenty-nine years had transformed inert pigments to embodied dreams had flowed from his wife as water from a deep spring. Now the well was dry. He was thrice in an alien land—Russia, France, and Bella lost to him. Drained numb, he stared into space, seeing without seeing the sparkling blue-bellied Hudson, the soft green cliffs of the Palisades. Sometimes the white excursion steamer passed, pennants flying. He didn't see it. Or he saw a barge on the Seine. Or the bridge over the Dvina where he had wooed Bella. Even though his fingers had begun to work again, these were conditioned reflexes, automatic twitches, the pictures were being created by his medulla oblongata, his sympathetic nervous system. His soul was waiting waiting.

> Tes pas, enfants de mon silence,
> Saintement, lentement placés,
> Vers le lit de ma vigilance
> Procèdent muets et glacés.

Without knowing it, he was waiting for the fertilizing steps of Valéry's bridegroom.

And the steps came. From a most unexpected quarter. One day a tall young Englishwoman accompanied by a sweet five-year-old girl appeared at Riverside Drive to fetch a bundle of Marc's socks to mend. She had been recommended to Ida by a mutual friend whom she met in Central Park where she had taken her daughter Jean to play. Surely Virginia Haggard McNeil did not look like a seamstress. Tall, slender, very attractive, volatile, she moved with astonishing swiftness, spoke with a melodious British accent that bespoke a class quite remote from the class that mends socks. Her nutbrown hair fell carelessly to the shoulders, her eyes were gray-blue and bright-alive, her broad smiling lips forever shaped wonderments and exclamations. Ida was charmed. "She had taken up painting rather timorously and produced pictures of a cloudy, ephemeral nature that suffered from her frantic determination to try and be herself, a thing it was difficult to do in the circumstances." Would Madame McNeil—who spoke,

as it turned out, rapid and fluent French—pose with her little girl? A
charming subject. So it began. Socks and sittings. Every week
Virginia brought back a bundle of nicely mended socks, and posed
hand-in-hand with Jean at Ida's end of the big sprawling flat. Now
they spoke French almost always. Occasionally, Virginia caught a
glimpse of the artist: usually silent, brooding, a Jeremiah, except
when he burst into Russian rages or lamentations in conversations
with his daughter. Sometimes Michel Gorday, Ida's husband, ap-
peared like an apparition. It was quite apparent that he and Ida were
not getting on too well.

One day the maid quit. Ida was furious. She was dying to get
away. She badly needed a holiday. Ever since her mother's death the
burden of mothering Marc had fallen upon her shoulders. Perhaps
Virginia might come every day and look after the flat and cook for
Marc Chagall? Yes, she said, if I may bring my daughter. "She took
me into the big studio overlooking the Hudson River and he came
forward smiling. His shyness was the same as mine. . . ."

So it began.

One could hardly imagine two worlds farther apart than that of
the fifty-seven-year-old Russian Jewish artist and that of the thirty-
year-old English girl who had been born in Paris and brought up in
Bolivia and Cuba, as her father Godfrey Haggard, a British diplomat,
shifted from post to post in the consular service.

They met when they needed each other. And mutual need flung
the bridge across their separate worlds. Marc was still in a state of
shock from the death of his beloved Bella only nine months ago. And
Virginia was a victim of a rebellious childhood and ten years of an
unhappy doom-struck, sex-starved marriage.

She felt that destiny had led her to this apartment on Riverside
Drive. For fatefully she had met him for the first time twelve years
before.

. . . at a British Embassy reception in Paris. Bella was friendly
with the Ambassador's wife who painted strange naïve pictures
inspired by dreams and visions. Marc gave her criticism and
advice. The Embassy seemed a most unlikely place to see
Chagall. He didn't frequent these circles for very long. I was a
shy art student of eighteen and he put me at ease immediately.

My father was Consul General and our style of life was conventional and oppressive to me.

Her father, Godfrey Haggard, was nephew of the novelist Rider Haggard; her mother Giorgiana, was of French Canadian background, hence Virginia absorbed French from her infancy.

I was beginning to revolt and sought more freedom by studying in the Academies of Montparnasse under Gromaire and Dufresne who made their appearance once a week to "correct" our work. I had been brought up mostly by strict maiden ladies (two aunts, three governesses and a host of school teachers, all maiden and all bigoted). I went to boarding school in Surrey and Toronto and was finally set free after a serious and providential illness and attended art school at the Art Institute of Chicago where my parents were living before going to Paris.

When I was nineteen I went to work in London where my brother, Stephen Haggard, was a famous actor. I worked in a theatrical painting studio and met people of a totally different milieu, mostly simple workmen. I was much attracted to a stage designer and scene painter, John McNeil, who was a Clydebank worker's son. He was talented and intelligent and spoke with a soft Scottish accent. His childhood and youth had been fraught with suffering and I was drawn to this vulnerable man. He had a project for founding an experimental repertory theater in Glasgow and we decided to live and work together. My father and my brother were violently opposed but confronted by my obstinacy and John's refusal to meet the family, they literally pushed me into marriage by defying me to prove the "honesty" of his intentions. Realizing the impossibility of coming to an understanding and resolved to break with my family I left Paris for Glasgow one morning at dawn.

Undoubtedly, McNeil's radical stance is what had appealed to Virginia in the first place; she married in revolt against respectability, against her soft-spoken parents who never quarreled in the presence of their two daughters.

Later, friends were to describe the Virginia of the war years as a

free-wheeling rebel, a truly independent spirit before the codification
of counterculture Hippiedom. And probably her philo-Semitism dates
from the same identification with outsiders and rejection of the
insiders from whom she derives. "I like Jews. I like people who are
frank and open and raise their voices and are not ashamed of their
feelings." Virginia was in rebellion against all upper-classism whether
in diplomacy or domesticity.

John was a Communist and I was attracted by his ideas, also
working with him promised to be interesting, but two years of
Glasgow plunged us both into a state of deep depression. He
gave up the theater project and discouraged me, from the very
beginning, from painting. I knew I would never touch a brush
again. I felt snuffed out and inexistent. I became quite ill and
incapable of doing anything whatever, but the day John decided
to return to London I jumped to my feet and started packing.
In London I taught handcrafts in an experimental school and
began to get interested in freer methods of education. John
relapsed into neurosis and became unable to work, so we went
to Paris where I got jobs as a governess but as I tried my free
methods on the children I fell into disagreement with all my
employers in turn.

In 1939, pregnant, she went with her husband to New York,
where her father was now British Consul General. "We made the
great mistake of accepting his generous hospitality." The young
couple moved into the elegant home at Sutton Place South but
"things went from bad to worse. It became evident to them that John
systematically turned down every chance of a job and refused to
consult a doctor. He wouldn't cooperate. And finally he was kicked
out." Virginia was permitted to stay because of her newborn baby
Jean; then after six months she too was asked to leave.

And now began the sordid saga: a series of tiny furnished rooms in
the 50's under the Third Avenue El; the husband subsiding into a
frozen do-nothingism, the young mother forced to go out and earn a
living for the three of them. Because she could take the baby with
her, Virginia got jobs as a cleaning woman. Moving every two or
three months because they couldn't pay the rent, the couple wound
up on West 83rd Street where Virginia used to take Jean, five years
old now, to play in Central Park.

"It was then that Ida's friend, whom I met in the park, sent me to her house to collect a bundle of socks to mend—Chagall's socks."

Her obligations were to look after the flat and cook. "I began to put the studio in order and collected innumerable scraps of paper covered with rough sketches and inscriptions in Russian and did as little sweeping as possible so as not to disturb him. Every time I passed I gave the Calder mobile a spin; it had just been given to him by Calder in an effort to cheer him up. He was painting furiously all the time." Now with Virginia ensconced Ida was free. Lerner recalls Ida's triumphant announcement: "My God! We've finally found a housekeeper for Father! She can really keep him company! It's marvelous!"

And off she went on a much-needed holiday. The fact that the pretty young housekeeper spoke French was an added advantage; Chagall still had no intention of learning English.

But he was not dreaming of France then; if anything, Bella's unexpected death had returned him almost corporeally to Vitebsk, the real Vitebsk, not his dream city. Browsing through his wife's Yiddish manuscript of *Burning Lights*, Chagall could see the sabbath dinner table gleaming with brass candelabra and snowy with linen, he could hear the familiar cadences and rock with his mother's heart-gesturing rowing motion of the blessing of the candles. And there through the window was the Hudson, a blue cape sparkling with rhinestones, and to add to the incongruity a tall English housekeeper, a pretty girl with a shy smile that emerged with sun-from-cloud unexpectedness. She served him his meals and spoke correct things to him in correct French—more correct than his and with a different accent. With Ida gone, the huge apartment seemed huger still. Their mutual shyness "brought us together."

He had begun to work again. The pain of loss could be mitigated only by *arbeit*. June July from morning to night he worked without a stop. Virginia looked at this man with wonder. He had lost his wife ten months ago: bereft of that essential presence, exiled to a strange land, the bulk of his paintings left in France, perhaps stolen during the Occupation, another great chunk of his art lost as had happened in his youth with the paintings left at La Ruche.

And yet, here he was, rushing every morning after breakfast to his big studio where he remained all day, day after day, repainting old canvases, re-evoking his dead wife in bridal images under *chuppahs* of

old Russia, cutting canvases apart and repainting them as if by so doing he was creating two or three new worlds out of one old one, painting, humming incongruously against a background of music.

The picture that was on the easel when I first entered the studio was *Nocturne* which he finished a year or two later. It was one of his simplest and strongest compositions, so strong that it bore no trifling with and I saw him put it on the easel many a time, look at it for a long while and then put it away. Another painting he worked on during that time was *Around Her* which had tortured him for months until he cut it into two. One half became a tragic painting with Bella weeping for her lost country and Marc at the easel with his head upside down. The other half, *Wedding Candles,* always remained a half and had the same charm and the same weakness as an enlarged detail in a book. Another was *The Soul of the Town,* a great metaphysical painting a lover of symbolism would delight in explaining without ever unravelling its mystery. The artist is two-faced, the heavenly bride has become simply a head with a twirling veil and the earthly woman is holding a cock tenderly in her arms; on the easel is Christ, the Jewish martyr, and a Torah in the sky seems to behold it all.

He alternated between joyous fantasies and tragic memories and one of the former was *The Naked Cloud,* an ecstatic pair of lovers with yellow bodies floating into the sky on a cloud. Another was *The Flying Sleigh,* a spirited, musical picture.

She looked at him with wonder. Because even a visitor from a remote land, like herself, could see that the vital forces were regathering in Marc Chagall. Beneath the facade of melancholy his life-affirming smile began hesitatingly to reappear; the playful Chaplinesque humor began to manifest itself amidst the gloom; his boundless energy drove him to paint from early morning to late afternoon; from the staring Egyptian monolith, he had become again the lightfooted fawn. He walked with his peculiar dancing step into the studio. Once in a while, amidst her household tasks, she became aware that he was staring at her, smiling, even winking. They were alone in the apartment a great deal.

Although he was working like a demon, Chagall hated solitude.

Frequently Virginia heard the sounds of music issuing from the studio: Chagall loved to paint to the accompaniment of Mozart. Sometimes in the evening, after a day's work in the studio, he would read a Yiddish paper: the Socialist *Foreword* or the more conservative but literary *Day*. He listened a lot to the radio trying to make out what was happening in postwar Europe. Occasionally he asked Virginia to translate for him.

One day when Virginia had served him his noonday meal, Chagall said: "Why don't you sit down and eat with me? Must I eat alone like a dog?"

He became very playful. His essential humor broke through the dark clouds. Virginia found him delightful: his colorful stories in correct and charmingly accented French, his broad acquaintance with painters and writers she had worshipped from afar, his personal encounters with "names," sometimes expressed with an extraordinary humility ("and they are planning a great retrospective for me at Paris ... for *me* ... a boychik from Vitebsk!"). He spoke to her about Apollinaire and Eluard, about writers more often than about other painters.

To Virginia the notion that she was now eating at the same table with Marc Chagall was extraordinary and yet as natural as fate. She knew of course who he was; after all, had she not in her teens been enrolled in three art schools in Paris—La Grande Chaumière, the Académie Scandinave and the Académie Chanson—and what budding painter was not aware of Marc Chagall in the 1930s?

Domestically alone with him in the large rambling flat she could not help but think of the artist's wife: how mondaine Bella had been at that British Embassy reception in Paris so many years ago (even before Virginia's marriage!), how sophisticatedly friendly Bella had been with the British ambassador Clark, whose wife was a painter of sorts. Bella absent was more intimidating than Marc present. She felt all thumbs and elbows, too young and raw, in the shade of that elegant lady.

And to think that her father had been stationed in Paris at the time! So the gears interlocked. The luminary she had seen on one occasion from afar, and whose works she had admired in the museums, was now seated opposite her at the luncheon table: playful and yet melancholy, a colorful and amusing conversationalist. He talked about poetry like a painter and painting like a poet. She came

to the conclusion that he had absorbed the meaning of books by some kind of intuition, osmosis. Certainly she rarely saw him read anything other than newspapers "in a desultory fashion but he devoured the pages on art."

A case of innocent affinities. They were two very unhappy people who helped each other. They became lovers. Inevitably. Ida was always away, darting about on her own affairs; Michel came to the apartment only on rare occasions. The father's new marriage fusing; the daughter's dissolving.

Now Virginia's life was split into daytime heaven and nighttime hell. Every evening, she returned from the vast sunlit apartment on Riverside Drive with its spectacular river views, a world of magic and alchemy and Yiddish humor and distinguished visitors and good talk and moments of love for which she was starved.

From this blaze of color she returned to the dingy furnished room, to her husband ever more locked into his bitter self, to his spew of hatred against the upper class (was not her father a diplomat?) against Jews (did she not indiscreetly praise her new employer?). Did John suspect her relationship with Chagall? She didn't know. But she did know that she had become terribly fond of Marc Chagall and she feared her husband's violence should he discover it. Perhaps Jean, in all her five-year-old innocence, might unwittingly reveal what she could not understand. Then what would happen?

Suddenly Ida returned.

She sensed that there was a change. She gave a supper party for Marc's fifty-eighth birthday and invited me to drink his health in a glass of vodka. She was tactful and kind but she had a way of scrutinizing me suddenly that made me ill at ease, as if she were trying to wring the secrets from my eyes. She didn't have to wring very hard, they told her everything she wanted to know.

Soon Ida announced that she had taken a place for the summer at Sag Harbor. Virginia must come too; she could bring the child, of course, and return "home" weekends. Ida insisted; she seemed delighted with the change in her father since Virginia's appearance on the scene. Did she suspect that the sinewy sweet young house-keeper had become something more than that? If she did, Virginia

had no way of knowing. Ida was very *rusée*. Although they were
almost the same age, Virginia felt naïve, clumsy, inarticulate in the
presence of this dynamic self-assured explosive lovely woman. When
Ida spoke to Marc (usually in Russian), one could see at a glance that
father and daughter were close as lovers. They even fought like
lovers.

Marc added his importunities to Ida's. And so she went with the
Chagalls to Sag Harbor. To her astonishment John assented; he even
seemed happy to see her go.

The summer at Sag Harbor was a delight. "Jean had her first sight
of the sea and Marc got brown and handsome. There were moments
of relaxed gaiety when we trailed down to the beach with friends and
feasted on fried blow-fish. I was still officially only a 'housekeeper.'

"It was in this widespread overgrown house with the endless
balconies, where stuffed gulls and albatrosses stood gravely around,
that Marc began the *Firebird* designs."

His new love—as unexpected as Bella's loss—was rapidly healing
that deep deep wound; Chagall's essential love of life was blossoming
in the sun of Virginia. He had become the very Firebird he was
designing. Sketch after sketch poured forth in a seemingly inexhaust-
ible burst. He was working in gouache, a medium always congenial
to his temperament.

He listened to the music all day long in the big bedroom
upstairs where he worked and at once he began to float in the
Stravinsky element, completely tuned in to its mysterious
archaic strength. He started sketching feverishly, jotting down
vague ideas, sometimes in color, sometimes in pencil. These
were barely more than abstract shapes, movements, masses.
They contained the living seed that would grow into birds,
trees and monsters. He soaked them in pools of colour and
nourished them with brilliance until something started moving.
A bird-woman emerged first of all with outstretched wings of
terrible beauty, sweeping into a sky of deepest blue; then a
strange forest where trees took root in the sky, followed by a
bird-cloud with a ladder leading up to it and finally a marriage
scene with a flaming canopy floating upwards. Everything had
wings in Marc's *Firebird*. The dancers would have to be
ethereal!

(When eventually Virginia saw the ballet the spell was broken when the dancers appeared. By contrast with Chagall's winged world they were not ethereal enough!)

The gouaches Virginia saw were strident, hallucinatory, savage as Stravinsky's music ululating its dervish spins and Scythian leaps out of Chagall's bedroom window and over the blue placid Sound. The bird-woman soaring acoss the blazing yellow space was Virginia. Virginia knew it and took a woman's joy and pride in it.

Glancing at these pagan joyful sketches, the Yiddish novelist Joseph Opatashu, Chagall's dearest friend, remarked with a smile, "Oy, Marc, you must be in love."

Joseph's wife nodded in sage womanly agreement. "Sasha, don't be a Quasha!" murmured Chagall, in an effort to deflect.

All their friends—and there were quite a few that summer—were aware of the change in Chagall. The critic Emily Genauer came, Max Lerner, Meyer Schapiro—very few painters or sculptors; they saw that the artist had emerged like Lazarus from the grave but did not suspect what had worked the miracle. But closer friends like the Opatashus suspected; and Ida was putting out tentacles to determine just how intimate her father was with the housekeeper. "Don't you want to invite your husband for a weekend?" The very thought terrified Virginia. And yet Ida's probing was not unsympathetic. She was not unsympathetic but she was not altogether sympathetic either. · One day Virginia put too much salt in the food. "Ah, you must be in love," remarked Michel teasingly. Another time, Virginia set her hair in two pigtails. "Ah, that's attractive," he said. "Who's it for?"

She was starting to live again. Boats, sunshine, and love in the big rambling house filled with stuffed birds and animals. There was lots of room for the body to move and the spirit to expand. Chagall worked all the time. If not at the canvas, he was scribbling on the little scraps of paper or drawing pads he always carried with him. Even while Virginia was driving, alongside her Marc was jotting mysteriously. Not always pictures. Writing too, usually in Russian, Virginia guessed, glancing at the mysterious curlicues and baby-round ingenuous letters, although she couldn't really distinguish Cyrillic script from Yiddish.

Of course she ate in the kitchen, and had her own room, but in the night, across the communicating balconies, she joined Marc. One night Jean cried Mamma! Mamma!—and Ida came out of her room to

see what was the matter. She saw Virginia running barefooted along the balcony.

She was very happy but on the brink of a catastrophe. Every other weekend she would come home to a more and more suspicious husband, until finally the truth was out.

John's reaction was terrifying. He shouted abuse all through the night and finally went out, declaring he was going to throw himself into the river.

But at dawn he was back home, ordering her to break with Marc immediately.

Unfortunately the child Jean was not shielded from these lugubrious and hysterical proceedings. Her childish cilia quivered to the tragedy of her parents. She had always been lovingly attached to her father, and he in turn had been as sweet and gentle with the child as he was occasionally hateful and acerb with the mother.

So, torn, shattered, fearful of her husband's threatened suicide and the effects separation might have on her daughter, Virginia capitulated. She returned to Sag Harbor, gathered her things and told Chagall that she was returning to her husband. The artist received this news with the awesome fatalism that she had already observed in him. Motionless as an Egyptian monolith (he always in motion!), dead-eyed (he with his bright fawn's eyes, skyblue, sparkling), silent, numb, he made no effort to stop Virginia. He didn't even kiss her. He was already *working*, Virginia observed amidst her tears and desperation, working at reconstructing his life again on new terms. (Seven years later, she was to observe a similar, if more violent, instance of his fatalism in the face of traumatic sundering.)

So in the late summer of 1945, Virginia went back to live with her husband.

He was absolutely adorable. Trying to console me. On the second day he was playing games with Jean. He had a generous streak in him. He and Chagall could share me, he suggested. I knew Chagall would never accept this but I took advantage of John's "offer" to return to Sag Harbor and I told Marc that my husband was being very generous, very tolerant. I could continue to work there but I must promise not to leave my husband. Chagall was of course terribly upset but at least he felt

this was a postponement of the crisis and so he accepted it. Accepted it with the same fatalism with which he had accepted my departure.

All this took place within a few days. I phoned Ida from New York and said I was coming back.

In the fall this strange ménage returned to Riverside Drive and the old torment began again. "Going back and forth from one man to another was sheer torture."

When she discovered she was pregnant, "Marc was distraught for he was not yet prepared to face this inescapable proof of our relationship." In desperation she suggested they consult an eccentric woman with an eccentric name, Quest Brown, a warm "uncanny" palmist married to a commonplace broker. As they sat before her, hands outstretched, she declared with the assurance necromancers share with priests that Virginia and Marc would be happy together and "What's more, you'll have a child—a boy."

At this, Marc, who had agreed to consult the palmist as a lark, was suddenly happy at the thought of a son: the dream of every Old Country Jewish father. Then and there they decided to name the baby David after Marc's younger brother.

And with this newfound strength, Virginia now resolved to break with her legal husband once and for all. To her surprise (except that his unpredictable veerings were the only unsurprising things about him), "John took it like a man." Indeed, he gave a legal paper to Virginia declaring that the child to come was Chagall's. Thus they separated. Calmly. The terrible marriage came to an end. Only Jean felt the loss of her father with anguish. When they came to collect their final belongings they found John had gone with a note saying he had returned to England and taken the child's favorite toy—a teddy bear—with him "as a memory." Jean burst into hysterical weeping. But she soon pushed this horrible episode deep into her subconscious and remained ever on loving terms with her eccentric father.

Before John's departure Chagall sent him a small sum of money and a suit of clothes.

"When I became pregnant I went into the country. Marc wanted complete secrecy."

Chagall was undoubtedly still embarrassed by his alliance, although

it was no longer a secret to his close circle of friends. Max Lerner recalls that Marc was "very ambivalent about Virginia. He very clearly enjoyed her, and having her there, but at the same time he was by no means sure of how we felt about her. We liked Virginia and used to have fun over the fact that she was the niece of Rider Haggard, quoting the lines:

> Where the Rudyards cease from Kipling
> and the Haggards ride no more

"Virginia kept herself very much in the background. She was shy. And Chagall, who wasn't very self-assertive either, didn't trust his own judgments about people. There was always this strange feeling: Marc Chagall had fallen in love with his housekeeper. Certainly it was very clear to all of us that Virginia Haggard was not just a housekeeper. We all took to her immediately and thought she was good for Marc. But it was a difficult period for Chagall. He's not a wise man about people. And he was mixed up about being in America. Sometimes he would say: '*Ach vos a Medina is doss!* Oh what a wonderful land this is!' and yet he wasn't at home in the United States. He had rediscovered Vitebsk in New York and yet it was a period of alienation for him. He missed France and he didn't. Ida was also torn about her father's new companion. She was anxious about what kind of influence Virginia would have upon him."

Amidst this churn of emotion and doubt, Virginia—her pregnancy now manifest—was hidden out in the country.

> I landed on a muddy day in the small village of Walkill. It was a depressingly typical American village but it proved to be a stepping stone to a grassy valley in the Catskills, called High Falls, where we found a simple wooden house with a screened porch and bought it outright.

All during his unwanted stay in the United States, Marc had been happiest in the country. Universal foliage and universal cows were easier for him to cope with than booming blatant New York. While nesting out in Walkill, Virginia spotted an ad in the paper and Marc and she went to the area in a taxi because they didn't own a car then. The place on the side of a ravine had a good view. Not far from

Kingston and Woodstock it was only a few hours' drive from the art world of New York. Marc was delighted. In this simple country house which was to be his home for the next two and a half years, Marc Chagall accomplished his important paintings between 1945 and 1948.

There was a smaller house next to it, almost an isba, and Marc surveyed it with rapture. His studio! There were rainwater cisterns, hand pumps and coal stoves and it reminded him of Vitebsk. We moved in that winter and when the snow came a yard high he was ecstatic. The inhabitants of our valley considered us with suspicious curiosity but they gradually got used to our strange appearance and came to our help. The American peasant [sic], especially in New York State, is a very conventional species. But they became our fast friends. While Mr. Purcell, the farmer, knocked the dividing walls out of the little house, in the big house Marc began work on *The Arabian Nights*. I read him the stories again and again. The sketches were spread all over the floor to dry. He was remarkably unconcerned by the puddles, blots and smudges that occurred and plodded away with concentrated determination.

The only friends who were in on our secret were Pierre Matisse, Marc's dealer, and Joseph Opatashu, the Jewish writer, and his wife Adèle [who had deduced from the ebullient *Firebird* sketches that Marc was in love]. With great warmth and humour they undertook to acquaint me with Jewish customs and ideas, taught me Jewish cookery and called me teasingly a "schicksele." We had gay times together.

In April 1946 James Johnson Sweeney opened Marc's Retrospective Exhibition at the Museum of Modern Art. The MOMA exhibition, which lasted from April 4 to June 23, showed 144 works and had an excellent catalogue by J. J. Sweeney.

"In May Marc left for Paris, Ida having paved the way for his first return since the war. He had chosen May purposely so as to be absent at the time of David's birth. Birth always had frightening associations for him and he was better out of the way."

In one of Marc's first letters from Paris he wrote:

France has changed a lot, I don't recognize it. America is more dynamic, but also more primitive. France is a picture already painted, America has still to be painted. But when I work in America it's like shouting in a forest, there's no echo.

In art the same names are still on everyone's tongue, Picasso and Matisse, Matisse and Picasso. Sometimes Rouault and Léger and Braque.

I avoid Montparnasse.

I am sending you articles so you can judge the vanity of all these empty words. Too much writing, too many papers, too many books! But there are some real poets like Eluard and Char. I lunch, I dine, I see endless people. I can't be alone and work. I'm longing for my little house. I can't kiss you enough, you and perhaps David too.

Shortly thereafter David was born, under the Cancer sign, like both of them, and Marc sent Virginia a joyful telegram.

In July he wrote:

The "Affaire Vollard" is a tremendous business. All these questions: Vollard, Matisse, Carré, Maeght, the exhibition, give me a pain in the belly. I would love to come home and work. Don't worry too much about the studio. I need very little, just light, tables and *walls,* nothing else!

I don't like the atmosphere here, especially alone. I don't feel famous, I'm still the same, I like solitude (with you) and a simple life.

In spite of all these preoccupations he managed to make a series of astonishing sketches which in 1953 became the "Paris Series." The central figure of many of these is a mother and child and one, *The Pont Neuf,* represents a birth with the mother lying in the foreground holding her baby, and hovering over her on each side are Marc with his palette and easel and Bella in her wedding gown. Others of the series inspired by David's birth are *The Madonna of Notre Dame, The Banks of the Seine, Quai aux Fleurs,* and *Notre Dame.*

According to Virginia, Chagall's brides in this series especially (and they appear frequently) are *always* Bella. The Madonna and Child, however, were usually Virginia and David.

When he returned from his first postwar Paris trip, the American autumn was waiting for him in High Falls with his family, the cows, chickens and cats and a pile of unfinished paintings he was itching to get his hands on.

In October 1947 Marc returned to Paris—the first flight for this painter of flights—"for his retrospective exhibition at the Musée d'Art Moderne." Emblematically a Russian Jew from Vitebsk was the first French painter chosen to celebrate the reopening of the museum after the Liberation. It was exalting but disturbing. He said: "A retrospective exhibition gives me the painful feeling that people consider my work is finished. I want to cry out like a man condemned to death: 'Let me live a little longer, I shall do better.' I feel I have hardly begun, like a pianist who hasn't yet settled down comfortably on his stool."

Everyone asked him: "Well are you back for good this time?"

But we had another winter and two more summers in High Falls. In winter we were embedded in peaceful snow and in summer there was a profusion of flowers which Marc painted with explosive joy. They were the starting point for many a picture, the blue delphiniums for *The Redhead,* finished later in France, the phlox, peonies, arums and roses for many others. In the evenings there were walks along our grassy valley with glowworms lining our path and crickets hypnotically insistent. It was a blissful period, without a shadow. Marc was a proud and affectionate father and David brought him a great deal of joy.

Now that he had walls, at last he could stretch out the enormous *Revolution* and try to discover why he was so dissatisfied with it. He had painted it from a smaller sketch but it lacked the freshness and brilliance of the latter. An English woman friend of mine who came to stay with us said she found it disturbing and chaotic and Marc suddenly decided to cut it into three pieces. He felt relieved and liberated, perhaps that is

why he gave the title of *Liberation* to one of the three. The other two are *Resistance* and *Resurrection.*

Pierre Matisse gave Marc a comfortable monthly allowance in exchange for a certain number of new paintings each year which he exhibited in his gallery. The arrangement had an excellent effect on Marc psychologically, he had no worries and felt perfectly secure. He told me that Bella had once asked him (at a time when he was already earning well) how much money he would need to feel perfectly secure and he replied: "I shall never have enough money, I shall *never* feel secure." Obviously the more money he earned the less secure he felt, the money itself creating other forms of insecurity.

I believe he seldom felt as free as he did in High Falls. He loved to go to New York and stroll in the Jewish quarter, eating strudel and talking to the merchants in their stalls. No one knew him, he could discuss their wares and bargain for a good price just like any other man. He would really have been happier living the life of a man who earns just sufficient for his needs; instead of that, the rest of his life was spent fighting the insecurity brought on by wealth.

Meanwhile letters were coming from Ida, more and more insistent. It was an obvious and inescapable fact that he must at last go back to France. He was glad to go back but reluctant to leave High Falls. He needed the stimulation of Paris, the dealers were waiting impatiently to promote his rise to fame and there was important work to do for Tériade, who had bought Marc's three great engraved works from Vollard's heirs. Yet he nourished a hope of keeping his hide-out. We locked up the house, leaving large quantities of our belongings. But we never saw High Falls again. After a couple of years the house began to rot and our belongings with it and Ida had to go back and put the finis on this chapter.

*

Virginia's testimony, photographs, and the paintings themselves leave little doubt that especially after having returned from his first

three months in Paris—a kind of reconnaissance trip—the painter and his young bride and newborn child settled down to what was to prove one of the happiest and most fruitful periods of Marc Chagall's life. The number of paintings, both new and reworked, produced during those blissful lyrical years is staggering; more significant is the atmosphere of new-won joy that blazes forth from them. These are frequently nuptial pictures, and if in the Chagallian nonrealistic world, it is dubious to point to real models, there can be no question that black-haired Bella was subtly becoming metamorphosed into taller, longer-necked, russet-haired Virginia. More and more frequently the crucifixions of the war years are now replaced by lyrical affirmations, lovers intertwine like twin rockets, long spirochetes and polychromatic fireworks.

At Riverside Drive Virginia had observed that Chagall was still revising works started long before. Habitually he would leave paintings around for years working on many at the same time like a chessmaster playing a dozen opponents simultaneously, shifting from one to the other as the mood struck him, turning them to the wall like putting potted bulbs in the cellar where they might ripen in the dark. It was an organic process of creation, related to his notion of "chemistry" of the picture "tissue." Hence, it is often impossible to fix specific dates to Chagall's works. Their gestation was unpredictable. Some of the early works dating from La Ruche were born of a single night of passion. Others grew imperceptibly over months, years. Marc liked to play the magician with these children of his: darting and stabbing at them with his brush-wand until he transformed them into something else. When he himself was surprised, then he knew that the picture "worked," that it was alive. Art as magic of course negates documentation: the place of Chagall's pictures is almost never the place in which his physical self happens to find itself; nor are Chagallian people real people.

Nevertheless, though we cannot simply deduce Chagall's life from his art (or vice versa), High Falls must have been conducive to happy picture-making. Photographs of those years reveal an astonishingly youthful man (he was sixty), buoyant with health and vitality. Entirely gone now is the melancholy which, during their first months together, still veined his love for Virginia. Radiant smile, collar open at the neck, the sweet clown tilt of the head, the feathery step of a ballerino. "He was wild with joy," says Virginia. The house was charming, cheap, and looked like an isba—all of which considerations

had led Chagall to buy it. A house built by a carpenter for himself. Their neighbors were a house painter and a plumber. Water came from a cistern. Later they sank a well. In the freezing winters they had coal fires. Jean walked a mile to a one-room country school and loved it.

In these primitive surroundings, embedded in the woods that reminded him of Russia, surrounded by children (he had become used to Jean and the newborn baby), animals, nature, and most of all, revitalized by his passion for Virginia, Chagall painted with joy and brio, painted like the Mozart he so admired, singing like a bird on a branch, a sheer overflow of well-being.

According to Virginia, Chagall certainly had no nostalgia for France despite his recent triumph there, and despite the fact that Ida was planning more great things, writing regularly from France that her father must come back, Jean Cassou wants to write a book about you; another important show is now being planned for the Stedelijk Museum in Amsterdam, etc. etc.

Marc was haunted by the thought that an artist who lives in exile lacks the precious contact with his own soil which is so vital to his art. . . .

The first Paris period was a voyage of discovery. He did not then know that he would settle there ultimately and the earth of his country was still clinging to his roots. On his return to France he made an effort to adapt himself to his new milieu and remain true to the old one. The paintings became more refined but from time to time there was a burst of the old fire again. Strangely enough the war and a new uprooting, though painful, had a salutary effect on his work. He was far from the refined intellectual world of Paris that sometimes disturbed him. New York was full of Russian Jews who charged him with new dynamics. He was still in exile but so were they and he shared their suffering.

This explains the fact that he delayed his return to France repeatedly for two years. He had been so far away from his native land that going farther still seemed somehow to make the distance less important.

Furthermore, the trip to France had not only rewarmed his love of his adopted country; it had also reawakened his alarm at the deep

roots of anti-Semitism in French society which had helped prepare the way for the easy Nazi victory in the six weeks' war. He adored living in the countryside. His whole being was happy in the United States. "I'm a foreigner. I'm a foreigner here and at the same time I'm at home because I'm a Jew." It was like going back to La Ruche.

He was well off but not wealthy. His love for pulling off *une bonne affaire* had less to do with finance than tradition. He could live comfortably on the retainer Pierre Matisse kept him on: in return for all his pictures produced during the term of the contract. Every few months Pierre Matisse—ironically amiable—would appear at High Falls and carry away everything, paying down cash on the barrelhead. Virginia was often enraged at the way the dealer bullied Marc: "I'll take that."

"But it's not finished."

"C'est fini! C'est fini!"

And despite Chagall's weak protestations, all the canvases—those which Marc considered finished and those he did not—would be strapped to the top of the automobile and carted off to the 57th Street gallery.

"Why do you permit that?" Virginia would protest afterward in great indignation. "No one has the right to tell an artist when a work is finished. Only he must make that decision."

"Well, maybe he was right ... *Peut-être il avait raison?*"

"Pas possible!"

"And if I make a misjudgment? And rework the picture until I spoil it ... ?"

"Then it probably deserved to be spoiled!"

She had strong beliefs in destiny. And she was disturbed by the Maestro's weakness. Later in France when Ida entered again into their lives she was often to see the daughter march into the studio and brusquely decide what has to be done with this picture ... change that ... that color is not harmonious ... that's finished ... leave it alone ... bien ... ça suffit ... ça no ... c'est nécessaire. ...

Occasionally she would turn all the pictures which had been faced to the wall, decide which were "ready" to be sold or not, while her father tried impotently to assert his authority both paternal and artistic over daughter and art work.

And after this tornado had left the studio, Chagall would utter a

long-drawn *whoosh!* of relief and shrug his shoulders. But he listened to her. She bullied him.

Sometimes, however, he fought his daughter. Then the voices rose, Russian consonants snapped and growled like bears, diphthongs *nyet-ed,* blue eyes blazed. Frequently the Master would abruptly end one of these cyclone sessions by slamming the door to go off to his studio, where he locked himself in and painted furiously all day. These scenes between father and daughter Virginia had already witnessed at Riverside Drive and Sag Harbor and was to witness again when they returned to France.

Up at High Falls, ensconced in the country, only their most intimate friends visited. Chagall still preferred, according to the rule of conservation of artistic energy, the company of writers to painters, noncompetitive, nonenervating relationships. Even in New York he had not frequented the company of many artists, and because of the language barrier, found himself more and more restricted to the circle of the French exiles.

And yet, although he sought out his French friends, it would be an exaggeration to say that Chagall suffered from nostalgia in America. His "Frenchness" after all is an external condition. Or more justly it is a stratum, rich and rewarding, laid over the deeper rock of Russian Jewishness. And in America, he found indeed more of that fundamental Russian Jewishness than he had in Paris, for the great bulk of Jewish immigrants to America had come from the Vitebsks and Vilnas and Pinsks—the very Pale of Settlement which had nurtured Marc Chagall, the crucible of his imagery and life-style.

Of his American years Chagall said:

In the United States ... I'm mainly impressed by its largeness and a feeling of exclusive freedom afforded me. In order to appreciate such freedom one must be free. It is possible that over the years I have come to know the air, clouds, and trees of this land; it is possible that I have learned to understand the "quiet" personality traits of the American; it is possible that I succeeded in incorporating them into my paintings. I breathe the wonderful air, but it is possible I could not internalize a local flavor and my paintings could not be considered creativity in themselves.

In short, I acquired new strengths from the hospitality. I

studied here and worked at the time man experienced a great
tragedy. Years passed ... I didn't get any younger. ...

I wish to point out here that one of the basic foundations in
art (in painting here) is a sense of the proper measure to
painting. And the human environment that surrounds the
painter—if not comfortable—can weaken or kill totally a true
sense of painting. The land and nature be blessed, as they help
the artist to open up and enrich his natural abilities. Everything
else depends on the human atmosphere which is important and
necessary exactly as a frame for a picture.

(Lecture at the University of Chicago, 1958.)

Surely the "air, clouds and trees" of High Falls and his passion for
Virginia set him "wild with joy." In the cold winters around the coal
fires he felt that he was back in the isbas of Vitebsk. His simple and
friendly neighbors occasionally became the Russian muzhiks of his
youth, slogging through the snow to borrow (or lend) an ax. Spring
clothed the bare branches of the forest with a new negligée of filmy
green, a perfumed green blush. More indifferent than ever to "real"
color, he painted the perfume of the forest and set the trees blushing
in blue. Love permeated bud and sod, sky and people. He and
Virginia were soaring through pink and orange skies, embracing
shamelessly over Vitebskparishighfalls, his new bride rocketing in a
white whish skyward. His images are riotously sexual.

Back in Eden, Chagall continued working on *The Arabian Nights*
engravings which he had been commissioned in America to do by the
publisher Kurt Wolff, a great friend of Claire Goll. After a
marvelous cycle of preparatory gouaches, now he worked on the
lithographs, both colored and black and white. As he drew on the
stone, Virginia read the gorgeous tales to him. "He loved to be read
to while he worked." And as she read and Marc's crayon evoked
breasts that became moons and jinni like the firebird, drenching half
of the edition in colors thick as musk, Virginia could not help
thinking of Bella reading to him as he created the illustrations for the
Bible, *Dead Souls,* and La Fontaine's *Fables.*

Thus the poet-painter translated images from words to visions rich
with Oriental splendor. The imagery had been conceived in the same
period as *The Firebird:* the ecstasy bursts from the same source. The

fisherman Abdullah, a wonder-working rabbi, a *zadik,* draws up a mermaid in his net while phallic fish cavort in celebration. In the *Night of Scheherazade* the ghost of Bella in a bridal veil, winged and fish-tailed, gazes at naked lovers, the man startled at the very lip of union. But Bella's arms are lifted in ambiguous benediction, and the entire scene is presided over by a giant bird with a yellow sun blazing on his breast.

The great retrospective which had been initiated by Sweeney at the New York Museum of Modern Art (April to June 1946), and then gone on to Chicago (November to January 1947), was now scheduled (in a reduced version) for the Musée National d'Art Moderne in Paris. Back in her beloved and familiar Paris, Ida had been the catalyst for arranging this show, and the series that soon spread all over Europe like a string of firecrackers. In 1946 eighty works were shown at the Stedelijk Museum in Amsterdam. In 1948 there was an exhibition at the Tate Gallery in London; and that same year Marc Chagall received a room all to himself in the French Pavilion, and won first prize for graphic art at the XXIV Biennale at Venice.

Energetic as her father, Ida's vital forces poured into the showing and marketing, as Marc's into the making of pictures. They were, these two, father-daughter lovers, an unbeatable team.

Virginia felt utterly outside.

As Virginia fretted about the difficulties of raising children in the American countryside where poison ivy confined them to the area around the house, from Europe a series of letters, phone calls, telegrams from Ida bombarded Marc in Eden. Papa, you must come back to Europe. Papa, this is where we belong. Forget all this nonsense of peace and love- and picture-making in the woods of upstate New York. . . .

So, in October of 1947 he had set off for his second trip to be on hand for the opening of the Paris retrospective. Again Virginia was left behind. She had not attended any of these great shows. She began to have premonitions. His new life (and hers) had been born and flourished in the New World. What would happen to their dream once they crossed the Atlantic? Would Paris—saturated with Bella—summon her up more tangibly than the ghost that still haunted Marc's canvases? And additionally—and certainly not ectoplasmically

but very much in the flesh—there would be that dynamic daughter intervening always between the artist and his wife. There was a priority of loves: Bella continued to exercise hers from the grave; Ida very much alive, considered herself Bella's successor. Virginia knew that she would always be the outsider. In France especially. In the woods of High Falls she did not have to exorcise the phantom of a prior love or the siren songs of a daughter busily organizing her father's ever-growing fame.

Part Eight
Return to France
1948-1952

But there was no choice. After years of dallying Marc Chagall and his new family (which he now openly acknowledged) sailed for France in August 1948. On the boat with them was the poet Jean Wahl—"an exceptionally brilliant man . . . a warm-hearted and amusing friend"—and so they floated across the Atlantic on a sea of metaphors.

"We went to live in a big crazy house with wooden turrets and gables in Orgeval, Seine-et-Oise. There was a wild wood around it and a pond. The chalet had been built around 1910 and was all full of wooden staircases leading up to towers, eaves dropping. Marc loved it. Raymond Cogniat says the house 'was as exciting and fantastic as his pictures, a house which seemed to be on the point of dissolving into the surrounding verdure.' "

Although they stayed nearly a year at Orgeval, this period was broken by numerous trips in connection with the series of retrospectives throughout Europe set off by the Paris and Amsterdam shows. Now in 1948 it was the turn for the Tate Gallery in London and the Venice Biennale; later the Kunsthaus in Zurich and the Kunsthalle in Bern.

Furthermore, since Orgeval, a little country village beyond Saint-

Germaine-en-Laye, was only about one hundred kilometers from Paris there was a steady stream of distinguished visitors to see the miracle of the indestructible Marc Chagall back in his familiar setting: ebullient, fecund, ambitious as ever, seemingly reborn from the tragedy of Bella's death, war and exile.

Amidst all this activity, in addition to his regular practice of reworking older pictures, he painted several new works such as *The Green Cock* in which the eleventh-century steeple of Orgeval appears.

"He had many visitors," Virginia recalls: "Paulhan, Guillevic, Zervos, Carré, Maeght, Estienne, Lassaigne, Tériade, Cassou, Leymarie, Jardot, Cogniat, Reverdy, etc. I remember Massine coming to propose Marc's collaboration on one of his ballets. Marc received him politely but distantly and as soon as the door was shut he said: 'He can dance on his head, but I shall never collaborate again with him.' "

The Greek-born Tériade, *who had inherited Vollard's plates and passion for graphic art, was printing *The Arabian Nights* lithographs. Often Virginia and Marc would go to St. Jean-Cap-Ferrat, invited to tea at Tériade's, where there would foregather many poets and writers in whose company Marc took great delight. Marc was already infatuated with the Côte d'Azur: the bediamonded sea, the meditative fishing boats rocking like Chassidim in *shul*. And he would be close to Tériade, who lived here half the year.

They had driven down from postwar Paris: drab, gray with the guilt of collaboration. The Côte d'Azur had become the new Montparnasse. Nearby at Vallauris lived Picasso; and Matisse, who had stayed at Vence until 1948, had now moved to Cimier above Nice.

St.-Jean was still only a village when we went there in 1949 and our Pension de Famille, a yellow stucco house with a stairway leading up sideways to the door, was a modest place: cool tiled floors and iron bedsteads, big white tables covered with fruit and flowers like a Bonnard painting. The children went to explore the peninsula and came back with sprigs of olive and mimosa. Tériade was waiting for us in his orange grove and a table was set in the garden with lobster and

*His true name is Efstratios Eleftheriades.

champagne. These were memorable days, among our happiest. Marc settled down in a small bedroom overlooking the sea and brought out pots of gouache and sheets of paper. I have seldom seen him more euphoric. He set to work excitedly to render the dazzling visions that were taking shape in his mind. A store of treasures was suddenly released from his memory at the sight of the sea and the palm trees and came pouring out in sumptuous array. Never before had he worked his gouaches so richly. He used a mixture of media which I think he alone discovered. He obtained depth and lustre by using sticks of oily pastel which he worked in thickly.

Tériade had a true insight into the artist's nature and never exerted an influence or made a suggestion that was not in keeping with the artist's deepest needs. His warmth and understanding for Chagall were such that it was one of their happiest relationships.

The two men were as different as it was possible to be. Tériade was brilliantly intellectual, highly cultivated, sensual, refined, secret, and in spite of his Buddha-like aspect perhaps capable of volcanic rage which his gentlemanly education kept under control.

By reversing this list of characteristics one may deduce in great part Virginia's evaluation of her husband. But she must already have known that secrecy and volcanic rage were also attributes of Marc Chagall.

Before the war Tériade had been an art critic who had written about Chagall. Now he was publishing the art and literary magazine *Verve*. More significantly he had purchased the prints from Vollard's estate, truly resurrected those *Dead Souls* from the tomb, publishing them in 1948, undoubtedly a factor which gained Marc the graphics award at the Venice Biennale.

He encouraged us to settle in St.-Jean and Marc and I were more and more excited by all the houses we went to see. Each one was reminiscent of some part of our lives in which houses have played a great part. He was always talking of retiring into the country and living with peasants, cows, and chickens, yet when it came to choosing a house, none of them was grand enough. "Chagall's house must have a certain standing," he said.

"I can't live in a house that has cow-dung on the path." I looked wistfully at white-washed farms with grassy paths. Finally there was one with a crazy garden full of rockeries, high, old-fashioned windows, tiled floors and enormous bedrooms and with our usual impulsiveness we decided we liked it then and there. As there were some other would be purchasers that day, we were afraid they might get it first, so Marc immediately signed an option and asked Tériade to advance him the money. But when Ida arrived she scolded us quite legitimately because the house was all stairs and very little sun. Sadly, we agreed and decided to give up the idea and Tériade was disappointed. Meanwhile we moved into this furnished house for the three months' optional period and Marc finished some of the gouaches he had begun at the Pension. These gouaches are among the most joyful he has ever done. The big blue St.-Jean-Cap-Ferrat was used as a poster for the retrospective exhibition at the Galerie des Ponchettes in Nice in 1952. Marc gave me this gouache which he said was "me." He gave me a large number of paintings and gouaches and when I left him I did not take them with me. What seems like an act of ingratitude was in reality an act of renunciation. I dearly loved those paintings and was moved by Marc's generosity, but I never regretted leaving them behind.

The Fishes at St.-Jean, a painting of great brilliance, together with the Blue Landscape and St.-Jean-Cap-Ferrat are paintings that mark a new style where elements of a powerful composition are bold and large and there are few embellishments. In each painting the Cap Ferrat landscape appears as seen from his window.

In the Fishes, the russet-haired taller figure is undoubtedly Virginia. Black-haired Bella had now practically disappeared except for occasional ectoplasmic appearances, always in a bridal veil.

At Cap-Ferrat, Marc was always talking about wanting a "wall." "Why doesn't someone give me a wall? I want to do a big mural." One day a couple of Englishwomen came to see them.

They simply knocked at the door and asked if they could see Marc, introducing themselves as Elizabeth Sprigge and Velona

Harris, theatre people from London. We soon found we had common friends through my brother. They had recently founded a small experimental theatre called the Watergate and quite simply wanted Marc (for whom they had a great admiration) to paint murals for the auditorium.

Virginia went to Marc's studio and told him. He came running.

But when he asked them how much they could pay, they cheerfully confessed they hadn't the first penny. We all laughed helplessly and the matter was dropped but meanwhile we became real friends. They suggested borrowing the paintings for one year and Marc gradually became intrigued by the idea. It was the first time anyone had actually asked him to make a mural painting.* He set to work and produced *The Blue Circus* and *The Dance*. I took them over with me, rolled up, and I remember the disgusted face of the English Customs Official when he asked me to unroll them for inspection. "You call that art?" he said.

This desire for a grander statement had indeed been growing in him for years. The future "monumental Chagall" was being born. He needed more space in which to spread his wings. A letter to Meyer Schapiro (in French) reveals his preoccupations at that time.

> Villa l'Aulnette
> Orgeval
> Seine-et-Oise
> 8 September 1949

DEAR FRIEND:

Don't think I have forgotten you during this long year since my departure from America. How are you? How are your family and your work?

America is so far away but I always feel close to that country where I spent the troubled years of the war but where I found so much understanding and where I could work, I believe, not

* Virginia forgets the enormous murals Chagall had painted for the Kamerny State Jewish Theatre in Moscow 1920-21. Hung in the auditorium, the canvas for the main wall measured twelve by thirty-six feet.

badly. Who knows, perhaps I will find the means of coming again to spend some time in America. Of course, that would be easier if I had the possibility of working.

You know perhaps that for a long time I've had a somewhat fantastic idea, that of a Don Quixote perhaps, but one to which I always cling. It's the idea of making mural paintings where I could express myself more broadly than in little pictures for collectors.

When I was still in New York I spoke about this to Dr. Kayser, Director of the Jewish Museum; he was very interested in it. We spoke a great deal about it, had discussions, measured the walls. We drank many cups of tea together but nothing came out of all that! We had an idea of setting up a Biblical Hall or a hall of Jewish Holidays in this museum, or God knows wherever.

I am aware of the radiance of your prestige and it seems to me that you might succeed in getting the "i"s dotted if there are any "i"s! But I don't have too many illusions about the energy and enthusiasm of Dr. Kayser.

Jewish institutions are not the only ones which would be of interest to me as backers for these murals. Perhaps there are Rockefellers or other rich non-Jews who might be interested in being patrons for mural projects.

I hope that you will forgive me bothering you with my dreams, perhaps impossible.

Send me news about yourself, I beg you; and don't forget that I want to remain in touch with you, for you know that I feel great sympathy for you.
Very cordially,

> Your
> MARC CHAGALL

Thus an idea in embryo during the American years eventuated twenty-five years later in the Musée National Message Biblique Marc Chagall at Nice. And the artist's driving ambition is revealed in every phrase: the word *"travaille"* appears three times in the first four sentences. The letter is obviously in Virginia's hand.

We moved from St-Jean to a big furnished house in Vence where Marc made an important series of drawings in ink and

wash directly inspired by his surroundings, the tall windows, the balconies with stone balustrades, the palm trees, the bouquets we bought in the Ponchettes flower market in Nice and the luscious fruits and vegetables of Vence in Provencal ceramic bowls; also the children when they consented to sit still for long enough. This was a period of contact with reality which he needed every now and then.

It was about that time that we went to Italy for the first time. He had received the first prize for his graphic work at the Biennale of Venice and we drove there via Bergamo and Verona where we met Ida and her friends the Buxembaums. Marc was elated and untiringly curious of everything. In Venice we spent a lot of time with Morandi for whom Marc had a real affection. Umbro Apollonio was our charming host. We went to see the Giottos in Padua and Marc was deeply moved. But it was Tintoretto who gave him the greatest shock. It was fascinating to accompany him in his first visit to the Scuola di San Rocco. He was bowled over by the savage strength of Tintoretto. His flying figures were very near to his own visions and the daring compositions delighted him.

We had dinner one night with Peggy Guggenheim who took us in her gondola to the Venice Theatre to hear a Mozart concert. She was dressed in a tight sheath of gold lamé which made it very difficult for her to step into the gondola and the gondolier had to lift her in.

Subsequently Peggy Guggenheim, like Calder and several other figures in the world of art, broke off all relationship with Chagall. A letter of inquiry having remained unanswered, I telephoned her in Venice to be advised curtly, rudely that "I have nothing to say about Marc Chagall" with which she hung up on me midsentence. It is fruitless to speculate as to the causes of this sundering of friendship; what is significant is that such abrupt cleavages have occurred more than once in Marc Chagall's life: Cendrars, Walden, Picasso, are cases in point.

Following the Biennale, where a photograph was taken of Marc and Morandi, the Italian painter-engraver whose work he admired, they made a side trip to Florence. In that beautiful city, seedbed of the Italian Renaissance, they visited the Uffizi, the Pitti, and many other galleries and churches. But somehow they never got to see the

Masaccio frescoes in the Carmine, whose earth-laden prophets Marc had, in *My Life,* compared to his father.

In Vence we set about trying to find a permanent house and finally settled for Claude Bourdet's house Les Collines. Bourdet's mother the poetess Catherine Pozzi had lived there for many years and it was here that Paul Valéry often came to stay with her. The house was full of his water colours and among them were portraits of Catherine. It was in a state of serious disrepair and for months with the help of the charming but ineffectual Vence workmen I supervised its restoration.

Virginia was delighted with the funny old Côte d'Azur villa painted yellow at that time. She took great joy in redecorating it, repainting the walls dazzling New England white and the shutters Tuscan green. Valéry's pictures were taken off the walls and substituted by Marc's.

Even if it had been Valéry's poems rather than his watercolors hanging on the walls, there was not likely to have been any rapport between the cerebral poet and the intuitive painter.

Valéry's entire aesthetic is at polar opposition to Chagall's: considering as it does a poem as an act of will, construction, conscious control, intellect rather than a mystical release of the subconscious. So there certainly could not have been any sympathetic vibrations from the author of *Le Cimetière Marin* and *La Jeune Parque* showering down upon the brow of the Vitebskite during the fifteen years of his residence at Les Collines. Only one Valerian precept would have sounded echoes: a poem is not finished; it is abandoned. Marc would certainly have understood that. He reworked his paintings endlessly.

So the Valéry watercolors were removed. With the exception of a small version of a Rodin *Washwoman* and another small statue by Henri Laurens, Chagall possessed no works of art other than his own (the Calder mobile had been given to Ida after the two men quarreled). Nor would he exchange paintings as so many other artists did. "*J'aime trop les miennes.* I like my own too much."

The studio, a separate building, had been rented for some years to a painter who made fake Matisses. The garden was big and beautiful with palms and orange groves and two gigantic

eucalyptus trees. At last everything was assembled under one roof, Marc's large collection of paintings from every period of his life, unfinished works, also hundreds of water colours, drawings and small sketches more or less piled up in disorder. I had all the latter mounted by two young artists, Vincent de Crozals and Annelise Nelk in the big studio downstairs and put away in large portfolios I had specially made for them. I also photographed every new picture and filed the photos in albums with numbers and titles.

Some of the drawings dated back to Russian days and were in a terrible condition. Now when Marc saw them all put to order and mounted with passe-partout, he was very pleased. And Virginia in her pre-Expulsion guilelessness knew her greatest pleasure in being a helpmeet, in winning Marc's approval. To be of service to a talented man so often inept in the practical affairs of life: this had profound roots in her character. Virginia needed to be needed. And she was unhappy when she doubted her capacity to fulfill that need.

Although she did a lot of classifying and was expected to answer letters ("I'm a terrible typist and secretary"), she never entered into the contractual and business tangles with dealers that had engulfed the Chagalls as soon as they returned to Europe. This was when André Maeght came into the picture. A Breton, a shrewd business-man with great flair, Maeght had made a great success after the war, lining up the best artists for his gallery. There was a terrific rivalry between Maeght, who had started from scratch, and Carré, the other most important dealer in Paris after the war. They were both fighting to get Matisse. Maeght already had a gallery on rue de Teheran. In New York Pierre Matisse had always been Chagall's dealer. Matisse didn't like Carré and so, to please his American dealer, Chagall decided to sign a contract with Maeght.

Ida, who was now separated from Michel Gorday, wanted to be Marc's dealer. She was very well placed, she was intelligent and knew how to arrange deals. Marc said: *Bien,* you can get commissions acting as an intermediary between Maeght and Chagall. But finally Maeght had a contract drawn in which he was to get the pick of Chagall's production, ousting Ida a little bit. Eventually she was entirely out of the picture but accepted this because it was best for her father.

All these maneuvers Virginia watched from afar like a spectator at a naval battle. She busied herself with the house and with her children, not worried now about poison ivy as she had been at High Falls.

At about this time Marc painted a large picture called *Le Soleil Rouge* from a small sketch. I squared it off for him and drew in the rough lines with charcoal. It was a mechanical process he didn't enjoy. When he enlarged a sketch he was always tempted to change everything. In this case the sketch was particularly beautiful and he wanted to preserve it. This painting was chosen by the Gobelins Manufacture for a tapestry but never executed.

A second version of *The Red Sun,* entitled *Red and Black World,* is surely a Chagallian view of Virginia. Swooping from lower left to upper right is a long blue-clad form with reddish long hair and exposed breasts. And curved horizontal to this obliquity is Marc, yellow (color of medieval Jewry?) against a red sun in which he appears again, reading a book, and out of which he devolves in pink, back and forth at once since his rump and his face both stare at us, playing the fiddle this time.

And below him a most elegant if somewhat sentimental goat bowing as he presents flowers.

The bottom of the picture is again snowy Vitebsk and floating above are the familiar menorah and the red cock.

The abundance of flowers, the courtly goat paying tribute, the extraordinary levitation of every element are vivid testimony of Chagall's happiness at that period.

He then started three very large paintings on biblical subjects, Moses, David, Abraham and the Three Angels. These were the beginning of the great series of biblical paintings on which he was to work for the next 25 years or so and which are now in his "Message Biblique" Museum in Nice. The idea of a series of religious paintings was beginning to take shape.

When he was not actually working, Marc was often scribbling and sketching ideas. Walking in the countryside, sitting in a café, driving in a car, he almost constantly filled small scraps of paper with more or less unrecognizable forms which became

ideas for paintings. Sometimes they were accompanied by notes in Russian, schemes of composition, colour annotations. There was a chest full of these scraps of paper in his studio. Some of them were notes in writing, thoughts, poems, observations.

About eight-tenths of his waking life was devoted to his work, in one way or another. Talking with friends was a welcome activity, travelling, observing, collecting impressions was a true pleasure. Both were connected with his work. He seldom talked of anything outside of art and matters closely connected with it. His travels often involved visits to museums and galleries, meetings with people of the art world; or else they were periods of uprooting and transplanting, periods of upheaval, but also of inspiration and renewal.

When there were no interruptions he started working early, stopped for an hour's walk before lunch and worked all afternoon until supper.

Eating was a pleasurable but time-consuming occupation and he generally dispatched it rather precipitously, without undue refinement. But he relished almost anything and if it reminded him of his childhood he waxed poetical. It was fun feeding him because he ate with such gusto.

Recreation had a small part in his life. I have never seen him play a game or indulge in any kind of sport except bathing in the sea and a very occasional game of "pétanque" when Ida and her friends prevailed on him. Yet he had the muscles of an athlete. His daily walk was a pleasure and a necessity and it kept him in perfect form. I introduced the custom of picnicking with the children and it made him relaxed and good-humored. After his nap he sketched the ideas suggested to him by the landscapes.

I remember Marc telling me that during the peaceful years in France there had been a time when he had become interested in football and often went to matches. Sometimes it seems to me that he glanced nostalgically across the sport pages in the newspapers. I never could quite imagine him as a football fan. He used to read the papers in a desultory fashion but he devoured the pages on art; as for books, I hardly ever saw him reading one. He "absorbed" books while others were obliged to read them.

There were unforgettable times with friends in country

taverns and Paris bistros where Ida's presence was a guarantee
of good fun. She always encouraged us to go for the choicest
item in the menu and chose the wines with imagination and
discernment. Sometimes the fun became so riotous that people
turned round amused. Marc, like Ida, had the gift of laughter
and their voices could be heard above all the others. The
standing joke was Marc's jealousy of Picasso and Matisse and he
was relentlessly teased about this.

From the start of their relationship, Virginia had been aware that
this child-man demanded that all attention be focused on himself. At
first he had even been jealous of the five-year-old Jean, who was then
suffering from the loss of her father. Now if Virginia lavished too
much attention on the baby David, the artist resented this siphoning
away of affection. Yet he had taken such pride in the unexpected gift
of a son in his late years that he had sent a snapshot of David to his
neighbor Picasso, who was so touched that he pinned it on the wall.
If Virginia stroked a cat, he would complain: "You don't caress me
like that." And on the rare occasions when the indefatigable Virginia
fell ill, Chagall resented her illness.

He wanted to be caressed; but he himself did little or no caressing.
He was not given to subtleties in conjugal affairs: he rarely kissed
Virginia, he stroked her less than she stroked the cat.

Little shafts of shadow in the Riviera sunshine. The atmosphere
sparkled with Ida's ". . . brilliant and amusing friends: Jacques
Prévert, Jacques and Assia Lassaigne, Claude and Ida Bourdet, Gea
Augsbourg, Charles Estienne, and others."

Most notable among the "others" whom Marc and Virginia saw
during those years were Picasso and Matisse. Chagall had always
been wary of Picasso's horns; their occasional conversations were
always a corrida. Nor were matters improved when his move to the
Riviera stimulated Chagall's interest in ceramics and after working at
several kilns in Antibes, Vence and Golf Juan, he began doing
pottery in the Madoura workshop at Vallauris . . . which Picasso
considered his private domain! At the pottery studio Picasso once
played a "diabolical" joke in Marc's absence: completing with a
careless sweep of the brush a perfect Chagallian image which
Chagall, still a tyro in ceramics, had been unable to execute.

Matisse at that time was very ill. He lived at Cimier over Nice

where the Biblical Museum was eventually established. On three occasions Virginia and Marc visited the Master in his very comfortable but not ostentatious house, with lovely large cool rooms, balconies, and a view of the blue Mediterranean. Matisse was always bedridden: over the wide bed was swung a special bedtable on which he could work. He also drew on the ceiling with charcoal attached to bamboo sticks.

Matisse was always a grand seigneur, Virginia remembers, gracious in his manners, somewhat regal. There was no hostility between him and Chagall as there was with Picasso. Marc liked Matisse's chapel at Vence but thought "it was not for prayer." At the time of their visits they talked about Matisse's book *Jazz* published by Tériade, who was now bringing out Marc's prewar graphics. The story later went around that when Matisse had pinned up on the wall of his studio the gouache-painted papers from which the *Jazz* designs were made, he found the color so bright that he was forced to wear sunglasses. But Marc probably felt that these brilliant unmodulated hues cancelled out each other; his own color sense involved endless modeling of small areas, infinitely more subtle than poster planes.

During these years too were initiated or continued other friendships with writers and some painters. Virginia recalls the poet Paul Eluard, "a mild sweet man, but when he was in a rage, he smashed things." Marc often saw Pierre Reverdy and Jacques Prévert, an especially close friend of Ida's, amusing, witty, always a welcome visitor. André Lhote was a very good friend. During the war all of Marc's pictures had been stored in a room of Lhote's house. Happily unlike his Walden and Cendrars experiences these were returned *in toto* and intact when Marc returned to France. André Masson, "a charming man," appeared, and Miró "with a round face like his paintings," and once Braque came to visit them for half a day.

"But Marc didn't go out of his way to visit people. He worked all the time. He lives to paint. If he didn't paint he couldn't live."

Yet despite his work obsession, if people rang the doorbell when Marc was free, he would open the door himself.

In Vence occasionally young painters came to the door with an armful of paintings to ask Marc for advice. They were mostly

foreigners, the French painters never dared to come unannounced. Marc received them with great kindness and gave them valuable criticism. He enjoyed these conversations and his faculty for seeing with the vision of another and understanding his problems was remarkable.

In 1950 Virginia recalls (and recalls it so vividly that she writes it in the present tense):

Marc is obsessed by the idea of doing large-scale religious paintings, but he wants to paint them for a special building where their religious character will be respected. This longing has been growing ever since we went to see Giotto in Padova and Fra Angelico in Florence.

His latest dream is a little stucco chapel painted ochre with a green tiled dome, called La Chapelle des Pénitents Blancs. It is no longer used for services but still belongs to the church. The door is always locked and the walls are growing damp. He often passes it when he goes walking and indulges in reverie. He calculates wall space, assesses light sources, inspects the state of the walls and ponders on the possibility of the church giving it to him. Whenever people of importance in the art world come to see him he shows it to them and the diocese has been notified of his desire. But for months now there has been no progress in the negotiations and the curé, however polite and friendly, has obviously received orders from the Bishop of Nice to use delaying tactics so as not to give a direct refusal. Since Léger the Communist decorated a church and Matisse has his own chapel, there are very few acceptable arguments against the decoration of an old unused chapel by Vence's most illustrious citizen.

Meanwhile Père Couturier, a refined and intelligent Dominican, subtle and imaginative and an artist himself, has asked Marc to decorate the baptistry of his church on the plateau of Assy in Haute-Savoie. He said he particularly wanted Chagall, a Jew, to decorate the baptistry and he was enchanted with one of the St. Jean gouaches, *La Madonne au Buisson* where a white madonna is floating in a burning bush, a gigantic fish over her

head. He said it would be perfect for the baptistry as the fish is the symbol of Christ.

He went to visit the church of Assy. The huge Léger mosaic in the porch makes it look more like a casino than a church and a row of massive cement pillars supports an incongruously frail chalet-like roof. But the interior has elegance and Matisse's omelette-yellow tiled altar is ravishing.

Marc has often said that his idea of Christ is of a Jewish martyr. He is afraid of feeling guilty towards the Jews if he accepts to decorate a baptistry. If he did so he would be virtually accepting the dogma of original sin and its purification through baptism. He weighs the conflicting opinions of Jews and Christians and gets no nearer to his own truth. He called a meeting of Jewish notables to discuss the matter and they seemed unopposed. He even wrote to Dr. Weizmann, who answered that if Chagall acted according to his own conscience and intuition he was bound to come to the right decision.*

I had a talk with Couturier as I was driving him to Nice. I said I thought the ideal place for Marc's murals would be a sort of temple where all the religions would be brought together in a place belonging to none of them. Marc's mysticism is essentially Jewish but any mysticism is all-embracing to those who seek a wider vision. The coming together of all religions virtually means the cancelling out of all religions and the creation of an all-embracing mysticism which each individual would interpret according to his own need. Couturier disagreed, politely but firmly.

One of the visitors at this time was Joseph Buxenbaum, whom Virginia had first encountered in Verona in 1948, one of Ida's jolly friends, now resident in Israel. Buxenbaum recalls the visit: "The studios were on two levels: the finished paintings upstairs, the work in progress downstairs. Suddenly Marc called me aside and conspiratorially led me into the downstairs studio which was kept locked. He said he had to do some work for a church and wanted to show it to me. There were some paintings turned to the wall. He turned

* Chagall's account of the reply of the President of Israel is more folklorish but essentially the same.

them about ... and they all dealt with Jewish themes. And Chagall looked at me with his eyes pleading. *'Ich ken nisht anders ...'* (I can't do otherwise)."

In 1951 the Bishop of Nice, thinking that he ought to appease any possible ill-feelings, announced that he would call on Chagall in person when he came to Vence for the First Communion ceremony. Virginia received the telephone message "but I completely forgot to tell Marc. We went to the seaside for a picnic and when we got back the gardener and his wife greeted us on the doorstep with a mixture of amusement and consternation. The Bishop and his suite had exchanged astonished smiles: 'Ah, ces artistes!'

"Marc found my lapsus rather revealing."

So the first years of return to France passed in joy and fecundity. Marc's production grew in scale and brilliance. He had already become so famous that counterfeit Chagalls were in circulation. Even in America, Kurt Wolff had once brought out a small painting which he had just bought at some unnamed "shop." Marc said that he had never done that work and wanted to tear it up but Wolff would not let him.

Beautiful years. Yet every day Virginia felt more that her romantic dream of Eden in the woods was being replaced by clamor on the Riviera. She would have to learn to play the role of celebrity's wife, to entertain the great, to greet presidents and preen and placate purchasers.

An inner voice told her that she wouldn't be very successful in playing this game.

*

In 1951 Ida helped to organize two big retrospective exhibitions in Jerusalem and Tel Aviv and Marc was invited to inaugurate the one in Jerusalem. It was his first return since the creation of the State of Israel and it promised to be triumphant. I was reluctant to accompany him, not from a lack of desire to see Israel but from a dislike of anything official. But he was very anxious that I should go.

Up until now our life had been reasonably intimate. I was not

present at any of the big retrospective exhibitions in Paris or in New York. I had never had to participate in any big official function and I felt uneasy about it, perhaps because I didn't profoundly believe in the role I had to play.

From now on Marc's life was more and more a public one. I had to try and play the part Bella would have played had she been there. I had to try and be worthy of her succession. Her beautiful dark eyes watched me from a girlhood photo, black hair falling in a thick braid down her back. Needless to say I felt hopelessly unworthy but I thought I might try and be myself instead. I didn't quite know what I was but I knew what I *wasn't*.

At that time I made the acquaintance of a group of young people who lived in a loose community and experimented in methods of curing illness without the help of medicine. One of them had been gravely stricken with tuberculosis and they had helped him to cure himself completely. The idea of helping others to do the same enthused me and I adopted vegetarianism and studied their methods. But I got discouraged by the sectarianism and narrow-mindedness of the leader of the group. I also realized the limits of vegetarianism. But meanwhile I left the children there while we were in Israel and three of the young people, who were my excellent friends, took care of them.

In 1951, when Marc Chagall and Virginia visited Israel, the Jewish state was two years younger than David, and Davidic too were the circumstances of its survival; already it had fought and won the first of four wars it was to have inflicted upon it by its Goliathan neighbors.

From the moment he set foot in the Holy Land Chagall was enraptured. Much had changed since his first visit twenty years earlier. But to him the landscape was Biblical if the inhabitants were not. Certainly the bronzed khaki-trousered Sabras speaking clipped Mandate English were not figures out of a Chagallian painting. They were neither Chassidic nor Biblical. Even if he understood English, Marc would not have understood them. They were tank drivers on the ground, not lovers in the air.

It didn't matter. With the stubbornness of a poet, Chagall saw

what he wanted to see: the land of Abraham, Isaac and Jacob, the eternal bride of Jerusalem, Rebecca at the well. Nothing had changed since Samson had swung the jawbone of an ass. To Chagall landscapes are inscapes. He looks without and sees within.

Besides, the pious praying at the West Wall in their long black caftans, flying ringlets, melodious wailing chant, their kneedipping and swaying and bobbing—all this was very familiar indeed. And if the younger Israelis spoke a curious Sephardic-accented Hebrew (when they were not speaking English) the denizens of Mea Shearim spoke the Ashkenazi Yiddish of Vitebsk. Marc felt entirely at home.

But what was familiar to Marc was exotic to Virginia. "I must have felt somewhat disconnected in Israel because the whole thing seemed so unreal, as if it were going on behind a pane of glass." Yet she was entranced. So entranced that she even carried off fairly well the role she had already suspected at Vence she was going to fluff— that of the charming hostess-wife of the world-renowned artist.

Now she had indeed to play that role, for Marc Chagall was being received in Israel like a conqueror.

> I was moved by the effusion and kindness of everyone. Their love for Chagall was overwhelmingly sincere. A dinner at Ben-Gurion's house was animated and gay because of his tremendous warmth and sense of humour. We also had dinner with Moshe Sharett [a member of the Cabinet] and paid a visit to President Chaim Weizmann. We visited the country from one end to the other. What most moved Marc was the sight of these bare brown hills around Jerusalem but at that time one could see nothing of the old town except from David's Tower.

Ben-Gurion, that indomitable Prime Minister, a terrier with a halo of white silky hair, received Chagall personally. So the artist and the Prime Minister, both with aureoles of silvery hair (Marc's had started to turn almost overnight after Bella's death), both with mobile Jewish countenances, chatted away in Yiddish. And Virginia was so dream-struck that she forgot to be embarrassed and clumsy.

One day Chagall showed Ben-Gurion a picture of a *balagola* (carriage) and driver in the sky.

Ben-Gurion: Who ever heard of a *balagola* in the sky?

Chagall: Who ever heard of a *balagola* on the ground?

It was the difference between an Israeli and a Diaspora Jew. But to

Marc, the P.M.'s remark set off uncomfortable echoes of his quarrels with Soviet commissars. Politicians were politicians. Their conception of art was a poster, a flag, a weapon. And his conception of art was a talisman, an icon, a wand—so magical in its birth and effect that one could not even term it a "conception." He didn't know where his pictures came from; better leave such diagnosis to critics, commissars . . . and prime ministers. They had, perforce, to deal with realism. As for him, Chagall, realism was a good brush to clean one's teeth with, not to paint pictures.

So, if through a pane of plate glass, Virginia saw kibbutzim and synagogues, a fledgling state, and herself (with equal unreality) being introduced as the wife of the greatest living "Jewish" artist.

Everyone who met her loved her. In a way, the Israel trip proved a small triumph for her too. She had exorcised the ghost of Bella on her own grounds, so to speak. Chagall's friends found Virginia charming. The tensions that had begun to manifest themselves in France the previous year were momentarily appeased. Here in Israel she found more natural food cultists like the group she had become involved in at Vence, an involvement which had become a source of acrimony between herself and Marc. Oddly, a great many of the the *Chalutzim* of the second *Aliyah* were vegetarians along with being Zionists and Socialists. Virginia felt a great wave of sympathy for these bronzed outdoor people, who were planting trees and eating nuts.

But although on the official level the Israel trip was a triumph, Chagall's relationship to the new state was (and is) ambiguous, nor were there lacking voices who criticized both his fantastic art and his equally fantastic politics.

Virginia listened but could not understand the debates that whirled wherever Marc appeared. She could not understand the words but she could read the wrath and passion in the flashing eyes and curling mouths of the contenders. There were those in Israel who could never stomach Chagall's *stetl* imagery. Those who had passed through the valley of death—with numbers tattooed on their forearms—were nauseated at roseate fairy-tale villages, pink clouds, and green donkeys. What was Chagall's metamorphosis of the drab East European reality but the "ideology of success"? And his attitude toward Israel? "Very ambiguous." And all those shining candles and crisp white tablecloths and lovers floating in the weightlessness of

their bliss—what had that to do with the reality of the ugly muddy towns, the miserable log cabins, the territorial ghetto life of the Pale, the cultural isolation of the Jews, the pogroms? "Why doesn't he ever paint a pogrom?"

"Not true! Not true! When he depicts a man flying alone over Vitebsk, clutching onto a Torah, isn't that a pogrom?" This marvelous remark was made to me by the Israeli sculptor Dani Karavan, a Sabra.

" 'Paris ... mon Vitebsk.' Whoever heard of a Russian Jew who felt nostalgia for his hometown? A Russian Jew wants only to blot its memory forever out of his consciousness! Yet Chagall wants to remember what we want only to forget!"

Some Eastern European intellectuals would argue that Chagallian Slavophile effusions were not untypical of Russian Jews. A Czech artist, Mikuláš Rachlík, pointed out to me that in all the vast Slavic domains only in Mother Russia could one find this mystic identification of the Jew with his "homeland." No Polish, Czech, Slovak, Yugoslav Jew ever feels he is more than a temporary visitor, his "country" more than a roadside inn on his long journey to Jerusalem. But the Russian Jewish intellectual, artist, professional succumbs to the mystic Dostoevskian-Tolstoyan spell of Russianness.

"A self-deluding fraud! A Jewish artist who likes to think of himself as international ... Russian ... French ... Pfui! What Russian! What French! *Er ist a Yid vie alleh fun uns! Aber er vill nit.* . . . He is a Jew like all of us! But he doesn't want. . . ."

So the debates raged as soon as the official reception had ended and the smiling charming Maestro had left the room with his tall sweet *shiksa* wife. Assimilationists envied him. Auschwitz survivors were bitter, German Jews snubbed his Pale of Settlement sentimentalism, intellectuals who were illogically sympathetic to the anti-intellectual Chassidic movement pointed out that Chagall's pictures and personality expressed love and joy and these constituted his essential Jewish bedrock below the strata of French and Russian culture.

"Even his images are not surrealist. His cows and flying lovers are just visualizations of expressions which are common in Yiddish talk. What is a *Luftmensch* but a flying man? Or the irony of 'I can play a violin *vie ein ku* ... like a cow?' ... Just as Breughel's imagery is frequently derived from Flemish folklore so is Chagall's a pictorialization of Yiddish tales."

No overlay of Muscovite-Gallicism could conceal the inevitable *payes* (earlocks)!

"His nostalgia is not prettification but genuine. I'm a Sabra of Russian-Polish-Lithuanian extraction and in my family there are some who reminisce warmly about the *stetl*. It wasn't all grim and drab. There was a certain poetry in the *stetl*. But Vitebsk wasn't a *stetl*. It was a big city with a sizable population. . . . Nor is he so naïve or helpless as he seems. Just look at his eyes.

"But so far as his Jewish theme is concerned we cannot fail to be puzzled by Chagall's aloofness from the State of Israel. One gets the impression that he is happier, more at home with the Jews of the Galut than with the new state of Israel. Is it a question of preferring the dream to the realization?"

From the Mount of Abutur Virginia and Marc looked down at Old Jerusalem white and bleached sand in the girdle of its massive walls, crowned by the twinkling gold and silver domes of two great mosques; and from the ridge on the other side their vision undulated with the lavender waves of the Judean Hills all the way to the heat haze of the Dead Sea. Here and there in the desert, dirty patches were Bedouin tents. A long-haired girl running after a camel, silhouetted against the citrus sun.

Chagall's stirrings of pride in the newborn Jewish state were stubbornly Biblical. When they visited a kibbutz and saw the khaki-skirted full-bosomed Israeli girls ("It must be the sun") working with cows and tractors Chagall's selective vision saw only Rebecca's well. He could not understand these vital young people working in the mechanized milking shed walking down the streaming fly-buzzing aisles between cows being automatically milked, snapping off the milking cusps from udders, spraying them clean with water from a hose. To these kids this was building Israel. Walking between two rows of cowflop and teats! The idealism of dugs and dung! Chagall saw his grandfather's slaughter shed, the Christ-Cow piteously bound.

A Bedouin leaned against his automobile while his tethered horse grazed nearby on the sparse desert grass.

Among Chagall's closest Israel friends is the distinguished Yiddish poet Abraham Sutzkever, a sandy-haired, ruddy-complexioned man with the blondish clipped moustache of a British colonel. Sensitive,

witty, of a Polish background not unlike the painter's Vitebsk, Sutzkever has written poetry whose imagery of Fiddleroses and Cellogirls shares the Chagallian flowing of things into things, a delight in unexpected transformations.

The poet and painter had first met back in 1935 in Vilna, Sutzkever's hometown. They shared Yiddishkeit, love of art, they vibrated well to each other although the poet is considerably younger.

In Israel, to which he had emigrated before the war, Sutzkever continues to write in his native Yiddish, feeling increasingly that he is writing in a dying tongue, the language of the Diaspora, almost entirely displaced by Hebrew, the language of the ancient and latter-day prophets, of Isaiah and tractor drivers. Is Yiddish living or dying? "It is dying to live," he replies with characteristic wit.

He and Chagall hit it off very well. The poet visits Marc at St. Paul whenever he comes to Europe. He possesses numerous Chagall watercolors, gifts of the artist, and his latest book of poetry is illustrated by several rather hastily executed Chagall drawings. Chagall has written to Sutzkever that he learns from his poetry how to paint. And Sutzkever for his part feels a sympathetic vibration for the artist, a fierce defensive love that wards off the arrows of criticism not unfrequently launched against his friend on his occasional visits to Israel. "No, he doesn't speak Hebrew. He lived in the United States for many years and he doesn't speak English either. So? I have a friend who talks twenty languages—all Yiddish. That's how it is with Chagall. Sometimes he writes to me in Russian—but that's Yiddish too!"

But understanding, as well as much communication, might be wordless. It is precisely this wordless intuitive understanding that attracts Chagall to Sutzkever. "He's very sensitive to people. He knows just by looking at his friend's face just what is going on in his head. I told him 'Marc, you're better than a doctor.' I come in and he reads my face. He knows how I feel without my saying it. He has a genius for people."

But he is very timid, according to Sutzkever. Especially to those who do not "love" him. He will pull away from these people. "Despite his world fame, he is really very shy, he feels very much alone. And as for his difficult relationship with Israel, the fault is equally if not more with the Israelis. They don't know how to deal

with him. He is a very sensitive man. And he is very angry—and justly so—with the botchery they have made in placing his Jerusalem windows. He will never forgive them for that."

(According to Teddy Kollek, mayor of Jerusalem, Chagall should be unforgiving of himself. "He was shown the architectural plans for the synagogue. But he can't read a plan. He's right of course. The Hadassah hospital synagogue is a disgrace, and a terrible, demeaning setting for those stunning windows. But Chagall should have known all that when he read the plans. He didn't.")

Sutzkever was present at the inauguration of a Chagall show during that second visit. Ben-Gurion said: "I hear you're a great painter but I don't understand. . . ." to which Chagall replied: "I hear you're a great statesman but I don't understand what you're doing with the *medina*" (homeland).

Since their first meeting forty years ago, the poet and the painter have met almost every year, either in Israel (increasingly less often in recent years) or in Vence, St. Paul, or Paris. Sutzkever has more than two hundred letters; a selection of twenty of these was published in *Di Goldene Keyt (The Golden Chain),* an Israeli (Yiddish) art and literary journal, edited by Sutzkever, on the occasion of Chagall's eighty-fifth birthday.

Once at the villa in St. Paul, Sutzkever exclaimed in admiration at the overwhelming beauty of several Chagall works on the wall.

"Don't waste your time here," said Marc. "This is all nothing . . . *alles gornisht,*" leading his friend into a small room: "Look at these. When I still could paint, when I knew something." And he showed him two small paintings done when Chagall was eight or ten years old. Sutzkever didn't think the paintings were superior to the great blush of passion he had been admiring, but he enjoyed Chagall's pixyish humor.

Always there is this play of mask and man. The shyness that Sutzkever mentioned was described as "magnetism" by a young Israeli art critic, Amnon Barzel. "He just enters a room and conquers everybody." But magnetism could be the mask of shyness, just as his seeming ingenuousness might be the mask of shrewdness. Professor Ulrich Middeldorf, who met Chagall at the University of Chicago, described him as "wicked, mischievous. You can see it in his eyes." He walks tiptoed, fawnlike, he has a magnetic glance and lips curling

and supple as fine swordblades. He is simple and very knowing, shy and subtle, cleareyed and calculating.

Werner Haftmann puts it well:

> Chagall himself wishes to be regarded as a painter; the constant references to him as a teller of fables and legends—as a poet, in short—make him indignant. Yet he has only himself to blame. This reputation is in complete accord with the whole style of his personality. When, at the beginning of 1912, he took up residence in La Ruche, the "beehive" of artistic bohemians in Paris, he quickly gained the nickname "le poète." And if one is confronted today by this small, vivacious, always slightly hallucinating man, with his blue eyes and curly tufts of hair and his incredibly mobile face constantly changing from serenity to sadness, from artful drollery to lightning intelligence, it is impossible to disregard the poetic charm of his personality, which so strangely oscillates between humble earnestness and unexpected spurts of clowning.
>
> Some of it is disguise—and this too is part of his persona—serving as a refuge and a defense, to guard the vulnerable nucleus of his artistry. A glance into the studio is granted to only a few. Chagall is busy there from dawn to dusk, but few know what he is doing. There he keeps himself to himself, an alchemist engaged in what he likes to call the "chemistry" of his painting, a man of the Cabala constantly immersed in a flood of highly enigmatic imagery. In the middle of a conversation a pensive shadow sometimes falls on his face, and the thread of an anecdote becomes tangled. His imaginative world has overtaken him again, and a sudden idea sends him into the studio.
>
> Chagall always carries his picture world with him. He needs to have his paintings around him. . . . Like a snail he carries his house on his back; it makes him feel at home wherever he goes and is a sanctuary from which he can put out feelers for further reconnaissance of his world.

Impressions of Chagall in Israel vary according to the observer. His many-faceted personality elicited many-faceted responses: negative and critical, loving and biting. But most young Israelis don't like

Chagall very much. Is it, I asked Barzel, because he is figurative? Or because he paints Jewish subjects?

"Both. A double reason for disliking him." To Abraham Sutzkever Marc Chagall is a fellow poet, a shy and loving genius. To David Lazar, a writer who came to Israel in 1941 from Krakow, Poland, the artist is a web of contradictions: simple and shrewd, naïve and sophisticated, generous and canny, emotional and Mephistophelian. The two men had met originally in Poland. On another later occasion they witnessed the horrors of Auschwitz. "Chagall wanted to see everything, know everything. We cried together. It was a very moving experience. Chagall identified the ruins of the Warsaw ghetto, Auschwitz, the Holocaust with his *stetl*, Vitebsk.

"Of course he is 'ambiguous.' All poets are. And first of all Chagall is a poet, a great poet. He's a very complicated man. All geniuses are. Michelangelo was complicated. Da Vinci was complicated. His soul is divided into three parts. He feels he owes a great deal to France. He is very proud of his Jewish heritage. And he has a deep sentiment for Russia—for its landscape, its art, its literature."

He always has the vision of his Vitebsk in front of his eyes. And when Jacob Glatstein, an American Yiddish poet, later criticized Chagall for his stained glass in the cathedrals of Metz, Reims, and Zurich, accusing the artist of having "converted"—"*geschmat*" is the more polemical Yiddish word, like the slapping of a dropped plank— Chagall's rueful reply was: "What a *kovet* [honor] for a Jew from Vitebsk to make the windows in the cathedral where French kings were crowned. . . . Besides I make only Biblical scenes from the Old Testament."

This isn't altogether true. In all his cathedral glass, Chagall depicts the Crucifixion. *The* Crucifixion, not the Martyrdom of the Jews. The tallith has disappeared, the menorah may accompany the prophets but it does not accompany Jesus on the Cross. When he designs it for a church, history is drained out of the symbol; it becomes abstract. And in these instances the abstraction of the Jesus figure, the elimination of personality, of specific human qualities in it is a sign of Chagall's lack of ease.

His pride in his Frenchness undoubtedly is a sign of gratitude for all that France has made possible. The ceiling of the Paris Opéra ("Vitebsk in a Secession setting" according to Lazar); the exposition

of his windows in the Louvre before shipment to Jerusalem; André Malraux's friendship and protection, his skirmishing with more conservative French critics who had criticized the Minister of Foreign Affairs for commissioning Chagall to redo the old academic ceiling: "This will set a precedent. We can't do that." Malraux: "Chagall has no precedent."

And as for his "Jewishness," which was, already at the time of his 1951 visit, under attack in the new-fledged Jewish state: Chagall, according to Lazar, has always felt deeply about *"unser land"* ("our land," as he always expresses it in his letters to Israelis). "What's going on in our land? *Vas herts sich in unser land?"* As far back as 1931 when he came with Bella for the first time to then Palestine, and when the Mayor of Tel Aviv, Dizengoff, came to him to propose setting up a museum, at the very time when the artist was working on his Bible etchings, Marc Chagall has been loyal to his own brand of Zionism. He has never hung his harp on the willows or forgotten his Jerusalem. But it is *his* Jerusalem, not at all the Zion of the Zionists, and that is where the disharmonies sound from the harp.

Of course the core of his problem is that in Israel there are no fiddlers on the roofs. They are being replaced by solar heating units.

After the Yom Kippur war, Chagall was criticized by Bileski, Professor of Yiddish Literature at Haifa University, in an article published in *Maariv* entitled: "Why Is Chagall Silent?" (with regard to the fate of Soviet Jewry forbidden to emigrate to Israel).

Lazar wrote to Chagall and enclosed the article. Perhaps he could speak some words of comfort and consolation? suggested Lazar in his letter.

Chagall's reply (undated), written in a beautiful clear Yiddish calligraphy, is very moving:

(in transliteration)

Yetz ist meiner nishoma unfertrogen mit unser schickel. Es iss mir shver tsu schloffen a nacht. Unt efsher las auch die einen meiner. Ich moetche tsu tun epis mit meiner bilder as in zey zol arein unser Yiddisher schichsal von heint nicht nor von nechtim. And ven men sacht vervos ist Chagall cloimost volten

zeh gedarf herrn mein pulse und vie azoi ich schvitz nit von
hitz. Ich kusch meiner teiere bruder von die land.

MARC CHAGALL

P.S. Ven men sugt vas varvos "schveight" Chagall cleirich
schveight as mein Museum Message Bible vas hot sich nit lang
ofetziel geefend in Nice. Schveight nisht und der spezieler saal
von mir vas hot sich offiziel geefend in Statmiese in Zurich
schweight auch nicht. Far *uns* Yidden. Ich cler azoi.

Now my soul is overcome with woe for our fate. It's hard for
me to sleep at night. Perhaps my eyes will not permit me to
sleep. I try to do something with my paintings so that our
Jewish soul shall penetrate them, them alone, and not from just
today or yesterday. And when they ask: why is Chagall
tightmouthed they should listen to my pulse and how I sweat
and not from the heat. I kiss my dear brother in the Land.

MARC CHAGALL

P.S. When they say: Why is Chagall silent? clearly I am
"silent" with the same "silence" of my Biblical Message
Museum which not long ago officially opened in Nice. That is
not silent and the hall especially set aside for me which officially
opened in the State Museum in Zurich is also not "silent." For
us Jews. I think so.

Nor was painting the only medium in which Chagall expressed his
concern. I have already quoted above the poem which Marc wrote in
1950 to the artist-victims of the Nazis, and which is now inscribed in
bronze on the walls of the Israel Museum of Jerusalem. Influenced no
doubt by his Yiddish-speaking friends, Marc wrote the poem in that
language rather than in the Russian which he was more likely to
employ for literary purposes.

Close friends of the artist are not at all surprised by Chagall's
occasional poetic effusions in Yiddish and Russian. To them he is
always a poet even when he paints, perhaps especially when he
paints. Abraham Sutzkever always refers to his friend as a "painter-
poet" even in personal letters between them. Since Chagall is prickly
on this point, and did not take offense, he obviously felt that
Sutzkever was using the phrase only in the most complimentary

sense. The extensive correspondence between the two friends reveals Chagall's modest literary aspirations for he always asks Sutzkever to "correct" his poor Yiddish before publishing his poems in *Di Goldene Keyt,* the leading Yiddish literary quarterly in Israel. Over a period of twenty-five years Chagall quite frequently contributed drawings to this periodical as well as poems and literary sketches. All of these contributions, needless to say, were *gratis:* an indication of his warm friendship with Sutzkever dating back to their first meeting in Poland in 1935, renewed subsequently in Paris and Israel, as well as attesting to Chagall's admiration for Sutzkever's efforts to sustain a Yiddish literary tradition at first under attack by the more fervent Hebrew-speaking Israelis as the shameful language of the Diaspora. I have already quoted Sutzkever's witty reply to my question whether Yiddish was "living or dying in the State of Israel?": "It's dying to live. *Es starbt zu leben."* Such sprightly humor appealed to Chagall's own goat-leaping fantasy. Indeed I gathered from conversations with Sutzkever, later confirmed by reading his memoir on the painter as well as his published correspondence, that a deep friendship exists between these two; Marc's letters reveal how profoundly Jewish Chagall really feels and how much he identifies with Israel as *"unser land."* His Yiddish letters, incidentally, are beautiful: rich with folk wit, colorful, often more truly poetical than his published poems.

Chagall's poetic side must not, however, be misunderstood. His painted poetry is not literature. A true painter—and Chagall is a true painter—embodies his poetry; he does not illustrate it. Chagall's sensitive awareness of this is the source of his irritable refusals to be considered a Jewish illustrator of Jewish folklore. In Paris, before the First World War, had he not warned Lunacharsky: "Above all, don't ask me why I paint in blue or in green or why a calf can be seen in the belly of a cow."

And in a recorded interview in 1944, in America, he had expressed himself with exemplary clarity:

> There is nothing anecdotal in my pictures—no fairy tales—no literature in the sense of folk-legend associations. Maurice Denis described the paintings of the synthetists in France about 1899 as plane surfaces "covered with colors arranged in a certain order." To the cubists a painting was a plane surface covered with form-elements in a certain order. For me a picture is a

plane surface covered with representations of objects—beasts, birds, or humans—in a certain order in which anecdotal illustrational logic has no importance. The visual effectiveness of the painted composition comes first. Every extra-structural consideration is secondary.

I am against the terms "fantasy" and "symbolism" in themselves. All our interior world is reality—and that perhaps more so than our apparent world. To call everything that appears illogical, "fantasy," fairy tale, or chimera would be practically to admit not understanding nature.

Impressionism and cubism were relatively easy to understand, because they only proposed a single aspect of an object to our consideration—its relations of light and shade, or its geometrical relationships. But one aspect of an object is not enough to constitute the entire subject-matter of art. An object's aspects are multifarious.

I am not a reactionary from cubism. I have admired the great cubists and have profited from cubism . . . [But] to me cubism seemed to limit pictorial expression unduly. To persist in that I felt was to impoverish one's vocabulary. If the employment of forms not as bare of associations as those the cubists used was to produce "literary painting," I was ready to accept the blame for doing so.

In painting, the images of a woman or of a cow have different poetic values. As far as literature goes, I feel myself more "abstract" than Mondrian or Kandinsky in my use of pictorial elements. "Abstract" not in the sense that my painting does not recall reality. Such abstract painting in my opinion is more ornamental and decorative, and always restricted in range. What I mean by "abstract" is something which comes to life spontaneously through a gamut of contrasts, plastic at the same time as psychic, and pervades both the picture and the eye of the spectator with conceptions of new and unfamiliar elements. . . .

The fact that I made use of cows, milkmaids, roosters, and provincial Russian architecture as my source forms is because they are part of the environment from which I spring and which undoubtedly left the deepest impression on my visual memory of any experiences I have known. Every painter is

born somewhere. And even though he may later return to the
influences of other atmospheres, a certain essence—a certain
"aroma"—of his birthplace clings to his work. But do not
misunderstand me: the important thing here is not "subject" in
the sense pictorial "subjects" were painted by the old academi-
cians. The vital mark these early influences leave is, as it were,
on the handwriting of the artist.

And later in 1947:

And so if in a painting I cut the head off a cow, if I put the
head upside down, if I have sometimes worked on paintings the
wrong way up, *it is not to make literature.* It is to give my
picture a psychic shock that is always motivated by plastic
reasons. . . . If finally, one nevertheless discovers a symbol in
my picture, it was strictly unintentional on my part. . . . *I am
against any sort of literature in painting.*

*

One day as Marc and Virginia were walking through Mea
Shearim, the quarter of the strict observing Chassidim, they heard
from a dingy house voices being raised in a domestic quarrel.
Gathered at the gate was a crowd all in caftans, prayer shawls, skull-
caps, their *payet* swinging as they made wry disapproving comments
above the screaming voices. It was a scene right out of Sholem
Aleichem, a bit of the *Galut* transported to the Holy Land. Marc felt
very much at home, but to Virginia it was as foreign as Tibet. So
they might share experiences but only on the surface; their deepest
roots were lodged in very remote and different pots of earth.

Another time at a reception, Chagall saw Sutzkever standing alone
in the corner. He ran over to him and pulled him aside: "Come over
to another room where you and I may talk. They're too many *goyim*
here."

Yet he is still flattered immensely by honors bestowed upon him
by the *"goyim."* "He's got the typical hangup of the *stetl* Jew," says
Lilik Schatz, son of one of the most important artists of the first
generation of settlers and founder of the famous Bezalel art school in

Jerusalem. Hence when the Bezalel family were in Paris they often met Chagall. "I was only a kid and was terribly impressed by Chagall's art but less so by his personality. He was a snob, always dropping the names of counts and dukes he knew. The typical chip-on-the-shoulder insecurity of the *Galut* Jew. I didn't like him. And he didn't like my paintings. That was back in the late thirties. Later I met him again in New York in the forties. I'd written an article about his art published in a Jewish magazine and then syndicated in 350 other magazines and papers. When I told Chagall about this, he said he already had all the clippings pasted up in his album. And we were driving in a car one day and he was in the back and picked up one of my paintings and said—"It's good. It's good."—I knew damned well he didn't think it was good. But my article had been reprinted in 350 magazines!

"Another time I was with him in New York. And he had been nasty about somebody's art. I once saw him reduce a woman painter to tears. Ripped her to shreds. And suddenly I saw the most ass-licking smile ooze over his face and he got up to welcome . . . Sidney Janis!

"But he's a great artist. . . ."

Almost invariably the harshest judgments of Marc Chagall end on this note. "But he's a great artist. He's a great poet. And a poet-artist must be forgiven everything. . . ."

Big, burly, balding, in his late fifties, a match projecting like a tiny anti-aircraft gun out of the corner of his mouth, and the manners of a friendly pug expressing himself in a flow of excellent English or French or his native Ivrit, Lilik Schatz is a close friend of Henry Miller and was one of his mentors in painting. But his characterization of Marc Chagall does not reflect merely his own personality and tastes. Rather his feelings about the Vitebskite were shared by many Israelis in 1951. And today perhaps Chagall's art and personality would arouse even more antagonism in Israel. For not only has the aesthetic gulf widened between the generations but Chagall's sentimental effusions about Mother Russia set up the wrong vibrations in Israelis angered at Soviet harsh treatment of Jews seeking emigration, and Russian military and political support of the Arabs. In view of this, Israelis are not likely to be impressed by the Maestro's irradicable love of his "hometown" Vitebsk.

Most vitriolic on this subject was I. Talphir, editor of *Gazith,* an
art journal published in Hebrew which exercises considerable influ-
ence in Israel. I interviewed Talphir in his office, heaped like an old
curiosity shop with piles of old magazines, books spilling over all the
shelves and the old rolltop desk, paintings pellmell on the walls, not
infrequently as crooked in their hanging as in their contents. Talphir
was a slight man with a drawn monkish face illuminated on occasion
by a bright smile in which incongruously the top middle tooth is
vigorously missing. We spoke in Yiddish, mine splintered, his
labored.

"I love Chagall despite the fact that I am bitter with him for his
failure to speak up in Russia about the Soviet treatment of Russian
Jews."

Through the open window shouts of Israeli kids booting a soccer
ball.

Talphir's attitude was that Chagall did not so much love the Jews,
Jewish tradition, the Yiddisher Folk, as he loved Vitebsk.

"He is still back in Vitebsk, in his cradle at birth when a fire
broke out. . . ."

"A subject for psychoanalysis . . . ," I remarked. (This phrase
struck Talphir, who came back to it several times.)

"He doesn't write Yiddish. I'm sure Sutzkever rewrites the poems
for him before publishing them. He feels Russian, he writes Russian,
and now he wants to be a Frenchman."

All this scoffing at Chagall's Jewishness, I felt unjustified especially
when Lazar read Chagall's letter to me the following day. Yet, with
all his barbed criticism and harpoon irony, Talphir insists that he
"loves" Chagall. "He's a poet and we must be patient with
geniuses. . . ."

The same attitude, the identical words Lazar repeated to me the
following day, the same words Sutzkever had used two days before.

". . . but he lacks real idealism, he is an ego-centered man. He has
no real love for the Jewish people." Becoming fervent now, flashing-
eyed, sucking explosively on an unlit pipe.

"The real *nishoma*—soul—of Chagall was Bella."

In a lecture at the University of Chicago in 1958 Chagall
remarked about how he ". . . benefited from travels to Spain,
Holland, Italy, Egypt, Israel and even to eastern France. In the East I

saw for the first time the rich greenery never found in my own country. In Holland I discovered an intimate, vibrating light that seems like the light of afternoon or early dusk. In Spain I found the inspiration of a mystical past, though it was somewhat cruel. In Israel I found the Bible."

In Israel I found the Bible. Is it any wonder that more than one Israeli, especially the younger Davidian warriors, were not and are not sympathetic to the artist so intent on "finding the Bible" that he doesn't see the remaking of the Bible in his own time?

Chagall loved Israel as he saw it: an oasis for Jews, a super-Vitebsk in the desert. But what he wants obsessively to preserve the Sabra wants to destroy forever, even the memory together with the Nazi-pulverized mortar of a thousand Vitebsks. What the Israeli wants to create is not an oasis, a refuge, a bomb shelter but a valid city of man. Where everybody is a Jew, there are no Jews. There are Israelis. What Chagall, imprisoned in his world of images, could not understand was that the bosomy girls in khaki uniforms, directing traffic or hitching rides on the roads, were no longer Rebeccas at the well nor Bella flying over the Eiffel Tower. These were Israelis and the Israeli might be defined as the cancellation of Diaspora Jewishness.

"His intuition with regard to people," writes Virginia, "was not as sure as the one he had for works of art." And she continues:

He "felt" them when it suited him to feel them, when nothing about them interfered with his work, when he and they were quivering together on the same thread across the abyss of time. But when they jolted him by making unpredictable movements then he quickly cut them off. He never made incursions into other people's lives, their problems and personalities did not interest him except in so far as they touched his own life. He often became totally indifferent towards a friend if he felt there were demands being made of him, either moral or material. A friend had to be adoring and disinterested always, asking nothing in return except the reward of being Chagall's friend, a true reward indeed.

There were two gifts he gave easily:

One was his dazzling half-moon smile that made his tilted

eyes tilt even more and the cheek bones pucker into dimples. His eyes had an extraordinary limpidity, they were pale blue reflections of all his inner visions, the humour, the malice and the tenderness of his painter's soul.

The second was his tireless inscribing of books, embellished with drawings or water colours, for all and sundry. He never refused a request. This was something that pleased and amused him. The title page often gave him ideas and he incorporated the printed letters into his design. Some of these sketches are full of beauty. This form of gift had the added beauty of costing nothing. It always amused him to think that he was making an object of value "out of nothing." Whereas every article of importance that had to be bought with money seemed to him an extravagance, he often willingly exchanged a painting for it, much to the advantage of the merchant

The only exchange he never made was for other artists' work (with the exception of a sculpture by Laurens and one by Rodin), he said he preferred his own!

There was one form of generosity he never practised. He resented being asked to lend money and if he was persuaded to do so by Ida or by me, his feelings towards the borrower often became strained. He used to repeat the well-known saying: "Never lend money to your friend lest he become your enemy."

But "fame is the spur." And surely the familiar longing of any artist to be remembered, to achieve fame, to be ranked with the great of his craft through the ages—surely this would seem to counterbalance the petty or shortsighted accusations of stinginess so frequently leveled against Marc Chagall.

Sutzkever's walls, and the walls of several other homes I have seen, are covered with Chagall drawings freely given as gifts. Indeed, he has been extraordinarily generous with donations of his work, even if we discount the colossal gifts of the Nice Biblical Museum collection, the UN window, the stained glass at Reims, the ceiling of the Paris Opéra, etc., as payments toward the perpetuation of Chagall's reputation for future generations.

"Don't tell Chagall he's a Jewish artist. He wants to be a universal artist." The speaker is an Israeli art historian.

"One can be universal through any subject matter," I said. "Think of all the centuries of traditional Christian iconography through which Piero della Francesca, Masaccio, Rembrandt, Michelangelo, even da Vinci (who wasn't even a Christian) had to assert their individualities—and universalities. Besides," I added laughing, "who is more universal than a Jew?"

"No," replied my interlocutor seriously. "He doesn't want to be known as a Jewish artist. He's afraid he'll be hung on the same wall as Mané-Katz or Reubin Rubin. That's one of the reasons— aside from his stinginess—he has not given pictures to the Israeli museums. He doesn't want to be known as a Jewish artist. But he can't help painting Jewish subjects. He's obsessed by his Jewishness.

"He's a very intelligent man. A remarkable man. Not at all naïve. Shrewd. Tells lies about himself. A different story every time."

"A fantasist?"

"Not a fantasist. He knows exactly what he's doing. Look into his eyes."

Despite the undercurrent of criticism Chagall's reception in the Holy Land was an unmitigated triumph. So much so indeed that Moshe Sharett proposed that the artist complete his pilgrimage from Vitebsk by settling down for the rest of his days in a house to be especially set up for him in Haifa. He was even given an old marriage ring symbolizing his marriage to Israel. Later Chagall turned down the offer.

Malicious wits said: "He doesn't want to leave France to Matisse."

<p style="text-align:center">*</p>

Virginia's memoir continues:

On the way back we stopped at Pompeii. The sight of these miraculously fresh painted walls made Marc want to hasten back to his work. He made a few rough sketches of *motifs* that attracted him particularly and stuffed them into his pockets with all the other scribblings he had done during the trip.

Back in Vence he started working on ceramics. In the Place

du Peyra (once painted by Soutine, with its huge tree sur-
rounded by a circular bench) there was a large ceramic shop
and next to it a potter's workshop and wheel. The potter's
name was Serge Ramel. Marc used to watch him when he
passed by on his daily rounds and they became friends. He was
a refined and intelligent man, cordial and enthusiastic. He
taught Marc the technique of ceramic and followed his whims
and fantasies with great sensitivity and respect and Marc
produced a series of beautifully accomplished works under his
guidance. It is not generally known that Serge Ramel was his
first teacher. When Marc left him to go and work with
Madoura in Vallauris he already had a certain command of the
medium and this gave him a freedom he would not otherwise
have had working in Picasso's own personal domain.

But "working in Picasso's own personal domain" was sticking
banderillas in the Malagan's hide. In *Life with Picasso* Françoise Gilot
gives us a vivid picture of the corrida of these two egos.
Before his return from America Chagall had written to Picasso
saying that he would soon be back in Europe and looked forward to
seeing him. Included in that letter was a photograph of David.

Pablo was rather touched, I remember, because he pinned up
the photograph of Chagall's son in our bedroom.
One day Tériade came to see Pablo about the illustrations for
his edition of Reverdy's *Chant des Morts,* and Pablo mentioned
Chagall's letter to him. "I'll be happy to see him," Pablo said.
"It's been a long time." Tériade said that Chagall's daughter,
Ida, was over at his place at the moment and that she would
enjoy seeing Pablo. So a week later, along with Michel and
Zette Leiris, we went over to Tériade's place in St.-Jean-Cap-
Ferrat for lunch and there was Ida, who had prepared a
sumptuous Russian meal for us. She knew Pablo's wife, Olga,
was Russian and she must have thought he had a taste for
Russian food. She put on all her charm for Pablo, and told him
how much his work meant to her. That was music to his ears,
of course. She was rather well set up, with curves everywhere,
and she hung over Pablo almost adoringly. By the time she had
finished, Pablo was in the palm of her hand, and he began

telling her how much he liked Chagall. So Ida finished off what her father had begun: she made Pablo want to see Chagall even before he had returned.

Several months later, Chagall arrived in the Midi. One of the first things he did was send word that he wanted to make pottery at the Ramiés and he came over, prepared to go to work. That was too much for Pablo. His fondness for Chagall wasn't built to withstand that and he showed it. Finally Chagall stopped coming. There was no quarrel; it was just that Pablo was much less enthusiastic once Chagall was back. But officially they were good friends.

About a year after that, Tériade invited us to lunch again. This time Chagall and Virginia were there. Virginia had a very pretty face, but was exceedingly thin and so tall as to tower over Chagall and Pablo and everyone else. Pablo, I could see, was aghast at her thinness. In addition she was, I believe, a theosophist and her principles prevented her from eating meat and about three-quarters of the rest of the food on the table. Her daughter, about ten, was there too, and followed the same dietary laws. Pablo found that so repugnant he could hardly bear to eat, either. I, too, was at the absolute limit of thinness for Pablo at that moment. Surrounded by skinny women he was in a bad mood and he decided to put it to good use. He started in on Chagall, very sarcastically.

"My dear friend," he said, "I can't understand why, as a loyal, even devoted, Russian, you never set foot in your own country any more. You go everywhere else. Even to America. But now that you're back again and since you've come this far, why not go a little farther, and see what your own country is like after all these years?"

Chagall had been in Russia during the revolution, and had been a commissar of fine arts in Vitebsk at the beginning of the new regime. Later, things went sour and he returned to Paris. In the light of that experience, he never had any desire either to return to his country or to see the regime flourish anywhere else.

He gave Pablo a broad smile and said, "My dear Pablo, after you. But you must go first. According to all I hear, you are greatly beloved in Russia, but not your painting. But once you

get there and try it awhile, perhaps I could follow along after. I don't know; we'll see how you make out."

Then suddenly Pablo got nasty and said, "With you I suppose it's a question of business. There's no money to be made there." That finished the friendship, right there. The smiles stayed wide and bright but the innuendos got clearer and clearer and by the time we left, there were two corpses under the table. From that day on Pablo and Chagall never set eyes on each other again. When I saw Chagall quite recently, he was still smarting over that luncheon. "A bloody affair," he called it.

Marc also started sculpture at this time, recalls Virginia, "inspired by an Italian marble-cutter's workshop opposite the entrance to Les Collines where he passed every day on his morning walks."

The completion by Tériade of the three great books of engravings commissioned by Ambroise Vollard was at last nearing an end, and Marc had to sign each engraving separately and colour some of the series. That meant laying out hundreds of them at a time and Ida decided the best place to do it would be in the big studio of her house in Gordes. She set up long trestle tables and the work went ahead cheerfully under her direction with pauses for fun and luscious meals and walks in the admirable countryside.

In the summer Marc and I and the children spent two weeks in a quiet village by the sea called Le Drammont. For the first time I posed for him in the nude and the gouache *Nude at Drammont* was finished later when I was gone. He also painted two rather tragic pictures *La Barque Bleue* and *Soleil à Drammont* where the shadow of things to come was already hovering.

*

So they had returned to Vence.

Not to capture France from Matisse but to continue to weave a life together that was already beginning to show some unraveling. The visit to Israel had confirmed Virginia's philo-Semitism. She liked frank explosive people. Her father and mother had never quarreled

openly although she knew that they disagreed very strongly. She liked Jewish ways and the gull-flying shape of Jewish mouths, and burning eyes and voices shouting in the language of Isaiah. She liked the baked land and the newly blossomed state and the Holy Places which as the wife of a Jew she could only spy from the rooftops across from the Mandelbaum Gate. Jordanian soldiers, their rifles at the ready, glared ruefully at the tall russet-haired *shiksa* unaccountably on the other side. Camels and Chassidim, earlocks and energy, if I forget thee O Jerusalem. . . . All this she carried home with her from Israel and the joint experience served to balm a growing hurt.

Virginia's involvement with the natural-cure group in Vence, just before their trip, had come about after Chagall's operation for prostatis in 1950. She had never seen Chagall sick for a single day and although he was then sixty-three he carried the years lightly, still moved with his peculiar dancer's step, and his blue eyes radiated energy. And although he never exercised in a formal sense, other than his daily walks (always sketching and writing as he went), he was a very healthy man, pink-faced, surprisingly strong.

Now suddenly after the surgical intervention she saw him relapse into that curious compound of strength and fatalism she had noted once before when she had announced at Sag Harbor that she was returning to her husband. Then Marc had sat dumbly as an Egyptian monolith, not uttering a word, making no effort to stay her decison. So now, mummified by fate, he was lying stiffly on the narrow hospital bed in Nice, as in a coffin: absolutely motionless, speechless, waiting. . . .

For two months, Virginia remained in the clinic, sleeping in the same room with Marc. Gradually he broke out of his torpor and she began reading to him as she had read *The Arabian Nights* and *Decameron* during those commissions. This time she read him a life of Mozart, some Balzac, Flaubert, and the letters of Van Gogh. She loved reading to him because of the extraordinary lucidity and vibrations with which he entered into the creative world of the author.

But during his convalescence she realized that Marc had broken out of his silence not through any rousing on her part, but as if the period of necessary waiting had ended. She watched the process and wondered if this fatalism were not something peculiarly Jewish, the sign of centuries, millennia of persecutions, pogroms, holocausts.

Even after he had returned home, completely cured, and had

become his energetic self again, working from dawn to dusk, his mind boiling with images and projects, the image of Chagall in the hospital, determined, set, almost grim, remained with Virginia.

"Marc had an incredible strength in him, a capacity to accept with grim determination, as long as his work was not threatened. I never saw a smile on his face during those two long months until he got back to work again."

Her observations in the hospital at Nice convinced her that "people were being butchered by orthodox medicine." She became more actively involved in the natural-cure group.

In this health group there was a young Armenian—I was sure he was a Jew—he had blazing black eyes, fantastic. A beautiful young man. He had been tubercular, very serious case, had had several operations to collapse his lungs. Now he was brown and healthy. Well, I fell in love with him, though only from a distance.

Marc noticed. He kept silent for several months. Then one day he remarked: "I suppose you are in love with that young Armenian?"

"I suppose so."

He kissed me. I was touched by his delicacy and seeming lack of jealousy.

And he didn't say another word on the subject.

She also sent the children to the school attached to the health group. Marc objected. They began to have quarrels on the subject. And one day he said: "I forbid you to go there! *Je te défends d'y aller!*"

"*J'y vais quand même!*"

Marc smiled. She read admiration and disapproval in the smile.

From then on, Virginia knew they were drifting. He had never spoken to her like that before.

Je te défends . . . !

In the autumn of 1951 Virginia got a divorce from John McNeil.

For years Marc had anxiously wanted me to get a divorce, it seemed to him of capital importance. But when Ida (who brought me a handsome leather suitcase to celebrate the occa-

sion) asked us when we were getting married Marc replied "We're in no hurry. What's marriage? A piece of paper" and I agreed.

With all his *stetl* imagery, Bible etching, and unwished-for reputation as a "Jewish artist," Marc Chagall is certainly not a practicing Jew. Virginia, in all their years together, recalls only a few instances when Marc "lapsed" into traditional religious practice. "No, he was not religious but he always felt he was a Jew. And he scorned *'quels juifs assimilés.'* When we were in America he loved to walk around the Jewish quarters and poke around the pushcarts. But his closest friend then was Opatashu who was a religious Jew. And one day some devout Jews at High Falls somehow convinced Marc to go to synagogue for Rosh Hashanah and to fast for Yom Kippur."

Opatashu also convinced Chagall that Virginia should convert and become a Jewess. Virginia thought the idea was just silly. "I'm not a Christian. So why should I become a Jew?" But under Opatashu's pressuring, Chagall insisted and these discussions were going on when Ida arrived and in her swift commanding way said: "What sort of nonsense is all this? *A quoi bon?*" And put a stop to it at once.

Yet, after David's birth the baby was circumcised by a doctor in a New York hospital in Orthodox style with a rabbi present.

"*A quoi bon?* What's the point of it?" had also been the phrase Marc had murmured in response to Ida's questioning "*Alors, vous allez-vous épouser?*" after Virginia secured her divorce.

"A marriage did take place but it was Ida's. In January (1952) she married Franz Meyer at the Hôtel de Ville in Vence and there was a joyful wedding lunch in Marc's studio."

Meyer was the scion of a wealthy Swiss family, an attractive and scholarly young art historian later to become director of the Kunsthalle Museum in Basel.

"Among the thirty guests were Tériade, Jacques Prévert, the Bourdets, Charles Estienne and Jacques Lassaigne. There was much hilarity when Jacques Prévert danced with Ida's mannish housekeeper who had a gift for clowning and wore tweeds and enormous boots."

The series of photographs of Ida's wedding reveals Marc as clowning proud father, a radiant and victorious Ida, a properly self-deprecating groom, and a modest and lovely Virginia—pictures which

betray the inevitable banalities: cutting the wedding cake, bride and groom teeth-grinningly linked, daddy-lover trying not to show his incestuous envy, defeated husband—all these clichés which not even the most skilled photographer could mitigate.

Also at the wedding was Charles Leirens, a Belgian photographer of great talent who had been director of the Palais des Beaux-Arts in Brussels and whom we had met in New York at the house of Kurt Wolff, the editor of Pantheon Books. Charles Leirens had come to High Falls to make a series of photos of Marc at work and had now come to Vence to make a 16mm film in colour.

The wedding and the retrospective exhibition at the Galerie des Ponchettes in Nice were part of the film as well as work on the ceramics at Madoura. . . .

Charles was a fascinating person with brilliant intelligence, a great sense of humor and a stimulating curiosity for everything. He was a year older than Marc and not as well preserved because he had been seriously ill with coronary thrombosis since our last meeting. I helped him carry the camera and we often went together to the Galerie des Ponchettes to shoot Marc's pictures. The long drives brought us closer and something was happening that it was going to be difficult to undo. For the third time I was drawn to someone who was in need of me. Marc was safe in his stronghold of creation but Charles was a vulnerable man. Perhaps I could not have brought myself to break up my life with Marc for a younger and a happier man, however much I might be in love.

When Marc went off to Paris on a trip, Virginia and Charles Leirens became lovers.

In Paris when Marc discovered the truth all the furies broke loose. His whole entourage knew of it in a matter of hours. At Marc's vernissage at the Galerie Maeght I was scrutinized with curiosity and disapproval.

"After the rage came cold fatalism." Now she observed the same psychological sequence she had observed in the hospital. His "in-

credible strength" manifesting itself again; his "capacity to accept with grim determination, so long as his work was not threatened."

He dove back into his work as into a bomb shelter.

The breach widened. It had been widening imperceptibly since I began to be interested in activities outside of his life. He resented this and began to withdraw into his own private world. He became more secret and preferred to work alone.

Finally I announced that I was going to leave. Although things had been going from bad to worse with us for some time, Marc never thought that I would leave him. He became absolutely furious.... But I *had* to leave. I knew that eventually I would leave even if there were no Leirens. Marc Chagall was becoming an Institution. I couldn't cope with that. I couldn't be hostess to Important People....

So I left. I left with just the clothes on my back. I didn't take any of the eighteen paintings which he had given me. Not one.

Virginia's flight in 1952 struck Chagall where he was most vulnerable—in his dependence upon a woman. First it had been the mother he adored. Then he had been the darling of his six sisters, after the death of David, the only boy. Then almost three decades of dependence upon Bella, "his real *nishoma*, his soul." Those who bore with him after Bella's death feared that her loss would prove fatal for the artist. But his reservoir was deep, fed by life-loving springs. And Virginia played a vital role in that recovery. She came at just the right time: her youth, her ebullience, her energy, perhaps even their difference in age and background: the Russian-French Jew, the Anglo-French Catholic, both lapsed, both wounded. Their lives had joined when they had to join, and now seven years later Virginia had fled with an even older man. "Joe! She's left me!" was the first remark he made to Buxenbaum, who visited him at Vence shortly after Virginia's flight. "She's left me! And for *what?!* A *photographchik!*"

"He was crazy about Virginia," Buxenbaum recalls. "And he's a very emotional man. Not sentimental. But emotional, yes. When he sees me, he kisses me. So this time, he kissed me and then he started to cry—'Joe! She's left me ...!'"

Max Lerner recalls that his friendship with Chagall commenced

about "the time he took up with Virginia. We liked her and thought she was good for Marc, and that he would cherish the son she gave him. Alas, it didn't work out that way. . . . After Virginia's flight he was terribly unhappy and again Ida had the problem of finding someone to help her father. . . ."

Jean remembers that she and David were told that they were going to visit their grandparents; only halfway to Paris did they learn that they would never return to Chagall. "I didn't miss him although I was grateful for what he had taught me about pictures. My chief regret was the gardener, a sweet friendly man. In that house we were all servants of the great god Art."

"Not long after that visit at Tériade's," writes Françoise Gilot,

Virginia left Chagall. One evening soon after that, we were at the ballet and met Chagall's daughter, Ida. She was very upset about Virginia's leaving. "Papa is so unhappy," she said. Pablo started to laugh. "Don't laugh," Ida said. "It could happen to you." Pablo laughed even louder. "That's the most ridiculous thing I've ever heard," he said.

But in spite of his personal differences with Chagall, Pablo continued to have a great deal of respect for him as a painter. Once when we were discussing Chagall, Pablo said, "When Matisse dies, Chagall will be the only painter left who understands what color really is. I'm not crazy about those cocks and asses and flying violinists and all the folklore, but his canvases are really painted, not just thrown together. Some of the last things he's done in Vence convince me that there's never been anybody since Renoir who has the feeling for light that Chagall has."

Long after that, Chagall gave me his opinion of Pablo. "What a genius, that Picasso," he said. "It's a pity he doesn't paint."

Virginia sums up her life with Chagall in these terms:

My departure was not violent, it was a logical conclusion to an unhappy situation. . . . I was hard to Marc because I felt trapped in a part I couldn't play. . . .

I knew that Marc was headed for greater fame and greater riches. The Great Machine that he had helped to set in motion was carrying him along with it inexorably. Already his own freedom was threatened but he didn't seem aware of the fact. He desired fame and riches, he didn't simply submit to them.

Later he said to Carlton Lake that if he were free he would work for himself and never sell anything. What prevented him from doing so? The Great Machine?

Looking back on our seven years together I have nothing but loving and grateful memories. In Marc's biographies he was supposed to have lived completely alone for seven years, a thing he would have been utterly incapable of doing. . . .

After twenty-five years' silence as a woman who 'never existed' I am glad at last to be able to exist again in this life that I shared for a while.

Had there been no child, that might have been the end of the Virginia interlude. But there was David, the surprising fruit of Chagall's aging loins. He had learned, despite his impatience with children, his ego-centered focusing on his work, to love the little boy as he had learned to love his step-daughter Jean. Now they were both gone, the only "possessions" Virginia had taken with her.

Some time after her dramatic departure Chagall signed a paper stating that the paintings he had given to Virginia were to be assigned to David when he reached his twenty-first birthday. A painting a year. Virginia thought the agreement was "very decent."

But in 1967, on his twenty-first birthday, David never received the paintings, or claimed them. Only six years later, in 1973, after much litigation did Chagall settle by agreeing to turn over eight paintings to David with the stipulation that he was to sell only one a year. The pictures are kept in a vault and lawyers for both parties must bring the keys to remove the painting to be sold. On the back of the frames was written: *Pour Virginia.*

When the settlement was made in 1973 there was included a surprising (to her) gift for Virginia—a watercolor. She sent a letter of gratitude but is certain that it never reached Chagall, all of whose mail is now sifted by his present wife. Except for one occasion, six months after she had left, Virginia has never again seen the artist with whom she had lived seven intense years. "I was with David in

the Galerie Maeght in Paris. I ran into Marc by chance. He gave me
his hand, kissed David, and walked on. Then he was gone. I've never
seen him again. Twenty-five years."

After Charles Leirens's death in 1964, twelve years after her
flight, Virginia used to go down to Vence occasionally. "On those
visits I followed the usual itinerary of Marc's walks, hoping that I
would meet him because I wanted to tell him that I still loved him,
that I felt guilty about having hurt him.

"But I had had to leave. I had to find out who *I* was, not go on
simply as the wife of the Famous Artist, the charming hostess to
Important People."

Their separation was inevitable. As inevitable as their union seven
years earlier. The Marc Chagall of 1952 had different needs than the
Marc Chagall of 1945. Shattered, helpless after Bella's shocking
death, Virginia had come along at just the right moment to revive
him with her youth and beauty and devotion. With full awareness of
the risks of oversimplification—an unforgivable sin when dealing with
the psyche—one might say that there was always an element of need
for a mother in Marc's love as there was always a certain yearning
toward a father-image and desire to be consolatrix to a helpless man
in Virginia's. So long as these two needs fulfilled each other, the
relationship worked.

Before their estrangement set in, Virginia's happiest moments with
Marc Chagall had been when he permitted her to play the role of
helpmeet. To put to order his pell-mell of sketches wrapped in
brown wrapping paper and just piled up on the shelves, to paste up
and remount his drawings, to make a photographic record . . . and he
would be pleased and that made her happy. To be in the studio with
him at High Falls and in Vence, to be lover and tidier-upper, just to
be alongside this vital beautiful man, with his dazzling half-moon
smile spinning off images like a catherine wheel, chromatic, phos-
phorescent, this canceller of Newton's Law, this astronaut before his
time—all this for many years had nourished Virginia's love and
admiration, fulfilled her needs.

But inexorably as Chagall's fame spread she noted that his genius
as an actor was being called upon more and more to enable him to
perform the expected role. He could put on his charm like a mask.
Even after a violent altercation with Ida. He could curry favor with the

rich, smooth-talk dealers and potential clients, be just clown enough (shrewd and steelgrayblue eyed) with just the right amount of white paint for the entertaining concealment. He became too conscious of his subconscious. And with visiting critics and art pundits, his talk about *"la chimie"* was just too easy, a put-on which had once been a discovery.

And worst of all he was becoming an institution, a monument. She knew very well that the Monument was frenzied and distraught about his work, subject to Hamletic spells of depression. She had seen him rigid with fatalism and flaming in anger. She began to find expressions of his weakness in *The Fallen Angel,* a painting which hung over the staircase in the house at Vence. The great slash of red so admired by all who saw it—"It's so *strong!"*—she read not as strength but as violence. It was too external. Great painting, she felt, was not material but magic. It had to be the living thing. Paintings live like a person. That's what Marc meant by *la chimie.* But now she observed that Marc couldn't really say what he meant, by now it had all become too glib. He was just saying it to put people off. He was such an actor.

And acting was precisely what was most antithetical to guileless Virginia. She could never play a role. And certainly not alongside one of the great masters of role-playing.*

* In less than two years after her flight, Virginia's new husband was stricken with cancer of the spine, two or three vertebrae eaten away, paralyzed from the waist down. For several years, Virginia served as Leirens's nurse. Subsequently he recovered sufficiently to resume his work as photographer and musicologist. They lived in Paris and then in Brussels until Leirens's death in 1964. Since then Virginia has been sharing her life with a Belgian filmmaker. Her son lives in Paris, her daughter Jean in England.

Part Nine

Vence, St. Paul
1952-Present

An ink sketch of Paradise, probably in preparation for the painting now at the Musée Biblique of Nice, reveals by direction and indirection, overtly and covertly, the Chagallian conception of Eden. In the Garden, amidst vegetation curvilinear and rectilinear (heart and head?) three strange creatures cavort: a female nude with a double head: donkey (or goat) and man (or woman). Ambiguity resides in every curve, *pentimenti* increase the number of fingers beyond the allotted five, the sex between the legs is undefined and without pubic hair. At the foot of this strange creature is a half-bust of Marc, hand to chest, praying or in adoration of the androgyne. To the right is a mysterious headless nude seen from the rear.

The past twenty-five years of Chagall's life have certainly been an Eden, an accumulation of success, a heaping of laurels. Specifications of his triumphs would become tiresome and add little but quantification to our understanding. But ambiguities persist: perhaps success is the greatest ambiguity.

Virginia had left him because she couldn't put up with Success. Virginia's successor, Valentina Brodsky, who married Marc Chagall in 1952, adjusts very well to Success, and helps the artist to do so. Happy with his new wife, calling upon her aid all the time, traveling

with her all over the world for the installation of new works or the reception of new honors, Marc Chagall's Garden seems immune from contamination. In the eyes of the public, at any rate, even such discerning and knowledgeable eyes as those of Georges Pompidou, then President of the French Republic, Chagall is *"le peintre de la joie de vivre, du bonheur et du rêve heureux."*

An oversimplification. In some ways an oversimplification cultivated by the artist himself. Chagall is not merely—not even mostly—"the painter of joy in life, happiness and happy dreams." He has also been the painter of nightmares, prophet of doom, horrors of the spirit and of the flesh, love as a painful tempest as well as an enchanted storm. His nocturnal scenes are of no real nights but the dark nights of the soul. His grotesquerie is not always pleasant, his dreams are not only happy.

And one suspects that behind the facade of what seems to be an impregnable edifice of worldly success and complacent satisfaction, the gnawing worm of doubt that inhabits every true artist's soul is still at work.

There can be no question that Virginia's precipitous flight was a blow to Chagall. A blow to his ego, a blow to his pride as an artist and as a man. All those who saw him during this trying period testify to this.

Somewhat later, Claire Goll met Chagall by chance on the Place Saint-Augustin in Paris. The artist berated her for having been "responsible"; all Virginia's friends were regarded with suspicion.

Finally Chagall calmed down and sighed:

"What will the history of art say in recounting that Virginia left Chagall for a photographer?" (Buxenbaum relates a similar lament.) After a few pensive moments he added that he had taken back all his pictures (Virginia had left them voluntarily), and now she would have nothing. "David, my son, will have them when he reaches twenty-one."

Claire Goll's account is a picture etched in too much acid to be entirely believed.

Gloomy, wounded, he slunk off to Gordes. Whenever he was in trouble he turned to his daughter for help. So once again, as at her mother's death, Ida had a melancholy father on her hands. And since

she lived now far away, she began again to cast about for a housekeeper.

Thus Valentina Brodsky came into the scene.

Summoned by Ida from London, where she had a fairly thriving millinery business, the jet-haired attractive woman twenty-five years Chagall's junior started as his housekeeper (as Virginia had) and soon became his wife (as had Virginia without "the piece of paper"). Stories differ concerning this metamorphosis. Some say that the coolly elegant Russian lady, daughter of the Brodskys of Kiev: a family fabled in Yiddish folklore for its fortune and high social position but reduced to poverty by the Revolution, had insisted on a guarantee of marriage even before she left London to assume the role of housekeeper. Other accounts would have it that Vava (her diminutive) modestly declares herself that she is not related to *the* Brodskys but rather to a collateral branch.

Whatever the case might be as to her origins and conditions, within only a few months after her introduction, the sixty-five-year-old artist and the forty-year-old Valentina Brodsky were married, on July 12, 1952, at Clairefontaine in the Forêt de Rambouillet. (Crespelle writes that six years later they were married a second time, having divorced after a trial period. "Apparently, both of them suffered from having been originally wed in circumstances displeasing to one of them.") With (and like) Virginia, Chagall had scorned "the piece of paper." With Vava, he amassed two!

What might well have been at issue was, in the French style, a more satisfactory new marriage contract. For certainly since 1952 to the present Madame Valentina Chagall has been the dominating influence in Chagall's life. Intelligent, very much concerned with money affairs, socially ambitious and dedicated to her role as wife of the great artist, Vava has systematically gone about effacing as much of Chagall's personal past as was possible. Bella was not effaceable. Bella was part of history, forever fixed in thousands of Chagall's canvases. To this day, according to Virginia Leirens, a bride in a Chagall painting always means Bella. And Bella the muse, the lover, the wife, the *nishoma* is at the center of the artist's memoir and has left her own vivid account of her first encounters with Marc Chagall. No, she could not be effaced. But Virginia could—and has been. The weighty art historical study by Ida's former husband, Franz Meyer, entirely omits seven years of the artist's life. And there can be no

doubt that this omission was at the behest of Madame Vava and her husband, who additionally did not hesitate to submit fifty pages of suggested revisions to the learned author. No communications reach Marc Chagall except through the approval of his wife. Appointments with the artist are made by her and terminated by her abrupt appearance to remind Marc that he has another appointment waiting or a task that must be performed.

The New York art critic Emily Genauer recalls a waggish conversation with the Maestro soon after his marriage.

"What do you think of her?"

"She's very nice."

"She's got *yiches*" (class, pedigree).

"You, the great Marc Chagall! Who can bring *yiches* to you?"

"When my father was hauling herrings, the Brodskys of Kiev were buying Tintorettos!"

Madame Chagall and the Maestro share a common Russianness if not quite the same Jewishness. And according to David, Chagall's son, Madame Vava has a fine sense of humor which delights Marc. "They joust with each other." Like Bella, and then Ida, Vava manages all Chagall's affairs, supervises his contracts and keeps him hard at work—although it would seem no spur were needed to goad this extraordinarily creative man to whom work is religion, his very reason for being. "If he stopped painting he would die. He lives only to paint."

Now as he settled comfortably into his new life with Vava, Chagall's life alternated for many years between Les Collines at Vence and a beautiful apartment on the Quai d'Anjou on the Ile-St.-Louis from which he could look onto the placid branch of the Seine and take his daily walks, stopping now and again to muse and scribble and sketch, as he meandered down charming storied streets and along the quais past lovers and grafitti. The wound of loss rapidly healed. He plunged back into his habitual work-refuge. Especially was this facilitated by his new wife's swift assumption of all the material and practical problems of his existence. And by her skill in handling these affairs, Madame Chagall began to shoulder aside even Ida from the important place she had held up to now in her father's life.

Every day more indeed Vava was beginning to assume the role of a new Bella. She was even dark like Bella and had similar glowing eyes. Photographs pinned to the wall of Chagall's study document

their astonishing similarity: two somnolently attractive Jewish women who have even taken the same mock-flirting pose, head inclined.

That Madame Vava swiftly became Chagall's manager cannot be denied. Whether she is his muse is another question. Perhaps the period of muses is done. That she has not served to spark as many works as had Bella or Virginia is probably as much due to the artist's old age as to her own specific temperamental contribution. But certainly she has done her best to obliterate as much of the obliteratable past as possible. Most of this expungeable past is post-Bella, first of all Virginia and then many of Marc's old friends who found their relationship—sometimes of many years standing—now inexplicably terminated.

One case may serve emblematically for all the others. Max Lerner had come to France as a war correspondent. Now he returned to Paris almost every year; and whenever he was there he visited Chagall either in the capital or down on the Côte d'Azur. "We continued the conversations we had started in America. Almost all of our talks were about contemporary politics, very little about art. He knew that I wasn't a great art critic. But he wanted my opinion on those matters that deeply concerned him: the situation of the Jews in Russia, the State of Israel. He always began our conversations by saying *'Ich vais gornisht von der politic. Ich bin a nar* ... I know nothing about politics. I am a fool.' And I would say: *'Du bist nit kein nar,* Marc. You're no fool, Marc. Your basic intuitions are better than a lot of sophisticated judgments.' We had been good friends for many years and I looked forward to those visits."

Lerner spent 1962 or 1963 in Paris on a Ford Foundation Fellowship, renting two apartments in Ida's house on the *rive.* That year he saw the Chagalls quite frequently.

In the late sixties Marc and Vava came to America on one of their by now regular trips. "At one point I guess I didn't get along with Vava. Later, I was talking to Leonard Lyons [the late newspaper columnist] about the Chagalls. He had seen them and written some items in his column about them. He was very proud of this and asked: 'Didn't you see them?' And I said, 'Yes, I saw them. But just between us, there's a real problem, as you must know. That is Vava. Because she's taken possession of him in such a way that she's cutting him off from all his old friends.' And I said this includes us as well."

Lyons tactlessly reported this conversation to Madame Chagall. "And the result was that immediately I got word from Chagall (I

forget whether a letter or through Ida) saying that Vava feels deeply wounded by what I had said and vowed she would never see me again, nor would she permit Marc ever to see me again. So I sat down and wrote a letter to Chagall in my transliterated tortured Yiddish, reporting what had happened and declaring I was sorry that I had confessed my feelings to Leonard Lyons. I wrote that I had no ill will and hoped this contretemps would not disturb our friendship. He wrote back and said no, it wouldn't.

"But that was the last time I ever heard from Marc Chagall. All this occurred in 1968."

*

Unlike Picasso, who hated to move, Chagall has always been a restless, curious traveler. Now with his new wife, and ever-increasing fame and means, he was enabled to indulge this need more than ever before.

Their first summer together, 1952, they went to Greece; this journey was followed by a second trip two years later.

The light of Greece entranced him. It was the same brilliant Mediterranean light he had experienced only the year before in Israel. Now he was with Vava as then he had been with Virginia. Sketching amidst the cricket hum of the temple of Olympia or looking down at the vast gray-green olive grove below the vatic heights of Delphi, Marc must have meditated with bitterness or stoic resignation at the dizzying successions of his personal life. One does not simply turn the psychological spigot and shut off the flow of seven years of sharing with a woman one has loved and by whom one has fathered a son. On the ruin-bestrewn Acropolis with Madame Valentina, her black hair gathered like a *korai's*, did images of laughing Virginia and the children sometimes obtrude between the lyric colonnades of the Parthenon?

The Greek trips eventually resulted not only in the color-drenched lithographs but also the sets and costumes for Ravel's *Daphnis et Chloé* which the Paris Opéra commissioned of him several years later.

Long voyages (between periods of work at Vence and Paris) were henceforth to be part of the regular pattern of his existence. In 1953,

he and Vava went to Turin for his biggest show thus far: a retrospective at the Palazzo Madama. In 1953 he went for the first time to England (neither he nor Virginia had attended the exhibition at the Tate Gallery in 1948) where he claims to have discovered a new "chemistry" of colors: murky golds and foggy yellows.

In 1955 there was an exhibition at the Kestner-Gesellschaft in Hanover; in 1956 exhibitions in Basel and Bern, as well an another lithograph series published by Tériade—this time the *Circus* prints which the astute Vollard had induced Chagall to make by providing him with a free seat at the Cirque d'Hiver every week. For Chagall, as indeed for Rouault, Picasso, and so many others, the circus is a central metaphor as well as a suggestive kaleidoscope of forms and colors.

Is he not after all the artist of the perpetual trapeze act? And long before he tackled the literal subject (insofar as Chagall can ever be literal about anything) what else were his Jews flying over Vitebsk, his levitating lovers, his upside-down trees and slanting Eiffel Towers but a metaphysical Circus? The air after all is the element where Chagall is most at home: he is the original *luftmensch* of modern art. And abolition of the law of gravity, reversals of reality, the fun house of distorted images which are not somehow fun but terrifying glimpses of the potential horror of living: Chagall had been grimacing and pirouetting—white-faced as a clown—in this world long before he actually created his marvelous circus lithographs for Vollard, and the later colored series for Tériade

In November 1956, en route from the Swiss exhibitions, the Chagalls arrived in Florence to make the rounds of the galleries and visit the sage of Settignano, Bernard Berenson, world-renowned critic of Italian Renaissance painting and co-founder of the art of attribution. The day before the visit Marc and Vava spent the afternoon at the villa of the Marchese Bino Sanminiatelli near Greve, twenty-five kilometers from Florence. One wonders whether the borsht-colored villa set up Russian memories in the artist.

Sanminiatelli, typically Tuscan in his tart humor ("without hair on the tongue") still preserves vivid memories of this encounter. When I spoke to the Marchese about this meeting, I was amused to conjecture the type of chemical reaction provoked by dropping Chagallian sugar into Tuscan acid. Sanminiatelli's sparkling recollec-

tions confirmed my anticipation; additionally he has memorialized this
meeting in a diary entry of November 30, 1956, published under the
title *Mi Dica Addio (Tell Me Goodbye)*.

30 November, Firenze. Marc Chagall offers me both hands,
speaking in the French of the Russians, that warm, beveled,
rounded off French. Every so often, in the midst of his talk, he
intersperses an adorable *mon petit*. He was born in Smolensk
(sic) at the borders of White Russia. Smallish-statured and with
a modest expression (but there's something in his gray eyes
which I still have to plumb: something absurd, between the
irrational and human nostalgia), he confesses to me at once that
he doesn't know how to draw, that setting out to draw for him
is a great problem, that tomorrow he must go to see Berenson
up at *I Tatti*, that sanctuary for initiates only, and that he is
apprehensive, he fears his art won't be understood by old Bibi.

Sanminiatelli reassured him. Bibi, he said, is on the verge of ninety
but he is still in good enough form to discomfort the young with his
knowledge of modern art which he doesn't even like:

He discusses the subject with grace and competence, filtering
his discourse with that little drop (which he always holds in
reserve) of biting wit, provided that he does not get the
impression that he has been led with polemical intentions onto a
terrain contiguous to the field where he is master.

Chagall told Sanminiatelli of his villa in Vence, two steps from the
chapel frescoed by Matisse. There was also a chapel at his disposition,
"white white, but it is an arduous task and embarrassing for a mystic
of his type."
(Probably an oblique reference to Chagall's qualms at working in a
Christian church which he had not yet done. Once the ice was
broken however at Assy the following year, Chagall never suffered
again from embarrassments proper to a "mystic of his type." To date
he has worked on six Christian churches.)

Matisse (he says again) never had any doubts about himself,
he was not a problematic person. The old man, recently

deceased with all the honors, held court, issued proclamations, surrounded and fawned upon by six secretaries and numerous hangers on, pronounced judgments and pompously allowed himself to be admired. Picasso also lives in those parts, but about him Chagall is reluctant to unbutton himself.

Sanminiatelli says that Picasso, now that he's used up his explosive charge, is remembered as being above all a perfect receiving instrument, but his facile inventions in series re-evoking Negro art, pre-Columbian art, etc., have a defect at their source: they lack the primitive and religious force which that powerful disturbing art possesses. Picasso's is the product of one who is neither religious nor primitive. Of Picasso, an excellent draughtsman, there will remain interesting experiments; that is, the "Picasso phenomenon" will remain which has captured all the orientations and anxieties of the century.

When I have done speaking Marc Chagall raises his eyes to heaven, smiles candidly (I don't know if that is the word) and squeezes my hand. "I won't cost much even when I am dead," he tells me savoring his own modesty. And after a bit: "One sees that you are very much *au courant* about these things."

Alongside me, seated at dinner the young wife Valentine Chagall, called Vava, with hair full of shadow and a glance sweetly feline. [Madame Chagall was then in her early forties, Chagall sixty-nine.] She is Russian, educated in England, and smokes cigars. Marc makes a face of a man scandalized and at the same time complacent. He admires his young wife, and with a thousand coquetteries induces his friends to admire her. He doesn't smoke, he is pure, all heart, humble as the devil dressed in a priest's habit. With regard to these discourses about his friends Matisse and Picasso, he confides in my ear that he doesn't give a damn about money, honors, celebrity, Picasso etc., and that he was created, fundamentally, for love.

"Picasso has more head than heart," Vava insists, "Picasso is sly and dangerous." But she would not perhaps have dared to say this in his domain where there is a clique of followers, *bravi*, a bodyguard prompt to defend the Maestro. "To admire him and praise him signifies to become his victim. He knows better

than anyone else how to gain control over people, possess them."

"A heart that an artist needs," says Sanminiatelli, heir of Machiavelli. "A dry heart." Finally he talks about the last Venice Biennale, final tableau of Surrealism, complete cast on stage, the classic "merry-go-round with a battered trumpet and down comes the curtain. Lights out. Last curtain-call."
Vava wants the Tuscan to repeat his impression to Marc.

She admires her husband as a genius. Marc Chagall is in the clouds like his paintings (but in the clouds there are invisible gears; and all those angels, cows, lambs and suchlike things are interwoven in his canvases like a perfect mechanism), he doesn't remember appointments, he doesn't set foot on solid ground: his young wife concerns herself with those matters, and especially a grown daughter by name Ida, who lives in Paris and is married to a Swiss, who organizes shows and sales, sees to the publications and manages her father's affairs with great shrewdness.

If one asks Marc Chagall something which might touch even slightly on his material interest, he falls from the heights, sniffs the air like a hunting dog who has picked up the scent of partridge, and says with a distracted air: *"Il faudra le dire à Vava, à Ida ... "* A different tack than Picasso's but remunerative nonetheless.

After dinner a group of girls arrive. They claim Chagall for themselves. Some have heard about him, heard his name, others believe they've seen one or another of his paintings, others learned at that moment that he is a famous painter, a cubist or something. Their intellectualism is to ask questions, to be vaguely curious. He looks at them like a child to whom the Befana [the Italian equivalent of Santa Claus] has brought a gift down through the chimney of the fireplace: perhaps angels and cows fallen from a sky resembling a Christmas tree. He admits that he is very sensitive to praise from young people. After a while I see him coiled up on a divan: surrounded, tickled, fondled, petted. He is squeezing the hand of a young girl and whispering: *"Mon petit ..."* (sic)

On December first Chagall comes again with Vava to have dinner at Vignamaggio with the Marchese. The heat of the season of San Martino brought forth flowers even that late in the year. Chagall, who loves the country, yielded to the spirit of the hour, the landscape. He admired the color of the house, the garden, the olive trees. And that oak wood still rich with fronds, to see it imprinted thus on the clear sky like an etching. "He discovers marvels and treasures in the corolla of a flower, in the meat of a fruit. His eyes gracefully and courteously wander everywhere." He impresses San-miniatelli as a man whose "place is distractedly beyond every limit. His ingenuous primitive world is immersed in an atmosphere so rarefied that it almost becomes thought: when it is not viewed in the abyss of exact abstraction. It's a measured game, between music and mathematics, which unfurls on the other side of that space which is ours, whose vibrations one encounters in an inhuman universe." (A sharp insight on the host's part. The artist's son David told me that Chagall had a passion for mathematics. "He didn't know much about it but I knew even less.")

Sanminiatelli reflects that Chagall's art makes ". . . more use of signs and symbols than of completed figures." His images are ". . . like babies, like paradise. They are woven with a grace so perverse that they end by dominating us after having disconcerted our natural aspiration for an intimate yet distant accomplishment." (In these tangled phrases the Florentine patrician is trying to explain why his "natural aspiration" toward classic art succumbed to Cha-gall's paradisical barbarisms.)

Then follows a passage which expresses the difficulties a Tuscan conditioned on Renaissance art has in appreciating Chagall's world. "All that is wearisome and light . . . like hunting butterflies . . . all figures whose order can be changed without abolishing them: in every case the result remains harmonious and closed." (Chagall's canvases may be read in all directions, turned around north south east or west as the artist frequently does while painting them.)

Chagall's art intoxicates the usually sober Tuscan. It arouses in him

fresh impressions of skies, of village festivals, of country holi-days, of mangers turned upside down, of sweet noonday naps with one's head lolling against the warm transparent belly of a

cow which summons around itself with its bell celestial prairies where absurd birds warble. Architecture constructed out of nullities, inexact flowers, and always the fear of discovering suddenly alongside us an object that we thought we had lost forever and which now looks at us with sweet wide open eyes.

Chagall is in love with everything, but especially with love. It's necessary that love be rare and precious ... not importunate.

However, he confides to Sanminiatelli that he doesn't love dogs, that he's afraid of them. For two reasons: one, because a dog bit him and left a scar, the other because he's never been good at, and never will be, drawing dogs.

"But that's not so for cows," says Sanminiatelli, unconsciously echoing Alberti.

"How many cows there are in your pictures: infantile cows, with a human eye, chiming as if they'd come down from the Milky Way like herds seen in a celestial aquarium."

"Oh, j'aime les vaches et les brebis!" he exclaims as he puts his signature under a wolf (an etching colored by hand, an illustration for the *Fables* of la Fontaine which I acquired years ago) telling me at the same time about two other books which he had illustrated: a Bible and a *Daphnis and Chloé* for which he had gone to Greece for ideas ... rare volumes, printed in limited editions ... I should make a deal with Ida to reserve a copy ... Ida treats her friends well, one can always come to an agreement with Ida ... Too bad that Vava smokes those long cigars, Vava accepts everything, she's not capable of saying no ... dangerous for a husband older ... But Vava is all brains ... isn't that true, *mon petit,* that Vava is all brains? ... Vava says instead that Marc is all heart, a great heart of an artist. A good combination, in short.

Chagall takes me under the arm, we should see each other more often, for longer intervals. As he speaks he seems to be wafting so many tiny discreet kisses. Full of admiration, he tells me that for two full hours the other day, only Berenson talked: and everybody listening to that intelligence so victorious over the years. He says that young people can admire the old, but

that there is a natural law which makes the old hostile and blind toward the young. Finally he confesses that despite his proclaimed mysticism, he loves to live and to love. Why not, after all? To be loved by a tree, by a mountain (but he is not thinking about a tree and a mountain) to love the marvelousness and the terror of nature. And also to contemplate, to take joy in, to savor of one's own substance. That's enough to fill a life. It's enough that a thing not remain as it was before having contemplated it. . . .

(Chagall was expressing a notion of vision as action: seeing as changing the world. Vision not conceived of as merely passive and receptive but as a pragmatic insertion of self into the world, so that one looks to seize, to shape, to capture, to modify. Curiously, this irrational mystic has arrived at the identical place of the rationalist Berenson, whose prehensile vision also resulted in a functional aesthetics: art as life-enhancing, one functions better in the world as a result of the art experience; not art for art's sake but art for life's sake.)

Chagall declares he wants to awaken a somnolent world with his art, to render it alive to the spirit, to make of every image a privilege. And as far as the future is concerned, to brutally ignore it: not to give a damn because after all we all march toward nullity.

Sanminiatelli replies that he thinks instead very often about death in order to tame it, so that it might be gentle and receive and conserve the result of our work after life. "Let us fall into the dark thinking that there is a tomorrow."

Chagall makes a grimace of disgust as if to push something off. He huddles closer to me as if to ask protection. He makes himself tiny tiny and whispers: *"Moi, je ne suis pas encore né."* ["Me, I have not been born yet."] And he begins to observe my nine-year-old grandson, precocious and full of common sense like children today. He explains: *"Votre petit fils est plus vieux que moi, il est né depuis neuf ans."* [Your little grandson is older than I. He was born nine years ago.] But he fears instantly that he's said something insincere. He looks at me anxiously, as if to ask me what I think of what he has said: *"Peut-être—il y a un peu de complaisance dans ce que j'ai dit, ne*

trouvez-vous pas?" ["Perhaps there's a bit of complaisance in what I've said, don't you think?"]

He seems to be seeking absolution. And I grant it to him, plenary, saying that yes, there was complaisance in what he had affirmed, but that the thing had been thought with sincerity. And that, after all, the age of reason is rather a moral age: one renders to good taste what as children was attributed to God. But what by now was a long way from having reached it. . . .

"Bravo, bravo, mon petit!"

"And now, dear friend," I conclude gesturing to the great space of greenery around us, "enough of serious and useless talk. Let us . . . think of our precious health and walk in the garden. . . ."

Chagall squints one eye and enthusiastically takes my hand, lively as a schoolboy on vacation.

An extraordinary account. All the more extraordinary if we contrast it with Bernard Berenson's impressions of the Chagalls published in his last diaries, *Sunset and Twilight:*

> *December 1, 1956, I Tatti* *
> Marc Chagall comes from Vitebsk but has nothing Jewish about him in looks, in manner, in any peculiarities. Yet he paints almost nothing but ghetto life—and in a semi-naïf, rather childish fashion, does it with enough feeling to "put it over." His wife looks as little Jewish as he, only she is dark, slight and with a sari and a wart on her forehead would pass muster as a high-class Hindu. Whence these curious types appearing in Jewry? The Hindu I cannot trace at all. The Egyptian-like Doro Levi or Anna Maria Cicogna † with their skulls so overdeveloped behind the ears, must go back to the far, faraway days, when Israel was in Egypt. In my own face and features I trace a Germanic something, not infrequent among Central and Eastern European Jews. To go back to Chagall, I enjoyed his simplicity, his candor. He, though a famous painter, seemed in no way inclined to talk about himself, no touch of the average painter's self-adulation and fathomless conceit.

* Dated incorrectly as 1954 in Berenson.
† Doro Levi—Italian archeologist, director of the Italian School of Archeology in Athens. Countess Anna Maria Cicogna—younger daughter of Italian financier Giuseppe Volpi.

These two journal entries—Sanminiatelli's and BB's—reveal the extraordinary reaches of the art of noncommunication. Chagall, all atremble, inarticulate in the presence of the erudite Bernard Berenson, who meanwhile is speculating about Jewish skulls, and how little Jewish Marc and Vava seemed!

Essentially it was a meeting between Mishnagid and Chassid: head and heart. Berenson's incredible snobbishness is revealed by all these divagations about the Chagalls' non-Jewish appearance: Vava so Hindu and Marc so Nordicly blue-eyed. We don't know in which language the two men communicated—probably French—but they might very well have spoken to each other in Yiddish, which was the household language of Berenson's first ten years in Lithuania.

For the world-famous Epicurean, aesthetician, connoisseur, host to kings and presidents of the United States, was born and spent the first decade of his life in Butremanz, twelve miles from Vilna, the Holy City of the Talmudists, His next thirteen years in America are the crucible in which a Lithuanian Jewish immigrant boy of ten is transformed into a Boston aristocrat.

Undoubtedly Marc would have been less awed had he known that the Sage of Settignano had worn his ritual locks until the age of twenty-two. At least he didn't find Marc "stuck up" but properly humble.

BB didn't realize that Marc Chagall is an expert at being humble.

*

The past two decades have been marked by a quest for new media and forms: ceramics, stained glass, mosaics, tapestries, cycles or sequences, and, much less significantly, sculpture. (The latter of course, as well as the mosaics and tapestries, are not executed by his own hand.)

With the enlargement of his fame has come the enlargement of the scale of his work. His old yearning for a "wall," a larger space in which to spread his wings, has certainly been fulfilled. Now we must take account of the Monumental Chagall. Enlargement of scale of course does not necessarily result in or from enlargement of concept. In some cases, for example the Metropolitan Opera murals, the size is

much too big for the idea: here aggrandizement cruelly serves to magnify the pettiness of the pictorial concept—because it is so big we see how small it really is.

But with the inevitable repetitiveness of so inexhaustible a cornucopia (Chagall's total production is probably equal to or greater than Picasso's), with the great mass of what might be called digital painting: automatic gestures of the trained hand, the crystallization of a stock set of images and the occasional overblowing of concept—with all the expected falling-off of creative power there have been astonishing renewals and achievements even in this artist's seventies and eighties.

Most especially in the field of stained glass. Certainly Marc Chagall must be accounted the greatest living master of stained glass. His first essay in this field dates from 1957 when Chagall finally executed various decorations for the baptistry of Notre Dame at Assy about which he had had some religious qualms seven years earlier.

Among these decorations were two stained glass windows, some marble sculptures in the Egyptian style of flattish reliefs incised in planes and a ceramic panel. "But," Virginia Leirens recalls, "the little chapel was never given to him. He was irritated about this and his feelings for Vence, 'ville de Matisse' grew more and more strained. (It peeved him when people addressed letters to him to 'Les Collines, Avenue Henri Matisse,' when 'Vence' was sufficient!) Some years after I left, a big building went up behind his house and that was the last straw, so he moved to St. Paul."

Actually this occurred in 1966, fourteen years after Virginia's departure. And when in 1969 the Foundation of the Biblical Message was inaugurated in Nice, Virginia was still able to rejoice ". . . that the idea Père Couturier had so disapproved of [that is, a truly ecumenical church, a dissolution of all religious creeds in "an all-embracing mysticism which each individual would interpret according to his own need"] had been carried out" in the Musée National Message Biblique Marc Chagall.

Two years after his first somewhat timid start at Assy (1957), where the windows are practically monochromatic, simple but subtle tones of yellow, Chagall created his first windows in Metz Cathedral (this was the beginning of his long collaboration with the master glassmakers Charles and Brigitte Marq of the famous Simon atelier in Reims, who have worked with Chagall on all his stained glass windows since then). In 1959 Marc Chagall was seventy-one years

old. At the age of seventy-three, in 1960-61, he created the magnificent stained glass for the Synagogue of the Hadassah-Hebrew University Medical Center just outside Jerusalem. In 1963-64, in his seventy-fifth year, he created the windows for the north ambulatory of Metz Cathedral. And that same year also he commenced the windows for the United Nations and for the Church of Pocantico Hills in Tarrytown, New York. In 1968 (he is now past eighty) another window for Metz. In September 1970, at the age of eighty-three, came the consecration of his windows in the choir of the Fraumünster, in Zurich. Two years later windows for a church in Tudeley, England. And finally, culmination of a dream of seventeen years, on June 14, 1974, the consecration of his windows in the apse of the Cathedral of Reims, burial place of France's kings, the national church of his adopted country. Marc Chagall was eighty-seven years old.

He has traveled very far indeed from his *stetl.*

If to this astonishing production we add the other monumental works created in the past quarter of a century—the exquisitely powerful tapestries and mosaics for the Knesset in Jerusalem, the dramatic if incongruous Vitebskian color wheel (reminiscent of Delaunay?) on the ceiling of the Paris Opéra, the murals in the Metropolitan Opera House in Lincoln Center, wall decorations in Tokyo and Tel Aviv, the Biblical Museum in Nice, with its cycle of large canvases, the mosaics in Chicago—the sheer quantitative achievement is staggering. And inasmuch as many of these works— the stained glass at Reims, the Paris Opéra ceiling, the Museum at Nice—are gifts of the artist, one can only surmise that the spur of fame has prodded Marc Chagall to leap free of Vitebsk . . . by carrying Vitebsk into the most incongruous settings.

The religious qualms which Virginia recalls at the time when Chagall was debating with himself whether to accept work in churches or not are revealed more dramatically in an article by the Yiddish poet Abraham Sutzkever published in *Di Goldene Keyt* in 1973.

Sutzkever recalls his first visit to Les Collines in 1950.

On one of our walks together in Vence we saw an old man in a straw hat sitting motionlessly as a model, clutching the balcony with waxen emaciated hands. That was Henri Matisse.

Chagall spoke of Matisse as of someone annointed. He showed me the chapel which Matisse had decorated and said that the city of Vence was offering him the *kovet* of doing a chapel.

What did I think about that? He wanted to know my feeling.

I told him that the idea was not to my liking . . . *die sach iss mir nit tsum hartsen!*

As for his argument that frescoes and wall painting in chapels would last for hundreds of years, that did not change my feeling that the work of so Jewish a painter as Chagall could not feel at home in a chapel.

Chagall told me that he had written about this to Dr. Chaim Weizmann then President of Israel. "And what did Weizmann answer?" I asked him eagerly.

Chagall replied as if he were letting me in on a secret.

"He answered, and indeed in Yiddish: 'I leave it to your own good taste.' "

Later I learned in Paris that Chagall had asked the Chief Rabbi of France for advice. The Chief Rabbi, far more bluntly, had told Chagall very simply: "It all depends on whether or not you believe in it."

That a Jew makes images for a Christian church is no more to be marveled at than that an atheist such as Perugino was purported to have been should have made the most pious pictures of Christian art. The artist's personal belief or lack of it matters less than his power of persuading you to believe. Thus one need not even share—one might even be rigorously contrary to—a given doctrine or faith or ideology, yet the great artist will convince us, *while we are experiencing his work*, of the truth of his world in which we are immersed. When I read *The Odyssey* I am a Greek polytheist; when I read Dante I am a Christian. Outside of those worlds I am neither. Art deals with experiential persuasion not take-home belief.

The misogynist Degas celebrated the female form. The "Jewish" artist Marc Chagall makes images of Christian churches. No one need complain. The problem arises only because Chagall is given to uttering various pronunciamentos tailored to his audience. For years he has been proclaiming that his only religion is love, that he is a universal artist, that he attends neither synagogue nor church, that his work is his prayer, etc., etc.

But another Chagall emerges from the extensive twenty-five years of correspondence with Sutzkever. Here he is a Jew and very much of a Jew though nonconforming and nonpracticing. Here one gathers the image of a Chagall who all his life has been living in a fortress surrounded by enemies. Occasionally he makes sorties out of his refuge to be honored (to his own amazement) by these very enemies, honored to the skies. He doesn't seek these honors. The Gentiles press him; they give him no rest; they want him to make windows for their churches.

The truth of the matter of course is that Chagall like many other great artists (Picasso is another) is a very canny businessman, aware always of the market for his work, and perfectly legitimately seeking to realize the maximum financial return for his efforts. Again there is nothing to be condemned in this: his compromises end in the contractual realm: in his work he is totally uncompromising, strictly attached to his own values, and these are frequently nonmarket values.

Even in those periods when the dominant (and most profitable) schools of painting were various brands of abstract or nonobjective art, Chagall stuck to his last, continuing to pour forth only those very images his subconscious demanded. He did what he had to do. *"Ich kann nisht anders* (I can't do otherwise)," as he told his friend in an unconscious echo of Lutheran stubbornness.

The publication of selections of twenty-five years of correspondence between Marc Chagall and Abraham Sutzkever together with the Yiddish poet's memoir of his continuing friendship with the artist, permits us to see another facet of that complex figure: Chagall the Jewish nationalist, the lover of Israel, the ever-faithful son of his people.

The two men had met for the first time in August 1935 at the Vilna Wissenshaftishe Institut where Marc Chagall had been invited to lecture. Bella accompanied him. To the then young Sutzkever the artist was already a legend. He heard him make a speech in "a pure Litvak [Latvian] Yiddish, fresh and colorful as rain and rainbow together. His hair was golden white like summer flax. His eyes had the twinkle of his paintings and he seemed his own angel with the palette."

At that meeting in Vilna Chagall said that Yiddish writers lack an

interest in plastic art. If Jews could have created the world of the Bible, that world of poets, they should also be able to create a great plastic art.

That summer afternoon their friendship was born. Sutzkever met with Chagall at the dacha of a literary friend and in the library together with Simon Dubnov, the great historian of Polish and Russian Jewry. He followed the artist to the big synagogue where he was sketching the interior. Vilna appealed to Chagall; it reminded him of his Vitebsk three hundred kilometers away, which he hadn't seen for thirteen years: the same *stetl* characters, the same gardens and cedars overhanging old mud walls. He left a laughing self-portrait as a gift to the Institute.

In September 1947, having miraculously survived the war and the Holocaust, Sutzkever emigrated to what was to become the following year the State of Israel—*Eretz Israel* as he always called it: the Land of Israel. There he read in a magazine that Marc Chagall had returned to Paris from America. Through a French friend Sutzkever learned that Chagall admired his poems very much (some had been published in New York); this gave him courage to write the artist "in a familiar warm tone to ask him to send a contribution (either with pen or brush) to the first issue of *Di Goldene Keyt*. Marc Chagall sent both. In the envelope was a poem in Russian with only the title written in Yiddish—*My Land*—together with a reproduction of one of Chagall's paintings entitled *Hatikva*—Hope." Included was Chagall's first letter (from Orgeval, September 1948, written in Yiddish as was all the subsequent correspondence between these two men) in which the artist states that he "cannot find" his Yiddish and asks the poet to rework the poem for him, saying that his Yiddish was not literary, that he had "learned it from my Mama" and "I'm not as well-provided with a word-baggage as you." Sutzkever "swallowed the compliment" but found in redoing the poem that his "word-baggage" was a defect rather than an advantage. "It lacked Chagall's airiness." He wrote to him about this and Chagall apparently "found" his Yiddish for he rewrote the poem. This was published in the second issue of *Di Goldene Keyt,* the first of many contributions—poems, sketches—by the artist over the next quarter of a century.

So, after their return to France, as Virginia busied herself with house and children and reorganizing Chagall's drawings, after a day

of painting he would write letters in colorful Yiddish to his friend
Abraham Sutzkever in the new State of Israel. Thus he entered into
a world—the world of Yiddishkeit—from which Virginia was perforce
excluded and not by linguistic gates alone. How could Marc share
with his young Gentile companion, beloved though she was to him, a
world, a set of values he had lived through with Bella?

But this he could—and did—share with Sutzkever. The friendship
between the two men, and the memoir and correspondence published
in 1973 reveal another Chagall than the public figure with his endless
talk of *chimie* and *amour.* Here the expressions of love sound genuine
indeed, the commitment to his Jewish tradition deeply felt, the
generosity overwhelming. Sutzkever was to acquire a house full of
Chagall drawings and watercolors, and his books were illustrated
gratis by the famous artist.

By the early fifties the correspondence had become more intensive.
Every letter from Chagall brought "a laughing self-portrait. These
letters are like his drawings. They are not letters which one reads
once and puts away in a box. They are laughing dancing letters like
the calling of birds in the forest telling each other stories that no one
is supposed to hear."

Sutzkever cites some examples of Chagall's epistolary style: "Now
I imagine that even when I go back I go forward . . . a wind broken
into shattered thunder. . . . Only that land is mine which is found in
my soul. . . ." Chagall is a poet always, whether he paints or writes
letters. And Virginia's notion that Chagall intuited through the pores
rather than read like ordinary folk is in sharp contrast to the figure of
these letters: a very literary Chagall who read every issue of *Di
Goldene Keyt* from cover to cover for twenty-five years and almost
never failed to write his appreciation to the editor Sutzkever.

In 1950 Sutzkever paid his first visit to Chagall in Vence. Since
then he has been to the artist's place either in Paris or in Vence or in
St. Paul at least once a year. "Such meetings make more sense out of
life."

Of this first visit, the poet has written a vivid account of which I
have already cited a section. "The artist met me in the garden of Les
Collines. From afar the house looked like raw linen stretched for a
painting. But to me the place was Marc Chagall. He embraced me."
Thus began one of the most beautiful weeks of the poet's life. Most
of the time Chagall was the original of the laughing self-portrait.

"But when I told him of the terrible things that had happened in the ghetto, the original of the laughing self-portrait not only ceased to laugh: his smile became covered with ashes."

Sutzkever saw at this time the stupendous painting *The Dead Man* of 1908. The six candles suggested to the poet a foreshadowing of the six million Jews who died nearly forty years later.

"I asked Chagall what was his intention in lighting six candles. His face turned silver gray as if within him a dark bird were trembling.

" 'That is how the picture came to me,' murmured Chagall."

After the walk in which they had seen Matisse and visited his chapel, it was manifest to the poet that Chagall was eager to show that he could do as well as Matisse. Sutzkever wanted to know wherein lay his neighbor's greatness. Chagall replied excitedly: "Not his *fauvism*. That was over after 1910 when I came to Paris the first time. It's his line. His line is the most delicate of any painter in France."

Chagall liked Matisse personally. They had exchanged pictures and Matisse had sketched Chagall's daughter Ida [now in the Israel Museum in Jerusalem]. He still admires Matisse.

In 1972 in St. Paul I saw hanging on his wall a drawing by Matisse and again we visited the black-and-white chapel. Once more I asked Chagall: "Where's the genius in all this?" And Chagall again trembled with the same joyful excitement of twenty-two years back: "What are you saying? It's Matisse!"

The next day we went to Antibes, a town where Picasso had decorated a wall as well as a chapel (sic) which became a Picasso museum. I noted how Chagall observed with close attention and cocked eye Picasso's work as he looks at art works and people who interest him. Again I asked: "What's so great about Picasso?" Chagall answered clearly and decisively:

"Picasso, this is a Gentile who can do anything. *Picasso, dos iss a Goy voss als kenner.*" Another time he gave another twirl to his humor, a sign that he really meant it: "The difference between me and Picasso is like that between my father and his father."

The same period in 1950 I had occasion to walk through various museums in Paris with Chagall. In the Museum of Modern Art Chagall admired the rose-and-orange flecked fire

of Bonnard. He prodded me full of artistic pleasure. "See Bonnard's colors! They are as pure as if you took them from the earth. One can't imagine earth colors to be any other way."

On the third day Chagall brought me to his studio where there stood all around the walls oils and gouaches for the Maeght Gallery show in Paris, illustrations for a *Thousand and One Nights*, Boccaccio's *Decameron*. [Also illustrations for Sutzkever's poems.] "I tried my hand at art criticism." Chagall shook his head. "Truly my pictures are my biography. I paint with the brush instead of with my mouth. In my paintings there is all the poverty of my childhood." He quoted Delacroix: Painting must be a holiday of colors.

Then he smiled a question: "Which pictures do you like? I want to know if you're a *maven* (expert)." I turned back to the entrance and looked at the first three. The first three I felt were purer Chagall than any of the others. Chagall measured them several times with his genius eyes twinkling and cocked. "Really?" he said. "Really."

When later I came to Paris to the Maeght Gallery on the rue de Teheran I didn't find any of the three pictures I had selected.

To leave this enchanted atelier full of Chagall's "picture-biography" was a wrench. Sutzkever was also aware of the Valérian vibrations in the house; Valéry was a poet whom he greatly admired. But he shrewdly realized that the dead poet who had occupied these premises could never influence the quick artist who now lived there. "Valéry is a hermetic poet, an intellectual. Chagall is a winged spirit." Chagall's pictures are full of secrets which he himself doesn't understand. Valéry writes: *I set myself a secret which it is not possible to plumb.* Chagall would have written: *I set myself a secret to discover the color of the spirit. . . .*

When I left, Chagall gave me a little gift: a self-portrait under the palm trees of his garden with blue flecks of stars. He held me under the arm and good-brotheredly whispered in my ear: "Such a sketch with such a technique I've never done for any Yiddish writer, not even for the French poet Eluard. Why I did this you know yourself and I don't have to explain my

love. If you ever need money, an evil which sometimes happens
in life (and he burst out laughing), sell the picture and have
yourself a good time!"

In April 1950 Chagall went to Paris especially to speak about
Sutzkever at the meeting of the Yiddish Literary and Journalism
Society and Vilna Circle in France. The speech was fervent with
expressions of the artist's esteem—both personal and literary—for the
poet and redounds with phrases like ". . . our old Jewish soul" and
"leaping over the high ghetto walls."

In 1962 when we were sitting with the artist in Tel Aviv
with the then mayor of the city, Mordechai Namir, Chagall was
downcast. He had just come from Jerusalem where his
Hadassah windows were installed in a corset. The Chagallian
smile, like a diamond with a lot of facets, was darkened. I tried
to cheer him up. Finally I said: "The building is not the main
thing so long as the windows are there. Some day you can
change them." Chagall's humor changed to great sarcasm: "It's
easy for you to say this. Just imagine that you had written a
poem which you considered the best and most beautiful of your
poems. Suddenly you find it published in a police journal!"
 When the cloud became a cloudiness and then only a misty
sun, he changed the subject. Artists come to him and bring
pictures for his judgments. Chagall says: "I can't tell you what
is a picture and what is not!" He always comes back to his birth
in Vitebsk and the fire. "From that time on," says Chagall, "I
am hiding myself . . . you ask from whom? From painters, from
critics, from the evil eye, from my own shadow. That's why I
would like to live and work in Israel. Here I will have no fear
of anyone. Here I won't have to hide. . . ."

The letters too abound in expressions of this sort. From Orgeval
on June 14, 1949 he writes that he is involved "up to the throat" in
illustrating Gogol, La Fontaine and Boccaccio but it would be "an
honor to be involved with your journal." He sends his friend Bella's
two books. "She was the muse . . . of Jewish art. . . . Were it not for
her my paintings would not have been as they were. Read her heroic
words. Simple and realistic like pearls, the pearls in her father's
shop." The following month: ". . . you are near to me. Your poems

are pictures. . . . You write that you are sick of beauty. I understand you. . . . But you are in such a Jewish atmosphere and our troubles have given you the deepest passport which other poets must struggle to achieve. . . ."

He tells Sutzkever that he might come to Israel since the Museum is considering setting up a big show there. "But giving blows today is more necessary" (a reference to the Independence War).

In August he reads Sutzkever's poem *Siberia* "and I am not cold." The following year from Vence now, July 25, 1950, he writes that he is tied hand and foot with work and would be happier if he had time to *shmoose* a bit with Sutzkever. "After all, Vence is a *Goyish* town filled with *paskudnicke* robbers. . . . One longs for Jews. All I can do is take the Bible in hand or make Jewish pictures to calm myself." He has not yet received the invitation from the Government of Israel but realizes that they have other worries. "What do they need me for as a guest? Me the weak pale quiet Jew. Read *My Life* again. How happy I would be to know how to creep about quietly and unnoticed among the folk. And the older one gets, the more one is drawn to the source. I am envious of you . . . you are in the Land. . . ."

On September 13, 1950 from Vence at another time of troubles for the young Jewish state, Chagall expresses his hopes that ". . . they shall allow us to live and create. . . . Unfortunately there are many of the non-circumcised who want to sink one another and in spite of the fact that I paint a typical Jew, in a concrete way I can do nothing." (One thinks of Auden's "Poetry makes nothing happen.")

But the artist believes in the skill of *"unser Land,"* our land, to traverse all obstacles. He has received the desired invitation from Minister Shazar, but it was written in Hebrew, so that he had to have it translated that the "Goy" (himself) might understand it. He hopes to come with his daughter who is his right arm. He praises (as always) the most recent issue of Sutzkever's magazine and then remarks that "in true painting there is also a literary content, but this is seldom reversed." He learns that someone in Tel Aviv is putting out an album on Chagall. "I am very hurt. It would be much better first to ask me or Ida about what and how to look at my work. . . ."

In October 1950, from Vence: He is planning a week in Italy in connection with a show in Bergamo. "With every trip I shake more with age (!). I want to continue to work . . . so long as I can make something big, the years are held off." Again he is concerned about

Israel and the condition of the Jews. They should settle the war quickly because "the Goyim are not leaving me at peace and are printing stories that I am making frescoes for their walls."

Vence, February 1951 . . . "What do you think of my pictures which are called Crucifixions but mean only our Jewish martyrdom? Would it be right to show these in Israel with other works? Or maybe not? I don't want to veil or conceal how our fathers and mothers truly were. I am also that way in my art. I hope so. But I wonder what the Rabbis will say. . . ."

After the 1951 trip to Israel (with Virginia, unmentioned in any of the letters) Chagall writes to his friend in March 1952 that he had never received official thanks from the Museum for the gift of his painting, *Jew with Dreaming Cow,* which he had presented. In August, he wishes he were back in the Holy Land so that he might be able to chat *viva voce* with his friend. He remembers that in Israel he had been "extraordinarily happy." Bella's books will soon appear and he hopes that on the anniversary of her death Sutzkever would mention ". . . in your, our, Yiddish journal" his "holy bride who lies beneath the soil of America."

So the letters continue through the fifties, with numerous references to *"unser Land,"* preoccupations about the political situation there, and a steady rain of praise for Sutzkever's poems and other publications in *Di Goldene Keyt.* In May 1961, he has received Sutzkever's *Siberia,* the cover of which he illustrated. He is pleased with the "beautiful publication" and this recalls the troubles he had had in the past with the "anglicized Jews" (a reference to Americans) who had wanted to add various blue *patchkerai* (messing up) to his illustrations for the Peretz and Niser poems. "But with the Jews I feel I never have any luck."

"You have no right to be unwell," he adds lovingly to Sutzkever. "Be happy though you are by nature pessimistic. Be a bit like me: clownish, childish, light-headed. Your journal lives. And the Soviet Yiddish writers have entered into the State of Eden. The best land is not Vitebsk but Tel Aviv with all her limitations."

On September 12, 1963, he thanks the poet for his gift of an anniversary volume, *Poems for My Fiftieth Year,* and tells him that it is his great good fortune to be living in "our land."

In 1964 from Vence: "I am working hard. I am traveling to Paris for the ceiling of the Opéra and perhaps to America for the U.N.

windows. No time. Perhaps you will hear what is happening to me and to my works. The world is full of enemies and a few friends also."

In June 1967, the Six-Day War aroused Chagall to prophetic fervor:

> I would like to be younger, leave my pictures and go to be together with you, bestow upon my last years the sweet pleasure of living amongst people loving as my colors. ... I have steadfastly believed that without a manly and Biblical feeling in the heart, life has no value. If the Semitic folk have survived in the difficult struggle for a bit of bread ... [it has been due to] ... our burning national ideals on our national earth. They [the Jews] want to show that they are like other folk. The anti-Semites seek to attack us as once had done the Pharoahs. But we passed through the sea of the ghettos and our victory was eternalized in the Haggadah. We stand before the world as an example of manly soul. Will the wind carry away all our ideals, our courage, our culture of twelve thousand years? History again places the task into our hands—easy or difficult. Let the world tremble when they hear our call for righteousness. Thousands upon thousands of people everywhere are with you. Only those without a land are with our enemies.
>
> Perhaps I am in my dotage. But I want to bless you instead of weeping and trembling. I would like to hope that the land of the great French Revolution, the land of Zola, Balzac, Watteau, Cézanne, Baudelaire, Claudel, Péguy will soon speak out to staunch this world shame. I hope that America with its democracy, [England] the land of Shakespeare and also [Russia] the land of Dostoevsky, Moussorsky, my native land, will begin to shout so that the world would have to put an end to this mania and give the people of Israel a possibility to live freely on their own land. ... No one will any longer be able to breathe when people permit their awareness to fall asleep. The last token of talent will awaken and their words will be left without a resonance. To allow Israel and the Jews to be suffocated is to destroy the soul of the entire Biblical world. No new religion can survive without that precise drop of heart's blood and we will see if we are worth to live any longer or to be disintegrated

by the atomic bomb. My anguish is in my eyes which you
cannot see and my hopes are locked in my windows of the
twelve tribes which now lie hidden among you in Israel.

From St.-Paul-de-Vence on September 26, 1967: On a recent trip
to Switzerland with Madame Valentina ". . . more than once I
thought to myself: if only I could run off to my small but deeply-
loved Land [Israel] to live out my years near you and breathe the air
of real people and push away the fiends who don't let us live."

In February 1968 he inquires anxiously about the situation in Israel
and philosophizes ". . . how unpleasant it is that idealism disappears
from people like the soul leaves the body." And a month later, on
March 25, he sends his book *Monotypes* and confesses that like
"many Jews throughout the world, I am unhappy about the troubles
in Israel and it is unpleasant and tragic to feel how few friends we
have in the world. Therefore we must be strong and not permit
anyone to crawl over our heads." He believes in the leaders and in
the youth. "You are lucky that you are all together. Breathe a bit for
me there also."

On March 26, 1969: ". . . Every day I read how thousands of Jews
everywhere think about Israel night and day. I can't pray. I can't ask
God. Let Him do something by Himself alone for your Jews in the
Land."

In June 1969, he hopes that Sutzkever will "prepare something
beautiful" for the magazine in celebration of the twenty-fifth anni-
versary of Bella's death. He is eager to come to Israel for the
inauguration of his Knesset tapestries which have just been shipped to
Israel with an accompanying technician. But he wants to wait a bit:
". . . at my age one must guard oneself like a bouquet of flowers: not
to shake it too much."

On October 12, 1969, with a comic burst of nostalgia, he writes:
"From my window in Paris I look out and see the Goyish gray light.
And I think of your air where my brothers, rich and poor, show the
world that they want to live like others in our Biblical land. My
God! . . . How beautiful were the days when I was in the Land.
Every day then in Tel Aviv was for me like those pictures which I
had not yet painted. Perhaps you will be in Paris where there is now
being prepared for the Goyim the great Vitebsk show in the Grand
Palais? Did you like my sketches for Bella's book? How young I was!

And I made those without spectacles! What do you think of her writing? The golden bride. Her breath shone like gold. She was all love, only love."

*

Strong, loving and witty, secure in his tradition, the Chagall of these letters is a most attractive figure whose vigorous declarations are oddly at variance with many of his public statements which abound in ambiguities and sentimental universalism.

Most contradictory is the reluctance expressed in the Sutzkever letters to "make walls for the Gentiles" who are "pressing" him, and the fact that he has made gifts of stained glass windows for Reims and Metz cathedrals, as well as executed works for the Fraumünster of Zurich, Notre Dame de Grâce at Plateau d'Assy, the Unitarian Church at Pocantico Hills, New York, and the Tudeley Church in Kent, in England. Furthermore, he has gratuitously included a Christ on the Cross in his gift of the Hammarskjöld Memorial Window at the United Nations headquarters at New York, despite the fact that UN policy is to avoid the inclusion of any obvious religious symbols in its decor. At this writing at any rate, the Hadassah Hospital synagogue is the only Jewish edifice possessing Chagallian stained glass; although he has made gifts of stupendous tapestries and mosaics to the Knesset in Jerusalem.

This disproportion of gifts and commissions has aroused rather bitter criticism in Jewish circles. "Perfectly understandable," S. L. Shneiderman, an astute Yiddish journalist, said bitterly to me. "Cathedrals are for eternity. Synagogues are for burning." Shneiderman has written a series of abrasively critical articles on Chagall for the *Jewish Daily Forward,* an extract of which, "The Crucifixion Theme in the Works of Marc Chagall," was published in English in *Midstream,* June-July 1977. In this article Shneiderman stresses that "the Jesus motifs Chagall introduced into the cathedrals show no association at all with Jewish martyrology. They are mere illustrations, as it were, of the story told in the Gospels."

The great triptych of windows at Reims are "the fulfillment of a dream Chagall, in his own words, had cherished for seventeen years." Indeed, Chagall's fascination with the Jesus theme, his

attraction to the Nazarene is expressed in *My Life* and his first important painting of the subject dates back to the *Golgotha* of 1912 now in the New York Museum of Modern Art, astonishingly prescient, in its chromatic splintering, of the stained glass to come. Shneiderman finds Jewish characteristics in the figures standing at the foot of the Cross as well as in Jesus "with twisted facial features bearing the marks of a martyred Jew." I should say rather that the mysterious blue child hanging in the air (there is almost no visible Cross) is too vague, too abstract to symbolize either a Crucified Christ (theologically) or a martyred Jew (historically).

Actually, Chagall had begun painting Christian religious themes based on Russian icons from the very beginning of his career. Even two years before the *Golgotha,* he had painted a *Holy Family* (1910). But here, again, his psychological feint against the "forbidden" imagery which so attracts him is to perform iconographical quick-change acts: the child in the *Holy Family* is bearded; the crucified Christ of the *Golgotha* is a child!

But there can be no question whatever about Chagall's intent in the series of crucifixions dating from the *White Crucifixion* of 1938. In this painting as in a number of others (the *Martyr* of 1940, the *Descent from the Cross* of 1941, the *Yellow Crucifixion* of 1943, etc.) the crucified figure wearing a tallith around his loins, and sometimes phylacteries on his forehead, the presence of Nazi brownshirts storming the Holy of Holies, Jews carrying the Torah, menorah candelabra at the foot of the Cross—all make the meaning unmistakable. All these pictures mean—and Chagall has said so explicitly—the martyrdom of the Jews under Hitler.

This generalized significance is personalized in some instances—a two-headed Chagall looking back at the wraith of Bella and forward at a painting of a Jewish Christ on the Cross, with Virginia below the Janus-faced artist *(The Soul of the Shtetl,* 1945). Another picture wherein the artist, palette in hand, stares up at a Byzantine-stiff tallith-draped Christ is oddly entitled *The Artist and His Model* (1959). I have already commented on the *Descent from the Cross* of 1941 where Chagall begins to inscribe his own name on the placard above the Christ. But in this case also, for all the personalization, the presence of a figure bearing a three-branched candelabrum, and the tallith draping the loins of the figure being lowered leave no room for doubt about the overall symbolism.

However, in works of the past quarter of a century—and not in the stained glass alone—the Crucifixion can hardly be said to stand explicitly for the martyrdom of the Jews. All specific characterizing props have disappeared from the figure: no prayer shawl, no phylacteries, the facial expression of the Crucified vague, generalized, impersonal. At Reims, in Zurich, at the UN the central symbol of Christianity has become dehistoricized so to speak, abstracted of temporal content: nor is the Cross surrounded by the clear allusions of menorahs, Torahs, shofar horns, etc., although the familiar Chagallian bestiary remains. In other words, the pictorial vocabulary has become generalized, or as Chagall would like to put it, "more universal." If it remains unmistakably Chagallian, it has become equally unmistakably drained of any specific Jewish content.

Throughout the Middle Ages and Renaissance of course the Old Testament was read as a foreshadowing of the New, and *ante legem post legem* parallelisms between Jewish prophecies and episodes and the Gospels are found in all the great Gothic cathedrals as well as in the Sistine Chapel. Such anticipatory reading of the Bible of course has never been accepted by the Jews, who have never accepted the messiahship of Jesus. That Chagall considers Jesus one of the great Jewish prophets (as he has declared on many occasions, and as his son David testified to me) is perfectly coherent with history and a certain kind of liberal Jewish faith. But when he places a Crucifixion in the background of his *Jacob's Ladder* or *Creation of Man,* at Nice, he is *nolente volente* inviting the spectator to read his iconography as Christian fulfillment of Jewish foreshadowing.

I don't agree with Shneiderman that Marc Chagall be held responsible for the fact that the Cathedral of Reims, for example, contains the usual allegorical female statues of the Synagogue Defeated and the Church Triumphant—the former blindfolded, and holding the tablets of the law reversed in its left hand, the crown falling off its head; or that the same church contains a huge bas-relief of a group of Jews bound in chains being led to the stake. Surely Chagall cannot be held responsible for, or be expected to know all the iconography contained in a historic French cathedral, nor need he insist on a certificate of purification before permitting his work to be shown there. Furthermore, historically, artists are not always expert with—and hence not always even the creators of—the iconography they depict. The eminent French art historian Emile Mâle points out

that allegorical interpretation of the Old Testament was so subtle that all iconography was directed by the clerics: the artist was simply an artisan who executed orders. Who but a theologian would know that the ass which bears the implements for Abraham's sacrifice "is the blind and undiscerning Synagogue"? Or that ". . . the wood that Isaac bears on his shoulder is the very Cross itself"?

Of course this thirteeth-century close-focused allegorizing resulting in appropriate imagery invented and controlled by the Church and only executed by the artist no longer obtains today when the artist is a free entrepreneur, a free inventor, restricted only by his own conscience. Chagall, it seems to me, has acted in these cases—as perhaps in his personal relations—according to a theory of expectations. The fervent Jew of the Sutzkever letters is the apostle of universal religion when it is a question of works in exalted locales.

Although Chagall therefore may be perfectly sincere in his intentions to provide "universal" symbols, he is incredibly naïve if he thinks that the Church will not exploit his "universal" symbols for its own parochial purposes. Already in his first church commission for the baptistry at Assy in Savoy we see this psychology at work.

In the catalogue to the many modern art works at Notre Dame de Toute Grace (which the enterprising Père Couturier commissioned from Bonnard, Matisse, Braque, Rouault, Bazaine, Richier, Léger, etc.) we read in a description of Chagall's ceramic tile mural (mistakenly called "mosaic") of Moses leading his people through the Red Sea:

> Chagall qui, en dépit de sa qualité d'Israélite, possède un sens liturgique aigu, n'a pas omis de faire figurer, dans un coin de tableau, la scène du Calvaire, baptême de sang du Seigneur, dont la passage de la Mer Rouge est la préfiguration. Toute la misère humaine afflue au pied de la Croix, comme une vague contre la grève tandis que s'écoule le temps du monde. Devinons aussi, avec un petit sourire ému, cette double silhouette qui semble flotter a l'écart de la scène principale: les deux êtres qu'on y voit représentent Chagall lui-même et sa femme étroitement enlacés.

> Chagall who, despite the fact that he is a Jew, *possesses a keen liturgical sense,* has not failed to depict in a corner of the work,

the scene from Calvary, baptism in blood of the Lord, *of which the passage of the Red Sea is a prefiguration.* All human misery gathers at the foot of the Cross, like a wave against the strand, whilst the world flows on in time. Let us observe also, with a touching little smile, that double silhouette that would seem to represent Chagall himself and his wife tightly interlaced. (italics mine—SA)

Yet at the bottom of the work, which Chagall made as a gift, "to emphasize [in Meyer's words] his refusal of any denominational commitment," he put the inscription: *"Au nom de la Liberté" de toutes les religions* (In the name of the freedom of all religions).

This inscription is not mentioned in the catalogue.

One is tempted to say to the artist: Observe the use that has been made of your "universal" imagery. Is Chagall so innocent that he does not realize that placing the Crucifixion in the background of a Passage of the Red Sea, in a work furthermore destined to be situated in a church, makes inevitable the reading we have cited?

As for the tolerant smile with which the theologian views the levitating lovers, perhaps it is Chagall who is smiling?

But of course the same church contains (in addition to stained glass by the devout Catholic Georges Rouault) a mosaic medallion of the Virgin by Fernand Léger, who also did, along the colonnade of the Porch, simplified designs of flowers, stars, and a chalice on which is written *Rose Mystique, Vase d'Honneur, Etoile du Matin*—a rather extraordinary example of cultural availability when one considers that Léger was a card-carrying member of the French Communist Party!

Among important contemporary artists whom Couturier induced to contribute was the sculptor Jacques Lipchitz, who created a bronze in which from the beak of the Dove descend three flaps of starry sky in the form of a reversed heart from which the Virgin emerges, her arms outstretched to the world, all borne by angels in full flight.

On the back of the work the artist inscribed the following:

Jacob Lipchitz, juif fidèle a la foi de ses ancêtres, a fait cette Vierge pour la bonne entente des hommes sur la terre afin que l'Esprit règne.

Jacob Lipchitz, a Jew faithful to the faith of his ancestors, made this Virgin for the good understanding of mankind upon the earth so long as the Spirit reigns.

Comments M. A. Couturier: "*Il règne déjà sur ce chef-d'oeuvre. Nous en avons la certitude.*" "It already reigns in this masterpiece. We are sure of it."

Madame Lipchitz, the artist's widow, told me that her husband had been an observing Jew for the final decades of his life, especially after his recovery from serious illness; and he was concerned that the collocation of his work in a Catholic church not be misunderstood.

The Chagallian sculptures at Assy—flattish Egyptian-like reliefs incised in planes, splendid interweavings of beast-man symbiosis with donkeys, hands, and fish in complicated but richly successful designs—contain quotations from the Psalms. His two stained glass windows—his first effort in this magic realm of light and color in which he has been soaring like one of his own angels ever since—are, according to the catalogue, "destined to materialize the rites and symbols of baptism."

Essential judgment of a work of religious art should be free of denominational and credal commitments. But artistic "meaning," the significances set into vibration by the art work, are never pure forms, aesthetic distillations, any more than they are abstractable iconography: the "literature" here given plastic form. We react to an art work totally; we are affected by all sorts of information, feelings, irrelevant to strictly artistic considerations. And among these irrelevant relevancies is the collocation of a work. Not only *what* we are seeing, but *where* are we seeing it?

What Chagall apparently does not realize is that an Abraham in a cathedral is not the Jewish Abraham but the figure of Christ *ante legem*: a forerunner, a hearkener of Jesus of Nazareth.

Were the Hadassah windows situated in Chartres or Notre Dame, the Twelve Tribes of Israel would become automatically at once the Twelve Disciples, Jonah's three days in the whale Christ's three days in limbo.

A cathedral is a mighty retort which alchemistically transforms everything within it. A cathedral is not a neutral place like a museum but a symbolic collocation of art works.

All his protestations of Jewishness have not prevented Marc Chagall (especially in the last two decades) from actively seeking to perpetuate his art, create a memory to himself in Christian cathedrals wherein his work has been and will continue to be interpreted according to tradition: the Old Testament as foretelling the New, which fulfills it and supplants it. I am certain that Marc Chagall does not read his Bible (and he is an assiduous reader of Holy Scripture) through those spectacles. He may convince himself that he is contributing toward a Universal Church. But Catholic is not always catholic: dogma does not permit coexistence of truth and, besides, the artist's truth is not the theologian's. Marc Chagall may protest that he is not responsible for what churchmen make of his windows, but he is responsible for placing his windows in edifices where they will inevitably be interpreted according to the churchmen.

Chagall's failure to take due account of the significance of the setting is perhaps merely another instance of this artist's total self-involvement. Similar criticism has been raised with regard to Chagall's *Firebird* and *Magic Flute* sets overwhelming all the other elements of the production. Nor in the case of his Hadassah windows did he realize—to his subsequent sorrow—the effect of the undistinguished architectural frame. In every case, we have Chagall so intent upon his own work that he seems unaware of the subtle variations in meaning (whether architectural or ideological) a setting inevitably plays upon the art work it contains.

*

Against the ever-widening fulfillments of his artistic destiny, Marc Chagall's private life contained, like all private lives, its moiety of unfulfillment, frustration, and unhappiness. All the smiles for visitors and photographers, all the official receptions and honors bestowed do not entirely expunge a certain sense of loss.

Within a few years after Virginia's departure, the illness of her new husband made it essential to send the son David off to private schools. So the boy's next five years or so were spent mostly in boarding schools in France, and visits to Chagall in the summers and on vacations. A photograph in Meyer's book shows David (who is never mentioned in the text and is otherwise unidentified in the

caption) in shorts and reading a book, his back to the scaffolding on which his father was at work on the mural *Commedia dell' Arte.*

In his early years, the boy used to spend summers with his father, and saw Ida quite frequently. Toward his half-sister, Ida, thirty years older than himself, David feels inevitably as toward an aunt who is "okay." "Okay" is one of David's key words; spoken in his charmingly French-accented English, it connotes a certain ironic acceptance.

Chagall wanted his son to become an architect but David showed little aptitude for studies, dropped out of school, and began playing with pick-up bands. Now married and with a child, David McNeil plays guitar in his own group, writes and sings poignant French folk lyrics somewhat in Bob Dylan style for his own compositions and has several records to his credit.

But apparently the idea of his son as a pop musician doesn't please Pop.* David doesn't see his father very often. On one of his last visits Chagall took his grandson, Dylan, into his studio but he did not invite David or his wife, Leslie, a dark attractive girl born in Casablanca of a Belgian father and a Moroccan Jewish mother.

In September 1975 the telephonist at my hotel in Paris called to say that a "M'sieu McNeil est ici." To my surprise, Chagall's son seemed at first glance a typical Californian: he is tall like his mother but has Marc's blue eyes in a somewhat more subdued version. Handsome, blondish, and gifted with a rather acerb wit, he expresses himself in colorful French-tinted English.

Our first meeting was in a poor and crowded little restaurant in the neighborhood where I ate the ubiquitous *pommes frites* washed down with a poisonous *vin ordinaire:* afterward we went to a bar for coffee and cognac and more talk. Later my wife and I visited David and his wife in their apartment in Montmartre.

All this while, smoking redolent Gauloises—"No, thank you, I prefer French cigarettes"—drinking wine or cognac, David reminisced at length about life with Father (whom he referred to either as "Chagall" or "Father").

Toward his mother (especially vis-à-vis the artist) David acts playfully protective, brotherly, proudly recalling the "ooh-la-las" she

* Ruefully David might reflect upon the fact that Domenico Modugno has ascribed a Chagall painting as the source of inspiration for the lyrics of his hit song "Volare . . . nel blu dipinto di blu . . ." "Flying . . . in the blue painted in blue . . ."

aroused from goggling Gauls when they went for promenades together in Paris or Brussels.

One gathered immediately that David loves and admires his father but has been terribly hurt by what he feels is a rejection.

Of his childhood in America, David remembers nothing. But he vividly recalls Vence and the contretemps of the Archbishop's visit. "Every year Maeght gave me a gift—a football, an etching by Miró. He's a very clever businessman." (On the walls of the apartment, otherwise sparsely furnished, there were colored lithographs by Miró, Chagall, Toulouse, some reproductions of drawings, and the beautiful blue poster of the Nice Musée Biblique which David says he had to buy.) The Chagall paintings left to him are kept in a vault. "I'd prefer not to sell them, although that's why they were left to me," he remarked rather acerbly. "I'd like to hang them on the walls—they're all personal things of me, Virginia, Jean—but I can't afford the insurance."

David said that he was a very difficult child, very active, "I tore up the place." He has warm touching memories of going for walks with Father. "He loves mathematics. He doesn't know very much about it but I knew even less. I was a perfect audience. He has a passion for mathematics. When we walked near the sea, he used to do drawings on flat stones for me.

"When I was thirteen, I wanted a Bar Mitzvah (the confirmation of Jewish youth). Somehow the idea was killed. Chagall is very religious. He reads the Bible all the time. Every night. He considers Christ one of the great Jewish prophets.

"When I was about fifteen I got fed up with boarding schools. I used to spend every summer at Les Collines [before La Colline, Chagall's present house]. We didn't get on too well—especially with Vava. I wanted to live with them when I was fifteen and they said that there was no room. No room in that big fuckin' house! And it wouldn't have worked out anyway. Father doesn't approve of my music and my films and my smoking and my drinking. He is against smoking and drinking and women."

"—Women? But he certainly likes women."

"—Oh yes [little shy smile] but *nice* women."

Again and again his admiration for his father illuminates the not infrequently melancholy hue of his reminiscences: "He's a master of repartée. 'Do you like Picasso?' someone asks him. 'I like him if he

likes me.' Marc and Vava get on well because they both have wit
and joust with each other."

Father speaks French very well. "Oh, he makes mistakes of course
but he does that *deliberately.*"

I spoke of Ida's charm. "Oh, that's nothing compared to Father!
His eyes! He can hypnotize anybody. *He's a magician!*"

He recalls going with Father to the Louvre every week. "We
went on Sundays. It was free then. No self-respecting Parisian would
go any other day. Father would stand in front of the Poussins for the
longest while. He was particularly interested then in Poussin—whom
he didn't like. But he felt he was the first great landscapist—if he left
out the figures. He didn't have the courage to leave it at that. Titian
of course was his great favorite—and Gauguin and Van Gogh.
Naturally I never looked at anything. I was only a kid and the waxed
floors of the Louvre were great for sliding.

"Father hates Delacroix. It's a technical thing. He points out that
the *chimie* of his painting is all wrong. It never dries. There is
something in the pigment like mercury which never dries. You have
to hang the picture upside down once in a while so it can settle. And
if you don't do that the pigment will flow down and off.

"Father is very conscious of painting techniques. He never studied.
He learned it all himself. He used only the very best tube pigments."

As for Chagall's working habits: "He's not like Picasso. When
Picasso paints or draws, you feel from the start that he knows just
what he's doing, what he's about to do. But Father seems lost. He
puts in a dab of color here, then there, it all seems so haphazard, he
doesn't seem to know what he's doing really. Then suddenly things
begin to appear. A kind of magic. Actually Father knows what he is
doing all the time.

"He reads everything about himself. He's a weak man, very
dominated by Vava. Very self-centered. Sure, he loves his grand-
children but still he seldom sees them. He's all wound up with his
own concerns.

"Yet he's a very generous man." (David hotly denies tales of
Chagall's alleged avariciousness). "He bought a farm next to his place
at Les Collines just to give it to the farmer who couldn't maintain the
place. He sends food and money and packages to his two surviving
sisters in Moscow. I helped make the packages myself. And I gather
they are quite well off. He is very generous to his family. When he

goes into a shop with Vava he wants her to buy buy buy—coats, dresses. He bought me gifts all the time. When he began to complain about what Virginia was spending on food, he wasn't rich. Then he finally said he would take over and cook the meals.

"He did—and it was *awful!*

"Vava and Maeght are in cahoots to keep Chagall working. I really don't believe he knows how much money he has. He's a *terrible* businessman. Every time he went into some enterprise, it was a *disaster.* He should know better. He's a Jew and his mother sold herrings. He should know how much herrings cost. But he *doesn't.* His dealers I am sure sell his works for fifty times what it cost them.

"And Father is perfectly right not to give to everyone who asks. Every year he used to contribute to some Jewish charity organization. Requests came from all over the world. He finally got sick of that. People came to see him just to get something out of him.

"Father is very Russian. I think he reads the Bible in Russian." (Undoubtedly a mistake on David's part. Perhaps he confuses Hebrew lettering for Cyrillic!) "He was very anti-Communist but now he has changed. He went back to Russia a few years ago even though he was very hesitant about it because of the destruction of Vitebsk during the war."

"Do you think his love of Vitebsk is genuine?"

"Oh yes! He talks about Vitebsk all the time. He really is homesick."

But with all the boy's love and admiration for Chagall, small events wedged them apart.

"Father is still very impressed by names. Important people. And everybody used to come: Pompidou. Malraux . . ." He remembers playing with Carl Sandburg as a kid. "I didn't give a hang about that. Virginia didn't either. But they did.

"He was always after me not to smoke, not to drink. All that. If I had a Jewish mother it would be different. But I'm British. I've got a British mother."

"But you've got a Jewish father."

"That doesn't matter. The important thing is to have a Jewish mother."

When he returned to Les Collines after a seven year absence, he found that the door to his father's house did not open easily.

"I call for an appointment. Finally, finally I get one of them.

'When can I come? *You* tell me. I have all the time. Now, tomorrow, next week, two weeks, 1987?. . . just tell me *when* . . .' "

Even Ida, according to David, sees her father very seldom, perhaps twice a year. "And even she doesn't stay at La Colline. She stays in a hotel!"

Ida's three children (by Meyer—"a square Swiss, he's okay") rarely see their celebrated grandfather. "It's like getting an appointment with *le Président de la République.* You have to make ten telephone calls. Even Ida's kids, me. Jean never sees him although he likes her very much. Now he's always after her to get married. She's in her mid-thirties and doesn't believe in marriage. Chagall doesn't understand that. He thinks a girl should get married."

Whenever David speaks of Chagall's knowledge, he is again the little son in the presence of the omniscient father. "He knows *everything!* I don't know how he does it but he knows all the latest novels, the plays, he reads the newspapers, he listens to broadcasts. He knows everything that is going on." (In contrast with Virginia's "He never reads. I never saw him read. He must learn things by osmosis. He is all intuitive.")

"Once when I was fifteen or so, Father saw me signing my name on the back of a letter. He asked: 'Why don't you sign *Chagall?*' I just didn't answer. In fact, I would have been proud to sign Chagall. But McNeil is okay for me. . . ."

Just before I left, David McNeil showed me a record with a picture of himself, serious in mien amidst the usual debris of beat kids, nudes, and scattering of instruments.

I translated one poignant lyric.

A Fairy came and tapped the boy with his wand. The parents could make him become anything. They chose to make him become Charlemagne. Then he falls off his horse. Now he will use a gun to see to it that his kid doesn't become victim to the same Fairy.

Moral: Don't trust a good Fairy.

In 1977, David's half-sister Jean, an intelligent, soft-spoken, introspective girl in her mid-thirties, reminisced to me at length about her years with Chagall. She recalled Sag Harbor and how Marc had

taken her for a walk ("the first and last time") and lifted her to his shoulders to protect her from a savage dog. "I didn't realize till much later that he was more frightened of dogs than I."

Later at High Falls Jean came to the studio and helped Chagall prepare grounds for gouaches. He had sketched her once in Sag Harbor and again in France, a bouquet with Jean lost in an enormous chair. At Orgeval she often went to the studio, climbing the high outside staircase to watch "papa" at work. At school she and David always used the name Chagall. "Once I took a brush and put a stroke of color on one of his paintings. So there's a work by Chagall with a slash of yellow by Jean."

She recalls the excitement in the house at the foundation of Israel, the toasts and songs. Ida was always warm and friendly and gave the children gifts. "But Orgeval already was a court. Venturi was an old dark man, Pierre Matisse a frequent visitor; later at Vence she knew Paloma and Claude, Picasso's children. She recalls Tériade's beautiful garden and Chagall always showing off his son. The grownups talked about art and Jean jested with Jacques Prévert.

Marc had a collection of art postcards. Once a week there was a session of showing these on an opaque projector. When Marc began doing pottery Jean also tried her hand. As Marc worked, his face assumed marvelous expressions, his lips moved, his body was strained. He wore floppy trousers, Canadian checked shirts and was as capricious as a child. He loved sweets. " '*Donnez-moi quelque chose de sucré pour ma bouche!*' I would never discuss anything serious with him. He always took it for granted that a woman would take care of him. Once when Virginia was away I served up hamburgers and mashed potatoes for Marc and some visitors. Chagall just took this for granted. I was very proud as a woman and terribly neglected as a child."

Even after their departure Chagall sent her gifts—art books, illustrated geographies—inscribed from "Ton Papà."

In the 1950s when Chagall had an appendix operation, Jean visited him at the hospital. Then in 1960, when David was staying with his father in Paris, Jean, after much effort, was allowed a visit. She was told "You can see your brother but you can't take him out." She called at the elegant Paris apartment and saw Marc Chagall "for five minutes but it wasn't the old Marc. From outside I phoned again to

take David for a walk and I was told that I was ill-mannered to insist.
"I've never seen Marc Chagall again."

In June 1973, following several preliminary trips by Ida, Marc
Chagall returned to Russia after an absence of fifty-one years. This
visit, widely publicized both in Europe and in the Soviet Union, was
the occasion for a number of bitter attacks in the Yiddish and Israeli
press. For Chagall's return to his "homeland" with its expected
accompaniment of cheers and tears occurred at the height of the
Soviet anti-Semitic and anti-Israel campaign when the Russians had
imposed an "emigration tax" on Jews wishing to leave the Soviet
Union for Israel—a form of legal governmentally organized blackmail.
I have already cited Chagall's letter to Lazar in response to these
attacks.

Again this is a case in which attachment to certain ideals proved
malleable under the pressure of other desires.

For years he had been attempting to convince the Soviet au-
thorities to ship some of his earliest works abroad for loan exhibitions.
At the last minute such permission has always been refused.

Hedrick Smith, then chief of the *New York Times* Bureau in
Moscow, has this report on the artist's visit:

> The return of Marc Chagall in 1973 after half a century in
> exile was an emotional homecoming that evinced all the passion-
> ate attachments of Slavic (sic) peoples to their native soil.
> When Henry Kamm, a *New York Times* colleague in Paris,
> saw Chagall after his visit, he found the Ukrainian-born (sic)
> Jewish painter positively radiant and rejuvenated. It seemed like
> the return of the prodigal. Before, Chagall had been read out of
> the family, ignored, not exhibited, even scorned as an antagonist
> of socialist realism. None of that had mattered now. Chagall
> was immensely flattered that the Soviets would want him,
> would show a few of his works that had been locked up in the
> vaults for decades, would ask him to sign the murals he had
> done for the old Jewish State Theatre. Back in Paris, buoyant
> and refreshed, he thrust a vase containing two dried bouquets
> under Kamm's nose and commanded: "Smell! Smell! No other
> flowers have that smell. I have not known it in fifty years."
> ... The passionate patriotism of the Russians contains not

only this deep and unwavering love of the homeland which Chagall, even as a Jew, shared. . . .

Part of the triumph was a poetry reading by Andrei Voznesensky in which there was a celebration in verse of the "return to Russia of Marc Chagall, so long a Soviet pariah. . . . The audience was deeply moved."

No doubt the artist was also deeply moved. But one cannot but wonder at Chagall's political naïveté. Even an alleged statement quoted in the French press a year after his visit to the effect that if he had to live his life all over again he would want to be a Communist failed to budge the Soviet authorities. Chagall's early paintings still remain locked up in the Fatherland.

For his ninetieth birthday on July 7, 1977, the cornucopia spilled over. Special celebrations were held all over France and the press and television were filled with pictures of smiling Chagall and his wife, Vava, and countless interviews were studded with the words *"amour"* and *"travaille,"* "chemistry" and the fire that had occurred at his birth. "Me, I do not understand Chagall"—the inevitable feint put off those who sought to trap the wary artist into an explicit explanation of his imagery.

And to a reporter from *Newsweek* who stirred up the ethnic waters with the question: "Do you consider yourself a Russian Jewish painter in terms of the original source of your artistic inspiration?" came the reply: "In art there is no nationalism. Russia is still in my heart. But without France I would not be Chagall." Curiously the Jewish component of the troika is missing.

On the Riviera there was a gala concert at which his friend and fellow Russian, the cellist Mstislav Rostropovich joined with violinist Isaac Stern, baritone Hermann Prey and flutist Jean-Pierre Rampal to sing or play in his honor. His Holiness Pope Paul VI sent a message.

Earlier that year President Giscard d'Estaing had pinned the Grand Cross of the Legion of Honor on Chagall's breast: the highest French decoration to be given to anyone but a head of state.

In October 1976, and again in June 1977, this astonishingly vigorous life-loving man had gone to Florence in connection with the official presentation of his gift of a 1945 self-portrait to the Uffizi

Gallery: a glowing poetic fawn's head against Notre Dame. On these visits he startled the *autorità* by bestowing kisses on flabbergasted Florentine officials not given to this brand of bizarre effusion.

On both these visits—the second to receive an official Italian equivalent of the Legion of Honor—the old man charmed the ladies, delivered himself of many subtle ironies and self-deprecating remarks, all interspersed with numerous expressions of "love"—love of Florence, love of Masaccio, ". . . and of your actions which radiate love." On these visits Chagall stayed at the Traballesi villa just outside Florence where special banquets were held in his honor, and where the silver-haired ebullient artist startled everyone by his lively wit and prowess with the *forchetta*—his still hearty appetite.

On October 17, 1977 the President of the French Republic came in person to inaugurate officially Chagall's exhibition at the Louvre. As the dainty, sprightly nonogenarian escorted the tall chief of state down those art-hallowed halls, did Marc Chagall recall his first arrival in Paris in 1910, when only the Louvre had served to convince him to remain in this strange foreign city "so far from Vitebsk"? Now the Louvre was honoring him with a show granted only to two other artists during their lifetime.

But Chagall, for all his protestations of being "a poor devil . . . I don't even know if I'm a painter," displayed an audacity in his Louvre show beyond either of his great predecessors. Braque in 1961 had not risked more than a selection; Picasso for his ninetieth birthday in 1971 showed eight old canvases dating from 1905 to 1945.

But Chagall, the timorous, dared to present sixty-two works, all painted since 1967!

The themes are familiar: in the background of *Job* (1975) a geometricized Christ recalls Cimabue; as the *Don Quixote* of the same year recalls the *Revolution*. But although the bulk of the work is reflex-painting, there are several unusual new formal probes: *Le Songe* and *La Rue du Village* (both of 1976) contain the novelty of bold dividing lines like cut paper between saturated color-fields; the impetus probably came from Chagall's collage try-outs for stained glass.

Thus, at this writing, Marc Chagall continues to enjoy life to the full and to work every day as if he were at La Ruche trying to make

his way. Major commissions these latter years have all been in the realm of stained glass or mosaic: most recently memorial windows for the late Mayor Richard Daley at the Art Institute of Chicago.

And if we examine the major achievements of the past quarter of a century, we find that although he now works for the most part in stained glass or mosaic, the basic vocabulary of forms has not changed. Inevitably with the years facility has replaced deep feeling. We find decorativeness and sweet, sometimes cloying color rather than the strong startling cacophonies of earlier periods.

But no matter how public the works, works in many cases resulting from the execution of commissions with assigned themes, nevertheless for Chagall the pictorial field is the deeply private, even secretive universe in which he works off his inner conflicts, finds a visual correlative for bodiless dreads and dreams.

Showing me the lyric windows of the Pocantico Church, the Reverend Marshall Smith illuminated the *Cherubim* window (the only window of the series lighted by artificial light controlled by a rheostat) and told me that only after almost ten years did he discover the Cross in the upper right-hand corner and this became the basis for a sermon entitled "Fractured Paradise." Obviously the Cross here, "hidden" as it were, was Chagall murmuring to himself—in a public work. Such "secrets" are to be found in all his works.

In fact, in a letter from Paris, April 27, 1965, regarding his own "explanations" for the Pocantico windows, Chagall writes that in every work of art, especially if it is intended for a holy place, there must always be present a large part of the mystery. "I believe that any special and detailed explanation of the content of a work of art by the artist himself takes away some of its value."

At the dedication of these windows, a reporter asked Chagall why he hadn't used for the *Daniel* window, Daniel in the lion's den. "Madame," he quipped, "Daniel was a visionary, not an animal trainer."

The Monumental Chagall is the early Chagall writ large. Unlike Picasso, this artist has not gone through sharply differentiated phases. Although a close reading of his *oeuvre* suggests to some critics a prewar Paris phase, a Revolutionary Russian phase, even a Gordes phase, fundamentally there has always been only the Chagall phase. His themes have remained unchanged whether they whirl on the

inner dome of the Paris Opéra or glow in the apse at Reims, the first dramatic vision to greet visitors entering that historic cathedral; or whether they are painted or stained glass or woven into tapestries, whether they are large or small, fundamentally Chagall has not modified the basic vocabulary of images and forms and colors he had already developed by the mid-twenties.

Consequently a detailed analysis of the monumental works he has achieved this past quarter of a century—and is continuing now— might well be left to historians of the particular rather than treated in a general biography.

Nor do I think it would be legitimate to deduce that the fixity, indeed obsessiveness, of Chagallian imagery is a symptom of artistic limitation. Many authors write but one book—sometimes in fifty volumes ostensibly on varying subjects. Thematics are frequently arrived at in one's youth or early manhood: the rest of one's life is rotating around that point: although the backdrops may change, media differ, and the circumference of the orbit become huge.

Chagall has had a few things to say and he has said them magnificently. Now he is saying them over and over; the master hand works on, as it were, automatically; we do not encounter in this case a Michelangelo of the *Nicodemus* or *Rondanini Pietà* or a Verdi of *Otello* and *Falstaff,* or a Beethoven of the last Quartets. That is to say, old Chagall has not revealed those astonishing renewals of late creativity, those inventions of new forms a half-century before their times. In the cases of Michelangelo and Beethoven, we feel that the suffering barrier has been breached: in his last works the artist has entered into a new realm of tranquillity beyond suffering; the *Heiliger Dankgesang* of Opus 132, the last two Pietàs.

But, although he has known his share of suffering—the death of Bella, the flight of Virginia, the years of privation and exile, his awareness of the Holocaust—Chagall's last twenty-five years have been, as he himself puts it: "a bouquet of roses."

But bouquets sniffed make decoration: bouquets embraced means pricking on thorns. And that draws blood . . . and art.

The zone between an artist's life and his art is an ambiguous terrain: we witness precise events through a fog of imprecision— everything is floating, looming, dwindling. This was true even in Vasari's day when art was visual in source and aim even if the

painted image inevitably passed through a prism of subjectivity.

But since modern art especially has more to do with interior than exterior vision, with psychology rather than optics, the life and art of certain artists—especially a Marc Chagall—cannot be separated. Chagall himself told Sutzkever that his paintings are his autobiography. Autobiography of his feelings, yes. But hardly a record of his actions in a long and dramatic life. Concealment is a basic motif in Marc Chagall: he hides in his pictures as he hides behind his elfin smile and winsome gestures. The lifelong obsession with certain images, sometimes the very style of the concealments, attempted or successful, and (less important) the very choice of subjects, the pictorial metamorphosis of "real" life—experienced or dreamed—into "painted" life all relate to biography. Having seen how the Tsadik ties his shoelaces, we are no less affected by his wisdom.

Dreamer and doer, pragmatist and poet, ironic sentimentalist, calculating somnambulist—Marc Chagall continues true to his own trajectory, chosen or willed, amazingly vital for his years, still flying.

Selected Bibliography

I list only those books and articles from which I have explicitly drawn. Following an initial category of general writings on Chagall and his times, the bibliography has been grouped under those chronological headings that convey a large sense of the major themes of that particular period in Chagall's life. Obviously, since all classification is *ex post facto,* a number of these works have served to stoke ideas and images for other periods as well as those under which they are listed. Wherever in the text I have used material from French, Yiddish, Spanish, or Italian sources, the translations are my own.

General Writings

Bucci, Mario. *Chagall.* Florence, 1970.
Canaday, John. *Mainstreams of Modern Art.* New York, 1962.
Cassou, Jean. *Chagall.* Paris, 1965.
Chagall, Marc. *Ma Vie.* Paris, 1931.
Cogniat, Raymond. *Chagall.* New York, 1965.
Crespelle, Jean-Paul. *Chagall: L'Amour, le Rêve et la Vie.* Paris, 1969.
Erben, Walter. *Chagall.* New York, 1957.
Gombrich, E. H. *Art and Illusion.* New York, 1960.

Haftmann, Werner. *Marc Chagall*. New York, 1973.

Hodin, J. P. *Modern Art and the Modern Mind*. Cleveland and London, 1972.

Jewish Museum. *Jewish Experience in the Art of the Twentieth Century* New York, 1976.

Jung, Carl G. *Man and his Symbols*. London, 1964.

Kramer, Hilton. *The Age of the Avant-Garde*. New York, 1972.

Malraux, André. *Les Voix du Silence*. Paris, 1952.

Meyer, Franz. *Marc Chagall*. New York and Cologne, 1961.

———. *L'Opera Grafica di Chagall*. Milan, 1957.

Neuman, Erich. *Art and the Creative Unconscious*. New York, 1959.

Ortega y Gasset, José. *The Dehumanization of Art*. New York, 1956.

Roditi, Edoard. *Dialogues on Art*. London, 1960.

Rosenberg, Harold. *The Anxious Object*. New York, 1964.

Roth, Cecil. *Jewish Art*. Rev. ed. by Bezalel Narkiss. New York, 1971.

Schneider, Daniel E., M.D. "A Psychological Approach to the Painting of Marc Chagall." *College Art Journal*, 1962.

Shneiderman, Samuel L. "The Crucifixion Theme in the Works of Marc Chagall." *Midstream*, New York. June–July 1977.

Stein, Leo. *Appreciation*. New York, 1947.

Sweeney, James Johnson. *Marc Chagall*. New York, 1957.

Venturi, Lionello. *Chagall*. Geneva, 1956.

Articles on Chagall in the *Jewish Daily Forward* (in Yiddish), New York. July 26 and 29, 1974; August 1 and 7, 1974; April 29, 1975; May 7, 1975.

Vitebsk 1887–1906

Aleichem, Sholem. *Jewish Children*. New York, 1922.

———. *The Old Country*. New York, 1946.

Chagall, Bella. *Lumières Allumées*. Paris, 1973.

Hebrew Literature. In Talmudic Treatises, "The Cabala." New York, 1901.

Howe, Irving. *World of our Fathers*. New York, 1976.

———. *The Jewish People Past and Present*. New York, 1946.

Malkin, M., and Yudavin, S. *Yiddische Volks Ornamenten*. Vitebsk, 1920.

Minkin, Jacob S. *The Romance of Hassidism.* New York, 1935.
Samuel, Maurice. *Prince of the Ghetto.* New York, 1948.
Schwob, René. *Chagall et l'Ame Juive.* Paris, 1931.
Shulman, Abraham. *The Old Country.* New York, 1974.
Singer, Isaac Bashevis. *In My Father's Court.* New York, 1948.

St. Petersburg 1906–10

Arts of Russia. World Publishing. New York, 1970.
Biely, André. *St. Petersburg.* New York, 1959.
Dawidowitz, Lucy. *The Golden Tradition.* New York, 1967.
Rubissow, Helen. *The Art of Russia.* New York, 1946.
Slonim, Marc. *From Chekhov to the Revolution.* New York, 1953.
Sutton, Denys. "The Tsar of Ballet." In *Apollo* Magazine, October, 1969.

Paris 1910–1914

Apollinaire, Guillaime. *Alcools.* Paris, 1920.
———. *Le Guetteur Mélancolique.* Paris, 1952.
Cendrars, Blaise. *Au Coeur du Monde.* Paris, 1947.
———. *Du Monde Entier.* Paris, 1947.
———. *Prose du Transsibérien.* Paris, 1913.
Chapiro, Jacques. *La Ruche.* Paris, 1960.
d'Ancona, Paolo. *Modigliani, Chagall, Soutine, Pascin.* Milan, 1952.
Ehrenburg, Ilya. *Les Années et les Hommes.* Paris, 1962.
Gide, André. *Anthologie de la Poesie Française.* Paris, 1949.
I Futuristi, Anthology of Italian Futurist Poets. Milan, 1960.
I Maestri del Colore. Issues on Chagall, Modigliani, Soutine, Miró. Fratelli Fabbri: Milan, 1966.
L'Arte Moderna. No. 29. Fabbri Editori: Milan, 1967.
Mellow, James R. *Charmed Circle: Gertrude Stein and Company.* London, 1974.
Michaud, Régis, ed. *Vingtième Siècle.* New York and London, 1933.
Modigliani, Jeanne. *Modigliani Senza Leggenda.* Florence, 1961.
O'Brian, Patrick. *Picasso.* New York, 1976.
Roditi, Edouard. "Les Peintres Russes de Montparnasse." In *Kikoine,* Paris, 1972.
Salmon, André. *La vie passionée de Modigliani.* Paris, 1957.
Soffici, Ardengo. *Scoperte e Massacri.* Florence, 1929.

Szittya, Emile. *Soutine et Son Temps.* Paris, 1955.
t'Serstevens, M. *L'homme que fut Blaise Cendrars.* Paris, 1977.

Berlin 1914

1913 Armory Show. 50th Anniversary Exhibition catalogue. New
 York, 1963.
I Maestri del Colore. Issues on Munch, Kirchner, Max Ernst, Gauguin,
 Kandinsky. Fratelli Fabbri: Milan, 1966.
Mehring, Walter. *The Lost Library.* Indianapolis, 1951.

Russia 1914–22

Babel, Isaac. *Collected Stories.* New York, 1952.
Baron, Hans. *Russian Jews Under the Soviets.* New York.
Birnholtz, Alan C. "The Russian Avant-Garde and the Russia
 Tradition." *Art Journal,* College Art Association, Winter, 1972–3.
Bowlt, John E. "Malevich's Journey into the Non-Objective World."
 Art News, New York, December, 1973.
Egbert, Donald Drew. *Social Radicalism and the Arts.* New York,
 1970.
Fischer, Louis. *Men and Politics.* New York, 1941.
–––. *The Life of Lenin.* New York, 1964.
Fitzpatrick, Sheila. *The Commissariat of Enlightenment.* Cambridge,
 1970.
Gray, Camilla. *The Russian Experiment in Art: 1863–1922.* London,
 1962.
Miele, Franco. *L'Avanguardia Tradita.* Rome, 1965.
Trotsky, Leon. "Literature and Revolution" (in *Soviet Russian
 Literature,* 1917–1950) Norman, Oklahoma, 1951.

Berlin 1922–23

Aronson, Boris. *Marc Chagall.* Berlin, Russian ed., 1923; Yiddish ed.,
 Berlin, 1924.
Debenedetti, Elisa. *I Miti di Chagall.* Milan, 1962.
Der Querschnitt. Berlin (all issues, 1922, 1923, 1924).
Gay, Peter. *Weimar Culture.* New York, 1968.

Kinser and Kleinman. *The Dream That Was No More a Dream (Germany 1890–1945)*. Cambridge, Massachusetts, 1969.
Kokoschka, Oskar. *My Life*. London, 1974.

France 1923–41

Alberti, Rafael. *Prosas Encontradas*. Madrid, 1970.
Anthonioz, Michel. *Omaggio a Tériade*. Naples, 1976.
Aragon, Louis. *Les Yeux d'Else*. Paris, 1948.
Arnheim, Rudolf. *The Genesis of a Painting*. California, 1962.
Berger, John. *Success and Failure of Picasso*. Middlesex, England, 1965.
Cahiers d'art. Paris, 1930–31.
Der Querschnitt. Berlin (all issues, 1930, 1931, 1932).
Draper, Theodore. *The Six Weeks War*. New York, 1944.
Gogol, Nicolai. *Dead Souls*. London, 1948.
Jean Paulhan à travers ses peintres. Paris, 1974.
Malraux, André. *Picasso's Mask*. New York, 1976.
Maritain, Raissa. *Chagall: ou, l'orage enchanté*. Geneva 1948
———. *Les Grandes Amitiés*. Paris.
McMullen, Roy, and Bidermanns, Iziz. *The World of Marc Chagall*. London, 1968.
Miller, Henry. *Peindre c'est aimer à nouveau*. Paris, 1962.
Vollard, Ambroise. *Souvenirs d'un Marchand de Tableaux*. Paris, 1937.

United States 1941–48

Bing, Rudolf. *The Memoires of Sir Rudolf Bing*. New York, 1972.
Cahiers d'Art. Paris, 1945–46.
Goll, Claire. *La Poursuite du Vent*. Paris, 1976.
Kernan, Julie. *Our Friend, Jacques Maritain*. New York, 1975.
Sweeney, J. J. "An Interview with Marc Chagall." *Partisan Review* #1, Winter, 1944.

France 1948–52 (Israel 1951 with references to the 1931 trip)

A testimony volume for Abraham Sutzkever's Fiftieth Birthday. [in Yiddish] Tel Aviv, 1963.
Di Goldene Keyt [Yiddish periodical]. Histadrut: Tel Aviv, Issue 60 (1967), 70–80 (1973).

Gazith [Art and Literary Journal in Hebrew]. No. 231–236 (June–November, 1962) and 337–340 (April-July, 1972), Tel Aviv.

Gilot, Françoise, and Lake, Carleton. *Life with Picasso.* New York, 1964.

Lazer, David. *Encounters on both Sides of the Curtain* [in Hebrew]. Masada Press: Israel, 1968.

———. *Essays and Profiles* [in Hebrew]. Masada Press: Israel, 1971.

Mintz, Ruth Finer, ed. *Modern Hebrew Poetry.* California, 1968.

Sutzkever, Abraham. *Di Fidlroyz.* [Poems 1970–72, in Yiddish], with drawings by Marc Chagall. Tel Aviv, 1974.

Valéry, Paul. *The Marine Cemetery,* trans. Sidney Alexander. Florence, 1949.

Vence, St. Paul 1952–Present

Amishai, Ziva. "Chagall's Jerusalem Windows." *Scripta Hierosolymitana.* Vol. XXLV, pp. 146–83, Jerusalem, 1972.

Berenson, Bernard. *Sunset and Twilight.* New York, 1963.

Foster, Joseph S. *Chagall: Posters and Personality.* New York, 1966.

Genauer, Emily. *Chagall at the "Met."* New York, 1971.

Greenberg, Clement. "Chagall." *Commentary,* New York, March, 1957.

Lassaigne, Jacques. *Ceiling of the Paris Opera.* New York, 1966.

———. *Munch: Unpublished Drawings.* Geneva, 1968.

Leymarie, Jean. *The Jerusalem Windows.* New York, 1967.

———. *Work on Paper.* Preface by Thomas M. Messer. Washington, D.C., 1975.

Male, Emile. *The Gothic Image.* New York, 1958.

Marc Chagall, a Celebration. Pierre Matisse Gallery, New York, 1977.

Musée National Message Biblique Marc Chagall. Nice, 1973.

Sanminiatelli, Bino. "Mi Dico Addio." *Diario, 1941–58.* Florence, 1959.

Schapiro, Meyer. "Chagall's Vision of the Old Testament." *Harper's Bazaar,* New York, November, 1956.

———. "La Bible de Chagall." *Verve,* 8: Nos. 33–34, Paris, 1956.

Smith, Hedrick. *The Russians.* 1976.

INDEX

501

Fierens, Paul, 294
Figaro, Le (newspaper), 240
Filosofov, Dimitry, 89
Fine Arts, School of, 209
Finkelstein, Louis, 346
Firebird (Stravinsky), 93, 114
 Chagall's sets for, 379-80, 384, 392, 481
First Duma (May 1906), 49, 54, 61, 86, 87
First German Autumn Salon (1913), 155-57
"First Meeting, The" (B. Chagall);
 from *Burning Lights,* 67-74
First State Exhibition of Revolutionary Art
 (1919), 201-2
First World War, *see* World War I
Fischer, Louis, 236
Fishermen at Antibes (Picasso), 323
Fishes at St.-Jean, The (Chagall), 400
Flaubert, Gustave, 435
Fleg, Edmond, 302
Flore, Café de, 315
Flowers in Mourillon (Chagall), 276
Flying Sleigh, The (Chagall), 376
Fokine, Mikhail, 114
Fornarina, the (Raphael's mistress), 295
Forward (newspaper), 377, 475
Four Seasons, The (restaurant), 344
France
 Phony War in, 321-22, 331, 335, 349, 390
 See also specific French cities
Francesca, Piero della, 35, 431
Francis, St., 309
Franz Meyer-Ida Chagall catalogue, 81
Fraumünster (church), Chagall's stained glass
 work for, 463, 475, 477
Free Academy, 44
Free French movement, 336, 338
French Communist Party, 316-17, 320
Freud, Sigmund, 33, 201, 278, 288
Frey, Varian (member of Emergency Rescue
 Committee), 323, 327
Fried, Ted, 351-52
From the Moon (Chagall), 134
Front Populaire, *see* Popular Front
 government
Fujita, 121, 281-85
Funeral, The (Chagall), 84
Furtseva, Madame, 240
Furtwängler, Wilhelm, 249
Futurism
 in Chagall's graphics, 270
 Italian, 135, 144

See also Russian Futurism

Gabo, Naum, 193, 285, 345
Gabo, Pevsner, 285
Gargallo (artist), 285
Gauguin, Paul, 89, 153, 337, 484
Gazith (journal), 428
Gedali (Babel), 185-86
Genauer, Emily, 380, 450
Genesis cycle, Chagall's plates for, 305
George, Waldemar, 258, 294
German Expressionism, 153, 199, 247-48,
 260, 291
 Chagall and
 Chagall as precursor of, 312
 Chagall's affinities with, 251
 in *Synagogue at Safed,* 304
 end of, 269
 Walden as spokesman for, 157
Gershwin, George, 280, 283
Gerzenstein, 61
Gide, André, 112, 195, 284
Gilot, Françoise, 432-34, 440
Giotto di Bondone, 22, 144, 164, 403, 410
Girard (artist), 119
Giscard d'Estaing, Valéry, 489
Glatstein, Jacob, 421
Gleizes, Albert Léon, 105, 129, 139
Glinka, Mikhail, 90
Gobelins Manufacture, 406
Gogol, Nikolai, 125, 221, 272, 470
Goldberg (lawyer), 59, 85
Goldberg, B. Z., 350
Goldberg, Leah, 268
Goldberg, Marissa, 350
Goldberg, Mrs. B. Z., 365
Golden Fleece group, 198
Goldene Keyt, Di (The Golden Chain;
 journal), 419, 424, 463, 466, 467
Golgotha (Dedicated to Christ; Calvary;
 Chagall), 51, 155-56, 311, 316, 352,
 476
Goll, Claire, 268, 326, 392
 on birth of Dada, 278
 at I. Chagall's eighth birthday, 275
 and death of B. Chagall, 363, 365
 joins French Communist Party, 320
 Léger and, 354
 V. McNeil's rupture with Chagall and, 448
 Mondrian and, 340
 in New York City, 334-41